American
Art in
The Newark
Museum

Cover:

Johann Jenny (attributed)
The House and Shop of David Alling ca. 1840-50
Oil on canvas 20½″ x 30″
39.265

American Art in The Newark Museum

Paintings, Drawings
and Sculpture

Research and publication
partially supported
by the National Endowment
for the Arts

The Newark Museum
Newark, New Jersey
1981

©1981 The Newark Museum
Published by The Newark Museum
49 Washington Street
P.O. Box 540
Newark, New Jersey 07101

Designed by Johnson & Simpson,
Newark, New Jersey

Printed by Craftsman Printing Co.,
Charlotte, North Carolina

Type set by Precision Graphics,
Pennsauken, New Jersey

Photographs of objects from the
collection were taken by Armen
Photographers, Stephen C. Germany
and Bill Witt. *Greek Slave* color
photograph by Jerry L. Thompson.

**Library of Congress Cataloging
in Publication Data**

Newark Museum.
American art in the Newark Museum.
Bibliography: p.
Includes indexes.
1. Art, American — Catalogs.
2. Art — New Jersey — Newark — Catalogs.
3. Newark Museum — Catalogs.
I. Title.
N6505.N48 1981 709′.73′074014932 81-18765
ISBN 0-932828-05-1 AACR2
ISBN 0-932828-06-x(pbk.)

Contents

Foreword

It gives me a sense of pleasure and satisfaction to present this volume to the general public and to scholars. This is the first publication documenting The Newark Museum's collection of American art in almost 40 years, during which time the size of the collection has tripled and it has attained deserved recognition for its quality and the breadth of its coverage.

Founder John Cotton Dana's insistence on the importance of collecting living American artists has given us a great legacy. Subsequent directors and curators have built well on that foundation, adding to it the necessary documentation of America's aesthetic development and the historical growth of American taste.

The Museum is fortunate to receive its operating budget from the City of Newark, the State of New Jersey and the County of Essex. Since its acquisitions funds are limited to membership contributions and small endowments, we are especially grateful to those donors who, over the years, have helped to build our collections by contributing their own treasures to enrich ours. In so doing, they have also confirmed their faith in the future of this institution.

There have been many generous contributors to this work. Of those giving of their expertise and time I wish to single out only a few who have made major efforts toward physical completion of the project. Former Curator Susan Solomon began the paintings section and continued work on it long after leaving the Museum. Curator Fearn Thurlow was entirely responsible for the sculpture section and has reviewed the total compilation. Volunteers Celeste Penney and Alberta Helms have endured hundreds of hours of tedium with cheerfulness and humor and their work has been invaluable. Both my assistant, Wilmot T. Bartle, and Mary Sue Sweeney, Publications Supervisor, have carried the project forward and have coordinated the efforts of the many hands involved to produce this finished work.

The donors of the funds which have enabled us to achieve publication deserve our deepest and enduring gratitude. Grants in 1972 and 1978 from the National Endowment for the Arts provided for preliminary research and for a partial match towards printing. The remainder of the design and printing budget was contributed by the following:

Mr. & Mrs. Wilmot T. Bartle

Mr. Abe Becker

Mr. & Mrs. Herman L. Braun

Chubb & Son, Inc.

The Geraldine R. Dodge Foundation

Engelhard Minerals & Chemicals Corporation

The E. J. Grassman Trust

International Business Machines Corporation

Mr. Robert Riggs Kerr

F. M. Kirby Foundation

The Philip & Janice Levin Foundation

The George A. Ohl Trust, through the First National State Bank

The Florence & John Schumann Foundation

The Hon. Esther K. Untermann

Samuel C. Miller
Director

Acknowledgements

The Painting and Sculpture Collection of The Newark Museum is predominantly an American collection. The last American catalogue, long out of print, was a selective one compiled by Holger Cahill and members of the Museum staff in 1944. Supplements have appeared from time to time as issues of the Museum's quarterly publication. These were augmented by surveys in 1959 and 1969 and by occasional exhibition catalogues and checklists.

This present publication covers the bulk of the department's collection acquired in the seventy years since the founding of The Newark Museum in 1909.

Essential to the production of this volume have been the services of former Curator Susan G. Solomon, who initiated the project and researched a major part of the painting collection, and Celeste Penney, a Newark Museum volunteer who effected its final compilation while also carrying out extensive research assignments.

Former Curator William H. Gerdts provided initial direction and extensive information as well as mid-passage review for the sculpture section. The assistance of Lewis Sharpe of the Metropolitan Museum of Art and Wayne Craven and his successors on the Index of American Sculpture at the University of Delaware is gratefully acknowledged.

The following libraries and their staff members have been particularly helpful: William Dane and Joan Burns of the Art Department and Charles Cummings of New Jersey Reference at the Newark Free Public Library; Mary Schmidt of the Marquand Library, Princeton University; Special Collections, Rutgers University; Art and Architecture Department, New York Public Library; Frick Art Reference Library; The New York Genealogical and Biographical Society.

Volunteer researchers and proofreaders included Cheryl Harper, Alberta Helms, Diane Pietrucha, Mary Chris Rospond, Mark Savitt, Donna Schaeffer, Judith Seidel, Janet Lax Toledano and Alex Ward.

From the Museum staff special thanks are due to Registrar Audrey H. Koenig, her secretary Ruth Barnet, who typed the manuscript, Assistant Librarian Helen Olsson and Curatorial Secretary Lois O'Brien.

Countless art historians, curators, dealers, donors, collectors and artists have answered inquiries. The names of many appear under the individual listings and in the bibliography. We regret that all whose help is so greatly appreciated cannot be listed.

Generally speaking, undocumented information is supported by correspondence and curatorial notes in the files of the Museum's permanent collection.

Fearn C. Thurlow
Curator of Painting and Sculpture

All gifts or bequests of J. Ackerman Coles or Emilie Coles were from the "J. Ackerman Coles Collection." All gifts or bequests of Joseph S. Isidor or Rosa Kate Isidor were from the "Joseph S. Isidor Collection."

History of the Painting and Sculpture Collection

Fearn C. Thurlow
Curator of Painting and Sculpture

The founding director of The Newark Museum, John Cotton Dana, was an innovative thinker and doer in the tradition of John Dewey. Since the Dana years (1909-1929), the Museum has continued its devotion to education and service to the community while encouraging the growth of American art and design. Frequently changing exhibitions, selected with care and intended for informative display, were among Dana's requirements, as was the emphasis on American works for the Painting and Sculpture Collection.[1] Twenty years after the founding of the Museum and at the end of his life, Dana summed up this policy: "...The museum of the city is no longer to be simply an object lesson on the achievement of artists, designers, and artisans of other countries and other times; but aims to be-

come, also, a stimulant to improvement in the arts as practiced in our city and our land today and tomorrow."[2]

The Museum was first housed in the Newark Free Public Library, which John Cotton Dana also headed, moving to its present location on former Marcus L. Ward property in 1926, into a new building given by Louis Bamberger. The site includes a walled garden, the historic Ballantine House and its Addition Building, a former insurance company office, which extends along the north side of the Garden.

Although space was limited, the collection had its beginnings at the Library location. Through loans from such galleries as Montross, Macbeth, Kraushaar

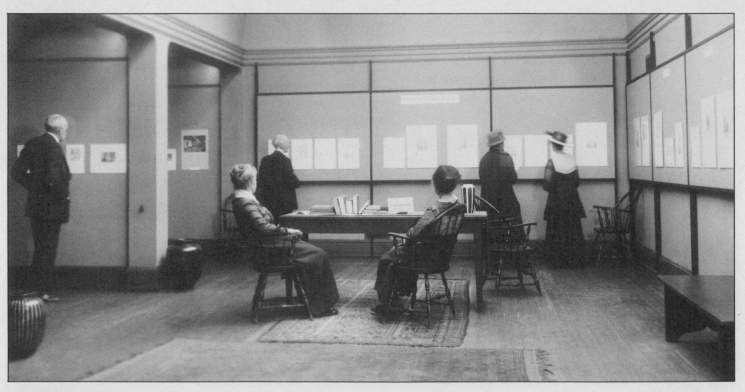

An exhibition of wood engravings by Rudolph Ruzicka in the Newark Museum gallery in the Newark Free Public Library, 1917.

and Grand Central, and organizations including the Society for Independent Artists and the National Sculpture Society, Dana arranged yearly exhibitions of contemporary American artists from which, with limited funds, a few works were purchased. "The Eight" were shown with some frequency and, in 1910, a painting of the Harlem River by Ernest Lawson was one of the first acquisitions. Well-known artists such as Childe Hassam were given one man shows but so, also, were such little-known modernists as Max Weber and John Marin.

"Art has always flourished where it is asked to flourish, and never elsewhere." Dana wrote in 1914, "and if we wish for a renaissance of art in America we must be students and patrons...".[3] This program was dramatically encouraged by the generosity of Mr. and Mrs. Felix Fuld. Between 1925 and 1928, thirty-nine contemporary works had been purchased with funds which the Fulds had given jointly or separately. One gift alone provided for the purchase of twenty works by sixteen artists including Lachaise, Bellows, Glackens and duBois.

Nineteenth century America was not neglected. By gift and bequest J. Ackerman Coles donated in 1920 and 1926 many works, including the Kensett *Paradise Rocks*, the important *Arch of Titus* by Healy, McEntee and Church, and paintings by S.F.B. Morse, William Tylee Ranney, Jasper Cropsey, Asher B. Durand and Albert Bierstadt. Another large important group came from the Marcus L. Ward Bequest, including family portraits by Lilly Martin Spencer and T. Buchanan Read. In 1926 Franklin Murphy, Jr., gave the keystone of the significant 19th century marble collection, the celebrated *Greek Slave* by Hiram Powers.

The original policy, which continues to this day, was to accept gifts of American and foreign

1. The Painting and Sculpture Collection is one of six art collections in The Newark Museum. The others are: Oriental, Decorative Arts, Classical, Ethnological, Coins and Medals. The Museum is a general one and there are also collections of the natural sciences and industrial objects.

2. John Cotton Dana, "The Museum as an Art Patron," *Creative Art*, 4, no. 3 (March 1929), p. xxv.

3. John Cotton Dana, *American Art: How it can be Made to Flourish*, The Hill-of-Corn Series, no. 1 (Woodstock, Vt.: The Elm Tree Press, 1929), p. 30.

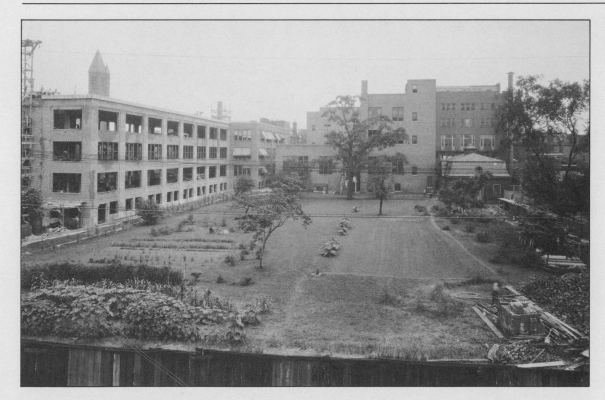

The Museum Garden, 1926: Addition Building (left), Main Building (center) and Marcus Ward carriage house (right).

art on a selective basis and to restrict purchases to works of American origin. The only exception was European bronzes, in which Dana had a great interest. Purchase funds at The Newark Museum come from private sources, except for recent matching purchase grants from the National Endowment for the Arts and its predecessor, the National Council on the Arts. The Felix Fuld and the Thomas L. Raymond Bequest Funds, two major sources for acquisition funds, were both established by 1929.

Dana's concern with craftsmanship, demonstrated in part by his acquisition of contemporary bronzes, contributed to his interest in Folk Art. It was not until just after his death in 1929 that two seminal Folk Art exhibitions, the first museum exhibitions of this genre in the country, were shown at The Newark Museum. Gifts and purchases from these shows established the Folk Art collection which now numbers some one hundred and fifty folk paintings and sculptures. Other objects, such as quilts, are in the Decorative Arts Collection.

John Cotton Dana was succeeded by his assistant Beatrice Winser. By 1944, when the Holger Cahill catalogue was published, additional bequest funds of great importance had been received from Wallace M. Scudder (1932), Sophronia Anderson (1938-39), John J. O'Neill, Jr. (1942) and from Louis Bamberger and his sister Mrs. Felix Fuld (1944).

By 1944 gifts and purchases, including works by Inness, Eakins and Cassatt, had enlarged the 19th century painting collection. Contemporary works purchased at that time included paintings by Alexander Brook, Charles Burchfield, William Gropper, Marsden Hartley, Edward Hopper, Charles Sheeler and Stuart Davis (who had had his first museum showing here in 1925). Gifts and bequests of works by contemporary artists included paintings by Davis, Arthur B. Davies, Childe Hassam, Maurice Prendergast and Florine Stettheimer. The Arthur F. Egner Memorial Fund provided for the purchase of works by Charles Demuth, Lionel Feininger, Isabel Bishop and Reginald Marsh. Arthur Egner, a noted collector of

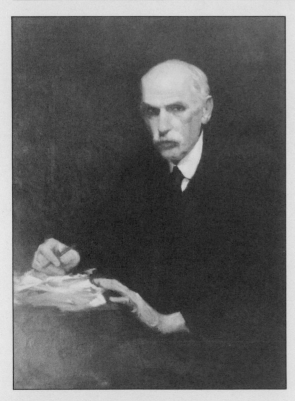

Portrait of John Cotton Dana, 1923 by Douglas Volk

The Newark Museum, main entrance, 1965.

contemporary American art, was President of the Board of Trustees of the Newark Museum Association when the celebrated five-panel work, *New York Interpreted,* by Joseph Stella entered the collection. The series was purchased with funds from the Felix Fuld Bequest.

With the advent of World War II, the WPA Federal Art Project officially closed and works commissioned under its jurisdiction for relief of artists during the Depression years were distributed to museums throughout the country. Apart from a very large number of prints, numerous works from the Easel, Mural and Sculpture divisions were received by The Newark Museum, among them paintings by Karl Knaths, Karl Zerbe and Louis Guglielmi. The most notable WPA sculpture acquired through this distribution was the large aluminum *Flight* by Jose de Rivera, commissioned for, but never installed at, the Newark Airport. The piece was lent temporarily to the Newark Airport (in 1979-80), in honor of the opening of its new facilities.

By 1944, the sculpture collection, in addition to the previously mentioned Powers and de Rivera works, included nineteenth century pieces by Ives and John Rogers; Beaux Arts period examples by Gutzon Borglum, Augustus Saint-Gaudens and Daniel Chester French, and contemporary work in the traditional idiom by Anna Hyatt Huntington and Mahonri Young. The "Moderns" included William Zorach and Reuben Nakian.

Early examples of Black artists in the collection were paintings by Hale Woodruff and Henry Ossawa Tanner, a pastel by Beauford Delaney and a drawing by Charles White.

A second important historical ethnic section was created by Miss Amelia White's gift in 1937 of a large group of watercolors by American Indians of the Southwest. This important collection, supplementing earlier purchases for the Museum by Holger Cahill in 1928, was finally exhibited in its entirety along with objects from the Ethnology collection in 1977.

Paintings by William Baziotes, Byron Browne and Peter Hurd were part of a large gift from Mr. and Mrs. Milton Lowenthal in 1949. The Cora L.

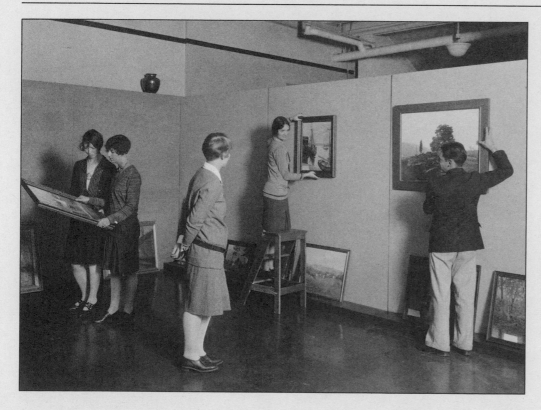

Museum Apprentices hanging an exhibition of works by the Outdoor Sketch Club, 1929.

Hartshorn Bequest in 1958 included paintings by Georgia O'Keeffe, Oscar Bluemner, Marsden Hartley, Yasuo Kuniyoshi and Arthur B. Carles.

By the 50th birthday of the Museum in 1959, nineteenth century additions of note included paintings by Jasper Cropsey, John Singer Sargent and the trompe-l'oeil masters J. F. Peto and William Harnett. Gift funds from Dr. and Mrs. Earl LeRoy Wood provided for the purchase of a James Peale still life. A portrait of the actress Linda Dietz by William Merritt Chase was purchased with funds from the Carl and Dorothy Badenhausen Foundation. *Mathilde and Robert* by Mary Cassatt, the keystone work *Arch of Nero* by Thomas Cole, and an additional work by Inness were added to the collection. Eighteenth century examples acquired in this period included a major Ralph Earl portrait, a small Benjamin West oil and, through The Members' Fund, John Singleton Copley's portrait of *Mrs. Joseph Scott* and John Wollaston's *New York Family Group.* A 1922 gift, *Imaginary Landscape,* was reattributed to William Williams, and a Rembrandt Peale descendant, Miss Carol Wirgman, gave a large group of paintings and sketches by various members of the Peale family. In 1949 the Joseph S. Isidor Collection of small paintings and miniatures, many of them American, came by bequest from Mrs. Rosa Kate Isidor, adding to her husband's previous bequests of twentieth century American sculpture.

The Folk Art collection, based on the nucleus of Herbert Ehlers's 1924 gift, *Captain Jinks,* and objects acquired from the 1929-31 exhibitions, was increased by purchases and gifts, among them *The Grave of William Penn* by Edward Hicks, gift of Mr. and Mrs. Bernard M. Douglas, and two Micah Williams pastel portraits.

Among twentieth century sculptures entering the collection

The American Painting and Sculpture exhibition, 1944-45, included the Arch of Titus, the Greek Slave and Captain Jinks.

by 1959 were a Calder mobile and pieces by Louise Nevelson and Sidney Gordin. Major nineteenth century examples were the rare and important plasters, studies by Thomas Eakins for his painting *William Rush Carving His Allegorical Statue of the Schuylkill*, given by Mr. Gerald Lauck.

Ten years later, in 1969, the Museum publication *Survey 60* recorded the collection's growth through the last years of Miss Coffey's term and the beginning of Samuel C. Miller's directorship. Notable additions of monumental American sculpture for installation in the Museum and Garden included works by David Smith, purchased with funds given by the Charles Engelhard Foundation, and James Rosati, acquired under a grant allocated by the National Council on the Arts. A large environmental work by George Segal was also purchased through the National Council on the Arts. The Museum acquired paintings by Wayne Thiebaud, Hans Hofmann, Josef Albers and Morris Graves, as well as examples from the historical twentieth century by I. Rice-Pereira, Adolf Gottlieb and Reginald Marsh.

To continue strengthening the Colonial and Federal period representation in the collection the portrait of *Mercy Hatch* by Gilbert Stuart and those of *Colonel Elihu Hall* and *Mrs. Hall* by Charles Willson Peale were purchased through The Members' Fund. Additional works by the Peale family — James, Raphaelle and Rembrandt — were acquired, thanks to Mrs. Engelhard, The Members' Fund and Mr. and Mrs. Orrin June. Mr. and Mrs. June also gave paintings by Whittredge, Buttersworth, Trumbull, Dunlap and Cropsey. The important Fitz Hugh Lane *The Fort and Ten Pound Island, Gloucester* from Mrs. Chant Owen and the large early Blakelock, *Western*

A gallery talk about Joseph Stella's <u>New York Interpreted</u>, *1944.*

Landscape, from the Newark and Essex Bank were important gifts of the decade. *At the Cabin Door*, a strong Winslow Homer of the Civil War period, was given by the Corbin family in memory of their parents. A major western landscape by Albert Bierstadt and *The Trout Stream*, a New Jersey landscape by George Inness, also entered the collection. Two works by William Rinehart were added to an already fine group of nineteenth century marble sculpture.

The Folk Art collection continued to grow in the sixties. Notable additions were *The Three Cummins Children*, given by Dr.

and Mrs. Earl LeRoy Wood, and purchases of an Ammi Phillips portrait and a handsome nineteenth century ram weathervane.

Interest in New Jersey artists had been strong since the Dana years. Purchasing from invitational and juried state shows continued under a program initiated in the fifties. Paintings by Richard Anuszkiewicz, Darby Bannard, Leon Kelly and Lee Gatch were among acquisitions from artists living or working in the state during the sixties. A significant group of Gatch works has continued to be assembled over the years since the purchase of *Pueblo Strata* in 1965.

The most recent acquisition of works by New Jersey artists has included paintings by Clarence Carter, Joseph Konopka, John

Goodyear and Adolf Konrad and sculpture by George Segal and the late Tony Smith.

In the 1970's, emphasis was placed on the purchase of Colonial and Federal painting, Folk Art, twentieth century abstraction and monumental contemporary sculpture to accompany the pieces by James Rosati and David Smith in the garden.

The most outstanding acquisition of the decade was the three-quarter length *Portrait of Catherine Ogden* of Newark (ca.

Turn of the Century exhibition, 1976-77.

1730) by Pieter Vanderlyn (The Gansevoort Limner). It joined the magnificently documented *Portrait of The Rev. Ebenezer Turell* (1732) by John Smibert and the *Portrait of Isabel Taylor* (ca. 1805) by Joshua Johnston. An eighteenth century work of great importance was William Williams' *Mary Magdalene,* a notable gift from former curator William H. Gerdts.

Nineteenth century purchases included the trompe-l'oeil *Clock* by John Haberle for the still life collection and *Sheep In a Landscape* by Susan Waters, the Bordentown artist.

Among gifts in this period were *Yosemite Falls* by William S. Jewett from Mrs. Charles W. Engelhard and the impressive turn-of-the-century *Gloucester Harbor* by Childe Hassam from Mrs. Russell Parsons. A Paris scene by Hassam was an innovative joint gift to The Newark Museum and the New Jersey State Museum from Mrs. Robert D. Graff.

Nineteenth and early twentieth century sculptures were augmented by the gift from James C. Ricau of a large marble by Joseph Mozier and the purchase of a bronze reduction of Gutzon Borglum's *Seated Lincoln,* the original of which is in front of the Essex County Courthouse in Newark. Mrs. J. Phelps Stokes gave a work by Borglum's brother, Solon, and a casting of *The Hands of Robert and Elizabeth Barrett Browning* (1853) by Harriet Hosmer.

After an exhibition of the Museum's Folk Art collection in 1974, this aspect of our holdings grew by the purchase of Pennsylvania and New Jersey frakturs, a Schimmel eagle and a twentieth century *Dragonfly* weathervane. A gravestone sculpture by the twentieth century Black stonecutter, William Edmondson, was also purchased with funds given in part by Mrs. René Pingeon. Gifts included a large group of nine-

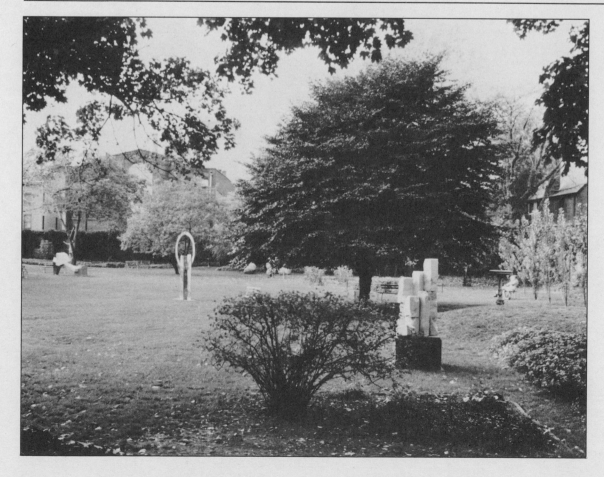

The Sculpture Garden includes works by (left to right) James Rosati, David Smith and Philip Pavia.

teenth century naive paintings from Miss Margaret Kinnane, a carpenter's weathervane, a jeweller's trade sign and a number of decoys.

The representation of Black artists in the collection has grown over the years. In 1971, the exhibition *Black Artists: Two Generations* recreated in part a 1944 show. Purchases from the 1971 exhibit were the impressive *Monument to Malcolm X* by Barbara Chase-Riboud, *Dream*, a collage by Romare Bearden, and

works by Ben Jones, William Hutson and Vincent Smith. With funding from the Prudential Insurance Company of America, the Museum also selected a travelling show from this exhibition. Since that time, drawings by Edward Bannister and the contemporary Francis Lebby have been added, as well as the above-mentioned Joshua Johnston and William Edmondson. Additional development of this group will continue.

The 1971 bequest from Niles Spencer's widow of 31 paintings and studies for paintings added significantly to the Museum's holdings of historic art material from the 1920's through the fifties and was the impetus for a Spencer retrospective exhibition. The following year Mrs. Spencer's sister, Mary Brett Reffelt, and nephew, Christopher Harrington,

added to the bequest a gift of 29 drawings, in addition to other archival material.

Geometric Abstraction, a 1978 exhibition of abstract artists, added impetus to acquisitions which had begun early in the seventies, with the purchase of a painting by Ralston Crawford and an oil by Burgoyne Diller, complementing a previously owned wood construction. Later purchases included paintings by Alfred Maurer, Jean Xceron, Charles Shaw, Paul Kelpe and Alice Trumbull Mason. Of the highest significance were a

The 1963 triennial exhibition of <u>Work by New Jersey Artists.</u>

sculpture by John Storrs and a Theodore Roszak from the 1930's. An early oil and a late columnar sculpture by Ilya Bolotowsky were also purchased to develop our abstract holdings. Important gifts included the Ad Reinhardt *Tryptych* from Jock Truman, who was instrumental in arranging other gifts of contemporary art.

Among major donors of works executed since 1950 are Mr. and Mrs. Henry Feiwel, Mr. Stanley Bard and Mrs. Robert W. Benjamin. Mr. and Mrs. John Wendler gave a large welded steel sculpture by Sol LeWitt. *Trexler* by Jon Carsman was given by Mr.

Lawrence Zicklin. Paintings by Theodoros Stamos were received from Mr. Clinton Wilder, Mr. James R. Johnson, Mrs. Esther Underwood Johnson and Betty Parsons, forming a nucleus of this artist's work. Works by John Hultberg, Jack Youngerman, Jim Dine and Samuel Adler also entered the collection.

As we enter the last quarter of the twentieth century, the collection of American painting and sculpture in The Newark Museum represents a fairly catholic, if individual, overview of three centuries of American art. It contains some noteworthy treasures in the national heritage. There are also lacunae, both of major artists and those of purely local and historic interest. In the twentieth century

we find no Arthur Dove or Regionalists of the Benton, Curry, Wood group. Representation of the "New York School" is generally weak, without Franz Kline or Jackson Pollock. With increased attention to American art and its escalating prices, the purchase of works as "historical" as yesterday becomes increasingly difficult. Furthermore, when collecting with limited funds, it seems counterproductive to fill in gaps only for the purpose of a label. We are increasingly indebted to donors for their generosity in expanding the collection.

Our American paintings and sculpture are a cultural resource

The Geometric Abstraction exhibition, 1978.

for the City, the State, the Metropolitan region and the nation. It is hoped that this listing will be a step in making works herein increasingly available to both scholars and the public.

Acquisition of works of art depends upon recommendations of the Director and Curators of The Newark Museum to the Trustees of The Newark Museum Association, which has title to the collection. The following have been instrumental in assembling the American Painting and Sculpture Collection described herein:

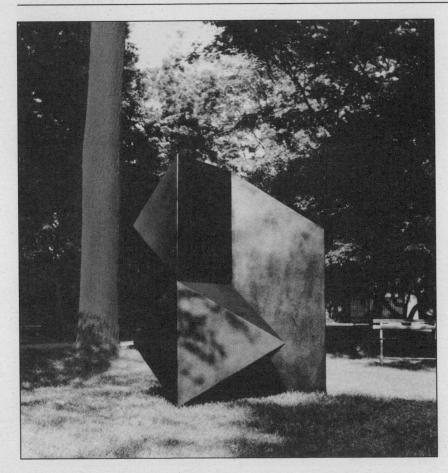

For J.C. (1969) by Tony Smith installed in the Sculpture Garden.

Color
Plates

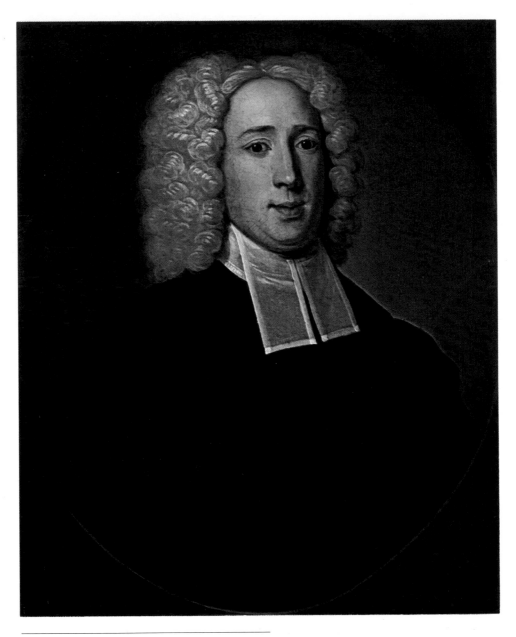

John Smibert
Portrait of Reverend Ebenezer Turell 1734
Oil on canvas 29½″ x 24½″
72.347

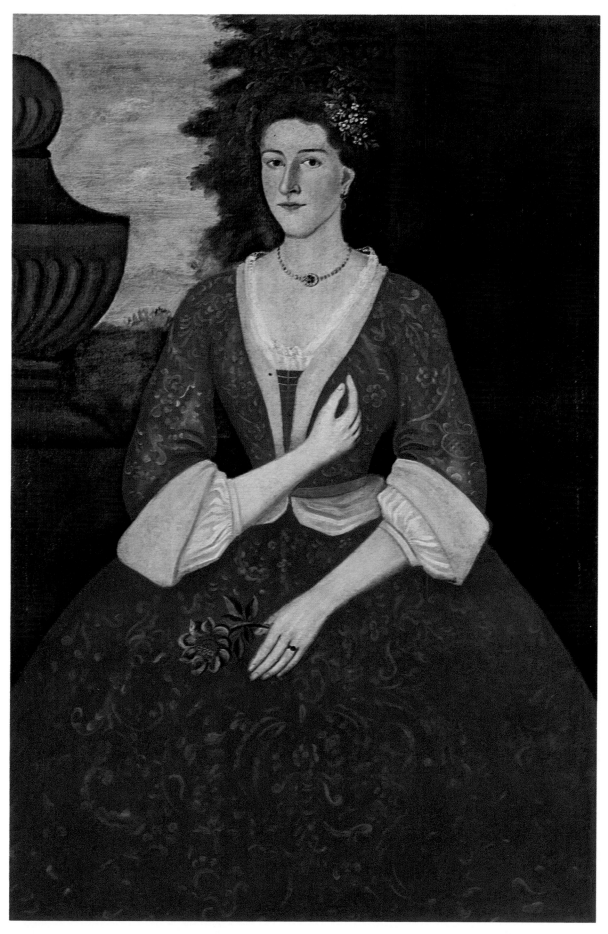

Pieter Vanderlyn
Portrait of
Catherine Ogden
ca. 1730
Oil on canvas
57″ x 37¼″
76.181

23

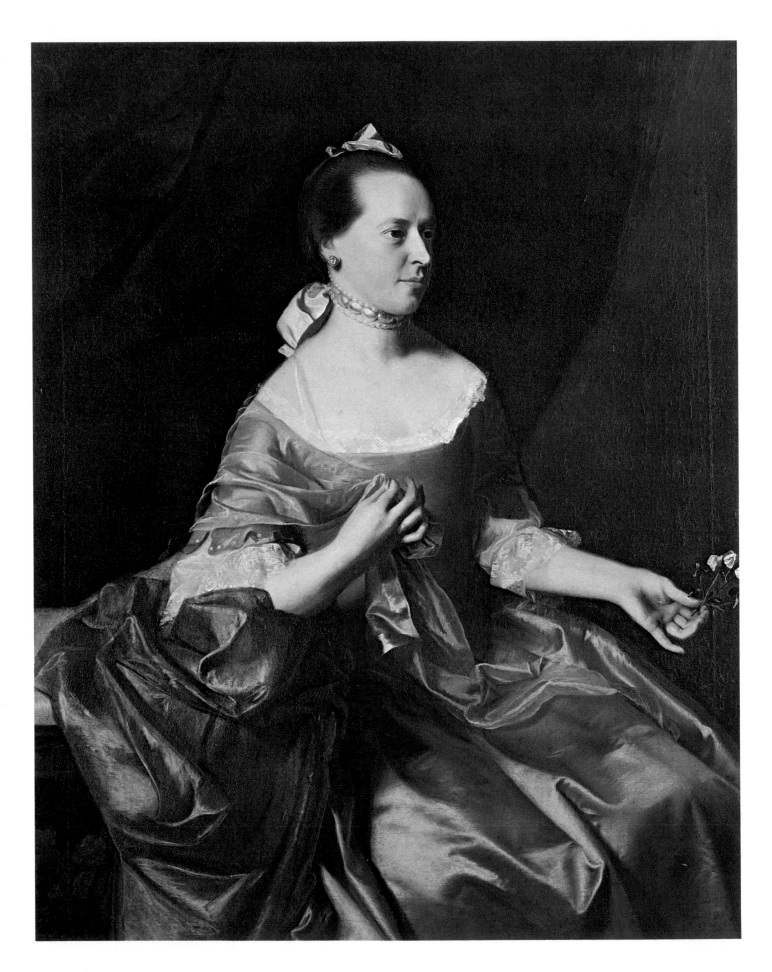

John Singleton Copley
Portrait of Mrs. Joseph Scott ca. 1765
Oil on canvas 69½″ x 39½″
48.508

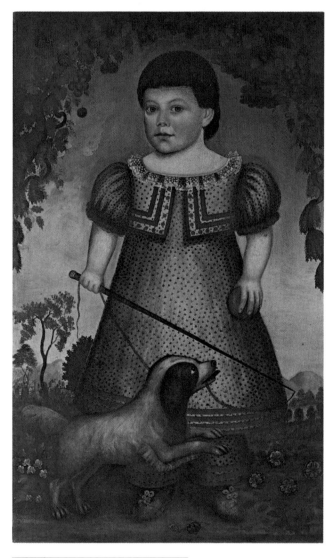

Artist Unknown
The Goying Child ca. 1832-35
Oil on wood 42″ x 25¼″
38.213

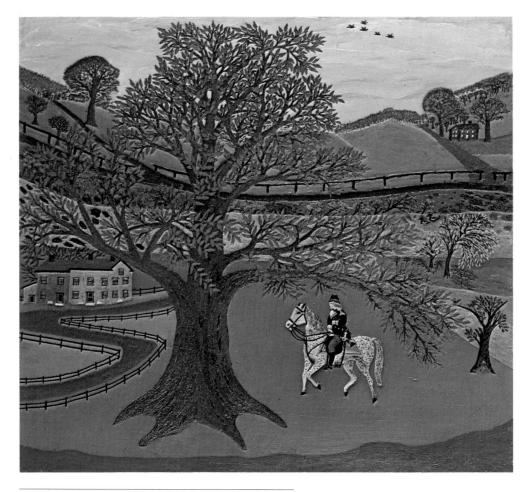

Joseph Pickett
Washington Under the Council Tree ca. 1914-18
Oil on canvas 34½″ x 38″
31.152

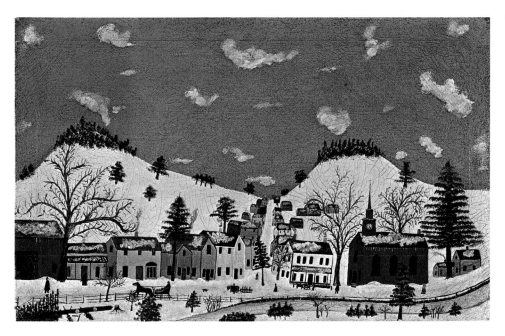

L. Whitney
American Landscape
Oil on canvas 18″ x 28″
31.149

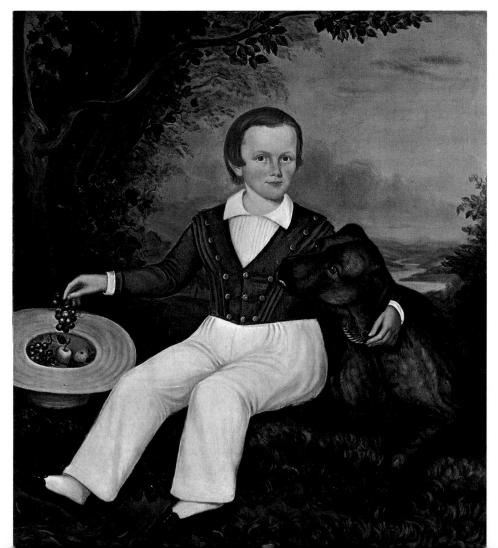

Joseph Whiting Stock
Portrait of Jasper Raymond Rand 1844
Oil on canvas 46″ x 41″
35.40

John Quidor
Young Artist 1828
Oil on canvas 20¼″ x 25⅝″
56.180

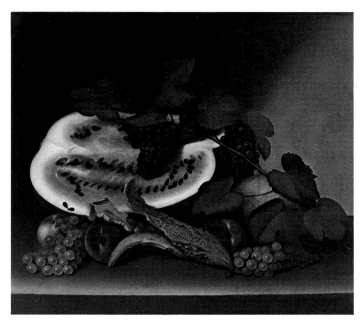

Raphaelle Peale
Still Life-Watermelon and Fruit 1822
Oil on canvas 22¼″ x 26¼″
60.581

Thomas Cole
The Arch of Nero 1846
Oil on canvas 60″ x 48″
57.24

Frederic Edwin Church
Twilight, "Short Arbiter 'Twixt Day and Night" 1850
Oil on canvas 32¼" x 48"
56.43

Fitz Hugh Lane
The Fort and Ten Pound Island, Gloucester 1848
Oil on canvas 20″ x 30″
59.87

Edward Hicks
Grave of William Penn 1847
Oil on canvas 24″ x 30″
56.62

J.W. Ehninger
Yankee Peddler
Oil on canvas 25¾″ x 32¼″
25.876

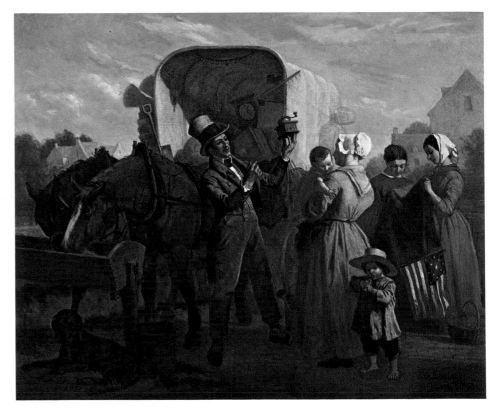

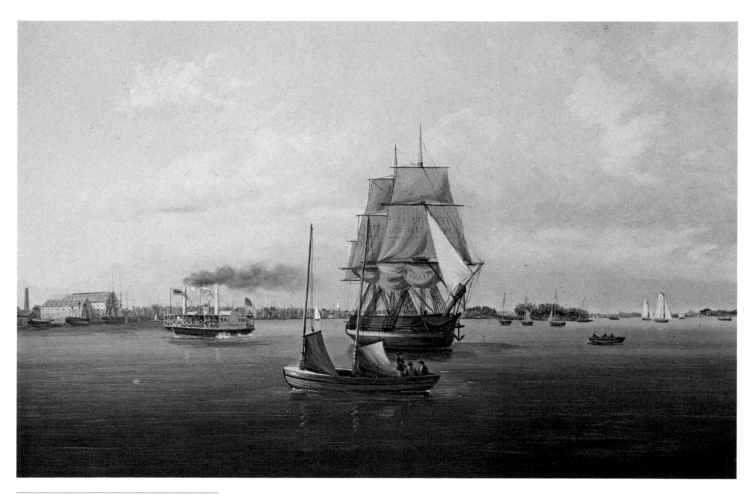

Thomas Birch
View of Philadelphia Harbor
from the Delaware River ca. 1840
Oil on canvas 19½″ x 30″
56.184

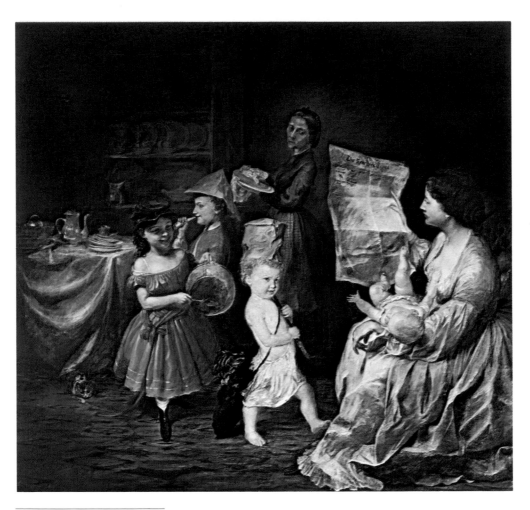

Lilly Martin Spencer
War Spirit at Home 1866
Oil on canvas 30″ x 32¾″
44.177

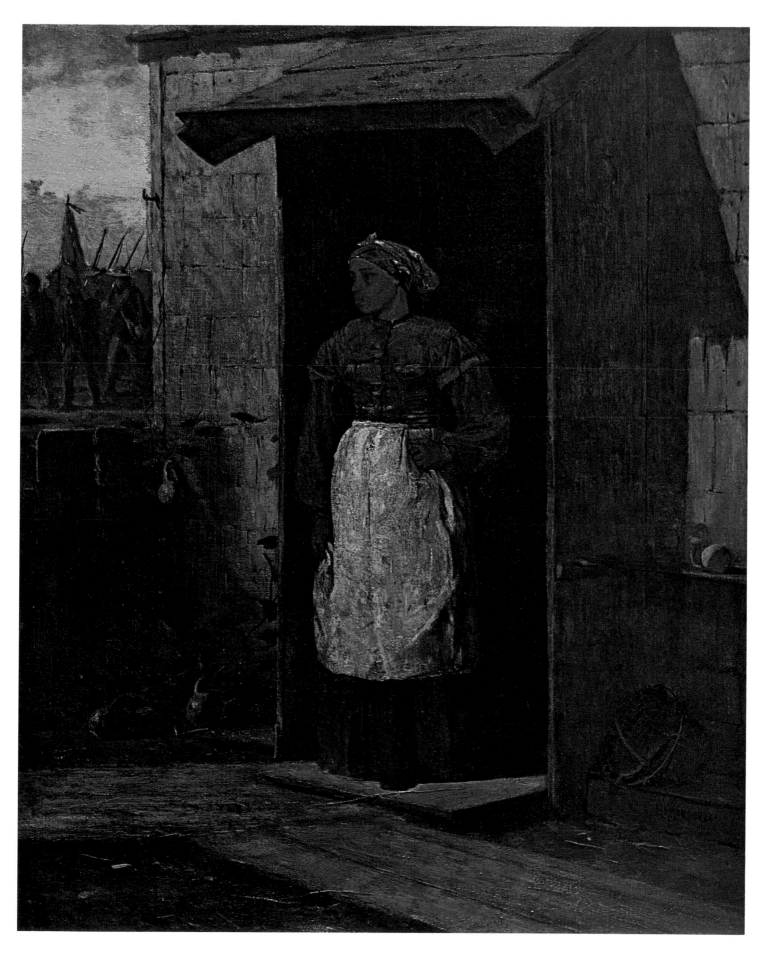

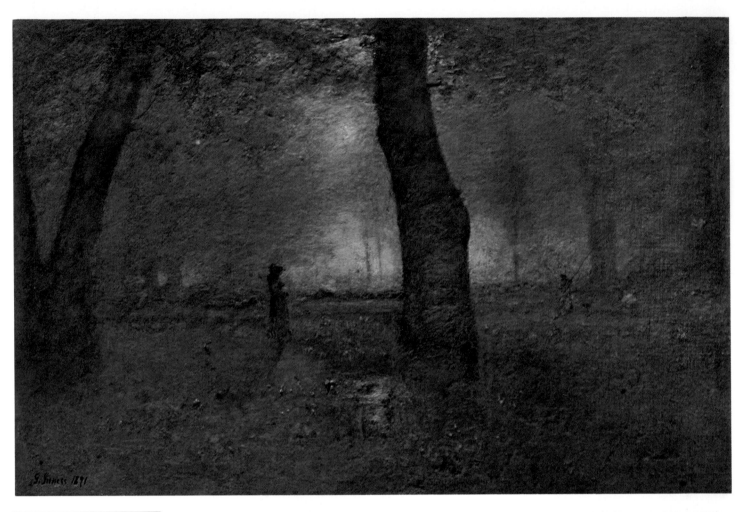

George Inness
The Trout Brook 1891
Oil on canvas 30¼″ x 45¼″
65.36

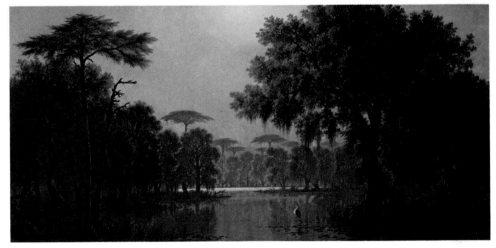

Joseph Meeker
Bayou Landscape 1872
Oil on canvas 20″ x 40″
65.119

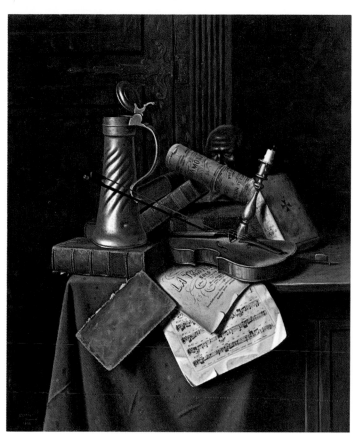

William Michael Harnett
Munich Still Life 1884
Oil on wood 14⅝″ x 11¾″
58.92

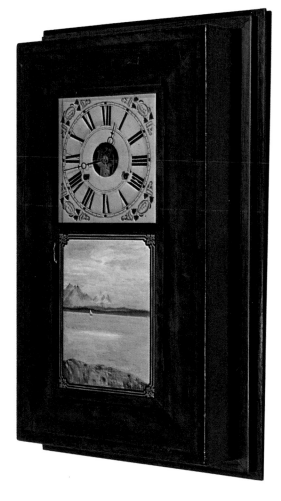

John Haberle
Clock
Oil on canvas
and wood
construction
28⅝″ x 18″ x 3¾″
71.166

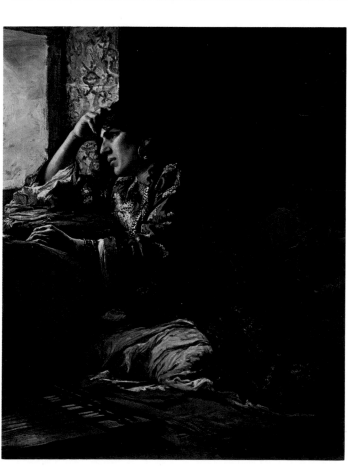

Frederick A. Bridgman
Aicha, A Woman of Morocco 1883
Oil on canvas 21½″ x 18½″
38.331

Childe Hassam
Gloucester 1899
Oil on canvas 32″ x 32″
73.76

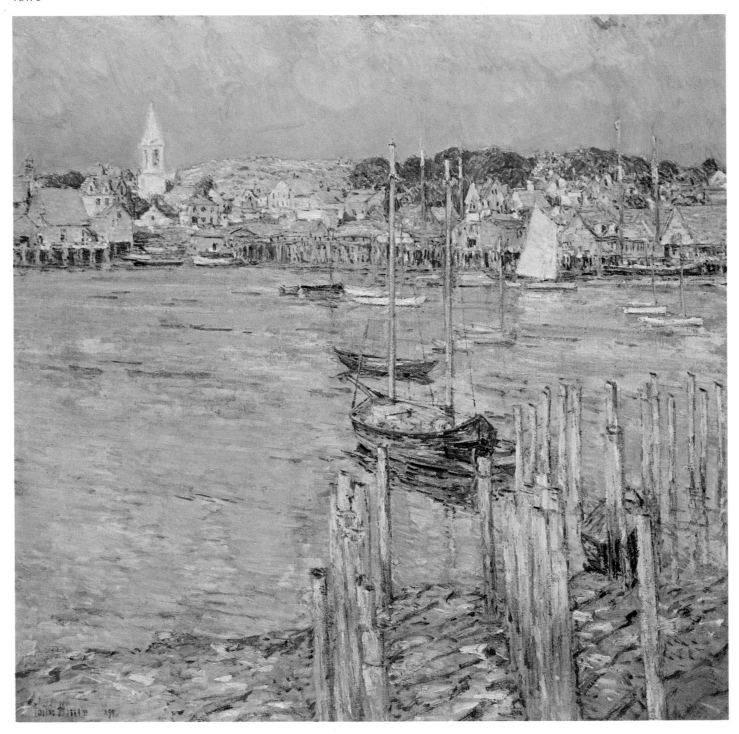

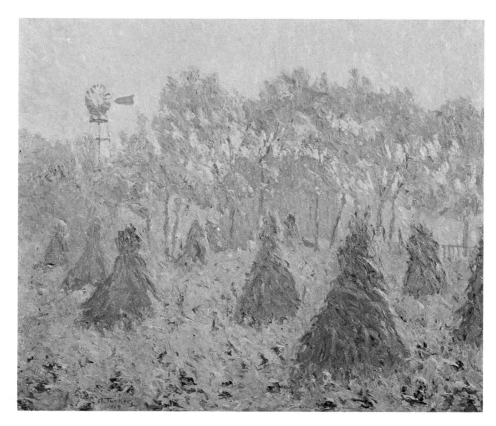

Allen Tucker
Corn Shocks and Windmill 1909
Oil on canvas 30″ x 36″
64.44

Eastman Johnson
Catching the Bee 1872
Oil on millboard 22⅞″ x 13¾″
58.1

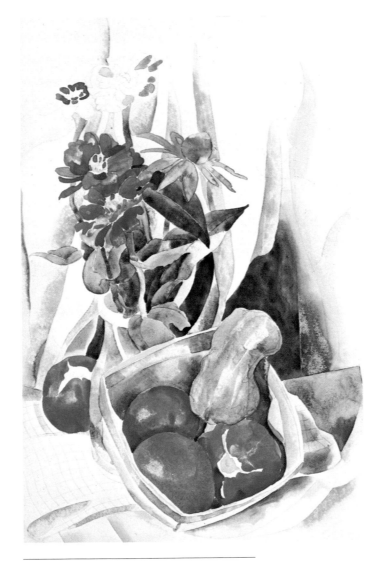

Charles Demuth
Tomatoes, Peppers and Zinnias ca. 1927
Watercolor on paper 18″ x 11⅞″
48.150

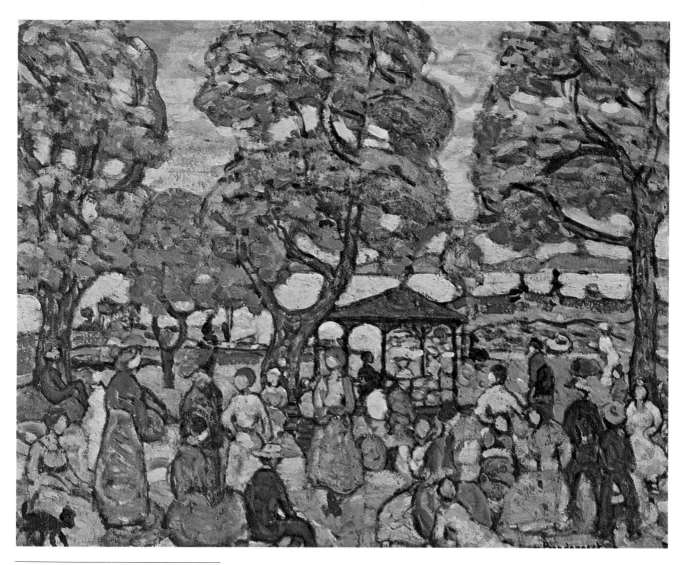

Maurice Prendergast
Landscape with Figures No. 2 1918
Oil on canvas 27″ x 32¾″
44.17

Joseph Stella
The Voice of the City
of New York
Interpreted 1920-22

When in 1913 I came back from Paris, I was amazed to find in America such wealth of forceful, eloquent material for a real Modern Art to be builded on. Soon in 1914 as a starting point, I produced "CONEY ISLAND, MARDI GRAS, BATTLE OF LIGHTS," a modern kermesse where pleasures are derived from machines. Two years after I painted "BROOKLYN BRIDGE," the prodigious bridge created for the conjunction of two worlds. In 1920, I seized "NEW YORK INTERPRETED." I could define New York in one sentence: A monstrous steely bar elevated by modern CYCLOPS to defy the GODS, struck by lightning. My chief concern was to render in a synthetic aspect this gigantic task. I used as time "the night" which invests every element with poetry. I selected as moods of my symphony the PORT, SKY SCRAPERS, THE BRIDGE and THE WHITE WAY. I placed in the center of my composition the SKY SCRAPERS in the form of a prow of a vessel sailing to the infinite, electricity opening at the base as guide with a pair of wings. THE WHITE WAY clamors with sounds and lights on both sides of these sky scrapers. On the flanks of the composition I painted on the right one, THE BRIDGE, on the left THE PORT. As a predella to this gigantic steely cathedral I opened the nets of subways and tubes. I believe that steel and electricity are the creative factors of modern Art: the electricity unmasks the new face of MODERN DRAMA, while the steel, reaching new heights with sky scrapers and bridges, creates a new perspective. In order to emphasize the static strength of my geometrical pattern, I traced with crude precision the vertical and horizontal lines in strong opposition to the fluctuating swirling curves of sounds and lights.

(From a letter of Joseph Stella in the Museum's files, 1944.)

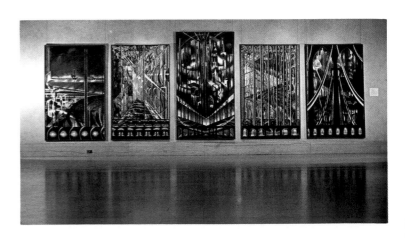

Joseph Stella
The Voice of the City of New York Interpreted 1920-22
The Port
Oil and tempera on canvas 88½″ x 54″
37.288A

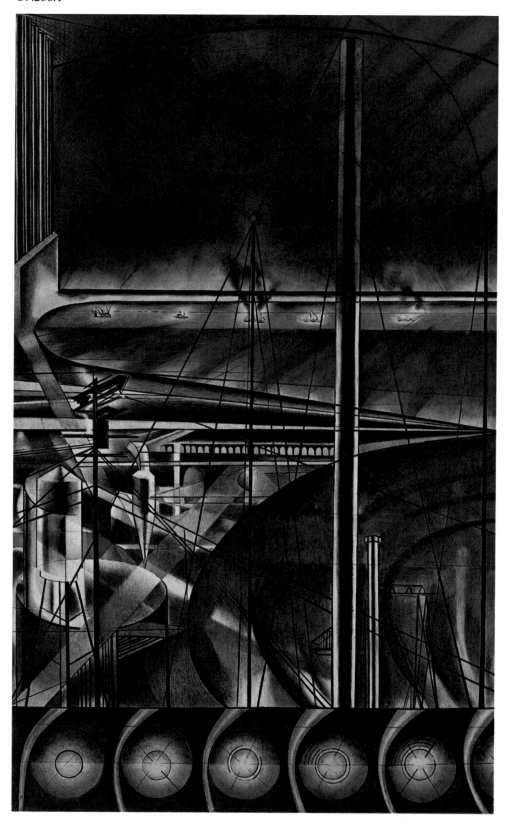

Joseph Stella
The White Way I
Oil and tempera on canvas 88½″ x 54″
37.288B

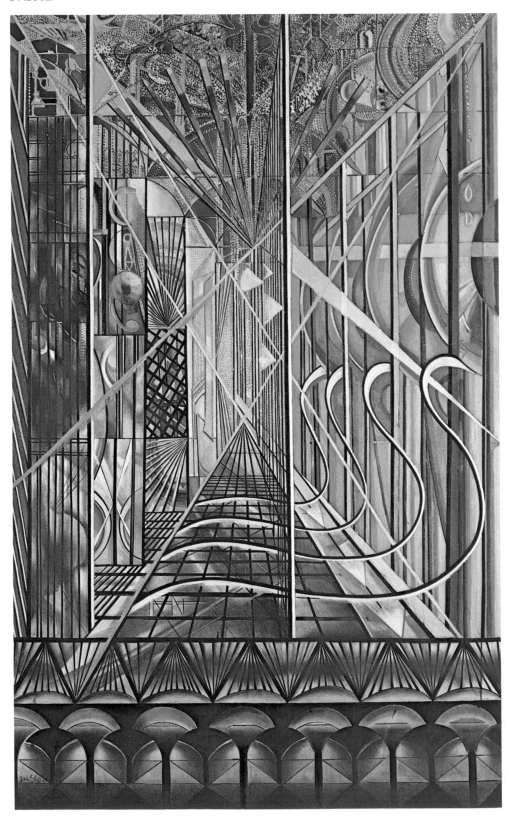

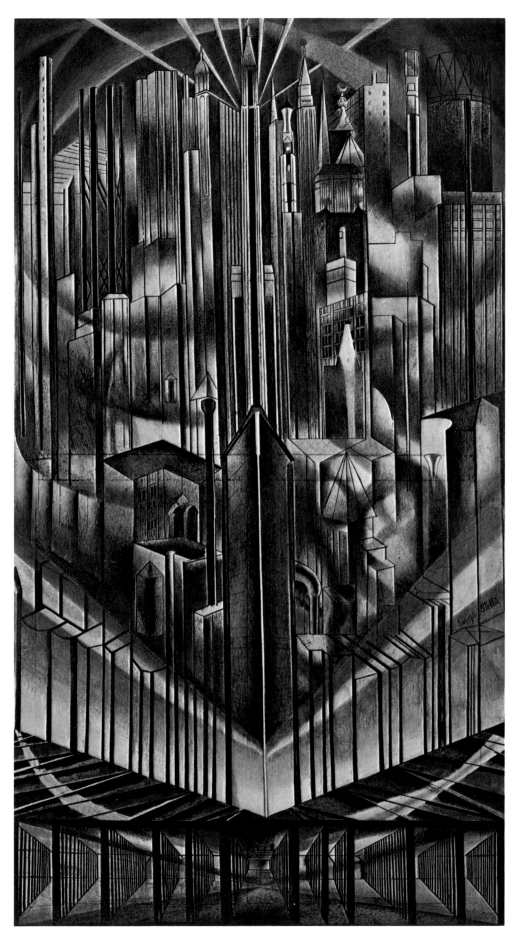

Joseph Stella
The Skyscrapers
Oil and tempera on canvas 99¾″ x 54″
37.288C

Joseph Stella
The White Way II
Oil and tempera on canvas 88½″ x 54″
37.288D

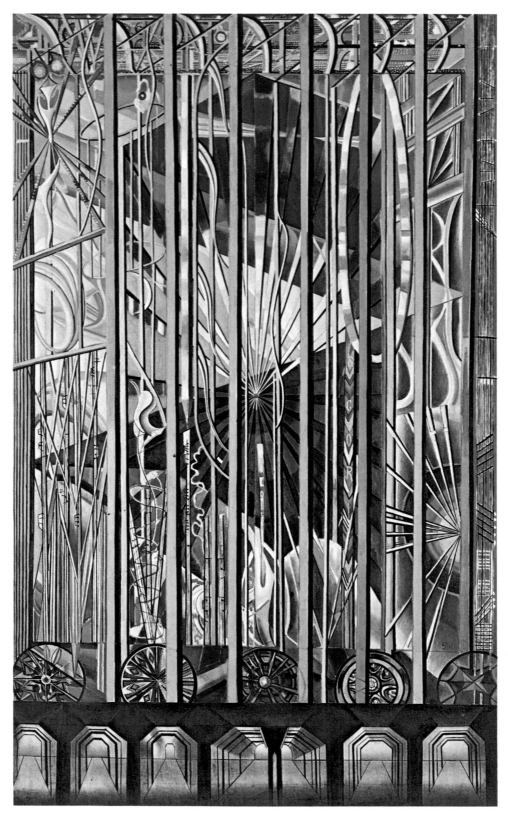

Joseph Stella
The Bridge
Oil and tempera on canvas 88½″ x 54″
37.288E

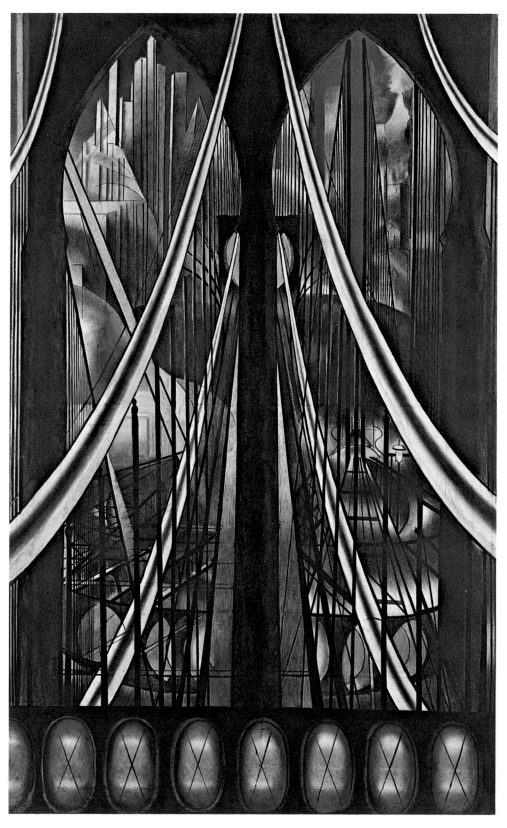

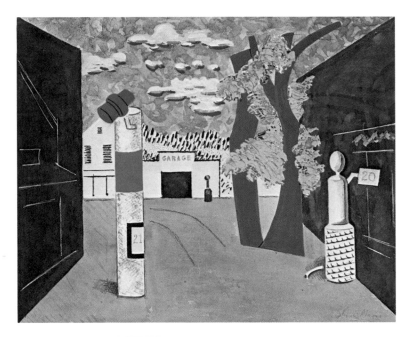

Stuart Davis
Town Square 1925-26
Watercolor on paper 15⅜″ x 22½″
30.74

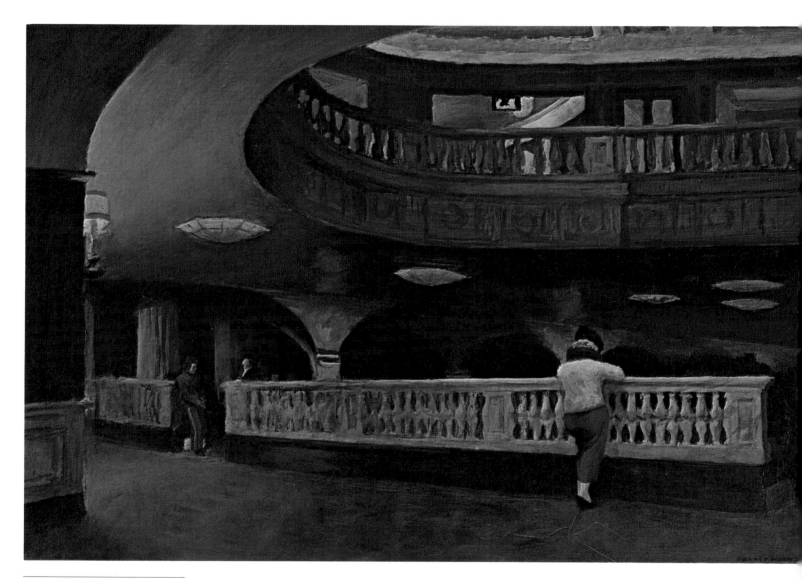

Edward Hopper
The Sheridan Theatre 1937
Oil on canvas 17⅛″ x 25¼″
40.118

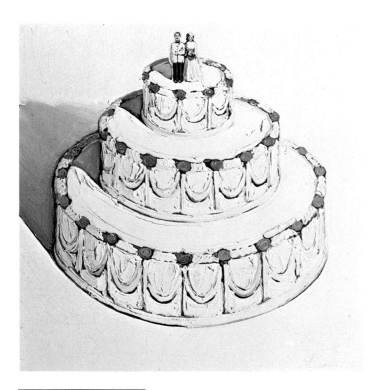

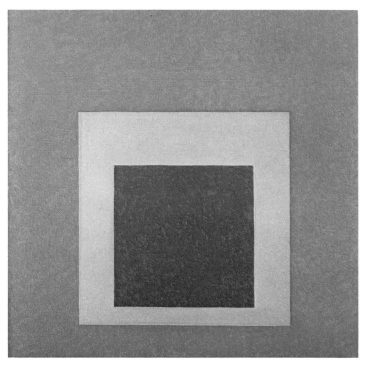

Wayne Thiebaud
Wedding Cake 1962
Oil on canvas 30″ x 30″
63.76

Josef Albers
Homage to the Square; "Alone" 1963
Acrylic on masonite 48″ x 48″
67.54

Jean Xceron
239 B 1938
Oil on canvas 57¼″ x 37⅞″
76.4

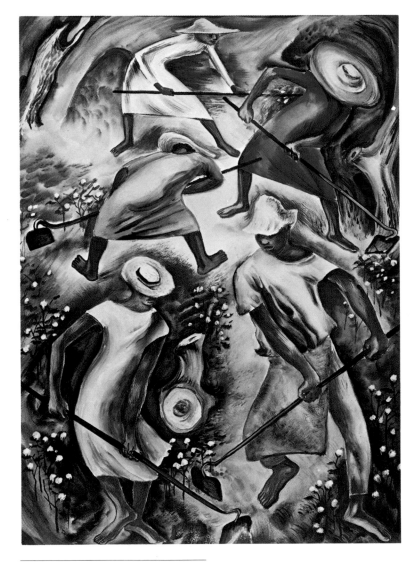

Hale Woodruff
Poor Man's Cotton 1944
Watercolor on paper 30½″ x 22½″
44.122

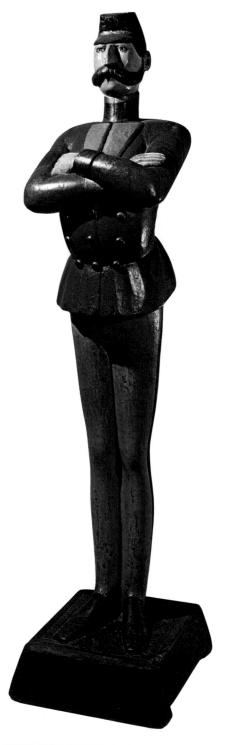

Thomas J. White (attributed)
Captain Jinks of the Horse Marines 1879
Painted wood 69½″ on 5½″ base
24.9

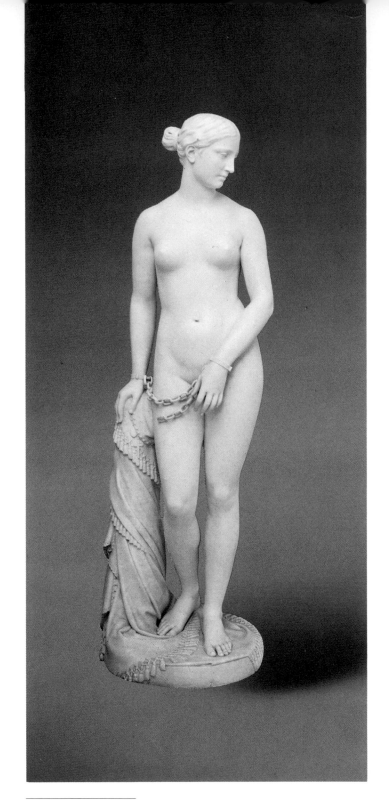

Hiram Powers
Greek Slave 1847
Marble 65½″
26.2755

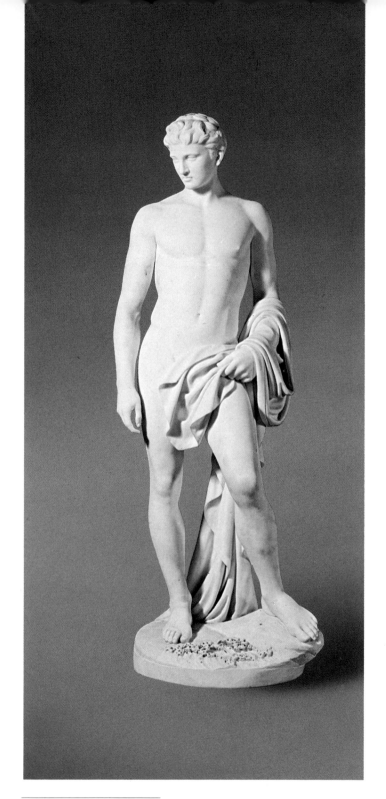

William Henry Rinehart
Leander ca. 1859
Marble 40½″
62.6

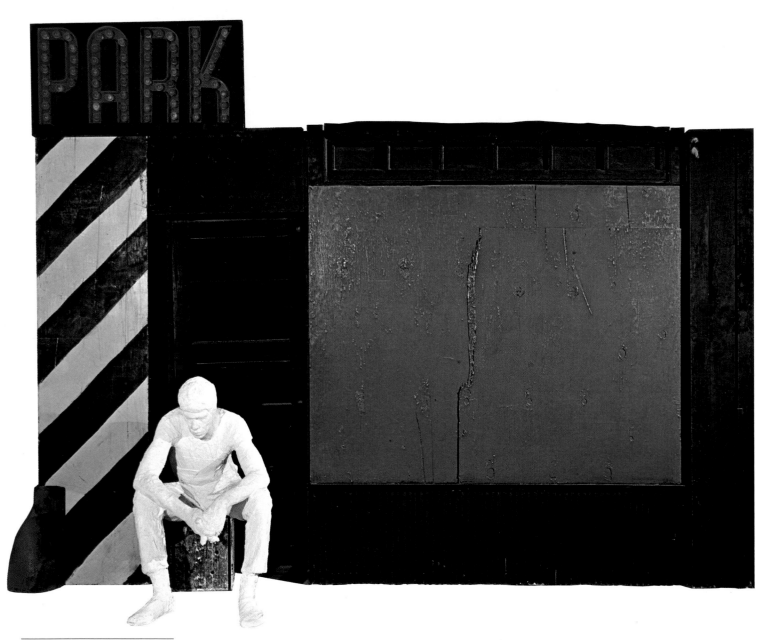

George Segal
The Parking Garage 1968
Mixed media 117¾″ x 155″
plaster figure 43¼″
68.191 A-J

Paintings and Drawings: Black and White

Joseph Badger
Portrait of Frances Tyng ca. 1750
Oil on canvas 35½″ x 28½″
51.93

Joseph Badger
Portrait of Joseph Tyler ca. 1765
Oil on canvas 35⅜″ x 29″
48.25

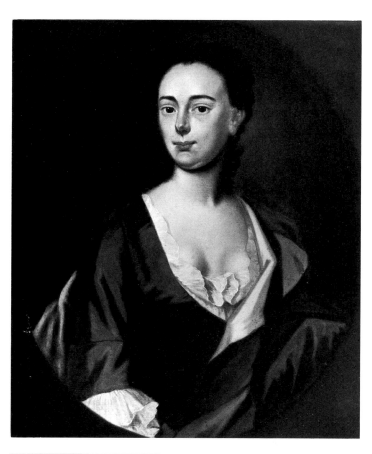

Jeremiah Theus
Portrait of a Woman
Oil on canvas 30⅛″ x 25¼″
56.61

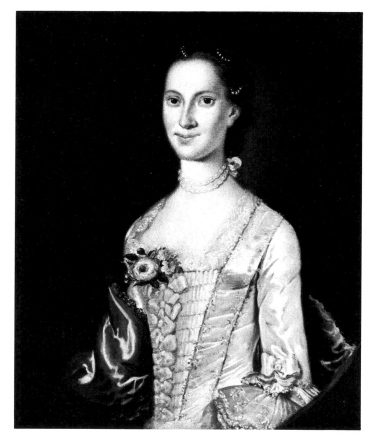

John Hesselius
Portrait of Mrs. Richard Sprigg ca. 1765-70
Oil on canvas 30⅛″ x 25⅛″
55.119

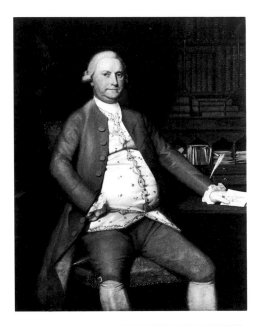

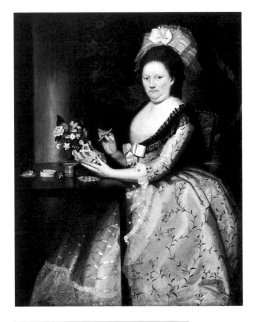

Ralph Earl
Portrait of John Hyndman ca. 1783-84
Oil on canvas 50″ x 40″
59.409

Ralph Earl
Portrait of Mrs. John Hyndman
ca. 1783-84
Oil on canvas 50¼″ x 40¼″
59.410

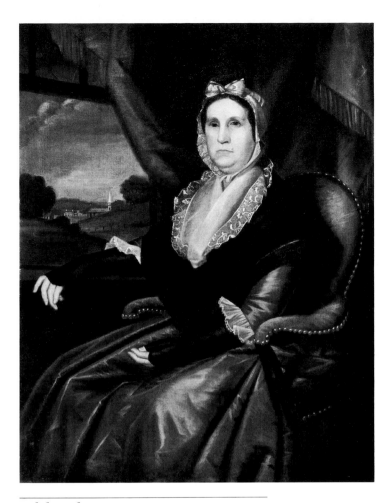

Ralph Earl
Portrait of Mrs. Nathaniel Taylor ca. 1790
Oil on canvas 47¾″ x 36¾″
47.51

Benjamin West
The Grecian Daughter Defending
Her Father 1794
Oil on canvas 19⅛" x 23"
56.177

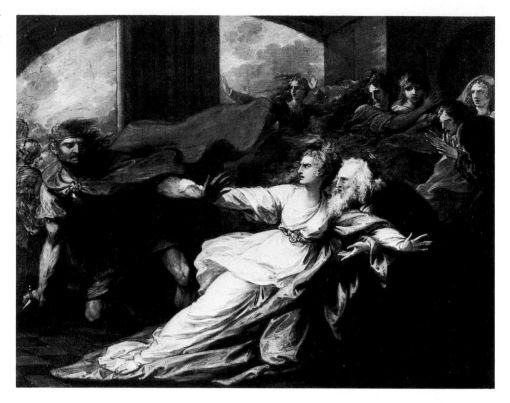

William Williams
Imaginary Landscape 1772
Oil on canvas 16⅜" x 18½"
22.275

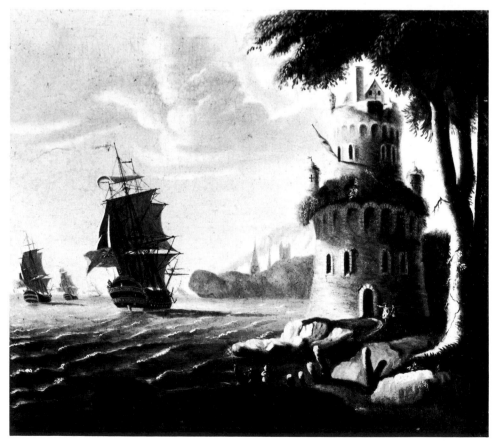

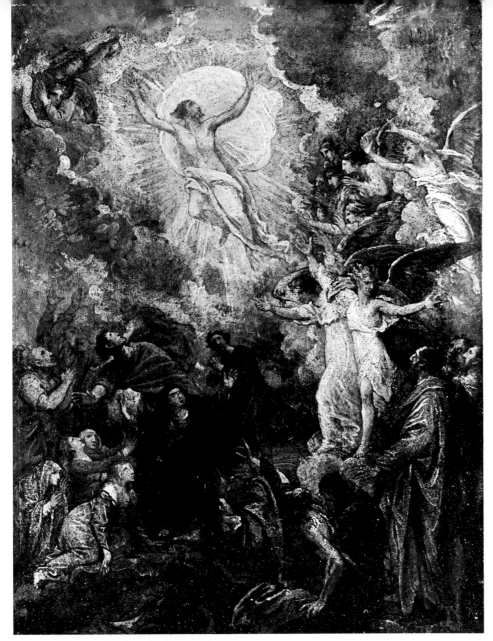

Benjamin West
Study for the Ascension ca. 1800
Oil on paper mounted on canvas 11⅛″ x 7⅞″
59.412

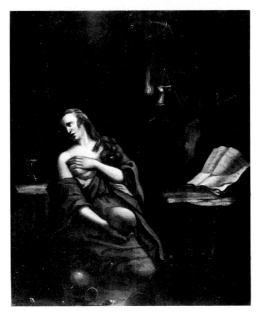

William Williams
Mary Magdalene 1767
Oil on cradled wood 21⅛″ x 16¼″
78.104

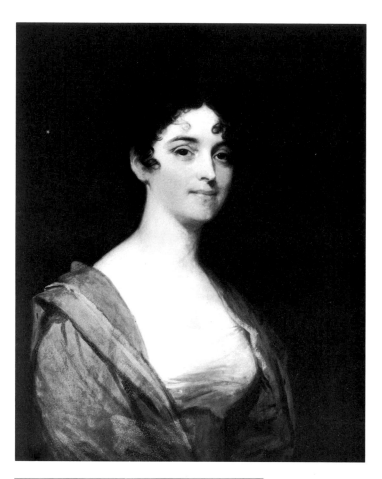

Gilbert Stuart
Portrait of Mercy Shiverick Hatch ca. 1810
Oil on wood 28″ x 22½″
62.141

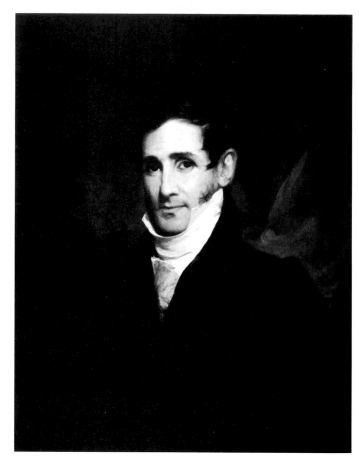

John Neagle
Portrait of Peter Maverick 1826
Oil on canvas 29¼″ x 23¼″
58.38

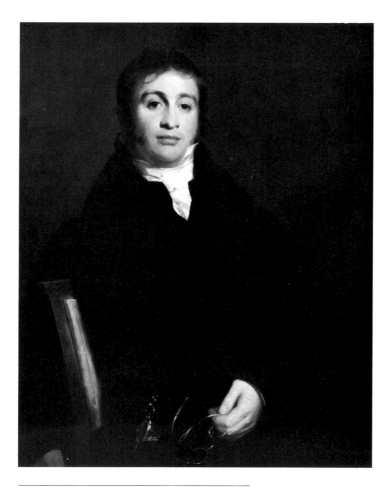

Thomas Sully
Portrait of John Clements Stocker 1814
Oil on canvas 36" x 27¾"
56.42

James Peale
Still Life with Grapes early 1820's
Oil on canvas 16⅛″ x 22⅛″
55.123

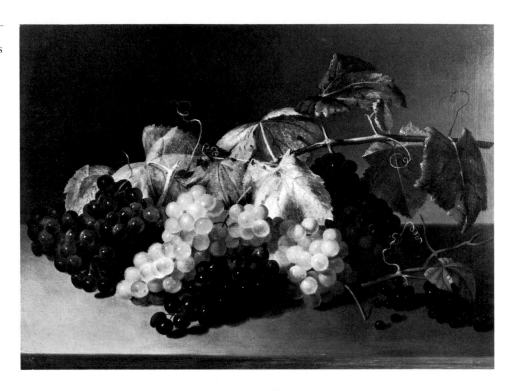

James Peale
Still Life with Fruit early 1820's
Oil on canvas 16⅛″ x 22⅛″
66.407

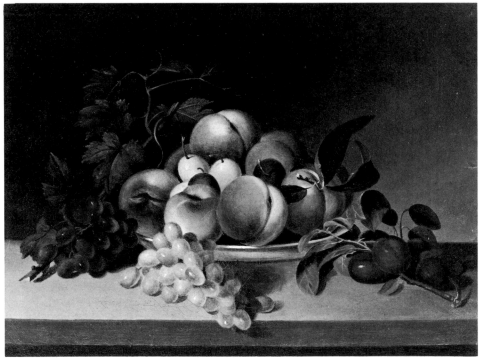

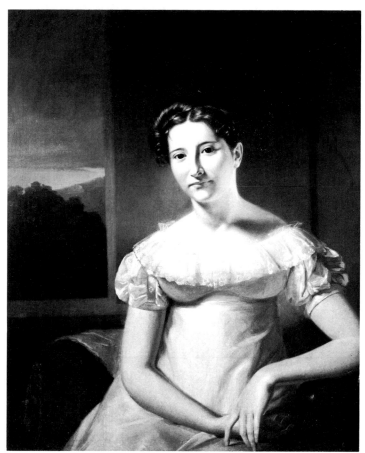

Felix Sharples
Portrait of Ann Wallace (attributed)
Pastel on paper 9⅜" x 7³/₁₆"
34.576

Charles G. Ingham
Portrait of Margaret A. Babcock ca. 1820
Oil on canvas 36¼" x 28"
53.15

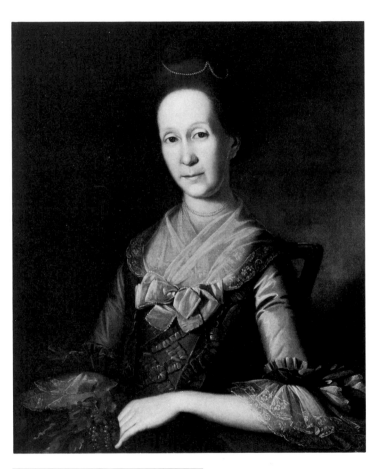

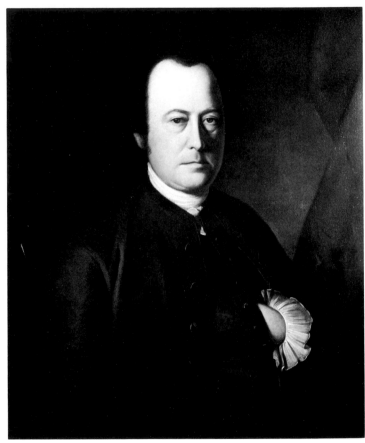

Charles Willson Peale
Portrait of Mrs. Elihu Hall 1773
Oil on canvas 30″ x 25″
63.128

Charles Willson Peale
Portrait of Colonel Elihu Hall 1773
Oil on canvas 30″ x 25¼″
63.127

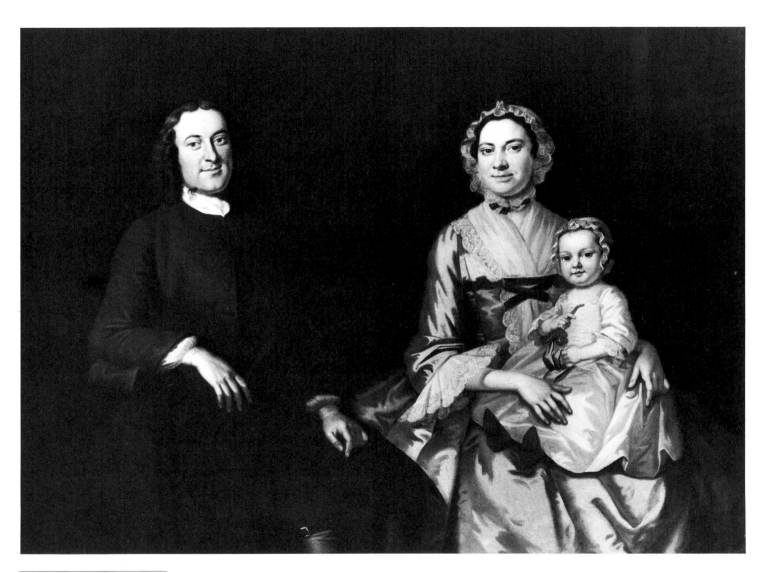

John Wollaston
Family Group ca. 1750
Oil on canvas 51¼″ x 71⅛″
56.231

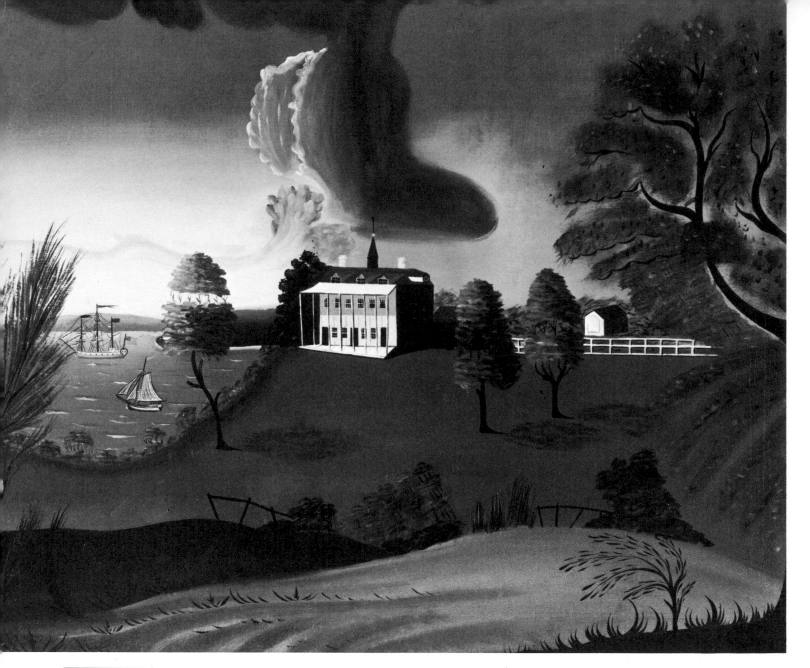

Artist Unknown
Mount Vernon post-1800
Oil on canvas 24″ x 30″
28.1310

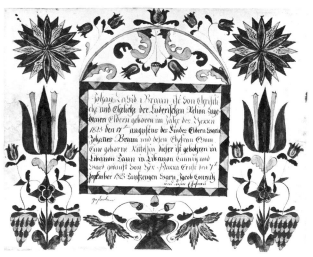

Abraham Huth
Baptismal Certificate of John David Braun 1823
Tempera, watercolor and inks on paper 12″ x 15⅛″
74.2

James Vanderpool
Portrait of James Van Dyke ca. 1787
Oil on canvas 41″ x 33″
21.1749

John Vanderpool
Portrait of Mrs. James Van Dyke 1787
Oil on canvas 41″ x 33″
21.1748

Ezra Ames
Portrait of Mrs. Thomas Humphrey Cushing ca. 1815
Oil on canvas 30″ x 25″
65.162

Joshua Johnston
Portrait of Isabella Taylor ca. 1805
Oil on canvas 30″ x 24⅞″
71.55

John Wesley Jarvis
Portrait of Mrs. James Robertson Smith ca. 1810-20
Oil on wood 33¼″ x 26½″
78.80

John Wesley Jarvis
Portrait of James Robertson Smith
Oil on canvas 33¼″ x 27¼″
78.81

Artist Unknown
Thomas S. Gill ca. 1818
Fraktur: watercolor and ink on paper 8″ x 10$^{1}/_{16}$″
77.441

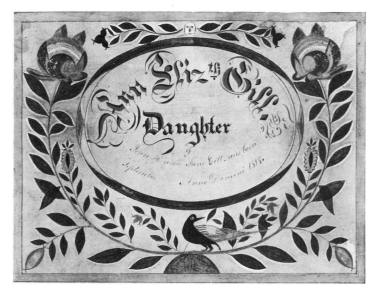

Artist Unknown
Ann Elizabeth Gill ca. 1818
Fraktur: watercolor and ink on paper 8$^{3}/_{16}$″ x 10″
77.166

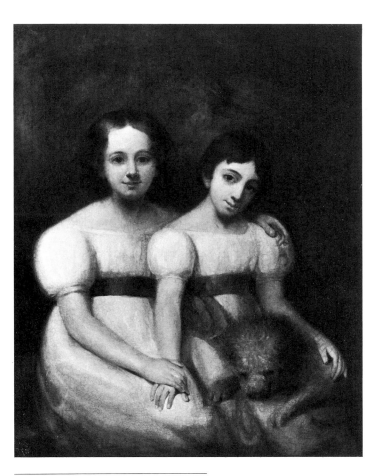

William Dunlap
Portrait of the Beck Sisters 1829
Oil on canvas 36″ x 30″
61.462

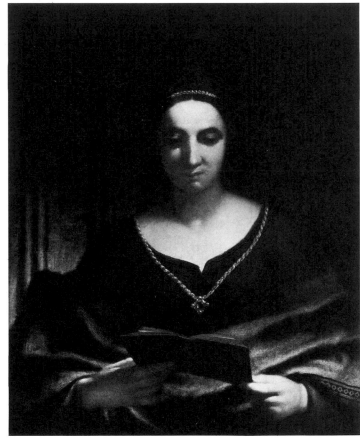

Washington Allston
A Roman Lady ca. 1831
Oil on canvas 30″ x 25″
65.35

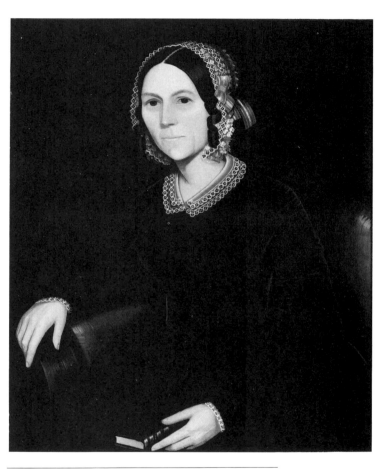

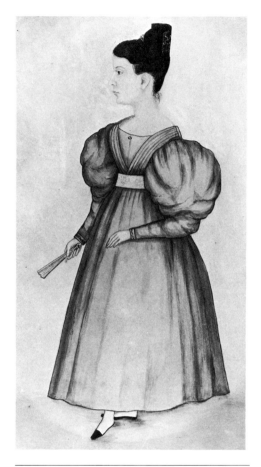

Ammi Phillips
Portrait of a Woman in a Black Dress ca. 1848
Oil on canvas 32½″ x 27½″
66.620

J. Evans
Portrait of Abigail Couvier Fellows 1832
Watercolor on paper 10⅛″ x 8⅛″
67.31

Artist Unknown
Portrait of a "Becker" Woman 1830
Oil on canvas 30½″ x 26½″
50.2144

Artist Unknown
Portrait of a "Becker" Man 1830
Oil on canvas 30½″ x 26½″
50.2145

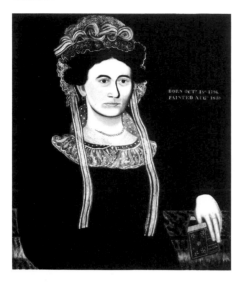

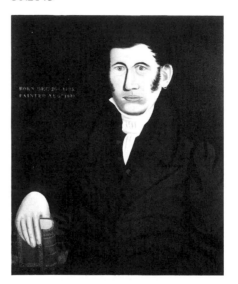

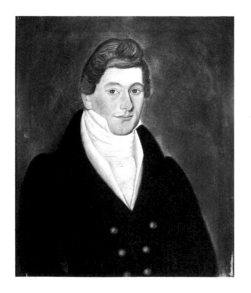

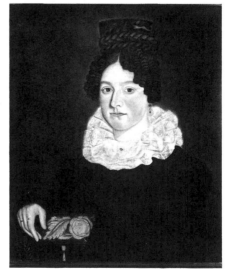

Micah Williams
Portrait of Abraham Hasbrouck
ca. 1825
Pastel on paper 26″ x 22″
51.19

Micah Williams
Portrait of Sarah Hasbrouck
ca. 1837
Pastel on paper 26″ x 22″
51.18

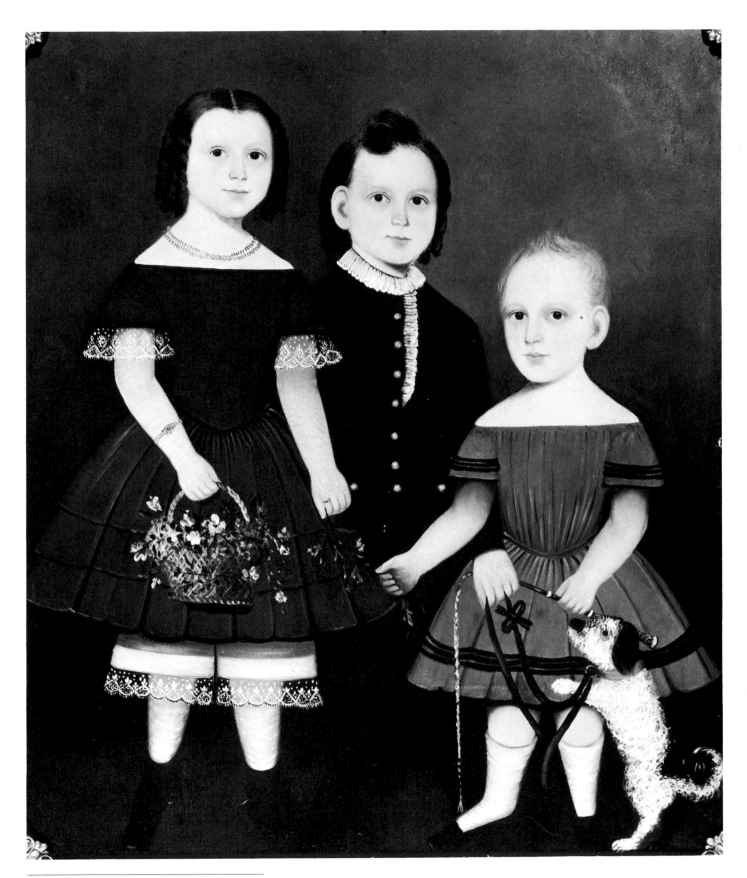

Artist Unknown
Three Children with Their Dog ca. 1840
Oil on canvas 42″ x 35″
66.409

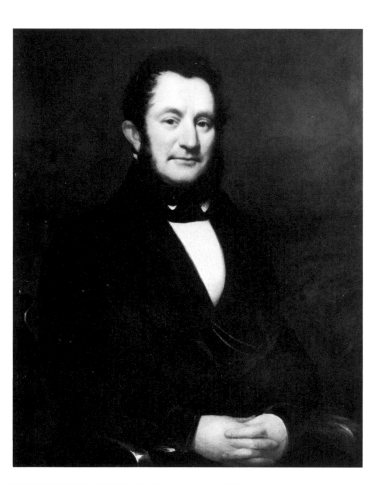

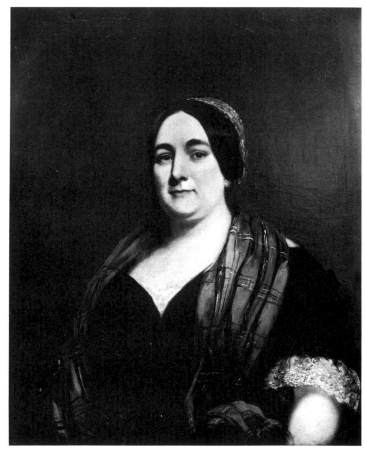

Samuel Lovett Waldo and William Jewett
Portrait of Mr. George Dummer 1840
Oil on wood 30¼″ x 25″
63.81

Samuel Lovett Waldo and William Jewett
Portrait of Mrs. George Dummer
Oil on canvas 30⅛″ x 25⅛″
63.80

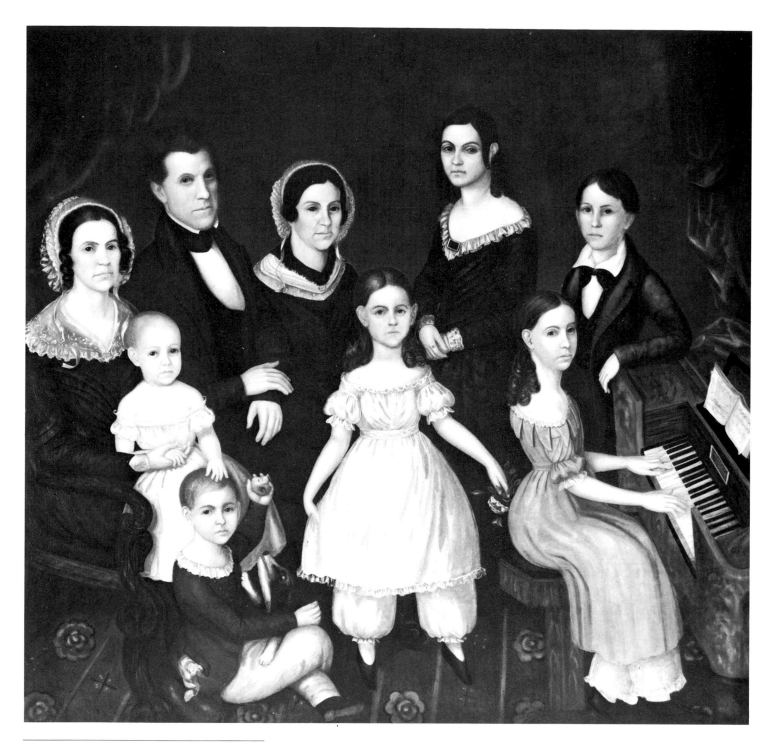

Horace Rockwell
The Lewis G. Thompson Family ca. 1844
Oil on canvas 66½" x 72½"
62.154

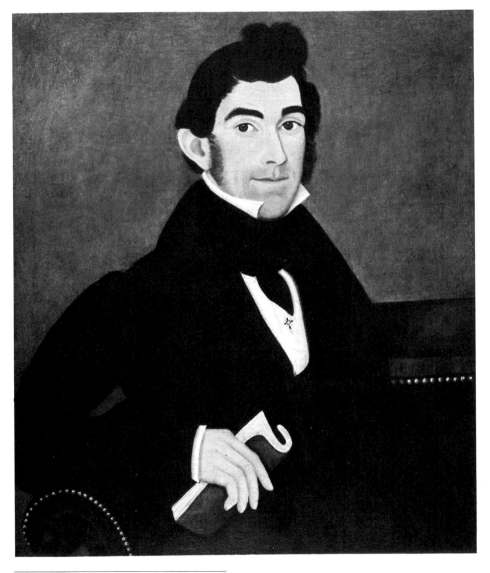

Micah Williams
Portrait of a Gentleman ca. 1819-29
Oil on canvas 30⅛″ x 25⅛″
77.203

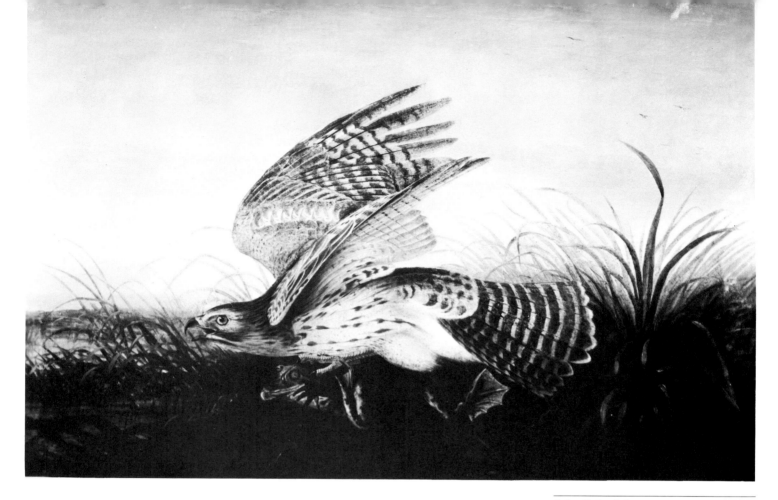

John J. Audubon
Red Shouldered Hawk with Bullfrog
Oil on canvas 26¼″ x 39″
26.527

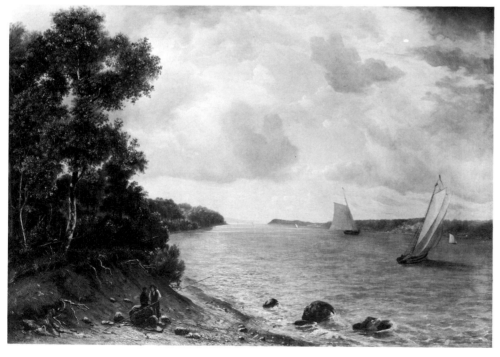

Victor Gifford Audubon
Landscape Along the Hudson 1842
Oil on canvas 31¼″ x 45⅛″
42.16

Joshua Shaw
American Forest Scenery 1843
Oil on canvas 18½″ x 24″
56.5

Samuel F.B. Morse
The Wetterhorn and Falls of
the Reichenbach ca. 1832
Oil on canvas 23″ x 16⅛″
26.1167

Asher B. Durand
Portrait of the Artist's Wife and Her Sister
1834
Oil on canvas 36¼" x 29⅛"
35.32

John Trumbull
Portrait of Mrs. William Leete Stone
ca. 1821
Oil on wood 23⅞" x 19⅞"
61.463

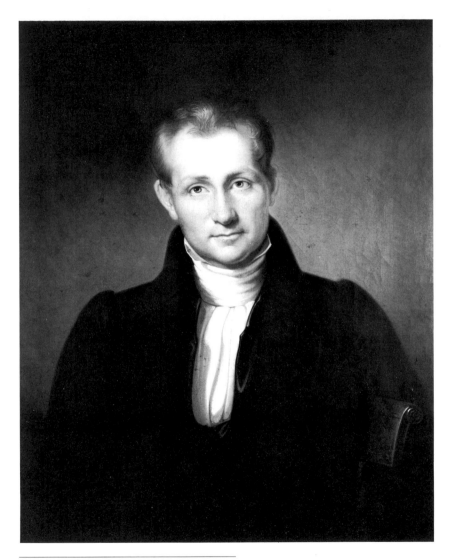

Rembrandt Peale
Portrait of William Rankin, Sr. 1834
Oil on canvas 30¼″ x 25¼″
47.52

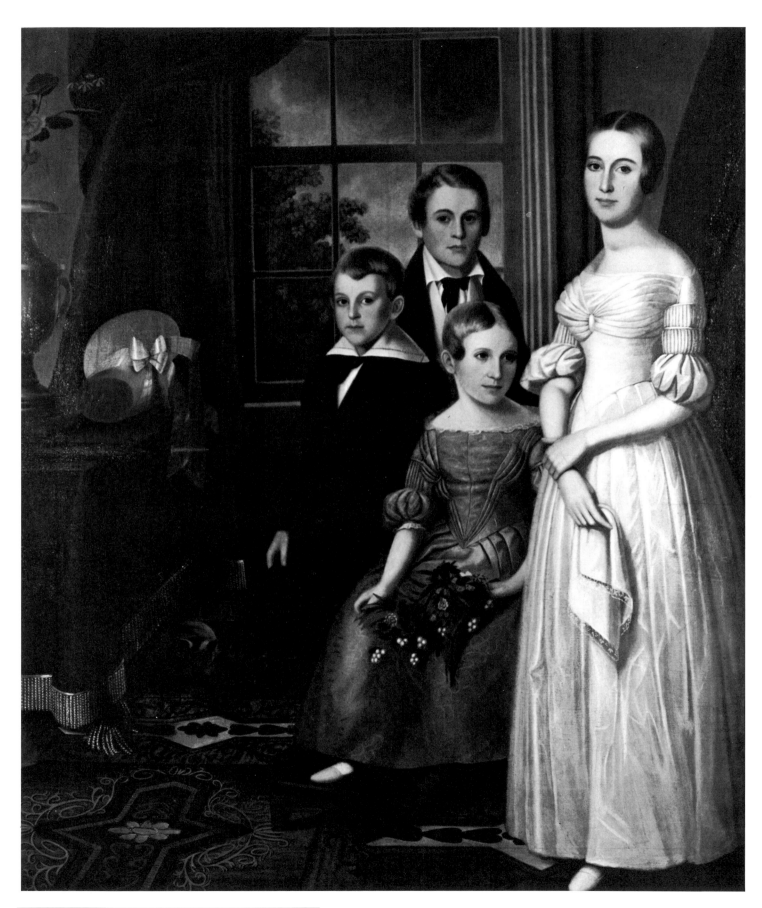

Oliver Tarbell Eddy
Portrait of the Children of William Rankin, Sr. 1838
Oil on canvas 71″ x 60″
47.53

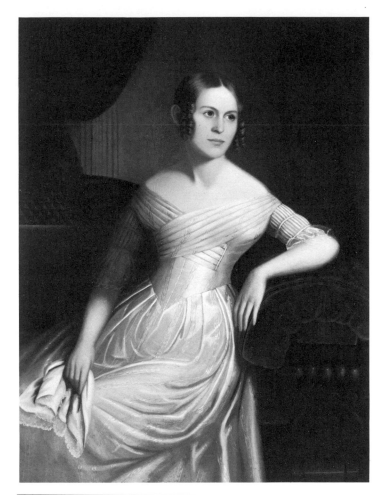

Oliver Tarbell Eddy
Portrait of Mrs. John L. Goble 1838-39
Oil on wood 50″ x 35¼″
57.122

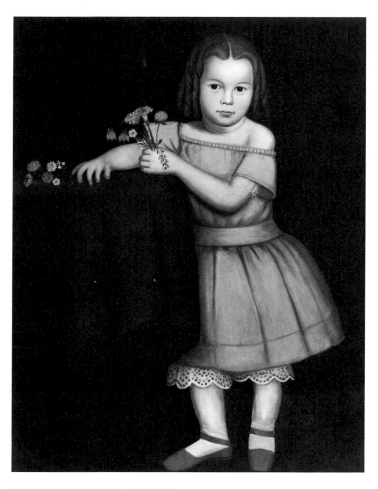

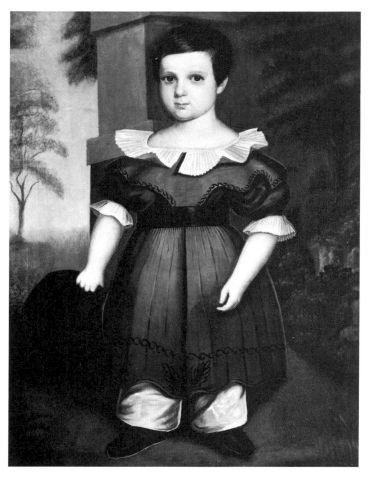

Artist Unknown
Girl with Flowers ca. 1840
Oil on canvas 36⅛″ x 29″
31.145

Artist Unknown
Little Henry Hills ca. 1835
Oil on canvas 36¼″ x 28¼″
61.21

Robert Street
Portrait of an Unidentified Man 1830
Oil on canvas 30″ x 25″
51.124

Lilly Martin Spencer
Portrait of Nicholas Longworth Ward
1858-60
Oil on canvas 50½″ x 40½″
21.1750

Thomas Buchanan Read
Portrait of Joseph Morris Ward 1846
Oil on canvas 50″ x 39½″
21.1754

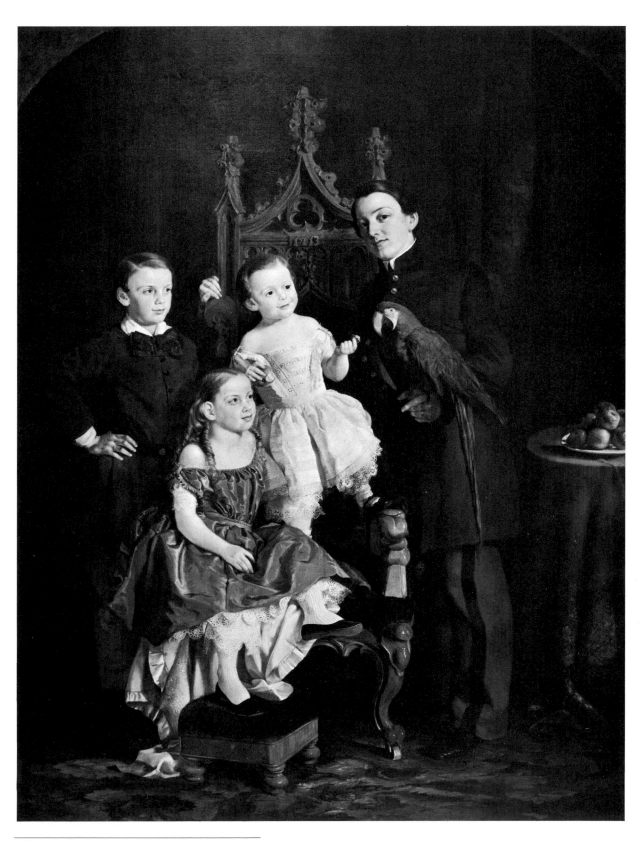

Lilly Martin Spencer
Four Children of Marcus L. Ward 1858-60
Oil on canvas 92″ x 68½″
21.1913

Alburtis De Orient Browere
Trail of the 49'ers ca. 1858
Oil on canvas 33″ x 48″
56.182

Alvan Fisher
Near Camden, Maine ca. 1847
Oil on canvas 34″ x 48″
61.9

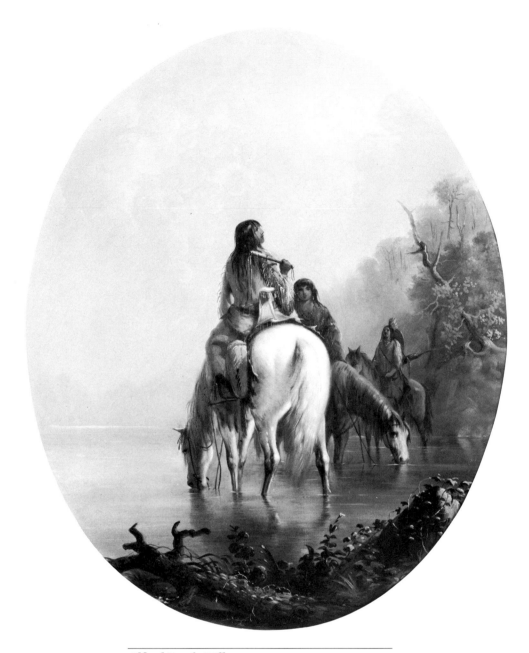

Alfred Jacob Miller
Shoshone Women Watering Horses ca. 1850's
Oil on canvas 24″ x 20″
61.444

George Caleb Bingham
Landscape: Lake in the Mountains ca. 1850
Oil on canvas 25″ x 30″
59.94

Thomas Doughty
Desert Rock Lighthouse 1847
Oil on canvas 27″ x 41″
39.146

George Loring Brown
Tivoli 1850
Oil on canvas 25½″ x 32¼″
57.13

Asher B. Durand
Landscape 1849
Oil on canvas 30″ x 42″
56.181

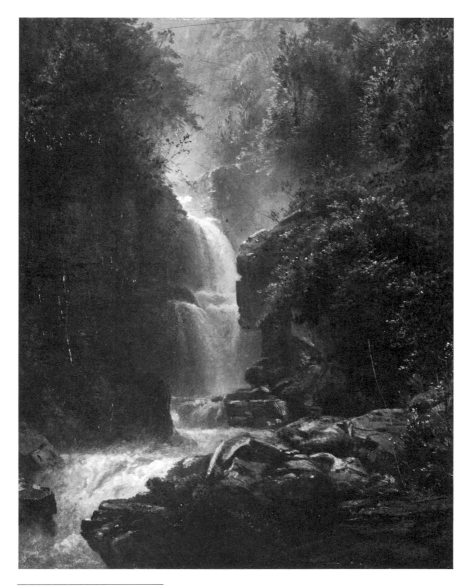

DeWitt Clinton Boutelle
Waterfall 1867
Oil on canvas 12¼″ x 10¼″
67.383

Rembrandt Lockwood
Study for the Last Judgement ca. 1850
Pencil and wash on paper 37″ x 24″
65.154

Albert Bierstadt
Sunshine and Shadow 1855
Oil on paper 18½″ x 13″
20.1209

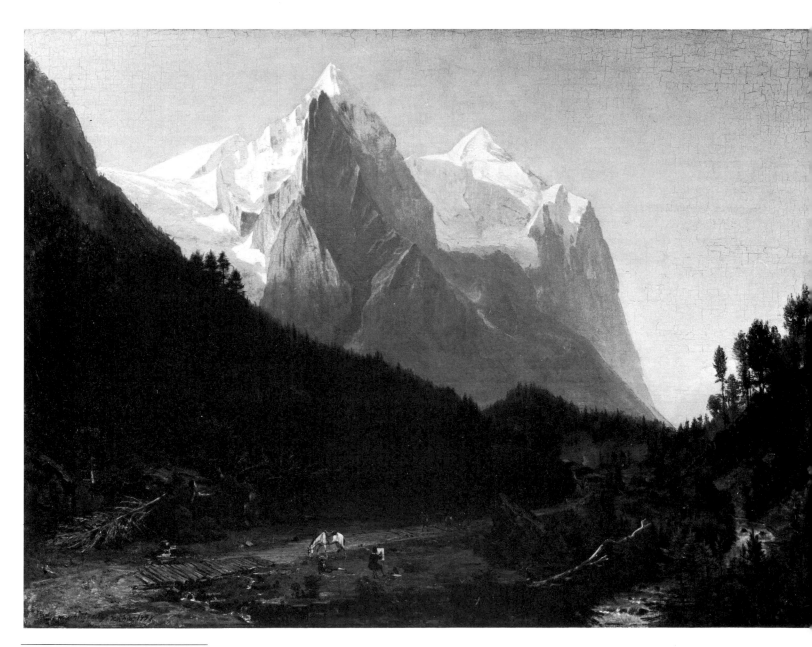

Thomas Worthington Whittredge
The Wetterhorn 1858
Oil on canvas 39½″ x 54″
65.143

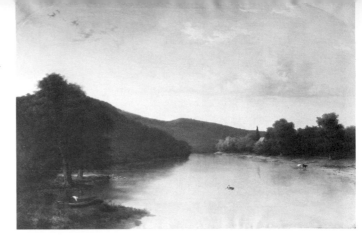

Walter M. Oddie
Landscape 1853
Oil on canvas 36″ x 50″
45.265

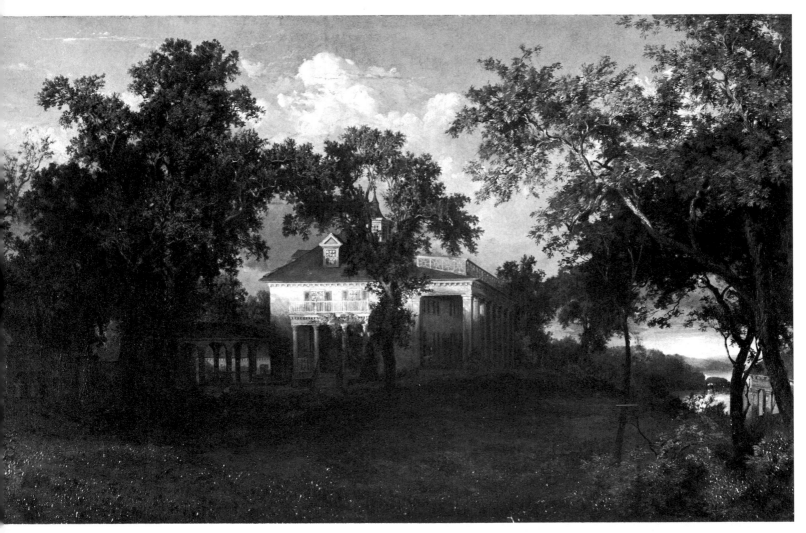

William Trost Richards
Mount Vernon 1855
Oil on canvas 30″ x 48″
66.39

Jennie Brownscombe
The Peace Ball at Fredericksburg 1897
Oil on canvas 31¾″ x 50¾″
26.1257

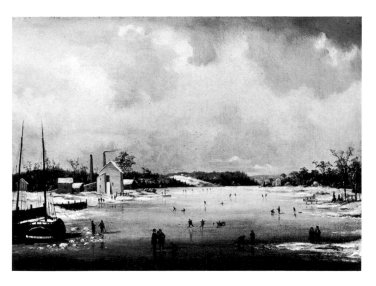

Edward Beyer
Skating on the Passaic 1852
Oil on canvas 13⅜″ x 18″
57.140

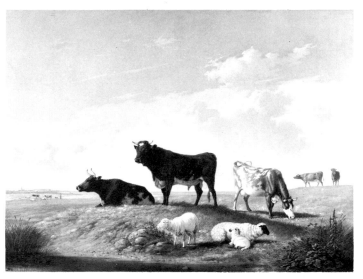

Thomas Hewes Hinckley
Cows and Sheep in a Landscape 1853
Oil on canvas 25½″ x 36″
61.11

Enoch Wood Perry
How the Battle Was Won 1862
Oil on canvas 22¼″ x 30½″
61.25

William Ranney
The Pipe of Friendship 1857-59
Oil on canvas 23″ x 36″
20.1342

Artist Unknown
Still Life: Flowers, Fruit, Decanter ca. 1850
Tinsel painting 19½″ x 24¼″
67.69

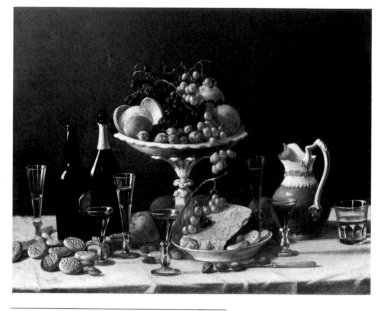

John F. Francis
Still Life – Grapes in Dish ca. 1850's
Oil on canvas 25″ x 30¼″
56.179

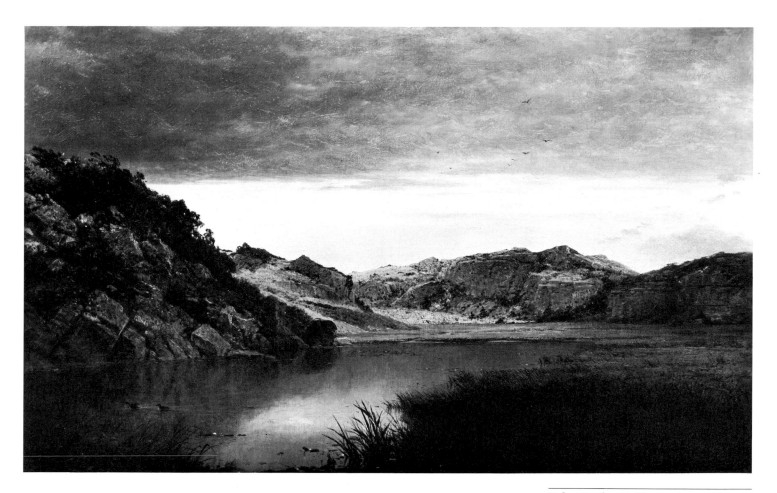

John Frederick Kensett
Paradise Rocks: Newport ca. 1865
Oil on canvas 18⅛″ x 29⅞″
20.1210

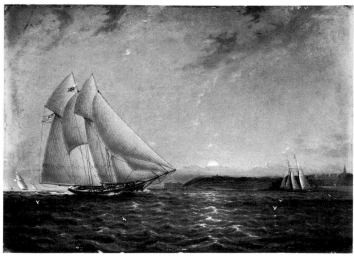

James E. Buttersworth
Harbor Scene late 1860's
Oil on cardboard 9″ x 13″
60.596

George Inness
Delaware Valley Before the Storm
ca. 1865
Oil on canvas 10″ x 14″
44.185

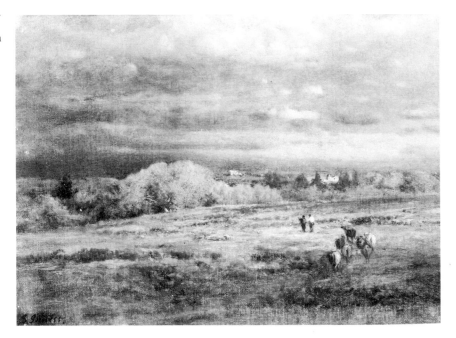

Jasper F. Cropsey
Italian Landscape 1879
Oil on canvas 32″ x 55½″
26.1235

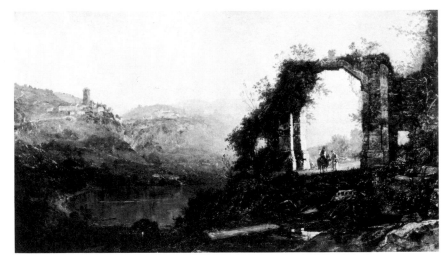

John Gadsby Chapman
Harvest on the Roman Campagna
1871
Oil on canvas 29¾″ x 71¼″
26.2788

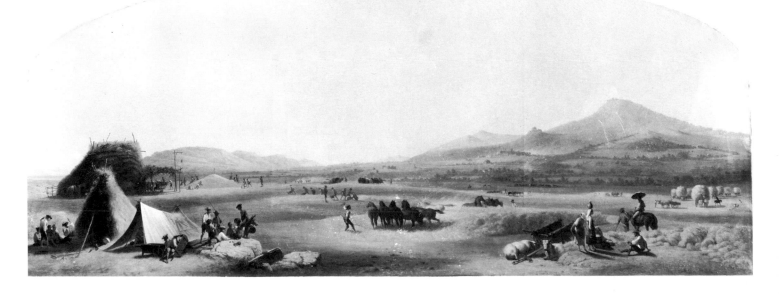

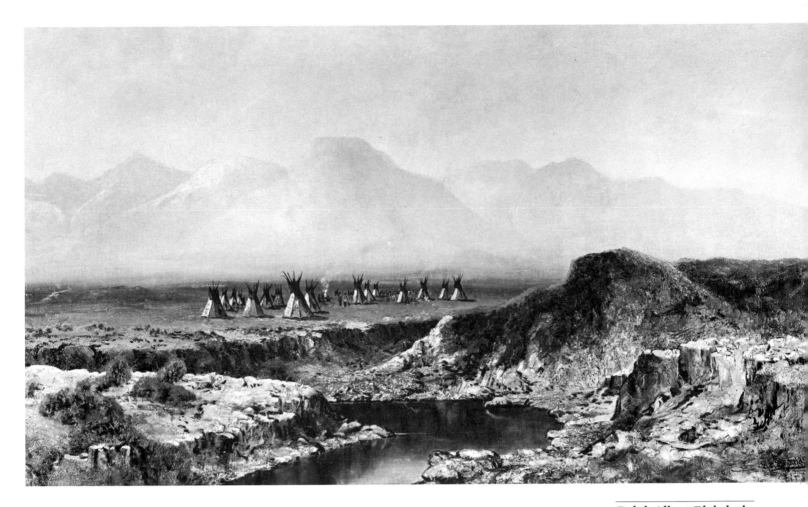

Ralph Albert Blakelock
Western Landscape
Oil on canvas 34¼″ x 60″
65.34

Thomas Buchanan Read
Sheridan's Ride 1870
Oil on canvas 29½″ x 24½″
21.2052

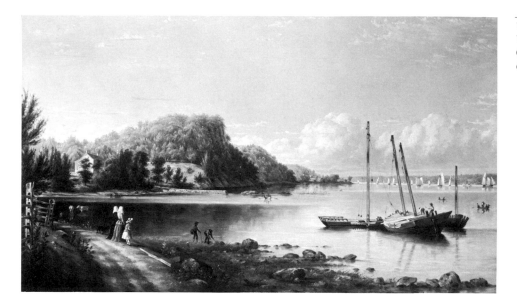

William Rickarby Miller
Weehawken Bluff on the Hudson 1871
Oil on canvas 20½″ x 34⅞″
63.74

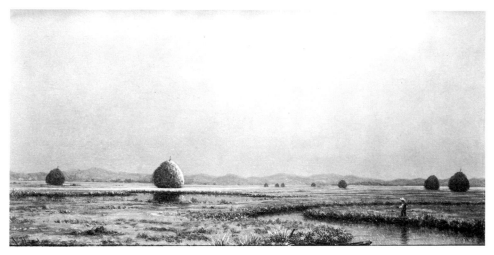

Martin Johnson Heade
Jersey Meadows with a Fisherman 1877
Oil on canvas 13⅝″ x 26½″
46.156

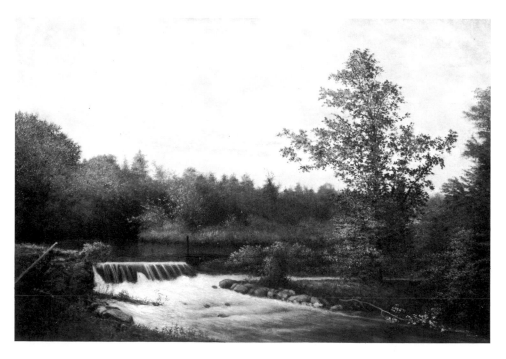

John Alexander McDougall
Milldam on the Whippany 1877
Oil on canvas 13⅜″ x 20⅛″
26.633

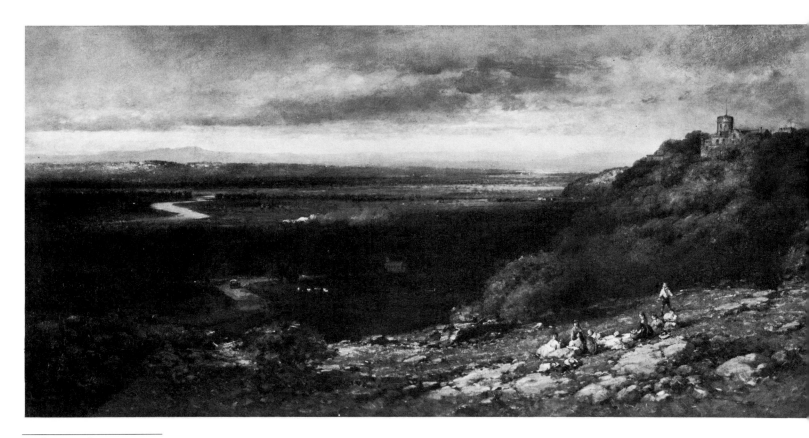

Andrew Melrose
Valley of the Hackensack
Oil on canvas 28¼″ x 58″
60.577

George Linen
Portrait of the Ballantine Children ca. 1873
Oil on board 13″ x 16½″
58.164

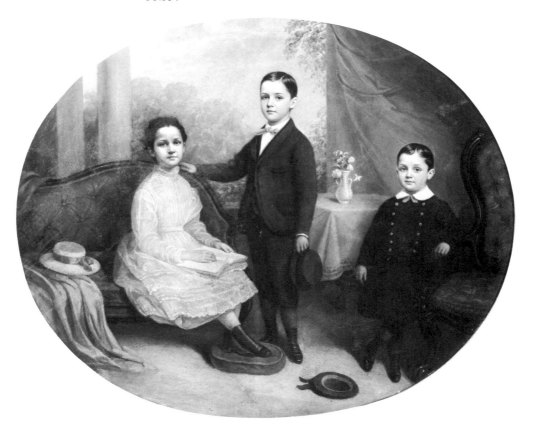

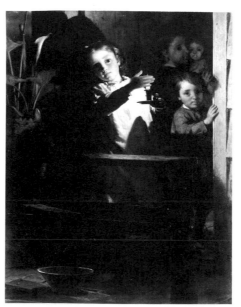

Seymour Joseph Guy
Children in Candlelight 1869
Oil on canvas 24⅛″ x 18⅛″
57.74

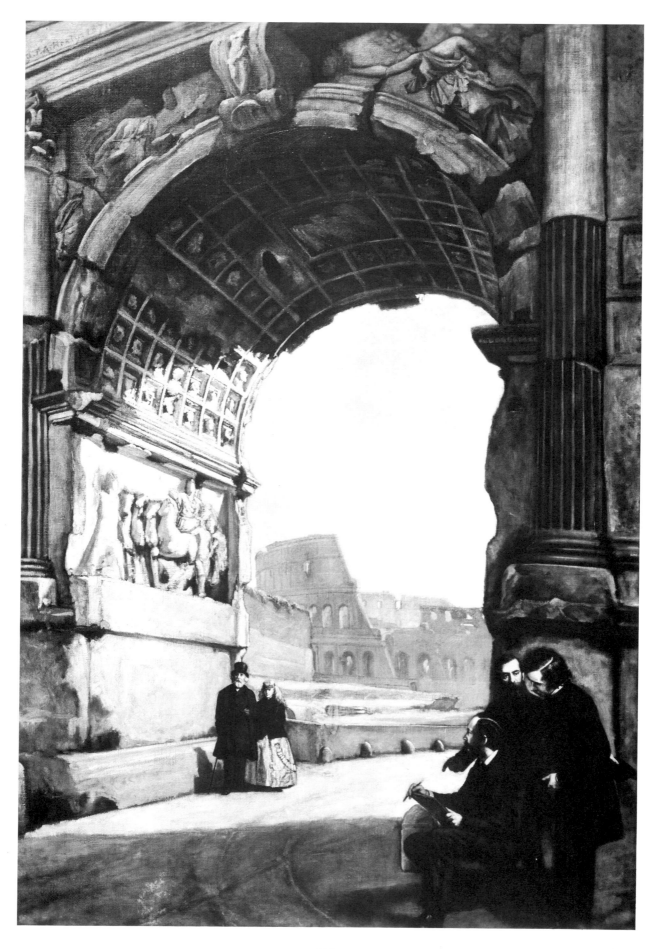

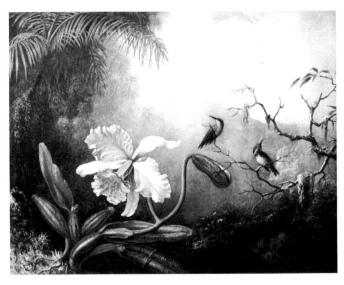

Severin Roesen
Still Life
Oil on canvas 12⅞″ x 16¼″
65.142

Martin Johnson Heade
Cattleya Orchid with Two Hummingbirds ca. 1880
Oil on canvas 16¼″ x 21¼″
65.118

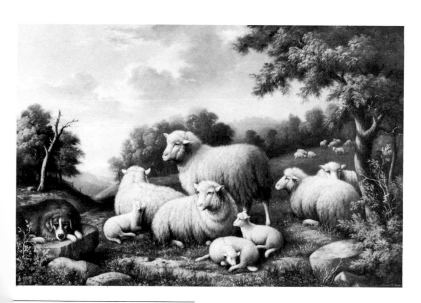

Susan C. Waters
Sheep in a Landscape ca. 1880
Oil on canvas 24″ x 36″
75.28

Arthur Fitzwilliam Tait
Barnyard Fowls 1869
Oil on canvas 16¼″ x 26¼″
69.181

C. Somers
Orange Mountains N.J.
Oil on canvas 23¾" x 32"
56.170

William Trost Richards
Twilight on the New Jersey Coast 1884
Oil on canvas 20⅛" x 40¼"
49.152

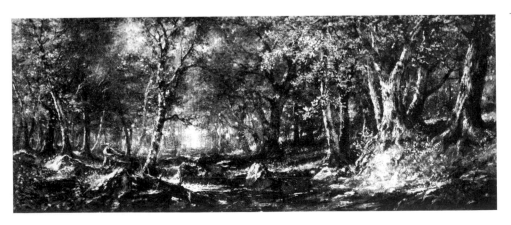

Daniel Huntington
Trout Brook ca. 1850
Oil on canvas 8¼" x 20"
26.1160

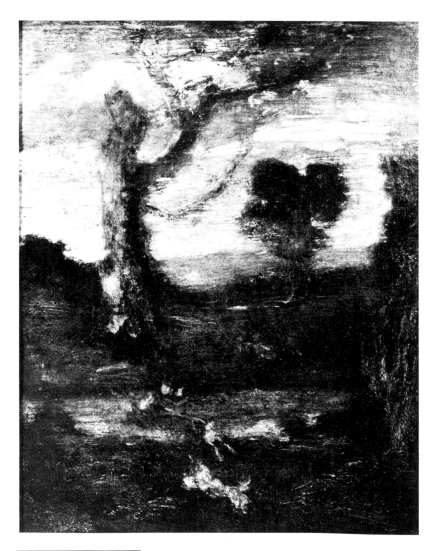

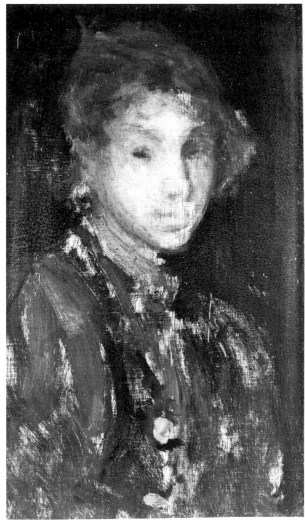

Albert P. Ryder
Diana's Hunt
Oil on canvas 18″ x 14″
55.116

James A.M. Whistler
Study, Head of a Girl ca. 1882-85
Oil on wood 11″ x 7″
62.4

John George Brown
Telling the News
Oil on canvas 24½″ x 30″
20.1211

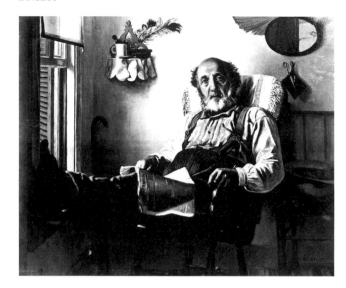

Elihu Vedder
Still Life Study: Old Pail and Tree Trunks ca. 1865
Oil on canvas 8½″ x 13⅞″
55.3

Worthington Whittridge
Millburn, New Jersey ca. 1885
Oil on canvas 20⅜″ x 15¼″
46.160

Winslow Homer
Beaver Mountain, Adirondacks; Minerva, New York ca. 1876
Oil on canvas 12⅛″ x 17⅛″
55.118

Thomas Eakins
Man in the Red Necktie ca. 1890
Oil on canvas 50″ x 36″
35.78

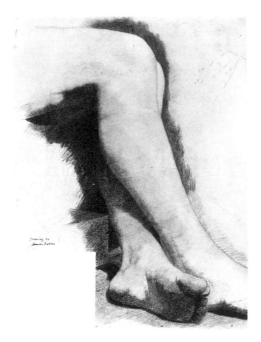

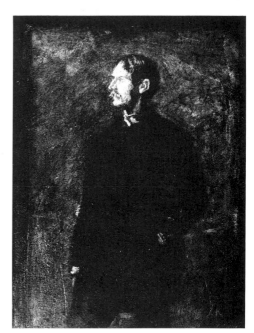

Thomas Eakins
Legs of a Seated Model ca. 1866
Charcoal on paper 23¾″ x 18½″
39.267

Thomas Eakins
Study, Portrait of Harrison S. Morris
ca. 1896
Oil on canvas 18¼″ x 13⅜″
39.266

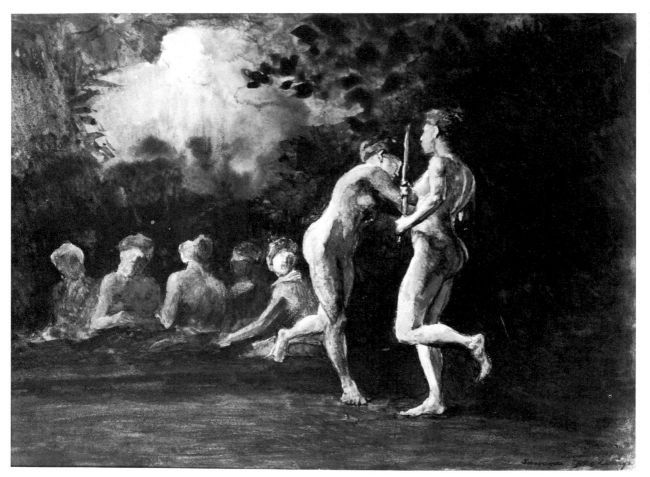

John La Farge
Evening Dance,
Samoa
ca. 1890
Oil on paper
8¾″ x 12¼″
45.97

John La Farge
Sunset at Papeete,
Looking toward
Moorea 1891
Watercolor on
paper 8¼″ x 13″
65.110

Mary Cassatt
Mathilde and Robert
ca. 1882
Oil on canvas
28¾″ x 23¾″
31.221

**Edward
Lamson Henry**
Lucy Hooper in Her
Living Room
in Paris 1876
Oil on canvas
12¼″ x 15¼″
59.375

**William
Merritt Chase**
Portrait of
Linda Dietz Carlton
ca. 1890
Oil on canvas
35″ x 29¼″
54.169

Abraham A. Anderson
French Cottage 1883
Oil on canvas 18″ x 24″
58.19

John Singer Sargent
Portrait of Sally Fairchild 1890
Oil on canvas 30″ x 25¼″
57.19

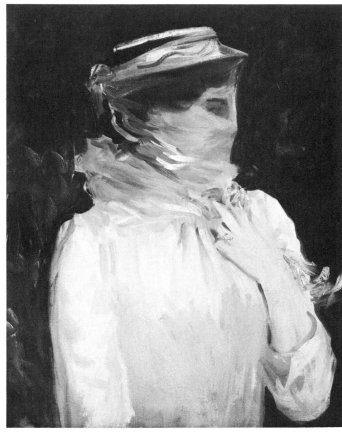

Robert Loftin Newman
The Good Samaritan 1886
Oil on canvas 9″ x 11″
25.1159

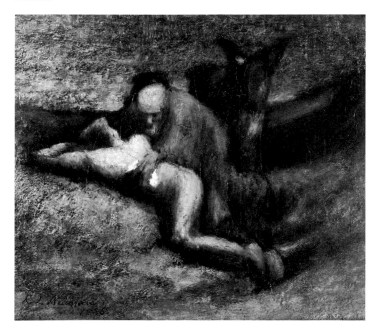

Charles Hawthorne
Calling of St. Peter ca. 1900
Oil on canvas 60″ x 48″
62.170

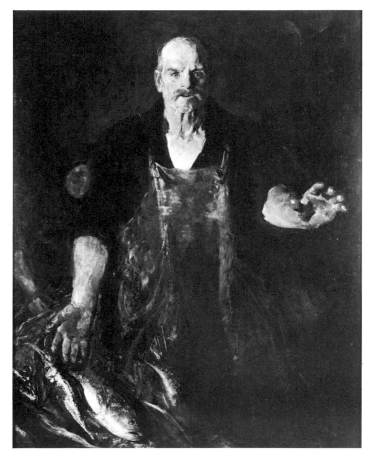

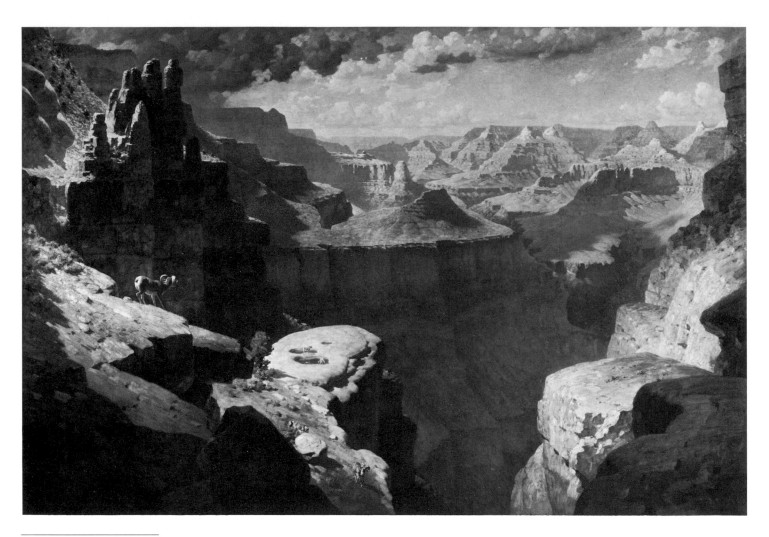

William Robinson Leigh
Grand Canyon 1911
Oil on canvas 66″ x 99″
30.203

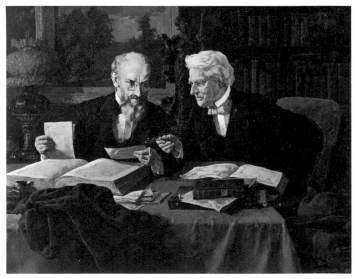

Louis Moeller
Dr. Abraham Coles in His Study
Oil on canvas 18¼″ x 24¼″
26.1227

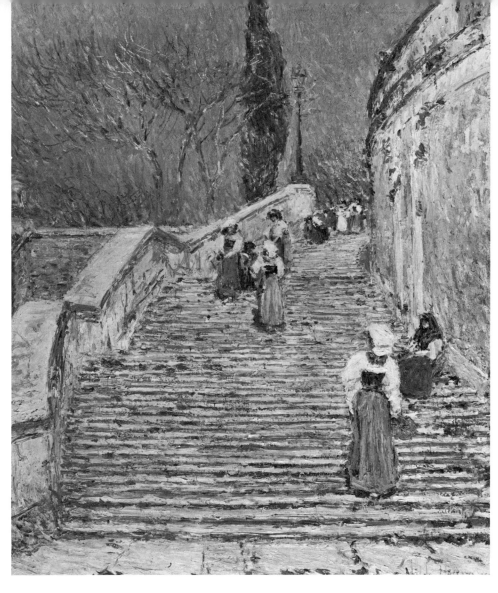

Childe Hassam
Piazza Di Spagna, Rome 1897
Oil on canvas 29¼″ x 23″
26.272

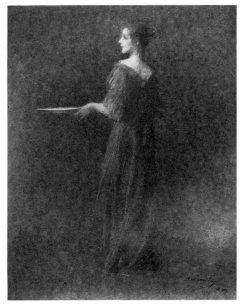

Thomas Wilmer Dewing
Pastel #207
Pastel on cardboard 14⅜″ x 11⅛″
44.196

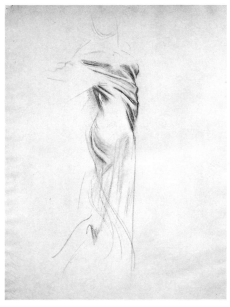

John Singer Sargent
Study of Drapery, Apollo, Muses 1917
Charcoal on paper 25″ x 18¾″
60.580

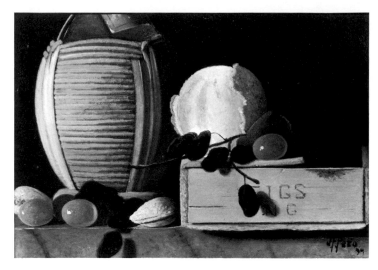

John Frederick Peto
Still Life: Wine Bottle, Fruit, Box of Figs 1894
Oil on cardboard 6″ x 9″
54.189

John Frederick Peto
Still Life with Lard Oil Lamp
Oil on canvas 14⅛″ x 24⅛″
54.196

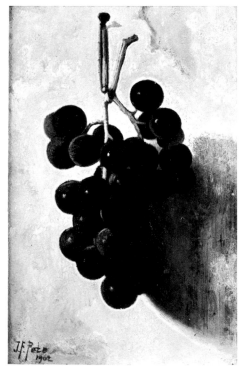

John Frederick Peto
Grapes 1902
Oil on academy board 8¾″ x 5¾″
54.188

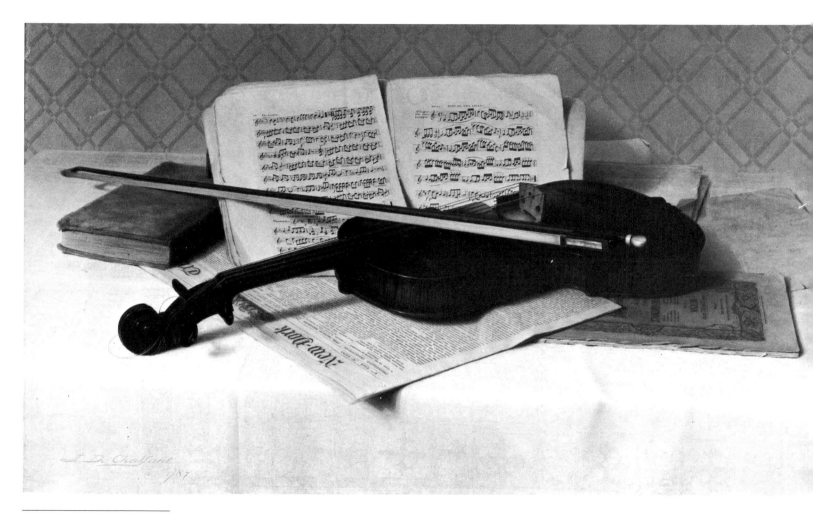

Jefferson David Chalfant
Violin and Music 1887
Oil on canvas 16½″ x 28½″
59.89

Ellen G. Emmet Rand
Portrait of
Oothout Zabriskie Whitehead 1906
Oil on canvas 91½″ x 37½″
78.79

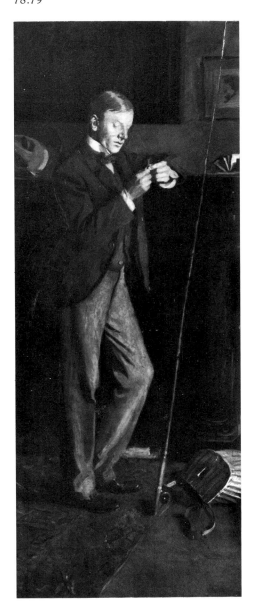

Mary Nimmo Moran
View of Newark from the Meadows ca. 1880
Oil on wood 8¼″ x 16″
56.171

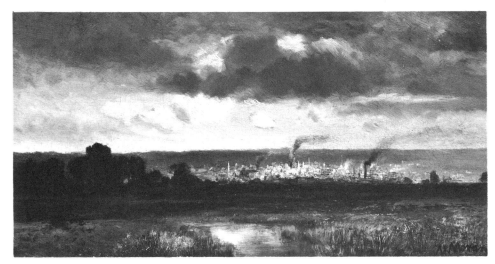

Everett Shinn
Mouqins 1904
Pastel on cardboard 18¾″ x 22⅝″
49.353

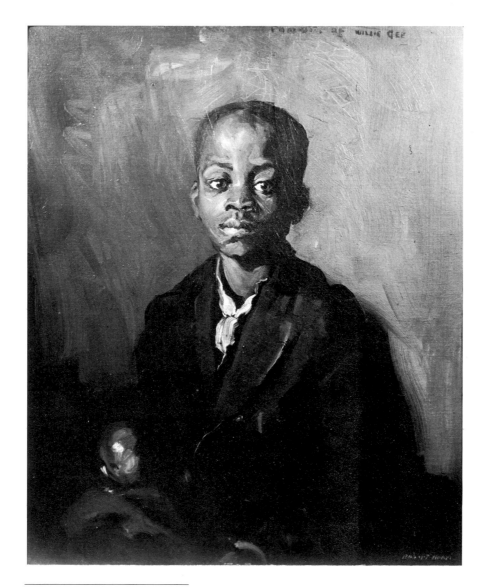

Robert Henri
Portrait of Willie Gee 1904
Oil on canvas 31¼″ x 26¼″
25.111

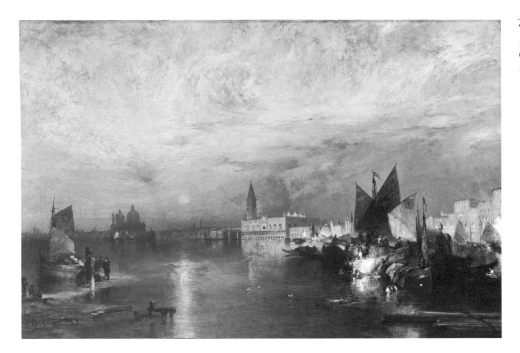

Thomas Moran
Sunset, Venice 1902
Oil on canvas 20¼″ x 30¼″
26.1313

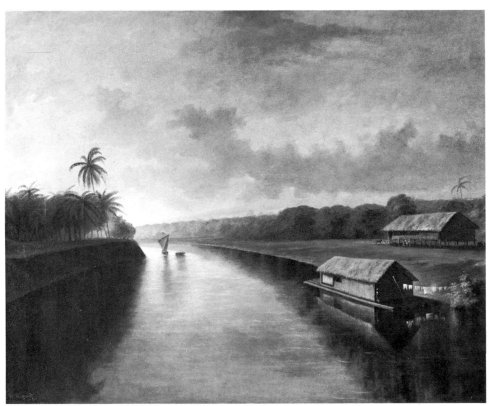

Louis Remy Mignot
Sunset on the Orinoco 1861
Oil on canvas 36″ x 46″
69.175

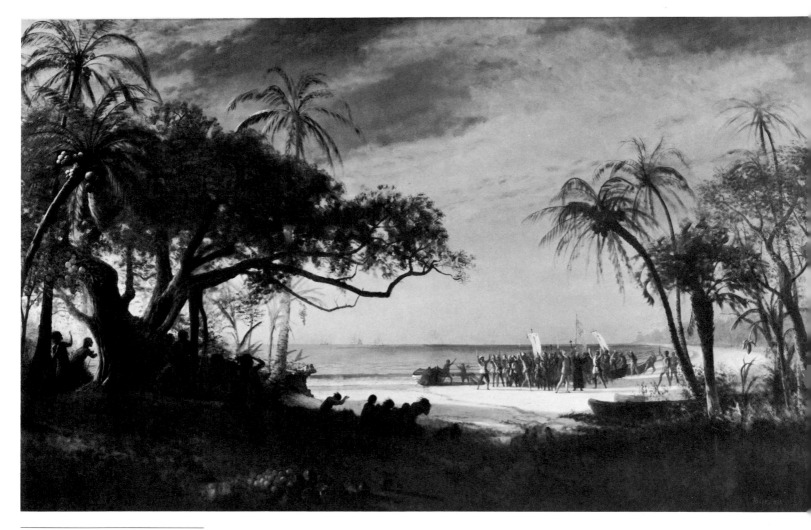

Albert Bierstadt
Landing of Columbus ca. 1893
Oil on canvas 72″ x 121″
20.1167

Arthur Parton
A Winter Dawn
Oil on canvas 35″ x 45″
65.131

Robert Swain Gifford
A Glimpse of the Sea
Oil on canvas 26⅛″ x 34⅛″
10.67

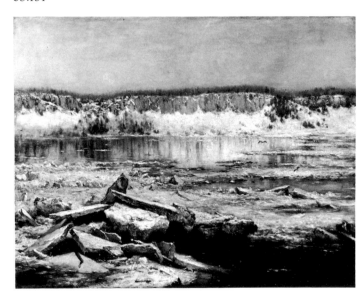

J. Alden Weir
Fording the Stream ca. 1910-19
Oil on canvas 25⅛″ x 30⅛″
66.404

Theodore Robinson
Moonrise 1892
Oil on canvas 15⅞″ x 22⅛″
65.120

George Bellows
Barnyard and Mountain 1922
Oil on canvas 16⅛″ x 24″
25.1080

Carleton Wiggins
The Red Oak
Oil on canvas 25¼″ x 30⅜″
29.263

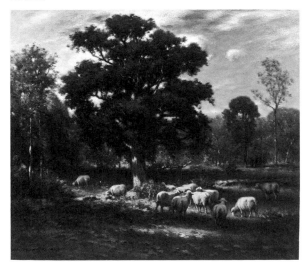

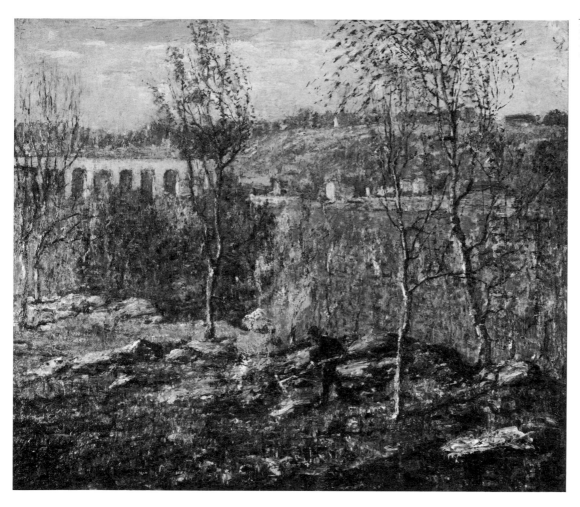

Ernest Lawson
Harlem River ca. 1910
Oil on canvas 25″ x 30″
10.11

Ernest Lawson
Landscape ca. 1901
Oil on canvas 18¼″ x 24¼″
29.630

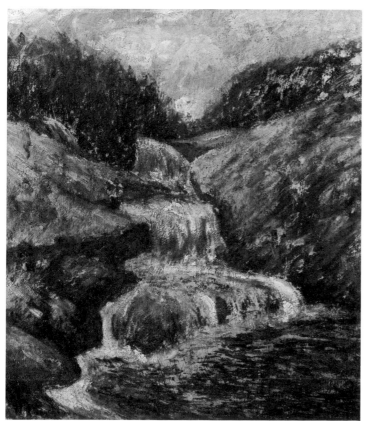

John Henry Twachtman
The Cascade ca. 1890's
Oil on canvas 28″ x 24¼″
64.237

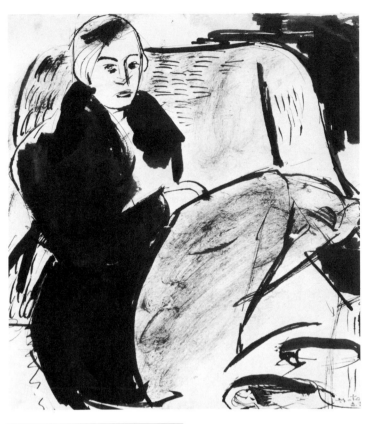

Lee Gatch
Drawing of Ray 1922
Pen and ink on paper 7¾" x 6¼"
72.189

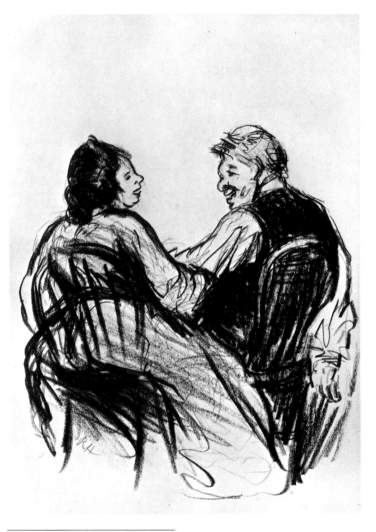

Robert Henri
Man and Woman Laughing
Charcoal on paper 10⅜" x 7⅞"
65.108

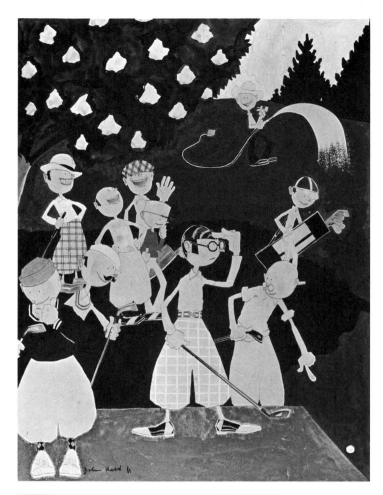

John Held, Jr.
Comedy that Appeals to the Gallery ca. 1923
Gouache on board 19⅛″ x 14⅞″
77.24

Niles Spencer
Table, Chairs, With Sea Beyond
Pen and ink on paper 13¼″ x 10⅛″
72.49

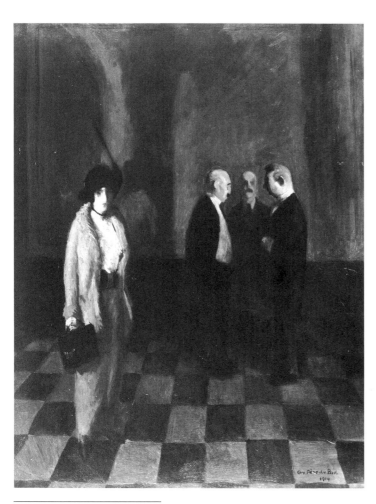

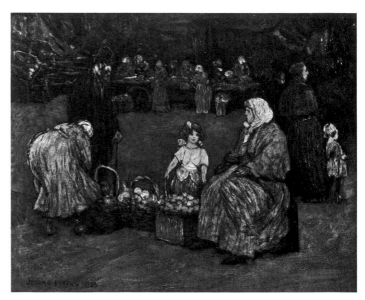

Jerome Myers
East Side Corner 1923
Oil on canvas 16″ x 19⅞″
24.858

Guy Pene du Bois
The Corridor 1914
Oil on canvas 28¼″ x 21¼″
25.1161

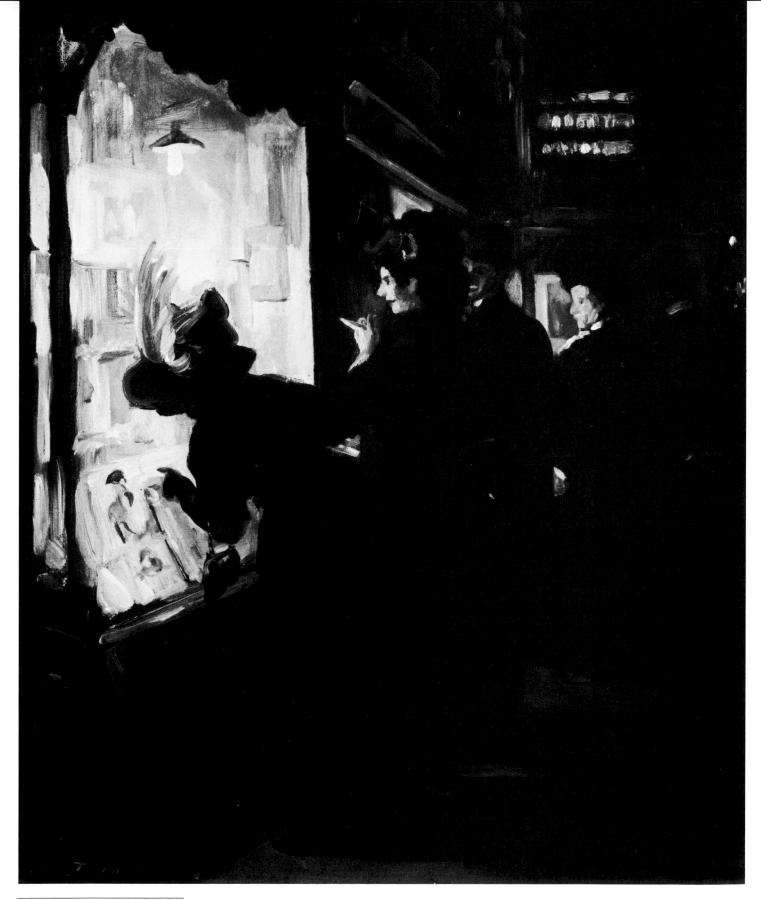

John Sloan
Picture Shop Window 1907
Oil on canvas 32″ x 25⅛″
25.1163

Childe Hassam
The South Gorge, Appledore, Isles of Shoals 1912
Oil on canvas 22¼″ x 18″
12.571

Frederick Judd Waugh
The Coast of Maine
Oil on canvas 30⅛″ x 40″
11.573

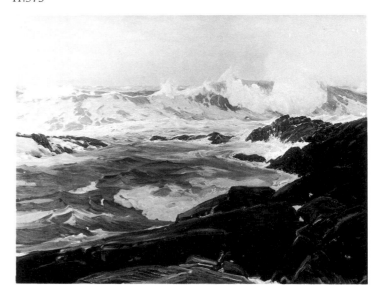

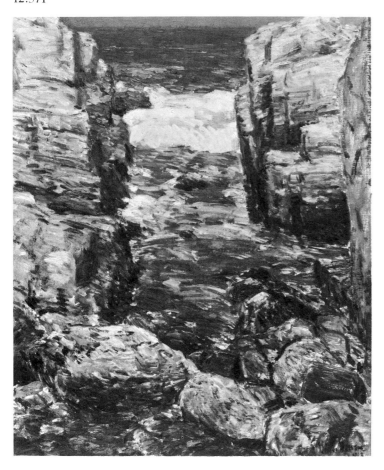

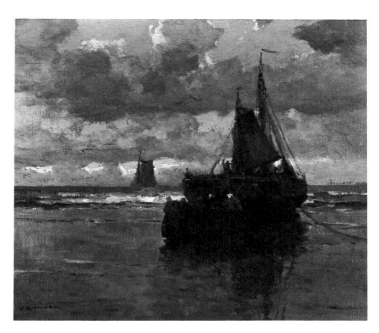

William Ritschel
Marine ca. 1910
Oil on canvas 20″ x 24″
10.9

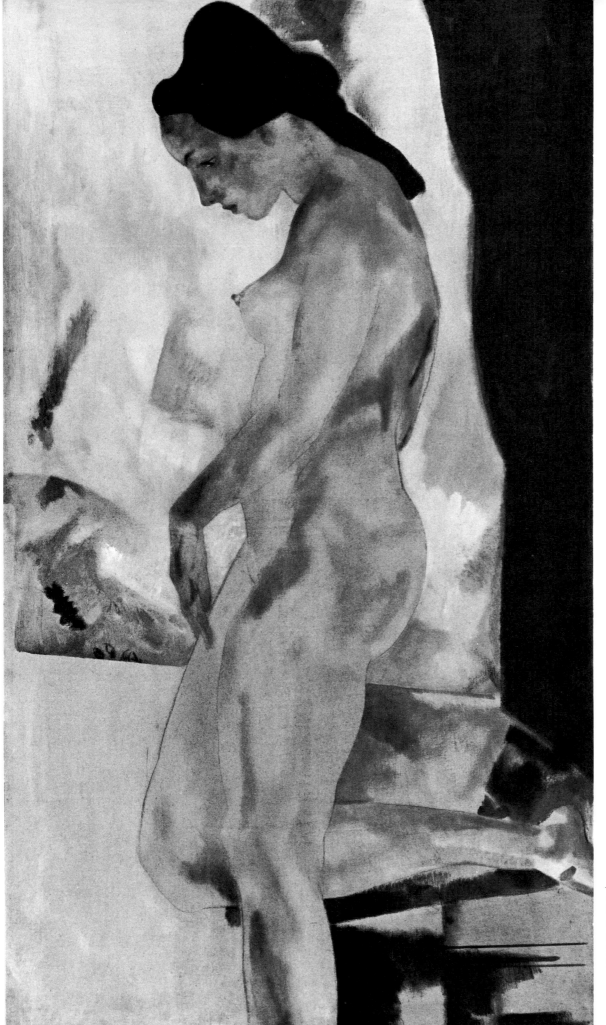

Arthur B. Davies
Marmoreal Dream
ca. 1920
Oil on canvas
66¼″ x 36¼″
31.324

Elihu Vedder
Adam and Eve Mourning Death of Abel 1911
Oil on canvas 14¼″ x 47¼″
55.2

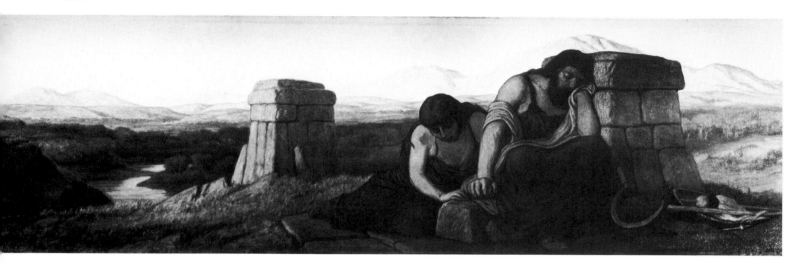

Henry Ossawa Tanner
The Good Shepherd 1920
Oil on canvas 32″ x 24″
29.910

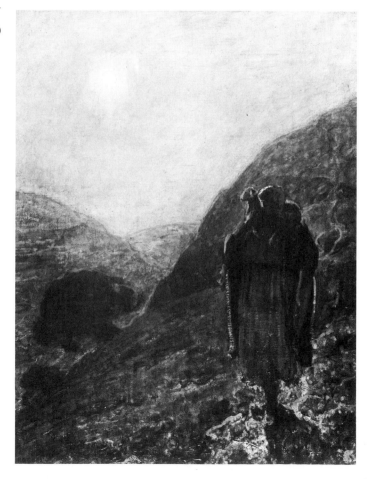

Louis Eilshemius
Dance of Sylphs ca. 1908
Watercolor on paper 13″ x 19¼″
57.3

Bryson Burroughs
The Age of Gold 1913
Oil on canvas 29¾″ x 36″
25.1171

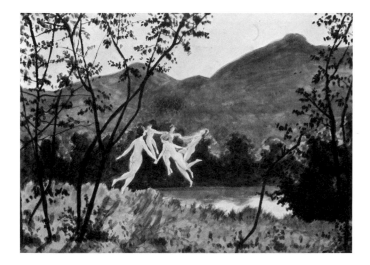

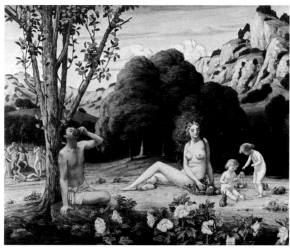

Arthur B. Davies
Nudes in a Landscape
Oil on canvas
34″ x 48¼″
58.186

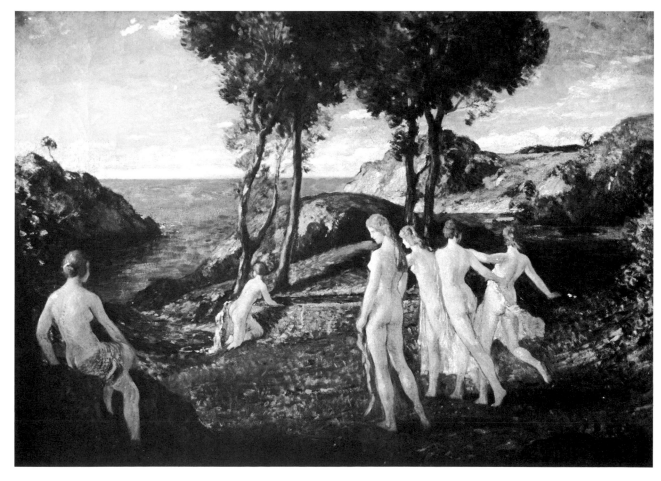

J. Francis Murphy
In the Shadow of the Hills 1910
Oil on canvas 27″ x 41″
67.156

J. Francis Murphy
The Mill Race 1897
Watercolor on cardboard 8¼″ x 12¼″
38.329

Louis Eilshemius
The Funeral 1916
Oil on wood 38¾″ x 59½″
43.92

John Singer Sargent
Camping at Lake O'Hara 1916
Watercolor 15¾″ x 20⅞″
57.86

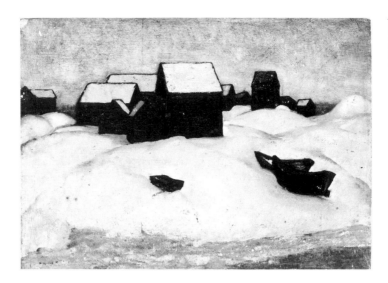

Niles Spencer
Houses on a Hill 1917
Oil on wood 11⅞″ x 16⅛″
71.123

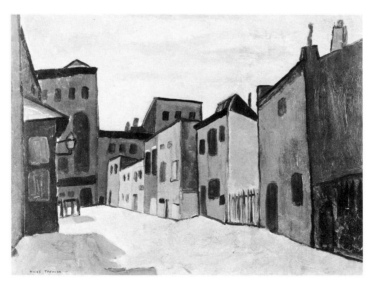

Niles Spencer
New York Alley 1922?
Oil on cardboard 11⅞″ x 15⅞″
71.120

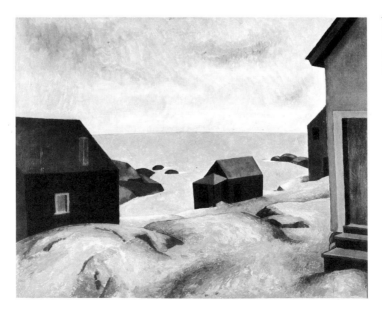

Niles Spencer
The Cove 1922
Oil on canvas 28″ x 36″
26.4

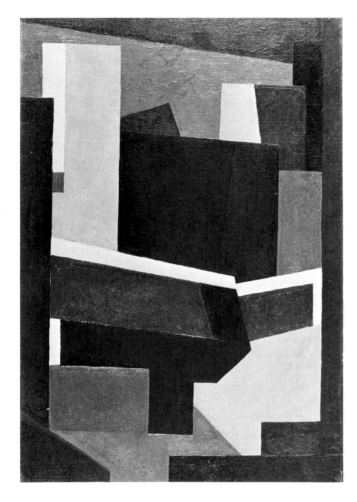

Niles Spencer
Above the Excavation #3 1950
Oil on canvasboard 15½″ x 10½″
71.119

Niles Spencer
Study for The Watch Factory ca. 1950
Gouache on cardboard 10½″ x 16″
71.118

Niles Spencer
Viaduct 1929
Oil on canvas 18¼″ x 21½″
71.113

Oscar Bluemner
The Hudson 1936
Gouache on cardboard 19¼″ x 24½″
43.197

Oscar Bluemner
The Last House
Watercolor on paper 10⅛″ x 13¼″
58.183

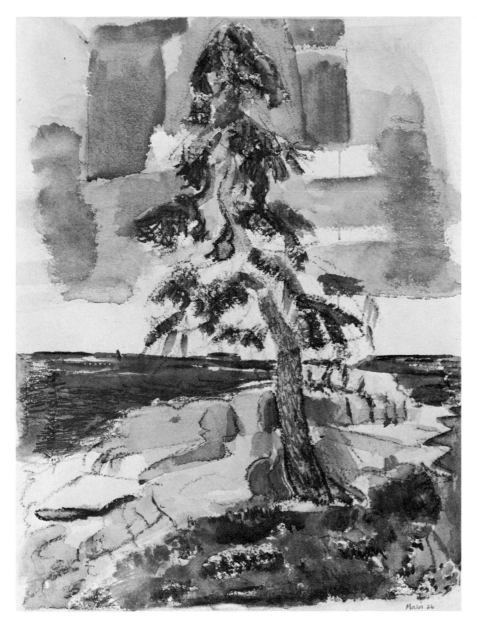

John Marin
Fir Tree 1926
Watercolor on paper 21¼″ x 17½″
30.76

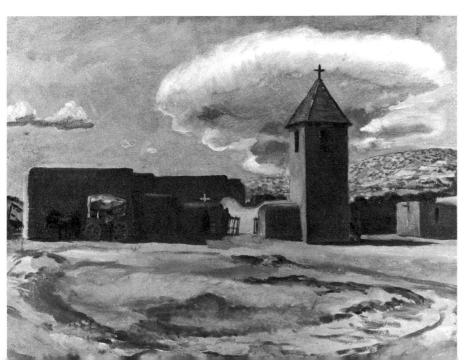

John Sloan
Church of the Penitentes Chimayo 1922
Oil on canvas 19⅞″ x 26⅛″
25.1164

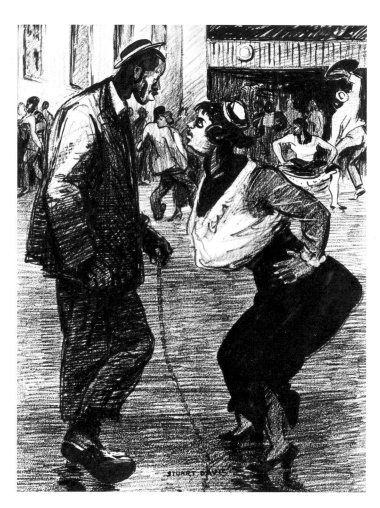

Stuart Davis
Negro Dance Hall ca. 1915
Crayon and ink on paper 25½" x 18⅞"
72.144

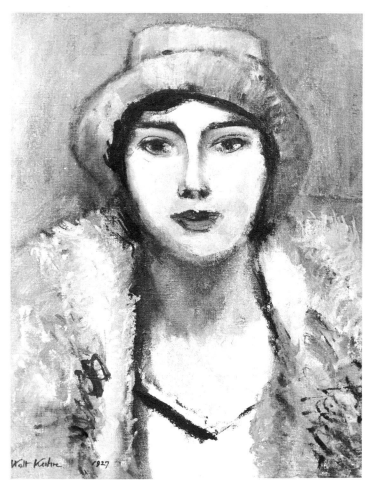

Walt Kuhn
Girl in Gray Furs 1927
Oil on canvas 20" x 16⅛"
56.8

William J. Glackens
At the Beach ca. 1918
Oil on canvas 25″ x 30″
25.1167

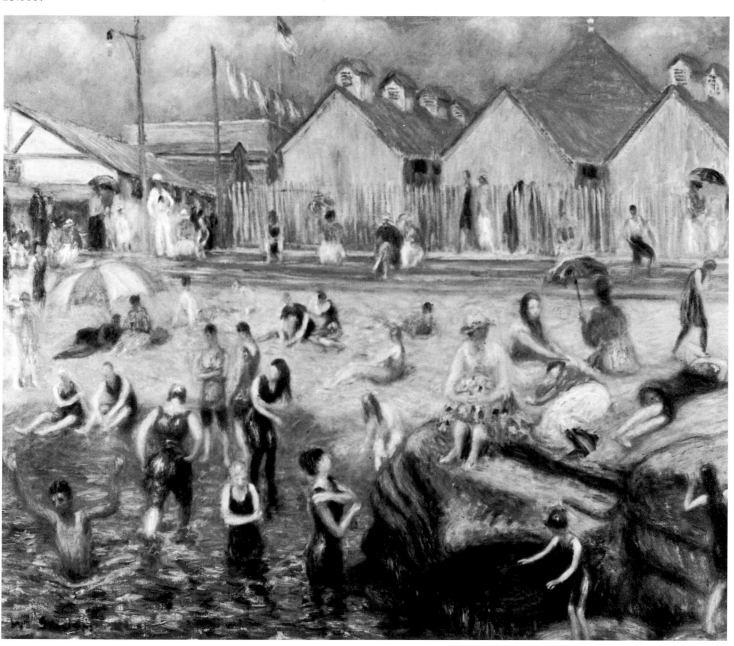

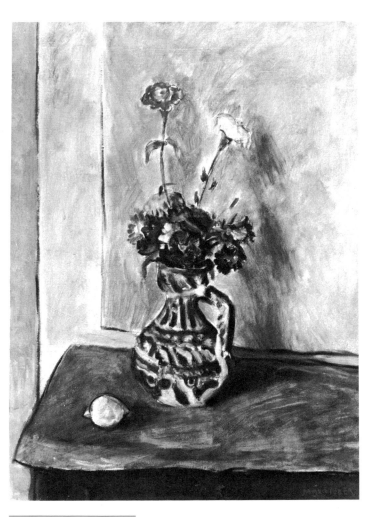

Max Weber
Zinnias 1927
Oil on canvas 28″ x 21″
28.698

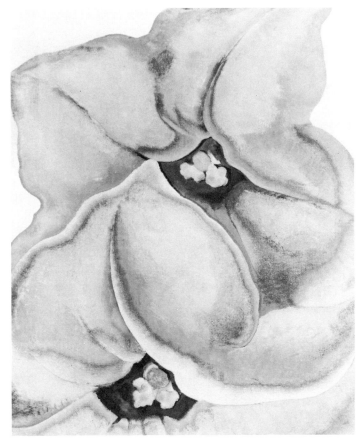

Georgia O'Keeffe
Purple Petunias 1925
Oil on canvas 15⅞″ x 13″
58.167

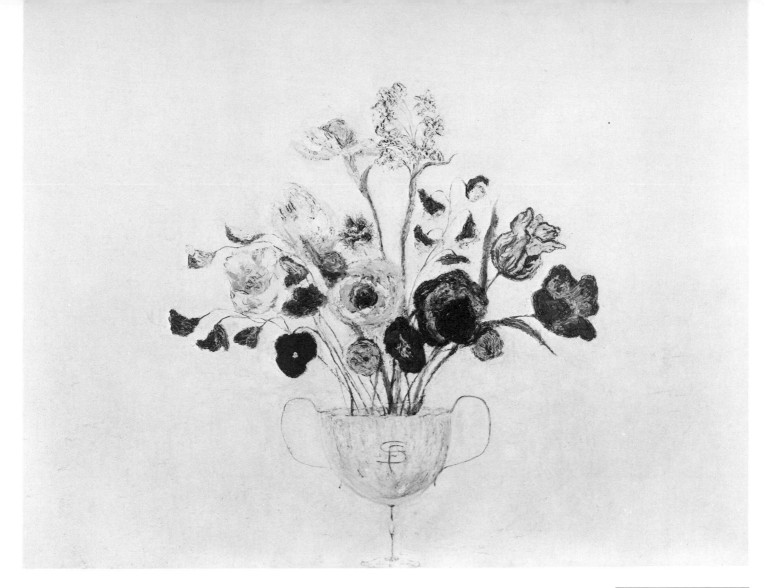

Florine Stettheimer
Flower Piece ca. 1921
Oil on canvas 25″ x 30″
44.176

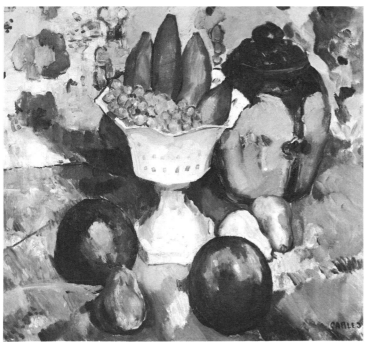

Arthur B. Carles
Still Life with Compote 1911
Oil on canvas 24⅛″ x 25⅛″
58.171

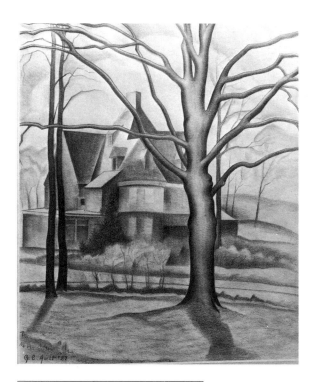

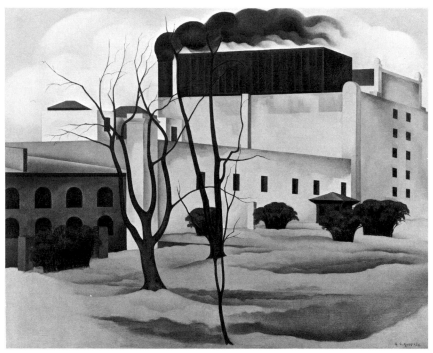

George C. Ault
Victorian House and Tree 1927
Pencil on paper 12″ x 10″
41.677

George C. Ault
Brooklyn Ice House 1926
Oil on canvas 24″ x 30″
28.1760

George C. Ault
From Brooklyn Heights 1925
Oil on canvas 30″ x 20″
28.1802

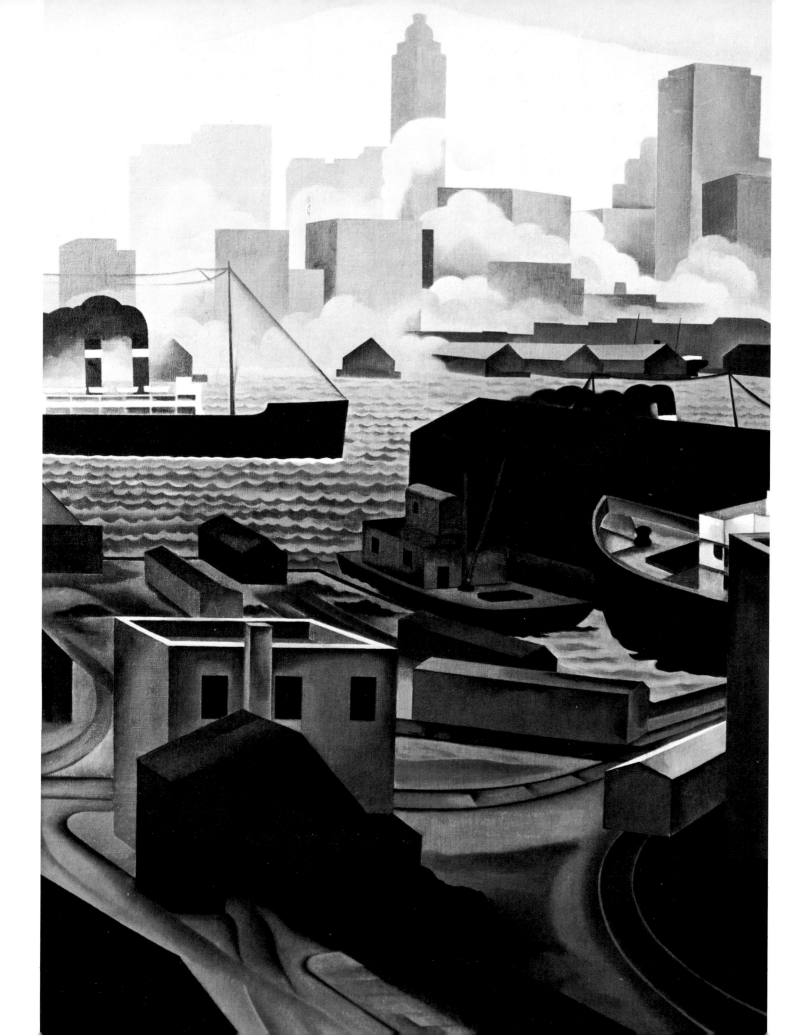

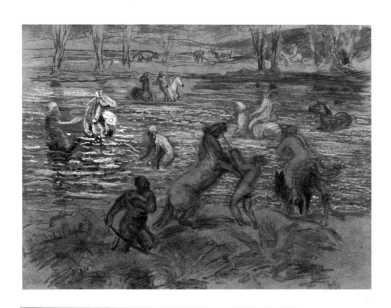

George O. "Pop" Hart
Bathing the Horses 1929
Pastel, pencil, gouache on parchment 18¼″ x 23⅞″
38.212

George O. "Pop" Hart
Landscape Near Bou Saada 1930
Watercolor on paper 18″ x 23⅞″
38.211

George de Forest Brush
A Memory 1925
Oil on wood panel 31½″ x 25″
26.201

Charles E. Prendergast
Figures 1918
Tempera, gold leaf, gesso on wood
27¾″ x 23¾″
36.90

Preston Dickinson
The Bridge ca. 1922-23
Pastel, gouache, pencil on paper 19″ x 12⅜″
30.73

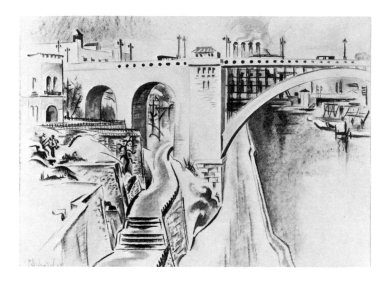

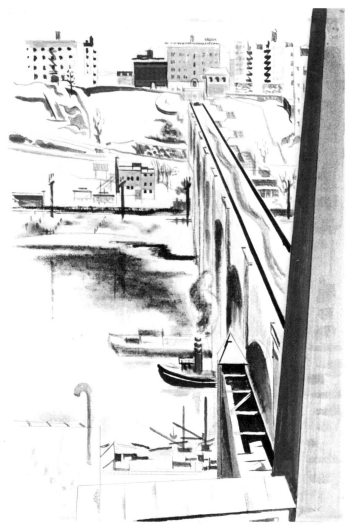

Preston Dickinson
Factories 1920
Pencil and gouache on paper 14⅛″ x 20¾″
55.159

Preston Dickinson
Washington Bridge 1922
Pastel, chalk, ink, graphite on paper 19″ x 25⅛″
51.149

Charles Burchfield
Evening
Watercolor on paper 33½″ x 45½″
44.39

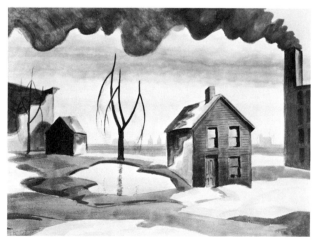

Charles Burchfield
Factory Town Scene ca. 1920-30
Watercolor on paper 16⅜″ x 22″
30.75

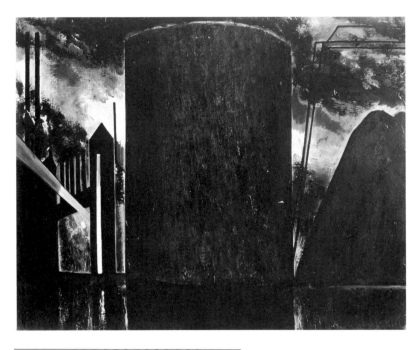

Joseph Stella
Factories at Night – New Jersey 1929
Oil on canvas 29″ x 36¼″
36.534

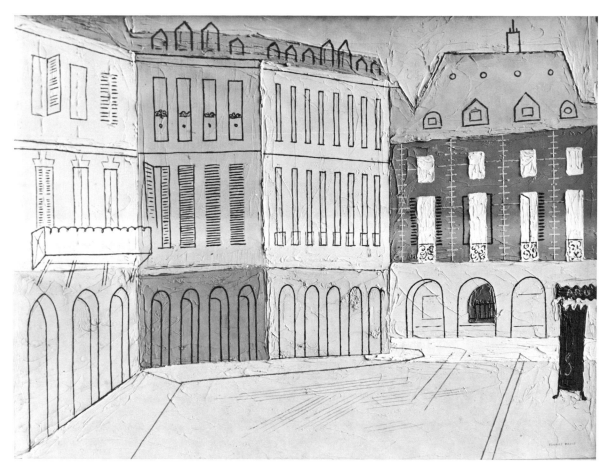

Stuart Davis
Place des Vosges No. 1
1928
Oil on canvas
21″ x 28¾″
37.119

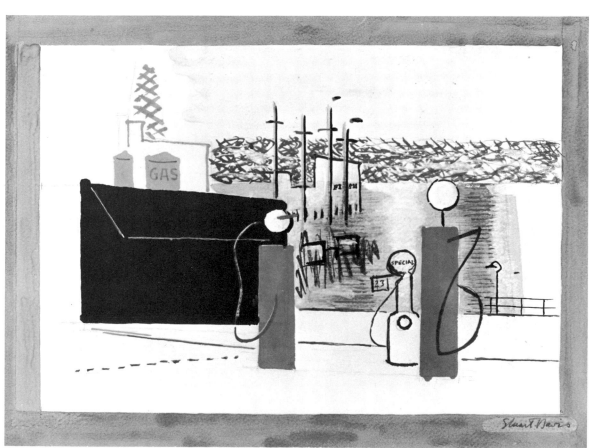

Stuart Davis
Gasoline Tank 1930
Watercolor on paper
15⅞″ x 20⅞″
37.112

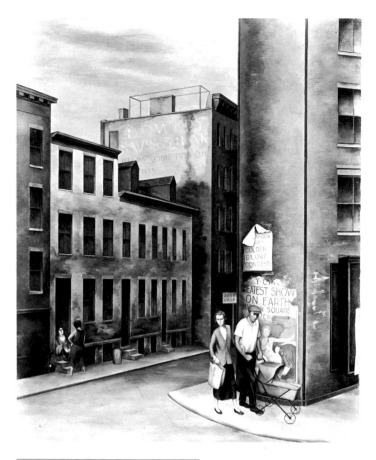

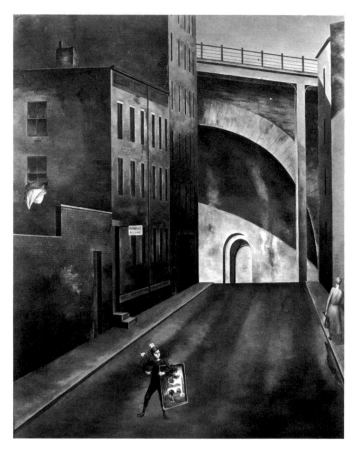

Louis O. Guglielmi
View in Chambers Street 1936
Oil on canvas 30¼" x 24¼"
43.192

Louis Guglielmi
Hague Street 1936
Oil on canvas 30⅛" x 24"
45.241

Abraham Walkowitz
Side Show at Coney Island
Oil on canvas 26″ x 40″
53.31

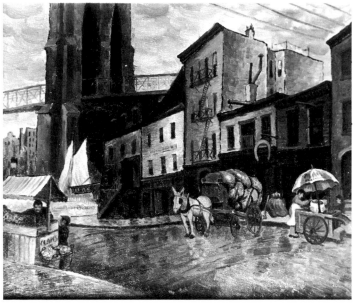

Glenn O. Coleman
Coenties Slip 1926
Oil on canvas 25″ x 30″
28.1550

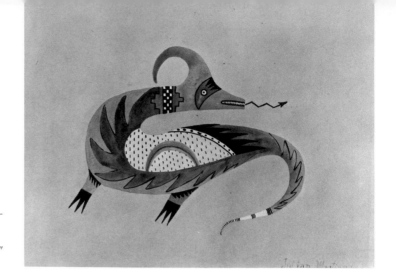

Julian Martinez
Plumed Serpent ca. 1935
Watercolor and gouache on paper 11″ x 13″
37.226

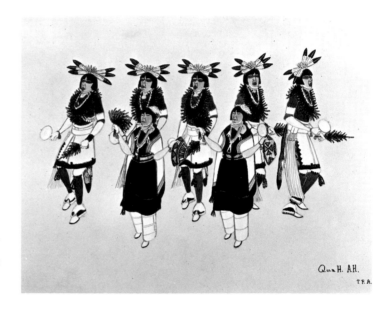

Tonita Peña
Seven Spring Ceremony Dance ca. 1920
Gouache on board 10⅞″ x 14″
37.197

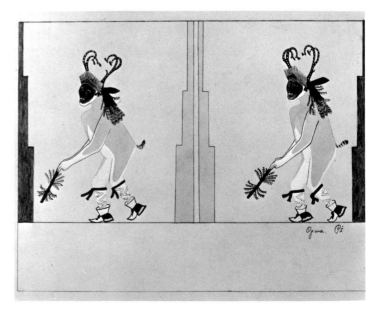

Oqwa Pi-Abel Sanchez
Deer Dance
Pencil, ink, gouache on paper 11¼″ x 14¼″
28.1451

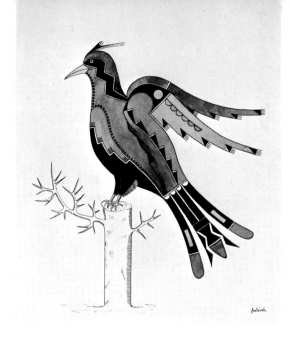

Awa Tsireh-Alfonso Roybal
Bird ca. 1930
Ink and gouache on paper 14″ x 11″
37.224

Fred Kabotie
Hopi Kachina ca. 1930
Gouache on paper 15″ x 21¾″
37.222

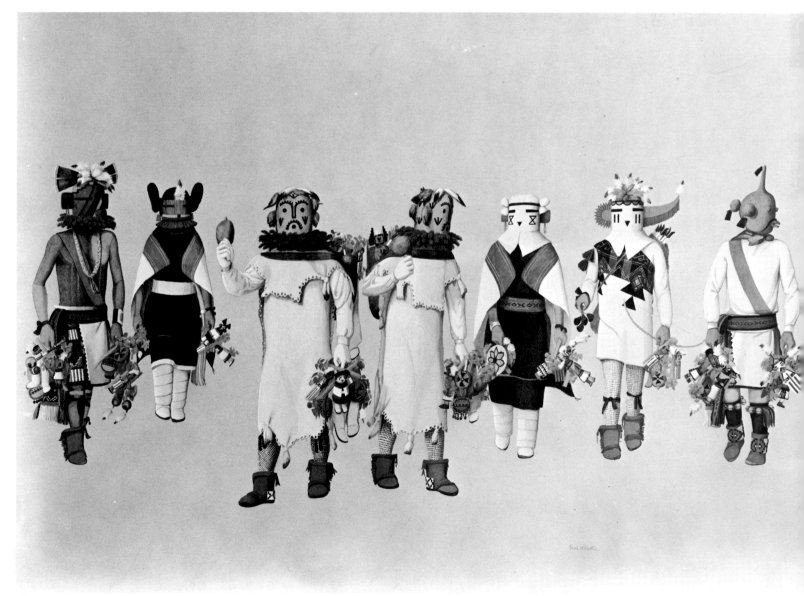

167

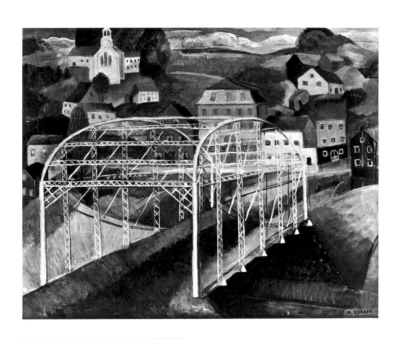

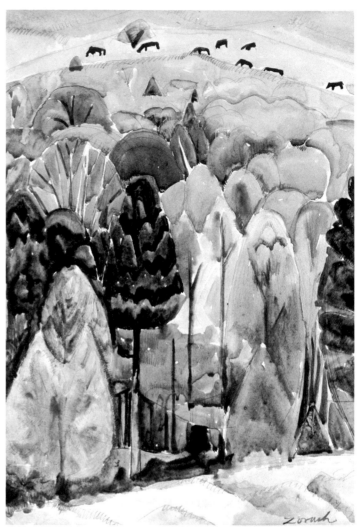

Marguerite Zorach
Bridge, New England 1930
Oil on canvas 25⅛″ x 31⅛″
37.121

William Zorach
Autumn 1917-20
Watercolor on paper 15⅝″ x 11⅜″
58.173

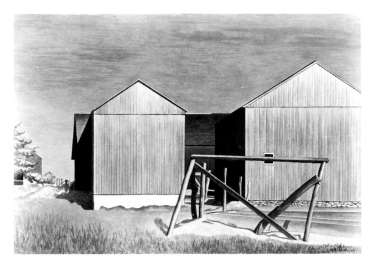

Charles Sheeler
Farm Buildings, Connecticut 1941
Tempera on cardboard 16″ x 21½″
44.170

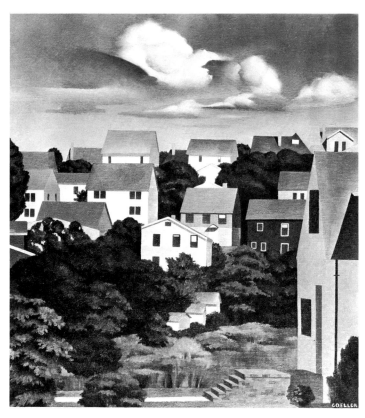

Charles L. Goeller
Suburban Development 1939
Oil on canvas 22″ x 20″
40.155

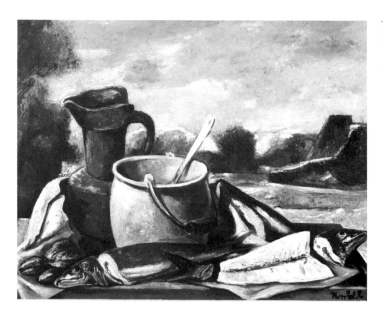

Bror Julius Olsson Nordfeldt
The Blue Fish 1942
Oil on masonite 32⅛″ x 40″
49.352

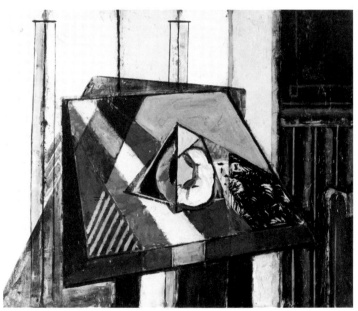

Alfred H. Maurer
Pastry on a Table ca. 1931
Oil on gessoed masonite 18¼″ x 21½″
75.235

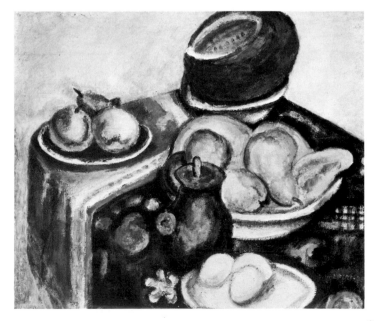

Samuel Halpert
Still Life: Spanish Series
Oil and encaustic wax on canvas 18″ x 21½″
58.169

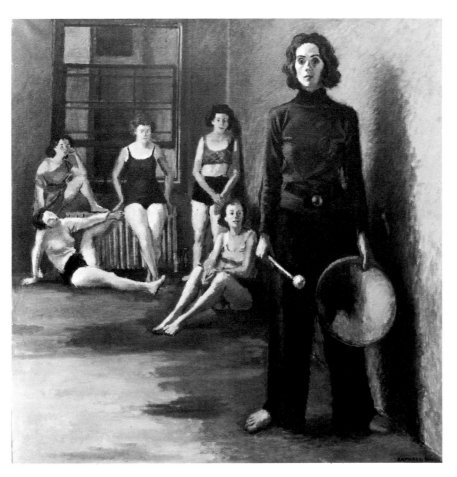

Raphael Soyer
Fé Alf and Pupils 1935
Oil on canvas 40″ x 37⅞″
37.5

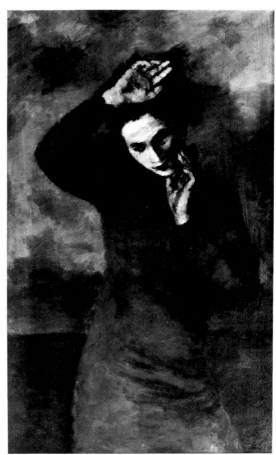

Alexander Brook
The Tragic Muse ca. 1933
Oil on canvas 40″ x 24″
40.119

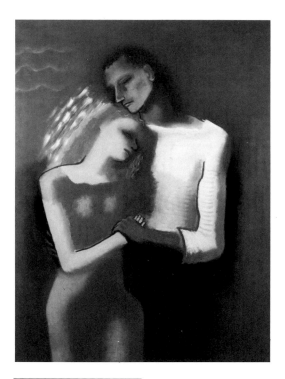

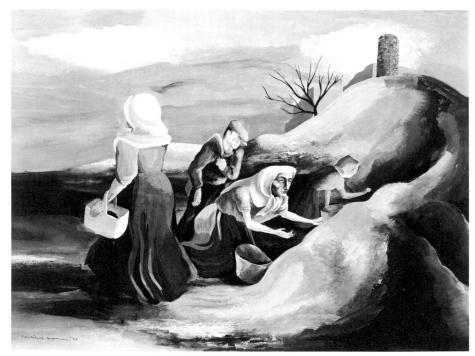

John Carroll
Two Figures 1929
Oil on canvas 50″ x 40″
54.209

Mitchell Siporin
Coal Pickers 1936
Gouache on paper 20⅛″ x 29⅞″
43.163

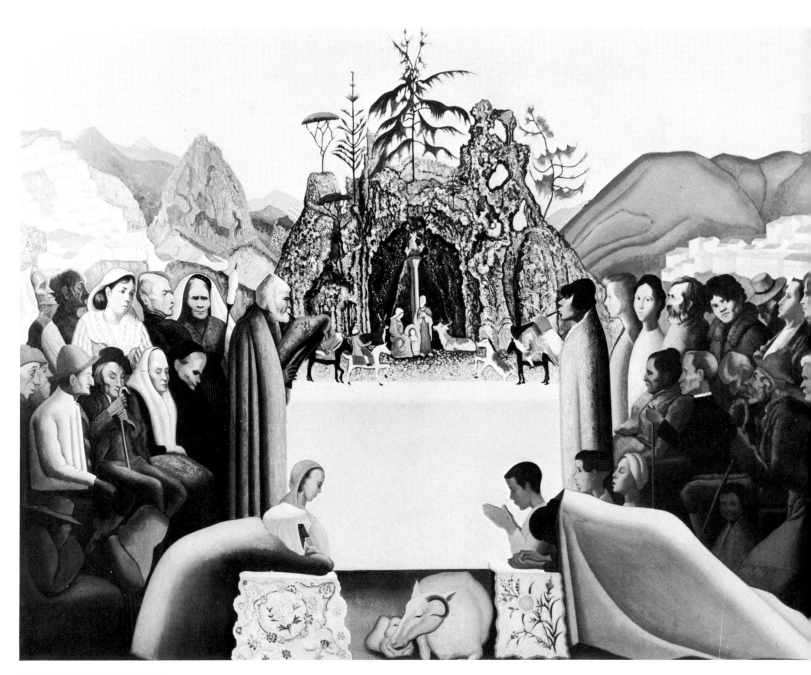

Joseph Stella
The Creche ca. 1929-33
Oil on canvas 61″ x 77″
40.242

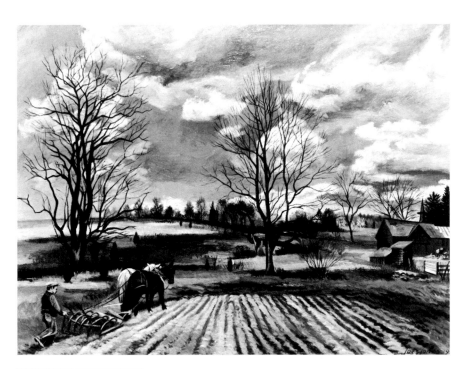

Joe Jones
Spring Plowing
Oil on canvas 30″ x 40″
45.6

Stanton Macdonald Wright
Yosemite Valley 1937
Pencil on paper 27⅞″ x 22⅞″
43.207

Ben Shahn
Little Church
Watercolor on paper 15¾″ x 23¾″
37.116

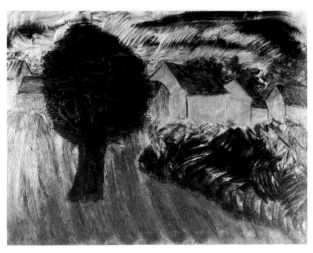

Milton Avery
Landscape, Vermont 1938
Oil on canvas 27⅞″ x 36″
50.116

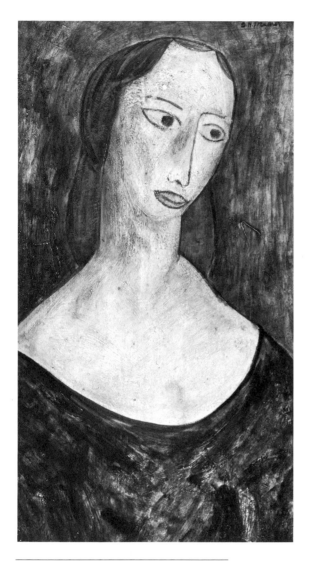

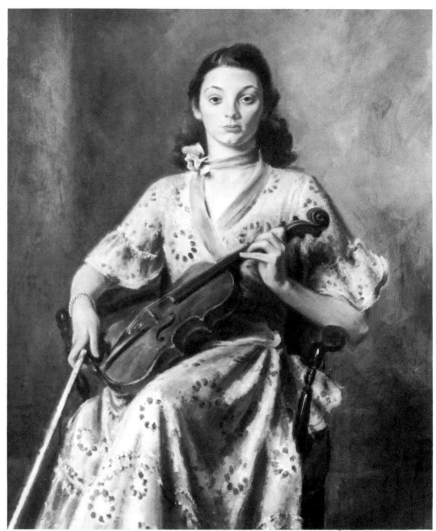

Alfred Henry Maurer
Head
Oil on composition board 21⅝″ x 11½″
77.332

Eugene Speicher
The Violinist ca. 1929
Oil on canvas 50″ x 40″
54.207

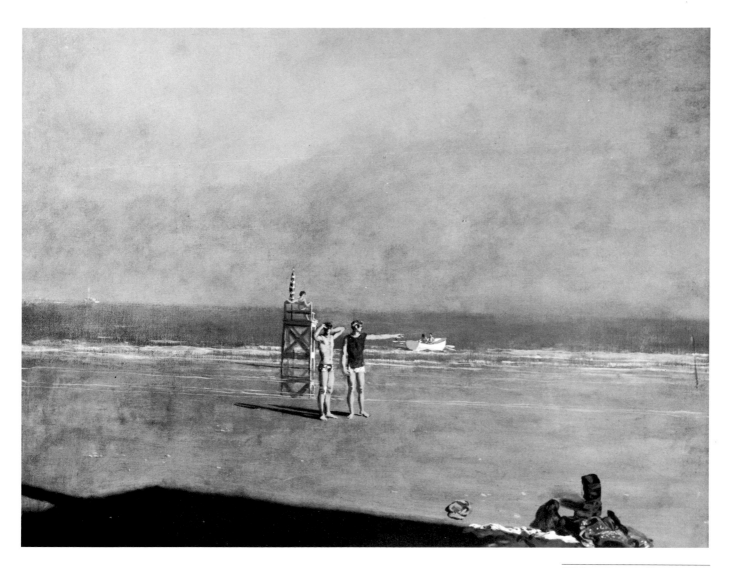

Walter Stuempfig
Life Guards ca. 1954
Oil on canvas 30⅛″ x 40⅛″
54.6

Max Weber
At the Mill 1939
Oil on canvas 40⅛″ x 48¼″
46.159

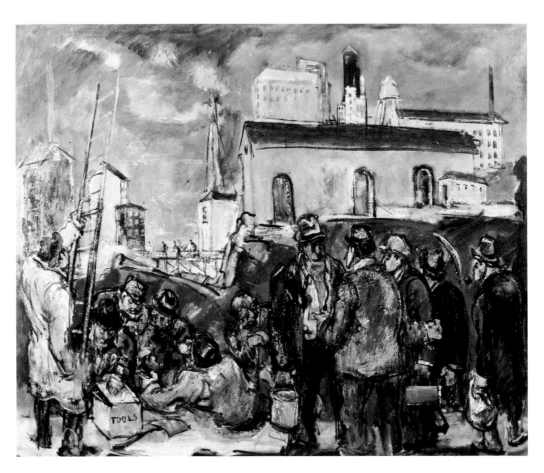

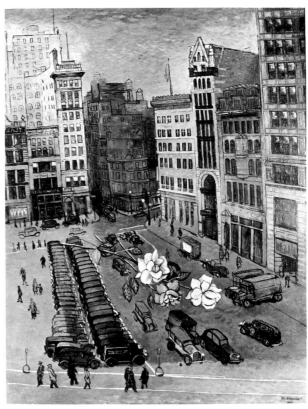

Morris Kantor
Farewell to Union Square 1931
Oil on canvas 36⅛″ x 27⅛″
46.154

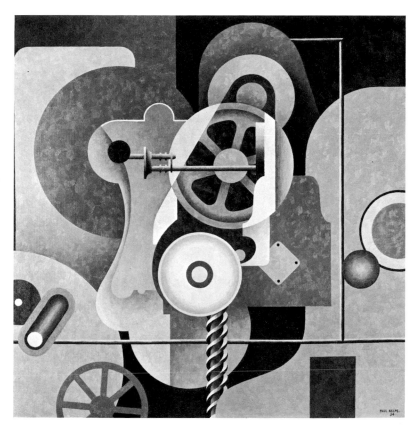

Paul Kelpe
Machine Elements 1934
Oil on canvas 24″ x 24″
78.164

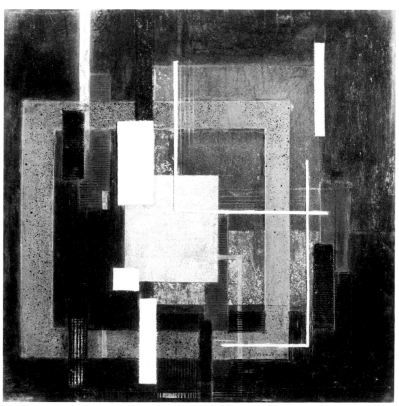

Charles G. Shaw
Polygon 1936
Oil on shaped plywood 27¼″ x 15⅞″
76.180

I. Rice Pereira
Composition in White 1942
Mixed media on parchment 18½″ x 18½″
44.173

Karl Zerbe
Brooklyn Bridge ca. 1946
Encaustic on canvas 36½″ x 40⅛″
46.112

James Wilfred Kerr
Old Erie Station – Waldwick 1943
Oil on masonite 19¼″ x 42″
78.35

John Koch
Supper Table 1939
Oil on Canvas 25″ x 30″
39.321

Isabel Bishop
Waiting 1937-38
Oil and tempera on gesso 29″ x 22¼″
44.41

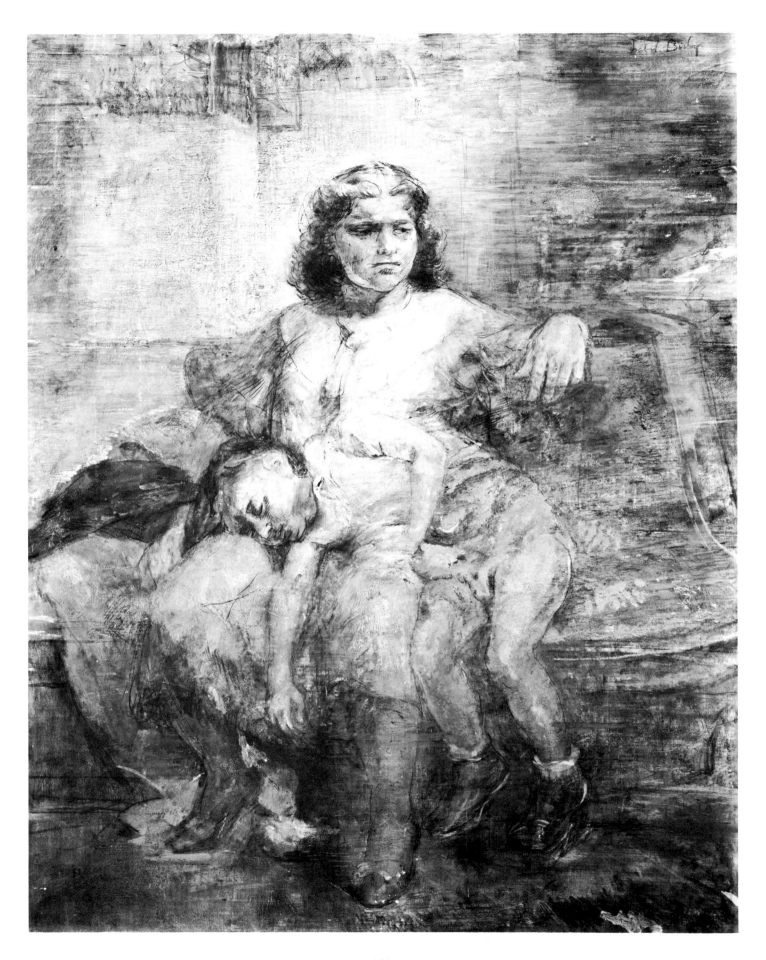

Adolph Gottlieb
The Mutable Objects 1946
Oil on canvas 30″ x 23½″
60.585

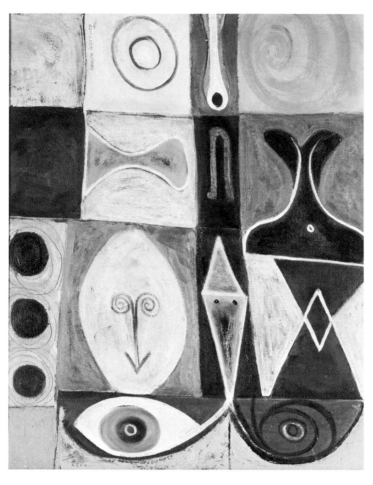

Marsden Hartley
Still Life – Calla Lilies
Oil on canvas board 26″x19″
58.170

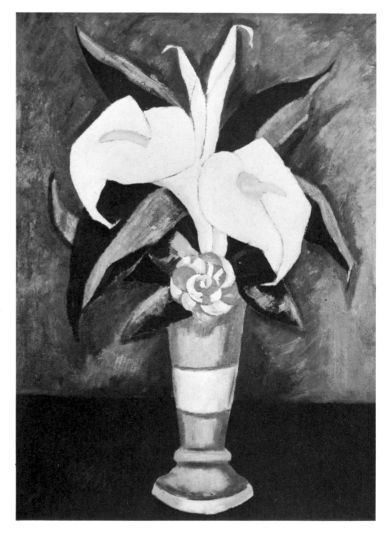

Ann Ryan
Untitled 1949
Paper and textile collage 7¼″ x 6¼″
56.162

Kay Sage
At the Appointed Time 1942
Oil on canvas 32″ x 39″
64.54

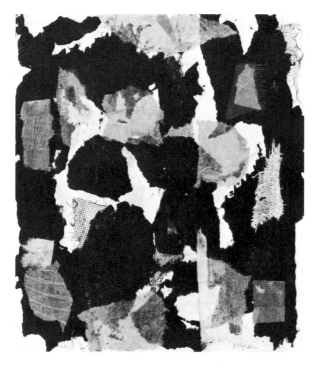

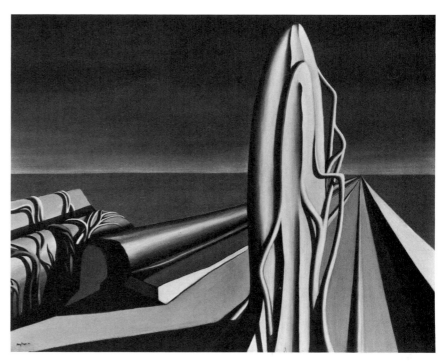

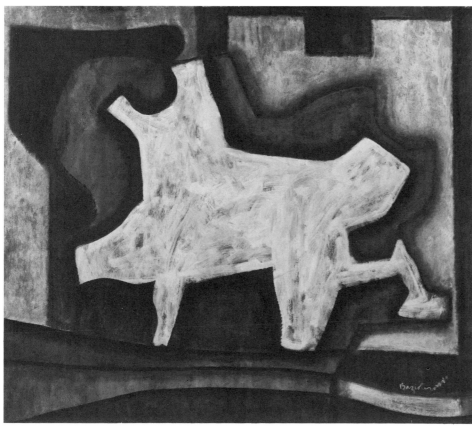

William Baziotes
White Silhouette 1945
Oil on canvas 36″ x 42″
51.163

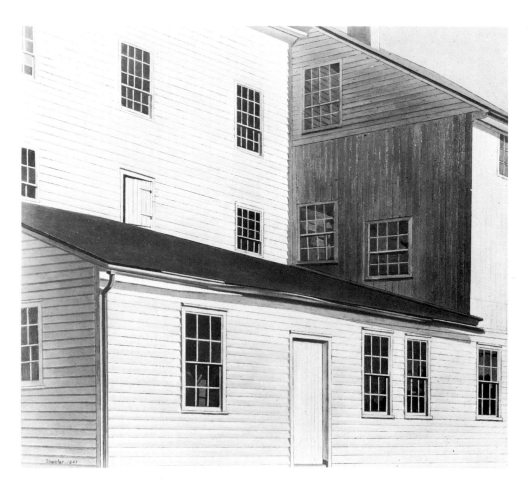

Charles Sheeler
Shaker Detail 1941
Oil and tempera on masonite 13¼″ x 14¼″
44.169

Henry Gulick
Spring — The Gulick Farm 1948
Oil on masonite 23¾″x 27¾″
49.354

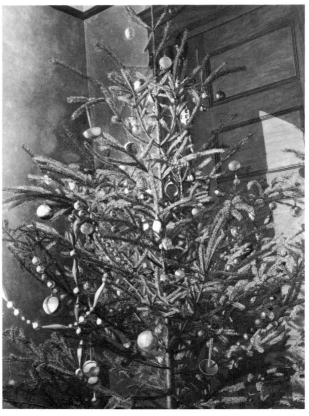

Charles L. Goeller
Maple Root 1949
Grease crayon on paper 21⅞″ x 13⅞″
50.59

Hans Weingaertner
Christmas Tree 1941
Oil on canvas 52½″ x 40½″
41.819

Nicolai Cikovsky
North Sea, Long Island 1945
Oil on canvas 28″x35⅛″
46.152

Julian Levi
Last of the Lighthouse 1941
Oil on canvas 43″x35″
46.129

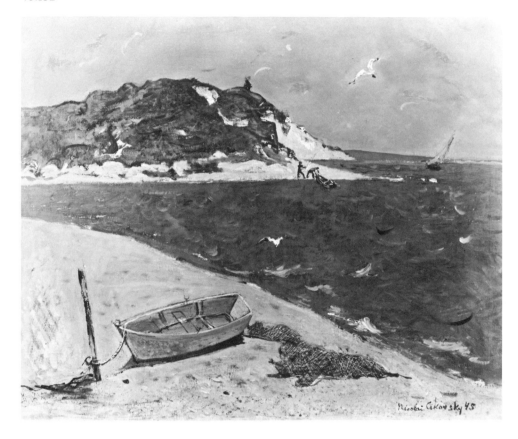

Yasuo Kuniyoshi
Milk Train 1940
Oil on canvas 24″ x 40¼″
40.154

Marsden Hartley
Mt. Ktaadn, First Snow #2 1939-40
Oil on academy board 24″ x 30″
40.123

Yasuo Kuniyoshi
Still Life 1928
Oil on canvas 30″ x 42″
58.178

Abraham Rattner
The Letter
Oil on canvas 29¼″ x 23½″
73.53

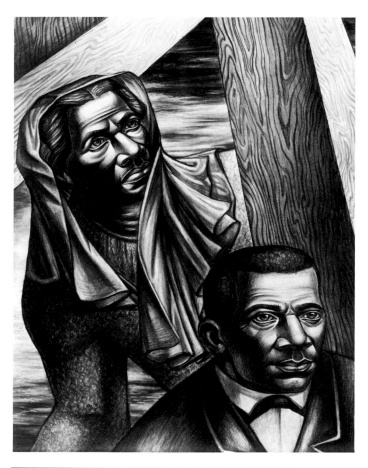

Charles White
Sojourner Truth and Booker T. Washington 1943
Pencil on board 37½" x 28"
44.100

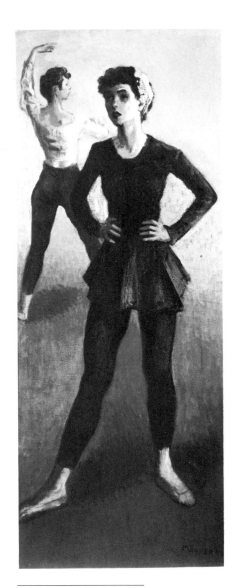

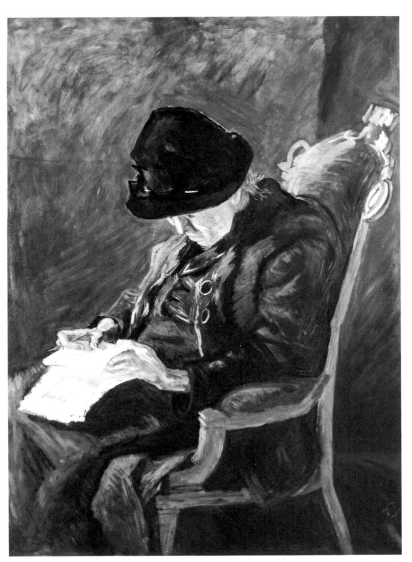

Moses Soyer
Dancers 1943
Oil on canvas 40″ x 16″
46.163

Franklin C. Watkins
Old Woman Reading Proof ca. 1930
Oil on canvas 40¼″ x 30⅛″
46.153

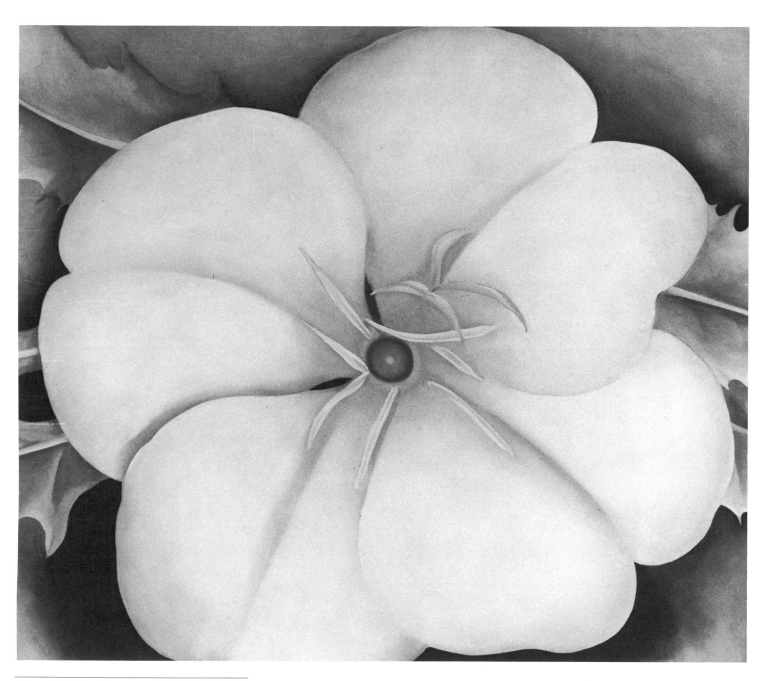

Georgia O'Keeffe
White Flower on Red Earth, No. 1 1943
Oil on canvas 26″ x 30¼″
46.157

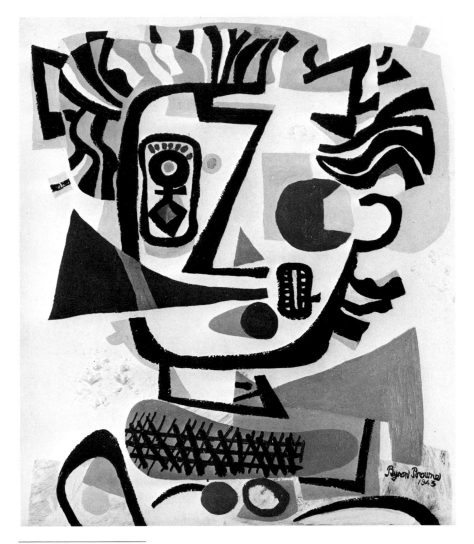

Byron Browne
Head of a Man 1943
Oil on canvas 28″ x 24″
46.170

Charles Sheeler
It's a Small World 1946
Oil on canvas 24″ x 20″
46.100

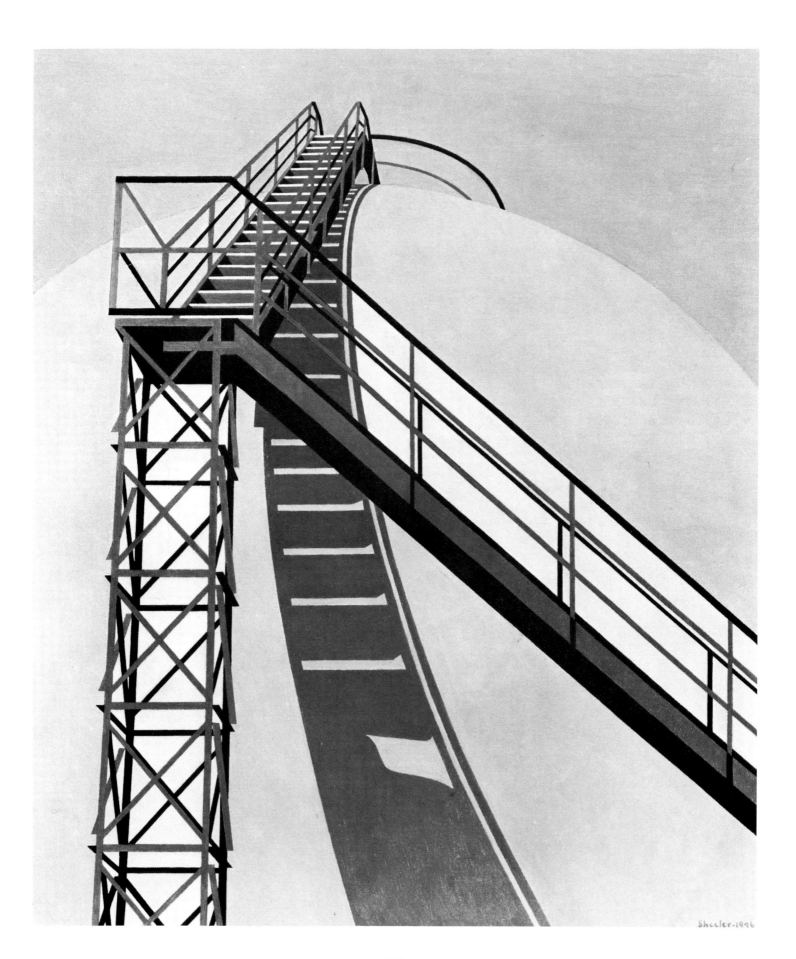

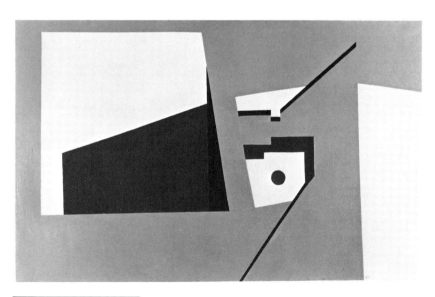

Balcomb Greene
Space 1936
Oil on canvas 22″ x 35″
77.165

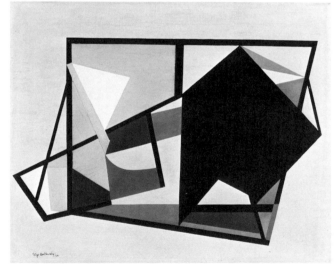

Ilya Bolotowsky
Composition with a Black Shape 1942
Oil on canvas 16″ x 20″
77.175

Leonid
Fishing Shrimps at Boulogne 1952
Oil on canvas 32″ x 49½″
54.205

Reginald Marsh
Steeplechase Park 1944
Watercolor on paper 26¾″ x 39¾″
61.460

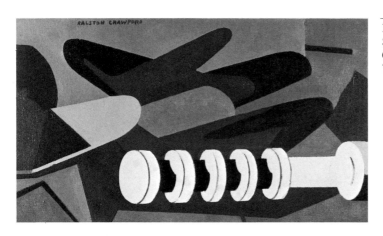

Ralston Crawford
Shaw's Propellors 1954
Oil on canvas 9″ x 16″
72.142

Lyonel Feininger
White Walls 1953
Oil on canvas 24″ x 17″
60.604

Alice Trumbull Mason
Leaven 1950
Oil on board 20″ x 16″
77.173

Alice Trumbull Mason
White Appearing 1942
Oil on masonite 12″ x 17″
78.189

Theodoros Stamos
Moon Dunes 1947
Oil on masonite 10″ x 38″
72.346

John Marin
Autumn Coloring No. 3-Maine 1952
Watercolor on paper 14¾″ x 19⅞″
55.87

Morris Graves
Each Time You Carry Me This Way 1953
Tempera and ink on paper 25″ x 42¾″
60.530

Edward Corbett
Provincetown #6 1959
Oil on canvas 60″ x 50″
60.573

Louis Spindler
Houses in Belleville 1951
Oil on canvas 23⅞″ x 40⅛″
77.184

John R. Grabach
Street in Newark 1954
Oil on canvas 24¼″ x 29¼″
57.88

Jack Tworkov
Xmas Morning 1951
Oil on paper 29⅛″ x 38⅞″
57.131

Louis Lozowick
Relic 1949
Casein on paper 20⅝″ x 10⅝″
57.87

Leo Dee
Self Portrait 1958
Pencil and paper collage 30″ x 36⅜″
59.376

Reginald Marsh
Hudson Burlesk Chorus 1950
Chinese ink on paper 22⅜″ x 31⅛″
61.461

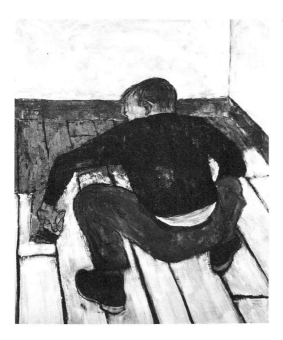

Henry Niese
Myself as a Painter 1956
Oil on canvas 54″ x 42″
60.576

Adolf Konrad
Reflections 1960
Oil on canvas 33″ x 46″
62.137

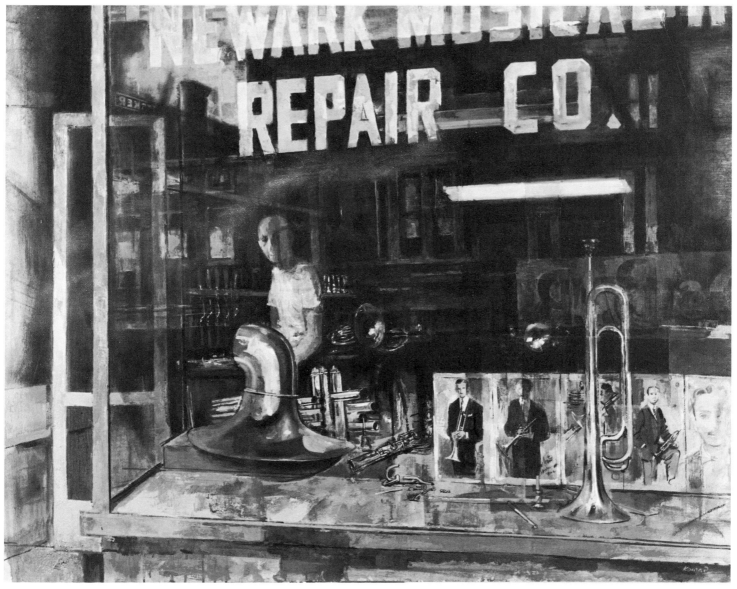

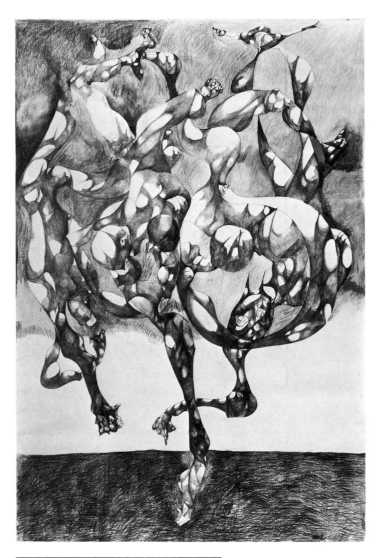

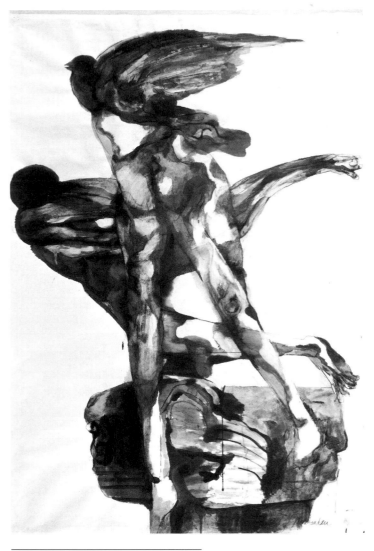

Leon Kelly
The Descencion 1963
Colored pencil on paper 59⅞″ x 40¼″
69.124

Jacob Landau
Winged Defeat 1964
Watercolor on rice paper 54″ x 37″
65.123

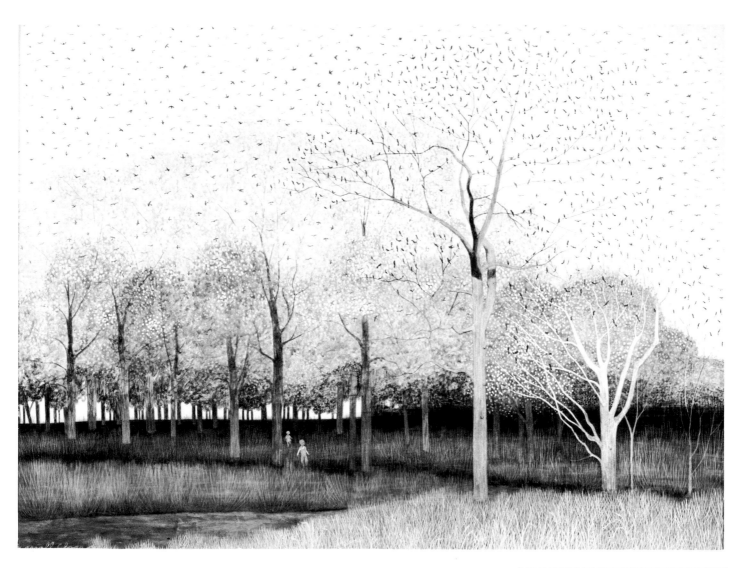

Carroll Cloar
The Time of the Blackbirds 1955
Tempera on masonite 23¹¹/₁₆″ x 31¹¹/₁₆″
56.4

Cleve Gray
Narcissus 1962
Oil on canvas 60″ diameter
72.173

Kenzo Okada
Sand 1955
Oil on canvas 68″ x 40¾″
73.116

Karl Zerbe
Osprey Nest 1955
Polymer, tempera and collage
on wood 49¾″ x 31¾″
56.185

Leon Kelly
Bather with a Cloth 1966
Oil on canvas 68½″ x 39″
68.133

Leo Dee
Reflections in White 1959
Oil on canvas 54″ x 36″
62.147

Ben Shahn
Abstraction 1956
Oil on masonite 168″ x 84″
62.12

Hans Hofmann
Laburnum II 1959
Oil on plywood 36″ x 23½″
60.582

Hyde Solomon
Coast 1958
Oil on canvas 56″ x 50″
61.19

Helen Frankenthaler
Untitled 1955
Oil and paper on canvas 54″ x 70½″
59.406

Robert Goodnough
Composition 1955
Oil on canvas 42″ x 52″
59.407

Kyle Morris
Fiery Cross 1959
Oil on canvas 60″ x 60″
60.575

211

Thomas George
Untitled Study ca. 1962
Oil on paper 3¾" x 4⅞"
71.104

Theo Hios
Untitled 1965
Acrylic on canvas 48" x 72"
78.18

Joseph Glasco
The Bride 1960
Oil on canvas 72″ x 48″
62.136

Richard J. Anuszkiewicz
Manifest 1965
Acrylic on masonite 36″ x 36″
66.37

Ad Reinhardt
Tryptych 1955
Oil on canvas 24″ x 10″
72.139

Burgoyne Diller
Number 47 1962
Oil on canvas 48⅛″ x 48¼″
70.67

Werner Groshans
Southern Landscape 1965
Oil on canvas 30″ x 40″
65.124

Walter Tandy Murch
Clock Study
Charcoal, chalk and pastel
on paper 20½″ x 14¾″
62.114

Jon Carsman
Trexler 1973
Acrylic on canvas 60″ x 70″
77.190

Catherine Murphy
View of Hoboken and Manhattan from Riverview Park 1973
Oil on canvas 37¼″ x 44½″
75.27

Louis Lynn
Chinese Laundry
Oil on canvas 28″ x 35″
62.119

Arnold A. Schmidt
Square in the Eye with Grey Around It 1965
Oil on canvas 48½" x 48½"
65.132

Eleanor Mikus
Tablet #162 1967
Epoxy on wood 47" x 38⅞"
72.197

Theodoros Stamos
Tundra Sun-Box 1969
Acrylic on canvas 70″ x 48″
73.7

Chester Arthur Boterf
Untitled
Oil on shaped canvas 64½″ x 83½″ x 19″
75.217

Lee Gatch
The Lamb 1957
Oil on canvas 19⅞" x 30⅛"
77.199

Lee Gatch
Fish Market ca. 1951
Oil on canvas 25⅜" x 32"
77.8

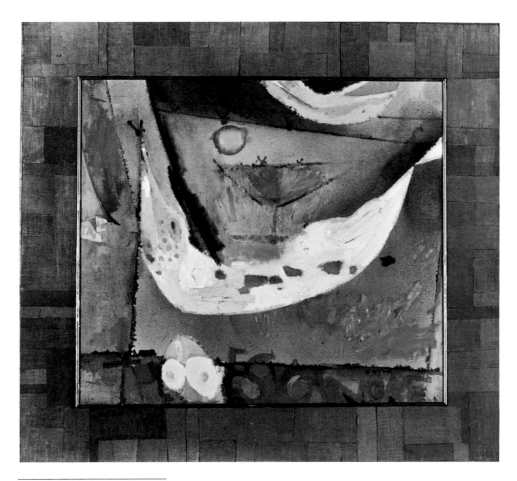

Lee Gatch
The Sycamore 1954
Oil on canvas 21⅛″ x 24⅛″
73.105

Lee Gatch
Angel Stone 1967
Stone Collage 46½″ x 25½″
77.208

Lee Gatch
Jurassic Flower 1968
Stone Collage 66½″ x 27¾″
69.114

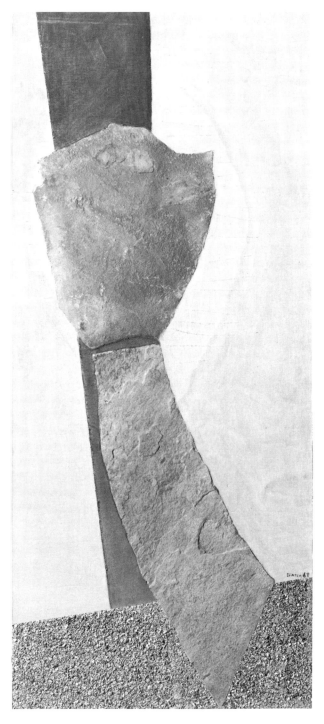

Lee Gatch
Pueblo Strata 1964
Stone Collage 27¼″ x 45″
65.107

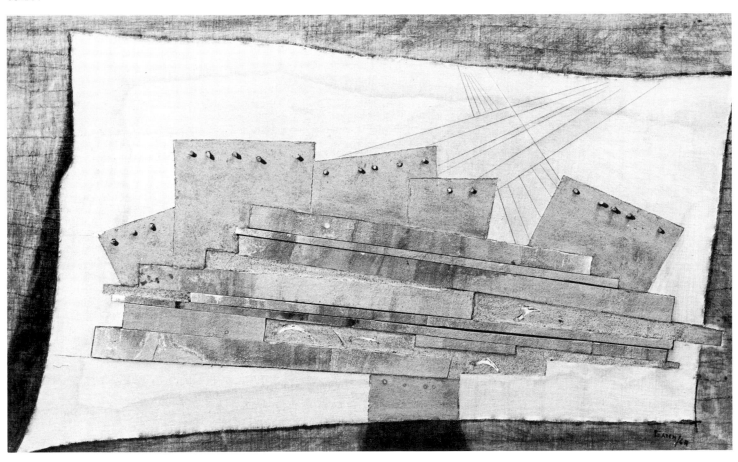

Willem de Kooning
Seated Woman
1966-67
Charcoal on tracing
paper 20″ x 24″
71.164

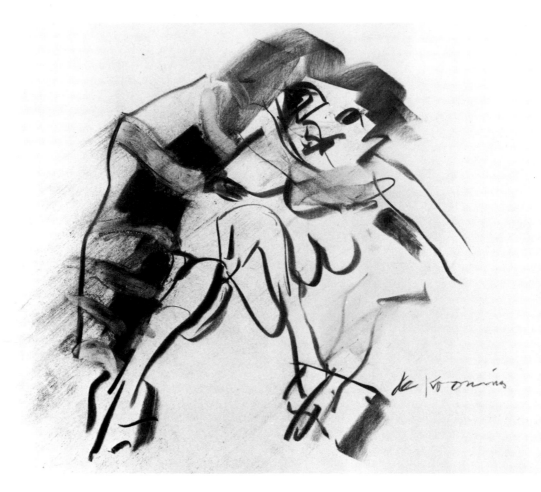

Darby Bannard
Stadium 1963
Acrylic on canvas 66¾″ x 62¾″
65.121

Lee Hall
Shore Stone 1977
Polymer tempera on linen 72″ x 66″
78.17

Irene Rice Pereira
Star Studding the Midnight Sea 1963-64
Oil on canvas 50¾″ x 31″
66.42

Esteban Vicente
Black in Gray 1968
Paper collage 45″ x 47½″
69.116

George Ortman
Zapotec 1966
Aluminum, acrylic, canvas construction 75″ x 90″
68.220

Richard Pousette-Dart
Untitled 1976
Pencil on paper 22½″ x 29⅞″
78.77

Randall Timmons
Untitled 1977
Acrylic on canvas 50½″ x 44″
78.28

Romare Bearden
Dream 1970
Collage 27¼″ x 45¼″
71.56

John Day
Erebos-Eastern Corridor 1973
Oil and collage on canvas 60″ x 66″
77.168

Edward Meneeley
Just Before Dawn 1971
Acrylic on canvas 86″ x 61½″ x 3¾″
74.54

Jack Youngerman
February 11, 1968 1968
Ink on paper 30″ x 40″
71.158

Angela DeLaura
DI 3-TG257 1970
Acrylic and ink on canvas 48″ x 48″
74.56

Wojciech Fangor
M35 1968
Oil on canvas 80″ x 68″
69.159

Clarence H. Carter
Transection #1 1966
Acrylic on canvas 77″ x 54″
78.84

Bill Hutson
Sasa of the First Creation Crossing a
Wet Bone Path North by Northeast 1971
Oil on canvas 96″ x 72″
71.165

Sculpture:
Black
and White

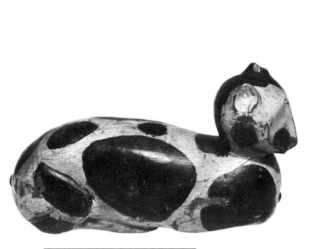

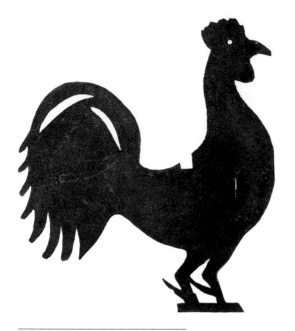

Artist Unknown
Cat 19th century
Painted wood 6″ x 11½″ x 4″
31.967

Artist Unknown
Rooster Weathervane
probably early 18th century
Sheet iron 43½″ x 38½″ x 1⅝″
67.1

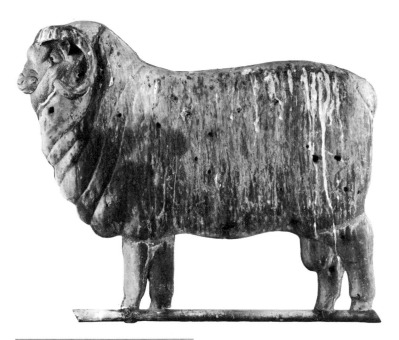

Artist Unknown
Ram Weathervane ca. 1860
Copper and zinc 27″ x 32½″ x 2″
69.21

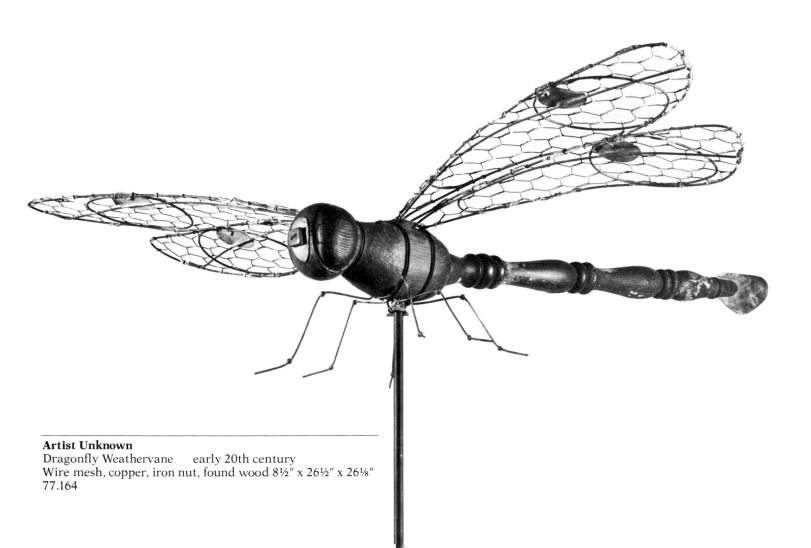

Artist Unknown
Dragonfly Weathervane early 20th century
Wire mesh, copper, iron nut, found wood 8½″ x 26½″ x 26⅛″
77.164

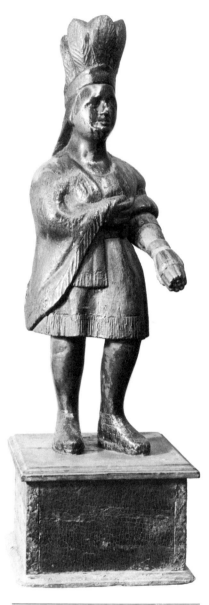

Artist Unknown
Indian Squaw Cigar Store Figure
19th century
Painted wood 42″ including base
58.165

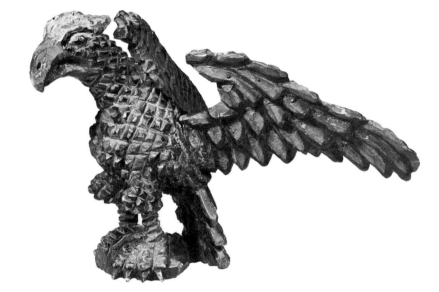

Wilhelm Schimmel
Eagle after 1865
Carved and painted wood 7¾″ x 12¼″ x 8½″
75.29

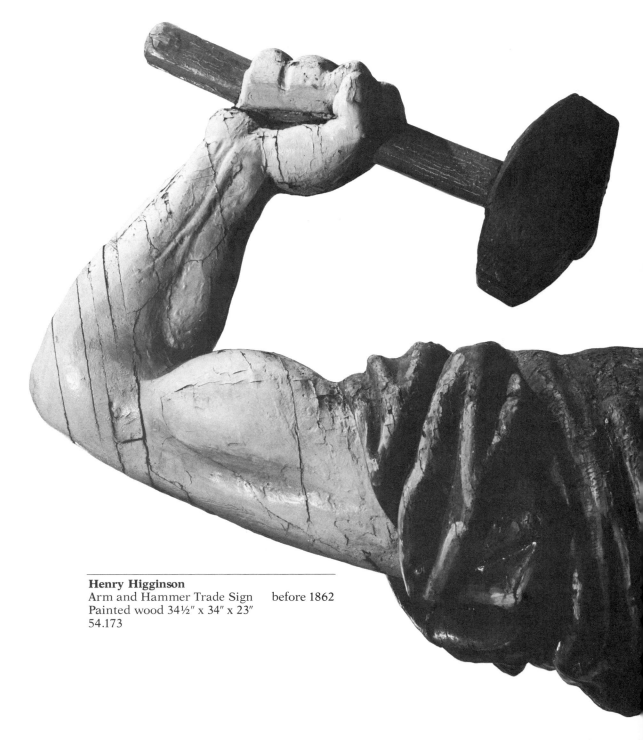

Henry Higginson
Arm and Hammer Trade Sign before 1862
Painted wood 34½″ x 34″ x 23″
54.173

James Haseltine
Cleopatra 1868
Marble 29½"
40.420

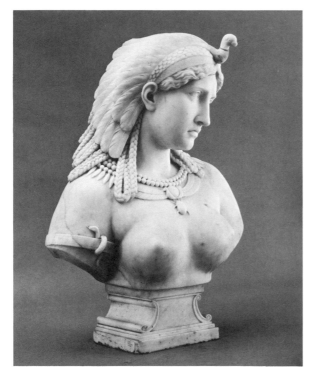

Hiram Powers
Proserpine 1860-61
Marble 20⅛" with integral base
22.81

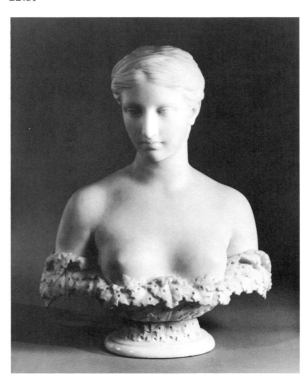

Albert E. Harnisch
Mrs. Marcus L. Ward 1872
Marble 26¾"
21.1990

Chauncey Bradley Ives
Ariadne (?) ca. 1871 (?)
Marble 25½"
00.352

Artist Unknown
Figurehead 19th century
Painted wood 27″ x 12½″ x 10″
62.142

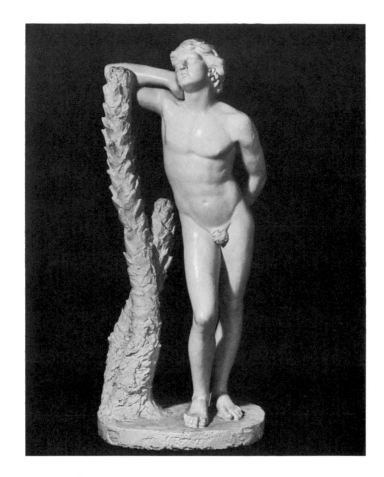

Anne Whitney
Lotus Eater 1868
Plaster 35¼"
63.75

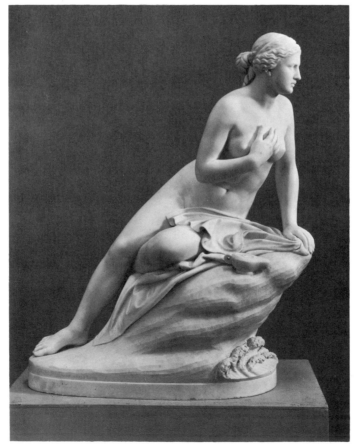

William Henry Rinehart
Hero 1871
Marble 34"
64.7

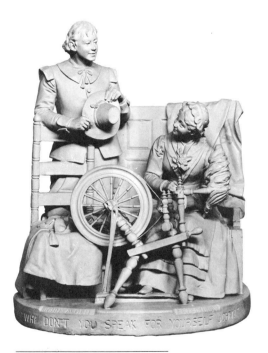

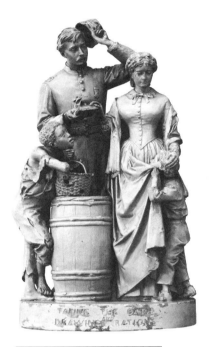

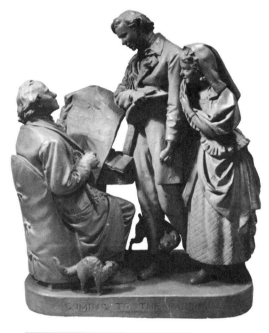

John Rogers
Why Don't You Speak
for Yourself, John? 1885
Painted plaster 22″
27.1338

John Rogers
Taking the Oath and
Drawing Rations 1866
Painted plaster 23″
45.1578

John Rogers
Coming to the Parson 1870
Painted plaster 22″
32.226

Hiram Powers
Joshua Huntington Wolcott ca. 1867
Marble 25″
65.151

Hiram Powers
Charity after 1871
Marble 25½″
19.792

Henry Kirke Brown
Henry Clay 1852
Bronze 12¾″
26.1044

John Frazee
John Marshall 1834
Plaster 32¼″, including 6″ base
64.19

William Wetmore Story
Young Augustus
Marble 23″
27.1247

Chauncey Bradley Ives
Sailor Boy ca. 1860
Marble 17½″
21.1991

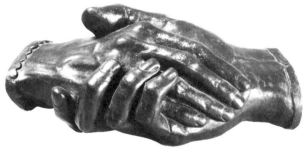

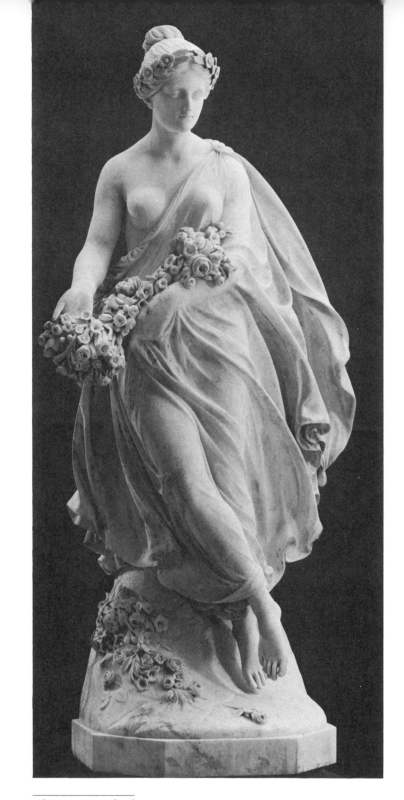

Harriet Hosmer
Hands of Robert and
Elizabeth Barrett Browning 1853
Bronze 3¼″ x 4½″ x 8¼″
76.8

Thomas Crawford
Flora 1853
Marble 86″
26.2786

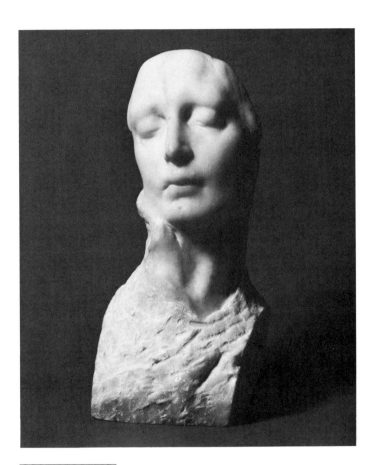

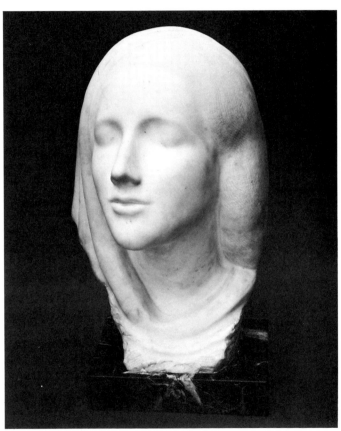

Gutzon Borglum
Untitled 1910
Marble 8½″
72.196

Elie Nadelman
Head of a Woman 1916-18
Marble 17⅜″
52.116

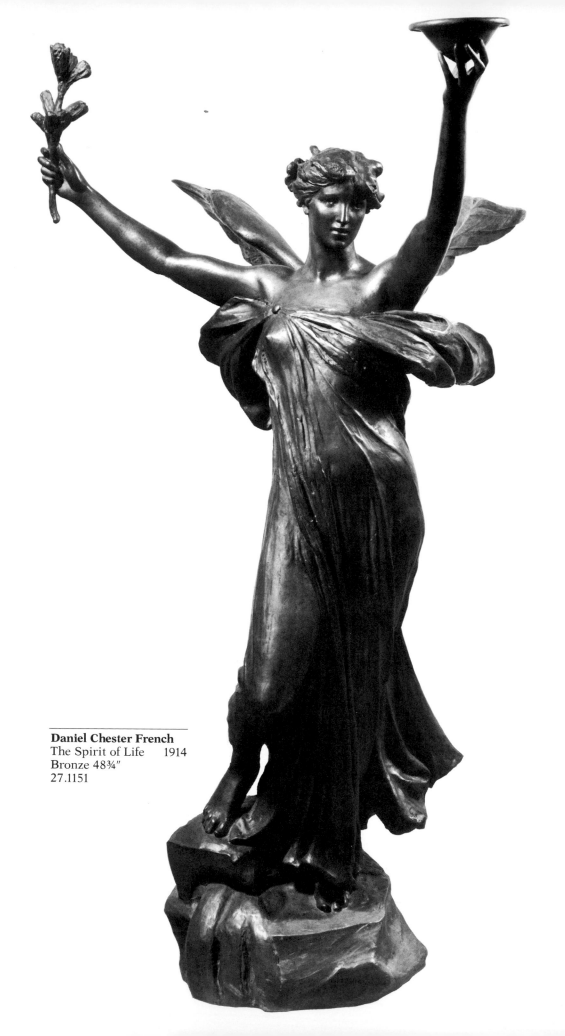

Daniel Chester French
The Spirit of Life 1914
Bronze 48¾"
27.1151

Bessie Onahotema Potter Vonnoh
The Dance 1897
Bronze 12¼"
14.407

Edith Woodman Burroughs
Circe 1907
Bronze 20½"
14.18

Bessie Onahotema Potter Vonnoh
Butterflies
Bronze 13⅛"
14.408

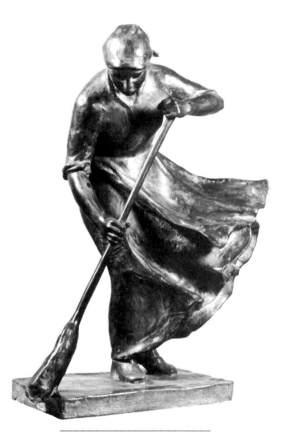

Abastenia St. Leger Eberle
Windy Doorstep 1910
Bronze 14″
13.304

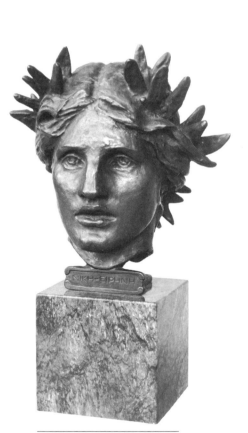

Augustus Saint-Gaudens
Victory 1904
Bronze 8″
27.287

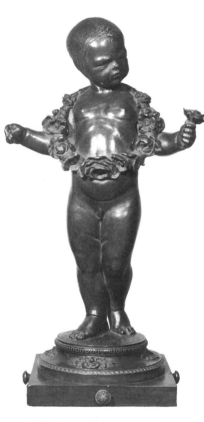

Herbert Adams
Infant Burbank 1905
Bronze 25½″
16.472

248

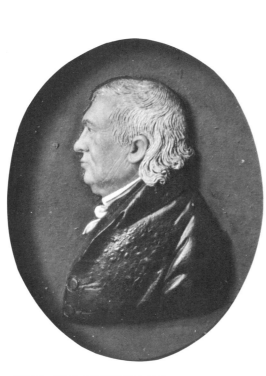

John Christian Rauschner
John McComb, Sr.
Wax relief 3¼″
23.481

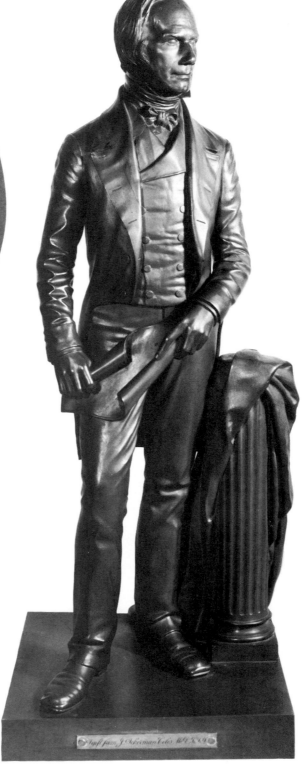

Thomas Ball
Henry Clay 1858
Bronze 30½″, including 1⅞″ base
19.718

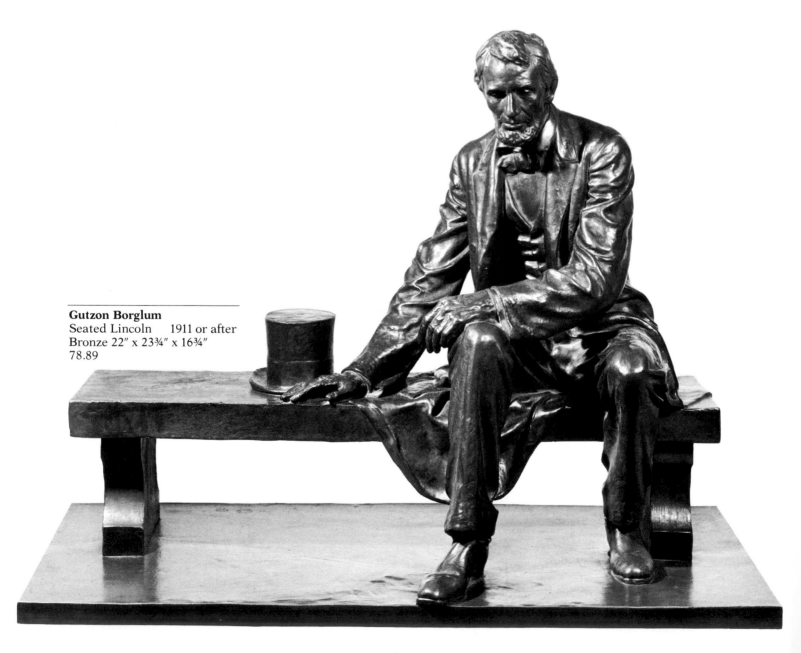

Gutzon Borglum
Seated Lincoln 1911 or after
Bronze 22″ x 23¾″ x 16¾″
78.89

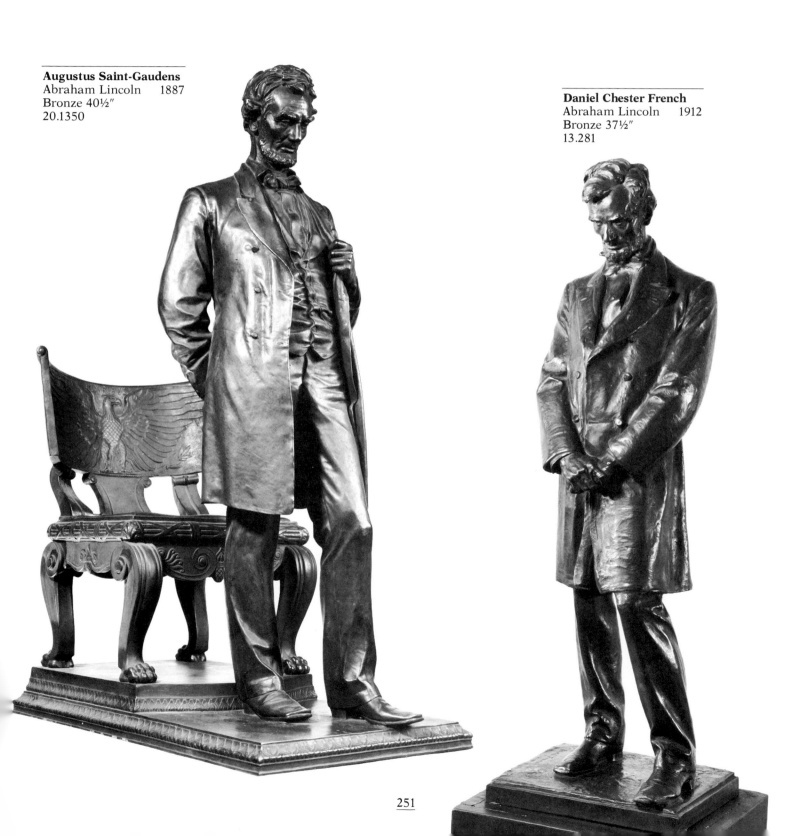

Augustus Saint-Gaudens
Abraham Lincoln 1887
Bronze 40½″
20.1350

Daniel Chester French
Abraham Lincoln 1912
Bronze 37½″
13.281

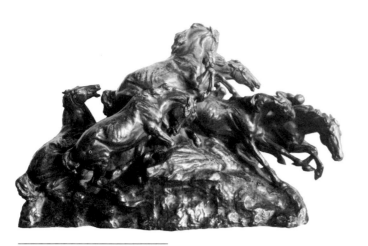

Gutzon Borglum
Mares of Diomedes 1904
Bronze 21″ x 34″ x 16″
16.568

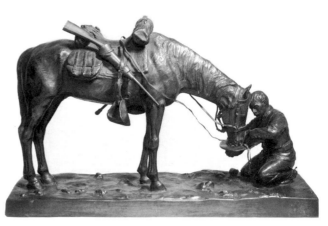

Charles Schreyvogel
The Last Drop 1904
Bronze 12″
25.1280

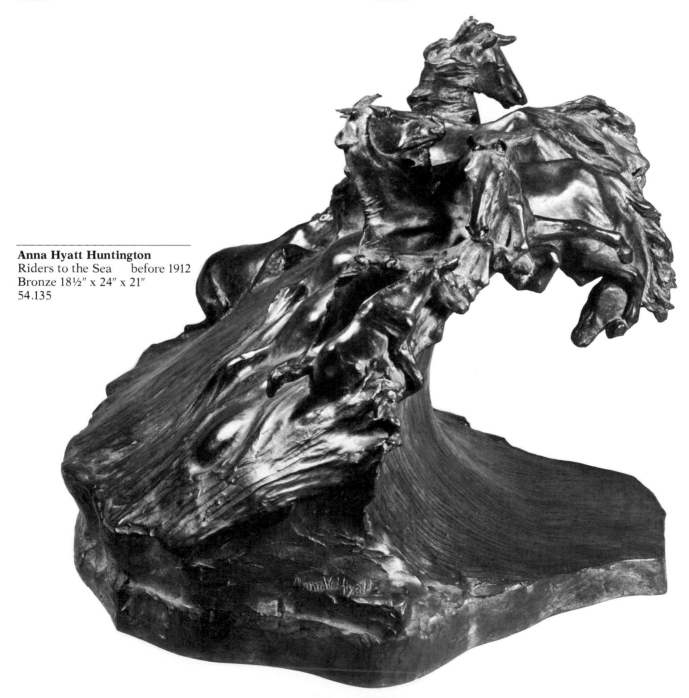

Anna Hyatt Huntington
Riders to the Sea before 1912
Bronze 18½″ x 24″ x 21″
54.135

Solon H. Borglum
Blizzard ca. 1900
Bronze 6¼″ x 10⅜″ x 7¾″
77.21

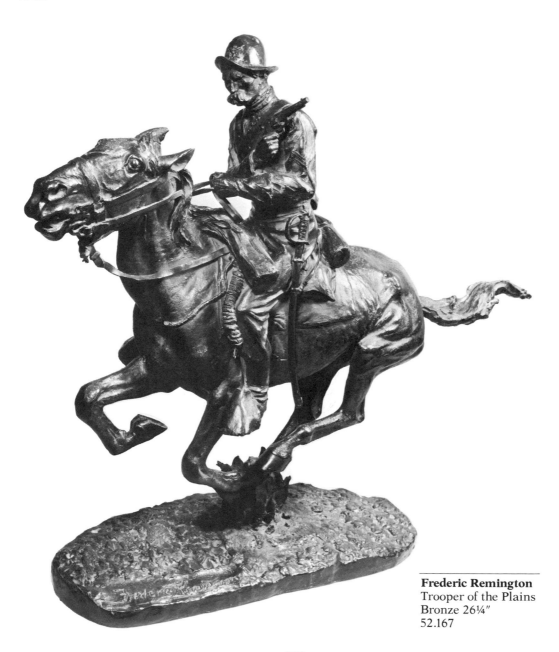

Frederic Remington
Trooper of the Plains
Bronze 26¼″
52.167

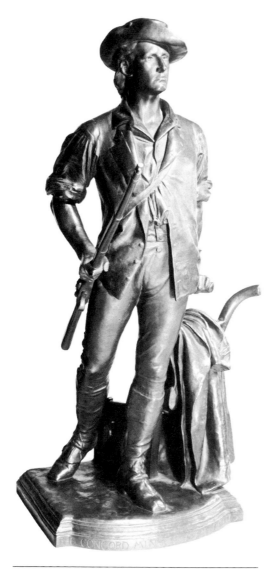

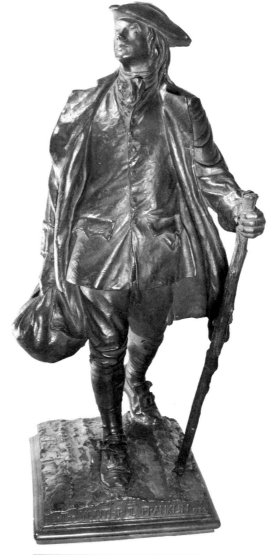

Daniel Chester French
The Concord Minute Man of 1775 1889-90
Bronze 32¼"
60.588

Robert Tait McKenzie
The Youthful Franklin 1914
Bronze 36½"
14.1073

John Massey Rhind
On the Lookout 1919
Bronze 22½″
61.30

Thomas Eakins
Group of five plaster casts taken from wax models made by
Eakins in connection with his painting, *William Rush
Carving His Allegorical Statue of the Schuylkill* 1877

Top, left to right: Nymph of the Schuylkill, 9½″; Head of
William Rush, 7¼″; George Washington, 8½″; bottom: Head
of Nymph, 7½″; The Schuylkill Freed, 4¾″ x 8½″ x 2¾″
59.414 A-E

255

Isidore Konti
Dancer 1927
Bronze 14½″
27.111

Max Kalish
Laborer at Rest
Bronze 15¼″
27.285

Mahonri M. Young
The Rigger 1917
Bronze 26⅝″
17.819

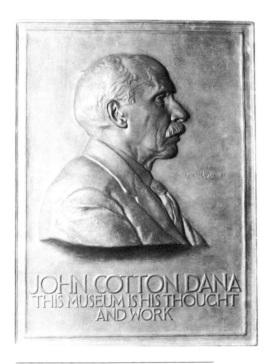

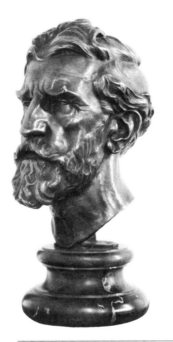

John Flanagan
John Cotton Dana 1928
Bronze plaque 37½″ x 27½″
34.660

John Flanagan
Augustus St. Gaudens 1924
Bronze 16¼″
26.2361

Edmond Thomas Quinn
Eugene O'Neill ca. 1922
Bronze 13¾″
58.187

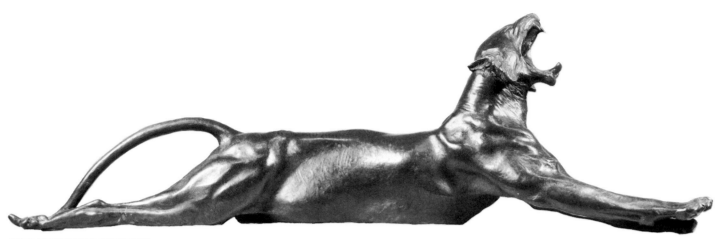

Anna Hyatt Huntington
Yawning Tiger 1911-19
Bronze 8⅜″ x 28⅛″
26.2364

C. Paul Jennewein
Cupid and Crane 1926-27
Bronze 21½″
27.1152

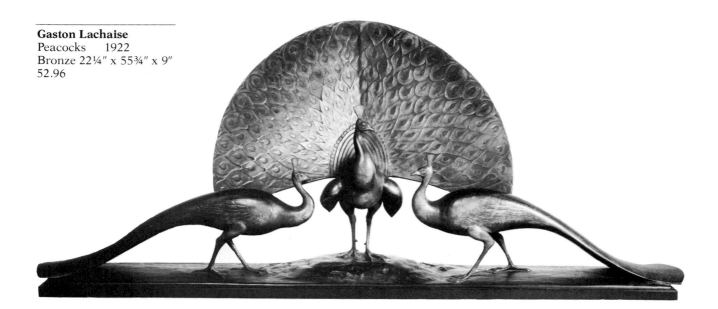

Gaston Lachaise
Peacocks 1922
Bronze 22¼″ x 55¾″ x 9″
52.96

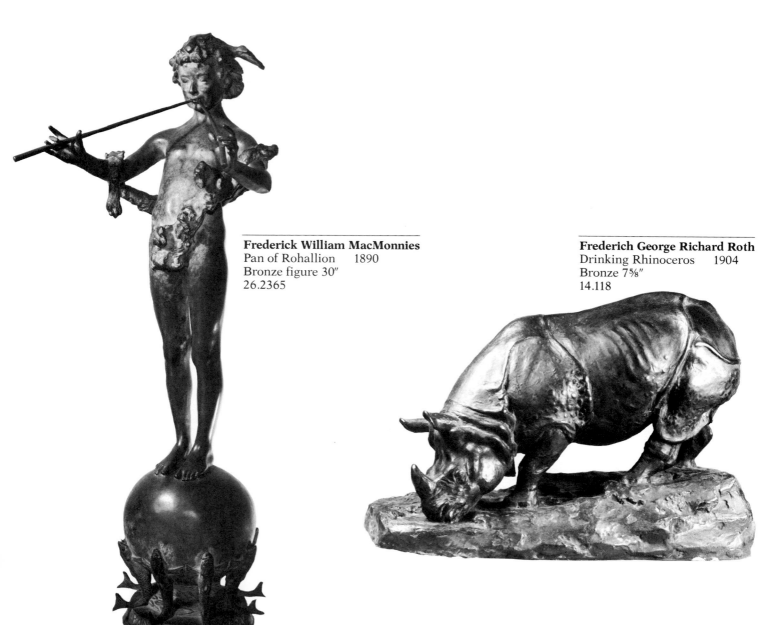

Frederick William MacMonnies
Pan of Rohallion 1890
Bronze figure 30″
26.2365

Frederich George Richard Roth
Drinking Rhinoceros 1904
Bronze 7⅝″
14.118

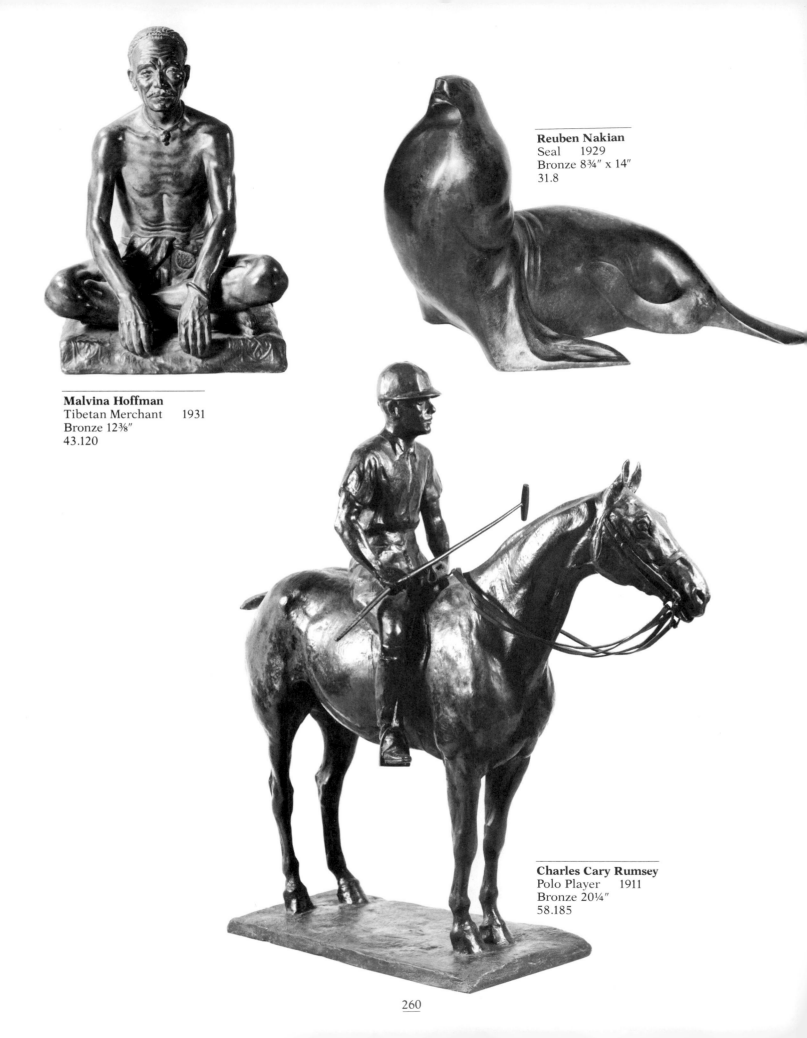

Reuben Nakian
Seal 1929
Bronze 8¾″ x 14″
31.8

Malvina Hoffman
Tibetan Merchant 1931
Bronze 12⅜″
43.120

Charles Cary Rumsey
Polo Player 1911
Bronze 20¼″
58.185

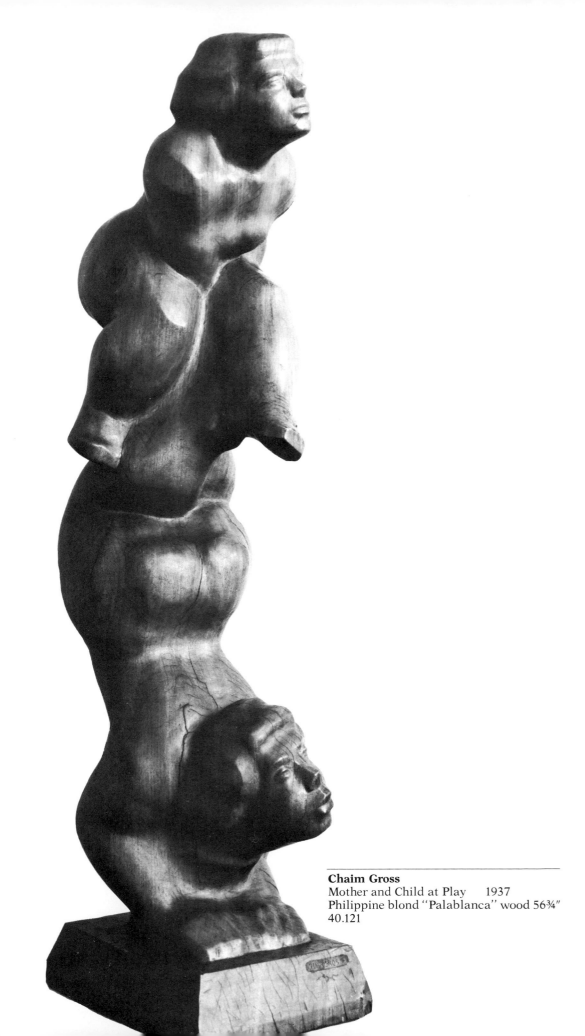

Chaim Gross
Mother and Child at Play 1937
Philippine blond "Palablanca" wood 56¾″
40.121

Jose Ruiz de Rivera
Flight 1936-38
Aluminum alloy 66" high
on a 69" base
43.78

Burgoyne Diller
Construction #16 1938
Painted wood 31⅞" x 27¾" x 5⅛"
59.377

John Storrs
Abstract Forms #1 1917-19
Granite and marble 34⅝" x 3¼" x 7½";
base, 3⅞" x 8" x 5¾"
78.106

Robert Laurent
Young Duck 1921(?)
White Wood 21″
27.1072

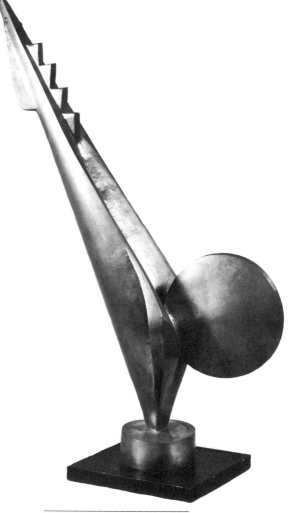

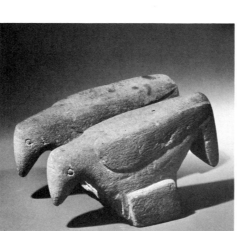

William Edmondson
Two Birds ca. 1939
Limestone 6¼″ x 7⅛″ x 9½″
78.165

Matthew Safferson
Rooster
Bronze 26½″ x 17¾″ x 5⅝″
43.151

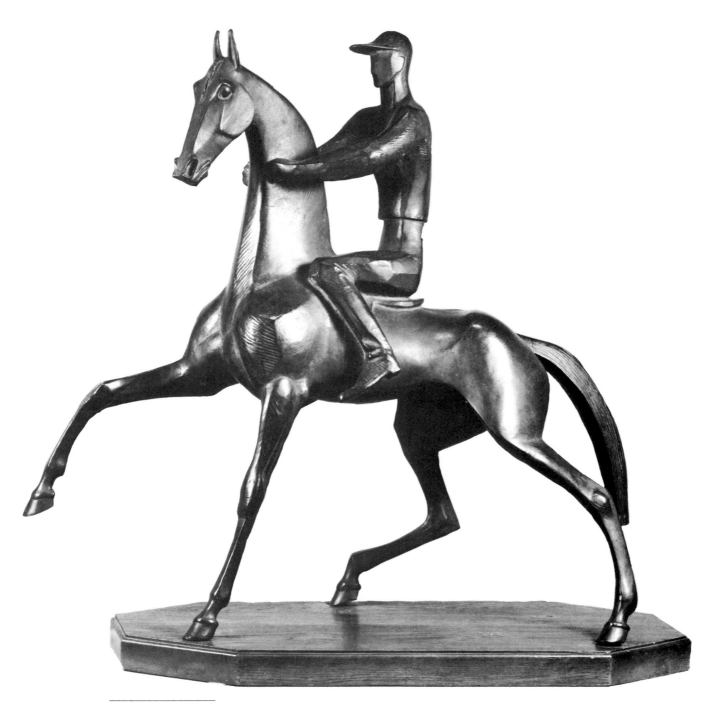

W. Hunt Diederich
The Jockey 1924
Bronze 23¼″
27.1073

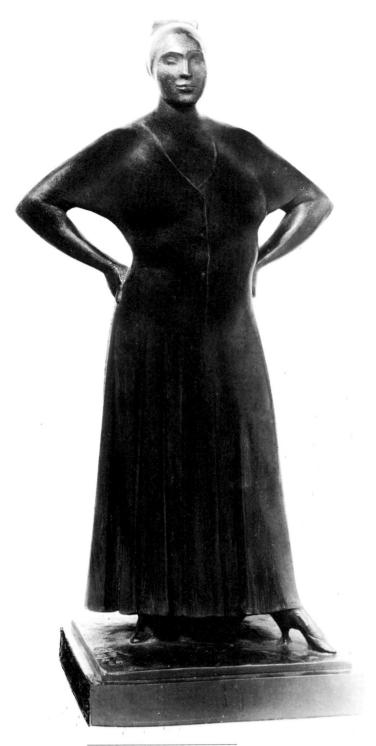

Gaston Lachaise
Figure of a Woman 1926
Bronze 15¼″
35.15

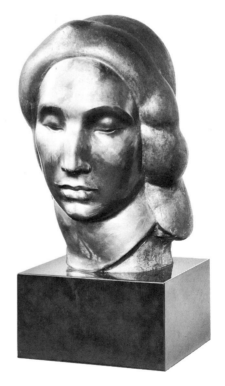

Gaston Lachaise
Head of a Woman 1923
Polished bronze 13″
27.1153

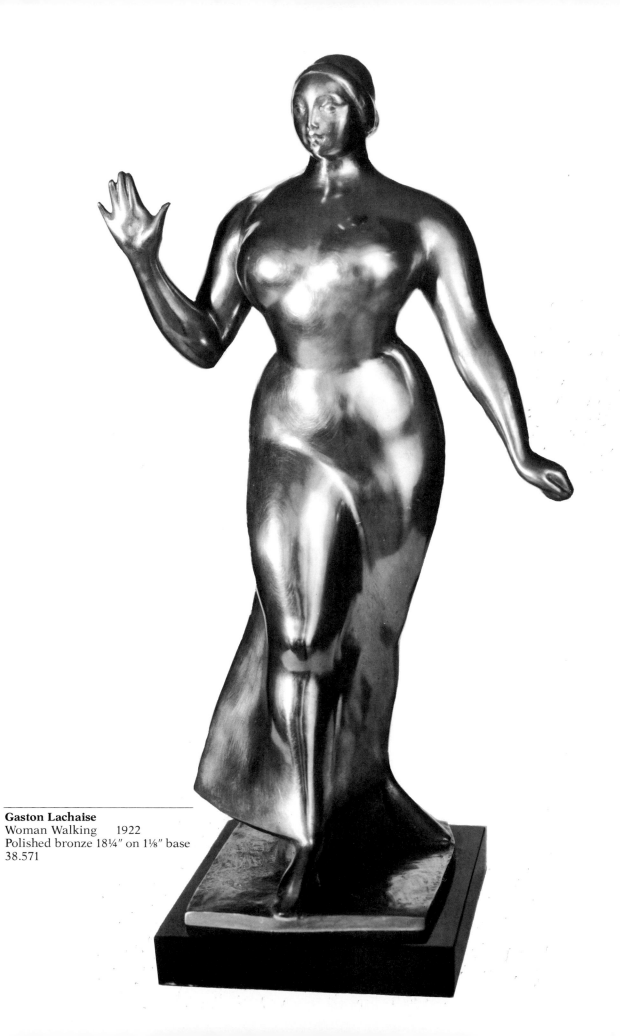

Gaston Lachaise
Woman Walking 1922
Polished bronze 18¼″ on 1⅛″ base
38.571

Dorothea Greenbaum
Bathsheba 1952
Hammered lead relief
35⅜″ x 15″ x 6″
55.88

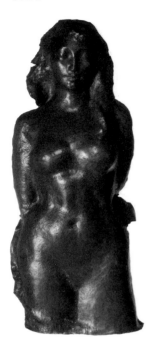

Lu Duble
Caja Poluna and Naqual 1947
Terra Cotta (Caxaca red clay) head with
cock headdress 14½″
48.338

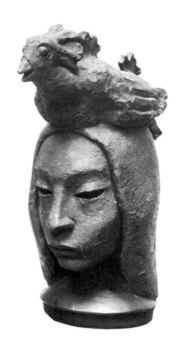

James Kearns
Seated Model
Bronze 11⅜″
59.379

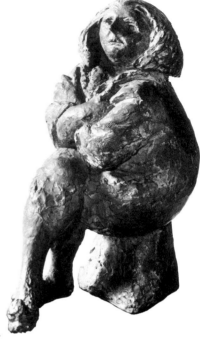

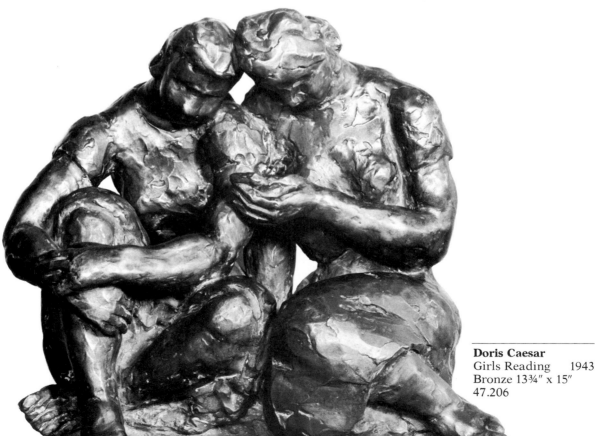

Doris Caesar
Girls Reading 1943
Bronze 13¾″ x 15″
47.206

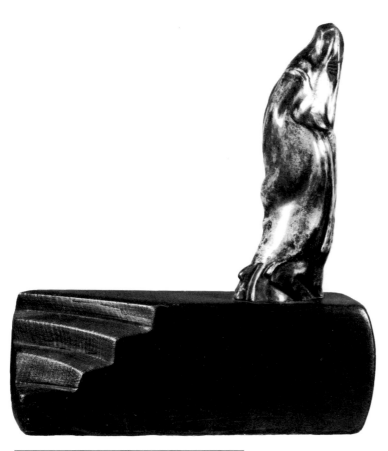

Alice Morgan Wright
Lady Macbeth 1920
Bronze figure on integral wood base 12⅜″
23.1860

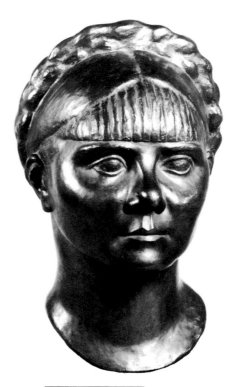

Duncan Ferguson
Mimi
Bronze 13⅞″
28.1762

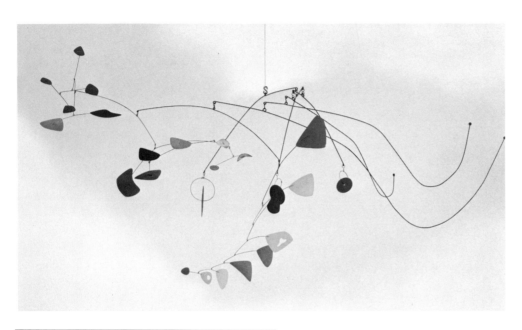

Alexander Calder
Big Red, Yellow and Blue Gong 1951
Steel, aluminum and bronze 56″ x ca. 96″ diam.
54.206

Ilya Bolotowsky
Eight Foot Trylon, Variation II 1965-77
Acrylic paint on wood 95¾″, exclusive of base;
8¾″ on each side
77.174

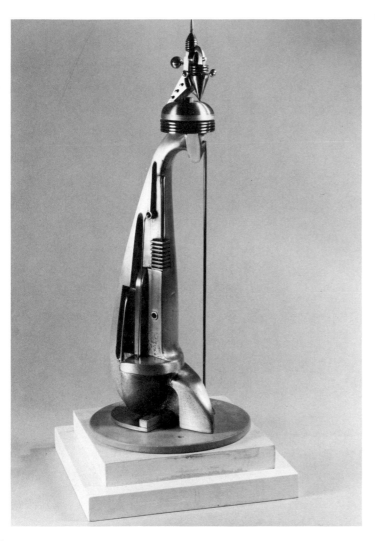

Theodore Roszak
Airport Structure 1932
Copper, aluminum, steel
and brass 19⅛″ x 7″ diam.
77.23

Jose Ruiz de Rivera
Construction #4 1953
Stainless steel 15″; 30½″ diam.
55.120

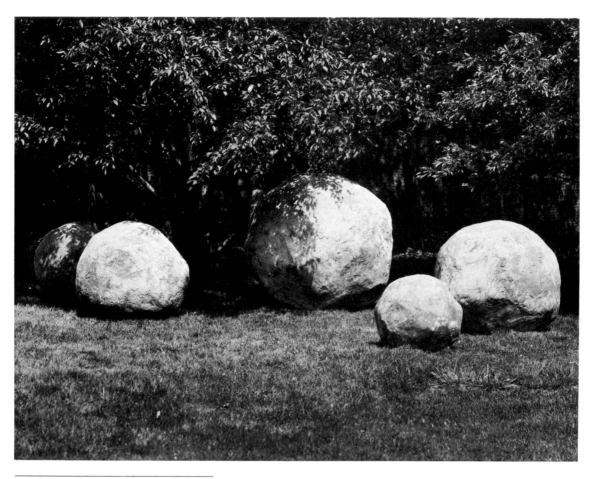

Grace F. Knowlton
Untitled 1973
Group of five ferro-concrete spheres
63¼″ to 24″ in diameter
74.22 A-E

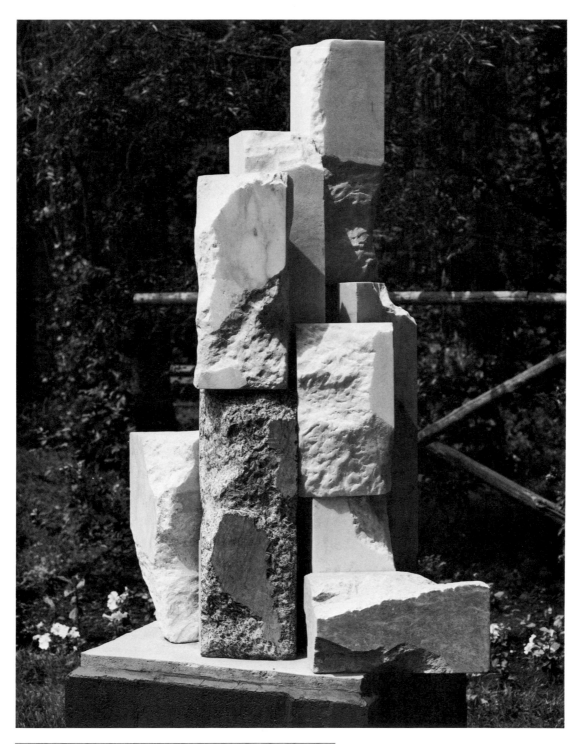

Phillip Pavia
No Object 1969
Carrara and African marble (12 blocks) 60¾″ x 38¾″ x 35″
74.23

Robert Mallary
Infanta 1960
Cardboard construction with paper collage 53″ x 28″
67.401

John Flannagan
The Ass 1932-33
Granite 8⅛″ x 14¼″
50.2116

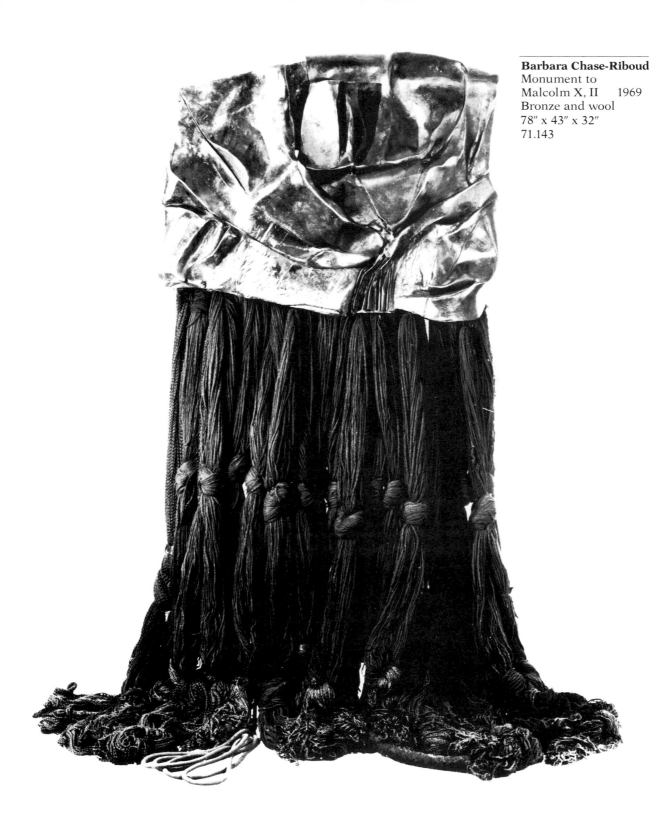

Barbara Chase-Riboud
Monument to
Malcolm X, II 1969
Bronze and wool
78″ x 43″ x 32″
71.143

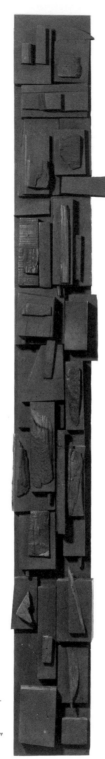

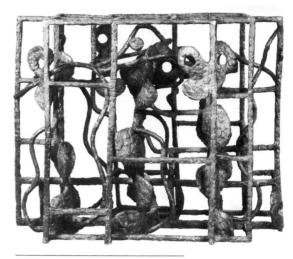

Peter Grippe
Symbolic Figure No. 4 1946
Bronze 17″ x 11″ x 22″
62.146

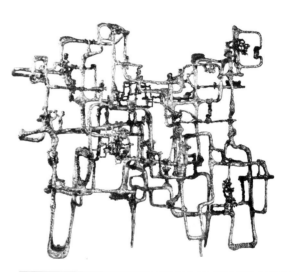

Ibram Lassaw
Galactic Cluster #1 1958
Manganese bronze, silicon bronze and nickel silver
33″ x 38½″ x 16″
60.583

Louise Nevelson
Dark Shadows 1957
Painted wood 72″ x 9¾″ x 4½″
57.12

276

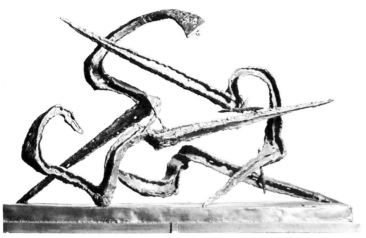

Herbert Ferber
Calligraph in Four Parts 1957
Welded bronze 14⅞″ x 25½″ x 11″
60.579

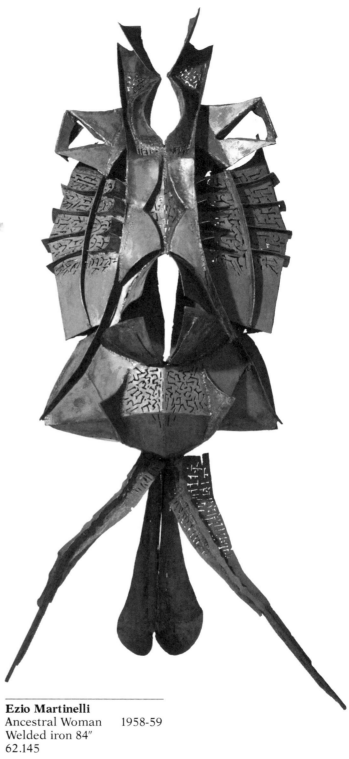

Ezio Martinelli
Ancestral Woman 1958-59
Welded iron 84″
62.145

Stanley Landsman
Snooker 1968
Light sculpture; wood, glass, electric parts
37¼" x 10⅝" x 10⅝"
76.138

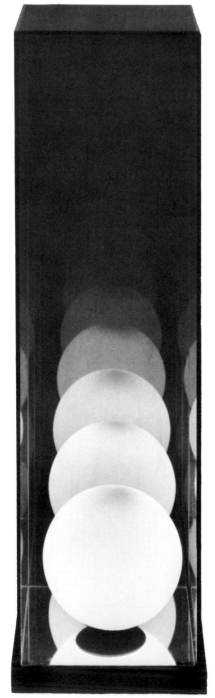

John Goodyear
Upright Light Box 1967
Wood, electric light and plexiglas construction
77" x 48¼" x 11½"
68.224

Stephen Antonakos
Blue Cross Neon
Neon tubes on aluminum
support and electrical components
48″ x 48″ x 9½″
72.337

George W. Rickey
Six Lines Horizontal Extended 1966
Stainless steel kinetic sculpture 24″ x 69″
67.52 A-G

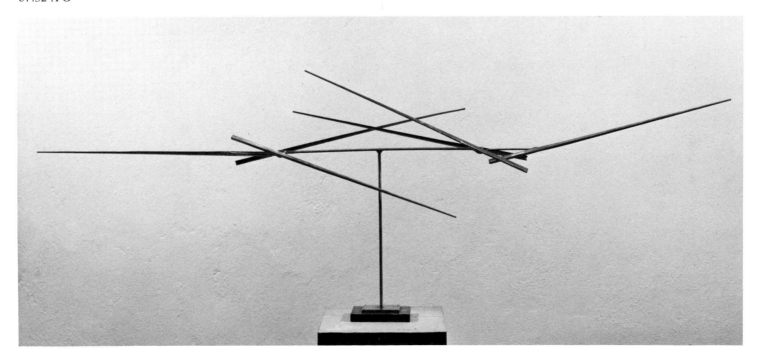

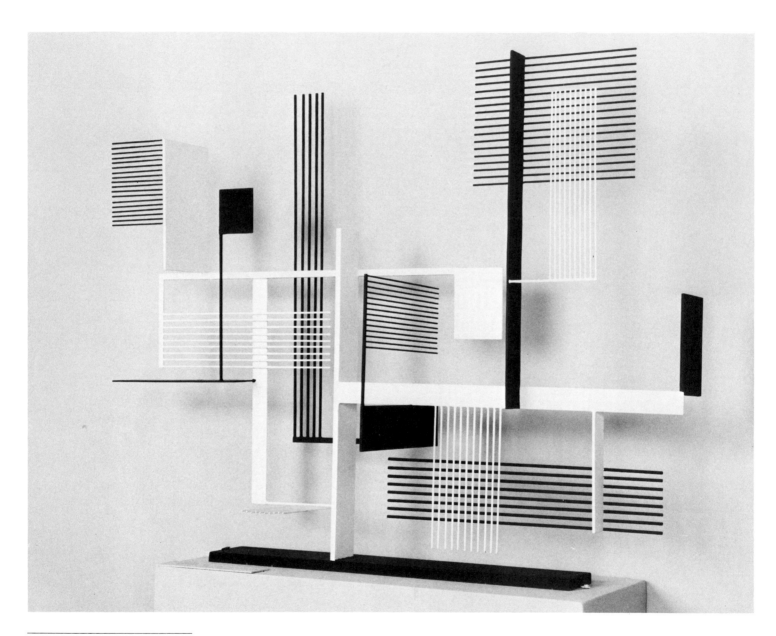

Sidney Gordin
Construction #5, 1951 1951
Painted steel 24⅛″ x 31″ x 8⅛″
56.3

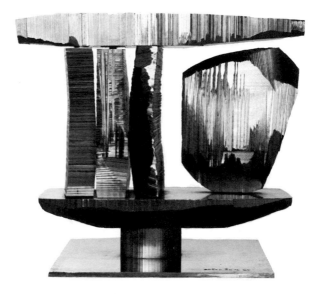

Jason Seley
Hanover II 1968
Welded chromium-plated steel 96″ x 48″ x 30″
69.180

Bernard Rosenthal
Rockingdam Castle 1962
Brass 11½″ x 13½″ x 8⅛″
62.144

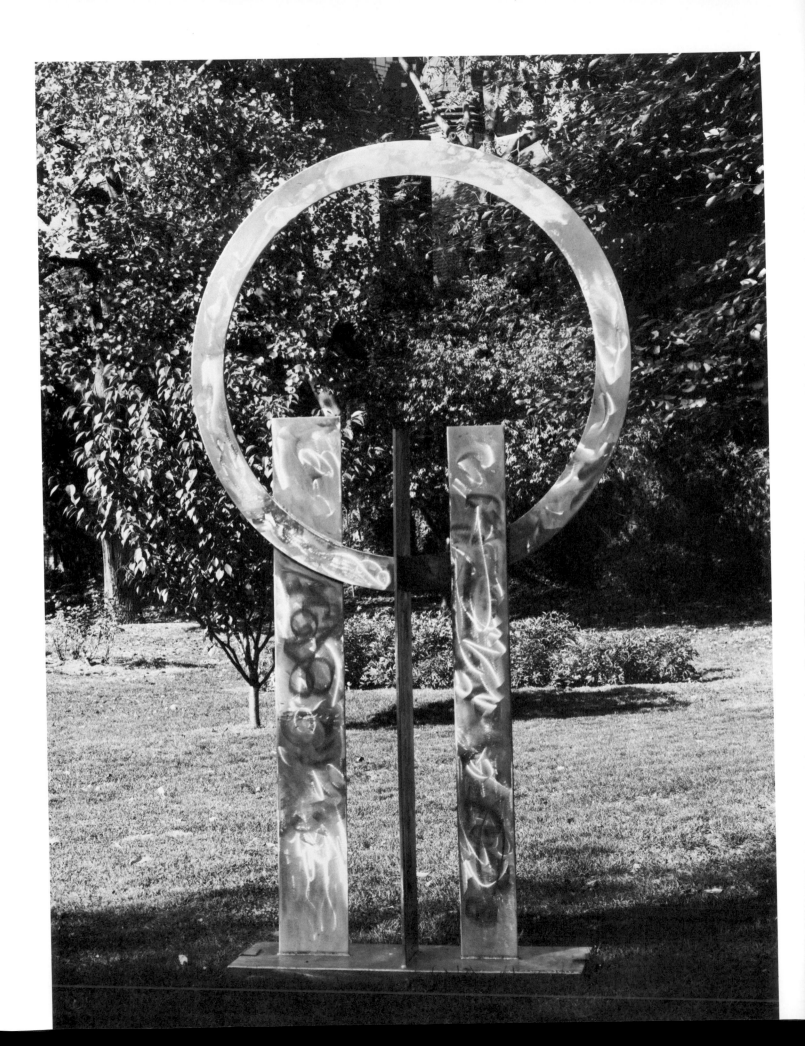

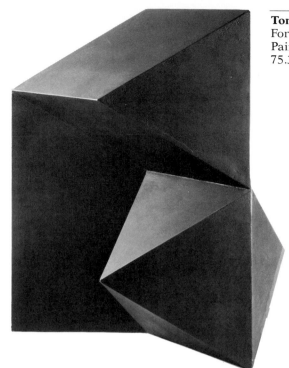

Tony Smith
For J.C. (maquette) 1969
Painted wood 20″ x 20″ x 14⅜″
75.309

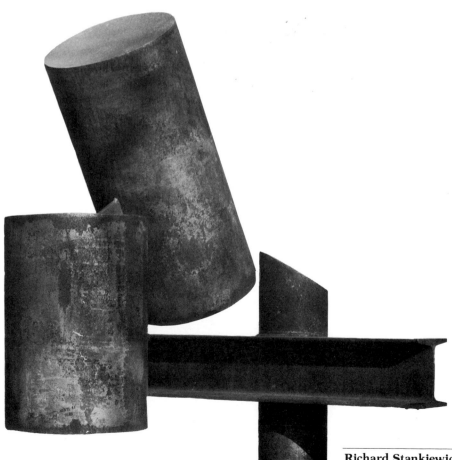

David Smith
Untitled 1964
Stainless steel
117½″ x 62½″ x 16¾″
67.157

Richard Stankiewicz
Australia No. 11 1969
Welded Cor-Ten steel 78″
74.55

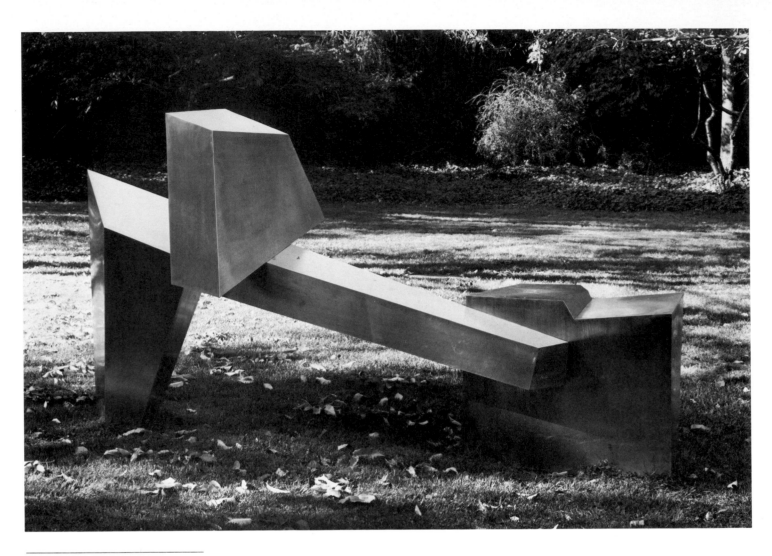

James Rosati
Pennine III 1966
Stainless steel 65½″ x 42″ x 115″
69.25 A-E

Catalogue of Paintings and Drawings

ARTIST UNKNOWN

Figures Holding Flower Pots late 18th century
Papyrotamia mounted on canvas 14⅜"x14⅜" (36.5x36.5 cm)
Unsigned
Ex-collection: American Art Association, New York, N.Y.
Purchase 1917 The General Fund 17.34

Bird and Flowers mid-19th century
Tinsel painting 10"x8" (25.4x20.3 cm)
Unsigned
Ex-collection: donor, Nutley, N.J.
Gift of Miss M. Alice Murray 1921 21.557

Portrait of Marcus L. Ward (1812-1884)
Oil on canvas painted for oval spandrel 30½"x24¼" (77.5x61.6 cm)
Unsigned
Ex-collection: painting remained in family until bequeathed.
Bequest of Marcus L. Ward, Jr. 1921 21.1746

(See Read 21.1752)

Portrait of a Man: Marcus L. Ward (1812-1884)
Charcoal on paper mounted on canvas 25¾"x20¾" (65.4x52.7 cm)
Signed: left side, monogram, possibly "W.T.H."
Ex-collection: painting remained in family until bequeathed.
Bequest of Marcus L. Ward, Jr. 1921 21.1747

Portrait of Marcus L. Ward, Jr. (1846-1920) **and Catherine A. Ward**
(1849-1860) ca. 1852
Oil on canvas 50"x40" (127.0x101.6 cm)
Unsigned
Reverse: C. G. Campbell & Co./125 Market St. No. 169/Nwk,
New Jersey
Ex-collection: painting remained in family until bequeathed.
Bequest of Marcus L. Ward, Jr. 1921 21.1753

*Children of Marcus L. Ward (1812-1884) and Susan Longworth Morris
Ward (1815-1901). (See Read 21.1751 and 21.1752)*

Portrait of the Daughter of Jo Ward
Oil on canvas oval 24"x20" (61.0x50.8 cm)
Unsigned
Ex-collection: painting remained in family until bequeathed.
Bequest of Marcus L. Ward, Jr. 1921 21.1758

*Joseph Morris Ward (1841-1911) was the son of Marcus L. Ward
(1812-1884) and Susan Longworth Morris Ward (1815-1901). He married
Alice Dean in 1869. They had two daughters; one died in infancy and the
other lived to be at least 13 years old. (See Read 21.1734)*

Portrait of Mrs. Marcus L. Ward [Susan Longworth Morris]
(1815-1901)
Oil on canvas painted for oval spandrel 29⅛"x24½" (74.0x62.2 cm)
Unsigned
Reverse: Mrs. Marcus L. Ward/portrait label, De Vausney & Mossop/
11 New Street/Newark, N.J. C.S. Mossop
Ex-collection: painting remained in the family until bequeathed.
Bequest of Marcus L. Ward, Jr. 1921 21.1760

(See Read 21.1751)

Portrait of a Man [probably John Morris (1754-1819)]
Oil on canvas 30"x24" (76.2x61.0 cm; oval)
Unsigned
Reverse: C. G. Campbell & Co/125 Market St./Newark, N.J.;
stamped, "…area/Phila"
Ex-collection: painting remained in family until bequeathed.
Bequest of Marcus L. Ward, Jr. 1921 21.1761

*Husband of Elizabeth Longworth Morris (1772-1858); father of Susan
Longworth Morris Ward (1815-1901). (See A.U. 21.1762)*

Portrait of a Woman [probably Mrs. John Morris (Elizabeth
Longworth) (1772-1858)]
Oil on canvas 30"x24" (76.2x61.0 cm; oval)
Unsigned
Reverse: on back of frame, C. G. Campbell & Co/125 Market
St./Newark, N.J.; in pencil, "Steven — Edward Payson/for of Dey St
—start @ 4.00"
Ex-collection: painting remained in family until bequeathed.
Bequest of Marcus L. Ward, Jr. 1921 21.1762

Mother of Mrs. Marcus L. Ward. (See A.U. 21.1761 and Read 21.1752)

Portrait of Daughter of Jo Ward
Oil on wood painted for oval spandrel 19¾"x23" (50.2x58.4 cm)
Unsigned
Ex-collection: painting remained in family until bequeathed.
Bequest of Marcus L. Ward, Jr. 1921 21.1763

The portrait depicts a sleeping or deceased child. (See A.U. 21.1754)

Portrait of Mrs. Alexander Hamilton [Elizabeth Schuyler] (1757-1854)
ca. 18th century
Watercolor on paper 7¼"x5¼" (18.1x13.0 cm)
Unsigned
Ex-collection: Mrs. Mango, London, Eng., sold at Christie's, London,
July 25, 1924; to donor, Newark and South Orange, N.J.
Gift of Louis Bamberger 1924 24.909

*Mrs. Hamilton was the widow of Alexander Hamilton who died in 1786.
The Museum of the City of New York owns the only known painting of
Mrs. Hamilton, done by Ralph Earl, signed and dated 1787. This
watercolor is a copy of that painting.*

Portrait of Mrs. Samuel M. Hewlett [Mary Fitz Randolph] (1818-1856)
19th century
Oil on canvas 24"x20" (61.0x51.0 cm)
Unsigned
Ex-collection: donor, Newark, N.J.
Bequest of Miss Jane Isabel Foxcroft 1924 24.2350

Subject was married ca. 1844 to Samuel M. Hewlett of Newark, N.J.

Interior of a Butcher Shop 1837(?)
Oil on canvas 26½"x30½" (67.3x77.5 cm)
Signed: lower left, "Wm. S. Mount" (later addition)
Reverse: no pertinent data recorded prior to relining 1961
Ex-collection: unnamed New York dealer; to donor, Passaic, N.J.
Gift of William F. Laporte 1925 25.877

*Dr. Alfred Frankenstein stated that the painting was not executed by any of
the Mounts. In 1958, then Curator William H. Gerdts, Jr., found in the
area of the signature, under ultra-violet, traces of an earlier signature and
the date "1837." (files)*

Portrait of J. Ackerman Coles as a Child (1843-1925) ca. 1853
Oil on canvas 24½"x31" (62.2x78.7 cm)
Unsigned
Ex-collection: donor, Scotch Plains, N.J.
Bequest of Dr. J. Ackerman Coles 1926 26.417

Landscape 19th century
Oil on canvas 24¼"x16⅛" (61.6x41.0 cm)
Signed: lower right, "JWE N R"
Ex-collection: donor, Scotch Plains, N.J.
Bequest of Dr. J. Ackerman Coles 1926 26.1229

*Signature on this painting has been read erroneously as "A. B. Durand"
and "S. W. Leach."*

Unidentified Man in Grey Coat 19th century
Oil on canvas 30″x25″ (76.2x63.5 cm)
Unsigned
Reverse: canvas stamp, "Prepared by/Edward Dechaux/New York"
Ex-collection: donor, Scotch Plains, N.J.
Bequest of Dr. J. Ackerman Coles 1926 26.1273

***Mount Vernon** post-1800
Oil on canvas 24″x30″ (61.0x76.2 cm)
Unsigned
Reverse: no pertinent data recorded prior to relining 1956
Ex-collection: donors, New York, N.Y.
Gift of the Misses Rose and Helen Nichols in memory of Walter S.
Nichols and Mary E. Tompkins Nichols 1928 28.1310

Painted from an aquatint drawn by Alexander Robertson and engraved by Francis Jukes. Published March 31, 1800, the aquatint was entitled "Mount Vernon, the Seat of the Late Lieutenant General, George Washington Commander-in-Chief of the Armies of the United States." The identical aquatint was also the source for Caleb Carter's painting, Mt. Vernon, *also owned by the Museum (30.534).*

The War Dance 20th century
Gouache on paper 11″x22½″ (27.9x57.2 cm)
Inscribed: lower center, "The War Dance"
Purchase 1928 28.1449

Purchased for the Museum in Santa Fe, N.M., by Edgar Holger Cahill.

Portrait of Henry Knoerr (1815-?) ca. 1840
Pastel 14″x10½″ (35.6x26.7 cm)
Unsigned
Ex-collection: donor, Newark, N.J.
Gift of Miss Louise Ochs 1929 29.438

Previously published as "in the manner of William Matthew Prior," it fits that description stylistically.

Portrait of an Unidentified Woman late 19th century
Oil on canvas 24″x20″ (61.0x50.8 cm; oval)
Unsigned
Ex-collection: donor, Belleville, N.J.
Gift of Mrs. William D. Cornish 1930 30.19

Portrait of an Unidentified Woman late 19th century
Oil on canvas 29¾″x25″ (73.0x63.5 cm)
Signed: lower left, "J. Haagy"
Ex-collection: donor, Belleville, N.J.
Gift of Mrs. William D. Cornish 1930 30.20

Flowers in Vase early 19th century
Watercolor on paper 10⅝″x11½″ (27.0x29.2 cm)
Unsigned
Ex-collection: donors, Newark, N.J.
Gift of the Misses Elizabeth and Mary Louise Carter 1930 30.535

Parrot on Cherry Branch early 19th century
Watercolor on paper 10¾″x11¼″ (37.3 x 28.6 cm)
Unsigned
Ex-collection: donors, Newark, N.J.
Gift of the Misses Elizabeth and Mary Louise Carter 1930 30.536

***Girl with Flowers** ca. 1840
Oil on canvas 36⅛″x29″ (91.8x73.7 cm)
Unsigned
Ex-collection: William Zorach, New York, N.Y.
Purchase 1931 Felix Fuld Bequest Fund 31.145

Acquired by William Zorach in Maine; lent as catalogue #36, Newark Museum exhibition, American Primitives, *1930-31. Previously published as* Portrait of a Child.

Baby with Cane 19th century
Oil on canvas 30″x25″ (76.2 x 63.5 cm)
Unsigned
Ex-collection: Mrs. Elizabeth Bacon, South Salem, N.Y.
Purchase 1931 Felix Fuld Bequest Fund 31.146

Acquired from Mrs. Elizabeth Bacon, mother of artist Peggy Bacon. Catalogue #1, Newark Museum exhibition, American Primitives, *1930-31.*

Portrait of a Mother and Child ca. 1845
Oil on canvas 27″x22¼″ (68.6x56.5 cm)
Unsigned
Reverse: no pertinent data recorded prior to relining in 1958
Ex-collection: Robert Laurent, New York, N.Y.
Purchase 1931 Felix Fuld Bequest Fund 31.147

Catalogue #20, Newark Museum exhibition, American Primitives, *1930-31.*

Trinity Church Newark 19th century
Watercolor and pencil on paper 8½″x6½″ (21.6x16.5 cm)
Unsigned
Gift of John Moore 1931 31.414

Responding to an Alarm 1871-81
Oil on canvas 32″x49½″ (81.3x125.7 cm)
Unsigned
Ex-collection: James A. Halsey, Newark, N.J. to Exempt Firemen's Association, Newark, N.J. 1898
Gift of Exempt Firemen's Association Newark 1932 32.87

Referred to as a depiction of "Minnehaha," the first steam fire engine used in Newark. According to Dorothy Budd Bartle, Newark Museum representative with the Newark Fire Museum, the engine depicted is probably Washington Engine No. 3, a later apparatus. Records show that the chief engineer received a two-wheeled gig to attend fires in 1871 and the man depicted, Lorenzo Dowd Trent, died in 1881. Thus the painting is dated 1871-81.

Portrait of Mr. Clark mid-19th century
Oil on canvas 30″x25¼″ (76.2x64.1 cm)
Unsigned
Ex-collection: donor, Montclair, N.J.
Gift of Dr. J. Henry Clark 1936 36.550

Portrait of the donor's father.

Untitled 1862-63
Pencil and watercolor on paper mounted on board 4⅛″x5¼″
(10.5x13.3 cm)
Unsigned
Ex-collection: donor, Bloomfield, N.J.
Gift of Mrs. Annabel Arveschang 1936 36.695A

According to donor all places depicted in 36.695 A,B,C,D were near Chattanooga, Tenn.

Untitled 1862-63
Pencil on paper 7″x12¼″ (17.8x31.1 cm)
Unsigned
One building in picture area identified as "Ass't Adj./Gen.'s Office."
Additional identifications given in bottom margin, left to right,
"Guard Tent; Provost/Marshalls Tent/Capt L. Galecki/Prov/Mar.;
I Gen's/Office/Capt E.A. Baldwin/a. Insp Gen'l; Chaplins Tent/Dr
Meading; Aid De Camp's/Tent/Capt L.H. Orlemann/A.D.C.; Capt
E.W./Brueninghausen/a.a. Gen'l; Gen'ls Tent/Gen'l W. Krzyranowski;
Kitchen"
Ex-collection: donor, Bloomfield, N.J.
Gift of Mrs. Annabel Arveschang 1936 36.695B

Head Quarters 2nd Brigade, 3rd Div. 11th Corps/Whiteside Tenn.
1862-63
Pencil on paper mounted on board 7⅛"x9¾" (18.1x24.8 cm)
Unsigned
Ex-collection: donor, Bloomfield, N.J.
Gift of Mrs. Annabel Arveschang 1936 36.695C

Mouth of the Hicajak-Cave Near Shell-Mound Tenn. 1862-63
Pencil on paper mounted on board 7½"x11" (19.0x28.0 cm)
Unsigned
Ex-collection: donor, Bloomfield, N.J.
Gift of Mrs. Annabel Arveschang 1936 36.695D

Portrait of John F. Anderson (1825-1898) ca. 1830
Oil on canvas 40"x30" (101.6x76.2 cm)
Unsigned
Reverse: label on frame, "Chas. G. Campbell/portrait and picture
framer/758 Broad St. Newark"
Ex-collection: sitter to his daughter, the donor, Newark, N.J.
Gift of Miss Sophronia Anderson 1936 36.80

Portrait of Mrs. Henry Anderson [Sarah Quackenbush] (1798-1869)
ca. 1830
Oil on canvas 33"x27½" (83.8x69.9 cm)
Unsigned
Reverse: no pertinent data recorded prior to relining
Ex-collection: sitter through family to her granddaughter, the donor,
Newark, N.J.
Gift of Miss Sophronia Anderson 1936 36.81

Portrait of Henry Anderson (1798-1841) ca. 1830
Oil on canvas 33"x27⅜" (83.8x69.5 cm)
Unsigned
Ex-collection: sitter through family to his granddaughter, the donor,
Newark, N.J.
Gift of Miss Sophronia Anderson 1936 36.82

Bowl of Flowers 1836 or before
Watercolor on velvet 12"x15" (30.5x38.1 cm)
Unsigned
Ex-collection: donor, Belleville, N.J.
Gift of Mrs. William D. Cornish 1936 36.86

*Donor indicated that this painting and two others (A.U. 36.87 and A.U.
36.88) were wedding gifts to her grandmother in 1836. Family tradition
has ascribed them to "Mr. de Forest" of New York City.*

Still Life: Fruit and Watermelon 1836 or before
Watercolor on velvet 22½"x27" (57.2x68.6 cm)
Unsigned
Reverse: label, AFA, *Surviving the Ages*, 1963-64
Ex-collection: donor, Belleville, N.J. (originally a gift to her
grandmother)
Gift of Mrs. William D. Cornish 1936 36.87

(See A.U. 36.86)

Landscape with Castle 1836 or before
Watercolor on velvet 23"x27½" (58.4x69.9 cm)
Unsigned
Ex-collection: donor, Belleville, N.J. (originally a gift to her
grandmother)
Gift of Mrs. William D. Cornish 1936 36.88

(See A.U. 36.86)

Still Life: Fruit ca. 1827
Watercolor on velvet 10⅛"x14" (25.7x35.6 cm)
Unsigned
Reverse: handwritten ink label, "Painted/about 1827/Thompson"
Ex-collection: private collection, New York, N.Y.
Anonymous gift 1937 37.123

"Thompson," artist or original owner, has not been further identified.

***The Goying Child** ca. 1832-1835
Oil on wood 42"x25¼" (106.7x64.1 cm)
Unsigned
Reverse: label, AFA, "Surviving the Ages", 1963-64
Ex-collection: remained in sitter's family until acquired from a
descendant named "Whiting" in Leominster, Mass., prior to 1936 to
Katrina Kipper, Accord, Mass.; to private collection, New York, N.Y.
(purchased from Kipper, 1936)
Anonymous gift 1938 38.213

*Family tradition maintained that the painting had been executed in
Shirley, Mass. Helen Kellog attributed the work to Ruth W. (1803-?) and
Samuel A. Shute (1803-1836), and supplied the date. (files)*

Seated Woman early 19th century
Pin-pricked paper with watercolor 6"x8¼" (15.2x21.0 cm)
Unsigned
Reverse: sticker, "Boret & Clausen"
Ex-collection: donor, Roselle, N.J.
Bequest of Miss Belinda H. Jouet in memory of her brother, Cavalier
H. Jouet 1938 38.424

Hall House ca. 1850
Oil on canvas 12¼"x10¼" (31.1x26.0 cm)
Unsigned
Reverse: no pertinent data recorded prior to relining, 1964
Ex-collection: descended in Alling family to donor, Bloomfield, N.J.
Gift of Louis Alling Conklin 1939 39.264

*Presumably the Newark house of John Hall, a partner in the chairmaking
firm of Hall and Alling.*

Top of the Orange Mountains ca. 1870
Oil on canvas 18¼"x24¼" (46.4x61.6 cm)
Unsigned
Reserve: label, AFA, *Surviving the Ages*, 1963-64 (painting relined in
1960)
Ex-collection: donor, Orange, N.J.
Gift of Miss Louise W. Van Ness 1939 39.320

*Donor said her father purchased the painting about 1870. William H.
Gerdts, Jr., tentatively attributed painting to Edward Kranich.*

Book Mark ("Lese — Zeichen") (Pennsylvania German) 19th century
Ink and watercolor 4"x3¼" (10.2x8.3 cm)
Unsigned
Reverse: label, American Folk Art Gallery, New York, N.Y.
Ex-collection: donor, New York, N.Y.
Gift of Mrs. Edith G. Halpert 1940 40.158

Still Life — Apples and Grapes late 19th century
Oil on sketching board 8"x9½" (20.3x24.1 cm)
Unsigned
Ex-collection: donor, New York, N.Y.
Gift of Mrs. Edith G. Halpert 1940 40.159

Portrait of a Black Man late 19th century
Watercolor on paper 22"x17" (55.9x43.2 cm)
Unsigned
Ex-collection: private collection, New York, N.Y.
Anonymous gift 1940 40.162

Portrait of Benjamin Frazee (1787-1878) 19th century
Oil on canvas 17″x14″ (43.2x35.6 cm)
Unsigned
Ex-collection: in family of sitter until donated by his great-granddaughter, the donor, Denville, N.J.
Gift of Mrs. James C. Peckwell 1942 42.168

Subject lived in Newark.

Portrait of Mrs. Benjamin Frazee [Susan Ogden Morehouse]
(1790-1852) 19th century
Oil on canvas 17″x14″ (43.2x35.6 cm)
Unsigned
Ex-collection: in family of sitter until donated by her great-granddaughter, the donor, Denville, N.J.
Gift of Mrs. James C. Peckwell 1942 42.169

Mrs. Frazee, originally from "Elizabethtown," was married in 1819.

Lt. Col. James Peckwell 19th century
Oil on cardboard 14¾″x10″ (35.6x25.4 cm)
Unsigned
Ex-collection: donor, Denville, N.J.
Gift of Mrs. James C. Peckwell 1942 42.173

Subject was in Newark's First Regiment in the Civil War; subsequently Chief of Police in Newark and Sheriff of Essex Co. (1874), according to a letter written by donor's wife.

Portrait of Mrs. John Bradford Taylor [Sarah Camp] ca. 1815
Oil on wood 25″x20½″ (63.5x52.1 cm)
Unsigned
Reverse: Torn label on frame (illegible), "Sarah Camp wife of/Bradford Taylor/and sixth in direct/line of descent from William Camp." *(files)*
Ex-collection: sitter to her sister, the maternal grandmother of donor, Chestertown, Md.
Gift of Miss Hope Wickes 1943 43.46

Wife of Dr. John Bradford Taylor, direct descendant of William Camp, an original settler of Newark

Book Mark (Pennsylvania German fraktur) 1785
Watercolor and ink on paper 5⅜″x3¼″ (13.7x8.3 cm)
Inscribed and dated: "Fleiseg Anno 1785"/"Henrich Ackerman(?)"
Ex-collection: Henry C. Mercer; to donor, Mystic, Conn.
Bequest of Miss Elisabeth Holden Webb 1943 43.246

Flyleaf from the New Testament (Pennsylvania German fraktur) 1792
Watercolor and ink on paper 6½″x3¾″ (16.5x9.5 cm)
Lettered and dated: "Das neue/testament/gehoret/mir/zu/", followed by a verse, below which is lettered, "Maria Hostatterin/Weschrieben den sten/mertz/Anno 1792/Ich freue/mich dich liebe/ich dis sind/in doch diegaben/die wir von/Jesu haben". Facing half of sheet written in ink, two indecipherable names and dates, "1805" and "1808"
Ex-collection: Henry C. Mercer; to donor, Mystic, Conn.
Bequest of Miss Elisabeth Holden Webb 1943 43.247

Sheet with Fraktur Decoration (Pennsylvania German) 1796
Watercolor and ink on paper 6⅛″x3⅜″ (15.6x8.6 cm)
Lettered on front: "Schaffe in mir Gott ein reines herz, und/gib mir einen neuen gewissen geist, verwi/mich nicht von deinen ungesicht, und/ — deinen ho ligen geist/nicht von mie"
Reverse: "Susanna Hosteterin Ann 1796/24 December"
Ex-collection: Henry C. Mercer; to donor, Mystic, Conn.
Bequest of Miss Elisabeth Holden Webb 1943 43.248

Translation: "Create in me a clean heart, O God, and renew a right spirit within me; cast me not away from thy presence; take not thy Holy Spirit from me."

Illuminated Verse (Pennsylvania German)
Watercolor and ink on paper 2¾″x4⅜″ (6.9x11.1 cm)
Ex-collection: Henry C. Mercer; to donor, Mystic, Conn.
Bequest of Miss Elisabeth Holden Webb 1943 43.249

Portrait of Seth Boyden (1788-1870)
Oil on canvas 30″x25″ (76.2x63.5 cm)
Unsigned
Ex-collection: donor, Newark, N.J.
Gift of Frank B. Crawford 1944 44.9

Portrait accompanied by photograph from which it was copied.

Broad and Market Streets, Newark 19th century
Oil on canvas 19½″x27⅞″ (49.5x70.8 cm)
Unsigned
Ex-collection: donor, Newark, N.J. (acquired prior to 1904)
Gift of H. Meyer 1944 44.84

This curious aerial view appears to be an early painting of the "Four Corners" in Newark with Archer Gifford's tavern in the left foreground, a building destroyed by fire in the 1830's. In the lower center is the town pump; at the right is Captain Treat's meetinghouse; the church in the upper right is the Old First Presbyterian Church.

The donor acquired the painting from an unidentified Newark woman who was about to destroy it.

Shippen Home, Fairmount Park 1809
Oil on canvas 13½″x17¾″ (34.3x45.1 cm)
Unsigned
Reverse: on canvas, "IM 1809"
Ex-collection: donor, New York, N.Y.
Gift of Robert C. McIntyre 1944 44.209

Donor believed that this painting represented the Shippen home which stood in Fairmount Park, Philadelphia. However, there is no record of a Shippen house there.

The initials on the reverse have not been identified.

Portrait of Matilda C. Havell (1857-?) ca. 1864
Oil on canvas 20¾″x17″ (52.8x43.2 cm; oval)
Unsigned
Ex-collection: donor, East Orange, N.J.
Gift of Miss Matilda C. Havell 1945 45.128

Painted when subject was age 7 and lived in Newark.

Portrait of Mrs. Horace Newton Congar [Isarella Reeves] (1825-1905)
ca. 1830
Oil on wood panel 30¼″x24″ (76.8x60.9 cm), opening 29¼″x23½″
(74.3x59.7 cm; oval)
Unsigned
Ex-collection: sitter, to her daughter, the donor,
Newark, N.J.
Bequest of Miss Florence Congar 1945 45.129

Family tradition held that portrait of Isarella Congar was done by an artist named "Harrison." Isarella Reeves and Horace Newton Congar were married in 1852. Mr. Congar's portrait by George Gates Ross (45.130), dated 1841, is similarly framed.

Stephen Crane Farm ca. 1900
Pastel on cardboard 16″x20½″ (40.6x52.1 cm)
Unsigned
Ex-collection: Max Herzberg; to Hubert R. Ede; to Stephen Crane Association
Gift of the Stephen Crane Association 1945 45.264

Stephen Crane, the novelist, was born in Newark in 1891. The pastel presumably depicts a farm in New York State near Port Jervis where Crane lived with relatives around the turn of the century. Herzberg is thought to have acquired the work from a Crane relative.

Portrait of a Woman (Portrait of a New Jersey Woman) ca. 1830's
Oil on canvas 30⅛"x25⅛" (76.5x63.8 cm)
Unsigned
Ex-collection: Samuel Barber or Delia Jewell Barber, Jersey City, N.J. to daughter, Theora Barber Thoms; to husband, the donor, Providence, R.I. (formerly East Orange, N.J.)
Gift of F. C. Thoms 1945 45.1577

Donor listed Barber, Bowne, Lambert, Vermilyea and Holbrook as possible families of sitter.

Portrait of Mrs. Warren E. Trusdell [Grace E.] **as a Child** ca. 1870's
Oil on canvas 40"x30" (101.6x76.2 cm)
Unsigned
Ex-collection: donor, Orange, N.J.
Gift of Mrs. Warren T. Stewart 1946 46.77

The Trusdells were a Newark family in the late 19th century.

Portrait of Warren E. Trusdell as a Child ca. 1870's
Oil on canvas 40"x30" (101.6x76.2 cm)
Unsigned
Ex-collection: donor, Orange, N.J.
Gift of Mrs. Warren T. Stewart 1946 46.78

Portrait of Josiah James (1769-1856) early 19th century
Oil on canvas 30¼"x25" (76.8x63.5 cm)
Unsigned
Reverse: label, "Vixseboxse Art Galleries/2258 Euclid Avenue. Cleveland O./Josiah James was the architect/builder superintendent of Trinity/Cathedral, which appears in the/background of the present painting./The portico also was added in 1809,/during the period in which James/worked. He had a long and honorable/connection with the cathedral./(Rev. Arthur Dumfer dean of Trinity/Cathedral supplied the abov in -/formation."
label, Vixseboxse label/"Portrait of Josiah James,/architect of Trinity Cathedral,/Newark, New Jersey./Early XIX Century."
Ex-collection: Trinity Church, Newark, sold at auction, American Art Association — Anderson Galleries, sale of Mrs. J. M. Carlisle works, May 23, 1939 (#97); to Vixseboxse Art Gallery, Cleveland, O.
Purchase 1946 Felix Fuld Bequest Fund 46.158

Provenance is unclear. Anderson Galleries claims to have bought the painting from Trinity Church, but the church has no such record. It is possible that it came from a private citizen closely linked with Trinity's history.

Portrait of Frederick Sheldon Faitoute (1834-1850) ca. 1846
Pastel on paper 21¾"x18" (55.3x45.7 cm; oval)
Unsigned
Ex-collection: sitter through his sister to his niece, the donor, Saugatuck, Conn.
Gift of Miss Marie C. Keene 1950 50.114

Brother of Ella Faitoute Burnham.

Portrait of Ella Faitoute Burnham (1847-1940) ca. 1852
Oil on canvas 19⅜"x15⅜" (49.2x39.1 cm; oval)
Unsigned
Ex-collection: sitter to her daughter, the donor, Saugatuck, Conn.
Gift of Miss Marie C. Keene 1950 50.115

Sister of Frederick Sheldon Faitoute.

*Portrait of a "Becker" Woman** 1830
Oil on canvas 30½"x26½" (77.5x67.0 cm)
Inscribed: above right of center, "Born Oct.ʳ 18th 1796/Painted Augˢᵗ, 1830."
Reverse: came relined to donor
Ex-collection: Alice Carleton Wilde, Cambridge, Mass.; to donor, New York, N.Y., 1943.
Gift of Mrs. Edith G. Halpert 1950 50.2144

Helen Kellogg attributed this and "Becker" man to Royall Brewster Smith (1801-1849). The donor bought the Wilde collection and exhibited it at The Downtown Gallery in 1944. In that exhibition the "Becker" portraits were catalogue #8. (files)

*Portrait of a "Becker" Man** 1830
Oil on canvas 30½"x26½" (77.5x67.3 cm)
Inscribed: above left of center, "Born Dec.ʳ 26th, 1795. Painted Aug.ˢᵗ 1830."
Reverse: came relined to donor
Ex-collection: Alice Carleton Wilde; to donor, New York, N.Y.
Gift of Mrs. Edith G. Halpert 1950 50.2145

Attributed to Royall Brewster Smith.

Portrait of an Architect mid-18th century
Oil on canvas 34¾"x28" (88.3x71.1 cm)
Ex-collection: Fred J. Johnston, Kingston, N.Y.; to Richard A. Loeb, Hampton, N.J.; to donors, New York, N.Y.
Gift of Colonel and Mrs. Edgar W. Garbisch 1951 51.126

According to Fred J. Johnston, the work was bought near Kinderhook, N.Y., from a family allied by marriage to the Van Rensselaer family. The portrait was described by Colonel Garbisch's secretary in 1952 as "thought to be of Stephen Van Rensselaer of Albany." Van Rensselaer was an amateur architect. Johnston reported the work as having once had a rounded top. Work had been relined and extensively restored before entering Museum collection. (files)

Portrait of Mrs. William Henry Condit [Celia Eliza Peak] (1813-?) **and Son William** (1838-?) ca. 1840
Oil on canvas 36¼"x29" (92.1x73.7 cm)
Unsigned
Reverse: label, Swain's Art Supply Store, Plainfield, N.J.
Ex-collection: donor, Brooklyn, N.Y.
Gift of Mrs. Henry Haynes 1952 52.94

Portrait of William Henry Condit (1838-?) 19th century
Oil on canvas 36¾"x29¼" (93.3x74.3 cm)
Unsigned
Reverse: label, Swain's Art Store, Plainfield, N.J.
Ex-collection: donor, Brooklyn, N.Y.
Gift of Mrs. Henry Haynes 1952 52.95

Nash Residence 1858
Oil on canvas 18"x24" (45.7x61.0 cm)
Inscribed: left of center, "Residence/D. D. Nash/61st 10th A./n./1858"
Ex-collection: donor, Newark, N.J.
Bequest of Mrs. Florence Peshine Eagleton 1954 54.118

The Lady of the Lake ca. 1830
Painting on velvet 30½"x24" (77.5x61.0 cm)
Unsigned
Ex-collection: Antiques, Inc., Whippany, N.J.
Purchase 1955 Mrs. Felix Fuld Bequest Fund 55.130

Sir Walter Scott's Lady of the Lake, *first published in 1810, was a popular theme of the early 19th century. Style of the Lady's hair places it around 1830.*

Portrait of General Edmund Schriver (1812-1899) ca. 1845
Oil on canvas 27″x22″ (68.6x55.9 cm) [oval opening]
Unsigned
Reverse: stencil, "Prepared by/Edward Dechaux/New York."; label,
"To General —/of Pennsylvania Class 1833-West Point —"
Ex-collection: Bernard R. Armour, Englewood, N.J.
Gift of Ruth, Rachel and Toby Armour in memory of their father
Bernard R. Armour 1955 55.157

*Full name and dates of the sitter supplied by U.S. Military Academy,
West Point, N.Y.*

*Label read, "General _____ _____/of Pennsylvania/
Class 1833 _____ _____ West Point/Inspector General
Army of the/Potomac _____ Governor of Fredericksburg/Staff of
General McDowell/and General Mead." (files)*

Portrait of Joseph Dunderdale (1776-?) ca. 1804-06
Watercolor and pencil on paper 8⅛″x6″ (20.6x15.2 cm; oval)
Unsigned
Ex-collection: donor, Montreal, Canada
Gift of Mrs. S. T. Peirce 1956 56.168

*Joseph Dunderdale and Maria Susanna Forbes were married in Newark,
N.J., by the Rev. Joseph Willard, Rector of Trinity Church, on May 29,
1806.*

Portrait of Mrs. Joseph Dunderdale [Marie Susanna Forbes] (1789-?)
ca. 1804-06
Watercolor and pencil on paper 8″x6″ (20.3x15.2 cm; oval)
Unsigned
Ex-collection: donor, Montreal, Canada
Gift of Mrs. S. T. Peirce 1956 56.169

Young Boy Holding Iliad (Portrait of a Boy) ca. 1770-1775
(previously attributed to Matthew Pratt)
Oil on canvas 36″x28″ (91.4x71.1 cm)
Unsigned
Ex-collection: private collection, Philadelphia, Pa.; sold at auction,
1955; to Hirschl & Adler Galleries, New York, N.Y.
Purchase 1956 Carl and Dorothy Badenhausen Foundation Trust
Fund 56.183

*Original attribution to Matthew Pratt is in question. E. P. Richardson has
also questioned its American Colonial designation. (corres.)*

European Landscape mid-19th century
Oil on canvas 35½″x48″ (90.2x121.9 cm)
Unsigned
Ex-collection: donor, New York, N.Y.
Gift of Robert J. Schoelkopf 1957 57.84

Attribution to Jasper F. Cropsey has been suggested.

Portrait of Daniel Ashby (1830-1907) ca. 1860
Oil on canvas 36¼″x30¼″ (92.1x76.9 cm)
Unsigned
Ex-collection: remained in sitter's family to a descendant, the donor,
Boston, Mass.
Gift of Mrs. Edgar C. Rust 1957 57.85

*Family tradition maintained that the painting was executed in New
Orleans prior to the Civil War. Ashby was a resident of Louisville (Bowling
Green), Ky.*

Waters House: Salem, Massachusetts
Oil on wood 19″x24⅛″ (48.3x61.3 cm)
Reverse: inscribed on panel, "BW" "1834"
label, Bland Gallery, N.Y.C.
label, "F. Grinnel & Son Looking Glasses"
Ex-collection: Harry MacNeil Bland Gallery, New York, N.Y.; to
donors, Stockton, N.J.
Gift of Mr. and Mrs. Bernard M. Douglas 1958 58.20

*The back of this painting also has an obscured primitive portrait of a
woman. Waters acquired the house in 1839.*

Still Life: Newark Times after 1893
Oil on canvas 6⅛″x8⅛″ (15.6x20.6 cm)
Signed: in varnish layer, "Harnett"
Reverse: stamp, on stretcher, "Fred. Keer & Sons, Newark"
Ex-collection: donor, Newton, Conn.
Gift of Henry Schnakenberg 1959 59.86

*Dr. Alfred Frankenstein has shown that the attribution to Harnett is
stylistically incorrect. He also pointed out that the Newark Times, which
existed from 1891 to 1894, used the Gothic type depicted in the painting
only in 1893 and 1894. William Michael Harnett died in 1892.*

*Several facts, however, point to a Newark origin: the tobacco label depicted
is that of the Newark firm of Campbell & Co. and the stamp on the
stretcher is that of a Newark framer. (files)*

Pennsylvania Town Scene ca. 1900
Oil on plywood 12″x22″ (30.5x55.9 cm)
Unsigned
Ex-collection: Mable Osborne Antiques, Upper Montclair, N.J.
Purchase 1960 Special Fund 60.584

Approximate dating by costume.

***Little Henry Hills** (1831-1837) ca. 1835
Oil on canvas 36¼″x28¼″ (92.1x71.8 cm)
Unsigned
Ex-collection: remained in subject's family until purchased from Mrs.
Warren Perkins of East Orange, N.J.
Purchase 1961 Museum Endowment Funds 61.21

Portrait painted in Fall River, Mass.

Portrait of Carrie L. Pridham (1845-1875) ca. 1850
Oil on canvas 44″x34″ (111.8x86.4 cm)
Unsigned
Ex-collection: remained in subject's family until donated by her
grandson, Brooklyn, N.Y.
Gift of James C. Paul 1964 64.242

*Carrie Pridham was born in Newark and was living in Newark when the
painting was executed. She was approximately five years old at the time.
She later married Thomas M. Carlile. (corres.)*

Birthday Regester: Abigail Clark (1794-1878)
Watercolor and ink on paper 16″x7⅝″ (40.6x19.4 cm)
Unsigned
Inscribed: top, "Birthday Regester"; bottom, "Abigail Clark/was Born
May; 25th/1794"
Ex-collection: subject's great granddaughter, donor, East Orange, N.J.
Bequest of Miss Elizabeth Beers 1966 66.408

*Prior to conservation work was backed with an 1813 Morristown, N.J.,
newspaper.*

*Abigail Clark lived in Mendham, N.J., when she married Henry Axtell
(1793-1863) of Mendham Township in 1814. She died in Newark where her
husband had been superintendent of the Foster Home, 270 North Broad
St., 1849-51.*

***Three Children with Their Dog** ca. 1840
Oil on canvas 42″x35″ (106.7x88.9 cm)
Unsigned
Reverse: no pertinent data recorded prior to relining, 1967
Ex-collection: with Aaltens Orange Auction Gallery, Orange, N.J.
Purchase 1966 Felix Fuld Bequest Fund 66.409

Painting found in Monmouth County, N.J.

Mourning picture: Raymond Family ca. 1812
Watercolor on paper 14½"x18" (36.8x45.7 cm)
Unsigned
Inscribed: left tombstone, "In Memory/of Rufus Raymond, Esq./who
died at Richmond/February ...AD 1812/Aged 25 years"; right
tombstone, "In Memory of/Abigail Raymond/who died at
Hudson/April ...AD 1812/Aged 14 years"; center urn, "Sacred/to the
Memory of/Henrietta Raymond/Aged 9 months"; angel's banner,
"There is rest in Heaven"
Reverse: label, Farnsworth Art Gallery, Wellesley College, N.E.T.,
February 1950
Ex-collection: American Folk Art Gallery, New York, N.Y. (The
Downtown Gallery)
Purchase 1967 Louis Bamberger Bequest Fund 67.55

Picture was found in Hudson, N.Y.

***Still Life: Flowers, Fruit, and Decanter** mid-19th century
Tinsel reverse painting on glass 19½"x24¼" (49.5x61.6 cm)
Unsigned
Reverse: label, "W. K. O'Brien & Bros." (picture frame manufacturers)
Ex-collection: Holger Cahill; Stockbridge, Mass.
M. Knoedler & Co., New York, N.Y.
Purchase 1967 Sophronia Anderson Bequest Fund 67.69

Portrait of John A. McDougall (1811-1894) 19th century
Watercolor and pencil on paper 18⅛"x14⅛" (46.0x35.9 cm)
Unsigned
Ex-collection: remained in family of sitter until donated by his great
granddaughter, Poughkeepsie, N.Y.
Gift of Mrs. Beatrice MacDougall Lindberg 1967 67.400

*The John A. McDougall depicted was the artist of Landscape (18.794) and
Milldam on the Whippany (26.633) and the father of John A., Jr. (67.395)
Mrs. Lindberg's father, Hugh, was one of John Jr.'s brothers. Possibly a self-
portrait.*

Portrait of Cyrus Griffin of Massachusetts ca. 1830
Oil on wood 25¾"x22" (65.4x55.9 cm)
Unsigned
Ex-collection: donor, a direct descendant, Lavallette, N.J.
Bequest of Miss Hélène Perry Griffin 1968 68.204

Dated by costume.

Three Cummins Children and a Dog ca. 1845
Oil on canvas 48"x42" (121.9x106.7 cm)
Unsigned
Reverse: no pertinent data recorded prior to relining, 1968
Ex-collection: painting remained in Cummins family until purchased
from Mrs. John Slack, Hackettstown, N.J.
Purchase 1968 Dr. and Mrs. Earl LeRoy Wood Endowment
Fund 68.216

*Mrs. Slack's father was John H. A. Cummins (born 1841), the boy with the
cap in this painting. The other children are Francis Adrian, the baby (born
1843), and sister Emma Georgianna (born 1838). The Cummins family
lived in Lafayette, N.J. (Sussex County).*

Portrait of Mrs. John Church Cruger [Euphemia White
Van Rensselaer] (1814-?) ca. 1820
Watercolor on paper 9⅝"x7½" (24.6x19.1 cm)
Unsigned
Reverse: tag, "Portrait of/Circa 1820/Euphemia White Van Rensselaer"
Ex-collection: painting descended to sitter's son, Colonel Stephen
Van Rensselaer Cruger; to his nephew by marriage, Wentworth Cruger
Bacon, Millbrook, N.Y.; to his wife by inheritance
Purchase 1969 Sophronia Anderson Bequest Fund 69.167

Portrait of Alexander Van Rensselaer (1816-?) 19th century
Watercolor on paper 8⅞"x6¾" (22.6x17.2 cm)
Unsigned
Ex-collection: painting descended to sitter's son, Colonel Stephen
Van Rensselaer Cruger; to his nephew by marriage, Wentworth Cruger
Bacon, Millbrook, N.Y.; to his wife by inheritance
Purchase 1969 Sophronia Anderson Bequest Fund 69.168

Portrait of Mrs. Edward Shippen [Mary Gray Newland] (1705-1778)
ca. 1750
Oil on canvas 50"x40" (127.0x101.6 cm)
Unsigned
Ex-collection: Edward Shippen; to his son, Joseph Shippen; to his son,
Henry Shippen; to his son, Evans Wallis Shippen; to his daughter,
Katherine Shippen Farr; to Mrs. Frank W. Bacon (1881); Victor Spark,
New York, N.Y. (1958); Hirschl and Adler Galleries,
New York, N.Y.
Purchase 1969 The Charles W. Engelhard Foundation 69.115

*Mary Newland became the second wife of Edward Shippen of
Philadelphia, Pa., in 1747. He was a Trustee of the College of New Jersey
which originated in Newark and moved to Princeton.*

*Mrs. Shippen's portrait is almost identical to Robert Feke's signed and
dated (1746) portrait of Mrs. Charles Willing, Mr. Shippen's sister (Henry
Francis duPont Winterthur Museum). Mrs. Shippen's portrait was once
ascribed to Feke, but its lack of strict mathematical proportions and its
dual perspective contributed to a reassessment of that attribution. Nathalie
Rothstein of the Victoria and Albert Museum, London, England, notes that
Mrs. Willing's dress fabric is in accordance with actual Spitalfield's
design, whereas Mrs. Shippen's, almost identical, conveys a design that
could not have been taken from the actual fabric. Thus, it is possible the
artist of Mrs. Shippen's portrait was copying the Willing
portrait. (files)*

Portrait of a Man 19th century
Oil on canvas 23"x19" (58.3x48.3 cm; oval)
Unsigned
Ex-collection: donor, West Orange, N.J.
Gift of Robert O. Driver 1970 70.76

Probably companion to A.U. 70.77.

Portrait of a Woman 19th century
Oil on canvas 23½"x19¾" (59.7x50.3 cm; oval)
Unsigned
Ex-collection: donor, West Orange, N.J.
Gift of Robert O. Driver 1970 70.77

Four Masted Schooner — Reefed 2nd half 19th century
Oil on canvas mounted on masonite 26¼"x42¾" (66.8x108.6 cm)
Unsigned
Ex-collection: donor, Woodbury, Conn.
Gift of Miss Margaret Kinnane 1973 73.85

Still Life on a Table mid-19th century
Oil on canvas 18"x22½" (45.7x57.0 cm)
Unsigned
Ex-collection: donor, Woodbury, Conn.
Gift of Miss Margaret Kinnane 1973 73.86

Portrait of a Man ca. 1835
Pen and watercolor on paper 4⅝"x3¾" (12.0x9.5 cm)
Unsigned
Ex-collection: donor, Woodbury, Conn.
Gift of Miss Margaret Kinnane 1973 73.88

Voyage of Life: Youth mid-19th century
(After Thomas Cole)
Oil on canvas 23″x29″ (58.5x74.0 cm)
Unsigned
Ex-collection: donor, Woodbury, Conn.
Gift of Miss Margaret Kinnane 1973 73.90

Presumably after an engraving of the 1840 oil painting by Thomas Cole.

Medallion Head of George Washington 19th century
Gouache and pen on glass 7″x7″ (18.0x18.0 cm) portrait head diameter
2⅜″ (6.0 cm)
Signed: under bust, "Duvivier Paris f Comitia Americana"
Inscribed: "Georgio Washington Supremo duci exercitum adsertori
libertatis"
Ex-collection: donor, Woodbury, Conn.
Gift of Miss Margaret Kinnane 1973 73.91

After Washington Before Boston *medal by Benjamin Duvivier (French,
1730-1819), commissioned by U.S. Congress in 1776.*

Portrait of Mrs. Isaac Baldwin [Ann Camp] (ca. 1793-1846) ca. 1845
Oil on canvas 30⅛″x24⅜″ (76.5x63.0 cm)
Unsigned
Reverse: Dechaux stencil
Ex-collection: Isaac Baldwin, Newark, N.J.; to Wickliffe E. Baldwin,
Newark, N.J.; to Henry Waldron Baldwin, Newark, N.J.; to Lathrop E.
Baldwin, South Orange, N.J.
Gift of Mrs. Lathrop E. Baldwin 1975 75.10

Wife of Isaac Baldwin.

Portrait of Isaac Baldwin (1790-1853) ca. 1845
Oil on canvas 30¼″x23¾″ (76.8x60.3 cm)
Unsigned
Reverse: Dechaux stencil upside down at top
Ex-collection: sitter, Newark, N.J.; to Wickliffe E. Baldwin, Newark,
N.J.; to Henry Waldron Baldwin, Newark, N.J.; to Lathrop E. Baldwin,
South Orange, N.J.
Gift of Mrs. Lathrop E. Baldwin 1975 75.11

*Baldwin was a well-known Newark jeweler and silversmith; elected 7th
Mayor of the City in 1845. Husband of Ann Camp Baldwin.*

Portrait of Horace E. Baldwin (1815-1852)
Oil on canvas 27″x22″ (69.0x56.4 cm)
Unsigned
Ex-collection: sitter, Newark, N.J.; to Wickliffe E. Baldwin, Newark,
N.J.; to Henry Waldron Baldwin, Newark, N.J.; to Lathrop E. Baldwin,
South Orange, N.J.
Gift of Mrs. Lathrop E. Baldwin 1975 75.12

Son of Isaac (A.U. 75.11) and Ann (A.U. 75.10) Baldwin.

Portrait of Wickliffe Erastus Baldwin (1817-1871)
Oil on canvas 30¼″x25″ (76.8x63.5 cm)
Unsigned
Ex-collection: sitter, Newark, N.J.; to Henry Waldron Baldwin,
Newark, N.J.; to Lathrop E. Baldwin, South Orange, N.J.
Gift of Mrs. Lathrop E. Baldwin 1975 75.13

*Sitter was a Newark jeweler and silversmith who joined his father
in business in the 1840's; later became a carpenter in business at
11 Franklin Street.*

Son of Isaac (A.U. 75.11) and Ann (A.U. 75.10) Baldwin.

Portrait of Henry Waldron Baldwin
Pastel mounted on canvas 15½″x11⅝″ (39.4x28.6 cm)
Unsigned
Ex-collection: Wickliffe E. Baldwin, Newark, N.J.; to Henry Waldron
Baldwin, Newark, N.J.; to Lathrop E. Baldwin, South Orange, N.J.
Gift of Mrs. Lathrop E. Baldwin 1975 75.14

Son of Wickliffe E. (A.U. 75.13) and Anne Elflida (A.U. 75.15) Baldwin.

Portrait of Mrs. Wickliffe E. Baldwin [Anne Elflida] ca. 1850
Oil on canvas 30″x25″ (76.7x63.3 cm)
Unsigned
Ex-collection: Wickliffe E. Baldwin, Newark, N.J.; to Henry Waldron
Baldwin, Newark, N.J.; to Lathrop E. Baldwin, South Orange, N.J.;
Gift of Mrs. Lathrop E. Baldwin 1975 75.15

***Ann Elizabeth Gill** (1818-1825) ca. 1818
Fraktur: watercolor, ink on wove paper 8³/₁₆″x10″ (20.7x25.4 cm)
Inscribed. "Ann Elizth Gill./Daughter/of/John H. and Jane Gill.
Was born/September Anno Domini 1818."
Reverse: on backing, "Conserved by/Gary Albright/Spring 77"
Ex-collection: purchased at Kimberleysville, Chester Co., Pa., auction,
1975 by Marc A. Williams, Somerville, Mass.
Purchase 1977 The Members' Fund 77.166

*According to research by Gary Albright, Ann Elizabeth, daughter of John
H. and Jane Gill of Gloucester County, N.J., died on July 13, 1825, and is
buried in the Swedesboro Churchyard.*

***Thomas S. Gill** ca. 1818
Fraktur: watercolor, ink, on wove paper 8″x10¹/₁₆″ (20.5x25.6 cm)
Inscribed: "Thomas S. Gill/Son of John (illeg.) and Jane Gill
was born"
Reverse: on backing, "Conserved by/Gary Albright/Spring 77"
Ex-collection: purchased at Kimberleysville, Chester Co., Pa. auction,
1975 by Marc A. Williams, Somerville, Mass.
Purchase 1977 The Members' Fund 77.441

*Unpublished paper by Gary Albright in Museum files states that the paper
for this fraktur and that of Ann Elizabeth Gill (A.U. 77.166) is the same
and was made by the Cox Mill in Mt. Holly (Burlington County).
Similarity of colors, rendering and physical condition also indicate that
the two frakturs were done at the same time. A reasonable assumption is
that prior to the birth of the expected child, one was made for a girl and
one for a boy. Hence, the document for "Thomas" was not filled in.*

ABBEY, EDWIN AUSTIN (1852-1911)

Pensive 1882
Pen and ink on paper 8″x5½″ (20.3x14.0 cm)
Reverse: "Edwin A. Abbey"
Ex-collection: Joseph S. Isidor, New York, N.Y., and Orange, N.J.; to
his wife, the donor.
Bequest of Mrs. Rosa Kate Isidor 1949 49.427

ABBOT, EDITH R. (1876-1964)

Dorset Farm mid-20th century
Oil on canvas 28⅛″x24⅛″ (71.4x61.2 cm)
Signed: lower right, "Edith R. Abbot"
Reverse: label, The National Arts Club, "Dorset Farm," lent by
the artist; label, artist's hand, "Farm —"/12 E. 97 St. NYC/Edith R.
Abbot
Ex-collection: estate of the artist; to donor, Charleston, S.C., and
Wayne, N.J.
Gift of Miss Mable Tidball 1964 64.241

ABDUR-RAHMAN, UTHMAN [Harold W. Taylor] (b. 1936)

Evolving Study 1970
Colored ink drawing on cardboard 10″x40″ (25.4x101.6 cm)
Signed and dated: lower right, "Monogram '70"
Reverse: label, The Newark Museum/7th Triennial Exhibit of New
Jersey Artists
Ex-collection: purchased from the artist
Gift of Continental Insurance Company 1971 71.103

ABRAMSON, MAURICE (b. 1908)

Blue and Red 1958
Oil on masonite 26½"x32" (67.3x80.0 cm)
Signed: lower left, "M Abramson"
Reverse: label, Newark Museum, *Work by New Jersey Artists*, 1958
Ex-collection: purchased from the artist
Purchase 1958 Wallace M. Scudder Bequest Fund 58.23

AGATE, ALBERT (1812-1846)

Scene of Fiji ca. 1839
Oil on canvas board 14"x11¾" (35.6x29.8 cm)
Unsigned
Reverse: torn label, handwritten in ink, "... on the/... of Weak —.
sad/... of the Fiji group)/painted by A. J. Agate."
Ex-collection: artist through family; to his sister's great-great niece, the
donor, Ossining, N.Y.
Gift of Mrs. C. D. Ferguson 1965 65.130

AGATE, FREDERICK S. (1803-1844)

Portrait of Benjamin Silliman (1799-1864), after Samuel F. B. Morse
ca. 1825
Oil on canvas 28½"x23¼" (72.4x59.0 cm)
Unsigned
Reverse: no pertinent data recorded prior to relining, 1963
Ex-collection: remained in family of artist until donated to the
Ossining (N.Y.) Historical Society by his descendant, Mrs. Melodia W.
Ferguson, Ossining, N.Y.
Gift of the Ossining Historical Society, through the courtesy of Mrs.
Melodia Ferguson 1959 59.420

*Agate was a student of Morse in 1824. The Morse portrait of Silliman
was executed in 1825; this copy may have been executed shortly after
Morse's original.*

AGATE, HARRIET (1807-1871)

At the Monument of Lysicrates (Greek Scene) ca. 1830 (attributed)
Oil on canvas 24"x20" (61.0x50.8 cm)
Unsigned
Reverse: no pertinent data recorded prior to relining, 1961
Ex-collection: remained in family of artist until donated to the
Ossining Historical Society by her great granddaughter, Mrs. Melodia
W. Ferguson, Ossining, N.Y.
Gift of Ossining Historical Society, through the courtesy of Mrs.
Melodia Ferguson 1959 59.419

*Dated by William H. Gerdts, Jr., to coincide with Greek Independence, the
painting shows a woman aiding a Greek soldier. Family tradition has
ascribed the painting to Harriet Agate.*

AHLAS, LAMBRO (b. 1927)

Maria
Oil on canvas 40½"x27½" (102.2x69.9 cm)
Signed: lower right, "Lambro Ahlas"
Reverse: label, Gallery 52 South Orange "White Blouse"
top stretcher, "Maria"
Ex-collection: with Gallery 52, South Orange, N.J.
Gift of Mr. and Mrs. Bernard Rabin 1976 76.6

ALBERS, JOSEF (b. Germany, 1888-1976)

*****Homage to the Square: "Alone"** 1963
Acrylic on masonite 48"x48" (121.9x121.9 cm)
Signed and dated: Lower right, A63
Reverse: inscribed, "48x48 Homage to the Square:/'ALONE'/Albers'
1963."; label, Sidney Janis Gallery
Ex-collection: Sidney Janis Gallery, New York, N.Y.
Purchase 1967 Membership Endowment Fund 67.54

*In a large space on reverse of panel between the artist's signature and date
is a description of paints as well as varnish used. The hand is different
from that of the artist and was presumably added in 1964 by the restorer,
Goldreyer, whose name is subscribed.*

ALLEN, BOYD (b. 1931)

Red Crypt 1960
Oil on canvas 70"x61" (178.0x155.0 cm)
Signed: lower right, "Boyd Allen"
Ex-collection: acquired from the artist, Hoboken, N.J.
Purchase 1961 Felix Fuld Bequest Fund 61.15

Purchased from The Newark Museum's 4th triennial exhibition, Work by
New Jersey Artists, *1961.*

ALLODOLI, C. (19th century)

Portrait of Sophronia Anderson (1856-1937) 1896
Oil on canvas 24½"x19½" (62.2x49.5 cm)
Signed and dated: upper left, "C. Allodoli/1896"
Ex-collection: donor, Newark, N.J.
Bequest of Miss Sophronia Anderson 1938 38.190

ALLSTON, WASHINGTON (1779-1843)

*****A Roman Lady** (A Roman Lady Reading) ca. 1831
Oil on canvas 30"x25" (76.2x63.5 cm)
Unsigned
Reverse: Museum files indicate the following label prior to relining,
"Museum of Fine Arts, Boston, #144, lent by Mrs. J. Elliot Cabot,
Clyde H., Brookline, 1884"
Ex-collection: E. Dwight, Boston, Mass. (1831-ca. 1850); Charles H.
Mills, Boston, Mass. (1856); Mrs. J. Eliot Cabot, Brookline, Mass.
(1881-84); Hugh Cabot, Boston, Mass. (1948); with Victor Spark, New
York, N.Y.; with Childs Gallery, Boston, Mass.; to Hirschl & Adler
Galleries, New York, N.Y.
Purchase 1965 The Membership Endowment Fund 65.35

*The date and provenance were worked out by Edgar Richardson from
recorded exhibitions. Included in Richardson's catalog and biography of
Washington Allston, #136.* A Roman Lady *was the title throughout the
19th century; Childs Gallery assigned the title,* A Roman Lady Reading.

AMES, EZRA (1768-1836)

Portrait of Marcia L. Ames (1796-1886) ca. 1815-20
Oil on canvas 30"x24" (76.2x61.0 cm)
Unsigned
Reverse: no pertinent data recorded prior to relining, 1960
Ex-collection: remained in artist's family until acquired from Mrs.
Lambert Whetstone of New Hampshire, a direct descendant.
Purchase 1960 Harry E. Sautter Membership Endowment
Fund 60.555

This painting may be Marcia L. Ames in Black, *listed in the 1836
inventory of Ames' estate. Marcia Ames was the artist's daughter.*

*****Portrait of Mrs. Thomas Humphrey Cushing** [Margaret N. McCrae]
ca. 1815
Oil on canvas 30"x25" (76.2x63.5 cm)
Unsigned
Reverse: no pertinent data recorded prior to relining
Ex-collection: Miss Florence V. Bessac, Natchez, Miss.; to Frederick
Hill, Catskill, N.Y. (1930); to estate of Frederick Hill (1952); to Hirschl
& Adler Galleries, New York, N.Y. (1953)
Gift of Mr. and Mrs. A. M. Adler 1965 65.162

*Mrs. Cushing's husband served in the American Revolution and became a
Brigadier General in the War of 1812. This portrait is entry #82 in Thomas
Bolton and Irwin F. Cortelyou's* Ezra Ames of Albany *(New-York
Historical Society, 1955). Ames did not include this portrait or one of
General Cushing in his account books. Bolton and Cortelyou have
assigned an approximate date on stylistic grounds.*

ANDERSON, ABRAHAM ARCHIBALD (1847-1940)

***French Cottage** 1883
Oil on canvas 18"x24" (45.7x61.0 cm)
Signed and dated: lower right, "A. A. Anderson — /1883."
Reverse: no pertinent data recorded prior to relining, 1974
Ex-collection: the artist to his daughter, the donor, Scarsdale, N.Y.
Gift of Dr. Eleanor A. Campbell 1958 58.19

ANDERSON LIMNER

Portrait of Asa Spenser (ca. 1805-49?) ca. 1830 (attributed)
Oil on wood 9⅛"x7⅛" (23.3x18.3 cm)
Unsigned
Reverse: pencil, "Asa Spenser Inventor of the Rose---ing machine
Philadelphia"
Ex-collection: donor, Woodbury, Conn.
Gift of Miss Margaret Kinnane 1973 73.92

Tentative attribution made by Frick Art Reference Library.

ANTONAKOS, STEPHEN (b. Greece 1925)

Untitled 1960's
Burlap collage on board 13⅛"x8¾" (33.4x22.4 cm)
Signed: lower left (vertically), "Antonakos"
Ex-collection: donors, New York, N.Y.
Gift of Mr. and Mrs. Paul Waldman 1969 69.170

ANUSZKIEWICZ, RICHARD (b. 1930)

***Manifest** 1965
Acrylic on masonite 36"x36" (91.5x91.5 cm)
Signed and dated: on reverse of board, "S 126/1965/Richard
Anuszkiewicz/1965"
Ex-collection: Sidney Janis Gallery, New York, N.Y.
Purchase 1966 Wallace M. Scudder Bequest Fund 66.37

Purchased from the Museum exhibition, Selected Works by
Contemporary New Jersey Artists, *1965.*

Rocket Red Apex 1969
Acrylic on canvas 84"x84" (213.4x213.4 cm)
Unsigned
Ex-collection: donor, Englewood, N.J.
Gift of the artist 1969 69.179

AUDUBON, JOHN J. (1785-1851)

***Red Shouldered Hawk with Bullfrog** (attributed)
Oil on canvas 26¼"x39" (66.7x99.1 cm)
Unsigned
Reverse: label, "Audubon Prints — Elephant Folio", Montclair Art
Museum, 1971; no pertinent data recorded prior to relining, 1957
Ex-collection: Mrs. Delancey Williams, Elmsford, N.Y. (artist's
granddaughter); to Champion H. Judson, Dobbs Ferry, N.Y. to his
daughter, the donor, Newark, N.J.
Gift of Mrs. Henry W. Hawley 1926 26.527

Painted after watercolor for plate #71 in the artist's The Birds of
America *Folio, Vol. I (London: Robert Havell, 1827-30) where it is
labelled* Winter Hawk.

*Although Joseph Bartholomew Kidd (ca. 1806-1889) is known to have
painted an oil copy of this plate under contract to Audubon, and although
there is no documentary evidence that Audubon did so, the attribution to
Audubon is continued on stylistic grounds with the support of Edward W.
Dwight (correspondence) who is familiar with the painting. The fact that
the work came from the artist's family is inconclusive, as Alice Ford has
pointed out. Ford makes a reasonable claim for Kidd on documentary
grounds, noting that Kidd's copy has not been located (correspondence).
The quality of the painting and the fact that it is not an exact copy of the
original watercolor argue for Audubon. The opinion of Mary C. Black and
Waldemar H. Friese have been generally supportive although allowing an
equal possibility that the work is by Kidd (correspondence). There is no
suggestion that Audubon's sons John W. or Victor painted this copy,
although they, as did John James, made oil copies from various plates.*

AUDUBON, VICTOR GIFFORD (1809-1860)

***Landscape Along the Hudson** 1842
Oil on canvas 31¼"x45⅛" (79.4x114.6 cm)
Signed and dated: lower left, "V.G.A./1842"
Ex-collection: donor, Orange, N.J.
Gift of George Parmly 1942 42.16

*Son of John J. Audubon. Another Hudson River view by Victor G.
Audubon, very similar to this one, is in the Karolik Collection, Boston
Museum of Fine Arts, Mass.*

AUGUSTA, GEORGE V. (b. 1922)

Portrait of Franklin Conklin, Jr. (1886-1966) 1965
Oil on canvas 30"x25" (76.2x63.5 cm)
Signed and dated: upper left, "Augusta/65"
Purchase 1965 65.135

*Commissioned by The Newark Museum Association to honor its President
from 1943-1963.*

(See Reinhardt 65.128)

AULT, GEORGE COPELAND (1891-1948)

***Brooklyn Ice House** 1926
Oil on canvas 24"x30" (61.0x76.2 cm)
Signed and dated: lower right, "G. C. Ault '26"
Ex-collection: acquired from the artist, New York, N.Y.
Purchase 1928 The General Fund 28.1760

*The artist indicated that he exhibited this work at the Whitney Studio
Club Members' Exhibit in 1927 and at his 1927 one-man show at the
J. B. Neumann Gallery.*

***From Brooklyn Heights**
1925
Oil on canvas 30"x20" (76.2x50.8 cm)
Signed and dated: lower right, "G. C. Ault '25"
Ex-collection: acquired from the artist, New York, N.Y.
Purchase 1928 The General Fund 28.1802

Date could also be read as '28.

Two Dahlias 1930
Watercolor on paper 7⅛"x11⅞" (18.0x30.0 cm)
Signed and dated: lower right, "G. C. Ault '30"
Reverse: inscribed by artist on paper, "Title: Two Dahlias/By: G. C.
Ault/Price $175⁰⁰/1930"; label on backing, First Municipal Art Exhibit,
Rockefeller Center, 1934; torn label on backing, Collectors of American
Art, 1938.
Ex-collection: donor, Woodstock, N.Y.
Gift of the artist 1941 41.676

***Victorian House and Tree** (House and Tree) 1927
Pencil on paper 12"x10" (30.5x25.4 cm)
Signed and dated: lower left, "G. C. Ault '27"
Reverse: inscribed by artist on paper, "Victorian House and Tree
(Summit, N.J.)/By: George C. Ault./Price: 60⁰⁰/1927"; handwritten label
on backing, "Title: Victorian House and Tree/(Summit, N.J.)/By:
George C. Ault/Price: 60.⁰⁰/1927"; similar label on paper indicates title
as "House and Tree"
Ex-collection: donor, Woodstock, N.Y.
Gift of the artist 1941 41.677

The house depicted belonged to the artist's father.

AUSTIN, DARREL (b. 1907)

The Family 1938
Oil on canvas 30¼"x24¼" (76.8x61.6 cm)
Signed: upper left, "Darrel Austin"
Reverse: inscribed on canvas, "Austin/Jan '38"; label, Perls Gallery
(#3308); label, Edith and Milton Lowenthal Collection
Ex-collection: with Perls Gallery, New York, N.Y.; to Edith and Milton
Lowenthal, New York, N.Y. (1943)
Gift of Mrs. Milton Lowenthal 1951 51.161

AVERY, MILTON (1893-1965)

Jugglers ca. 1931-33
Gouache on paper 12⅛"x18" (30.8x45.7 cm)
Signed: lower right, "Milton Avery"
Reverse: label, (private collection), N.Y.C.
Ex-collection: private collection, New York, N.Y.
Anonymous gift 1937 37.108

The artist stated that this work was executed in 1933. Label on reverse indicates it entered a private collection in 1931.

***Landscape, Vermont** 1938
Oil on canvas 27⅞"x36" (70.8x91.5 cm)
Unsigned
Ex-collection: Valentine Dudensing, New York, N.Y. to donor,
New York, N.Y. (1948)
Gift of Roy R. Neuberger 1950 50.116

The artist indicated this work was executed in 1938 and exhibited at the Valentine Gallery, New York, N.Y., in 1939.

AWA TSIREH [Alfonso Roybal] (ca. 1895-1955)

***Bird** ca. 1930
Ink and gouache on paper 14"x11" (35.6x27.9 cm)
Signed: lower right, "Awa Tsireh"
Reverse: label, Gallery of American Indian Art, New York, N.Y.
inscribed, 266A title and artist
Gift of Miss Amelia E. White 1937 37.224

Artist from San Ildefonso pueblo, N.M.

Two Women ca. 1930
Pencil on paper 11¼"x14¼" (28.6x 36.2 cm)
Unsigned
Gift of Miss Amelia E. White 1937 37.162

Woman Chasing Deer Dancer ca. 1930
Pencil on paper 11¼"x14¼" (28.6x36.2 cm)
Unsigned
Gift of Miss Amelia E. White 1937 37.163

Mountain Sheep Chasing Man ca. 1930
Pencil on paper 11¼"x14¼" (28.6x36.2 cm)
Unsigned
Gift of Miss Amelia E. White 1937 37.164

Mountain Sheep Chasing Clown ca. 1930
Pencil on paper 11¼"x14¼" (28.6x36.2 cm)
Unsigned
Gift of Miss Amelia E. White 1937 37.165

Woman Chasing Two Turkeys ca. 1930
Pencil on paper 11¼"x14¼" (28.6x36.2 cm)
Unsigned
Gift of Miss Amelia E. White 1937 37.166

Man in Costume of Buffalo Dance ca. 1930
Pencil on paper 11¼"x14¼" (28.6x36.2 cm)
Unsigned
Gift of Miss Amelia E. White 1937 37.167

Woman Chasing Deer Dancer ca. 1930
Pencil on paper 11¼"x14¼" (28.6x36.2 cm)
Unsigned
Gift of Miss Amelia E. White 1937 37.168

Butterfly Dance ca. 1930
Pencil on paper 11¼"x14¼" (28.6x36.2 cm)
Signed: lower right, "Butterfly Dance Awa Tsireh"
Gift of Miss Amelia E. White 1937 37.169

Man in Costume of Eagle Dance ca. 1930
Pencil on paper 11¼"x14¼" (28.6x36.2 cm)
Unsigned
Gift of Miss Amelia E. White 1937 37.170

Man with Rattle and Evergreen Branch ca. 1930
Pencil on paper 11¼"x14¼" (28.6x36.2 cm)
Unsigned
Gift of Miss Amelia E. White 1937 37.171

Woman Chasing Turkeys ca. 1930
Ink and watercolor on paper 10¾"x13¾" (27.3x34.9 cm)
Signed: lower right, "Awa Tsireh"
Reverse: label on backing, Gallery of American Indian Art #194A
Gift of Miss Amelia E. White 1937 37.194

Man on a Black Horse ca. 1935
Ink and gouache on paper 11"x14" (27.9x35.6 cm)
Signed: lower right, "Awa Tsireh"
Gift of Miss Amelia E. White 1937 37.230

Zuni Shalako Kachina ca. 1920
Gouache on paper 12¼"x7¼" (31.1x18.4 cm)
Signed: lower right, "Alfonso Roybal"
Reverse: inscribed on backing, "Gallery of American Indian Art,
850 Lexington Avenue, New York, N.Y."
Gift of Miss Amelia E. White 1937 37.257

Title previously recorded as Dancer with a Mask.

Buffalo Dancers ca. 1930
Gouache on paper 13½"x23½" (34.3x59.7 cm)
Signed: lower right, "Awa Tsireh"
Reverse: label on backing *Exposition of Indian Tribal Arts*, 1931
Gift of Miss Amelia E. White 1937 37.260

AYASO, MANUEL (b. Spain 1934)

Vision Sobre Valle de Los Caidos No. 2. 1961
Black chalk, ink wash, pen and ink 14½"x21½" (36.8x54.6 cm)
Signed: upper left, "Ayaso"
Ex-collection: with Cober Gallery, New York, N.Y.
Purchase 1961 Rabin and Krueger American Drawing
Fund 61.16

BADGER, JOSEPH (1708-1765)

***Portrait of Joseph Tyler** (1730-1774) ca. 1765
Oil on canvas 35⅜"x29" (89.9x73.7 cm)
Unsigned
Reverse: label, "Joseph Badger 1730-1774/owner/Frederick
S. Whitwell/166 Marlborough Street/Boston"
Ex-collection: sitter's daughter, Lucy Tyler Whitwell; to her son,
Samuel Whitwell; to his children, Sophie, Henry, Samuel and
Frederick A. Whitwell; to Frederick A.'s son, Frederick S. Whitwell,
Boston, Mass. 1880; sold at Whitwell auction (November, 1935) to
P. D. Orcutt, Boston, Mass.; to Richard Morrison, Boston, Mass. and
Victor Spark, New York, N.Y.
Purchase 1948 Louis Bamberger Bequest Fund 48.25

***Portrait of Frances Tyng** [later Mrs. Joseph Tyler] (1733-1769)
ca. 1750
Oil on canvas 35½"x28½" (90.2x72.4 cm)
Unsigned
Reverse: handwritten label, "_____Tyler 1733-1769/_____of Judge
John Tyng/_____name and address of former owner/Frederick S.
Whitwell/1667_____rlborough Street/Boston, Mass" (written twice)
Ex-collection: (same as 48.25) to donors, New York, N.Y. (1948)
Gift of Colonel and Mrs. Edgar Garbisch 1951 51.93

The portraits of Mr. and Mrs. Tyler remained together until 1948. Colonel and Mrs. Garbisch presented "Mrs. Tyler" expressly to unite the two paintings. This, the earlier portrait, was probably painted prior to their marriage in 1757.

BANNARD, WALTER DARBY (b. 1931)

***Stadium** 1963
Acrylic on canvas 66¾"x62¾" (169.5x159.4 cm)
Unsigned
Ex-collection: Tibor de Nagy Gallery, New York, N.Y.
Purchase 1965 Wallace M. Scudder Bequest Fund 65.121

Purchased from the Museum exhibition, Selected Works by Contemporary New Jersey Artists, 1965

BANNISTER, EDWARD M. (b. Nova Scotia 1828-1901)

Sea with Sails 19th century
Pencil on paper 3⅜"x5½" (8.6x14.0 cm)
Signed: lower right, "E.M.B."
Reverse: inscribed, "In Newport Harbor"
Ex-collection: James W. C. Ely; to Miss Ruth Ely, Providence, R.I., by inheritance; to The Providence Athenaeum, Providence, R.I., by bequest
Purchase 1977 Museum Purchase Fund and Felix Fuld Bequest
Fund 77.176

Landscape, Field with Flowers 19th century
Pencil on paper 3"x5⅝" (7.6x14.3 cm)
Signed: lower left, "E. M. Bannister"
Reverse: a pencil drawing of two figures holding large object
Ex-collection: (same as 77.176)
Purchase 1977 Museum Purchase Fund and Felix Fuld Bequest
Fund 77.177

BARNET, WILL (b. 1911)

Flight of Terns 1960
Oil on canvas 36"x42" (90.0x106.7 cm)
Signed: lower right, "Will Barnet"
Reverse: label, Waddell Gallery, New York, N.Y.; label, Cincinnati Art Museum; label, Dayton Art Institute (Circulating Gallery)
Ex-collection: with Waddell Gallery, New York, N.Y. donors, New York, N.Y.
Gift of Mr. and Mrs. Gerald Sykes 1970 70.66

BART-GERALD, ELIZABETH (20th century)

Jamaica Blue and Black 1973
Gouache on paper 11"x14" (28.9x36.5 cm)
Signed and dated: lower right, "E. Bart — February 1973"
Ex-collection: acquired from the artist by the donors, New York, N.Y.
Gift of Mr. and Mrs. Marshall F. Dancy 1976 76.124

Winedark Wave 1976
Gouache and collage on paper 10⅝"x14¼" (27.0x36.2 cm) collage
22½"x30" (57.2x76.2 cm) paper
Signed and dated: lower left, "E. Bart '76"
Ex-collection: acquired from the artist by the donors, New York, N.Y.
Gift of Mr. and Mrs. Marshall F. Dancy 1976 76.125

BASKIN, LEONARD (b. 1922)

Two Boys
Pen and ink on paper 26⅞"x40⅛" (68.3x102.0 cm)
Unsigned
Reverse: on backing in pencil, "Grace Borgenicht Gallery/1018 Madison Ave. NY/L. Baskin/'Two Boys'."
Ex-collection: Grace Borgenicht Gallery, New York, N.Y.; private collection, New York, N.Y.
Anonymous gift 1962 62.118

BAYLINSON, ABRAHAM S. (b. Russia 1882-1950)

Still Life: Flowers 1927
Oil on canvas 24"x20" (61.0x50.8 cm)
Signed and dated: lower left, "AS: Baylinson/1927"
Ex-collection: purchased from the artist, New York, N.Y.
Gift of Mrs. Felix Fuld 1928 28.699

Portrait of Abraham Walkowitz (1878-1965) 1943
Pastel on paper 18½"x15" (47.0x38.1 cm)
Signed and dated: lower right, "To my Friend Walkowitz/AS Baylinson/1943"
Ex-collection: donor, New York, N.Y.
Gift of Abraham Walkowitz 1949 49.348

Executed for One Hundred Artists and Walkowitz *exhibition at the Brooklyn Museum in 1944, a show organized by Walkowitz as an experiment with different artists' perceptions and renderings of a single person. Many of those works were given to Walkowitz who subsequently presented them to The Newark Museum.*

BAYRAK, TOSUN (b. Turkey 1926)

Flower Rain 1963
Oil on canvas 56"x50" (142.2x127.0 cm)
Signed: lower right, "Tosun/'63"
Ex-collection: donor, Short Hills, N.J.
Gift of Mrs. Mary M. Peer 1964 64.53

Status Quo 1965
Mixed media on canvas 27¾"x28"x5" (70.5x71.2x12.7 cm)
Signed: center, "B"
Reverse: label, World House Galleries, New York, N.Y.; label, John Simon Gallery, New York, N.Y.
Ex-collection: donor, New York, N.Y.
Gift of the artist 1971 71.162

BAZIOTES, WILLIAM (1912-1963)

***White Silhouette** (Still Life — White Silhouette) 1945
Oil on canvas 36"x42" (91.5x106.7 cm)
Signed: lower right, "Baziotes"
Reverse: inscribed "'White Silhouette'/William Baziotes"; label, Kootz Gallery; label, Whitney Museum of American Art, *Annual Exhibition of Painting and Sculpture*, 1945
Ex-collection: with Kootz Gallery, New York, N.Y.; to donors, New York, N.Y.
Gift of Mr. and Mrs. Milton Lowenthal 1951 51.163

Date indicated by Kootz Gallery at time of purchase.

BEAL, GIFFORD (1879-1956)

In the Park 1924
Oil on canvas 24"x24" (61.0x61.0 cm)
Signed and dated: lower right, "Gifford Beal 24"
Reverse: label, American Federation of Arts, "American
Impressionism", 1963-64
Ex-collection: acquired from the artist, New York, N.Y.
Gift of Mrs. Felix Fuld 1925 25.1165

One of 16 paintings purchased with funds provided by Mrs. Felix Fuld.

Rockport Fishermen with Net (Rockport Fisherman) pre-1927
Watercolor 9¼"x12¼" (23.0x31.1 cm)
Signed: lower left, "Gifford Beal"
Reverse: inscribed (probably in artist's hand), "Rockport Fisherman
with Net #75"; label, private collection, 1927
Ex-collection: private collection, New York, N.Y.
Anonymous gift 1937 37.109

BEARDEN, ROMARE (b. 1914)

Adoration of the Wise Men 1945
Oil on masonite 22¼"x28⅛" (56.5x71.8 cm)
Signed: upper left, "Bearden"
Reverse: inscribed, "Romare Bearden/Adoration of the/Wise
Men/22¼"x28"/Nov. 45"; label, Kootz Gallery, New York, N.Y.
Ex-collection: Kootz Gallery, New York, N.Y.; to donors, Plainfield, N.J.
Gift of Mr. and Mrs. Benjamin E. Tepper 1946 46.164

Exhibited at the Kootz Gallery in 1945. Part of a series, The Passion of
Christ, *begun by the artist when he was in the U.S. Navy during World
War II.*

***Dream** 1970
Collage on board 27¼"x45¼" (69.3x115.0 cm)
Unsigned
Ex-collection: with Cordier and Ekstrom, New York, N.Y.
Purchase 1971 Wallace M. Scudder Bequest Fund 71.56

BECKMANN, HANNES (b. Germany 1909)

Radiant 1963
Oil on canvas 34"x33¾" (86.4x85.7 cm)
Signed: lower left, "h.b./63"
Reverse: inscribed, "Radiant/Hannes Beckmann/oil 1963"
Ex-collection: acquired from the artist, New York, N.Y.
Purchase 1964 Mrs. Felix Fuld Bequest Fund 64.13

Purchased from the Museum's 5th triennial exhibition, Work by New
Jersey Artists, *1964.*

BEERMAN, MIRIAM (20th century)

Ram
Crayon, tusche and oil on lithograph paper 34¾"x44¼" (88.3x112.4 cm)
Unsigned
Ex-collection: the artist, Upper Montclair, N.J.
Gift of Edison Parking Associates 1978 78.75

Iranian Bull 1977
Collage: paper, printed matter, ink, mixed media 30"x22⅜"
(76.2x56.8 cm)
Signed and dated: lower right, "M. Beerman/77"
Ex-collection: donor, Upper Montclair, N.J.
Gift of the artist 1978 78.76

BEERS, JULIE HART (1835-1913)

Heigh ho!
Oil on canvas 23"x15" (58.4x38.0 cm)
Signed: lower left, "Julie H. Beers"
Reverse: on canvas, "Heigh ho! Daisies and Buttercups"
Ex-collection: donor, South Orange, N.J.
Gift of Mrs. Lathrop E. Baldwin 1975 75.9

BEGAY, KEATS (20th century)

Horse Race ca. 1935
Gouache on paper 11¾"x26¾" (29.8x67.9 cm)
Signed: lower right, "K. Begay"
Reverse: label, Gallery of American Indian Art, New York, N.Y. #255A
Gift of Miss Amelia E. White 1937 37.227

Artist a member of Navajo tribe.

BEITL, JOSEPH G. (b. Austria 1841-1929)

Silver Lake, Old Bloomfield Road in 1874 1916
Oil on canvas 27"x48" (58.6x122.0 cm)
Signed and dated: lower left, "Jos. G. Beitl/1916"
Reverse: label, "Silver Lake on the Old Bloomfield Road/in1874/Mrs.
Jos. G. Beitl/855 Broad Street/Newark, N.J. 10-7-21"
Ex-collection: donor, Newark, N.J.
Gift of the artist 1921 21.964

Portrait of John Brown 1867
Oil on canvas 25"x19" (63.5x48.3 cm)
Signed: Left of center, "Jos. G. Beitl"
Ex-collection: donor, Essex Fells, N.J.
Gift of Carl F. Walter 1922 22.259

Painted from a photograph.

Portrait of Marcus L. Ward (1812-1884) 1886
Oil on canvas 50"x36⅛" (127.0x91.8 cm)
Signed and dated: center left, "J. G. Beitl/1886"
Ex-collection: Marcus L. Ward, Jr., Newark, N.J.; to Marcus L. Ward
Post 88, Dept. of N.J. Grand Army of the Republic, Newark, N.J.
Gift of Edwin Briden for Marcus L. Ward Post 88, Newark, N.J.
1929 29.614

Portrait of Alfred Lister (1821-1890) ca. 1860
Oil on canvas 30¼"x25¼" (76.8x64.1 cm)
Unsigned
Reverse: label, Cary and Kenny
Ex-collection: painting remained with family of sitter until donated by
his daughter, Bloomfield, N.J.
Gift of Mrs. Ida B. Miller 1936 36.558

*Alfred Lister was a prominent Newark businessman and landowner who
founded Lister Agricultural Chemical Works. Painting dated by family.*

BELCHER, HILDA (1881-1963)

Portrait of a Young Girl (Figure and Flowers) ca. 1944
Watercolor on paper 12½"x11⅜" (31.8x28.9 cm)
Signed: lower left, "Hilda Belcher"
Ex-collection: donor, Maplewood, N.J.
Bequest of Dr. Donald M. Dougall 1954 54.197

Possibly a companion work to Catalpa Tree.

The Catalpa Tree 1944
Watercolor on paper 12¾"x11⅛" (32.4x28.3 cm)
Signed: lower right, "Hilda Belcher"
Ex-collection: donor, Maplewood, N.J.
Bequest of Dr. Donald M. Dougall 1954 54.198

Though this work was previously published as Untitled – Head of a Negro
Girl, *the artist indicated that the title is* The Catalpa Tree. *Executed in
Savannah, Ga.*

In the Plaza (Untitled Mexican Street Scene) 1939
Watercolor 13¼"x10¼" (33.7x26.0 cm)
Signed: upper left, "Hilda Belcher"
Ex-collection: donor, Maplewood, N.J.
Bequest of Dr. Donald M. Dougall 1954 54.199

*Artist indicated that this work was painted in April, 1939, in Taxco,
Mexico.*

Portrait of Armando Bautista 1939
Watercolor on paper 19¼"x18" (48.9x45.7 cm)
Signed: lower right, "Hilda/Belcher"; bottom center, "Armando Bautista"
Ex-collection: donor, Maplewood, N.J.
Bequest of Dr. Donald M. Dougall 1954 54.200

Artist indicated that this work was painted in April, 1939, in Mexico City.

BELLOWS, GEORGE (1882-1925)

*****Barnyard and Mountain** (Three Pigs and a Mountain) 1922
Oil on canvas 16⅛"x24" (40.9x61.0 cm)
Signed: lower left, "GeoBellows"
Reverse: inscribed, "Barnyard and Mountain"; label, AFA, *Surviving the Ages*, 1963
Ex-collection: acquired from the artist, New York, N.Y.
Purchase 1925 25.1080

Exhibited under the title Three Pigs and a Mountain *in the Bellows Memorial Exhibition in 1925; purchased with funds donated by Mrs. Felix Fuld.*

Children and Summer ca. 1920
Oil on wood panel 18"x22" (45.7x55.9 cm)
Signed: lower right, "Geo Bellows"
Reverse: inscribed, "Children and Summer Geo. Bellows/Geo Bellows"; torn label, Worcester (Mass.) Art Museum; label, AFA, *Surviving the Ages*, 1964
Ex-collection: purchased from the artist, New York, N.Y.
Gift of Mrs. Felix Fuld 1925 25.1162

BENN, BEN (b. Russia 1884)

Still Life with Fruit 1934
Oil on canvas 25"x30" (63.5x76.2 cm)
Signed and dated: lower right, "Ben Benn.34"

Allocated by United States Public Works of Art Project, through its New York Regional Committee 1934. 34.164

Young Woman Reclining 1920's
Oil on canvas 12"x16" (30.5x40.7 cm)
Signed: lower left, "Ben Benn"
Ex-collection: donor, New York, N.Y.
Gift of Miss May E. Walter 1958 58.34

Approximate date supplied by artist.

Man and Bird (Man with Bird) 1949
Oil on canvas 25"x30¼" (63.5x76.8 cm)
Signed and dated: lower right, "Benn.49"
Reverse: inscribed, "Men [sic] and Bird/Ben Benn/49"
Ex-collection: the artist, New York, N.Y.
Gift of Mr. and Mrs. Ben Benn 1958 58.90

BENNET, RAINEY (b. 1907)

Memoirs of a Farm (Garden Scene; Memories of a Farm; Garden Entrance) 1936
Watercolor and pen and ink on paper 12¼"x15¾" (31.1 x 40.0 cm)
Signed: lower left, "RBennet"; lower right, "RBennet"
Reverse: on backing, Federal Art Project Studios/Works Progress Administration/433 E Erie St., Chicago, Ill.; inscribed by artist "Garden Entrance Rainey Benne/Feb. 18-1936."; on backing, WPA label, "Memories of a Farm" has been written over "Garden Entrance"; pen and ink sketch of a house and garden
Allocated by the WPA Federal Art Project through Harry Hopkins 1945 45.235

BEN-ZION (b. Russia 1897)

Calla-Lillies 1940
Oil on canvas 36¼"x24⅛" (92.1x61.3 cm)
Signed: lower right, "Ben Zion"
Allocated by the WPA Federal Art Project through the Museum of Modern Art 1943 43.160

The artist indicated that this work was executed in 1940.

BERMAN, LEONID (see "LEONID")

BERRY, JOHNNIE E. (19th century)

Child with Blue Sash (The Little Emperor) 1865
Pastel drawing 28⅜"x21" (82.1x53.3 cm)
Signed and dated: lower right, "Johnnie E. Berry, 1865"
Ex-collection: The Kramer Collection; Mr. and Mrs. Elie Nadelman, Riverdale, N.Y.
Anonymous Gift 1938 38.215

The picture was found in Woodstock, N.Y. It was copied from a Currier and Ives print entitled The Little Emperor.

BEYER, EDWARD (b. Germany 1820-1865)

*****Skating on the Passaic** 1852
Oil on canvas 13⅜"x18" (34.0x45.7 cm)
Signed: lower left on boat, "Ed. Beyer Newark 1852"
Inscribed: next boat to left of signature, "New Jersey"
Ex-collection: Rankin family, Newark, N.J.; to A. Scheiner Antiques, Newark, N.J.; to Walter Wallace, New York, N.Y.
Purchased with an anonymous gift 1957 57.140

BIERSTADT, ALBERT (1830-1902)

*****Landing of Columbus** ca. 1893
Oil on canvas 72"x121" (182.9x307.3 cm)
Signed: lower right, "ABierstadt"
Ex-collection: donor, Scotch Plains, N.J.
Gift of Dr. J. Ackerman Coles 1920 20.1167

Gordon Hendricks noted that Bierstadt painted three versions of this scene. The largest, painted in 1892, was a gift from the artist to his second wife, who later gave it to the American Museum of Natural History; it no longer exists. Another is owned by the City of Plainfield, N.J., a gift from Dr. Coles in 1919. The Newark version is unfinished and differs from the Plainfield work.

Landscape
Oil on canvas 13½"x19½" (34.3x49.5 cm)
Signed: monogram; lower left, "AB"
Ex-collection: donor, Scotch Plains, N.J.
Gift of Dr. J. Ackerman Coles 1920 20.1208

*****Sunshine and Shadow** 1855
Oil on paper 18½"x13" (47.0x33.0 cm)
Signed: lower left, "ABierstadt"; lower right, "Cassel 1855"
Ex-collection: in artist's private collection until 1862; donor, Scotch Plains, N.J.
Gift of Dr. J. Ackerman Coles 1920 20.1209

Study for a larger work done in 1862. Both depict exterior of a church in Cassel, Germany. Date could also be interpreted as 1853. Either date places this work within artist's Düsseldorf period.

Lake at Franconia Notch, White Mountains ca. 1857-58
Oil on canvas 13½"x19¼" (34.3x48.9 cm)
Signed: lower right, "ABierstadt"
Reverse: penciled inscription on top of stretcher, "Mirror Lake"/Franconia Notch/White/Mts." "Mirror Lake" is in a hand different from the rest of the inscription
Ex-collection: donor, Scotch Plains, N.J.
Gift of Dr. J. Ackerman Coles 1926 26.1165

Since Mirror Lake is not at Franconia Notch, "Mirror Lake" does not appear in the title. Could be dated ca. 1857-58 when Bierstadt was traveling in the White Mountains.

Bison
Oil on canvas 13⅞"x19" (35.2x48.3 cm)
Signed: lower right, "ABierstadt"
Ex-collection: donor, Scotch Plains, N.J.
Gift of Dr. J. Ackerman Coles 1926 26.2375

*Western Landscape** (Mount Whitney) 1869
Oil on canvas 36¼"x54½" (92.1x138.4 cm)
Signed and dated: lower right, "ABierstadt/1869"
Reverse: label, "Loaned to the Pennsylvania Academy of The Fine Arts
by/C. H. Clark/Register 188/No. 609." Painting has been relined.
Ex-collection: C. H. Clark, Philadelphia, Pa.
to Clark's granddaughter, Anne F. Williams
with M. Knoedler and Company, New York, N.Y.
Purchase 1961 The Members' Fund 61.516

This painting was known for many years as Mount Whitney. *However,
Gordon Hendricks has shown that title is incorrect because Bierstadt
could not have seen Mt. Whitney until 1871. He also pointed out that the
topography does not resemble that of Mt. Whitney. Crystal Lake in
southwest Mono County, near Yosemite, is a strong possibility since
Bierstadt visited the Yosemite region in 1864. It is also possible that he
painted* Western Landscape *in Europe before 1869 as a pastiche of
separate elements he saw in the Yosemite region in 1864.*

Landscape (attributed)
Oil on paper mounted on canvas 11"x15¼" (27.9x38.7 cm)
Unsigned
Ex-collection: George Guerry, New York, N.Y.;
to donors, New York, N.Y.
Gift of Mr. and Mrs. Orrin W. June 1960 60.595

BINGHAM, GEORGE CALEB (1811-1879)

*Landscape: Lake in the Mountains** (Landscape: Rocks, Trees and
Stream; A Mountain Gorge) ca. 1850
Oil on canvas 25"x30" (63.5x76.2 cm)
Unsigned
Ex-collection: Robert Campbell, St. Louis, Mo.
to his son Hugh Campbell, St. Louis, Mo.
sold at auction of Campbell Estate (Feb. 1941) at Ben J. Selkirk and
Sons, St. Louis, Mo., #427 in catalog
to William A. Hughes, Newark, N.J.
Gift of Mr. and Mrs. William A. Hughes 1959 59.94

*E. Maurice Bloch assigned the current title and tentative date to this work
(#2096 in E. Maurice Bloch's* George Caleb Bingham, *a catalogue
raisonné, L.A., 1967). Bloch's assignment is earlier than J. F. McDermott's
estimate of 1853-56 (*Bingham: River Portraitist, *University of Oklahoma
Press, 1959). Bloch pointed out the similarity between Bingham's* The
Concealed Enemy *of 1845 (Peabody Museum, Harvard University) and
Joshua Shaw's* Reedy River Massacre, *ca. 1838 (Brigham Young
University). He noted further that Bingham probably saw Shaw's work
during trips to Philadelphia in 1838 and 1843. Because of strong
compositional and pictorial links between* Concealed Enemy *and this
Bingham and also to another Shaw in The Newark Museum collection,*
American Forest Scenery, *1843, Bloch's earlier date seems justified.*

BIRCH, THOMAS (b. England 1779-1851)

*View of Philadelphia Harbor from the Delaware River** ca. 1840
Oil on canvas 19½"x30" (49.5x76.2 cm)
Unsigned
Ex-collection: with Kennedy Galleries, New York, N.Y.
Purchase 1956 Sophronia Anderson Bequest Fund 56.184

Painting depicts League Island; Navy Yard is at extreme left.

BIRMELIN, ROBERT (b. 1933)

Tree and Shadow 1960
Pastel on paper 28"x23" (71.2x58.4 cm)
Unsigned
Ex-collection: with Stable Gallery, New York, N.Y.
from artist's collection through the Ford Foundation Purchase Plan
Gift of the artist and the Ford Foundation 1963 63.29

BISHOP, ISABEL (b. 1902)

*Waiting** 1937-38
Oil and tempera on gessoed pressed wood 29"x22¼" (73.7x56.5 cm)
Signed: upper right, "Isabel Bishop"
Reverse: label, Golden Gate International Exposition, San Francisco,
Calif., 1939; label, Newport Art Association Annual Exhibition, 1942;
label, AFA, *Mother and Child in Modern Art*, 1965; torn label, 48th
Annual Exhibition, Art Institute of Chicago; stamp on stretcher, Jones
Street Workshop
Ex-collection: with Midtown Galleries, New York, N.Y.
Purchased 1944 The Arthur F. Egner Memorial Fund 44.41

*The artist indicated a date of 1938; however, the Art Institute of Chicago
48th Annual Exhibition was in 1937. A 1935 pen and ink study for*
Waiting *is in the Whitney Museum of American Art.*

Portrait of Abraham Walkowitz (1878-1965) 1943
Ink and wash drawing 13⅝"x10¾" (34.6x27.3 cm)
Signed: lower left, "To Abraham/Walkowitz/Isabel Bishop"; below it
but erased, "To Abraham Walkowitz/Isabel Bishop"
Reverse: inscribed and dated on backing in artist's hand, "Medium
brush on ink/Isabel Bishop/Portrait of Walkowitz/1943"
Ex-collection: donor, New York, N.Y.
Gift of Abraham Walkowitz 1949 49.344

Executed for exhibition, One Hundred Artists and Walkowitz, *Brooklyn
Museum, 1944. Lower right of paper shows small sketch with framing
instructions.*

BLAINE, NELL (b. 1922)

Beginning of Autumn (Woodstock, New York) 1962
Oil on canvas 26"x36" (66.0x91.4 cm)
Signed and dated: lower right, "N. Blaine '62"
Reverse: inscribed "Nell Blaine/Beginning of Autumn/(Woodstock,
N.Y.)/Oil on canvas/1962/26"x36"; sticker, "Phoenix Gallery: Nell
Blaine/Beginning of Autumn/Col. Arthur Cohen"; sticker, "AFA
Painterly Realism/Jan 1970 — Jan 1971/Lender Arthur Cohen"
Ex-collection: with Zabriskie Gallery, New York, N.Y.
Gift of Arthur W. Cohen 1976 76.131

BLAKELOCK, RALPH A. (1847-1919)

Indian Encampment (Navajo Basketmakers)
Oil on canvas 8½"x16⅝" (21.6x42.2 cm)
Signed: lower right, "R A Blakelock-"
Reverse: label, AFA, *Surviving the Ages*, 1963; label, University of
Nebraska Blakelock Inventory, #93
Ex-collection: Frederick S. Gibbs, New York, N.Y. (1901); to Joseph S.
Isidor, New York, N.Y.; to his wife, the donor (1941)
Bequest of Mrs. Rosa Kate Isidor 1949 49.423

*Norman Geske of the University of Nebraska added the second title. He
also noted a reference to an exhibition of Gibbs-owned Blakelocks in
1901. (files)*

New York Landscape
Oil on wood panel 6⅛"x4" (15.6x10.2 cm)
Signed: lower left, "R. Blakelock"
Reverse: label, University of Nebraska Blakelock Inventory, #92
Ex-collection: Joseph S. Isidor, New York, N.Y.; to his wife, the donor
(1941)
Bequest of Mrs. Rosa Kate Isidor 1949 49.424

*Western Landscape**
Oil on canvas 34¼"x60" (87.0x152.4 cm)
Signed: lower right, "R. A. Blakelock"
Reverse: label, Corcoran Gallery of Art, *Wilderness* 1977; label,
University of Nebraska Blakelock Inventory #202; painting relined
1963
Ex-collection: William Hurley, East Orange, N.J.; to National Newark
and Essex Bank (ca. 1945)
Gift of the Board of Directors, National Newark and Essex Bank
1965 65.34

Landscape
Oil on panel 9¾"x13⅞" (24.8x35.3 cm)
Unsigned
Reverse: on panel and frame, "CA 9263"; sticker, "Vandyke Panel
Manufac/18 Beaver St/44177"; label, "Montclair Art Museum/Jan 31
— March 14, 1971"; sticker on frame, "3-38"
Ex-collection: donor, Verona, N.J.
Gift of Dr. Milton Luria 1977 77.32

Golden Glow 1902 (attributed)
Watercolor, pen and ink on paper mounted on cardboard 8⅜"x10⅞"
(21.3x27.6 cm)
Signed and dated: lower left, "R A Blakelock"; lower right, "1902"
Ex-collection: donor, Scotch Plains, N.J.
Gift of Dr. J. Ackerman Coles 1920 20.1203

BLASHFIELD, EDWIN H. (1848-1936)

Head Study, Drawing #89 ca. 1905
Charcoal on paper 25"x19½" (65.0x49.5 cm)
Signed: lower left, "EH Blashfield"; lower right (in a box), "Study for
Head/in a decoration/for the Iowa State Capitol"
Ex-collection: with Grand Central Art Galleries, New York, N.Y.
(1927); to donor, South Orange and Newark, N.J.
Gift of Louis Bamberger 1928 28.162

A study for the 1905 mural, Westward, *in the Iowa State Capitol, Des
Moines.*

Character Study, Drawing #90 ca. 1905
Charcoal on paper 36"x25¾" (90.5x65.4 cm)
Unsigned
Ex-collection: with Grand Central Art Galleries, New York, N.Y.
(1927); to donor, South Orange, and Newark, N.J.
Gift of Louis Bamberger 1928 28.163

May also be a study for Blashfield's Westward *mural.*

BLATAS, ARBIT (b. Lithuania 1908)

Portrait of Abraham Walkowitz (1878-1965) ca. 1943
Oil on canvas 40"x30" (101.6 x 76.2 cm)
Signed: lower right, "A. Blatas"
Ex-collection: donor, New York, N.Y.
Gift of Abraham Walkowitz 1948 48.512

Executed for exhibition, One Hundred Artists and Walkowitz, *Brooklyn
Museum, 1944, although it is not the portrait by Blatas which was
illustrated in the exhibition catalogue.*

BLUEMNER, OSCAR (b. Germany 1867-1938)

*****The Hudson** (Hudson River) 1936
Gouache on cardboard 19¼"x24½" (48.9x62.2 cm)
Signed and dated: lower right, "-36 Bluemner"
Reverse: inscribed, "365-28/P.W.A. 1936/Oscar Bluemner/"The
Hudson"/15x20 gouache/Mr. Perkins"; small drawing of skull and
crossbones; label, New York Cultural Center, *Oscar Bluemner
Retrospective,* 1969
Allocated by the WPA Federal Art Project 1943 43.197

*****The Last House** (Landscape)
Watercolor on paper 10⅛"x13¼" (25.7x33.6 cm)
Signed: lower left, "Bluemner"
Reverse: inscribed, "two/The Last Ho-"; on backing, "landscape by
Oscar Bluemner/bought from Stieglitz/March 22 - 1927." (written by
donor)
Ex-collection: with Intimate Gallery, New York, N.Y.; to donor, Short
Hills, N.J. (1927)
Bequest of Miss Cora Louise Hartshorn 1958 58.183

Secaucus Harbor 1912
Crayon on paper 7¾"x10" (19.7x25.4 cm)
Signed and dated: lower left, "OJB [monogram]/Secaucus N.J./South
12.30P./1912"
Inscribed: top center "S"; top right"....paper too rough/Charpas
English Hartman"
Gift of Mr. and Mrs. Stuart P. Feld 1977 77.210

View at Paterson, New Jersey
Crayon on paper 5½"x7⅞" (14.0x20.0 cm)
Signed: lower left, "OJB" [monogram]
Inscribed and dated: lower right edge, "Paterson Feb 1-12 E.3.30P."
Reverse: inscribed in artist's hand, upper left, "To F."; upper right,
"Patterson South DLWRR, Canal bank/Governor St. car line"; "note
Feb 20-16" (long text in German concerning color selection); lower left,
"Whatman"; numbered in different hand, "1022"
Gift of Mr. and Mrs. Stuart P. Feld 1977 77.211

BLUME, PETER (b. Russia 1906)

Rehak's Barns 1934
Pencil on paper 8"x12⅝" (20.3x32.1 cm)
Signed and dated: lower left, "Peter Blume 1934"
Reverse: stamp, on backing, Peridot Frames, N.Y.C.; label, WPA,
#3710; label, Wadsworth Atheneaum, "Blume Exhibition", 1964
Allocated by the WPA Federal Art Project 1934 34.168

*The artist said the scene in this drawing existed a few hundred feet from
his own house. He did two other versions for the Public Works of Art
Project.*

BLUMENSCHEIN, ERNEST L. (1874-1960)

Untitled 1910
Oil and pencil on board 18½"x12⅛" (47.0x30.8 cm)
Signed: lower left, "To 'Joe' from Blumy/Mch 191-"; lower right, "•B•"
Reverse: "Drawn by E•L• Blumenschein/May 1910"; label, E Lefévre
(framers) 16 New Street/Newark, N.J.; label, Isidor Col/#65
Ex-collection: Joseph S. Isidor, New York, N.Y.; to his wife, the donor
(1941)
Bequest of Mrs. Rosa Kate Isidor 1949 49.431

*This picture contains an oil sketch of a bearded figure with a palette and a
pencil drawing of a friar.*

BOARDMAN, SEYMOUR (b. 1921)

Untitled 1959
Oil on canvas 45"x34" (114.3x86.4 cm)
Reverse: "Boardman"
Ex-collection: donors, Great Neck, N.Y.
Gift of Mr. and Mrs. Robert C. Scull 1961 61.26

Date supplied by donors.

BOGGS, EDWARD BRENTON (1820-1895)

Untitled 1864
Watercolor on paper 4⅞"x7" (12.4x17.8 cm)
Dated: lower center, "1864"
Reverse: inscribed by donor on backing, "Done by my grandfather
Edward Brenton Boggs/rector of St. Stephen's Church Newark/about
the date on bottom must mean Mt. Prospect Ave., where this/was all
woodland. I don't know what the 'tower'/could be. Any churches are far
away and below eye level, here/and those had spires. This must be
'Forest Hill'. HBA"; inscribed, in pencil, "Mt. Prospect St•/18??"; pencil
drawing of two figures, horse, tree
Ex-collection: artist to granddaughter, the donor, Summit, N.J.
Gift of Mrs. Helen Boggs Agate 1977 77.452

BOHROD, AARON (b. 1907)

Fullerton Avenue 1939
Gouache on paper 19¾"x26½" (50.2x67.3 cm)
Signed and dated: lower right, "Bohrod 39"
Reverse: inscribed in artist's hand, "Bohrod/'Fullerton Ave'/#3658"
and "Industrial Buildings, Fullerton Avenue/Aaron Bohrod"; label,
WPA Art Program (#A936A)
Allocated by the WPA Federal Art Project 1945 45.236

Artist indicated that the scene is possibly North Halsted Street in Chicago. (files)

BOLOTOWSKY, ILYA (b. Russia 1907)

***Composition with a Black Shape** 1942
Oil on canvas 16"x20" (40.7x50.8 cm)
Signed and dated: lower left, "Ilya Bolotowsky/42"
Reverse: top stretcher, "'Composition with a Black Shape' 1942/By
Ilya Bolotowsky 69 Tiemann Pl. N.Y.C.", bottom stretcher, "16"x20"
Abstraction, 1942/oil"
Ex-collection: with Grace Borgenicht Gallery, New York, N.Y.
Purchase 1977 Charles W. Engelhard Bequest Fund and Anonymous
Fund 77.175

BONAVITO, TED (b. 1918)

Aesthetics In High Key
Oil on casein on corrugated cardboard 39¾"x9¾" (101.0x24.8 cm)
Signed: lower right, "Bonavito"
Reverse: label, New Jersey Artists/The Newark Museum/March 29-
May 1, 1955
Ex-collection: acquired from the artist, Bloomfield, N.J.
Mrs. Felix Fuld Bequest 1955 55.82

BOOTH, CAMERON (1892-1980)

Early Mass 1923
Oil on canvas 42"x54" (116.7x137.2 cm)
Signed and dated: lower right, "Cameron Booth/-1923-"
Reverse: label, AFA, Booth Retrospective, 1963
Ex-collection: acquired from the artist, St. Paul, Minn.
Purchase 1927 The General Fund 27.480

*Artist indicated painting was done on a Chippewa Indian Reservation
near Walker, Minn. Purchased from exhibition,* Painting and Watercolors
by Living American Artists, *by vote of Newark Museum Staff.*

BOOTHE, POWER ROBERT (b. England 1945)

Untitled 1973
Pencil and wash on paper 13⅝"x13⅝" (34.7x34.7 cm)
Signed and dated: lower right margin, "Power Boothe July 1973"
Reverse: sticker, A M Sachs Gallery/29 W. 57 St./New York, N.Y. 10019
Ex-collection: with A. M. Sachs Gallery; to donors, New York, N.Y.
Gift of Mr. and Mrs. Henry Feiwel 1977 77.235

BOTERF, CHESTER ARTHUR (b. 1934)

***Untitled**
Oil on shaped canvas 64½"x83½"x19" (163.8x212.1x48.3 cm)
Unsigned
Gift of Henry Feiwel 1975 75.217

BOTKIN, HENRY A. (b. 1896)

A New England Town ca. 1933
Oil on canvas 11¾"x18½" (29.9x47.7 cm)
Signed: lower left, "Botkin"
Reverse: stamped on stretcher, "Oct 16 1933"
Ex-collection: with The Downtown Gallery, New York, N.Y.; to donor,
New York, N.Y.
Gift of George Gershwin 1933 33.240

*This painting was purchased by Mr. Gershwin from a 1933 exhibition at
The Downtown Gallery. Date on stretcher indicates when it entered the
Gershwin collection. The Newark Museum received the painting on Oct.
24, 1933.*

Subterranean 1959
Oil on paper 9½"x16½" (24.1x42.0 cm)
Signed: lower left, "Botkin"
Reverse: inscribed on backing, "Subterranean Botkin/1959"
Ex-collection: to donor, New York, N.Y.
Gift of Mrs. Kay Hillman 1965 65.144

Included in Botkin exhibition, Five Years of Painting, *at the Riverside
Museum, New York, N.Y., 1961.*

BOTTICHER, PAUL G. (?-1903)

Stone Bridge Broad Street, Newark
Pencil sketch on paper 5"x8" (12.7x20.3 cm)
Signed and inscribed: top, "Stone bridge, Broad St. Newark,
N.J./washed away by the flood Aug. 9th 1867/'sketched by Paul G.
Botticher"
Ex-collection: donor, Newark, N.J.
Gift of Mrs. J. Lovel Paulmier 1944 44.126

BOUGHTON, GEORGE HENRY (b. England 1833-1904)

Portrait of Rose Standish ca. 1881-84
Oil on wood 23½"x15½" (59.7x39.3 cm)
Signed: lower right, "G. H. Boughton"
Reverse: label, "G. H. Boughton/Portrait of Rose Standish/owner —
James U. Parker"
Ex-collection: James U. Parker; donor, Scotch Plains, N.J.
Bequest of Dr. J. Ackerman Coles 1926 26.1225

*Susan E. Strickler, Virginia Museum of Fine Arts, dated the painting. She
believes that it is one of three or more versions of the same subject. It is
listed in the 1920 Coles exhibition as "gift of Miss Emilie S. Coles." (files)*

BOUTELLE, DeWITT CLINTON (1820-1884)

***Waterfall** 1867
Oil on canvas 12¼"x10¼" (31.3x26.1 cm)
Signed and dated: lower right, "Boutelle/1867"
Ex-collection: Robert H. Offord, Bay Head, N.J.
Purchase 1967 The Edward F. Assmus Fund 67.383

BOXER, STANLEY (b. 1926)

Untitled 1968
Paper collage on canvas 70"x72" (177.8x182.9 cm)
Signed and dated: lower right, "68/S. Boxer"
Ex-collection: Rose Fried Gallery, New York, N.Y.; to donors,
Larchmont, N.Y.
Gift of Mr. and Mrs. Henry Feiwel 1970 70.84

Galaxyofvegetables 1974
Mixed media: paper, watercolor, ink and pastel 19½"x25½"
(49.5x64.6 cm)
Signed and dated: lower right, "S. Boxer '74"
Reverse: sticker, Andre Emmerich Gallery, Inc., 41 East 57th Street,
New York, N.Y.; on masking tape, "Boxer #4"
Ex-collection: donors, New York, N.Y.
Gift of Mr. and Mrs. Henry Feiwel 1977 77.216

Bewareoftreesbearingfruit 1974
Pencil, pastel, watercolor, on paper 19⅝"x25⅜" (49.8x64.3 cm)
Signed and dated: lower right, "S. Boxer '74"
Reverse: sticker, Andre Emmerich Inc., New York, N.Y. 10022
Ex-collection: donors, New York, N.Y.
Gift of Mr. and Mrs. Henry Feiwel 1977 77.236

BRACKMAN, ROBERT (b. Russia 1898-1980)

Still Life #3 (The Mask) 1933
Oil on canvas 32"x42" (81.3x106.7 cm)
Signed: lower left, "Robert Brackman"
Reverse: inscribed, "Still Life #3/by Robert Brackman/Noank, Conn";
label, XXIst Biennial International Art Exhibition, Venice, 1938
Ex-collection: with William Macbeth Inc., New York, N.Y.
Purchase 1937 Exhibit Purchase Fund 37.4

Date was supplied by artist.

BRECHER, SAMUEL (b. Austria 1897)

North River ca. 1951
Oil on canvas 22"x26" (55.9x66.0 cm)
Signed: lower left, "S. Brecher"
Ex-collection: private collection, New York, N.Y.
Anonymous gift 1951 51.152

*The scene depicted was near 14th Street and the North River in New York.
The painting received an honorable mention in the Salmagundi Club
Annual Exhibition of 1951, from which its date was determined.*

BREININ, RAYMOND (b. Russia 1910)

Brown Earth 1937
Tempera on paper 20"x30" (50.8x76.2 cm)
Signed and dated: lower right, "Breinin/37"
Allocated by the WPA Federal Art Project 1943 43.200

Road by Night ca. 1935-43
Oil on canvas 30"x40" (76.2x101.6 cm)
Signed: lower right, "Breinin"
Allocated by the WPA Federal Art Project 1945 45.237

BRENNER, MICHAEL (1885-1969)

Study — Nude Figure
Pen and ink on paper 12½"x6¾" (31.7x17.1 cm)
Unsigned
Ex-collection: Arthur B. Davies; to private collection, New York, N.Y.
Anonymous gift 1940 40.329

BREWSTER, ANNA RICHARDS (1870-1952)

Cambridge College 1897
Watercolor on paper 24½"x16¾" (62.2x42.5 cm)
Signed: lower left, "AR.1897"
Reverse: on backing in pencil, "W. J. Brewster/Hartsdale N.Y."
Ex-collection: donor (artist's husband), Scarsdale, N.Y.
Gift of Dr. William T. Brewster 1959 59.381

Daughter of William Trost Richards.

Back Lane in Clovelly 1896
Oil on canvas 12⅝"x9⅝" (32.1x24.5 cm)
Signed and dated: lower left, "AMRichards-/February 1896"
Ex-collection: donor, Scarsdale, N.Y.
Gift of Dr. William T. Brewster 1959 59.382

BRIDGMAN, FREDERICK ARTHUR (1847-1928)

*****Aicha, A Woman of Morocco** 1883
Oil on canvas 21½"x18½" (54.6x47.0 cm)
Signed and dated: lower right, "F A Bridgman/1883"
Ex-collection: donor, Newark, N.J.
Bequest of G. Wisner Thorne 1938 38.331

Subject was a famous model in the Paris studios of the day. (files)

BRIGANTI, NICHOLAS P. (b. Italy 1895)

Bits of New York (Madison Square) ca. 1919
Oil on canvas 28¼"x16⅛" (71.6x40.9 cm)
Signed: lower right, "N. Briganti"
Ex-collection: donor, Scotch Plains, N.J.
Gift of J. Ackerman Coles 1919 19.780

The Riva, Venice
Oil on canvas 20"x28" (50.8x71.2 cm)
Signed: lower right, "N. Briganti"
Reverse: inscribed, "Riva Schiaveni, Venice"
Ex-collection: Dr. J. Ackerman Coles, Scotch Plains, N.J.
Gift of Miss Emilie Coles 1926 26.1236

BRITTON, EDGAR (b. 1901)

Study for Mural — "Work and Recreation" early 1940's
Gouache on masonite 12⅞"x26⅛" (32.8x66.7 cm)
Signed: lower right, "Edgar Britton"
Reverse: handwritten label, "#71 Mural Sketch/Work and Recreation"
Ex-collection: donors, New York, N.Y. (ca. 1943)
Gift of Mr. and Mrs. Holger Cahill 1959 59.383

Study for Mural, "Construction" early 1940's
Gouache on masonite 12¾"x19⅜" (32.4x49.2 cm)
Signed: lower right, "Edgar Britton"
Reverse: on panel, label, "Mural Sketch/Construction Panel 'Paid for
by H. Cahill'"; on panel, "#74"
Ex-collection: donors, New York, N.Y.
Gift of Mr. and Mrs. Holger Cahill 1959 59.384

BRODERSON, ROBERT (b. 1920)

Boy and Birds 1961
Gouache and wash on paper 19⅜"x11" (49.5x28.0 cm)
Signed: upper right, "Broderson"
Reverse: label, Catherine Viviano Gallery, 42 E 57th Street, NYC
Ex-collection: with Terry Dintenfass, Inc., New York, N.Y.
Gift of Mrs. Robert M. Benjamin 1974 74.21

BROOK, ALEXANDER (1898-1980)

*****The Tragic Muse** ca. 1933
Oil on canvas 40"x24" (101.6x61.0 cm)
Signed: lower right, "A.Brook."
Reverse: label, Wadsworth Atheneum, lent by The Downtown Gallery;
label, New York World's Fair Contemporary Art, 1939, lent by Frank K.
M. Rehn Gallery; label, circulating exhibition of United States Works
shown in Latin America, 1941; label, Museum of Modern Art, *Romantic
Painting in America*, 1943; label, Addison Gallery of American Art,
Phillips Andover Academy, 1946; label, traveling exhibition of U.S.
Committee of the International Association of Plastic Arts, 1956-57;
label, Musée Galliera, Paris, *Contemporary American Painters*, 1957;
label, Museum of Art, Ogunquit, Maine
Ex-collection: The Downtown Gallery, New York, N.Y.; to Frank K. M.
Rehn Gallery, New York, N.Y.
Purchase 1940 Felix Fuld Bequest Fund 40.119

*Date of painting was determined by its inclusion in a 1933 Museum of
Modern Art exhibition. The artist revarnished and signed the work in 1944,
after it was acquired by the Museum.*

Dancer Resting ca. 1931-32
Oil on canvas 14"x12" (35.6x30.5 cm)
Signed: upper left, "A.Brook"
Reverse: stretcher is stamped, "Jan 4 1932"
Ex-collection: with The Downtown Gallery, New York, N.Y.; to donor,
Gross Point Farms, Mich.
Gift of Robert H. Tannahill 1947 47.213

*The artist recalled that The Downtown Gallery exhibited the painting
around 1931.*

Portrait of Peggy Bacon (1895-) 1933
Oil on canvas 40"x25¾" (101.6x65.4 cm)
Signed and dated: lower left, "A. Brook-'33"
Reverse: stamp, The Downtown Gallery, N.Y.C. (also torn Downtown
label); label, Ogunquit Museum of Art, 1956
Ex-collection: with The Downtown Gallery, New York, N.Y.; to donors,
New York, N.Y.
Gift of Mr. and Mrs. Lesley G. Sheafer 1954 54.208

BROWERE, ALBURTIS DE ORIENT (1814-1887)

*****Trail of the 49'ers** ca. 1858
Oil on canvas 33"x48" (83.8x121.9 cm)
Signed: lower right, "A.D.O. Browere"
Reverse: no pertinent data recorded prior to relining, 1971
Ex-collection: C. K. Johnson, Kingston, N.Y.; to Vose Galleries,
Boston, Mass. (1953)
Purchase 1956 Edward F. Weston Bequest Fund 56.182

Painting depicts a scene in Panama almost identical to Browere's Going
to California: Crossing the Isthmus, *owned by his descendent, Everett
Millard, Highland Park, Ill. Both were done ca. 1858 at the time of the
artist's second trip to California. In 1852 Browere travelled to California by
rounding Cape Horn and in 1858 he travelled the Chagres River route
across the Isthmus.*

BROWN, GEORGE LORING (1814-1889)

*****Tivoli** (The Falls of Tivoli) 1850
Oil on canvas 25½"x32¼" (64.8x82.5 cm)
Signed and dated: lower left, "G.L.Brown/Paris 1850"
Reverse: originally on back, before relined, "View of the Great Cascade
and the 'Temple of the Sybil' at Tivoli; near Rome, painted from nature
for E. Lenox, Esq. of N.Y. by G. L. Brown, Paris, 1850"
Ex-collection: E. Lenox, New York, N.Y.; to James Lenox, New York,
N.Y.; to Lenox Library, New York, N.Y.; to New York Public Library,
Lenox Collection (1895); to Coleman Auction Galleries (sold at auction
April, 1943); to A. F. Mondschein (dealer), New York, N.Y.; to George
Guerry, New York, N.Y.
Purchase 1957 The G. L. Brown Fund 57.13

*No. 24 in the Coleman auction at which the New York Public Library sold
part of the Lenox Collection. Although the Library records show that the
painting was sold at that auction, the auction catalog does not list a G. L.
Brown painting; lot no. 24 is listed as "another lot." The* Guide to the
Paintings and Sculpture Exhibited to the Public *of the Lenox Library,
1877, records this work was "painted to order, Paris, January, 1851." The
confusion of dates may result from the distinction between completion
date and the date it entered the collection. (files)*

BROWN, JOHN GEORGE (1831-1913)

Of Other Days
Oil on canvas 30"x25" (76.2x63.5 cm)
Signed: lower left, "JG•Brown NA•"
Reverse: label on stretcher (in artist's hand), "J. G. Brown/'Of Other
Days'"
Ex-collection: American Art Association
Purchase 1914 The General Fund 14.119

*****Telling the News**
Oil on canvas 24½"x30" (62.2x76.2 cm)
Signed: lower right, "J. G. Brown N.A."
Ex-collection: donor, Scotch Plains, N.J.
Gift of Dr. J. Ackerman Coles 1920 20.1211

Vanity 1899
Oil on canvas 24"x18" (61.0x45.7 cm)
Signed and dated: lower left, "J. G. Brown NA/1899"
Ex-collection: donor, Scotch Plains, N.J.
Gift of Dr. J. Ackerman Coles 1920 20.1212

BROWNE, BYRON (1907-1961)

*****Head of a Man** 1943
Oil on canvas 28"x24" (71.2x61.0 cm)
Signed: lower right, "Byron Browne/1943"
Reverse: inscribed, "Byron Browne/1943"; label, The Pinacotheca,
New York, N.Y.; label, Mortimer Brandt Gallery, New York, N.Y.
Ex-collection: Mortimer Brandt Gallery, New York, N.Y.; to The
Pinacotheca Gallery, New York, N.Y.; to donors, New York, N.Y.
Gift of Mr. and Mrs. Milton Lowenthal 1946 46.170

Circus Tumblers 1946
Oil on canvas 38"x30" (96.5x76.2 cm)
Signed: lower right, "Byron Browne"
Reverse: inscribed, "Byron Browne/-1946/Circus Tumblers-/N.Y.C.";
label, Kootz Gallery; label, Whitney Museum of American Art, 1946
Ex-collection: Samuel M. Kootz Gallery, Inc., New York, N.Y.; to
Whitney Museum of American Art (1951)
Gift of Mr. and Mrs. Samuel Kootz 1958 58.2

Received from the donors through the Whitney Museum of American Art.

BROWNE, GEORGE ELMER (1871-1946)

Ponte de Valentré ca. 1929
Oil on canvas 39⅝"x31½" (100.6x80.0cm)
Signed: lower left, "Geo. Elmer Browne"
Ex-collection: with Grand Central Gallery, New York, N.Y.; to donors,
New York, N.Y.
Gift of Mr. and Mrs. H. H. Wehrhane 1929 29.911

*Although the artist recalled that this work was painted in 1930, the
Museum received it in 1929.*

BROWNE, GEORGE ELMER (1871-1946) [sailboat]

DAVIS, WARREN (1865-1925) [reclining figure]

GROLL, ALBERT L. (1866-1952) [Indians and teepees]

SANDOR, MATHIAS (1857-1920) [Indians in pueblo]

SCHREYVOGEL, CHARLES (1861-1912) [cowboy on horseback]

WIGGINS, CARLETON (1848-1932) [sheep in pasture]

Six Scenes on a Wooden Palette
Oil on wood 17"x27" (42.2x68.6 cm)
Signed: lower right, "Warren Davis"; lower left, "Mathias Sandor";
middle left, "A. L. Groll"; upper middle, "Chas Schreyvogel"; upper
right, "Carleton Wiggins"; middle bottom, "Geo. Elmer Browne"
Ex-collection: Joseph S. Isidor, New York, N.Y. and Orange, N.J.; to his
wife, the donor (1941)
Bequest of Mrs. Rosa Kate Isidor 1949 49.469

BROWNSCOMBE, JENNIE (1850-1936)

Season of Flowers (May Day) 1896
Watercolor on paper 13"x39½" (33.0x100.3 cm)
Signed: lower right, "Jennie Brownscombe/Copyright 1896"
Ex-collection: W. C. Klackner, London and Paris; donor,
Scotch Plains, N.J.
Bequest of Dr. J. Ackerman Coles 1926 26.1212

The artist stated that this work was titled Season of Flowers *and that it
had been commissioned by W. C. Klackner, the London publisher and art
dealer.*

***The Peace Ball at Fredericksburg, Va.** 1897
Oil on canvas 31¾"x50¾" (80.7x128.9 cm)
Signed: lower left, "Jennie Brownscombe/Copyright"
Ex-collection: W. C. Klackner, London and Paris; donor,
Scotch Plains, N.J.
Bequest of Dr. J. Ackerman Coles 1926 26.1257

W. C. Klackner commissioned Brownscombe to paint the 1781 ball held in Fredericksburg, Va., in 1897. It was probably executed in England and was exhibited at the National Academy of Design in 1897.

Mr. Klackner died about 1920. Although his nephew, George C. Klackner of New York, N.Y., inherited the copyright, it is not known if he actually owned the work at any time.

BRUCE, EDWARD (1879-1934)

Tuscan Hills
Oil on canvas 30"x62" (76.2x157.5 cm)
Signed: lower right, "Edward Bruce"
Reverse: label (artist's hand), "Tuscan Hills/by Edward Bruce"
Ex-collection: donor, Convent, N.J.
Gift of Mrs. Paul Moore 1962 62.149

BRUMBACK, LOUISE UPTON (1872-1929)

Winter Landscape ca. 1918
Oil on canvas 30¼"x36" (76.9x91.5 cm)
Signed: lower left, "Louise Upton Brumback"
Reverse: handwritten label, "The New York Society of Women
Painters/at the Art Center (lent by Newark Museum)"
Anonymous gift 1924 24.907

Artist indicated that this painting was exhibited ca. 1916 at the National Academy of Design. Academy exhibition catalogues do not list that title. The artist, however, did show River Bank *in the Academy exhibition of 1918 (#358).* Winter Landscape *may be that painting.*

The Harbor
Oil on canvas 25¼"x30" (64.1x76.2 cm)
Signed: lower left, "Brumback"
Reverse: sticker on frame, "C.M.A."
Ex-collection: the artist, New York, N.Y.
Gift of Mrs. Felix Fuld 1925 25.1156

BRUSH, GEORGE De FOREST (1855-1941)

***A Memory** 1925
Oil on wood panel 31½"x25" (88.0x63.5 cm)
Signed and dated: lower right, "Geo De Forest Brush/1925"
Reverse: label, Grand Central Art Galleries, December 1929
Ex-collection: with Grand Central Art Galleries, New York, N.Y.; to donor, East Orange, N.J.
Gift of Louis Bamberger 1926 26.201

BUGBIRD, MARY BAYNE (b. 1889)

Callaghan's 1955
Oil on canvas 20"x40" (50.8x101.6 cm)
Unsigned
Ex-collection: donor, Summit, N.J.
Gift of the artist 1965 65.148

BUGBIRD, MARY BAYNE (b. 1889) and BELLOWS, GEORGE (1882-1925)

Female Model
Charcoal drawing on paper 24¼"x19" (61.6x48.2 cm)
Signed and inscribed along bottom: "This drawing by George Bellows/when I studied with him at the League (Art Students League)/signed Mary Bayne (previous to my marriage to Herbert Copelin Bugbird in 1916). Ca. 1910. 1911."
Ex-collection: donor, Summit, N.J.
Gift of Mrs. Mary Bayne Bugbird 1965 65.147

BUNCE, LOUIS (b. 1907)

Pacific Shore 1956
Oil on canvas 45"x29½" (104.3x75.0 cm)
Signed and dated: lower right, "Louis Bunce '56"
Ex-collection: donor, New York, N.Y.
Gift of Waldo Rasmussen 1965 65.155

BUNDY, HORACE (1814-1883)

Portrait of a Woman
Oil on canvas 28⅛"x24⅜" (71.4x62.0 cm)
Reverse: on canvas, "H Bundy Painter/Claremont/June 1846"
Ex-collection: donor, Saxtons River, Vt.
Gift of Mrs. Brooks Shepard 1960 60.603

Portrait of a Mother and Child 1840's
Oil on canvas 29"x24" (73.7x61.0 cm)
Unsigned
Ex-collection: Claremont, N.H. collection; to unidentified Claremont, N.H., dealer; to a "Mrs. Pearson", Denver, Colo.; to donor, Saxtons River, Vt.
Gift of Mrs. Brooks Shepard 1965 65.149

This unsigned portrait originally came from a Claremont, N.H., house which had another Bundy, signed and dated May, 1846. The costume in the painting would date it in the 1840's.

BURCHFIELD, CHARLES (1893-1967)

***Factory Town Scene** (Factory Town) ca. 1920-30
Watercolor on paper 16⅜"x22" (41.6x55.9 cm)
Signed: lower left, "Chas. Burchfield"
Reverse: label, *The Nature of Charles Burchfield/A Memorial Exhibition,* Munson-Williams-Proctor Institute, Utica, N.Y. 1970
Ex-collection: with Frank K. M. Rehn Gallery, New York, N.Y.
Purchase 1930 The General Fund 30.75

According to Rehn Gallery this work was executed in 1920 and reworked in 1929. In correspondence the artist gave 1930 as the actual date and stated that he aimed to express two moods "separate in themselves, but each dependent on and influencing the other: – that is to say, weather and industry."

***Evening** 1932
Watercolor on paper 33½"x45½" (85.1x105.6 cm)
Signed and dated: lower right (with monogram), "CVB/1932"
Reverse: label, M. Knoedler & Co., 1971 (Benefit Museum American Folk Art); label, *Charles Burchfield – His Golden Years,* University of Arizona, 1965-66
Ex-collection: Frank K. M. Rehn Gallery, New York, N.Y.
Purchase 1944 Edward F. Weston gift 44.39

The artist, in correspondence, stated that Evening *was conceived to have four meanings: it symbolizes the end of day, the end of the year, the end of the lives of the three old people under the trees, and "also 'Evening' of a certain phase of farm life in America. The old farms are going and a new conception is coming in."*

BURLIN, PAUL (1886-1969)

The Paddock ca. 1921-24
Oil on canvas 19¾"x28¾" (50.2x73.1 cm)
Signed: lower left, "Paul Burlin"
Ex-collection: Arthur F. Egner, South Orange, N.J.; purchased from Egner estate sale, Parke-Bernet Galleries (May 4, 1945) (#161)
Purchase 1945 Thomas L. Raymond Bequest Fund and Endowment Interest Fund 45.141

Approximate date supplied by the artist.

Composition 1953
Watercolor on paper 22"x30" (56.0x76.3 cm)
Signed and dated: lower left, "Paul Burlin/1953"
Reverse: on stretcher, "-C F 249"; top stretcher, "C Khehne"; label, The Downtown Gallery 6/29/63 (giving date as 1950)
Gift of Jules Reiner 1973 73.114

Harbor Scene early 20th century (attributed)
Watercolor on paper 5¾"x7⅛" (14.6x18.1 cm)
Signed: lower right, "Burlin"
Ex-collection: private collection, New York, N.Y.
Anonymous gift 1940 40.339

The signature, unusual for Burlin, might indicate that Harbor Scene *is an early work.*

BURNETT, SUSAN (1817-1887)

View in Scotland
Watercolor on velvet 24½"x29½" (62.2x75.0 cm)
Unsigned
Ex-collection: remained in artist's family until donated by her nephew, Newark, N.J.
Gift of Frank B. Crawford 1944 44.11

Title of work was painted on its glass mat. The artist was a daughter of Newark inventor Seth Boyden (1788-1870).

BUROS, LUELLA

Street in Winter ca. 1940
Watercolor on paper 19¼"x24" (48.9x61.0 cm)
Signed: lower right, "Luella Buros"
Reverse: "Street in Winter/Luella Buros/32 Lincoln Ave./Highland Park, N.J."
Ex-collection: the artist, Highland Park, N.J.
Purchase 1942 Sophronia Anderson Bequest Fund 42.94

BURROUGHS, BRYSON (1869-1934)

The Age of Gold 1913
Oil on canvas 29¾"x36" (75.6x91.4 cm)
Signed and dated: bottom left of center (on rock), "Bryson/Burroughs/1913"
Reverse: label, Metropolitan Museum of Art, *Burroughs Memorial Exhibition*, 1935
Gift of Mrs. Felix Fuld 1925 25.1171

BUTCHKES, SIDNEY (b. 1922)

Compass Bianco (S-66-9) 1965
Acrylic on canvas 58"x58" (147.3x147.3 cm)
Unsigned
Ex-collection: donors, Great Neck, N.Y.
Gift of Mr. and Mrs. Lester Francis Avnet 1968 68.254

BUTTERFIELD, CHARLES (19th century)

Portrait of a Gentleman 1881
Pencil and charcoal on canvas 30"x24¾" (76.2x62.9 cm)
Signed: lower left (monogram), "Butterfield/1881"
Anonymous gift 1956 56.144

BUTTERSWORTH, JAMES E. (b. England 1817-1894)

Harbor Scene (New York Harbor Scene) late 1860's
Oil on cardboard 9"x13" (22.9x33.0 cm)
Signed: lower right, "J. E. Buttersworth"
Reverse: stamped, Prepared Millboard/Winsor & Newton/London
Ex-collection: George Guerry, New York, N.Y.; to donors, New York, N.Y.
Gift of Mr. and Mrs. Orrin W. June 1960 60.596

The New York setting of this work is in question. The date is assigned on stylistic grounds.

CALCAGNO, LAWRENCE (b. 1916)

Untitled 1955
Watercolor on paper 22"x30" (55.9x76.2 cm)
Signed and dated: lower left, "Calcagno '55"
Ex-collection: donor, New York, N.Y.
Gift of Paul Ganz 1960 60.590

36-III-75 1975
Watercolor and mixed media on paper 21¼"x29¼" (54.0x74.3 cm)
Signed: lower right, "Lawrence Calcagno"; lower left, "Mixed media 36-III-75"
Ex-collection: donor, Taos, N.M.
Gift of the artist 1975 75.100

Painted in March, 1975, at MacDowell Colony, Peterborough, N.H. (corres.)

CALDER, ALEXANDER (1898-1978)

Abstraction 1944
Gouache on paper 22½"x31" (57.2x78.8 cm)
Signed and dated: lower right, "Calder '44"
Ex-collection: the artist, New York, N.Y.
Gift of Samuel Kootz 1959 59.90

CALLAHAN, KENNETH (b. 1906)

Revelation 1957
Tempera on paper 12½"x12½" (31.8x31.8 cm)
Signed: lower right, "Kenneth Callahan"
Ex-collection: donor, New York, N.Y.
Gift of Dr. Charles H. Goodsell 1961 61.452

Painting executed while artist was traveling in Europe. (corres.)

CAMPANELLA, VINCENT (b. 1915)

Linear Movement 1946
Watercolor on paper 15½"x22½" (39.4x57.2 cm)
Signed: lower right, "Campanella"
Reverse: label, Art Institute of Chicago, 59th Annual Exhibition, 1948; label, Frank K. M. Rehn Gallery
Ex-collection: with Frank K. M. Rehn Gallery, New York, N.Y.
Gift of the Childe Hassam Fund of the American Academy of Arts and Letters 1950 50.2120

Date of September, 1946, and the location as Monhegan Island, Me., supplied by artist. (files)

CANDELL, VICTOR (b. Hungary 1903)

Ascendant 1952
Charcoal and ink drawing on paper 30"x21⅞" (76.2x55.6 cm)
Signed: lower left, "Candell"
Reverse: label, The Metropolitan Museum of Art, American Watercolor and Drawing Association, 1952
Ex-collection: donor, New York, N.Y.
Gift of Paul Ganz 1960 60.589

Another study for the (60"x32") painting of the same name and date is in the collection of the Whitney Museum of American Art.

Port O'Call 1962
Oil on canvas 16"x17" (40.6x43.1 cm)
Signed and dated: lower left, "Candell 62"
Ex-collection: donors, New York, N.Y.
Gift of Mr. and Mrs. Raymond Horowitz 1965 65.113

CAN-NA-QUA (20th Century)

White Dancer
Watercolor on paper 11"x8" (27.9x20.3 cm)
Signed or inscribed: lower right, "Can-na-qua/White Dancer"
Purchase 1928 28.1461

Purchased for The Newark Museum in Santa Fe, N.M., by Edgar Holger Cahill. Artist possibly from Zuni pueblo, N.M.

CARLES, ARTHUR B. (1882-1952)

*Still Life with Compote** (Still Life) 1911
Oil on canvas mounted on wood 24⅛"x25⅛" (61.2x63.8 cm)
Signed: lower right, "Carles"
Ex-collection: purchased in 1912 from "291" Gallery, New York, N.Y.;
donor, Short Hills, N.J.
Bequest of Miss Cora Louise Hartshorn 1958 38.171

*Exhibited at the Salon d' Automne, Paris, October 1-November 8, 1912
(#291, Nature Morte).*

CARROLL, JOHN (1892-1959)

Georgia (Portrait of Georgia) 1935
Oil on canvas 16"x14" (40.5x35.5 cm)
Signed and dated: lower right, "John Carroll/35"
Ex-collection: with Frank K. M. Rehn Gallery, New York, N.Y.
Purchase 1936 Felix Fuld Bequest Fund 36.91

*Two Figures** 1929
Oil on canvas 50"x40" (127.0x101.6 cm)
Signed: lower right, "John Carroll"
Reverse: label, Corcoran Gallery, 12th Exhibition of Contemporary Oil
Painting, 1930-31; label, Cincinnati Art Museum, 39th Annual
Exhibition, 1932; label, Art Institute of Chicago, 45th Annual
Exhibition; label, Carnegie Institute of Art
Ex-collection: Frank K. M. Rehn Gallery, New York, N.Y.; to donors,
New York, N.Y.
Gift of Mr. and Mrs. Lesley G. Sheafer 1954 54.209

Date supplied by the artist. (files)

Head (Portrait of a Girl) 1928
Oil on canvas 20"x16" (50.8x40.6 cm)
Signed: lower left, "John Carroll"
Ex-collection: donors, New York, N.Y.
Gift of Mr. and Mrs. Lesley G. Sheafer 1954 54.210

*Previously called Portrait of a Girl. The artist in correspondence supplied
date and indicated that he preferred Head. (files)*

CARSMAN, JON (b. 1944)

*Trexler** 1973
Acrylic on canvas 60"x70" (152.5x177.8 cm)
Signed and dated: lower right, "Jon Carsman 73"
Reverse: top stretcher, "Jon Carsman Trexler (1973) 60"x72" [sic]
acrylic on canvas"
Ex-collection: donors, New York, N.Y.
Gift of Mr. and Mrs. Lawrence Zicklin 1977 77.190

CARTER, CALEB (1782-1847)

Mount Vernon 1803
Oil on canvas 25¾"x34¾" (65.4x88.3 cm)
Unsigned
Reverse: inscribed (prior to relining, 1960), "1803/Mount Vernon The
Seat/of the Late L.ᵗ G.ⁿ G. Washington)/(monogram)"
Ex-collection: remained in artist's family until given by his great-
great-granddaughters, Newark, N.J.
Gift of the Misses Elizabeth and Mary Louise Carter 1930 30.534

*Caleb Carter, a Newark resident, was a carriagemaker by trade, (corres.)
He copied this work from an aquatint drawn by Alexander Robertson and
engraved by Francis Jukes, published March 31, 1800. The same aquatint
was the basis of another painting in the Museum's Folk Art collection
(A.U. 28.1310).*

*Carter's painting was displayed as #5 in the Museum's exhibition,
American Primitives, 1930-31.*

CARTER, CLARENCE H. (b. 1904)

Triptych 1966
Pencil and acrylic on glass fiber paper mounted on wood panel
A 60"x22" (152.4x55.9 cm);
B 30"x22" (76.2x55.9 cm);
C 30"x22" (76.2x55.9 cm); base
D 32"x72"x10¼" (181.3x182.9x126.0 cm);
 overall height with base: 63½" (161.3 cm)
Reverse: each panel signed "Clarence H. Carter 66"
Ex-collection: the artist, Milford, N.J.
Anonymous gift 1978 78.82 A-D

*Transection #1** 1966
Acrylic on canvas 77"x54" (195.0x137.2 cm)
Signed and dated: lower right, "Clarence H. Carter 66"
Reverse: "Clarence H. Carter 66"
Ex-collection: the artist, Milford, N.J.
Anonymous gift 1978 78.84

CARTOTTO, ERCOLE (b. Italy 1889-1946)

Portrait of John Cotton Dana (1856-1929) 1935
Pencil drawing on paper 28¼"x21⅞" (71.8x55.6 cm)
Signed: lower right, "Ercole Cartotto"
Ex-collection: acquired from the artist, Darien, Conn.
Purchase 1935 Thomas L. Raymond Bequest Fund 35.205

*Mr. Dana was the founding Director of The Newark Museum from
1909-1929.*

Rhododendrons ca. 1935
Pastel on paper 20"x26" (50.8x66.0 cm)
Signed: lower left, "Ercole Cartotto"
Ex-collection: acquired from the artist, Darien, Conn.
Purchase 1935 Thomas L. Raymond Bequest Fund 35.206

Portrait of Beatrice Winser (1869-1947) 1935
Oil on canvas 31⅞"x25¾" (81.0x65.5 cm)
Signed: lower left, "Ercole Cartotto"
Ex-collection: acquired from the artist, Darien, Conn.
Purchase 1935 Wallace M. Scudder Bequest Fund 35.207

Miss Winser was Director of The Newark Museum from 1929-1947.

Portrait of Arthur F. Egner (1882-1943) 1936
Oil on canvas 42⅛"x33⅞" (107.0x106.0 cm)
Signed: lower left, "Ercole Cartotto"
Reverse: inscribed and dated, "Arthur F. Egner, Esq/Portrait by/Ercole
Cartotto/Feb. 14, 1936/Newark, N.J."
Ex-collection: acquired from the artist, Darien, Conn.
Purchase 1936 Edward F. Weston Gift 36.84

*Arthur F. Egner, born in Newark, was associated with the law firm of
McCarter, Williamson and McCarter. He was President of the Board of
Trustees of The Newark Museum from 1932-1943.*

Drawing of a Young Girl (Drawing of a Child) ca. 1935
Silver point drawing on paper 12"x10⅝" (30.5x27.0 cm)
Signed: lower right, "Ercole Cartotto"
Ex-collection: acquired from the artist, Darien, Conn.
Purchase 1936 Wallace M. Scudder Bequest Fund 36.89

The approximate date was established at time of acquisition.

CARUSO, BRUNO (b. Italy 1927)

The Fence
Oil on wood 19½"x23½" (49.5x59.7 cm)
Signed: bottom center, "Bruno Caruso"
Ex-collection: Spook Farm Gallery, Far Hills, N.J.
Purchase 1956 Mrs. C. Suydam Cutting Special Gift Fund 56.237

CASILEAR, JOHN W. (1811-1893)

Landscape
Oil on canvas 7"x11½" (17.8x29.2 cm)
Signed: lower left (monogram)
Ex-collection: donor, Maplewood, N.J.
Gift of Dr. S. D. Stephens 1964 64.4

CASSATT, MARY (1845-1927)

*Mathilde and Robert** (Femme Tenant un Jeune Garcon Serre Contre
Elle: Au Fond, un Lac; Mother and Child) ca. 1882
Oil on canvas 28¾"x23¾" (73.0x60.3 cm)
Unsigned
Reverse: wax seal on stretcher, "Vente/Collection Mle/X/30 Mars 1927/
Mary Cassat"; stamp on stretcher, "A. M. Reitlinger #54"; stamp on
canvas, "F. Dupré/141.Faubourg St Honore"; label, Lucien Lefebvre-
Foinet; label, E. A. Milch, Inc.; label, Carnegie Institute of Art,
American Classics of the 19th Century, 1957
Ex-collection: the artist to Mathilde Vallet, Paris (inherited from the
artist, 1927); sold at auction, Collection de Mademoiselle X (1927); to
Simonson Gallery, Paris; to Louis Kronberg, New York, N.Y.
Purchase 1931 Felix Fuld Bequest Fund 31.221

*Mathilde Vallet was Mary Cassatt's housekeeper-companion. Mathilde's
inheritance was dispersed in two sales: the 1927 Collection of
Mademoiselle X and the 1931 Mathilde X sale. The wax seal and the
stamp of A. M. Reitlinger verify that this painting was exhibited as #54
and sold in 1927.*

*The subjects of the paintings are Mlle. Vallet and the artist's nephew,
Robert Cassatt (1873-1944). In her catalogue raisonné, Adelyn Breeskin
dates this work ca. 1885. However, a Cassatt portrait (dated 1885) of
Robert (aged 13) and his father in the Philadelphia Museum of Art depicts
a more mature child, and a pastel of Robert at age 9 (B. Lande Collection,
Montreal) is closer in appearance to the child in the Newark work.*

CHALFANT, JEFFERSON DAVID (1856-1931)

*Violin and Music** 1887
Oil on canvas 16½"x28½" (41.9x72.4 cm)
Signed and dated: lower left, "J. D. Chalfant-/.87"
Reverse: no inscription recorded prior to relining, 1959
Ex-collection: H. Wood Sullivan; Madison Avenue Silver Shop, New
York, N.Y.; to Jack Bender, New York, N.Y.
Purchase 1959 The Carl W. Badenhausen 50th Anniversary
Fund 59.89

CHAMPNEY, J. WELLS (1843-1903)

Houses by the River
Watercolor on paper 10"x13¾" (25.4x34.9 cm)
Reverse: signed, "J. Wells Champney"
Ex-collection: donor, South Orange, N.J.
Bequest of Mrs. Felix Fuld 1944 44.318

CHAPIN, JAMES (1887-1979)

Man Sharpening Scythe ca. 1926
Watercolor on paper 18¾"x14¾" (47.6x37.5 cm.)
Unsigned
Inscribed: lower left, "Man Sharpening Scythe"
Reverse: torn label on backing, Art Institute of Chicago, Watercolor
Exhibition, 1926; note to "return to 11 East 13th St. — N.Y. City"
Ex-collection: private collection, New York, N.Y.
Anonymous gift 1937 37.110

Portrait of Marion Boelling (Marion) 1929
Oil on canvas 44"x34" (101.8x86.4 cm)
Signed and dated: lower left, "James Chapin .29"
Reverse: inscribed on canvas, "'Marion'/James Chapin/29"
Ex-collection: donors, New York, N.Y.
Gift of Mr. and Mrs. Lesley G. Sheafer 1954 54.211

CHAPMAN, JOHN GADSBY (1808-1890)

*Harvest on the Roman Campagna** 1871
Oil on canvas 29¾"x71¼" (75.6x181.0 cm)
Reverse: inscribed on canvas, "Harvest on the Roman Campagna/For
Mrs. A. Tilden N.Y./by/John G. Chapman/Rome 1871"
Ex-collection: Mrs. A. Tilden, New York, N.Y.; to donor, Scotch Plains,
N.J.
Bequest of Dr. J. Ackerman Coles 1926 26.2788

*According to correspondence from Mrs. Robert Osborne, Chapman made
several versions of this scene. A full-size 1866 version was exhibited at the
Pennsylvania Academy in 1866 and may have been No. 67 in the Yale
University Art Gallery exhibition, American Art From Alumni
Collections, April, 1868. A full-size 1867 version commissioned by Robert
O. Fuller, Cambridge, Mass., is now in the Museum of Fine Arts, Boston.
A half-size 1868 version was commissioned by Hinman Hurlbut,
Cleveland, O., and is now in the Hurlbut Collection at the Cleveland
Museum. A full-size 1871 version commissioned by E. C. P. Lewis was
formerly owned by the Osborne Gallery, New York, N.Y.*

CHASE, WILLIAM MERRIT (1849-1916)

Portrait of Louis M. Frank (1856-1910) ca. 1900
Oil on canvas 30"x25" (76.2x63.5 cm)
Signed: lower left, "W^m M. Chase"
Ex-collection: the Frank Family
Anonymous gift 1943 43.47

Louis Frank was one of the founders of L. Bamberger & Co., Newark, N.J.

*Portrait of Linda Dietz Carlton** (Portrait of an Actress; Portrait of the
Actress Linda Dietz) ca. 1890
Oil on canvas 35"x29¼" (74.3x89.0 cm)
Unsigned
Reverse: painting came to the Museum already relined; stretcher was
inscribed "Linda Dietz Carlton" (files); label, Whitney Museum of
American Art, "P.3039"; label, Portraits, Inc.
Ex-collection: estate of the artist; sold at auction, The Paintings and
Other Artistic Property left by the Late William Merrit Chase, N.A.,
American Art Galleries, New York, N.Y. May 14-17, 1917 (#97); F.S.
Pratt, New York, N.Y.; Mrs. W. I. Clark, Worcester, Mass.; Hon. C. V.
Whitney, Old Westbury, N.Y.; to M. Knoedler & Company, New York,
N.Y. (1951)
Purchase 1954 The Carl and Dorothy Badenhausen
Foundation Trust 54.169

Portrait of Mrs. Francis Guerin Lloyd [Matilda Herbert]
(1855-1945) ca. 1912
Oil on canvas 36⅛"x28¾" (91.7x93.0 cm)
Signed: upper left, "Wm.M. Chase"
Reverse: label, "L. Goddyn, Bruges"
Ex-collection: sitter to her daughter, the donor, Gladstone, N.J.
Gift of Mrs. Owen Winston 1957 57.35

Portrait of Mr. Francis Guerin Lloyd (1846-1921) ca. 1912
Oil on canvas 36⅛"x28¾" (91.7x73.0 cm)
Signed: lower left, "Wm.M. Chase"
Reverse: label, "L. Goddyn, Bruges"
Ex-collection: sitter to his daughter, the donor, Gladstone, N.J.
Gift of Mrs. Owen Winston 1957 57.36

CHAVEZ, EDWARD ARCENIO (b. 1917)

Evening Chores 1937
Oil on masonite 17"x33" (43.2x83.8 cm)
Signed and dated: lower right, "Edward Chavez/1937"
Allocated by the WPA Federal Art Project 1943 43.210

Redstone, Colorado 1938
Oil on composition board 17¼"x24¼" (43.8x61.6 cm)
Signed: lower right, "Edward Chavez"
Allocated by the WPA Federal Art Project 1945 45.238

*Artist indicated that painting is part of a series of Colorado landscapes,
"one of my earliest works." (files)*

CHEYNEY, RUSSELL (1881-1945)

Verrochio's Statue of Colleone, Venice 1924
Oil on canvas 28"x38" (71.2x96.5 cm)
Signed and dated: lower right, "Russell Cheyney 1924"
Ex-collection: donor, Plainfield, N.J.
Gift of Louis K. Hyde, Jr. 1927 27.400

CHIANG, PAUL (b. China 1928)

Newark Museum ca. 1977
Gouache on paper 21"x27" (53.3x68.6 cm)
Reverse: Newark N.J./Public Lib./P. Chiang
Ex-collection: donor, Pine Brook, N.J.
Gift of the artist 1977 77.182

*Although the building depicted is the Museum,
the artist called it "Public Lib."*

CHILDS, BERNARD (20th Century)

One Square Millimeter of Skin 1963
Oil with sand on canvas 36"x25½" (91.5x64.8 cm)
Signed and dated: lower left, "Childs '63"
Reverse: on backing, "One Square Millimeter of Skin 1963"
Ex-collection: the artist to donor, New York, N.Y.
Gift of Stanley Bard 1972 72.336

CHIN, CHEE (20th Century)

Landscape 1937
Watercolor on paper 15"x22¾" (38.1x57.8 cm)
Signed and dated: lower right, "Chee Chin 1937"
Reverse: label, FAP #3 9950-C; label, Fed. Project 1150
Allocated by the WPA Federal Art Project 1943 43.206

CHURCH, FREDERIC EDWIN (1826-1900)

***Twilight, "Short Arbiter 'Twixt Day and Night"** (Sunset) 1850
Oil on canvas 32¼"x48" (82.0x122.0 cm)
Signed and dated: bottom center, "F. E. Church/-50"
Reverse: label, R. W. Norton Art Gallery, Shreveport, La., *Artists of the Hudson River*, 1973; no pertinent data recorded prior to relining
Ex-collection: National Academy of Design Exhibition, #349 (1850); to American Art Union; to Robert Dillon, New York, N.Y. (1850); to Lucius Tuckerman Collection (1907); to Victor Spark, New York, N.Y.; to M. Knoedler and Company, New York, N.Y. (1946)
Purchase 1956 Wallace M. Scudder Bequest Fund 56.43

Catalogue #261 in the 1850 American Art Union exhibition, distributed on December 20, 1850. An engraving was made at that time. Col. Merl Moore supplied data on the provenance of the work and the fact that it was lent by Lucius Tuckerman to the National Gallery of Art for one year in 1907. (corres.)

According to William H. Gerdts, this may be the work Twilight in New England *sold at Leavitt's Auction House, New York, in April, 1878, from the Samuel P. Avery Collection. (files) David Huntington suggested that the view is not specific but a generalized scene of New England (Vermont, in particular). (corres.)*

Evening in the Tropics (Tropical Scene) ca. 1853
Pencil and chalk sketch 12"x18¾" (30.5x47.6 cm)
Unsigned
Reverse: on backing, not in artist's hand, "Sketch by/F. E. Church N.A."; shipping label, From Museum of Fine Arts, Boston, to Yale University Art Gallery
Ex-collection: John J. Bowden, Bayside, N.Y.
Purchase 1956 The General Fund 56.186

On the backing is a clipping, possibly from an exhibition catalog, which reads, "Church painted South America, as in Evening in the Tropics, *1853, inspired by Von Humbolt's travels." The painting after this sketch is now at the Wadsworth Athenaeum. (files)*

Landscape (attributed to F. E. Church)
Oil on canvas 18"x30" (45.7x76.2 cm)
Signed: lower right, "F. E. Church"
Ex-collection: donor, Scotch Plains, N.J.
Gift of Dr. J. Ackerman Coles 1924 24.2496

CHURCH, F. E. (see: Healy, *Arch of Titus*)

CHURCH, FREDERICK STUART (1842-1923)

Wooded Landscape ca. 1898
Oil on canvas 19¾"x36" (50.2x91.4 cm)
Signed: lower right, "F. S. Church Copyright 1898"
Ex-collection: donor, Newark, N.J.
Gift of Mrs. John W. Howell 1940 40.126

CICERO, CARMEN L. (b. 1926)

Abstraction 1954
Oil on canvas 40¾"x58¾" (103.5x149.2 cm)
Signed and dated: lower right, "Cicero 54"
Ex-collection: purchased from the artist, Newark, N.J.
Purchase 1955 John J. O'Neill Bequest Fund 55.83

CIKOVSKY, NICOLAI (b. Russia 1894)

***North Sea, Long Island** 1945
Oil on canvas 28"x35⅛" (71.1x89.2 cm)
Signed and dated: lower left, "Nicolai Cikovsky 45"
Ex-collection: Associated American Artists, New York, N.Y.
Purchase 1946 Wallace M. Scudder Bequest Fund 46.152

Portrait of Abraham Walkowitz (1878-1965) ca. 1943
Oil on canvas 20"x16" (50.8x40.7 cm)
Signed: lower right, "Nicolai Cikovsky"
Ex-collection: donor, New York, N.Y.
Gift of Abraham Walkowitz 1948 48.513

Executed for exhibition, One Hundred Artists and Walkowitz, *Brooklyn Museum, 1944.*

CITRON, MINNA (b. 1896)

Platinum Blonde 1932
Oil on canvas 24"x20" (61.0x50.8 cm)
Signed and dated: upper left, "Minna Citron '32"
Ex-collection: the artist to donor, Newark, N.J.
Gift of Harry Wright 1932 32.224

Staten Island Ferry 1937
Oil on masonite 25¼"x16⅜" (64.2x41.6 cm)
Signed and dated: center right, "Minna Citron 37"
Ex-collection: Rabin & Krueger Gallery, Newark, N.J.
Purchase 1939 Felix Fuld Bequest Fund 39.198

CLOAR, CARROLL (b. 1913)

***The Time of the Blackbirds** 1955
Tempera on masonite 23-11/16"x31-11/16" (58.5x78.9 cm)
Signed: lower left, "Carroll Cloar"
Reverse: inscribed on masonite, "'The Time of the Blackbirds'/Carroll Cloar — Memphis/1955"
Ex-collection: The Alan Gallery, New York, N.Y.
Purchase 1956 Mrs. Felix Fuld Bequest Fund 56.4

CLOSSON, WILLIAM BAXTER (1848-1926)

Pluming Himself
Oil on canvas 44"x24" (111.8x61.0 cm; oval spandrel)
Signed: lower left, "W. B. Closson"
Reverse: label on frame, Charleston S.C. Exposition; label on frame, Paris Exposition of 1900; label on middle stretcher, Worcester Art Museum; label on top stretcher, "Pluming Himslf./Painted by William Baxter Closson,/of Magnolia and Newton, Mass."
Ex-collection: donor, Newton, Mass.
Gift of Mrs. William B. Closson 1929 29.285

CLOUGH, ROGER (b. 1935)

The Tree 1965
Pen and ink on paper 14"x17" (35.6x43.2 cm)
Ex-collection: donor, Bethayres, Pa.
Gift of Frank J. Bompadre 1966 66.40

CLUTZ, WILLIAM (b. 1933)

Woman in Purple 1959
Oil on canvas 72"x36" (182.9x91.4 cm)
Signed: bottom right of center, "Clutz"
Ex-collection: with David Herbert Gallery, New York, N.Y.
Purchase 1962 The Summer Foundation for the Arts, Inc.,
Fund 62.133

COATES, ROSS (b. Canada 1932)

Untitled 1963
Pencil on paper 11⅞"x14⅞" (30.2x37.8 cm)
Signed: lower right, "Coates 1963"
Reverse: inscribed on backing in artist's hand, "Ross Coates/Untitled drawing — 1963"
Ex-collection: donors, New York, N.Y.
Gift of Mr. and Mrs. Paul Waldman 1969 69.123

COHEN, ADELE (b. 1922)

Lacrymosa 1963
Oil on canvas 70¼"x82½" (178.4x209.6 cm)
Reverse: signed on canvas, "Cohen/66 Burbank/Snyder N.Y."; on vertical top stretcher, "M 389.2:64"; label, The Members Gallery/Albright-Knox Art Gallery; label, The Marine Trust Company Award; label, Institute of Contemporary Art, Boston, Mass. Northeastern Regional Exhibition of *Art Across America*/May 1-June 6/1965
Ex-collection: donor, Snyder, N.Y.
Gift of the artist 1976 76.191

COLE, THOMAS (1801-1848)

*****The Arch of Nero** (The Arch of Nero, Part of the Ancient Aqueduct Near Tivoli) 1846
Oil on canvas 60"x48" (152.4x121.9 cm)
Signed and dated: far right of center, "T. Cole/1846"
Reverse: label, Vose Galleries, Boston; stamp on canvas, "Geo F. Rownet & Co./Manufacturers/51 Rathbone Place/London"
Ex-collection: George Guild, Boston, Mass.; John C. Miles; to Benjamin C. Ellis, Boston, Mass. (Miles' grandson); to Vose Galleries, Boston, Mass.
Purchase 1957 Sophronia Anderson Bequest Fund 57.24

#15 in the 1846 exhibition at the American Art Union. Sold at that time to George F. Guild of Boston, who was still the owner in 1848 when this painting was #61 in the Cole Memorial Exhibition at the American Art Union. (corres.) Cole's A View Near Tivoli (Morning) *is in the collection of the Metropolitan Museum of Art, New York, N.Y.*

Landscape (attributed to Cole)
Oil on canvas 40½"x23½" (102.8x64.8 cm)
Signed: lower right, "T.C."
Ex-collection: donor, Scotch Plains, N.J.
Gift of Dr. J. Ackerman Coles 1926 26.1166

The attribution to Cole has never been substantiated.

COLEMAN, GLENN O. (1877-1932)

*****Coenties Slip** 1926
Oil on canvas 25"x30" (63.5x76.2 cm)
Signed: lower right, "Coleman"
Ex-collection: purchased from the artist, Long Beach, N.Y.
Purchase 1928 The General Fund 28.1550

Dated at the time of its 1932 publication in the Whitney Museum of American Art's American Artist Series.

COPLEY, JOHN SINGLETON (1738-1815)

*****Portrait of Mrs. Joseph Scott** [Freelove Olney] (1733-1817) ca. 1765
Oil on canvas 69½"x39½" (176.5x100.3 cm)
Unsigned
Reverse: no pertinent data recorded prior to relining
Ex-collection: descended family of sitter: Mrs. Wolcott (1836); Mrs. E. M. Winslow (possibly Martha Scott Winslow, 1864); Charles Winslow; The Misses Winslow, Boston, Mass. (possibly Lucy Waldo Winslow, 1873); George Scott Winslow, Jr.; to his wife; to her daughter Katherine Winslow Roeder Pollock, Dedham, Mass. (1934); to Richard C. Morrison, Boston, Mass.
Purchase 1948 The Members' Fund 48.508

According to Boston Athenaeum incoming loan records, the painting was lent by a Mrs. Wolcott in 1836, and Mrs. E. M. Winslow in 1864.

A companion portrait of Mr. Scott also descended in the sitter's family. On stylistic evidence, both paintings have been dated 1765, eleven years after the Scotts' marriage.

CORBETT, EDWARD (1919-1971)

*****Provincetown #6** 1959
Oil on canvas 60"x50" (152.4x127.0 cm)
Unsigned
Ex-collection: Grace Borgenicht Gallery, New York, N.Y.
Purchase 1960 Felix Fuld Bequest Fund 60.573

CORIZ, SANTIAGO (20th century)

Male Dancer
Watercolor on paper 23"x14½" (58.4x36.8 cm)
Inscribed: upper right, "Coriz"
Purchase 1928 28.1460

The artist is from the Santo Domingo pueblo, N.M. The painting is unfinished. Purchased for the Museum in Santa Fe, N.M., by Edgar Holger Cahill.

CORNOYER, PAUL (1864-1923)

Rainy Day, Columbus Circle (Rainy Day, Columbus Circle, New York)
Oil on canvas 22¼"x27¼" (56.5x69.2 cm)
Signed: bottom left, "Paul Cornoyer"
Reverse: handwritten label, "Rainy Day, Columbus/Circle./Cornoyer 15.982."
Gift of The Newark Museum Trustees 1915 15.982

COX, KENYON (1856-1919)

Unknown Lady 1877
Pencil on paper 5"x2⅝" (12.7x6.4 cm)
Signed and dated: lower right, "Cox/1877"
Reverse: sketch of lower male torso
Ex-collection: donor, the artist's son, Essex, Mass.
Gift of Allyn Cox 1962 62.134

Donor indicated Cox drew this sketch of Francesco Laurana's bust of an unknown lady, possibly Queen Joan of Naples, in the Louvre. (corres.)

CRAFT, DOUGLAS D. (b. 1924)

#1-Onondaga Series 1977
Painting: mixed media, collage, graphite, Castell polychrome, distemper, acrylic varnish on canvas 24½"x26"(61.5x66.1 cm)
 "©"
Reverse: lower right on canvas, DC; label, artist, title and medium
 77
Ex-collection: purchased from artist by donor, New York, N.Y.
Gift of Mrs. Mildred C. Baker 1978 78.46

Purchased from Jersey City Museum exhibition, May, 1978

CRAIG, THOMAS BIGELOW (1849-1924)

The Mill Pond, Rutherford
Oil on canvas 20¼"x30¼" (51.4x76.8 cm)
Signed: lower left, "Thos. B. Craig"
Reverse: label, "The Mill Pond/painted by Thos B. Craig A.N.A."
Ex-collection: donor, East Orange, N.J.
Bequest of Mrs. Felix Fuld 1944 44.321

CRANE, BRUCE (1857-1937)

Autumn ca. 1910
Oil on canvas 22"x30⅛" (55.9x76.5 cm)
Signed: lower right, "Bruce Crane"
Ex-collection: Frederick J. Keer, Newark, N.J. (a framer and painting dealer)
Purchase 1910 The General Fund 10.10

One of the first three American paintings purchased by the Museum. The others were Ernest Lawson's Harlem River *(10.11) and William Ritschel's* Marine *(10.9).*

Spring
Oil on canvas 19½"x30" (49.5x76.2 cm)
Signed: lower right, "Bruce Crane"
Ex-collection: donor, Newark, N.J.
Bequest of G. Wisner Thorne 1938 38.330

CRANE, FREDERICK E. (1847-1915)

Hills, Dorset, Vermont ca. 1901
Oil on canvas 45"x55½" (114.3x141.0 cm)
Signed: lower left, "Fred E. Crane"
Ex-collection: donor, Bloomfield, N.J.
Gift of Henry W. Crane 1919 19.720

No relationship of the donor to the artist has been established.

Nightfall at Dorset, Vt. (Among the Hills) ca. 1901
Oil on canvas 25⅛"x30" (64.2x76.2 cm)
Signed: lower right, "Fred E. Crane"
Ex-collection: donor, Bloomfield, N.J.
Gift of Henry W. Crane 1919 19.721

CRAWFORD, RALSTON (b. Canada 1906-1978)

*****Shaw's Propellors** 1954
Oil on canvas 9"x16" (23.0x40.5 cm)
Signed: upper left, "Ralston Crawford"
Reverse: on stretcher, "Title: Shaw's Propellors/Ralston/Crawford/9"x16""
Ex-collection: Grace Borgenicht Gallery, New York, N.Y.; Zabriske Gallery, New York, N.Y.
Purchase 1972 Felix Fuld Bequest Fund 72.142

According to the artist the painting resulted from a visit to a site on Staten Island which Charles Shaw had described to him as a propellor "graveyard." (files)

"CREEMER" (18th century)

The Prodigal Son 1798
Ink and watercolor on paper mounted to wood panel 10"x12" (25.4x30.5 cm)
Signed: top center, "Creemer/1798"
Inscribed: upper right, "Miss Caty/Hadden Merited/this Picture ..."
Ex-collection: private collection, New York, N.Y.
Anonymous gift 1937 37.118

Found in Bridgeport, Conn. (files)

CROCKER, DICK (b. 1891)

Taxco Square
Watercolor on paper 15"x21½" (38.1x54.6 cm)
Signed: lower right, "Dick Crocker"; metal label front, N.J. Water Color Society/19th Annual, 1961./Kresge-Newark Purchase Award
Gift of Kresge-Newark 1961 61.37

From a pencil sketch done several years earlier. (files)

CROPSEY, JASPER F. (1823-1900)

Landscape 1878
Oil on canvas 12⅛"x20¼" (30.8x51.5 cm)
Signed and dated: lower right, "J. F. Cropsey 1878"
Reverse: no pertinent information recorded prior to relining, 1976
Ex-collection: donor, Scotch Plains, N.J.
Bequest of Dr. J. Ackerman Coles 1926 26.1204

William S. Talbot identified this as definitely by Cropsey. (files)

*****Italian Landscape** (View of Nemi; Lake Nemi) 1879
Oil on canvas 32"x55½" (81.3x141.0 cm)
Signed and dated: lower right, "J. F. Cropsey/1879"
Reverse: label, Cleveland Museum of Art, #15540/8
Ex-collection: donor, Scotch Plains, N.J.
Bequest of Dr. J. Ackerman Coles 1926 26.1235

William S. Talbot believed that this is Lake Nemi (Italy) which Cropsey exhibited as #490 in the National Academy of Design exhibition, 1879. Cropsey painted Nemi several times and did sketches of it as early as 1847.

*****Greenwood Lake** 1862 or 1864
Oil on canvas 27½"x53" (69.8x134.6 cm)
Signed: lower right, "1862 (or 1864) J. F. Cropsey"
Ex-collection: donor, Madison, N.J.
Gift of Mrs. Hilda Potter in memory of Eleanor B. Gifford
1956 56.11

William S. Talbot believed that this work should be dated 1864, thus making it an American work instead of English. He also thought that it was the Greenwood Lake listed as #465 in the 1865 National Academy of Design show. Talbot noted that Cropsey recorded a Greenwood Lake sold at the end of 1864 to George Gifford. A description of that painting in the May 12, 1865, New York Times matches this one, as does the connection to the Gifford family.

Greenwood Lake 1871
Oil on canvas 12"x20" (30.5x50.8 cm)
Signed: lower left, "J. F. Cropsey/1871"
Ex-collection: donor, Orange, N.J.
Gift of Miss Mary Dyckman 1959 59.368

Imaginary Landscape 1850
Oil on canvas 14⅜"x21½" (36.5x54.6 cm)
Signed and dated: lower right, "J. F. Cropsey/1850"
Ex-collection: donors, New York, N.Y.
Gift of Mr. and Mrs. Orrin W. June 1960 60.593

CUMMINGS, WILLARD W. (b. 1915)

Portrait of Katherine Coffey (1900-1972) 1958
Oil on canvas 55½"x32¼" (141.0x81.9 cm)
Signed and dated: lower left, "Willard Cummings/1958"
Ex-collection: commissioned through Maynard Walker Gallery, New
York, N.Y.
Purchase 1958 Franklin Conklin, Jr. Purchase Fund 58.91

Miss Coffey was Director of The Newark Museum from 1949 to 1968.

CURTIS, RONALD (20th century)

Wave #4 1967
Acrylic on canvas. Four panels:
A 8⅛"x8¼" (20.6x20.9 cm)
B 79"x8" (200.6x20.3 cm)
C 102"x8" (259.1x20.3 cm)
D 111¾"x8" (283.8x20.3 cm)
Unsigned
Reverse: label, Selected Work by Contemporary N.J. Artists,
Newark Museum, 1968
Ex-collection: purchased from the artist, Roosevelt, N.J.
Purchase 1968 Carrie B. F. Fuld Bequest Fund 68.132 A-D

CUSUMANO, STEFANO (b. 1912)

Landscape 1957
Flow pen on paper 25¼"x37¾" (64.1x95.9 cm)
Signed and dated: lower right, "Cusumano '57"
Ex-collection: donor, New York, N.Y.
Gift of Charles Z. Mann 1962 62.11

CUTHBERT, VIRGINIA (b. 1908)

Talpa Grave Yard ca. 1949
Oil on panel 22"x36" (90.5x55.9 cm)
Signed: lower right, "Virginia Cuthbert"
Reverse: "Virginia Cuthbert (twice)/Oil on panel (twice)/#37
Talpa Grave Yard, c. 1949"
Ex-collection: acquired by donor from artist, Buffalo, N.Y.
Anonymous gift in memory of Nell Schoellkopf Ely Miller
1975 75.193

CUYPERS, FRANCIS A.

Portrait of Lydia Lavinia Ward (1821-1858) 1859
Oil on canvas 30"x25" (76.2x63.5 cm; upper two corners of stretcher
arched and canvas bent over stretcher to fit)
Signed and dated: lower right, "F. A. Cuypers/NJ/1859"
Ex-collection: remained in Ward family, Newark, N.J.
Marcus L. Ward, Jr. Bequest 1921 21.1759

Posthumous portrait from a daguerreotype of sister of Marcus L. Ward
(1812-1884). See Read 21.1752.

DABO, LEON (1868-1960)

Seashore early 20th century
Oil on canvas 30"x34" (76.2x86.4 cm)
Signed: lower right, "(monogram) Leon Dabo"
Ex-collection: donor, New York, N.Y.
Gift of Henry Wellington Wack 1926 26.213

DALZEL, M. J. (19th century)

The Cottagers
Watercolor 24"x31⅞" (61.0x81.0 cm)
Signed: right side, "The Cottagers. M. J. Dalzel"
Reverse: inscribed on black glass mat, "The Cottages M. J. Dalzel"
Ex-collection: Phoenix family, Mendham, N.J.; donor, East Orange, N.J.
Gift of Joseph A. Vanderhoof 1924 24.2351

Collage element at right: figure of child cut out and pasted on. Dalzel was
supposedly an early 19th century missionary in Turkey.

DANOVICH, FRANCIS (b. 1920)

Round House 1938
Watercolor on paper 21½"x29¼" (54.6x74.3 cm)
Signed: lower left, "F. Danovich"
Reverse: label, WPA Art Program; label, WPA Contemporary Arts Project
— New York World's Fair, 1940, Queens
Allocated by the WPA Federal Art Project 1943 43.202

Date supplied by artist.

DATZ, A. MARK (b. Russia 1889-1969)

Field Day
Oil on canvas 20½"x16½" (52.1x41.9 cm)
Signed: lower right, "A. Mark Datz"
Ex-collection: the artist, New York, N.Y.
Gift of Harry Mizrach through the Federation of Modern Painters and
Sculptors, Museum Gift Plan 1955 55.162

DAVIES, ARTHUR B. (1862-1928)

Indian Fantasy ca. 1918
Oil on canvas 17⅝"x16⅛" (44.8x41.0 cm)
Unsigned
Ex-collection: Macbeth Gallery, New York, N.Y., to donor, New York,
N.Y.
Bequest of Miss Lillie Bliss 1931 31.322

Previously dated "about 1920," but was included in A. B. Davies
exhibition at Macbeth Galleries, 1918 (#1 of oils in "Large Gallery").

Miss Bliss was a patron of Davies.

Footlog on Jonathan Creek, North Carolina
Oil on canvas 11¼"x13" (28.6x33.0 cm)
Signed: lower right, "A. B. Davies"
Reverse: label, *Painting by AB Davies*, Tucson Art Center, 1967; label,
Painting by AB Davies, University of Utah, 1967; label, *The Eight*,
Museum of Modern Art, 1964 (painting relined 1965)
Ex-collection: donor, New York, N.Y.
Bequest of Miss Lillie Bliss 1931 31.323

In the Museum of Modern Art exhibition, The Eight, *1964, this painting*
was grouped with works of 1898 and 1904, although its exact date is not
known. Davies' Valley of the Jonathan *at the Museum of Fine Arts,*
Boston, dates from 1908.

***Marmoreal Dream** ca. 1920
Oil on canvas 66¼"x36¼" (168.3x92.1 cm)
Unsigned
Reverse: Painting relined prior to entering Newark Museum collection;
label, Brooklyn Museum, 1926 (lent by Miss Bliss); label, from Museum
of Modern Art to Macbeth Galleries, Museum No. 31.292; label, *Arthur*
B. Davies Centennial (#65), Munson-Williams-Proctor Institute, 1962
Ex-collection: Macbeth Galleries, New York, N.Y.; to donor, New York,
N.Y.
Bequest of Miss Lillie Bliss 1931 31.324

Exhibition at Macbeth Galleries, 1920, confirms ca. 1920 dating on
stylistic evidence. Also exhibited as an anonymous loan in A. B. Davies
Memorial Exhibition (#117) at Metropolitan Museum of Art, 1930, and
#47 in the Bliss Memorial exhibition at the Museum of Modern Art, 1931.

Wing on the Sea ca. 1918
Oil on canvas 20¼"x42½" (51.4x108.0 cm)
Signed: lower left, "A. B. Davies"
Reverse: label, Montross Gallery, New York City; label, *AB Davies Centennial* (#71) Munson-Williams-Proctor Institute, 1962
Ex-collection: Macbeth Galleries, New York, N.Y.; to donor, New York, N.Y.
Bequest of Miss Lillie Bliss 1931 31.325

Previously dated "about 1920," but was included in A. B. Davies exhibition at Macbeth Galleries, 1918 (#28). Exhibited as anonymous loan in A. B. Davies Memorial Exhibition at the Metropolitan Museum of Art, 1930 (#114).

Nude Study: Torso and Arm
Charcoal and white chalk drawing on brown paper 17¾"x13¼" (45.1x33.7 cm)
Unsigned
Ex-collection: artist to his son, the donor, Congers, N.Y.
Gift of Mr. and Mrs. Niles M. Davies 1958 58.94

Study of Female Nude
Charcoal and white chalk drawing on brown paper 17¾"x13⅛" (45.1x33.3 cm)
Unsigned
Ex-collection: the artist to his son, the donor, Congers, N.Y.
Gift of Mr. and Mrs. Niles M. Davies 1958 58.95

***Nudes in a Landscape**
Oil on canvas 34"x48¼" (86.4x122.6 cm)
Unsigned
Ex-collection: donor, New York, N.Y.
Gift of Miss Mary A. H. Rumsey 1958 58.186

According to William H. Gerdts, the title is Orchard of Bounties. *(files)*

Study of Female Figure and Head early 20th century
Chalk drawing on grey paper 14½"x10⅛" (36.8x25.7 cm)
Unsigned
Ex-collection: estate of Arthur B. Davies; to Castellane Gallery, New York, N.Y.; to donors, East Orange, N.J. (1950's)
Gift of Mr. and Mrs. Harry L. Tepper 1970 70.37

Drawing extends over two pieces of paper pasted together.

Study of Tahamut prior to 1910-15
White chalk drawing on grey paper 14"x10⅛" (35.6x25.7 cm)
Unsigned
Ex-collection: estate of Arthur B. Davies; to Castellane Gallery, New York, N.Y.; to donors, East Orange, N.J. (1950's)
Gift of Mr. and Mrs. Harry L. Tepper 1970 70.38

Drawing extends over two pieces of paper which overlap. Date and subject have been identified by the artist's daughter, Ronnie Owen. Tahamut, a full-bred Indian and a frequent Davies model, became tubercular about 1910-15 and Davies sent him to Arizona where he subsequently died. Mrs. Owen felt that this study and #70.39 must have been done prior to Tahamut's illness. (files)

Study of Tahamut prior to 1910-15
Chalk drawing on brown paper 7"x12½" (17.9x30.5 cm)
Unsigned
Ex-collection: estate of Arthur B. Davies; to Castellane Gallery, New York, N.Y.; to donors, East Orange, N.J. (1950's)
Gift of Mr. and Mrs. Harry L. Tepper 1970 70.39

DAVIS, LEW E. (b. 1910)

Farm — Watchung Mts. 1934
Oil on composition board 18¼"x23¾" (46.4x60.3 cm)
Signed: lower right, "Lew E. Davis"
Reverse: inscribed and dated in artist's hand, "Farm-Watchung Mts./Lew E. Davis/1934"
Allocated by the N.Y. Regional Committee of the U.S. Treasury Department, Public Works of Art Project 1934 34.299

Railroad Siding 1934
Gouache on paper 16"x20" (40.6x50.8 cm)
Signed and dated: lower right, "Lew E. Davis/34"
Allocated by the N.Y. Regional Committee of the U.S. Treasury Department, P.W.A.P. 1934 34.300

Cottage Place ca. 1933-34
Gouache 6"x20" (40.6x50.8 cm)
Signed: lower right, "Lewis Davis"
Allocated by the N.Y. Regional Committee of the U.S. Treasury Department, P.W.A.P. 1934 34.301

DAVIS, STUART (1894-1964)

***Town Square** 1925-26
Watercolor on paper 15⅜"x22½" (39.1x57.1 cm)
Signed: lower right, "Stuart Davis"
Reverse: inscribed on mat, possibly in artist's hand, "Stuart Davis-Town Square"; stamp on backing, "The Downtown Gallery"
Ex-collection: The Downtown Gallery, New York, N.Y.
Purchase 1930 The General Fund 30.74

Painted in Rockport, Me. In 1940, Davis wrote that his "four pictures (30.74, 37.111, 37.112 and 37.119) in The Newark Museum are all records of my interest in the various color-space positions which I have found in nature and which are everybody's property who has energy enough to look for them." He also stated that his four works were painted between 1928 and 1930. (files)

Street in Paris 1928
Gouache on cardboard 19⅝"x15⅛" (49.9x38.4 cm)
Signed: lower right, "Stuart Davis"
Ex-collection: private collection, New York, N.Y.
Anonymous gift 1937 37.111

The title when received was Rue du Main. *No such street exists, although there is a Rue du Maine in Paris. The street sign in the painting is a generalized rendering in which the name appears to be "Rue des Ra," followed by an abstracted arrondissement numeral.*

***Gasoline Tank** (Gas Pumps) 1930
Watercolor on paper 15⅞"x20⅞" (40.3x53.0 cm)
Signed: lower right, "Stuart Davis"
Ex-collection: private collection, New York, N.Y.
Anonymous gift 1937 37.112

***Place des Vosges No. 1** 1928
Oil on canvas 21"x28¾" (53.4x73.1 cm)
Signed: lower right, "Stuart Davis"
Reverse: label, National Collection of Fine Arts, *Davis Memorial Exhibition*, 1965
Ex-collection: private collection, New York, N.Y.
Anonymous gift 1937 37.119

Date supplied by the artist. (files)

***Negro Dance Hall** ca. 1915
Crayon and ink on paper 25½"x18⅞" (64.8x47.9 cm)
Signed: bottom center, "Stuart Davis"
Ex-collection: the artist, to his wife, New York, N.Y.
Gift of Mrs. Stuart Davis 1972 72.144

The dance hall was probably in Newark, where jazz in Black clubs and halls was an inspiration to those interested in popular music. Davis made many drawings of these scenes.

DAVIS, WARREN (See George Elmer Browne 49.469)

DAY, JOHN (b. 1932)

*Erebos-Eastern Corridor** 1973
Oil and collage on canvas 60"x66" (152.3x167.5 cm)
Reverse: middle stretcher, "Erebos Grand Couloir de l'Est/John Day";
label, Alonzo Gallery; label, Hudson River Museum International
Exhibition 11/16/74-1/19/75; label, Galerie Darthea Speyer, Paris
Ex-collection: with Alonzo Gallery Inc., New York, N.Y.
Purchase 1977 The Members' Fund 77.168

Purchased from 1st New Jersey Artists Biennial 1977.

DAY, WÖRDEN (b. 1916)

Wilderness 1959
Oil and collage on canvas 48"x72" (120.9x182.9 cm)
Signed: middle right, "Worden Day"
Ex-collection: the artist, Upper Montclair, N.J.
Gift of the artist 1962 62.126

Date supplied by the artist. (files)

DE BOSCHNEK, CHRISTIAN (b. France 1947)

Untitled 1973
Oil on canvas 88"x69" (223.5x175.3 cm)
Reverse: inscribed, "Christian de Boschnek/88x69/#27/1973"
Ex-collection: with Stan Gurell, New York, N.Y.
Gift of Ira Howard Levy 1976 76.146

DE DIEGO, JULIO (Spain 1900-1979)

Bridge and Blue Characters 1943
Oil on canvas 14"x30" (35.6x76.2 cm)
Signed and dated: lower right, "de Diego/'43"
Ex-collection: the artist, Woodstock, N.Y.
Gift of Mrs. C. Suydam Cutting 1951 51.39

*Selected from Artists Equity Association exhibition at The Lighthouse,
New York, N.Y.*

DEE, LEO (b. 1931)

*Self Portrait** 1958
Pencil and paper collage 30"x36⅜" (76.2x92.4 cm)
Signed and dated: upper right, "Leo Dee 1958"
Ex-collection: purchased from the artist, Newark, N.J.
Purchase 1959 Rabin and Krueger American Drawing
Fund 59.376

*Reflections in White** 1959
Oil on canvas 54"x36" (137.2x91.5 cm)
Signed and dated: lower right, "Leo Dee/'59"
Ex-collection: purchased from the artist, Newark, N.J.
Purchase 1962 Mrs. Felix Fuld Bequest Fund 62.147

DE HAVEN, FRANKLIN (1856-1934)

Symphony — Golden Morning
Oil on canvas 24"x30" (61.0x76.2 cm)
Signed: lower left, "De Haven"
Reverse: handwritten label on stretcher (probably in artist's hand),
"Golden Morning/Maranacook Maine"
Ex-collection: donor, New York, N.Y.
Gift of Mrs. Emily Marx in memory of Mrs. Selma Laufer
1929 29.265

DEHN, ADOLF (1895-1968)

Park Scene 1924
Pen and ink on paper 16"x20¾" (40.6x52.7 cm)
Signed and dated: lower right, "Adolf Dehn 1924./-Seid Fruchtbar und
Vermehret Euch.-/For Margaret, Adolf."
Ex-collection: donor, New York, N.Y.
Gift of Mrs. Margaret DeSilver 1959 59.404

Paris, Springtime 1924
Pen and ink on paper 13⅜"x18⅛" (34.0x46.7 cm)
Signed and dated: lower left, "Adolf Dehn 24. Paris, Springtime"
Ex-collection: donor, New York, N.Y.
Gift of Mrs. Margaret DeSilver 1959 59.405

*The artist aided Mrs. DeSilver in her selection of these works from her
collection as a gift to the Museum. (files)*

de KOONING, WILLEM (b. Holland 1904)

*Seated Woman** 1966-67
Charcoal drawing on tracing paper 20"x24" (50.8x61.0 cm)
Signed: lower right, "de Kooning"
Ex-collection: with M. Knoedler & Co., New York, N.Y.
Purchase 1971 Sophronia Anderson Bequest Fund 71.164

DeLANEY, BEAUFORD (b. 1905)

Portrait of a Man 1943
Pastel on paper 19⅛"x17" (48.6x43.2 cm)
Signed and dated: lower right, "Beauford DeLaney 43"
Reverse: label on backing, "Bienfang Paper Company/NYC to ship to
Elting Paint Supply Co/NYC"
Ex-collection: donor, New York, N.Y.
Gift of the artist 1943 43.137

DeLAURA, ANGELA (b. 1943)

*D1 3-TG257** 1970
Acrylic and ink on canvas 48"x48" (122.0x122.0 cm)
Reverse: "Angela DeLaura 1970"
Ex-collection: with Touchstone Gallery, New York, N.Y.
Purchase 1974 with grants from the National Endowment for the Arts
and the Charles W. Engelhard Foundation 74.56

DE MERS, JOSEPH (b. 1910)

Post No Bills
Watercolor on paper (sight) 14"x21½" (35.6x54.6 cm)
Unsigned
Allocated by the WPA Federal Art Project 1943 43.201

DEMUTH, CHARLES (1883-1935)

*Tomatoes, Peppers and Zinnias** ca. 1927
Watercolor on paper 18"x11⅞" (45.7x30.2 cm)
Unsigned
Reverse: very faint preparatory pencil drawing for this work; inscribed
(not by artist) on original cardboard mounting, "Executed by Charles
Demuth about 1927. Willed to Cobert [sic] E. Locker"
Ex-collection: bequeathed by artist to Robert E. Locher, Lancaster, Pa.;
to Richard Weyand, Lancaster, Pa., by inheritance; Kraushaar
Galleries, New York, N.Y.
Purchase 1948 Arthur F. Egner Memorial Fund 48.150

*Correspondence from Alvord Eiseman indicates that the inscription on
reverse was written by either Robert E. Locher (who inherited all unsold
Demuth watercolors) or Richard Weyand (who inherited watercolors from
Locher).*

DERRICK, WILLIAM R. (1857-1941)

Ghost Tree before 1937
Oil on canvas 21¾"x29¹⁵/₁₆" (55.4x76.0 cm)
Signed: lower left, "Derrick"
Reverse: label, written by donor, "Restored Vibert's Restoration 1937"
Ex-collection: donor, Short Hills, N.J.
Bequest of Miss Cora Louise Hartshorn 1958 58.179

The Pond
Oil on canvas 21¾"x30" (55.3x76.2 cm)
Signed: lower left, "Derrick"
Ex-collection: donor, Short Hills, N.J.
Bequest of Miss Cora Louise Hartshorn 1958 58.175

The pond depicted was on the Hartshorn estate in Short Hills. (files)

Mother Turkey with Chicks (Mother Turkey)
Oil on canvas 26½"x36" (67.3x91.4 cm)
Signed: lower left (twice), "WR Derrick"
Reverse: hand written label, "Property of Cora L. Hartshorn"; label
hand written by donor, "Willed to Newark Museum/ 'Mother Turkey
with Chicks'/Painted at Short Hills, N.J./ by William R. Derrick"
Ex-collection: donor, Short Hills, N.J.
Bequest of Miss Cora Louise Hartshorn 1958 58.180

DEWING, THOMAS W. (1851-1938)

*Pastel #207** (Standing Female)
Pastel on cardboard 14⅜"x11⅛" (36.5x28.2 cm)
Signed: lower right, "TW Dewing/207"
Ex-collection: Victor Spark, New York, N.Y.
Gift of Mr. and Mrs. Victor Spark in memory of Pfc Donald W. Spark
U.S.M.C.R., born August 17, 1923, Long Branch, N.J., killed in action
June 1944, Saipan, Marianas Islands, and dedicated to the Fourth
Marine Division, Fleet Marine Force 1944 44.196

DIAMOND, MARTHA (b. 1944)

Untitled
Acrylic on paper 35¼"x21¾" (89.5x55.3 cm)
Signed: lower right, "Martha Diamond"
Ex-collection: with Brooke Alexander Inc., New York, N.Y.; to donors,
New York, N.Y.
Gift of Mr. and Mrs. Henry Feiwel 1977 77.237

DICKINSON, PRESTON (1889-1930)

*The Bridge** (Highbridge) ca. 1922-23
Pastel, gouache, pencil on paper 19"x12⅜" (48.3x31.5 cm)
Unsigned
Reverse: label, The Downtown Gallery, N.Y.C. ("Landscapes"); stamp
on original backing, The Downtown Gallery
Ex-collection: The Downtown Gallery, New York, N.Y.
Purchase 1930 The General Fund 30.73

*A collotype of this work by Piper and Company was authorized and issued
by Charles Daniel, New York, N.Y.* (corres.)

*Washington Bridge** 1922
Pastel, chalk, ink and graphite on paper 19"x25⅛" (48.3x63.8 cm)
Signed and dated: lower left, "P Dickinson/22"
Ex-collection: donor, Short Hills, N.J.
Gift of Miss Cora Louise Hartshorn 1951 51.149

Exhibited at the Pennsylvania Academy of Fine Arts, 1922, in 20th Annual
Philadelphia Watercolor *exhibition.*

Western Landscape (Outskirts of Omaha, Nebraska) 1924
Pastel on paper 14"x20" (35.6x50.8 cm)
Signed: lower right, "P. Dickinson"
Reverse: label, Walker Galleries, New York, N.Y.; label, Daniel Gallery,
New York, N.Y.
Ex-collection: Daniel Gallery, New York, N.Y. (exhibited as #1 in
Recent Pastels by Preston Dickinson, 1927); to Walker Galleries, New
York, N.Y.; sold at Parke Bernet Galleries, sale #283, lot #8, May 8,
1941; to Bernard Armour, Englewood, N.J.
Gift of Ruth, Rachel and Toby Armour in memory of their father
Bernard R. Armour 1955 55.158

***Factories** 1920
Pencil and gouache on paper 14⅛"x20¾" (35.9x52.7 cm)
Signed and dated: lower right, "P. Dickinson. 20—"
Reverse: label, The Daniel Gallery; torn label, Pennsylvania Academy
of Fine Arts exhibition *Works Showing Later Tendencies in Art,* 1921;
Brooklyn Museum label also recorded
Ex-collection: Daniel Gallery, New York, N.Y.; Walker Gallery, New
York, N.Y.; sold at Parke Bernet Galleries, sale #283, lot #13, May 8,
1941, to Bernard Armour, Englewood, N.J.
Gift of Ruth, Rachel and Toby Armour in memory of their father
Bernard R. Armour 1955 55.159

DILLER, BURGOYNE (1906-1965)

***Number 47** 1962
Oil on canvas 48⅛"x48¼" (122.24x122.55 cm)
Unsigned
Reverse: written on stretcher, "#47 Diller Estate"; label, Museum of
Modern Art, *Art in Embassies* (Budapest); label, Walker Art Center,
Burgoyne Diller Exhibition
Ex-collection: with Noah Goldowsky Gallery, New York, N.Y. (estate of
Burgoyne Diller)
Purchase 1970 Newark Museum Purchase Fund 70.67

DIMOCK, EDITH (1876-1955)

Street Sweepers 1926
Watercolor on paper 8⅝"x11¾" (21.9x29.8 cm)
Signed and dated: lower right, "E. Dimock 1926"
Ex-collection: purchased from the artist, New York, N.Y.
Purchase 1929 The General Fund 29.136

Artist was married to William Glackens.

At the Louvre 1927
Watercolor on paper 8½"x12" (21.6x30.5 cm)
Signed and dated: lower right, "E. Dimock 1927"
Ex-collection: purchased from the artist, New York, N.Y.
Purchase 1929 The General Fund 29.137

DOBKIN, ALEXANDER (1908-1975)

Portrait of Abraham Walkowitz (1878-1965) 1943
Oil on canvas 19"x15⅛" (48.3x38.4 cm)
Signed: lower left, "Alexander/Dobkin"
Inscribed; on stretcher, "Alexander Dobkin/Portrait of A. Walkowitz
1943 oil"
Ex-collection: donor, New York, N.Y.
Gift of Abraham Walkowitz 1949 49.346

Executed for exhibition, One Hundred Artists and Walkowitz,
Brooklyn Museum, 1944.

DOGANCAY, BURHAN (b. Turkey 1929)

Untitled 1977
Acrylic on canvas 48"x48" (121.9x121.9 cm)
Reverse: signed on canvas, "B Dogancay/1977/New York";
"B Dogancay" (twice); in ink on edge of canvas, "Richie/1334"
Anonymous gift 1978 78.36

DONATI, ENRICO (b. 1909)

Knight of Akkad 1959
Mixed media on canvas 70"x80" (177.8x203.2 cm)
Signed: lower right, "Donati"
Reverse: inscribed, " 'Sargon Series'/Knight of Akkad/Enrico
Donati,/1959/(monogram)"; label, Betty Parsons Gallery,
New York, N.Y.
Ex-collection: with Betty Parsons Gallery, New York, N.Y.
Purchase 1960 Sophronia Anderson Bequest Fund 60.574

DOUGHTY, THOMAS (1793-1856)

*Desert Rock Lighthouse** 1847
Oil on canvas 27"x41" (68.6x104.1 cm)
Signed and dated: left of center, "T. Doughty/T.D./Paris/1847"
Reverse: no pertinent data recorded prior to relining, 1962
Ex-collection: William McDermott, New York, N.Y.; to his daughter,
the donor, Caldwell, N.J.
Gift of Mrs. Jennie E. Mead 1939 39.146

This painting has been published incorrectly as Eddystone Lighthouse. *It
is a later version of Doughty's* Desert Rock Lighthouse, Maine, *exhibited
at the Boston Athenaeum in 1836.*

DOZIER, OTIS (b. 1904)

Eagle in Crags 1944
Oil on masonite 17⅞"x24⅛" (45.3x61.3 cm)
Signed and dated: lower right, "Otis Dozier/44"
Reverse: inscribed "Eagle in Crags 208"
Ex-collection: with M. Knoedler & Co., New York, N.Y.
Purchase 1945 Thomas L. Raymond Bequest Fund 45.304

DREIER, KATHERINE (1877-1952)

The Garden 1918
Oil on canvas 25"x30" (63.5x76.2 cm)
Reverse: signed and dated, "K. S. Dreier/The Garden/1918"
Ex-collection: donor, New York, N.Y.
Gift of Mrs. Charmion Von Wiegand 1958 58.145

DRUMMER, JOHN E. (b. 1925)

Untitled 1959
Mixed media construction (wood, pebbles, nails) on plywood 96"x48"
(243.8x121.9 cm)
Reverse: signed and dated, "5.59/.D"
Ex-collection: donor, New York, N.Y.
Gift of Mrs. Nancy Ohlin Kalodner 1969 69.173

du BOIS, GUY PÈNE (1884-1958)

*The Corridor** 1914
Oil on canvas 28¼"x21¼" (71.8x54.0 cm)
Signed: lower right, "Guy Pène du Bois/1914"
Reverse: label, AFA, *Surviving the Ages*, 1963-64; label, Nutley Art
Exhibit at Franklin School, Nutley, N.J.
Ex-collection: probably purchased from artist, Stonington, Conn.
Gift of Mrs. Felix Fuld 1925 25.1161

*Artist indicated date ca. 1923-24, contradicting the date on the canvas. He
also stated the painting was done from memory of a scene at the Jefferson
Market Court House, 10th Street and 6th Avenue, New York, N.Y. (files)*

Figure Study 1936
Oil on parchment 17⅝"x11⅞" (44.8x30.2 cm)
Signed and dated: lower right, "Guy Pène duBois/1936"
Reverse: torn label, "Quantico, Md."
Ex-collection: donors, Belmont, N.Y.
Gift of Mr. and Mrs. James M. Hancock 1955 55.91

DUFNER, EDWARD (1872-1957)

Luxembourg, Paris 1903
Oil on canvas 7¼"x9½" (18.4x24.1 cm)
Signed and dated: lower left, "E. Dufner"; lower right, "Luxembourg —
Paris — 1903"
Ex-collection: Joseph S. Isidor
Gift of estate of Rosa Kate Isidor 49.425

DUNCAN, FRANK (b. 1915)

Aquidneck Farm 1956
Oil on canvas 17"x29" (43.2x73.7 cm)
Signed: lower left, "Duncan"
Ex-collection: acquired from the artist
Gift of the American Academy of Arts & Letters Childe Hassam Fund
1957 57.23

DUNLAP, WILLIAM (1766-1839)

*Portrait of the Beck Sisters** (The Sisters) 1829
Oil on canvas 36"x30" (91.4x76.2 cm)
Signed and dated: lower left, "W. Dunlap/1829"
Ex-collection: Dr. R. Beck; to Catherine Beck Van Cortlandt; to Mrs.
Catherine Van Cortlandt Mathews and Mrs. William V. Mason; to
Victor Spark, New York, N.Y.; to donor, New York, N.Y.
Gift of Mr. and Mrs. Orrin W. June 1961 61.462

Executed in Albany, N.Y., this painting was exhibited as The Sisters *in the
1830 National Academy of Design annual exhibition in New York City.
Catherine Beck (1818-1895) married Pierre Van Cortlandt III and Helen
Beck married William Parmelee. (files) Dunlap was author of* History of
the Rise and Progress of the Arts of Design in the United States, *1834.*

DURAN, RONALD [Tolene] (d. 1961)

Bow, Arrow and Shield Dance ca. 1930
Gouache on paper 10⅞"x14" (27.6x35.6 cm)
Signed: lower right, "Bow, Arrow and Shield Dance/Picuris Pueblo,
N.M./by Tolene"
Gift of Miss Amelia E. White 1937 37.156

DURAND, ASHER B. (1796-1886)

*Portrait of the Artist's Wife and Her Sister** 1834
Oil on canvas 36¼"x29⅛" (92.1x74.0 cm)
Unsigned
Inscribed and dated lower left, "M.F./JCF/183[4]"
Ex-collection: painting descended through the children of Durand's
second wife, Mary Frank, to donor, Maplewood, N.J.
Bequest of Mrs. Helen Thompson Durand 1935 35.32

*David Lawall showed that the inscription refers to Durand's second wife
Mary Frank (1811-1857), the figure on right, and her sister Jane Cordelia
Frank (1820-1886). This painting is possibly Durand's* Full Length
Portrait of Ladies, *#90 in 1834 National Academy of Design exhibition.
(corres.)*

*Landscape** 1849
Oil on canvas 30"x42" (76.2x106.7 cm)
Signed and dated: lower left, "A. B. Durand/1849"
Reverse: label, "Jo y" (John Levy?); label, Asher B. Durand,
Montclair Museum of Art, 1971
Ex-collection: William S. Appleton, Boston, Mass.; M. Knoedler & Co.,
New York, N.Y.
Purchase 1956 Wallace M. Scudder Bequest Fund 56.181

William H. Gerdts suggested that this is Durand's A View of Schroon
Lake, *#11 in the 1850 National Academy of Design annual exhibition.*

DURAND, ELIAS WADE (1824-1908)

Landscape Study ca. 1900
Oil on canvas 16⅞"x21¼" (42.9x54.0 cm)
Unsigned
Ex-collection: collection of the artist; to his granddaughter, Effie
Durand Gray, Irvington, N.J.; to Nathan Krueger (Rabin and Krueger
Gallery), Irvington, N.J.
Gift of Rabin and Krueger Gallery 1961 61.36

*Artist's granddaughter, Effie Durand Gray, stated that this is one of
about 50 unfinished studies left by the artist at his death. His father,
Cyrus Durand, was a brother of Asher B. Durand. (corres.)*

DUVENECK, FRANK (1848-1919)

Girl with Red Blouse ca. 1900
Oil on canvas 22"x18" (55.8x45.7 cm)
Signed: left of center (with monogram)
Inscribed on stretcher: "Frank Duveneck/Girl with Red Blouse/L-8095"
Ex-collection: acquired from the artist by donor, New York, N.Y.
Gift of Mrs. Marie R. MacPherson 1952 52.49

*A note on the back of an early photo of this painting says "painted in 1902
in Cincinnati, Ohio." (files)*

DYER, BRIGGS (b. 1911)

Street in Galena 1938
Oil on canvas 25"x37" (63.5x94.0 cm)
Signed: lower left, "B. Dyer/Galena"
Reverse: on stretcher, "Lincoln Park/April 1938"
Reverse: label, Corcoran Gallery of Art, 17th Biennial Exhibition of
Paintings by Contemporary American Artists, 1941 (#294 in exhibition)
Ex-collection: with Contemporary Arts Gallery, New York, N.Y.; to
donors, New York, N.Y. (1943)
Gift of Mr. and Mrs. Milton Lowenthal 1946 46.171

*The artist stated that he executed the painting from a watercolor done
previously in Galena, Ill. (files)*

DZUBAS, FRIEDEL (b. 1915)

Forgetmenot 1968
Acrylic on canvas 19"x242" (48.3x614.7 cm)
Reverse: signed and dated, "Dzubas/68"
Ex-collection: donor, New York, N.Y.
Gift of the André Emmerich Gallery 1969 69.136

EAKINS, THOMAS (1844-1916)

***Man in the Red Necktie** (Portrait of Dr. Joseph Leidy II) ca. 1890
Oil on canvas 50"x36" (127.0x91.4 cm)
Signed: lower right, "Eakins"
Reverse: inscribed, "T.E." (photos of initials made during 1948
restoration); painting was relined prior to entering Newark Museum
collection; handwritten label, attached to frame, "For Exhibition
at/Philadelphia Art Alliance Bldg./25: S. 18th St."
Ex-collection: Mrs. Thomas Eakins; Newman Gallery, Philadelphia, Pa.
Purchased 1935 Wallace M. Scudder Bequest Fund 35.78

*The first and larger version of Eakins' two portraits of Dr. Leidy, the
anesthetist who is also depicted in Eakins' painting of* The Agnew Clinic
*(1889). The date of the second portrait of Dr. Leidy, 1890, gives some
indication of the date of Newark's work.*

*According to Gordon Hendricks, Eakins' wife may have executed both the
signature and the handwritten label (files). She owned the painting in
1929, when it was included in the Philadelphia Art Alliance's group show,*
Portraits of Prominent Philadelphians by Distinguished Artists. *The
Philadelphia Art Alliance has no record of the painting being included in
any of its Eakins exhibitions. (files)*

***Study, Portrait of Harrison S. Morris** (1856-1948) ca. 1896
Oil on canvas 18¼"x13⅜" (46.4x34.0 cm)
Signed: lower right "Eakins"
Reverse: label, Eakins Estate 1939 135/295/Babcock Galleries agent;
label, No. 3934; label, 22. Study for Portrait of M. S. Morris 1896;
handwritten label, "Study for Portrait of a Man/Harrison S.
Morris/Painted by Thomas Eakins/This is a typical example of Mr.
Eakins/method in painting his pictures, by making/a preliminary
study of his subject"
Ex-collection: estate of artist's widow; to Miss Madeline Williams;
E. C. Babcock, New York, N.Y.
Purchase 1939 Wallace M. Scudder Bequest Fund 39.266

*Harrison S. Morris was managing director of the Pennsylvania Academy
of The Fine Arts from 1892 until 1905. The final, larger version of this
portrait was painted by Eakins at the time of Morris' marriage, June 1896.
The sketch was probably done the same year. It is possible that the
handwritten label was added by the artist's widow.*

In Lloyd Goodrich's Thomas Eakins: His Life and Work, *1933, this sketch
(#295) is described as "squared off for enlarging; canvas mounted to
cardboard." The mounting was rectified in a 1953 restoration and the grid
is apparent.*

***Legs of a Seated Model** ca. 1866
Charcoal on paper 23¾"x18½" (60.3x47.0 cm)
Inscribed: upper right, "T.M./L.O./?/P.N."; lower left, "Drawing
by/Thomas Eakins"
Reverse: label on backing, "Eakins Estate 1939/Babcock Galleries,
agent/Drawing #200/39,legs"
II
Ex-collection: estate of the artist's widow; to Miss Madeline Williams;
E. C. Babcock, New York, N.Y.
Purchase 1939 Wallace M. Scudder Bequest Fund and Endowment
Fund 39.267

*This drawing was irregular in size before restoration, having been clipped
6"x5¼" from lower left. Above the removed area is the inscription,
"Drawing by/Thomas Eakins." Gordon Hendricks feels this was written by
Eakins' student, Charles Brigler. (files) Originally dated by Lloyd
Goodrich in* Thomas Eakins: His Life and Art *(#11), 1933, as work done
before an early trip to Europe.*

EARL, RALPH (1751-1801)

***Portrait of Mrs. Nathaniel Taylor** [Tamar Boardman] (1723-95)
ca. 1790
Oil on canvas 47¾"x36¾" (121.3x93.3 cm)
Unsigned
Ex-collection: Nathaniel Taylor, Jr.; to Nathaniel William Taylor; to
George Taylor; to George Taylor Stewart; to George Taylor Stewart,
Johnson, R.I.; to Nathalie Taylor Stewart; with E. B. Leete Co.,
Guilford, Conn.; with John Levy Galleries, New York, N.Y.
Purchase 1947 Sophronia Anderson Bequest Fund 47.51

*From 1789 to 1795, Ralph Earl is known to have painted at least nineteen
members of the Boardman family as well as many members of the Taylor
family. (files) The last Taylor descendant to own this painting also owned
the companion portrait of the Reverend Nathaniel Taylor, pastor of the
Congregational Church in New Milford, Conn., from 1749 to 1800. Mrs.
Taylor's father had been his predecessor there. (files)*

***Portrait of John Hyndman** ca. 1783-84
Oil on canvas 50"x40" (127.0x101.6 cm)
Unsigned 59.409
Reverse: (before lining) handwritten label, "This Portrait of
Mr/Hyndman belongs to/Miss Mary L. MacPherson"/signed "Isabella
Hutchins"

***Portrait of Mrs. John Hyndman** ca. 1783-84
Oil on canvas 50¼"x40¼" (127.6x102.3 cm)
Unsigned 59.410
Reverse: (before lining) inscribed "The Property of/Miss Mary _____
MacPherson"; "This Picture and the/companion are the property
of/Miss Mary L. MacPherson"
Ex-collection: Miss Mary L. MacPherson; Victor Spark (purchased in
England); to donors, New York, N.Y.
Gifts of Mr. and Mrs. Orrin W. June 1959

*Lawrence Goodrich has dated the Hyndman portraits. They were
presumably painted in England, where Earl resided from 1778 to 1785.
(corres.) The paintings were cut down in size before the Museum received
them. A folded sheet of paper in the subject's left hand, inscribed "John
Hyndman Esq/London," identifies the sitter.*

EATON, CHARLES WARREN (1857-1937)

Green and Gold 1933 or before
Pastel on canvas 24"x20" (61.0x50.8 cm)
Signed: lower left, "Chas Warren Eaton"
Reverse: label, "Exempt Label/1933/American Water Color
Society/Green and Gold/Charles Warren Eaton/Bloomfield, N.J./
W. Budworth and Son"; sticker on frame, "#12-9"; "Newcomb-Macklin
Co., New York" (framer)
Gift of Woman's Club of Orange, N.J. 1976 76.127

EDDY, OLIVER TARBELL (1799-1868)

***Portrait of the Children of William Rankin, Sr.** 1838
Oil on canvas 71"x60" (180.3x152.9 cm)
Unsigned
Reverse: handwritten label, "Portrait of/children of William/Rankin/
artist not known"; no pertinent date recorded prior to relining
Ex-collection: painting remained in family of William Rankin until
bequeathed to The Newark Museum by his grandson, Princeton, N.J.
Bequest of Dr. Walter M. Rankin 1947 47.53

*Painting depicts the four youngest Rankin children: Lucinda Caroline
(1822-1900), Henry Van Vleck (1825-63), Matilda Whiting (1829-38) and
John Joseph (1831-53). The painter and date are documented by Rankin
family correspondence. Other Rankin portraits in the Museum collection
are Eddy's portraits of Phebe Rankin Goble (49.218, 57.122), William
Rankin (56.172) and Rembrandt Peale's portrait of William Rankin
(47.52).*

***Portrait of Mrs. John L. Goble** (Phebe Ann Rankin in Blue)
(1814-90) 1839
Oil on wood 30"x24½" (76.2x62.2 cm)
Unsigned
Ex-collection: sitter; to her sister Mary Rankin Ward; to her grandson,
donor, Newark, N.J.
Gift of Dr. William Rankin Ward 1949 49.218

*This portrait of the third child of William and Abigail Rankin was
executed after the larger Eddy portrait of her in the collection (57.122).
Painter and date are documented in family correspondence.*

Portrait of William Rankin, Sr. (1785-1869) 1839
Oil on wood 30"x24½" (76.2x62.2 cm)
Unsigned
Ex-collection: sitter, Newark, N.J.; to his daughter Mary Rankin Ward;
to her grandson Dr. William Rankin Ward, Newark, N.J.
Gift of the family of Dr. William Rankin Ward 1956 56.172

*Painter and date are documented in family correspondence. William
Rankin was a prominent Newark hat manufacturer and a founder and
first president of the Newark Library Association (1847).*

Portrait of Mrs. John L. Goble [Phebe Ann Rankin]
(1814-1890) 1838-39
Oil on wood 50"x35¼" (127.0x89.5 cm)
Reverse: see note below
Ex-collection: sitter; to her sister Caroline Rankin Hall; to Miss Amy
Duryee; to donor, South Orange, N.J.
Gift of John L. Rankin 1957 57.122

*Painter and date are documented in family correspondence. The
confusion with the portrait of the sitter's father by Rembrandt Peale
(47.52) is evident in the one label on reverse: "portrait of/(Miss) Phoebe
[sic] Ann Rankin/Goble/daughter of Wm. Rankin/by Rembrandt Peale."
Sitter is the same as in Eddy 49.218.*

EDIE, STUART C. (b. 1908)

Still Life 1934
Oil on canvas 16⅜"x9¾" (41.6x24.8 cm)
Signed: lower left, "Edie"
Allocated by the U.S. Treasury Department, PWAP 1934 34.163

Still Life 1934
Gouache on paper 12¾"x14⅞" (32.4x37.8 cm)
Signed: lower right, "Edie"
Allocated by the U.S. Treasury Department, PWAP 1934 34.306

EGGERS, O. R. (19th century)

House of Abraham Ward
Watercolor on paper 9¼"x13⅜" (23.5x34.0 cm)
Signed: lower right, "O. R. Eggers"
Ex-collection: donor, New York, N.Y.
Gift of Mrs. A. R. Estey 1920 20.713

EGGLESTON, BENJAMIN OSRO (1867-1937)

Autumn Day
Oil on canvas 25"x30" (63.5x76.2 cm)
Signed: lower right, "Benjamin Eggleston"
Ex-collection: donor, New York, N.Y.
Gift of Henry Wellington Wack 1927 27.405

EHNINGER J. W. (1827-1889)

***Yankee Peddler**
Oil on canvas 25¾"x32¼" (65.4x81.9 cm)
Signed and dated: lower right, "J. W. Ehninger./Paris 1850"
Reverse: no pertinent data recorded prior to relining, 1969; label,
Whitney Museum of American Art, *The Painter's America*; label,
Oakland (Calif.) Museum, *The Painter's America*
Ex-collection: donor, Passaic, N.J.
Gift of William F. Laporte 1925 25.876

EILSHEMIUS, LOUIS MICHAEL (1864-1941)

By the Spring ca. 1913-21
Oil on cardboard 18¼"x15¼" (46.4x38.7 cm)
Signed: lower right, "Eilshemius"
Reverse: label, Perls Gallery (#2188), New York, N.Y.
Ex-collection: donor, Chicago, Ill.
Gift of Daniel Goldberg 1945 45.313

*This Eilshemius, as well as 45.314, 315, 316 and 317, were consigned to
Perls Gallery in 1945 and subsequently returned unsold to Mr. and Mrs.
Daniel Goldberg.*

*That Eilshemius did not use cardboard until 1901 and that his full
signature appears only on works he executed between 1889 and 1913 help
date this painting. His painting career ended in 1921.*

Landscape with Bathers ca. 1913-21
Oil on cardboard 15½"x20¼" (39.4x51.5 cm)
Signed: lower right, "Eilshemius"
Reverse: label, Perls Gallery (#2185), New York, N.Y.
Ex-collection: donor, Chicago, Ill.
Gift of Daniel Goldberg 1945 45.314

Bathers in Rocky Lake 1920
Oil on cardboard 15¼"x22½" (38.8x57.2 cm)
Signed and dated: lower right, "Eilshemius"; lower left, "1920—"
Reverse: label, Perls Gallery (#2187), New York, N.Y.
Ex-collection: donor, Chicago, Ill.
Gift of Daniel Goldberg 1945 45.315

The Blue Mountains 1920
Oil on cardboard 12¾"x20" (32.4x50.8 cm)
Signed and dated: lower left, "Eilshemius"; lower right, "1920—"
Reverse: label, Perls Gallery (#2186), New York, N.Y.
Ex-collection: donor, Chicago, Ill.
Gift of Daniel Goldberg 1945 45.316

Painted on two layers of cardboard pressed together.

Landscape with Bathing Figures (Landscape with Bathers) 1919
Oil on cardboard 22"x30¼" (55.9x76.8 cm)
Signed and dated: lower left, "Eilshemius—"; lower right, "1919—"
Reverse: label, Perls Gallery, New York, N.Y.
Ex-collection: donor, Chicago, Ill.
Gift of Mrs. Kathryn Goldberg 1945 45.317

Albuquerque Sketchbook ca. 1902-03
Bound, cloth-covered sketchbook, each page: 4⅝"x7" (11.8x17.8 cm)
Unsigned
Inscribed: on inner cover in artist's hand, "Viewpoint
growth/Albuquerque"
Inside cover: label, "Goupil's/Fifth Avenue/&/Twenty-Second Street"
Ex-collection: donor, Stockton, N.J.
Gift of Bernard M. Douglas, Jr. 1941 41.155

Eilshemius travelled in the southern United States, ca. 1902-03.

***The Funeral** 1916
Oil on wood 38¾"x59½" (98.8x151.2 cm)
Signed and dated: lower right, "1916 — Eilshemius"
Ex-collection: Rabin & Krueger Gallery, Newark, N.J.
Purchase 1943 Felix Fuld Bequest Fund 43.92

*Painted by Eilshemius forty years after the death of his brother Victor,
as a memorial. (files)*

***Dance of Sylphs** ca. 1908
Watercolor on paper 13"x19¼" (33.0x48.9 cm)
Signed: lower right, "Eilshemius"
Ex-collection: donors, Stockton, N.J.
Gift of Mr. and Mrs. Bernard M. Douglas 1957 57.3

The date has been tentatively established by similarity to the 1908 oil, The
Dream, *in the Roy Neuberger collection.*

Soldiers in a Landscape 1913-21
Oil on cardboard mounted on masonite 29"x39⅝" (74.3x100.0 cm)
Signed: lower right, "Eilshemius"
Ex-collection: Leo Castelli, Provincetown, Mass. (ca. 1959-61); to
donors, New York, N.Y.
Gift of Mr. and Mrs. Herman Schneider 1962 62.111

ELLIOTT, PHILIP CLARKSON (b. 1903)

Fantasy for Nell ca. 1962
Enamel with collage on masonite 12⅝"x10⅜" (32.1x26.4 cm)
Signed: lower right, "Phil Elliott"
Reverse: inscribed, "In Virginia Cuthbert — Philip Elliott
Retrospective, Charles Burchfield Center, Western New York Forum for
American Art"
Ex-collection: acquired by donor from artist
Anonymous gift in memory of Mrs. Nell Schoelkopf Ely Miller
1975 75.191

EMBRY, NORRIS (1921-1981)

Untitled ca. 1970
Watercolor and collage on paper 21⅜"x29⅛" (54.4x73.9 cm)
Signed: lower right, "Norris"
Ex-collection: donors, Larchmont, N.Y.
Gift of Mr. and Mrs. Henry Feiwel 1970 70.86

EVANS, J. (19th century)

***Portrait of Abigail Couvier Fellows** (1804 -?) 1832
Watercolor on paper 10⅛"x8⅛" (25.7x20.6 cm)
Reverse: "Abigail Couvier Fellows,/Born in Wiscasset, Maine/Nov
14th/1804 Married Moses/Wood in Boston Mass April 1835 — This
portrait/given by her to daughter Martha born/Aug 13th 1838 at No
Hawk St./Albany N.Y. Married Samuel Cary/Bradt at 49 Chester St.
Albany N.Y./Jan 20, 1857. Given by her to/daughter Mary Ellington,
born 49 Chestnut St. Albany Sept 15/1862. Married Rev. Wm H. A. Hall
at/49 Chestnut St. Albany N.Y. June/7th 1892. This portrait
painted/Boston, Mass 1832"
Watermark: J Whatman/Turkey Mill 1829
Ex-collection: Descended in family of sitter; to donor, Morristown, N.J.
Gift of Miss Dorothy Hall 1967 67.31

Gail and Norbert H. Savage in Three New England Watercolor Painters
*(1974) list this work as 1830-32 and the subject as Abigail Courier (or
Couvier) Fellows. They also note that Moses Wood was listed in Hoffman's*
Albany Directory *as a provision dealer.*

EVANS, MINNIE (b. 1892)

#101 ca. 1970
Crayon, tempera, collage on paper 12"x8⅞" (30.5x22.5 cm)
Signed: lower right, "Minnie Evans"
Ex-collection: with Mrs. Nina H. Starr, New York, N.Y.
Purchase 1972 Thomas L. Raymond Bequest Fund 72.141

EVETT, KENNETH (b. 1913)

Landscape
Gouache on paper 8¾"x11" (22.2x27.9 cm)
Unsigned
Allocated by the WPA Federal Art Project 1945 45.239

FAGGI, ALFEO (b. Italy 1885)

Seated Male Nude ca. 1928
Red chalk on paper 15"x9⅞" (38.1x25.1 cm)
Signed: lower right, "A Faggi"; paper mark, lower left, "M/Jano"
Reverse: on paper, initials of former collection
Ex-collection: purchased December, 1928, by donor, New York, N.Y.
Anonymous gift 1940 40.340

FANGOR,WOJCIECH (b. Poland 1922)

NJ 11 1965
Oil on canvas 37"x36¾" (94.0x93.3 cm)
Reverse: signed and dated, "Fangor/NJ 11/1965"
Ex-collection: Fairleigh Dickinson University, Madison, N.J.
Gift of the International Artists' Seminar, Fairleigh Dickinson
University 1966 66.637

***M35** 1968
Oil on canvas 80"x68" (203.0x172.7 cm)
Reverse: signed and dated, "Fangor/M35/1968"
Ex-collection: with Chalette Galerie, New York, N.Y.
Purchase 1969 The Members' Fund 69.159

FARNHAM ALEXANDER (b. 1926)

Canal Gear 1967
Oil on canvas 26″x32″ (66.0x81.3 cm)
Signed: lower right, "A. Farnham"
Ex-collection: purchased from the artist, Stockton, N.J.
Purchase 1968 Franklin Conklin, Jr. Bequest Fund 68.131

Purchased from Newark Museum exhibition, New Jersey Artists, *1968.*

FARRER, HENRY (b. England 1843-1903)

A Gray Day 1899
Watercolor on paper 12″x18″ (30.5x45.7 cm)
Signed and dated: lower left, "H. Farrer 1899"
Ex-collection: donor, South Orange, N.J.
Bequest of Mrs. Felix Fuld 1944 44.322

FAST, FRANCIS REDFORD (1883-1953)

Untitled ca. 1938-1945
Tempera finger painting on paper 17¾″x15″ (45.1x38.1 cm)
Signed: lower left, "F. R. Fast"
Reverse: upper left, stamp, Devoe/Sterling Bristol
Ex-collection: donor, Hillsdale, N.J.
Gift of the artist 1945 45.174

FAUSETT, DEAN (b. 1913)

Landscape
Watercolor on paper 19¾″x28½″ (50.2x72.4 cm)
Signed: lower left, "Dean Fausett"
Ex-collection: purchased at auction by donors, Scarsdale, N.Y.
Gift of Mr. and Mrs. Alan Temple 1959 59.373

FEININGER, LYONEL (1871-1956)

Greiffenberg 1945
Watercolor on paper 12⅝″x19″ (32.1x48.3 cm)
Signed and dated: lower left, "Feininger"; lower right, "23•9•45•"
Ex-collection: Van Dieman-Lelienfeld Galleries, New York, N.Y.
Purchase 1948 Arthur F. Egner Memorial Fund 48.511

White Walls 1953
Oil on canvas 24″x17″ (61.0x43.2 cm)
Signed: lower right, "Feininger"
Reverse: inscribed in pencil on stretcher, "Lyonel Feininger: 1953 'White Walls'"; label, Curt Valentin Gallery, #16065
Ex-collection: Curt Valentin Gallery, New York, N.Y.; to donors, Scarsdale, New York (1955)
Gift of Mr. and Mrs. Alan H. Temple 1960 60.604

FENELLE, STANFORD (b. 1909)

Evening Hills 1937
Watercolor on paper 19″x25½″ (48.3x64.8 cm)
Signed and dated: lower left, "Fenelle '37"
Reverse: label, WPA
Allocated by the WPA Federal Art Project 1943 43.205

FERBER, HERBERT (b. 1906)

Sculpture Study 1973
Gouache on paper 10½″x29½″ (26.7x74.9 cm)
Signed and dated: lower right, "Ferber 7-71"; "For Margery & Henry from/HF-73"
Ex-collection: donors, New York, N.Y.
Gift of Mr. and Mrs. Harry Kahn 1978 78.34

FERRIS, F. (20th century)

Gathering (Turning) 1941
Watercolor on matboard 20″x14 15/16″ (50.8x38.0 cm)
Signed and dated: lower right, "F. Ferris 41"
Reverse: label, WPA (936A)
Allocated by the WPA Federal Art Project 1943 43.18

This work and 43.19, 21 and 22 by Ferris depict steps in glass making and blowing.

Shaping 1941
Watercolor on matboard 20″x15″ (50.8x38.1 cm)
Signed and dated: lower right, "F. Ferris 41"
Reverse: label, WPA (A936A)
Allocated by the WPA Federal Art Project 1943 43.19

Glory Hole (The Blowing Hole) 1941
Watercolor on matboard 20″x15″ (50.8x38.1 cm)
Signed: lower right, "F. Ferris 41"
Reverse: label, WPA (A936A)
Allocated by the WPA Federal Art Project 1943 43.21

The Shop 1941
Oil on canvas 24″x30″ (60.96x76.2 cm)
Signed and dated: lower right, "Ferris/41"
Reverse: label, WPA; stamp on stretcher, "Mar 17 1941"; stamp on stretcher, "24 Anco, Rd; Glendale L.I."
Allocated by the WPA Federal Art Project 1943 43.22

FIENE, ERNEST (b. Germany 1894-1965)

Road to the Village (Entrance to the Village) 1926
Oil on canvas 20¼″x28¼″ (51.4x71.8 cm)
Signed: lower right, "Ernest Fiene"
Ex-collection: Kraushaar Galleries, New York, N.Y.; to donor, New York, N.Y.
Gift of Joseph S. Isidor 1927 27.1239

FIORDALISI, PETER (b. 1904)

Windy Day on the Cliffs 1959
Oil on canvas 22″x28″ (55.9x71.2 cm)
Signed and dated: lower left, "Fiordalisi/59-"
Ex-collection: donor, Weehawken, N.J.
Gift of Edward Crandall 1964 64.244

FISCHER, IDA (1883-1956)

Untitled ca. 1956
Oil on canvas 24″x30″ (61.0x76.2 cm)
Reverse: label on frame, "Ida Fischer/30 Jones St/New York 14"/"handwritten by Ida Fisher" (sic) in another hand (donor)
Ex-collection: acquired by donor, 1956
Anonymous gift 1956 56.444

FISCHER, SAM (b. 1921)

Olive Grove 1957
Oil and collage on masonite 30⅛″x47¾″ (76.5x121.3 cm)
Signed and dated: lower right, "S. Fischer 57"
Reverse: upper right, "Fischer/'57 24"; top bracer, "The Grove"
Ex-collection: donor, New York, N.Y.
Gift of Harry Kahn 1969 69.174

FISH, JANET (b. 1938)

Five Glasses Short 1974
Pastel on paper 20″x26″ (50.8x66.0 cm)
Signed and dated: lower right, "Janet Fish 1974"
Ex-collection: with Kornblee Gallery, New York, N.Y.
Gift of Mr. and Mrs. Robert Benjamin 1975 75.22

FISHER, ALVAN (1792-1863)

*__Near Camden, Maine__ (View of Camden, Maine) ca. 1847
Oil on canvas 34″x48″ (86.4x121.9 cm)
Unsigned
Reverse: label, Vose Galleries; label, Museum of Fine Arts, Boston
(*Centennial of the Works of Alvan Fisher*, 1962)
Ex-collection: painting remained in family of the person who secured
this work directly from Fisher; to Harold C. Speed, Boston, Mass.; to
Vose Galleries, Boston, Mass.; to donors, New York, N.Y.
Gift of Mr. and Mrs. Orrin W. June 1961 61.9

*Fred B. Adelson, in an unpublished work on Fisher, hypothesized that
this painting could be Fisher's* Indians Visiting the Old Hunting
Grounds *which the artist sold at Harding's Gallery, Boston, Mass., to a
"Mr. Lawrence" in April, 1847 (#42 in sale). Adelson based his
argument on comparison of the Newark painting with similar ones at the
White House, the Corcoran Gallery, Washington, D.C., and at the Delaware
Art Museum. If he is correct, Newark's painting would be dated somewhat
earlier than "circa 1850." Although the Museum accepts Adelson's theory
and date, it was thought best to retain the previous title.*

FORST, MILES (b. 1923)

Three Majas
Oil on canvas 51″x63½″ (129.5x161.3 cm)
Unsigned
Ex-collection: with Hansa Gallery, New York, N.Y.
Purchase 1959 Anonymous Fund 59.378

FORTESS, KARL (b. 1907)

Black Dell
Oil on canvas 40″x22″ (101.6x55.9 cm)
Signed: lower left, "K Fortess"
Ex-collection: private collection, New York, N.Y.
Anonymous gift 1953 53.127

FOSSUM, SYDNEY (b. 1909)

The Tracks 1938
Gouache on mat 22″x25⅝″ (55.9x65.1 cm)
Signed and dated: lower right, "Fossum/-38"
Reverse: label, WPA Art Program; label, WPA, Contemporary Arts
Project — New York World's Fair, 1940, Queens
Allocated by the WPA Federal Art Project 1943 43.198

FOSTER, BEN (1852-1926)

Landscape ca. 1926
Oil on canvas 20″x15″ (50.8x38.1 cm)
Unsigned
Reverse: label on frame, "To be delivered to Mr. Edwin Baldwin/19 W
31st St/NYC"; label on stretcher, "Landscape/painted by Ben Foster
NA/Property of Edwin Baldwin Esq/31 Nassau St NY"; label on
stretcher, "Consign #/95" "Oct 6/1926"
Ex-collection: Edwin Baldwin, New York, N.Y.; with American Art
Gallery, New York, N.Y.
Gift of Mrs. Felix Fuld 1927 27.18

FOSTER, JOHN M. (b. 1894)

King's Folly 1934
Charcoal on paper 10⅛″x12¼″ (25.7x31.1 cm)
Unsigned
Anonymous gift 00.389

Drawing for PWAP lithograph of the same title (34.317).

The Bridge 1934
Charcoal on paper 9¾″x13⅞″ (24.8x34.7 cm)
Signed: lower right, "John M. Foster"
Anonymous gift 00.390

Drawing for PWAP lithograph of same title (34.318).

Erie Railroad 1934
Pencil on paper 10″x14⅜″ (25.4x36.5 cm)
Signed and dated: lower right, "J. M. Foster/34"
Anonymous gift 00.391

Drawing for PWAP lithograph of the same title (34.319).

FRANCIS, JOHN (1808-1886)

*__Still Life — Grapes in Dish__ (Luncheon Piece) ca. 1850
Oil on canvas 25″x30¼″ (63.5x76.8 cm)
Unsigned
Reverse: label, AFA, *A Century of American Still Life Painting*, 1966-67;
label, Triton Museum of Art, San Jose, Calif.; no pertinent data
recorded prior to relining, 1958
Ex-collection: M. Michelotti, New York, N.Y.; to M. Knoedler & Co.,
New York, N.Y. (1940); to Prew Savoy, Washington, D.C. (1941); to Lee
Rombotis, New York, N.Y.; to M. Knoedler & Co., New York, N.Y.
(1954)
Purchase 1956 Anonymous Gift Fund 56.179

Wolfgang Born in his 1947 book, Still Life Painting, *felt that this painting
would pre-date 1854.*

FRANKENTHALER, HELEN (b. 1928)

*__Untitled__ (Abstraction) 1955
Oil and paper on canvas 54″x70½″ (137.2x179.0 cm)
Signed: lower right, "Frankenthaler"
Ex-collection: Tibor de Nagy Gallery, New York, N.Y.; donor, New
York, N.Y.
Gift of Paul Ganz 1959 59.406

FRERICHS, WILLIAM (b. Holland 1829-1905)

Dog Rocks Off the Coast of Ireland
Oil on canvas 21″x33″ (53.3x83.8 cm)
Signed: right of center (on rock), "W Frerichs"
Ex-collection: donor, East Orange, N.J.
Gift of Mrs. Julius Merrill Foote 1919 19.226

*The artist was a Newark painter and restorer who taught amateur painting
classes. He often copied other artists' work. (corres.)*

FRIEDMAN, ARNOLD (1874-1946)

Polo Player ca. 1930
Watercolor, pen and ink on paper mounted on cardboard 9½″x14⅛″
(24.1x35.9 cm)
Signed: lower right, "Friedman"
Ex-collection: with The Downtown Gallery, New York, N.Y.
Purchase 1930 Forest Hill Literary Society Fund 30.56

FUCHS, EMIL (1866-1921)

Portrait of Mrs. Harry Whitney McVickar 1910
Oil on canvas 50½″x40½″ (128.3x102.9 cm)
Signed and dated: lower left, "Emil Fuchs/1910"
Ex-collection: sitter to daughter, Mrs. Henry A. Robbins, New York,
N.Y.; to another daughter, the donor, New York, N.Y.
Gift of Mrs. Theron R. Strong 1934 34.183

FULLER, GEORGE (1822-1884)

Woman Sweeping Up Twigs
Oil on canvas 13⅝″x10⅝″ (34.6x27.0 cm)
Signed: bottom left (monogram), "GF"
Ex-collection: donors, New York, N.Y.
Gift of Mr. and Mrs. Victor Spark 1959 59.88

This painting could be Girl with Broom *(1862), owned by the Fuller estate
in 1886.*

GALLATIN, ALBERT E. (1882-1952)

Abstraction with Violin (Abstraction)
Oil on canvas 20"x16⅛" (50.8x41.0 cm)
Reverse: signed and dated, "A. E. Gallatin/May 1939"
Ex-collection: unknown source to an East Hampton, N.Y., thrift shop; to donor, New York, N.Y.
Gift of The New Gallery 1957 57.142

GANSO, EMIL (1895-1941)

Nude Figure
Pen, ink and wash on paper 15"x11½" (38.1x29.2 cm)
Signed: lower right, "Ganso"; above head of figure "112", upside down
Ex-collection: private collection, New York, N.Y.
Anonymous gift 1940 40.330

Iowa River 1941
Oil on wood 14¼"x21¼" (36.8x54.0 cm)
Signed and dated: lower right, "Ganso/41"
Ex-collection: donor, New York, N.Y.
Gift of Mrs. Aline Liebman 1947 47.214

GARCIA, SAN JUANITO

Warriors — Comanche Dance ca. 1930
Gouache on paper (formerly on board) 11¼"x18" (28.6x45.7 cm)
Signed: lower right, "San Juanito Garcia/Santo Domingo"
Reverse: label on backing, "(Brooklyn Museum) *The Dance in Art* 1936/ Lent by Gallery of American Indian Art"
Gift of Miss Amelia E. White 1937 37.157

The artist was from Santo Domingo pueblo, N.M. Title previously recorded as Warriors.

GARDNER, BARBARA (b. 1923)

Girl Rider 1975
Oil on canvas 34"x34" (86.4x86.4 cm)
Signed and dated: lower right, "1975 BG"
Ex-collection: donor, Saddle River, N.J.
Gift of the artist 1977 77.213

GASSER, HENRY (b. 1909)

Querril's Place 1943
Watercolor on paper 20"x24¾" (50.8x62.9 cm)
Signed: lower right, "H. Gasser"
Reverse: "The Querrils/Place"; label, Montclair Art Museum
Ex-collection: with Macbeth Galleries, New York, N.Y.
Purchase 1944 Wallace M. Scudder Bequest Fund 44.174

Created from an earlier sketch done in northern New Jersey. (files)

Steps of Paris (Steps in Paris) ca. 1964
Watercolor on paper 29¾"x37½" (75.5x95.7 cm)
Signed: lower right, "H. Gasser/Paris"
Reverse: on paper backing, in artist's hand, "Steps of Paris/ Henry Gasser"
Ex-collection: purchased from the artist, South Orange, N.J.
Purchase 1964 Franklin Conklin Jr. Endowment Fund 64.12

Purchased from The Newark Museum fifth triennial exhibition, Work by New Jersey Artists, *1964.*

GATCH, LEE (1902-1968)

*****Pueblo Strata** 1964
Stone collage: mixed media, stone, pigment and aggregate on wood support 27¼"x45" (69.2x114.3 cm)
Signed and dated: lower right, "Gatch/64"
Ex-collection: with Staempfli Gallery, New York, N.Y.
Purchase 1965 Sophronia Anderson Bequest Fund 65.107

Purchased from Newark Museum exhibition, Selected Works of Contemporary New Jersey Artists, *1965.*

*****Jurassic Flower** 1968
Stone collage: mixed media, stone, pigment and aggregate on wood support 64½"x27¾" (163.8x70.5 cm)
Signed and dated: lower right, "Gatch/'68"
Reverse: estate stamp, "Lee Gatch/title:/Jurassic Flower"
Ex-collection: with Staempfli Gallery, New York, N.Y.
Purchase 1969 The Charles Engelhard Foundation Fund 69.114

Untitled
Pen and ink on cardboard 5⅝"x4⅜" (14.4x11.2 cm)
Unsigned
Reverse: inscribed by artist's wife, "Drawing by Lee Gatch/subject & date?/authenticated by/Elsie D. Gatch."
Ex-collection: the artist to his wife, the donor, New York, N.Y.
Gift of Mrs. Elsie D. Gatch 1972 72.186

Portrait of a Man
Pen and ink on paper 4¼"x3¾" (10.9x9.7 cm)
Unsigned
Ex-collection: the artist to his wife, the donor, New York, N.Y.
Gift of Mrs. Elsie D. Gatch 1972 72.187

Inscribed on reverse of folder by artist's wife, "Drawing by Lee Gatch/ authenticated by Elsie D. Gatch/Jack Tworkov?"

Study for Mural ca. early 1920's
Pencil and watercolor on paper mounted on cardboard 6½"x7¼" (16.6x18.5 cm)
Unsigned
Reverse: inscribed on cardboard mount by artist's wife, "Possible Mural Project/(Student)/France/authenticated by/Elsie D. Gatch."
Ex-collection: the artist to his wife, the donor, New York, N.Y.
Gift of Mrs. Elsie D. Gatch 1972 72.188

*****Drawing of Ray** 1922
Pen and ink on paper mounted on cardboard 7¾"x6¼" (19.8x15.9 cm)
Signed and dated: lower right, "Gatch/22…"
Reverse: inscribed by artist's wife, "Drawing of Ray, youngest/sister of Lee Gatch/authenticated by/Elsie D. Gatch."
Ex-collection: the artist to his wife, the donor, New York, N.Y.
Gift of Mrs. Elsie D. Gatch 1972 72.189

Portrait of Helen 1932
Pen and ink on paper 9¼"x7" (23.6x17.8 cm)
Signed and dated: lower right (in pencil), "Gatch 1932"
Ex-collection: the artist to his wife, the donor, New York, N.Y.
Gift of Mrs. Elsie D. Gatch 1972 72.190

Inscribed on reverse of folder, "Drawing by Lee Gatch/subject – his sister Helen/authenticated by Elsie D. Gatch."

Untitled 1920's
Pencil on paper 8"x5" (20.3x12.9 cm)
Unsigned
Ex-collection: the artist to his wife, the donor, New York, N.Y.
Gift of Mrs. Elsie D. Gatch 1972 72.191

Inscribed on reverse of folder, "Drawing by Lee Gatch/student – / authenticated by Elsie D. Gatch."

Untitled
Pencil on paper 10⅞"x8¼" (27.8x20.8 cm)
Unsigned
Ex-collection: the artist to his wife, the donor, New York, N.Y.
Gift of Mrs. Elsie D. Gatch 1972 72.192

Inscribed on reverse of folder, "Drawing by Lee Gatch/date?/ authenticated by Elsie D. Gatch."

Untitled
Pencil on paper 10"x8" (25.4x20.4 cm)
Unsigned
Ex-collection: the artist to his wife, the donor, New York, N.Y.
Gift of Mrs. Elsie D. Gatch 1972 72.193

Inscribed on reverse of folder, "Drawing by Lee Gatch/date?/ authenticated by Elsie D. Gatch."

Untitled
Pencil on paper 11⅝"x8¾" (29.5x22.3 cm)
Unsigned
Reverse: inscribed on mat by artist's widow, "Drawing by Lee Gatch/subject — his sister Ray — influence negro sculpture/ authenticated by Elsie D. Gatch."
Ex-collection: the artist to his wife, the donor, New York, N.Y.
Gift of Mrs. Elsie D. Gatch 1972 72.194

***Fish Market** ca. 1951
Oil on canvas 25⅜"x32" (64.0 x 81.3 cm)
Signed: lower right, "Gatch"
Ex-collection: donor, New York, N.Y.
Gift of Mrs. John S. Schulte 1977 77.8

This work won the Joseph E. Temple Award, 2nd Biennial American Painting and Sculpture, Detroit Institute of Arts, 1959.

***The Sycamore** 1954
Oil on canvas 21⅛"x24⅛" (54.0x61.5 cm)
Signed: lower right, "Gatch"
Reverse: label, Whitney Museum 1955 Annual; label, World House Galleries; label, Grace Borgenicht Gallery; label, Staempfli Gallery Inc.; inscription (top), Lee Gatch (stamp) "The Sycamore"
Ex-collection: Grace Borgenicht Gallery, New York, N.Y.; to Mr. and Mrs. Sampson R. Field, New York, N.Y.; with Staempfli Gallery, New York, N.Y.
Purchase 1973 Sophronia Anderson Bequest Fund and the W. Clark Symington Bequest Fund 73.105

A preliminary version, black and white oil on canvas, was commissioned by Art News *for the 1955* Art News Annual *as an illustration for Marianne Moore's poem* The Sycamore. *It appears on page 95 of the publication. (files)*

***The Lamb** 1957
Oil on canvas 19⅞"x30⅛" (51.0x76.5 cm)
Signed: lower right, "Gatch"
Reverse: label, World House Galleries (artist, title, medium, dimensions and date)
Ex-collection: donors, Sandy Hook, Conn.
Gift of Dr. and Mrs. Louis Wasserman 1977 77.199

Frame includes canvas collage.

***Angel Stone** 1967
Stone collage: mixed media, stone, pigment and aggregate on wood support 46½"x25½" (118.1x63.4 cm)
Signed and dated: lower right, "Gatch/67"
Reverse: stamped, "Lee Gatch/Angel Stone"; label, Staempfli Gallery Inc/C-3280; label, Newark Museum exhibition, *Lee Gatch Exhibition/March 2-12, 1972*; label, "Lee Gatch/Angel Stone, 1967"
Ex-collection: donor, London, England
Gift of Mrs. John W. Wendler in memory of
Mrs. Nell Schoelkopf Ely Miller 1977 77.208

Fossil Tablet 1962
Stone collage: mixed media, stone, pigment and aggregate on wood support 25⅞"x20¼" (64.7x51.4 cm)
Signed and dated: lower right, "Gatch/62"
Reverse: stamped, "Lee Gatch/Title"; written, "Fossil Tablet"; written, "Mydbiehst" (illeg.); label, #12 Fossil Tablet, 1962; label, #17 Fossil Tablet, 1962/Coll Mr. & Mrs. George Rickey, East Chatham; masking tape, 657 Staempli [sic] Gallery
Ex-collection: with Staempfli Gallery, New York, N.Y.; to donors, East Chatham, N.Y.
Gift of Mr. and Mrs. George Rickey 1978 78.167

GENTH, LILLIAN (1876-1953)

Artist's Mother, Hermitcliff
Oil on canvas 16"x19" (40.7x48.3 cm)
Signed: lower left, "L. Genth"
Ex-collection: the artist to donors, Bronxville and New York, N.Y., by inheritance
Gift of Mrs. William H. Bender, Jr., and Miss Edythe Haskell 1958 58.18

Portrait of James McNeill Whistler (1834-1903)
Oil on canvas 21½"x16" (55.0x42.0 cm)
Signed: lower left, "L. Genth"
Ex-collection: donor, Bronxville, N.Y.
Gift of Mrs. Nellie C. Bender 1975 75.1

GEORGE, THOMAS (b. 1918)

***Untitled study** ca. 1962
Oil on paper mounted to mat board 3¾"x4⅞" (9.5x12.4 cm)
Reverse: signed on mount lower right, "George"
Inscribed: on backing, artist, title, dimensions, medium; "c. 1962/Coll Jock Truman/NYC"
Ex-collection: acquired from the artist by donor, New York, N.Y.
Gift of Jock Truman 1971 71.104

GEORGES, PAUL (b. 1923)

Portrait of Aristodimos Kaldis (1900-1979) 1961
Oil on canvas 52"x44¾" (132.0x113.6 cm)
Reverse: signed and dated, "Georges 1961"
Ex-collection: Allan Frumkin Gallery, New York, N.Y.
Purchase 1961 The Sumner Foundation for the Arts, Inc. Fund 61.517

GERARD, JOSEPH (b. 1910)

Nude pre 1950
Watercolor on paper 19"x12½" (48.2x31.8 cm)
Signed: lower right, "Gerard"
Reverse: inscribed in pencil, "Krueger/Collection/1950"
Ex-collection: Rabin and Krueger Gallery, Newark, N.J.
Purchase 1957 The General Fund 57.43

Head of a Woman
Watercolor on paper 13½"x10¼" (34.3x25.9 cm)
Signed: lower left, "Gerard"
Gift of Rabin and Krueger Gallery 1957 57.53

GIBRAN, KAHLIL (1883-1934)

Nude Study 1916
Watercolor on paper 11"x8½" (29.9x21.6 cm)
Signed and dated: lower right, "To T.L.R. with Love from K.G. 1916"
Ex-collection: Mayor Thomas L. Raymond, Newark, N.J.; purchased from Raymond estate
Purchase 1929 The General Fund 29.124

Portrait of Mayor Thomas L. Raymond of Newark (1875-1928) 1919
Pencil on paper 23⅛"x17⅞" (59.4x45.4 cm)
Signed and dated: lower right, "1919"
Ex-collection: donor, Savannah, Ga.
Gift of Mrs. Mary Haskell Minis 1932 32.160

Gibran and Raymond were good friends. Mrs. Minis had control of all paintings and drawings in the estate, and donated this drawing because of Raymond's association with Newark and the Museum. Raymond was mayor of Newark in 1915-18 and 1925-28.

GIFFORD, ROBERT SWAIN (1840-1905)

*A Glimpse of the Sea
Oil on canvas 26⅛"x34⅛" (66.3x86.1 cm)
Signed: lower left, "R. Swain Gifford"
Ex-collection: donor, Montclair, N.J.
Gift of William Evans 1910 10.67

GIFFORD, SANFORD ROBINSON (1823-1880)

*Summer Afternoon ca. 1855
Oil on canvas 30"x42" (76.2x106.7 cm; oval spandrel)
Signed and dated: bottom center, "SRGifford 1855"
Reverse: label, Gifford Exhibition, University of Texas, 1970, 1971 (#4);
label, Hudson River School, R. W. Norton Gallery, 1973
Ex-collection: John H. Prentice (1855); Arthur Newton Gallery,
New York, N.Y.; to Orrin W. June (1961)
Gift of Mr. and Mrs. Orrin W. June 1961 61.10

*Whether the inscribed date reads 1853 or 1855 is unclear. Nicholas
Cikovsky reads 1853. Illa J. Weiss, however, suggested in a doctoral thesis
(Columbia University, 1968) that the scene represents Mt. Chocorua, N.H.,
which Gifford did not sketch until 1854. The fact that this work was
exhibited in the 1855 Annual Exhibition of the National Academy of
Design (#145) substantiates the later date since paintings were usually
executed in the year of the annual or the year immediately preceding.*

GILBERT, ISOLDE THERESE (b. 1907)

Millbridge Road 1936
Watercolor on paper (sight) 10¼"x14½" (26.0x36.8 cm)
Signed and dated: lower right, "Isolde Therese Gilbert 1936"
Allocated by the WPA Federal Art Project 1945 45.240

GILES, HOWARD (1876-?)

Untitled 1918
Watercolor on paper 11½"x15½" (29.2x39.4 cm)
Signed and dated: lower right, "H. Giles 18"
Ex-collection: donors, Newark, N.J.
Gift of Dr. and Mrs. Jasper Coghlan 1954 54.204

GILES, WILLIAM (20th century)

Memphis II ca. 1960-61
Oil on canvas mounted on plywood
at largest, 45"x45½" (114.3x114.9 cm)
Unsigned
Ex-collection: acquired from artist by donor, Ossining, N.Y.
Gift of Richard Cohn 1968 68.252

GIOBBI, EDWARD GIOACHINO (b. 1926)

Untitled 1968
Pencil and watercolor on board 9⅛"x14⅞" (23.3x37.8 cm)
Unsigned
Ex-collection: the artist to donors, New York, N.Y.
Gift of Mr. and Mrs. Henry Feiwel 1977 77.225

GIRONA, JULIO (b. Cuba 1915)

Conflict 1956
Oil on canvas 38"x50" (96.5x127.0 cm)
Signed: upper right, "Julio Girona"
Ex-collection: with Bertha Schaefer Gallery, New York, N.Y.
Purchase 1958 Felix Fuld Bequest Fund 58.21

*Purchased from The Newark Museum's 3rd triennial exhibition, Work by
New Jersey Artists, 1958.*

GLACKENS, WILLIAM J. (1870-1938)

*At the Beach ca. 1918
Oil on canvas 25"x30" (63.5x76.2 cm)
Signed: lower left, "W Glackens"
Reverse: label, *The Art of William Glackens* Rutgers University Art
Gallery, 1967
Gift of Mrs. Felix Fuld 1925 25.1167

Included in the Glackens Memorial Exhibition *at the Whitney Museum,
December 1938-January 1939.*

GLASCO, JOSEPH (b. 1925)

*The Bride 1960
Oil on canvas 72"x48" (182.9x 121.9 cm)
Signed and dated: lower right, "J. Glasco 60"
Reverse: label, Catherine Viviano Gallery, New York, N.Y.
Ex-collection: Catherine Viviano Gallery
Purchase 1962 Sophronia Anderson Bequest Fund 62.136

No. 3 in artist's one-man show at Catherine Viviano Gallery, 1961.

GLEITSMAN, RAPHAEL (b. 1910)

Winter Sun ca. 1943
Oil on composition board 16"x20" (40.6x50.8 cm)
Signed: lower right, "Raphael Gleitsman"
Ex-collection: with Macbeth Gallery, New York, N.Y.; to donor,
New York, N.Y.
Gift of Mrs. Edith Lowenthal 1945 45.8

Purchased from a group exhibition at the Macbeth Gallery, June, 1943.

GLINTENKAMP, HENRY (1887-1946)

Women on Stoop
Pastel on green paper 8"x6" (20.2x15.7 cm)
Unsigned
Reverse: stamp with Davis Gallery seal; label on backing, Davis
Gallery, New York, N.Y.
Ex-collection: Davis Gallery; to donors, New York, N.Y.
Gift of Mr. and Mrs. Raymond J. Horowitz 1965 65.111

GODOWSKY, FRANCES (20th century)

Red and Green — No. 12
Oil on canvas 12⅜"x10⅜" (31.4x26.4 cm)
Signed: lower left, "F. Godowsky"
Ex-collection: donor, New York, N.Y.
Gift of Mrs. Kay Hillman 1966 66.31

GOELLER, CHARLES L. (1901-1955)

*Suburban Development 1939
Oil on canvas 22"x20" (55.9x50.8 cm)
Signed: lower right, "Goeller"
Reverse: label, Virginia Museum of Fine Arts, Richmond, Va. 1940; The
Corcoran Gallery of Art, Washington, D.C. 1939; The Pennsylvania
Academy of The Fine Arts; Whitney Museum of American Art, New
York, N.Y. 1938 (# 5)
Ex-collection: purchased from the artist, Elizabeth, N.J.
Purchase 1940 Thomas L. Raymond Bequest Fund 40.155

*Artist stated that this was a "view down McGotty Place from the corner of
Union Ave., Irvington." (files)*

*Maple Root 1949
Grease crayon on paper 21⅞"x13⅞" (53.0x35.2 cm)
Signed: lower right, "Charles L. Goeller"
Ex-collection: purchased from the artist, Elizabeth, N.J.
Purchase 1950 Arthur F. Egner Memorial Fund 50.59

*Artist indicated that this work was executed in 1949. (files) It was
exhibited in Associated Artists of New Jersey (#76) and at the Riverside
Museum in February, 1950.*

New Jersey Meadows ca. 1946
Oil on canvas 25⅛"x36½" (64.1x92.7 cm)
Signed: lower left, "Goeller"
Ex-collection: purchased from the artist, Elizabeth, N.J.
Purchase 1952 Felix Fuld Bequest Fund 52.23

Purchased from the Museum exhibition, Work by New Jersey Artists,
*1952 (#31). The artist's daughter, Mrs. Hilda Goeller Newell, said that this
painting was reproduced in the* Newark Sunday Call *on September 29,
1946. The painting was exhibited in the* Associated Artists of New Jersey
3rd New York Exhibition *at the Riverside Museum in 1947. (corres.)*

Meadow Flowers 1949-50
Oil on canvas 30¼"x20" (76.8x50.8 cm)
Signed: lower right, "Goeller"
Ex-collection: donor, Elizabeth, N.J.
Bequest of the artist 1955 55.103

Catalogue #29 in the Riverside Museum exhibition, Associated Artists of
New Jersey, *1950, and #30 in The Newark Museum exhibition,* Work by
New Jersey Artists, *1952.*

Factory Yard ca. 1938
Oil on canvas 43"x34" (109.2x86.3 cm)
Signed: lower right, "Goeller"
Ex-collection: donor, Elizabeth, N.J.
Bequest of the artist 1955 55.104

Date supplied by the artist's daughter. (corres.)

You're Only a Sort of Thing in His Dream (Self-Portrait)
Oil on canvas 20"x16" (50.8x40.6 cm)
Signed: lower right, "Goeller"
Ex-collection: donor, Elizabeth, N.J.
Bequest of the artist 1955 55.105

GOLDTHWAITE, ANNE (ca. 1870-1944)

The Coiffeur
Watercolor on paper 14¾"x18⅝" (62.8x47.3 cm)
Signed: lower right, "Anne Goldthwaite"
Reverse: torn label, The Downtown Gallery, New York, N.Y. (only
documentary evidence that this work was handled by The Downtown
Gallery)
Ex-collection: private collection, New York, N.Y.
Anonymous gift 1937 37.113

Market Scene
Oil on canvas 13"x16" (33.0x40.7 cm)
Signed: lower left, "Anne Goldthwaite"
Ex-collection: donors, Lee, Me.
Gift of Herman A. E. Jaehne and Paul C. Jaehne 1937 37.127

The Team
Watercolor on paper 16"x17⅞" (40.6x45.4 cm)
Signed: lower left, "Anne Goldthwaite"
Reverse: label, The Downtown Gallery, New York, N.Y. (only
documentary evidence that this work was handled by
The Downtown Gallery)
Ex-collection: private collection, New York, N.Y.
Anonymous gift 1940 40.343

A Cafe in the Midi (Parrot) ca. 1912
Gouache on paper 11¼"x14" (28.6x35.6 cm)
Signed: lower right, "Anne Goldthwaite"
Reverse: inscribed on backing, "Anne Goldthwaite/112 E 10/A Cafe in
the Midi/$50"
Ex-collection: private collection, New York, N.Y.
Anonymous gift 1940 40.349

GOOD, MINETTA (?-1946)

At the Country Auction 1935
Oil on canvas 52"x46¼" (132.1x117.5 cm)
Signed: lower right, "Minetta Good"
Ex-collection: donor, New York, N.Y.
Gift of Miss Dorothea Mierisch 1949 49.153

People depicted in painting lived in environs of Middle Valley, N.J. (corres.)

GOODELL, IRA CHAFFEE (1800-ca. 1875)

Woman with Red Shawl ca. 1830 (attributed)
Oil on wood 26¼"x18¾" (66.7x47.6 cm)
Unsigned
Ex-collection: Robert Laurent, New York, N.Y.
Purchase 1931 Felix Fuld Bequest Fund 31.148

Robert Laurent lent this painting to the Museum exhibition, American
Primitives, *1930-31 (#19).*

GOODNOUGH, ROBERT (b. 1917)

*****Composition** 1955
Oil on canvas 42"x52" (106.7x132.0 cm)
Signed: lower right, "Goodnough"
Ex-collection: Tibor de Nagy Gallery, New York, N.Y.; to donor,
New York, N.Y.
Gift of Paul Ganz 1959 59.407

GOODYEAR, JOHN L. (b. 1930)

Space Shift Suite #1 CSTR 1972
Space Shift Suite #2 RTSC
Space Shift Suite #3 TSCR
Space Shift Suite #4 RCTS
Space Shift Suite #5 CRTS
Space Shift Suite #6 STRC
Acrylic on Rives paper each 22"x22" (55.9x55.9 cm)
Signed and dated: lower right, "John Goodyear '72 — CSTR",
"— RTSC", "— TSCR", "— RCTS", "— CRTS", "— STRC"
Ex-collection: acquired from the artist by donor, New York, N.Y.
Gift of Peter H. Stroud 1978 78.178-183

GORMAN, WILLIAM D. (b. 1925)

I Bring My Lunch 1960
Casein on paper 21¾"x17" (55.2x43.2 cm)
Signed: left of center, "Gorman"
Ex-collection: the artist, Bayonne, N.J.
Gift of Kresge, Newark 1960 60.560

*Exhibited at the 18th annual New Jersey Watercolor Society exhibition,
Kresge, Newark, 1960. Date supplied by artist. (files)*

GORSON, AARON HENRY (1872-1933)

Pittsburgh Mills at Night early 20th century
Oil on canvas 34"x44" (86.4x111.8 cm)
Signed: lower left, "A. H. Gorson"
Ex-collection: donor, New York, N.Y.
Gift of Henry Wellington Wack 1926 26.215

GOTTLIEB, ADOLPH (1903-1974)

*****The Mutable Objects** 1946
Oil on canvas 30"x23½" (76.2x59.7 cm)
Signed and dated: lower right, "Adolph Gottlieb/46"
Reverse: inscribed, "The Mutable Objects/April/1946/Adolf Gottlieb";
label, Kootz Gallery
Ex-collection: Kootz Gallery, New York, N.Y.; to donor, New York, N.Y.
Gift of Col. Samuel A. Berger 1960 60.585

GRABACH, JOHN R. (1899-1981)

*Street in Newark 1954
Oil on canvas 24¼"x29¼" (61.6x74.3 cm)
Signed: lower right, "John R. Grabach"
Ex-collection: with Grand Central Art Galleries, New York, N.Y.;
Rabin & Krueger Gallery, Newark, N.J.
Purchase 1957 Wallace M. Scudder Bequest Fund 57.88

Date supplied by artist. (files)

GRAVES, MORRIS (b. 1910)

*Each Time You Carry Me This Way 1953
Tempera and ink on paper 25"x42¾" (63.5x108.6 cm)
Signed and dated: lower right, "Graves '53"
Reverse: inscribed, "No. 55/'Each Time You Carry Me This Way'/(light
version)"
Ex-collection: with Willard Gallery, New York, N.Y.
Purchase 1960 Louis Bamberger Bequest Fund 60.530

GRAY, CLEVE (b. 1918)

*Narcissus 1962
Oil on canvas 60" (152.4 cm) diameter
Signed and dated: lower right, "Gray 62"
Reverse: inscribed, "'Narcissus'"
Ex-collection: with Staempfli Gallery, New York, N.Y.; to donor,
New York, N.Y.
Gift of Mrs. Robert M. Benjamin 1972 72.173

GRAY, HENRY PETERS (1819-1877)

Portrait of Alice Jones (1837-1895) ca. 1850
Oil on canvas 16⅞"x13⅞" (42.8x35.3 cm)
Signed and dated: lower left, "Henry P-J ... Gnoll/1850"
Ex-collection: donor, Pittsford, N.Y.
Gift of Mrs. Alice Roff Estey 1924 24.2326

*Sitter, the child of James M. Jones (Gray 24.2327) and the artist Electra
Ward Jones (20.711), was a direct descendant of John Ward who came to
Newark with Robert Treat in 1666.* (files)

Portrait of James M. Jones (1808-1880) ca. 1845
Oil on canvas 14"x12" (35.6x30.5 cm)
Unsigned
Reverse: stamp, "Prepared/by/Theo. Kelley/near 55½ Wooster St./
New York"
Ex-collection: painting remained in sitter's family; to his niece, the
donor, Pittsford, N.Y.
Gift of Mrs. Alice Roff Estey 1924 24.2327

*The 1845 date traditionally associated with this work agrees with the
apparent age of the sitter. Subject married Electra Ward (see Jones 20.711).*
(files)

GREACEN, EDMUND (1877-1949)

Hudson River Twilight (Hudson River by Twilight) 1913
Oil on canvas 26⅛"x36¼" (66.4x92.1 cm)
Signed and dated: lower right, "Edmund Greacen 1913 —"
Reverse: label (hand written by artist), "'Hudson River
Twilight'/Edmund Greacen/142 E. 18th St./N.Y. City"; label, AFA,
Surviving the Ages, 1963-64
Ex-collection: donor, New York, N.Y.
Gift of Joseph S. Isidor 1922 22.110

Idle Hours (Summer Hours) 1921
Oil on canvas 26"x36" (66.1x91.5 cm)
Signed and dated: lower left, "Edmund Greacen 1921-"
Reverse: label (torn), Worcester Art Museum, title of
"Mist and _____" (last word may be "Such" or "Summer"); on
frame, "carved by Albert Milch/Carved — Frames /
78 West _____ St., N.Y."
Ex-collection: donor, Newark and South Orange, N.J.
Gift of Louis Bamberger 1925 25.1134

Untitled landscape
Oil on canvas 20⅛"x6⅛" (51.2x41.0 cm)
Signed: lower right, "Edmund Greacen"
Ex-collection: Joseph S. Isidor, New York, N.Y.; to his wife, the donor,
by inheritance (1941)
Bequest of Mrs. Rosa Kate Isidor 1949 49.468

GREENE, BALCOMB (b. 1904)

*Space 1936
Oil on canvas 22"x35" (55.8x80.8 cm)
Signed: lower right, "BG"
Reverse: inscribed in pencil, on backing, "Signed on back of painting
'Balcomb Greene Painting — Space — 1936 20/31'"; label, Forum
Gallery, New York, N.Y. #8051; label, ACA Galleries, New York, N.Y.
Ex-collection: with ACA Galleries, New York, N.Y.
Purchase 1977 Charles W. Engelhard Bequest Fund 77.165

GREENE, GERTRUDE (1904-1956)

Structure and Space 1950
Oil on canvas 40"x29½" (101.6x74.9 cm)
Signed: lower right, "Gertrude Greene"
Reverse: inscribed, top stretcher, "B 1950 501 1950"; left stretcher,
"Structure and Space"; right stretcher, "Gertrude Greene 1950"
Ex-collection: to donor, New York, N.Y., by inheritance
Gift of Balcomb Greene 1976 76.132

GREENWOOD, MARION (1909-1970)

Portrait of Abraham Walkowitz (1878-1965)
Oil on canvasboard 16"x11⅞" (40.7x30.2 cm)
Signed: lower right, "Marion Greenwood"
Reverse: inscribed and dated, "'Portrait of/Walkowitz'/by/
Marion/Greenwood/1943"
Ex-collection: donor, New York, N.Y.
Gift of Abraham Walkowitz 1947 47.224

Executed for exhibition, One Hundred Artists and Walkowitz,
Brooklyn Museum, 1944

GRIEFEN, JOHN (b. 1942)

All Ireland 1968-69
Acrylic on canvas 108"x59½" (274.4x160.0 cm)
Reverse: signed and dated, "All Ireland/Griefen/68-69"
Ex-collection: Kornblee Gallery, New York, N.Y.; to donors,
Larchmont, N.Y.
Gift of Mr. and Mrs. Henry Feiwel 1970 70.55

GRILLO, JOHN (b. 1917)

Yellow Birds 1959
Oil on canvas 48"x48" (121.9x121.9 cm)
Signed and dated: lower right, "59/Grillo"
Ex-collection: donor, New York, N.Y.
Gift of Dr. Charles H. Goodsell 1960 60.591

GRINDROD, J. (19th century)

Residence of Marcus L. Ward Esq ... Newark N.J.
Pencil on paper 8⅝"x13" (21.9x33.0 cm)
Signed: "(title) J. Grindrod Del."
Ex-collection: donor, Newark, N.J.
Bequest of Marcus L. Ward 1921 21.117

*Marcus Ward moved to this residence in 1841. The Museum building, 49
Washington Street, now occupies the site.*

GROLL, ALBERT L. (1866-1952)

Harmony in Silver ca. 1905
Oil on canvas 25″x34⅞″ (63.5x88.6 cm)
Signed: lower right, "A L Groll"
Reverse: label, AFA, *Surviving the Ages*, 1963-64
Ex-collection: donor, New York, N.Y.
Gift of Mrs. Emily Marx in memory of Mrs. Selma Laufer
1929 29.264

Exhibited at the National Academy of Design in 1905, providing an approximate date.

GROLL, ALBERT L. (1866-1952)

see George Elmer Browne (49.469)

GROPPER, WILLIAM (1897-1977)

Hostages 1942
Oil on canvas 21″x32⅛″ (53.4x81.9 cm)
Signed: lower right, "Gropper"
Reverse: label, Associated American Artists; label, Phoenix Art Museum, Gropper Retrospective, 1968
Ex-collection: Associated American Artists, New York, N.Y.
Purchase 1944 Sophronia Anderson Bequest Fund 44.172

Artist's correspondence states that date of the painting was 1942, the same year it was exhibited in an A.C.A. Galleries exhibition.

GROSHANS, WERNER (b. Germany 1913)

Southern Landscape 1965
Oil on canvas 30″x40″ (76.2x101.6 cm)
Signed and dated: lower left, "Groshans/65©"
Ex-collection: the artist, Weehawken, N.J.
Purchase 1965 Louis Bamberger Fund 65.124

Purchased from the Museum exhibition, Selected Works by Contemporary New Jersey Artists, 1965.

GROSZ, GEORGE (b. Germany 1893-1959)

A Piece of My World 1939
Oil on canvas 32″x24″ (81.3x61.0 cm)
Reverse: on canvas, "George Grosz Pictor/1939/a piece of my world/Douglaston/Lg. Isl."; label, Whitney Museum of American Art (1953 Work of George Grosz, traveling exhibition); label, Associated American Artists
Ex-collection: with Walker Galleries, New York, N.Y.; with Associated American Artists, New York, N.Y.
Purchase 1944 Sophronia Anderson Bequest Fund 44.40

The artist wrote in 1943: "This oil of mine, a piece of my world, belongs to a series of oils which I painted around 1934-1936 . . . in anticipation of time to come, a kind of a pyre, the symbol of the burning ruins of an Europe gone to pieces and rubble ..."

The artist's statement does not agree with the date on the canvas. It is possible that this painting was reworked at the later date or he may have forgotten the actual date since he continued the series beyond 1936. His 1944 exhibition at Associated American Artists was entitled, A Piece of My World in a World Without Peace.

GUGLIELMI, LOUIS (b. Egypt 1906-1956)

View in Chambers Street 1936
Oil on canvas 30¼″x24¼″ (76.8x61.6 cm)
Signed: lower left, "Guglielmi"
Reverse: label, WPA (#A936A)
Allocated by the WPA Federal Art Project 1943 43.192

Date supplied by artist. The painting was shown at The Downtown Gallery in 1938 and at the New York World's Fair in 1940. (files)

Hague Street 1936
Oil on canvas 30⅛″x24″ (76.5x61.0 cm)
Signed: lower left, "Guglielmi"
Reverse: on stretcher, "Louis Guglielmi Hague Street"; label, Museum of Modern Art, Circulating Exhibit, 1936 (38.711); label, FPA (#9950-C)
Allocated by the WPA Federal Art Project 1945 45.241

Artist supplied the date of March, 1936. The painting was shown at the Phillips Memorial Gallery, Washington, D.C., in June of that year and at the New York World's Fair, 1940. (files)

GULICK, HENRY T. (1871-1964)

Spring — The Gulick Farm 1948
Oil on masonite 23¾″x27¾″ (60.3x70.5 cm)
Reverse: inscribed, "H.T.G. May '48"; label, Montclair Art Museum, Henry Gulick exhibition, 1974
Ex-collection: acquired from the artist, Middletown, N.J.
Purchase 1949 Edward Weston Gift 49.354

The Dining Room 1949
Oil on masonite 20″x30″ (50.8x76.2 cm)
Reverse: inscribed, "H.T.G. Feb. '49/to Henry from Gramps"; label, Newark Museum, *Work by New Jersey Artists*, 1952; label, Montclair Art Museum, Henry Gulick exhibition, 1974
Ex-collection: purchased from the artist, Middletown, N.J.
Purchase 1952 Mrs. Felix Fuld Bequest Fund 52.54

Purchased from The Newark Museum 1st triennial exhibition, Work by New Jersey Artists, 1952.

GURR, LENA (b. 1897)

Study for "Rehearsal" 1975
Casein on paper 15½″x20⅝″ (39.4x52.4 cm)
Signed: lower right, "Lena Gurr"
Ex-collection: donor, Brooklyn, N.Y.
Gift of the artist 1978 78.30

GUSSOW, BERNAR (b. Russia 1881-1957)

Elevated Station pre-1908
Oil on canvas 30″x25″ (76.2x63.5 cm)
Signed: lower left, "B. Gussow"
Ex-collection: purchased from the artist, New York, N.Y.
Gift of Mrs. Felix Fuld 1928 28.697

Artist indicated that this work was exhibited in New York City in 1908. (files)

Main Street
Black crayon and watercolor on paper 23⅛″x17¾″ (58.9x20.3 cm)
Signed: lower right, "B. Gussow"
Reverse: inscribed, "Main Street"
Ex-collection: private collection, New York, N.Y.
Anonymous gift 1940 40.341

GUY, SEYMOUR JOSEPH (b. England 1824-1910)

Children in Candlelight 1869
Oil on canvas 24⅛″x18⅛″ (61.3x46.1 cm)
Signed: far right of center, "Guy/1869"
Ex-collection: Victor Spark, New York, N.Y.
Purchase 1957 C. Suydam Cutting Special Gift Fund 57.74

Painting may have been based on a poem by Henry C. Work, Come Home, Father. (files)

GWATHMEY, ROBERT (b. 1903)

End of Day 1942
Oil on canvas 30"x25" (76.2x63.5 cm)
Signed: lower left, "Gwathmey"
Reverse: no pertinent data recorded prior to relining, 1971; etched into frame, "frame made for/Robert Gwathmey/by Carl Sandelin framemaker/133 E. 60th Street/N.Y.C."; label, A.C.A. Galleries, N.Y.C. (lent by Mr. and Mrs. Lowenthal for one-man show, 1946)
Ex-collection: with A.C.A. Galleries, New York, N.Y.; to Edith and Milton Lowenthal, New York, N.Y. (1943)
Gift of the Edith and Milton Lowenthal Foundation 1970 70.36

First exhibited at the Art Institute of Chicago's 54th Annual Exhibition of Painting and Sculpture, 1943.

HAAGY, J. (19th century)

Portrait of an Unidentified Woman late 19th century
Oil on canvas 29¾"x25" (73.0x63.5 cm)
Signed: lower left, "J. Haagy"
Ex-collection: donor, Belleville, N.J.
Gift of Mrs. William D. Cornish 1930 30.20

HABERLE, JOHN (1856-1933)

New Haven Monuments 1882
Pencil on paper 9⅝"x7⅜" (24.4x18.7 cm)
Unsigned
Dated: lower right, "May 1882"
Inscribed: on monument at center, "Gettysburg/Fort Fisher,/Erected AD 1870/by the State of Connecticut"
Ex-collection: artist to his daughter, Vera Haberle Demmer, New Haven, Conn.; to Hirschl & Adler Galleries, New York, N.Y. (1967)
Purchase 1968 Franklin Conklin Jr. Memorial Fund 68.229

*Clock
Oil on canvas and wood construction 28⅝"x18"x3¾" (72.7x45.8x9.5 cm)
Signed: in upper right of landscape panel, "Haberle"
Reverse: label, Cincinnati Art Museum; label, Hirschl & Adler Galleries, N.Y.C.
Ex-collection: artist to his daughters, Vera Haberle and Mrs. Anthony Fresneda, New Haven, Conn.; to Abby Aldrich Rockefeller Folk Art Collection, Williamsburg, Va. (1962); to David and David, Philadelphia, Pa. (1966); Hirschl & Adler Galleries, New York, N.Y.
Purchase 1971 Charles W. Engelhard Foundation 71.166

Four years after the Abby Aldrich Rockefeller Folk Art Collection purchased Clock *from the Haberle family, it was decided that the work was not appropriate as a "folk" object and it was decessioned. (corres.)*

HAGEMAN, MARY (ca. 1857-1931)

Theodore Amerman Homestead
Oil on canvas 28½"x48¼" (72.4x122.5 cm)
Signed: lower left "(monogram)/1892"
Reverse: no pertinent data recorded prior to relining, 1974
Ex-collection: painting descended in artist's brother's family; to his daughter, Springfield, Mass.; to Paul Hamel, Springfield, Mass. (1964); to Vose Galleries, Boston, Mass. (1964)
Purchase 1964 Thomas L. Raymond Bequest Fund 64.47

The artist's brother, The Reverend Herman Hageman, was married to Maria Van Camp Amerman, whose father's property in South Branch, N.J., is depicted in this painting. Amerman was a land and mill owner. The painting shows his own house and those of the mill employees.

Mary Hageman painted the subject from a photograph. According to her nephew, Herman Hageman, except for possible art studies when she lived for a time in Nyack, N.Y., she was self-taught and all of her paintings were copied from prints or photographs. (files)

HAGNY, JOHN (b. Germany 1833-1876)

Portrait of Albert H. Clark (Portrait of Bearded Man) (? - 1890)
Oil on canvas 30"x25" (76.2x63.5 cm; oval spandrel)
Signed: lower left, "Hagny"
Ex-collection: remained in sitter's family until donated by a descendant, Newark, N.J.
Gift of Mrs. A. L. K. Clark 1927 27.391

The sitter was a Newark resident and masonry contractor. (files)

HALL, LEE (b. 1934)

*Shore Stone 1977
Polymer tempera on linen 72"x66" (182.9x167.6 cm)
Signed and dated: lower right, "Lee Hall 77"
Reverse: signed on horizontal stretcher, "Lee Hall Shore Stone/Summer 1977 polymer tempera"; handwritten label, "Arts and Letters"; stamped, "Betty Parsons Gallery/24 W 57th Street/New York, N.Y. 10009"
Ex-collection: acquired from the artist, Providence, R.I.
Gift of the American Academy and Institute of Arts and Letters: Childe Hassam and Eugene Speicher 1977 Funds 1978 78.17

HALLER, EMANUEL (b. 1927)

Red Jag 1975
Watercolor on paper 24¾"x21" (62.7x53.4 cm)
Unsigned
Ex-collection: acquired from the artist, North Plainfield, N.J.
Purchase 1977 Thomas L. Raymond Bequest Fund 77.167

Purchased from The Newark Museum/New Jersey State Museum exhibition, 1st Biennial of New Jersey Artists, 1977.

HALPERT, SAMUEL (b. Russia 1884-1930)

Summer 1920
Oil on canvas 36½"x28¾" (92.7x73.0 cm)
Signed: lower right, "S. Halpert-20"
Reverse: label, Gallery of Modern Art, N.Y.C., *The Twenties Revisited*, 1965; label, Milwaukee Art Center, *Inner Circle*, 1966; label, Whitney Museum of American Art
Gift of Mrs. Felix Fuld 1925 25.1160

One of 16 American paintings purchased by the Museum with funds provided by Mrs. Fuld.

The model for the figure depicted was the artist's wife Edith; the scene was Lake Mahopoc, N.Y. (corres.)

*Still Life: Spanish Series
Oil and encaustic wax on canvas mounted on masonite 18"x21½" (45.7x54.0 cm)
Signed: lower right, "S. Halpert"
Reverse: label, Daniel Gallery, New York, N.Y.; written, "Painted with wax-do not varnish"
Ex-collection: donor, Short Hills, N.J.
Bequest of Miss Cora Louise Hartshorn 1958 58.169

HAMILTON, JAMES (b. Ireland 1819-1878)

*Lowering Weather ca. 1867
Oil on canvas 23"x42" (58.4x106.7 cm)
Signed: lower right, "Hamilton"
Reverse: inscribed, "Lowering Weather/J Hamilton/Phila" (photo in files; painting relined, 1961)
Ex-collection: through artist's family; to his granddaughter, the donor, Philadelphia, Pa.
Gift of Miss Katherine A. Reed 1959 59.93

Date is that traditionally associated with the painting, which was #135 in the Pennsylvania Academy of The Fine Arts Annual Exhibition, 1868.

HARDING, CHESTER (1792-1866)

Portrait of Daniel Webster (1782-1852) ca. 1850
Oil on canvas 30¼"x25⅛" (76.9x63.2 cm)
Unsigned
Reverse: label on frame, "J. H. Flanegan, Carver & Gilder, Hereford
[England]" (painting has been relined)
Ex-collection: Victor Spark, New York, N.Y.; to donors, New York, N.Y.
Gift of Mr. and Mrs. Orrin W. June 1961 61.543

HARLOFF, GUY (b. 1933)

Untitled 1972
Crayon, gouache, collage on paper 21½"x12½" (54.6x31.8 cm)
Signed and dated: "1972 Harloff Chelsea Hotel New York"
Ex-collection: acquired from artist by donor, New York, N.Y.
Gift of Stanley Bard 1972 72.335

HARMON, LILY (b. 1912)

Portrait of Abraham Walkowitz (1878-1965) 1943
Oil on canvas 20"x16" (50.8x40.6 cm)
Signed and dated: upper right, "Lily Harmon/1943"
Ex-collection: donor, New York, N.Y.
Gift of Abraham Walkowitz 1948 48.23

Executed for the exhibition, One Hundred Artists and Walkowitz,
Brooklyn Museum, 1944.

HARMS, ELIZABETH (b. 1924)

#11 1975
Watercolor on paper 13⅝"x19⅝" (34.6x49.8 cm)
Signed: lower right, "E. Harms"
Ex-collection: with Fischbach Gallery, New York, N.Y.
Gift of Mrs. Mildred Baker 1975 75.101

HARNETT, WILLIAM MICHAEL (1848-1892)

***Munich Still Life** 1884
Oil on wood 14⅝"x11¾" (37.1x29.8 cm)
Signed and dated: lower left, "W. M. Harnett/Munich/1884"
Ex-collection: Mrs. Guy Witthaus, New York, N.Y.
Purchase 1958 Mrs. Felix Fuld Bequest Fund 58.92

Alfred Frankenstein referred to this painting as Literary Still Life. *He
pointed out that the predating of books depicted was "an old Harnettian
trick" intended to play on the mind of the viewer. In this case, Harnett
has shown a copy of Tasso's* Gerusalemme Liberata *(1580) and dated it
"1560" on its spine. According to Frankenstein, "Harnett loved that little
joke and almost always dates Shakespeare and such about two decades
before the work in question was created."*

HARRITON, ABRAHAM (b. Romania 1893)

Portrait of Abraham Walkowitz (1878-1965) ca. 1943
Oil on canvas 16⅛"x20 3/16" (40.8x51.3 cm)
Signed: upper left, "Harriton"
Inscribed: on stretcher, "My friend Walkowitz Abraham Harriton"
Ex-collection: donor, New York, N.Y.
Gift of Abraham Walkowitz 1951 51.89

Executed for exhibition, One Hundred Artists and Walkowitz, *Brooklyn
Museum, 1944.*

HART, GEORGE OVERBURY "POP" (1868-1933)

Cock Fight 1926-28
Watercolor on paper 16"x22" (40.6x55.9 cm)
Signed and dated: lower right, "Hart/Mex-1926"; bottom, left of center,
"Cock Fight"
Reverse: label, Cleveland Museum of Art, *American Painting from 1860
until Today,* 1937
Ex-collection: donor, Newark, N.J.
Gift of Arthur F. Egner 1928 28.1759

*Executed in Oaxaca, Mexico. Despite the signature with date, the artist
maintained that this work was executed in 1928. (files)*

Landscape with Goats 1928
Watercolor on paper 17½"x23⅞" (44.4x60.6 cm)
Signed and dated: lower left, "Hart/Mex 28"
Reverse: label, Montclair Art Museum (1931); label, The Downtown
Gallery
Ex-collection: with The Downtown Gallery, New York, N.Y. (estate of
artist)
Purchase 1935 Thomas L. Raymond Bequest Fund 35.141

Purchased from the Museum exhibition, Pop Hart Retrospective, *1935.
It had previously won an award at the American Watercolor Society
in 1929.*

The Racetrack 1929
Ink and wash on paper 8⅛"x10⅝" (20.6x27.0 cm)
Signed and dated: lower left, "Hart 29/Palma"; bottom center, "The
Race Track"
Reverse: stamp on backing, "D.G.", probably Downtown Gallery
Ex-collection: with The Downtown Gallery, New York, N.Y. (estate of
the artist)
Purchase 1935 Thomas L. Raymond Bequest Fund 35.142

Painting was executed in Majorca.

***Landscape Near Bou Saada** 1930
Watercolor on paper 18"x23⅞" (45.7x60.6 cm)
Signed and dated: lower right, "Hart/1930"; lower left, "Landscape
Near Bou Saada"; (below it, "Bou Saada Algeria" has been erased)
Ex-collection: private collection, New York, N.Y.
Anonymous gift 1938 38.211

***Bathing the Horses** 1929
Pastel, pencil, gouache on parchment pasted on paper and attached to
mat board 18¼"x23⅞" (46.3x60.6 cm)
Signed and dated: lower right, "Hart/1929"
Reverse: on mat board, "Bathing the Horses"
Ex-collection: private collection, New York, N.Y.
Anonymous gift 1938 38.212

This work has been published as Men and Horses. *(corres.)*

Untitled 1917
Tempera on Belgian linen 117½"x71" (298.5x180.3 cm)
Unsigned
Ex-collection: the artist to Dr. T. K. Peters, Dunwoody, Ga., and
Sebastapol, Calif.; to donor, New York, N.Y.
Gift of Miss Dorothy C. Miller 1976 76.145

*This mural was painted as a set decoration for a film made by the World
Film Company, Fort Lee, N.J. (corres.)*

HART, JAMES McDOUGAL (1828-1901)

Pastorale Scene (Pasture Scene)
Oil on canvas 20⅛"x32" (51.1x81.3 cm)
Signed: lower right, "James•M•Hart•"
Ex-collection: donor, Scotch Plains, N.J.
Gift of Dr. J. Ackerman Coles 1920 20.1199

HART, WILLIAM (1823-1894)

Evening Glow
Oil on canvas 6¾"x12½" (17.1x31.8 cm)
Signed: lower left, "Wm. Hart"
Ex-collection: donor, Scotch Plains, N.J.
Gift of Dr. J. Ackerman Coles 1924 24.2454

HARTLEY, MARSDEN (1877-1943)

***Mt. Ktaadn, First Snow #2** 1939-40
Oil on academy board 24"x30" (60.9x76.2 cm)
Signed and dated: "Mt. Ktaadn (Maine)/First Snow #2/Marsden
Hartley/1939-40"
Reverse: label, San Francisco Museum of Art, lent anonymously; label,
Stedelijk Museum, "Modern American Painting", 1950; board marked,
"Prepared academy board for oil ptgs. F. Weber Co., Phil., Pa."
Ex-collection: Hudson D. Walker Gallery, New York, N.Y.
Purchase 1940 Felix Fuld Bequest Fund 40.123

Exhibited at the Hudson Walker Gallery in March, 1940.

***Still Life – Calla Lillies**
Oil on canvas board 26"x19" (66.0x48.3 cm)
Unsigned
Reverse: inscribed on panel, "'Still Life'/by Marsden Hartley/Charles
Daniel"; label, in donor's hand, "Willed to Newark Museum/'Calla
Lillies'/by Marsden Hartley"
Ex-collection: Charles Daniel Gallery, New York, N.Y.; to donor, Short
Hills, N.J. (1922)
Bequest of Miss Cora Louise Hartshorn 1958 58.170

Waterfall – New Hampshire (The Brook – New Hampshire)
Oil on composition board 26"x15½" (66.0x39.4 cm)
Unsigned
Reverse: label in Stieglitz' hand, "'An American Place'/509 Madison
Avenue-Room 1710/(S.E. corner 53rd Street)-New York/'Waterfall'-New
Hampshire/by Marsden Hartley"; label, in donor's hand, "Willed to
Newark Museum"; note in donor's hand on back of board, "Waterfall-
New Hampshire/by Marsden Hartley/bought from Stieglitz/New
York"; label (framer), "Geo. F. OF."
Ex-collection: An American Place, New York, N.Y.; to donor, Short
Hills, N.J. (1930)
Bequest of Miss Cora Louise Hartshorn 1958 58.176

The Shell – Green, Red, and White
Oil on composition board 15¼"x18⅜" (38.7x46.6 cm)
Unsigned
Reverse: label in Stieglitz' hand, "'An American Place'/509 Madison
Avenue — Room 1710/(S. E. corner 53rd. Street/-New York./Still Life
by/Marsden Hartley"; label on frame, "Geo. F. OF, Inc./Picture
Framer"
Ex-collection: An American Place, New York, N.Y. to donor, Short
Hills, N.J. (1930)
Bequest of Miss Cora Louise Hartshorn 1958 58.177

HARTSHORN, CORA LOUISE (1873-1958)

Trees 1903
Crayon on paper 17½"x21½" (44.5x54.6 cm)
Signed: lower left, "C. L. Hartshorn"
Ex-collection: remained in collection of the artist, Short Hills, N.J.
Bequest of the artist 1958 58.182

*When Miss Hartshorn died, many of her paintings, documented with
original labels, came to the Museum. (files)*

HASSAM, CHILDE (1859-1935)

***The South Gorge, Appledore, Isles of Shoals** (The Gorge) 1912
Oil on canvas 22¼"x18" (56.5x45.7 cm)
Signed and dated: lower right, "Childe Hassam/1912"
Reverse: "CH 1912"
Ex-collection: purchased from the artist, New York, N.Y.
Purchase 1912 The General Fund 12.571

***Piazza di Spagna, Rome** 1897
Oil on canvas 29¼"x23" (74.3x58.4 cm)
Signed and dated: lower right, "Childe Hassam 1897"
Reverse: handwritten label on frame, "18/Saloffer"
Ex-collection: donors, Somerville, N.J.
Gift of the Misses Lindsley 1926 26.272

***Gloucester** 1899
Oil on canvas 32"x32" (81.0x81.0 cm)
Signed: lower left, "Childe Hassam '99"
Reverse: signed and dated, "C.H. 1899"; label, title, artist, dimensions,
No. 18192; label, The Milch Gallery, New York, N.Y.; label, M. Knoedler
& Co. No. 69844; label, Coe-Kerr No. 3747
Ex-collection: the artist; to Academy of Arts and Letters (by bequest)
through Milch Gallery, New York, N.Y.; to John Fox, Brookline, Mass.;
to Milch Gallery, New York, N.Y.; to donor, West Orange, N.J.
Gift of Mrs. J. Russell Parsons 1973 73.76

Les Bouquinistes du Quai Voltaire, Avril 1897
Oil on canvas 21⁹/₁₆"x14⁹/₁₆" (54.8x37.0 cm)
Signed and dated: lower left, "Childe Hassam 1897"
Reverse: canvas stencil "Couleurs Tableaux/L. Prevost/quai (?) Paris";
label: pen, on stretcher (title); inscribed: pencil, on stretcher (title);
pencil, "cleaned Feb. 3, 1926 A. B. Holm"
Ex-collection: William O. Goodman, Chicago, Illinois, to his daughter,
the donor, Far Hills, N.J.
Gift of Mr. and Mrs. Robert D. Graff to the New Jersey State Museum
and The Newark Museum 1976 76.164

(New Jersey State Museum number A76.79)

*According to Kathleen M. Burnside of Hirschl & Adler Galleries, the work
was exhibited in March and April, 1929, at the Buffalo Fine Arts Academy,
Albright Art Gallery, as* Quai Voltaire, April, *and subsequently at the
Macbeth Gallery, New York, as* April, Quai Voltaire. *(corres.)*

HAWTHORNE, CHARLES (1872-1930)

***Calling of St. Peter** (Call of Peter) ca. 1900
Oil on canvas 60"x48" (152.4x121.9 cm)
Signed: upper left, "CHawthorne"
Ex-collection: Forbes & Wallace Department Store, Springfield, Mass.
(1900); sold at auction, Plaza Art Galleries, late 1930's (buyer
unknown); Mitchell Work, Belleville, N.J. (1961); Bernard Rabin,
Newark, N.J.
Gift of Bernard Rabin in memory of Nathan Krueger 1962 62.170

HEADE, MARTIN JOHNSON (1819-1904)

***Jersey Meadows with a Fisherman** (Jersey Meadows) 1877
Oil on canvas 13⅝"x26½" (34.6x67.3 cm)
Signed and dated: lower left, "M. J. Heade/1877"
Reverse: label, "#930 M. Heade"
Ex-collection: Harry Shaw Newman Gallery, New York, N.Y.
Purchase 1946 Sophronia Anderson Bequest Fund 46.156

*Theodore Stebbins gave the painting, #203 in his catalogue raisonné of
Heade's work, the descriptive title,* Jersey Meadows with a Fisherman.

*Cattleya Orchid with Two Hummingbirds (Orchid and Hummingbirds) ca. 1880's
Oil on canvas 16¼"x21¼" (41.3x54.0 cm)
Signed: lower left, "M J Head"
Reverse: painting has been relined; contemporary hand on stretcher, "Heade, M. J. Orchid, Hummingbirds EK #9 16 x 27/CSXX"; label, Museum of Fine Arts Boston, #4354; label, Kennedy Galleries
Ex-collection: Kennedy Galleries, New York, N.Y.
Purchase 1965 The Members' Fund 65.118

Title and approximate date were supplied by Theodore Stebbins in his catalogue raisonné of Heade's work (#28). Stebbins also felt that the birds depicted are Calathorax Heliodore (Heliodore's wood stars), which are native to Cuba.

HEALY, G. P. A. (1813-1894)
CHURCH, FREDERIC E. C. (1826-1900)
McENTEE, JERVIS (1828-1890)

*Arch of Titus 1871
Oil on canvas 74"x49" (188.0x124.5 cm)
Signed: upper left, "G. P. A. Healy. 1871"
Reverse: label, Wadsworth Atheneum *(Off for the Holidays*, 1955); label, Milwaukee Art Center, *Inner Circle*, 1966; label, Kennedy Galleries, *Brooklyn Art Association*, 1970; no other pertinent data recorded prior to relining, 1963
Ex-collection: Marshall D. Roberts (purchased from the artist in Rome, 1874); sold at sale of Roberts' paintings, Ortgies Gallery, New York, N.Y. (January 19, 1897); to donor, Scotch Plains, N.J.
Bequest of Dr. J. Ackerman Coles 1926 26.1260

The two figures under the arch have always been identified as Henry Wadsworth Longfellow and his daughter, Edith. Although there was a suggestion in the 1940's that the three artists in front of the arch were George Healy, Sanford Gifford and Launt Thompson, in The Museum Vol. 10, No. 1, William H. Gerdts identifies the figures as Frederic Church sketching with Healy and McEntee looking over his shoulders. These identifications are substantiated by review of the 1874 exhibition at the Brooklyn Art Association (The Nation, December 10, 1874, p. 385, and Appleton's Art Journal, January, 1875, p. 27).

In Appleton's Art Journal the painting is referred to as The Arch of Constantine. Mr. Gerdts' observation that the Colosseum is not visible through the Arch of Constantine but can be seen through the Arch of Titus, and the provenance supplied by the artist's granddaughter, Marie de Mare, support the fact that the two titles refer to the same painting.

David Huntington has indicated that Arch of Titus, completed in 1871, was begun as early as 1869.

The Illinois State Museum at Springfield has a 25"x30" study for this painting which shows one pillar plus part of the background Colosseum. The group of artists contains a fourth figure. Robert Evans, the Illinois curator, believes the figure is Tiburce de Mare, Healy's son-in-law. Evans also feels that the study was executed entirely by Healy. (corres.)

HELD, JOHN, JR. (1889-1958)

*Comedy that Appeals to the Gallery ca. 1923
Gouache on board 19⅛"x14⅞" (49.0x37.8 cm)
Signed: lower left, "John Held, Jr."
Ex-collection: donors, Scotch Plains, N.J.
Gift of Mr. and Mrs. Benjamin H. Haddock 1977 77.24

The title appears on the mat. This painting was bought at a house sale.

HELDER, Z. VANESSA (b. 1904)

Old Thompson House ca. 1935-43
Oil on cardboard 18"x23" (45.7x58.4 cm)
Signed: lower left, "Z/Vanessa/Helder"
Reverse: label, WPA Art Program
Allocated by the WPA Federal Art Project 1943 43.204

HELIKER, JOHN E. (b. 1909)

Boat Yards, Long Island Sound 1942
Oil on canvas 20"x32" (50.8x81.3 cm)
Signed and dated: lower right, "Heliker '42"
Reverse: inscribed in pencil, "Boat Yards L.I."
Ex-collection: with Kraushaar Galleries, New York, N.Y.; to donors, New York, N.Y.
Gift of Mr. and Mrs. Milton Lowenthal 1949 49.350

Exhibited at the Metropolitan Museum's Artists for Victory exhibition, January, 1943, prior to Kraushaar showing.

HENRI, ROBERT (1865-1929)

*Portrait of Willie Gee 1904
Oil on canvas 31¼"x26¼" (79.4x66.7 cm)
Signed: lower right, "Robert Henri"; upper left, "Portrait of Willie Gee"
Reverse: inscribed (prior to relining, 1967), "Robert Henri/Willie Gee"; label, Brooklyn Museum, *The Triumph of Realism*, 1968
Ex-collection: acquired by Corcoran Gallery of Art, Washington, D.C., from the artist, 1919; returned to artist 1924 as partial payment for another painting; private collection, New York, N.Y.
Anonymous gift 1925 25.111

X-rays have revealed another Henri portrait under Willie Gee. The concealed portrait is upside down. The painting was exhibited widely from the time it was executed, including: Rochester Art Club, 1904; Pennsylvania Academy of The Fine Arts and the Art Institute of Chicago, 1905.

Correspondence from Violet Organ of Westport, Conn., indicates the painting was done in New York in 1904.

Portrait of Mary Gallagher ca. 1924
Oil on canvas 24"x20" (61.0x50.8 cm)
Signed: lower left, "Robert Henri"
Reverse: no pertinent data recorded prior to relining, 1971
Ex-collection: acquired from the artist, New York, N.Y.
Gift of Mrs. Felix Fuld 1925 25.1168

One of 16 paintings purchased by the Museum with funds provided by Mrs. Felix Fuld.

Mary Gallagher was a fisherman's daughter on the Island of Achill, Ireland. Henri was there in 1913 and again in the years from 1924 until 1929. The date was established on stylistic grounds. (corres.)

*Man and Woman Laughing
Charcoal on paper 10⅜"x7⅞" (26.3x20.0 cm)
Signed: lower left, "RH"
Reverse: notation, that this "is Horowitz 232"
Ex-collection: estate of the artist; to Hirschl and Adler Gallery, New York, N.Y.; to donors, New York, N.Y.
Gift of Mr. and Mrs. Raymond J. Horowitz 1965 65.108

HENRY, EDWARD LAMSON (1841-1919)

*Lucy Hooper in Her Living Room in Paris 1876
Oil on canvas 12¼"x15¼" (31.1x38.7 cm)
Signed and dated: lower right, "E L Henry Paris/1876"
Reverse: no pertinent data recorded prior to relining, 1959
Ex-collection: The Old Print Shop, New York, N.Y.; to Berry Hill Galleries, New York, N.Y.
Purchase 1959 Wallace M. Scudder Bequest Fund 59.375

Lucy Hooper was the wife of Robert Hooper, the American Vice Consul in Paris. According to Elizabeth McCausland in The Life and Work of Edward Lamson Henry, she ran an "amateur drawing room" at her apartment on the Rue Neuve des Petits Champs. The Henry's visited her on their honeymoon, 1875-76.

HERING, HARRY (1887-1968)

White Wyandottes 1929
Oil on canvas 25"x30⅛" (60.5x76.5 cm)
Signed and dated: lower right, "H Hering 1/29"
Reverse: label, "Royal/Art Framing Co., Inc."
Ex-collection: donors, New York, N.Y.
Gift of Mr. and Mrs. Lesley G. Sheafer 1954 54.215

Artist based this painting on a watercolor he had done near Lakewood, N.J. (files)

HERRERA, CARMEN (b. Cuba 1915)

Cadmium – #4 1965
Acrylic on canvas 48"x48" (121.9x121.9 cm)
Unsigned
Ex-collection: with Cisneros Gallery, New York, N.Y.; to donors, Larchmont, N.Y.
Gift of Mr. and Mrs. Henry Feiwel 1970 70.87

HERRERA, VELINO (SHIJE) [Ma Pe Wi] (1902-1975/6)

War Dancers ca. 1920
Gouache on board 9½"x20½" (24.1x52.1 cm)
Signed: lower left, "Velino Shije/Santa Fe, N.M."
Reverse: label on backing, Gallery of American Indian Art, New York, N.Y./A. E. White #32
Gift of Miss Amelia E. White 1937 37.154

The artist was from Zia pueblo, N.M.

Design: Tree and Birds ca. 1930
Ink and gouache on paper (formerly on board) 18"x25½" (45.7x64.8 cm)
Signed: lower right, "Ma Pe Wi"
Reverse: stamp, "Spanish and Indian Trading Co."
Gift of Amelia E. White 1937 37.216

War Dancers ca. 1930
Gouache on paper (formerly on board) 10½"x20¾" (26.7x52.7 cm)
Signed: lower right, "Ma Pe Wi"
Reverse: inscribed, "Moon Dance"; label on backing, Gallery of American Indian Art, New York, N.Y./A. E. White #33
Gift of Miss Amelia E. White 1937 37.217

Two Men on Horses early 1920's (?)
Gouache on board 14"x19½" (35.6x49.5 cm)
Signed: lower right, "Ma Pe Wi"
Gift of Miss Amelia E. White 1937 37.221

Corn Dance ca. 1920
Gouache on paper (formerly on board) 21½"x29⅛" (54.6x74.0 cm)
Signed: lower right, "Ma Pe Wi"
Reverse: label on backing, 18th Biennial International Art Exhibition — Venice, 1932
Gift of Miss Amelia E. White 1937 37.244

Deer ca. 1930
Gouache on paper 22"x16" (55.9x40.6 cm)
Signed: lower right, "Ma Pe Wi"
Gift of Miss Amelia E. White 1937 37.245

HESSELIUS, JOHN (1728-1778)

*****Portrait of Mrs. Richard Sprigg** [Margaret Caile] (ca. 1745-96)
ca. 1765-70
Oil on canvas 30⅛"x25⅛" (76.5x63.8 cm)
Unsigned
Reverse: label, "Margaret Caile, daughter of John Caile to/ ... ecca Ennals, an Englishman, who settled/ ... ern shore of Maryland/ ... 1770-1771"
Ex-collection: The Misses M. Louise and Emily B. Steuart, Baltimore, Md. (great-great-granddaughters of subject); to their niece, Mrs. Harold Taylor; to her daughter, Mrs. Delano Ames III, Baltimore, Md.; to Robert Carlen Gallery, Philadelphia, Pa. (1953); to Hirschl & Adler Galleries, New York, N.Y. (1955)
Purchase 1955 The Members' Fund 55.119

Other family portraits by Hesselius at the Art Institute of Chicago and the Metropolitan Museum of Art help confirm the date.

HEUSSER, ELEANOR (20th century)

Overlooking the City 1951
Pen and ink on paper 19¼"x26⅝" (48.9x67.6 cm)
Signed: lower right, "E. Heusser"
Ex-collection: acquired from the artist, Paterson, N.J.
Purchase 1952 Frederick Pierson Field Memorial Fund 52.30

Purchased from The Newark Museum first triennial exhibition, Work by New Jersey Artists, 1952.

HICKS, EDWARD (1780-1849)

*****Grave of William Penn** 1847
Oil on canvas 24"x30" (61.0x76.2 cm)
Signed and dated: on stretcher, "Painted by Edw. Hicks in his 68th year, for his/friend William H. Macy of New York 1847"
Inscribed: lower left of painting front, "Grave of Wm. Penn at Jordans in England with the Old Meeting House/burial ground and J.J. Gurney and friends looking at the grave"
Reverse: handwritten label on stretcher, "Presented to/George Macy/from/his grandmother/E.L. Macy"
Ex-collection: William H. Macy, New York, N.Y.; E. L. Macy; to George Macy; to donors, Stockton, N.J.
Gift of Mr. and Mrs. Bernard M. Douglas 1956 56.62

HICKS, THOMAS (1823-1890)

Portrait of Nehemia Perry (1816-81) (attributed)
Oil on canvas 34"x27" (86.4x68.6 cm)
Unsigned
Ex-collection: donor, Montclair, N.J.
Gift of Mrs. F. Sutton 1923 23.1866

Nehemia Perry, a resident of Newark, was elected a candidate of the Constitutional Union Party to the 37th and 38th Congresses, March 4, 1861 – March 3, 1865, and elected Mayor of Newark in 1873.

HIGGINS, EUGENE (1874-1958)

Portrait of Abraham Walkowitz (1878-1965) 1943
Oil on canvas 18"x14¼" (45.7x36.2 cm)
Signed: lower left, "Eugene Higgins"
Reverse: inscribed on canvas, "Portrait of the artist/Abraham Walkowitz/by Eugene Higgins/1943"
Ex-collection: donor, New York, N.Y.
Gift of Abraham Walkowitz 1947 47.223

Executed for exhibition, One Hundred Artists and Walkowitz, Brooklyn Museum, 1944.

HILL, HOMER (1917-1968)

Red Sky 1955
Tempera on paper 23"x28¾" (58.4x73.0 cm)
Signed and dated: upper left, "Homer Hill '55"
Ex-collection: acquired from the artist, Chatham, N.J.
Purchase 1955 Mrs. Felix Fuld Bequest Fund 55.117

HILLSMITH, FANNIE (b. 1911)

The Wing Chair 1956
Collage: charcoal, tempera, crayon on burlap mounted on board
15¾"x11⅞" (40.0x30.2 cm)
Signed: lower right, "F. Hillsmith '56"
Reverse: label, Peridot Gallery, New York, N.Y.; ink label, title, media,
size and artist
Ex-collection: donor, New York, N.Y.
Gift of Henry M. Fuller 1965 65.117

HINCKLEY, THOMAS HEWES (1813-1896)

*__Cows and Sheep in a Landscape__ 1853
Oil on canvas mounted on board 25½"x36" (64.8x91.5 cm)
Signed and dated: lower left, "T.H. Hinckley 1853"
Ex-collection: donors, New York, N.Y.
Gift of Mr. and Mrs. Orrin W. June 1961 61.11

HINE, CHARLES COLE (1827-1871)

Illinois Farm
Oil on canvas 17¾"x25¾" (45.1x65.4 cm)
Unsigned
Ex-collection: remained in artist's family until donated by his
daughter-in-law, Webster Grove, Mo.
Gift of Mrs. Charles G. Hine 1942 42.207

HIOS, THEO (b. Greece 1910)

*__Untitled__ 1965
Acrylic on canvas 48"x72" (121.9x182.9 cm)
Unsigned
Ex-collection: acquired by donors from artist
Gift of Dr. and Mrs. Lewis Balamuth 1978 78.18

HIRSCH, STEFAN (b. Germany 1899-1964)

Winter Night 1928
Oil on panel 22½"x19¾" (57.2x50.2 cm)
Signed and dated: lower right, "Hirsch/1928"
Ex-collection: private collection, New York, N.Y.
Anonymous gift 1929 29.215

*The artist indicated that this depiction of Central Park West at 73rd Street
was part of a New York City series. (corres.)*

Three Donkeys 1932
Oil on canvas 29¾"x39½" (75.6x100.3 cm)
Signed and dated: lower right, "1932/Stephen/Hirsch/
with lightening device"
Reverse: signed and dated, as above; label, The Downtown Gallery;
label, Art Institute of Chicago, *A Century of Progress*, 1933; label,
Pennsylvania Academy of The Fine Arts, Annual Exhibition of Painting
and Sculpture, 1933 (#87)
Ex-collection: The Downtown Gallery, New York, N.Y.; to donor,
Convent, N.J. (1933)
Gift of Mrs. Paul Moore 1962 62.150

HOEBER, ARTHUR, JR. (1854-1915)

Autumn Landscape, Mrs. Baker Raking Leaves 1885
Oil on canvas 19⅞"x35" (50.5x88.9 cm)
Signed: lower right, "Arthur Hoeber"
Ex-collection: A. J. Wills; to donor, Boston, Mass.
Gift of Walter W. Patten, Jr., 1964 in memory of his grandfather,
A. J. Wills 64.261

*The donor stated that this painting was executed by Hoeber for Wills. It
is not known if Mrs. Baker was related to Wills, but the work was also
reported to have been in the collection of the Baker family, Claverack, N.Y.,
at one time. (files)*

HOFFMAN, D. (19th century)

Untitled 1873
Charcoal, chalk and pencil on paper pasted on cardboard 20⅞"x27⅞"
(53.0x70.8 cm)
Reverse: on wood backing, "D. Hoffman 1873/Copper Mill(?)";
"D Hoffman/artist"
Ex-collection: donor, Millburn, N.J.
Gift of Judge and Mrs. Melvin P. Antell 1971 71.111

HOFMANN, HANS (b. Germany 1880-1966)

*__Laburnum II__ 1959
Oil on plywood 36"x23½" (91.5x59.7 cm)
Signed and dated: lower right, "59/Hans Hofmann"
Reverse: inscribed on panel, "Laburnum II 1959/36x23½/oil on
plywood panel/Hans Hofmann/cat. No 980"; label, Kootz Gallery
Ex-collection: Samuel M. Kootz Gallery, Inc., New York, N.Y.
Purchase 1960 Felix Fuld Bequest Fund 60.582

"No 980" refers to the artist's own records.

HOLM, EDWIN (b. 1911)

Just a Fancy 1938
Watercolor on paper 19½"x24⅞" (49.5x63.2 cm)
Signed and dated: lower left, "E. Holm '38"
Reverse: label, Museum of Modern Art, loan (39.1820);
label, WPA, #9950
Allocated by the WPA Federal Art Project 1943 43.161

HOLSTON, EDITH [Garside Powers] (20th century)

Landscape, Singac 1939
Oil on canvas 21"x25" (53.3x63.5 cm)
Signed: lower right, "Garside/Powers"
Allocated by the WPA Federal Art Project 1954 54.203

HOLZHAUER, EMIL (b. Germany 1887)

On the Village Limits ca. 1933
Watercolor on paper 22⅞"x31" (58.2x78.7 cm)
Signed: lower right, "Holzhauer"
Allocated by the United States Treasury Department Public Works
of Art Project 1934 34.167

*The painting depicts the area of Cold Spring on the Hudson where the
artist lived for several years prior to 1940. (files)*

HOMER, WINSLOW (1836-1910)

*__Beaver Mountain, Adirondacks; Minerva, New York__ ca. 1876
Oil on canvas 12⅛"x17⅛" (30.8x43.5 cm)
Signed: lower right, "Winslow Homer"
Reverse: torn label, Carnegie Institute of Art, Pittsburgh — lent by
Mrs. Leland Hayward; on backing, 9731 A C8238; stamp on canvas,
Dechaux stencil
Ex-collection: Rev. Prescott, Boston, Mass. (gift from the artist);
William J. Kaula, Greenville, N.H.; J. W. McBrine, Boston, Mass.;
M. Knoedler & Co., New York, N.Y.; Maynard Walker Gallery, New
York, N.Y.; Margaret Sullavan, New York, N.Y.; Leland Hayward,
New York, N.Y.; Babcock Galleries, New York, N.Y.
Purchase 1955 Louis Bamberger Bequest Fund 55.118

*Approximate dating of this painting results from its stylistic and
compositional similarity to the* Two Guides *(1876) at the Robert Sterling
and Francine Clark Institute, Williamstown, Mass.*

***At the Cabin Door** 1865-66
Oil on canvas 23″x18″ (58.4x45.7 cm)
Signed: lower left, "Homer 65"; lower right, "Homer 1866"
Reverse: no pertinent data recorded prior to relining, 1966
Ex-collection: Elijah Kellogg, Elizabeth, N.J.; to his wife Martha Banks
C. Kellogg (1884); to her daughter Clementine Kellogg Corbin; to her son
Horace Kellogg Corbin; to donors, Westfield, N.J.
Gift of Mrs. Hannah Corbin Carter; Horace K. Corbin, Jr.; Robert S.
Corbin; William D. Corbin; and Mrs. Clementine Corbin Day in
memory of their parents, Hannah Stockton Corbin and Horace Kellogg
Corbin 1966 66.354

*Gordon Hendricks has raised the question of why this painting was
signed twice. A logical suggestion is that the artist worked on the
painting again after first completing it in 1865.*

Seascape 1895 (attributed)
Oil on canvas 8¾″x14″ (22.2x35.6 cm)
Signed and dated: lower left, "Homer 1895"
Ex-collection: donor, New York, N.Y.
Gift of Jack Bender 1957 57.123

*When this sketch was restored in 1957, X-ray revealed the presence of
another painting beneath it. There is general consensus among scholars,
including Lloyd Goodrich, that this painting was probably not executed by
Homer. (files)*

HOMITSKY, PETER (b. Germany 1942)

Roof Tops – Newark 1975
Oil canvas 26″x22″ (66.1x56.0 cm)
Unsigned
Reverse: label, Alonzo Gallery
Ex-collection: with Alonzo Gallery, New York, N.Y.; through the
Summit Art Center, Summit, N.J.
Gift of the Alex Aidekman Family Foundation 1977 77.200

HONDIUS, GERRIT (b. Holland 1891-1970)

Circus Girl ca. 1930-35
Oil on canvas 30″x24″ (76.2x61.0 cm)
Signed: lower left, "G. Hondius"
Ex-collection: Louis Shapiro; to donor, New York, N.Y.
Gift of Miss May E. Walter 1958 58.26

*In 1958 the artist indicated that the five Hondius paintings donated by
Miss Walter came from the Louis Shapiro Collection and had been
executed at least 25 years earlier. (corres.)*

Female Nude ca. 1930-35
Oil on wood 21¾″x17¾″ (52.7x45.1 cm)
Signed: lower left, "G Hondius"
Ex-collection: Louis Shapiro; to donor, New York, N.Y.
Gift of Miss May E. Walter 1958 58.27

Fisherman and Net ca. 1930-35
Gouache on paper 16″x22″ (40.6x55.8 cm)
Signed: lower right, "G Hondius"
Ex-collection: Louis Shapiro; to donor, New York, N.Y.
Gift of Miss May E. Walter 1958 58.28

Gansevoort Market, New York ca. 1930-35
Oil on canvas 16″x21″ (40.6x53.3 cm)
Signed: lower right, "G.-Hondius"
Ex-collection: Louis Shapiro; to donor, New York, N.Y.
Gift of Miss May E. Walter 1958 58.29

Longpier, Portland, Maine ca. 1930-35
Oil on wood 16½″x21½″ (42.0x54.6 cm)
Signed: lower right, "G. Hondius"
Ex-collection: Louis Shapiro; to donor, New York, N.Y.
Gift of Miss May E. Walter 1958 58.30

Still Life with Aqua Cloth 1967
Oil on board 30″x24″ (73.6x60.9 cm)
Signed: lower right, "Hondius"
Ex-collection: donor, New York, N.Y.
Gift of Dr. Emanuel K. Schwartz 1971 71.177

HOPKINS, SUSAN MILES (?-1853)

Mausoleum of Sufter Jung Delhi 1841
Ink on paper 18¾″x27⅛″ (47.6x68.9 cm)
Signed and inscribed: along bottom, "Mausoleum of Sufter Jung
Delhi. (symbol) Drawn and painted by S. M. H. Bridgton New Jersey.
Nov, 1841."
Ex-collection: remained in artist's family until donated by her niece,
Montclair, N.J.
Gift of Miss Gertrude Tubby 1956 56.175

HOPKISON, CHARLES (1869-1962)

The Church at Delft 1926
Watercolor on paper 22″x14½″ (55.8x36.8 cm)
Signed: lower right, "C.H."
Ex-collection: private collection, New York, N.Y.
Anonymous gift 1937 37.114

Date was supplied by the artist. (files)

HOPPER, EDWARD (1882-1967)

***The Sheridan Theatre** 1937
Oil on canvas 17⅛″x25¼″ (43.5x64.2 cm)
Signed: lower right, "Edward Hopper"
Reverse: label in artist's hand, "The Sheridan Theatre/Edward
Hopper"; label, University of Arizona, Edward Hopper exhibition,
1963; label, Art Institute of Chicago, 54th Annual Exhibition, 1943;
label, Sao Paulo Biennial, 1957; label, Pennsylvania Academy of The
Fine Arts, *American Taste in Art* (lent by Rehn Gallery)
Ex-collection: with Frank Rehn Gallery, New York, N.Y.
Purchase 1940 Felix Fuld Bequest Fund 40.118

*The theatre was a New York landmark located at Seventh Avenue and
12th Street.*

HOWE, OSCAR [Mazuha Hokshina] (b. 1915)

Horses ca. 1935
Gouache on paper 9¾″x21¾″ (24.8x55.2 cm)
Signed: lower right, "O. Howe"
Reverse: label, Gallery of American Indian Art, New York, N.Y.
Gift of Miss Amelia E. White 1937 37.228

The artist is a member of Yanktonai Sioux tribe.

HUBBELL, HENRY SALEM (1870-1949)

Augustine ca.1904
Oil on canvas 44″x29″ (111.8x73.7 cm)
Signed: lower right, "Henry S. Hubbell"
Reverse: label, St. Louis, Louisiana Purchase Exposition, 1904
Ex-collection: donor, New York, N.Y.
Gift of Henry Wellington Wack 1926 26.212

HUDSON, ROBERT (b. 1938)

Ghost Hand in the Corner 1976
Pencil, pastel, watercolor, collage, charcoal on paper 31⅝″x41¾″
(81.0x106.0 cm)
Signed and dated: lower left, "Robert Hudson '76"
Reverse: label, Allan Frumkin Gallery Inc.
Ex-collection: with Allan Frumkin Gallery Inc., New York, N.Y.; to
donors, New York, N.Y.
Gift of Mr. and Mrs. Henry Feiwel 1977 77.240

HULTBERG, JOHN PHILLIP (b. 1922)

Rusted Land 1968
Oil on canvas 50"x68" (127.0x172.7 cm)
Reverse: "John Hultberg"
Ex-collection: donor, Englewood Cliffs, N.J.
Gift of Stanley Bard 1971 71.145

HUNTINGTON, DANIEL (1816-1906)

*****Trout Brook** ca. 1850
Oil on canvas 8¼"x20" (21.0x50.8 cm)
Signed: lower left, "D. Huntington"
Reverse: stamp on canvas, "(symbol), 772, Runaway"
Ex-collection: Dr. Abraham Coles, Newark, N.J.; to his son, the donor,
Scotch Plains, N.J.
Bequest of Dr. J. Ackerman Coles 1926 26.1160

Huntington exhibited a Trout Brook *as #7 in the 1848 American Art
Union exhibition, from which it was sold to C. N. Dunlap of Zanesville, O.*

Portrait of Abraham Coles (1813-91) 1898
Oil on canvas 30"x25" (76.2x63.5 cm)
Signed and dated: lower left, "D. Huntington/1898"
Ex-collection: Dr. Abraham Coles, Newark, N.J. to his son, donor,
Scotch Plains, N.J.
Bequest of Dr. J. Ackerman Coles 1926 26.2789

*Dr. Abraham Coles, a Newark physician and litterateur, had a particular
interest in the Newark Free Public Library. His son was a major benefactor
of The Newark Museum.*

HURD, PETER (b. 1904)

Portrait of H. Reginald Bishop 1940
Egg tempera on gesso panel 20"x18½" (50.8x47.0 cm)
Signed: lower right, "Peter Hurd"
Reverse: inscribed, "*H. Reginald Bishop*/Cameo/Peter
Hurd/June/1940/Egg tempera/on/Gesso"; inscribed, "10/16/44";
inscribed on stretcher, "Edith A. Lowenthal"; label, AFA exhibition,
Surviving the Ages 1963-1964; label, Macbeth Galleries (2); stamp on
stretcher and panel, "(monogram) A1125"
Ex-collection: Macbeth Galleries, New York, N.Y.; to donor,
New York, N.Y.
Gift of Mrs. Edith Lowenthal 1945 45.7

*H. Reginald Bishop was associated with Hurd at the San Patricio Ranch in
Mexico. Bishop trained ponies and played on the Corale polo team.* (files)

HUTCHINS, MAUDE PHELPS (20th century)

Seated Figure
Pencil and charcoal on paper 14"x9⅞" (35.5x25.1 cm)
Unsigned
Ex-collection: private collection, New York, N.Y.
Anonymous gift 1940 40.331

Paper is watermarked, "F. Weber/Philadelphia"

Reclining Figure
Pencil and charcoal on paper 10"x14" (25.9x35.5 cm)
Unsigned
Ex-collection: private collection, New York, N.Y.
Anonymous gift 1940 40.333

Paper is watermarked, "F. Weber Co./Phila/"

Nude Figure
Pencil and charcoal on paper 13¹⁵/₁₆"x9⅞" (35.4x25.1 cm)
Unsigned
Ex-collection: private collection, New York, N.Y.
Anonymous gift 1940 40.332

Paper is watermarked, "F. Weber Co./Philadelphia"

Tiger Cat
Pencil on paper 8¾"x11¾" (22.2x29.8 cm)
Unsigned
Ex-collection: private collection, New York, N.Y.
Anonymous gift 1940 40.334

HUTH, ABRAHAM (19th century)

*****Baptismal Certificate of John David Braun** 1823
Fraktur: tempera, watercolor and ink on paper 12"x15⅛" (30.5x38.4 cm)
Inscribed: "Lebanon County, Pennsylvania September 1823"
Ex-collection: Edgar William and Bernice Chrysler Garbisch;
purchased at Sotheby Parke Bernet Sale 3593, January 23-24,
1974, #182
Purchase 1974 Katherine Coffey Fund 74.2

*According to John Gordon, New York, N.Y., Abraham Huth was active in
the 1820's in Lebanon, Pa., and adjoining counties. He was associated
with the Kimberling Church, possibly as its pastor. Huth was related to
or influenced by Konrad Trevitz.*

HUTSON, BILL (b. 1936)

*****Sasa of the First Creation Crossing a Wet Bone Path North by
Northeast** 1971
Oil on canvas 96"x72" (243.8x182.8 cm)
Reverse: inscribed on canvas, "Sasa of the First Creation/Crossing a
Wet Bone Path/North by Northeast/B./January Hutson 1971 N.Y."
Ex-collection: purchased from the artist, New York, N.Y.
Purchase 1971 Prudential Insurance Company Fund 71.165

Purchased from The Newark Museum exhibition, Black Artists: Two
Generations, *1971.*

INGHAM, CHARLES CROMWELL (1796-1863)

*****Portrait of Margaret A. Babcock** (1804-1826) ca. 1820
Oil on canvas 36¼"x28" (92.1x71.2 cm)
Unsigned
Reverse: painting relined before entering collection
Ex-collection: descended in family of sitter to grandniece and
grandnephew, the donors, Westport, Conn.
Gift of Miss Mary Elizabeth Morris and John B. Morris 1953 53.15

INMAN, HENRY (1801-1846)

The Children of Bishop George W. Doane 1835
Oil on canvas 25"x31¼" (63.5x79.4 cm)
Signed and dated: upper right, "Inman. 1835"
Reverse: painting relined prior to entering collection
Ex-collection: Bishop George W. Doane, Burlington, N.J.; to his
brother, Bishop William Doane, Albany, N.Y.; to his granddaughter by
inheritance (1913); to her son, Dr. William Doane Frazier, Narberth, Pa.
Purchase 1959 Louis Bamberger Bequest Fund 59.83

*The children are George Hobart Doane (1830-1905), who converted to
Roman Catholicism and became Monsignor Doane of Newark, and
William Croswell Doane (1832-1913), who became the first Episcopal
Bishop of the Diocese of Albany, N.Y. He was at one time rector of his
father's former parish, St. Mary's Church, Burlington, N.J.*

Portrait of Rev. William Stone (1759-1840) 1823
Oil on canvas 30½"x25" (77.5x63.5 cm)
Unsigned
Reverse: label on frame, "Rev. William Stone/Painted by
Henry/Inman in/1823 in N.Y. City"
Ex-collection: descended in family of sitter;
to donors, Port Charlotte, Fla.
Gift of Mr. and Mrs. Douglas Stone 1965 65.160

*Rev. Stone was a Congregationalist minister who fought in the
Revolutionary War before he attended Yale. His daughter-in-law was
Susannah Pritchard Wayland Stone of Trumbull's portrait (61.463), and
his grandson is depicted in Taggart's portrait of William Leete Stone
(65.159).*

INMAN, JOHN O'BRIAN (1828-1896)

St. Valentines Day, 1890 ca. 1890
Oil on wood 5″x9½″ (12.7x23.5 cm)
Signed: lower left, "J.O.B. Inman"
Ex-collection: donor, Plainfield, N.J.
Gift of Mrs. L. R. Fort 1964 64.68

J. O. B. Inman was the son of the painter Henry Inman.

INNESS, GEORGE (1825-1894)

*Delaware Valley Before the Storm ca. 1865
Oil on canvas 10″x14″ (25.4x35.5 cm)
Signed: lower left, "G. Inness"
Reverse: label, American Federation of Arts,
Major Work in Minor Scale
Ex-collection: Milch Gallery, New York, N.Y.
Purchase 1944 Wallace M. Scudder Bequest Fund 44.185

Date was suggested on stylistic grounds by LeRoy Ireland.

Golden Sunset, Medfield (Home from Pasture) ca. 1862-64
Oil on canvas 39½″x29½″ (100.3x74.9 cm)
Signed: lower right, "G. Inness"
Ex-collection: private collection 1881-1919 (remained with one family);
Copley Gallery, Boston, Mass.; to Macbeth Gallery, New York, N.Y.,
1919; Elmer E. Smathers, New York, N.Y. (sold at E. E. Smathers sale,
Parke-Bernet Gallery, March 6, 1948, #90); Macbeth Gallery,
New York, N.Y.
Purchase 1948 Wallace M. Scudder Bequest Fund 48.334

Known as Golden Sunset, Medfield *until the E. E. Smathers sale at*
Parke-Bernet Gallery, March 6, 1948, where the title was changed to
Home from Pasture. *(corres.)*

LeRoy Ireland in correspondence, arrived at the approximate date, noting
that Inness' Medfield period extended from 1859 to 1864. A smaller
(17¼″x23½″) Golden Sunset of 1863 was included in the Inness
Centennial Exhibition at the Buffalo Fine Arts Academy, 1925 (#23).

*The Trout Brook 1891
Oil on canvas 30¼″x45¼″ (76.8x104.9 cm)
Signed and dated: lower left, "G. Inness 1891"
Reverse: painting relined prior to entering the Museum collection
Ex-collection: M. Knoedler & Co. (purchased April 1952, Parke-Bernet
Gallery, lot #666, sale #337); James W. Ellsworth, New York, N.Y.;
Bernon S. Prentice, New York, N.Y.; to Hirschl & Adler Galleries,
New York, N.Y.
Purchase 1965 The Members' Fund 65.36

According to correspondence from LeRoy Ireland, this was probably
painted in the "vicinity of Montclair, N.J." The painting was recorded
and illustrated in George Inness, Jr.'s Life, Art and Letters of
George Inness, Sr., *1917, p. 240.*

Landscape (Large Tree, Cows) (attributed)
Oil on wood 4¾″x6″ (12.1x15.2 cm)
Unsigned
Ex-collection: donor, New York, N.Y.
Gift of A. S. Wilder 1968 68.241

If this is an Inness work, it would have been painted early in his career.

INNESS, GEORGE, JR. (1853-1926)

Landscape
Oil on wood panel 9″x11¼″ (22.9x28.6 cm)
Signed: lower right, "Inness Jr."
Ex-collection: The Howard W. Hayes Collection
Gift of Mrs. Louis Pennington 1949 49.540

No. 9 in the Howard W. Hayes Collection catalogue, Newark Free Public
Library, 1906.

IPCAR, DAHLOV (b. 1917)

Kings Row ca. 1953
Oil on canvas 20″x30″ (50.8x76.2 cm)
Signed: lower left, "Dahlov Ipcar"
Reverse: label, Pennsylvania Academy of The Fine Arts,
Annual Exhibition, 1953
Ex-collection: donor, New York, N.Y.
Gift of Irving Shapiro 1955 55.81

JACOBSEN, ANTONIO (b. Denmark 1850-1921)

Portrait of the Pilot Boat New Jersey (Seascape;
Pilot Boat New Jersey) 1903
Oil on canvas 22⅛″x35⅞″ (57.1x91.1 cm)
Signed and dated: lower right, "Antonio Jacobsen/
West Hoboken, NJ 1903"
Reverse: label, American Federation of Arts, *Surviving the Ages*, 1964
Ex-collection: donor, New York, N.Y.
Gift of Mrs. Bella C. Landauer 1938 38.511

Mrs. Landauer purchased this painting for the Museum although her 1938
correspondence did not reveal where. Jacobsen painted at least five other
portraits of the same boat. Two other boats in the painting are marked. The
boat at left background is the Deutschland *and in the right foreground the*
vessel's sail carries the number "19."

JANSEN, RICHARD H. (b. 1910)

Division Street ca. 1937
Gouache on paper pasted to mat 20¾″x27½″ (52.7x69.8 cm)
Signed: lower right, "R. H. Jansen"
Reverse: label, "Wisconsin Federal Art Project/Richard Jansen/
Division Street/Dec 17 1937"
Allocated by the WPA Federal Art Project 1943 43.195

Date on the reverse is that of delivery to WPA.

JARVIS, JOHN WESLEY (1780-1840)

Portrait of Mrs. King Perrin ca. 1810-15
Oil on wood 27″x20″ (68.6x50.8 cm)
Unsigned
Purchase 1956 John J. O'Neill Bequest Fund 56.178

Not listed in Harold Dickson's monograph on Jarvis.

*Portrait of Mrs. James Robertson Smith (Hannah Rhea Caldwell)
(1767-1825) ca. 1810-20
Oil on wood 33¼″x26½″ (84.5x67.3 cm)
Ex-collection: A. Pennington Whitehead, Newark, N.J.; to his daughter
Anna Caldwell Whitehead Duer, New York, N.Y.; to her husband
Edward Rush Duer, New York, N.Y.; to his nephew, the donor,
New York, N.Y.
Gift of A. Pennington Whitehead in memory of Mrs. James Cox Brady
1978 78.80

The subject was the daughter of the Reverend James Caldwell, hero of the
Battle of Springfield, and Hannah Ogden Caldwell, who was shot and
killed by British troops at Connecticut Farms near Elizabethtown sixteen
days before the Battle of Springfield. She was also the wife of James
Robertson Smith and the great-great-grandmother of donor. (Rand 78.79).
See Dickson (#218), listed as canvas.

*Portrait of James Robertson Smith (1761-1817)
Oil on canvas 33¾″x27¼″ (85.7x68.7 cm)
Ex-collection: (see Jarvis 78.80)
Gift of A. Pennington Whitehead in memory of
Mrs. James Cox Brady 1978 78.81

Smith was the husband of Hannah Rhea Caldwell.
See Dickson (#217).

JEFFERSON, JOSEPH (1829-1905)

Landscape
Oil on canvas 18"x26" (45.7x66.0 cm)
Signed: lower left, "To George A. Colt/from his friend/J. Jefferson"
Ex-collection: George A. Colt; to donor, Scotch Plains, N.J.
Bequest of Dr. J. Ackerman Coles 1926 26.1228

Milldam on the Miramachi 1894
Oil on canvas 17½"x28½" (44.5x72.4 cm)
Signed and dated: lower left, "J. Jefferson 94"
Reverse: torn label, Buffalo Academy of Fine Arts
Ex-collection: donor, Summit, N.J.
Gift of Charles H. Ault 1929 29.29

JENNIS, STEVAN (b. 1945)

Dog in Window 1973
Latex and pencil on paper 29⅜"x21½" (74.6x54.5 cm)
Unsigned
Ex-collection: with Hundred Acres Gallery, New York, N.Y.; to donors,
New York, N.Y.
Gift of Mr. and Mrs. Henry Feiwel 1977 77.231

JENNY, JOHANN (1786-1854)

***The House and Shop of David Alling** ca. 1840-50 (attributed)
Oil on canvas 20½"x30" (52.1x76.2 cm)
Unsigned
Ex-collection: remained in Alling family; to Louis Alling Conklin,
Bloomfield, N.J.
Purchase 1939 Thomas L. Raymond Bequest Fund 39.265

*David Alling was a well-known Newark chairmaker. His house and shop
were located on Broad Street near Fair, in an area known as
"Frenchman's Place." Another version of the same scene is owned by the
New Jersey Historical Society. The Frick Art Reference Library has made
the tentative stylistic attribution to Jenny.*

JEWETT, WILLIAM SMITH (1812-1873)

***Yosemite Falls** 1859
Oil on canvas 52⅛"x42" (132.2x106.7 cm)
Reverse: inscribed, "Yosemite Falls by W. Jewett/1859"; sticker,"M.
Knoedler & Co. A-5569/Yosemite Falls W. Jewett/A5569"; sticker on top
frame, "Phoenix Art Museum 10/6/72-11/26/72 *National Park and the
American Landscape*, photo #59153. Crayon 10/5340 photo"
(stamped); sticker on backing, "Plastic varnish 259 AAF 46/7"; sticker
on bottom stretcher, "NCFA TL 102. 1971. 103 William S. Jewett/
Yosemite Falls/Lent by Knoedler"; crayon on left vertical frame,
"Spark 30 E 55th St."; upside down, "2418-7 73? 4-19"
Ex-collection: M. Knoedler & Co., Inc., New York, N.Y.; Hammer
Galleries, New York, N.Y.; to donor, Far Hills, N.J.
Gift of Mrs. Charles W. Engelhard 1977 77.5

JEWETT, WM. (See Waldo, Samuel Lovett)

JOHNSON, AVERY F. (1906)

Going Ashore, Early Morning ca. 1940
Watercolor on paper 14½"x21¼" (36.8x54.0 cm)
Signed: lower right, "Avery Johnson"
Ex-collection: acquired from the artist, Denville, N.J.
Purchase 1942 Sophronia Anderson Bequest Fund 42.95

Key West
Watercolor on paper 21¼x29½" (54.0x74.9 cm)
Signed: lower right, "Avery Johnson"
Ex-collection: the artist, Denville, N.J.
Gift of Kresge, Newark 1959 59.374

*Winner of 1959 New Jersey Watercolor Society exhibition at
Kresge, Newark.*

JOHNSON, BUFFIE (b. 1912)

Snowstorm 1952
Oil on canvas 25"x26¾" (63.5x67.9 cm)
Reverse: "Snowstorm/Buffie Johnson/1952"; signed on lower stretcher,
"Buffie Johnson"; on right stretcher, "Buffie Johnson"; label, Rose
Fried Gallery, New York, N.Y.
Ex-collection: Rose Fried Gallery; to private collection (1956)
Anonymous gift 1956 56.6

JOHNSON, EASTMAN (1824-1906)

Portrait of Stephen Andrew Florentine Peletier
Charcoal and chalk on grey paper 11¾"x9⅛" (29.8x23.2 cm)
Unsigned
Inscribed: along bottom, "Stephen Andrew Florentine Peletier"
Ex-collection: Albert Rosenthal (1940); to donors, New York, N.Y.
Gift of Mr. and Mrs. Victor Spark, in memory of Pfc Donald W. Spark
USMCR, born August 17, 1923, Long Branch, NJ., killed in action, June
1944, Saipan, Marianas Islands, and dedicated to the Fourth Marine
Division, Fleet Marine Force, 1944 44.197

#340 in the Eastman Johnson catalogue raisonné by John Baur (1940).

***Catching the Bee** 1872
Oil on millboard 22⅞"x13¾" (58.1x34.9 cm)
Signed and dated: lower left, "E. Johnson 1872"
Reverse: label, Vose Galleries
Ex-collection: Edgar R. Arnold, Jamestown, R.I.; with Vose Galleries,
Boston, Mass.
Purchase 1958 Wallace M. Scudder Bequest Fund 58.1

*Exhibited at the National Academy of Design in 1873. The subject of
Catching the Bee was adapted into Johnson's Hollyhocks (1876), now at
the Museum of Art, New Britain, Conn. (corres.)*

JOHNSTON, DAVID CLAYPOOL (1798-1865)

***Republican Candidates' Dream**
Pencil on Paper 4⅞"x7¾" (12.4x19.7 cm)
Unsigned
Inscribed: along bottom in pencil, "Republican candidates' dream";
within drawing, "White House"; "non inter-/ventions"; along margin
in ink, "wert thou a man thou wouldn't have mercy on me."; stamped,
"Perry's Shadow"
Ex-collection: Mrs. M. C. Donovan, Dorchester, Mass. (artist's
granddaughter); to donors, New York, N.Y.
Gift of Mr. and Mrs. Victor Spark, in memory of Pfc Donald W. Spark
USMCR, born August 17, 1923, Long Branch, N.J., killed in action, June
1944, Saipan, Marianas Islands, and dedicated to the Fourth Marine
Division, Fleet Marine Force, 1944 44.193

Boy with Dog
Pencil on paper 5⅝"x7¼" (14.3x18.4 cm)
Signed: lower right, "Johnston"
Ex-collection: Mrs. M. C. Donovan, Dorchester, Mass. (artist's
granddaughter); to donors, New York, N.Y.
Gift of Mr. and Mrs. Victor Spark, in memory of Pfc Donald W. Spark,
USMCR, born August 17, 1923, Long Branch, N.J., killed in action, June
1944, Saipan, Marianas Islands, and dedicated to the Fourth Marine
Division, Fleet Marine Force, 1944 44.194

Perry's London (Caricature of Society)
Pencil on paper 4⅝"x7⅜" (11.8x20.0 cm)
Unsigned
Stamped: upper left, "Perry's London/Perfection _____ed/for the
Patent/Peruvian Pens"
Ex-collection: Mrs. M. C. Donovan, Dorchester, Mass. (artist's
granddaughter); to donors, New York, N.Y.
Gift of Mr. and Mrs. Victor Spark, in memory of Pfc Donald W. Spark,
USMCR, born August 17, 1923, Long Branch, N.J., killed in action, June
1944, Saipan, Marianas Islands, and dedicated to the Fourth Marine
Division, Fleet Marine Force, 1944 44.195

JOHNSTON, JOSHUA (active 1796-1824)

***Portrait of Isabella Taylor** (ca. 1785-1819) ca. 1805
Oil on canvas 30"x24⅞" (76.2x63.2 cm)
Unsigned
Ex-collection: Henry Long, Baltimore, Md.; to Jesse Long; to Mrs.
William Binns, Pittsfield, Ill.; to Mrs. Herbert A. Tuohy, Washington,
D.C. (great-granddaughter of Henry Long); Peridot-Washburn Gallery,
New York, N.Y.
Purchase 1971 Membership Endowment Fund 71.55

*Family legend states that Isabella, who never married, is portrayed reading
a letter from her lover who was lost at sea. She was brought to this country
by her uncle, Henry Long (1774-1850), who came from Belfast, Ireland,
and was a successful merchant in Baltimore, Md. (files)*

JONES, BEN (b. 1942)

High Priestess of Soul 1970
Acrylic, tinsel, paper stars on paper 40"x30" (101.5x76.2 cm)
Signed and dated: lower right, "Ben Jones 3/70"
Ex-collection: acquired from the artist, Newark, N.J.
Gift of Prudential Insurance Company of America 1971 71.94

The subject is the singer, Nina Simone.

JONES, ELECTRA WARD (1812-1891)

All Quiet on the Potomac 1862
Pencil on paper 7"x5½" (57.8x14.0 cm)
Unsigned
Inscribed: along bottom, " 'All quiet on the Potomac'"
Reverse: in pencil, "Back and stand/c³/41/49 R5/247/
Mrs. MH Ward/LWQ/Sat"
Ex-collection: remained in artist's family until donated by her niece,
Pittsford, N.Y.
Gift of Mrs. Alice Roff Estey 1920 20.711

*Electra Ward Jones' sister married Erastus Roff, of an old Newark family.
See also H. P. Gray's portraits 24.2326 and 24.2327 for
Jones-Estey connection.*

JONES, EUGENE ARTHUR (?-1962)

Moonlight
Oil on canvas 30"x36" (76.2x91.4 cm)
Signed: lower left, "Eugene Arthur Jones"
Ex-collection: donor, New York, N.Y.
Gift of Henry Wellington Wack 1926 26.216

JONES, JOE [Joseph John] (1909-1963)

***Spring Plowing** 1942
Oil on canvas 30"x40" (76.2x101.6 cm)
Signed and dated: lower right, "Joe Jones 1942"
Ex-collection: Associated American Artists Gallery, New York, N.Y.;
to donor, New York, N.Y. (1943)
Gift of Mrs. Edith Lowenthal 1945 45.6

Rockaway River 1950's
Oil on canvas 24"x36" (61.0x91.4 cm)
Unsigned
Ex-collection: donor, Summit, N.J.
Gift of Mrs. Mary Bayne Bugbird 1965 65.146

JONES-SYLVESTER, CARYL (b. 1943)

"207" 1973
Oil on burlap 114"x93" (289.8x236.4 cm)
Unsigned
Gift of the artist 1973 73.15

JOY, JOSEPHINE H. (1869-1948)

Corn Patch, Summer Squash and Vines ca. 1938
Oil on canvas 30"x24⅛" (76.2x61.2 cm)
Signed: lower right, "Josephine H. Joy"
Reverse: label, WPA (San Diego, California), lists title and date,
"9-6-38" (Project 9701-D); monogram incised on stretcher
Allocated by the WPA Federal Art Project, through the Museum of
Modern Art 1943 43.154

The Three Graces ca. 1939
Oil on canvas 30"x24" (76.2x61.0 cm)
Signed: lower right, "Josephine H. Joy"
Reverse: etched on stretcher, "The Three Graces"; label, WPA (San
Diego, Calif.), lists title, "4-20-39" (Project 9701-D); label, Museum of
Modern Art (42.515)
Allocated by the WPA Federal Art Project, through the Museum of
Modern Art 1943 43.156

Night Blooming Cereus (Flowers) ca. 1939
Oil on masonite 40"x30" (101.6x76.2 cm)
Signed: lower right, "Josephine H. Joy"
Reverse: label, WPA (San Diego, California) lists title, date "2-23-39"
(Project 9701-D); label, Museum of Modern Art 42.506
Allocated by the WPA Federal Art Project, through the Museum of
Modern Art 1943 43.157

JULLIARD, SYLVAIN (19th century)

Brethren's Church on Staten Island
Pencil on paper 5"x7½" (12.7x19.1 cm)
Inscribed: lower margin, "drawing by Sylvain Julliard"
Ex-collection: donor, East Orange, N.J.
Gift of Miss Agnes S. Zimmermann 1946 46.176

KABOTIE, FRED [Nakayoma] (b. 1900)

Hopi Rain God ca. 1930
Ink and gouache on board 14"x14" (35.6x35.6 cm)
Signed: lower right, "F. Kabotie"
Reverse: label on backing, Gallery of American Indian Art,
New York, N.Y. A. E. White #23
Gift of Miss Amelia E. White 1937 37.153

The artist is from Hopi pueblo, Ariz.

Single Figure ca. 1930
Gouache on paper 13⅜"x8" (34.0x20.3 cm)
Signed: lower right, "Fred Kabotie"
Inscribed: lower left, "Pri/EYB"; lower center, "Fire"
Reverse: inscribed, "Single Figure, Fred Kabotie #B34"; "No 13"
Gift of Miss Amelia E. White 1937 37.155

***Hopi Kachina** ca. 1930
Gouache on paper 15"x21¾" (38.1x55.2 cm)
Signed: lower center, "Fred Kabotie"
Gift of Miss Amelia E. White 1937 37.222

KAESELAU, CHARLES A. (b. Sweden 1889-1972)

Winter 1937-38
Watercolor on paper 19-13/16"x26⅞" (50.3x68.3 cm)
Signed: lower left, "Charles Kaeselau"
Reverse: label on backing, WPA (#936A); on paper,
"W.P.A./1938/Winter 18x24/Charles Kaeselau"
Allocated by the WPA Federal Art Project 1945 45.242

The artist supplied a date of 1937.

KAISH, MORTON (b. 1927)

Red Nude Dressing, Rome 1972
Mixed media on board 27¾"x30¼" (70.5x76.8 cm)
Signed: lower right, "M. Kaish"
Reverse: label, Staempfli; label, artist, title, "Rome 1972", dimensions
Ex-collection: donor, New York, N.Y.
Gift of Mrs. Charles Stachelberg 1977 77.197

KANTOR, MORRIS (b. Russia 1896-1974)

*****Farewell to Union Square** 1931
Oil on canvas 36⅛"x27⅛" (91.8x68.9 cm)
Signed: lower right, "M. Kantor/1931"
Reverse: label, Columbus Gallery of Fine Arts (travelling ICA Boston
exhibition 1948-1950); painting has been relined
Ex-collection: with Frank K. M. Rehn Galleries, New York, N.Y.
Purchase 1946 John Cotton Dana Fund 46.154

*The artist wrote: "Everyday from my studio window I used to see two rows
of cars posed in the same formation and people passing by in the same
routine which impressed me to be aimless – the day I started the painting
was gray and undecided – this was the last one of a series of paintings I
did of the Square before I moved out to the country – this being so, I threw
in the roses for good chear [sic]."*

KAPLAN, JOSEPH (b. Russia 1900-1980)

Double Feature 1956
Oil on canvas 50"x40" (127.0x101.6 cm)
Signed: lower right, "Joseph Kaplan"
Ex-collection: acquired from the artist, New York, N.Y.
Purchase 1962 Living Arts Foundation, Inc. Fund and the
Daniel Weisberg Fund 62.125

*Date supplied by artist. Painting was exhibited at Salpeter Gallery, New
York, N.Y., 1956; Audubon Artists, New York, N.Y., 1957; Provincetown Art
Association, 1958, and Cape Cod Art Association, 1958. (files)*

*The artist wrote: "In many walks around the tawdry movie area on West
42nd Street, I was fascinated to observe that the glaring signs and neon
lights seemed to have a solid identity of their own, in contrast to the
strolling figures which to me appeared empheral [sic] and somewhat
unreal . . ."*

KARFIOL, BERNARD (b. Hungary 1886-1952)

Sailboats, Ogunquit 1927
Oil on canvas 30"x40" (76.2x101.6 cm)
Signed: lower right, "Bernard Karfiol"
Gift of Mrs. Felix Fuld 1928 28549

Date supplied by artist at time of purchase.

KATCHADOURIAN, SARKIS (b. Iran 1886-1947)

Portrait of Abraham Walkowitz (1878-1965) ca. 1944
Oil on canvas 16⅛"x20⅛" (40.7x51.1 cm)
Signed: lower left, "S. Katchadourian"
Reverse: inscribed on canvas, "-Walkowitz-/by/
Sarkis Katchadourian/152 W. 57/New York"
Ex-collection: donor, New York, N.Y.
Gift of Abraham Walkowitz 1948 48.336

*Executed for the exhibition, One Hundred Artists and Walkowitz,
Brooklyn Museum, 1944.*

KAUFMAN, DONALD (b. 1935)

Highbridge 1968
Acrylic on canvas 45"x45" (114.3x114.3 cm)
Signed and dated: upper right, "'Highbridge' Don Kaufman 1968"
Reverse: label, Richard Feigen Gallery #3825B
Ex-collection: donors, Bedford Village, N.Y.
Gift of Mr. and Mrs. Richard Feigen 1974 74.1

KAUFMAN, N. ROBERT (1914-1959)

Calvary 1954
Oil, casein, ink on board 96"x48" (243.8x121.9 cm)
Unsigned
Ex-collection: estate of the artist (#43 in estate inventory);
to Walter Weiss (The Arts Fund, Inc.), New York, N.Y.
Gift of The Arts Fund, Inc. 1960 60.605

KAUFMAN, STUART (b. 1926)

Pucilli 1957
Oil on canvas 44½"x34" (113.0x86.4 cm)
Unsigned
Ex-collection: donor, Newark, N.J.
Gift of Rabin and Krueger Gallery 1957 57.121

KELLY, LEON (b. France 1901)

*****Bather with a Cloth** (Bather with a Striped Towel) 1966
Oil on canvas 68½"x39" (174.2x99.1 cm)
Reverse: inscribed and dated on canvas, "No. 676/Leon Kelly/1966
/Bather with/a Cloth"; inscribed on stretcher, "Ex. 1 man show - Peale
House. Pa. Academy 1967"
Ex-collection: acquired from the artist, Loveladies, N.J.
Purchase 1968 Membership Endowment Fund 68.133

*Purchased from The Newark Museum's 7th triennial exhibition,
New Jersey Artists, 1968.*

*****The Descencion** [sic] 1963
Colored pencil on paper 59⅞"x40¼" (152.1x102.2 cm)
Signed and dated: lower right, "Leon Kelly Cahors/1963";
lower left, "1963 Kelly Leon"
Ex-collection: donor, the artist's daughter, Cambridge, Mass.
Gift of Miss Paula Kelly 1969 69.124

*A detail for a fresco painting, Falling Figures, The Descencion, 1963,
no. 936. (files)*

KELLY, RAY (b. 1945)

Untitled 1972
Pencil on paper 21½"x27" (52.1x68.6 cm)
Signed and dated: lower right, "R.K '72"
Reverse: inscribed, "Hold Ray Kelly";
masking tape label, "Kelly #8"
Ex-collection: donors, New York, N.Y.
Gift of Mr. and Mrs. Henry Feiwel 1977 77.223

KELPE, PAUL (b. Germany 1902)

*****Machine Elements** 1934
Oil on canvas 24"x24" (61.0x61.0 cm)
Signed and dated: lower right, "Paul Kelpe/34"
Ex-collection: with Carus Gallery, New York, N.Y.
Purchase 1978 Charles W. Engelhard Bequest Fund 78.164

KENSETT, JOHN FREDERICK (1816-1872)

*****Paradise Rocks: Newport** ca. 1865
Oil on canvas 18⅛"x29⅞" (46.0x75.9 cm)
Signed: lower right (monogram), "JFK"
Reverse: label, AFA travelling exhibition, *J. F. Kensett*, 1969; label, AFA
travelling exhibition, *Hudson River School*, 1960; painting relined
before entering Museum collection
Ex-collection: donor, Scotch Plains, N.J.
Gift of Dr. J. Ackerman Coles 1920 20.1210

Villa Borghese 1841
Pencil and gouache on paper 8"x7⅞" (20.3x20.0 cm)
Unsigned
Inscribed: lower right, "Borg-ery Villa March 8"/1841"
Ex-collection: donor, New York, N.Y.
Gift of John Preston 1960 60.602

Catskill September 1 1856 1856
Pencil on paper 10⅞"x14½" (27.6x36.2 cm)
Unsigned
Inscribed: lower right, "Catskill Sept 1st 1856"
Notation of colors along bottom of paper: "1 Buckweat field 2 Plowed
Fields 3 cool green 4 Thin of grass 5 Buckweat 6 grass in patches
7 Brownish green 8 Rich green 9 yellowish green 10 yellow trees
11 Brown leaves and grass 12 gray sandrift 13 Brown mud"
(corresponding to numbered areas in sketch)
Ex-collection: Old Print Shop, New York, N.Y.;
to donor, New York, N.Y.
Gift of Paul Magriel 1961 61.12

From Platz, Mer de Glace (View of Platz) ca. 1845
Watercolor on paper 7¼"x10⅝" (18.4x27.0 cm)
Unsigned
Inscribed: lower right, "from Platz/Mer de Glace.Sep 5/8"
Reverse: paper pasted on backing; label on backing, "American
Drawings, Paul Magriel Collection"; label in pencil on backing, "From
a Kensett/Note Book. Purchased from Jos. Hechel/Ex. Coll.
Vincent Colyer/friend of J. Kensett"
Ex-collection: Vincent Colyer; Joseph Hechel; Harry Bland Gallery,
New York, N.Y.; to donor, New York, N.Y.
Gift of Paul Magriel 1966 66.34

*Kensett took a walking tour from France through Switzerland into Italy,
arriving in Rome in October, 1845. "Platz" in the environs of the Mer de
Glace on Mont Blanc has not been located. Colyer was a painter as well as
a friend of Kensett's. Kensett tried in vain to rescue Colyer's wife from
drowning shortly before his own death.*

KERKAM, EARL C. (1890-1965)

Girl with Red Hair
Oil on board 18"x14" (45.7x35.5 cm)
Signed: upper right, "Kerkam"
Ex-collection: donor, New York, N.Y.
Gift of Alfred A. Doran 1962 62.28

Cubist Portrait
Oil on canvas 24"x19" (60.9x48.3 cm)
Unsigned
Ex-collection: donor, New York, N.Y.
Gift of Alfred A. Doran 1962 62.29

Nude Figure Study
Ink wash, watercolor, crayon on paper 17½"x14⅛" (44.4x35.9 cm)
Signed and dated: lower left, "Kerkam 51"
Ex-collection: donor, New York, N.Y.
Gift of Alfred A. Doran 1962 62.30

Nude Figure Study
Ink wash on paper 17⅝"x14⅛" (44.7x35.8 cm)
Signed and dated: upper left, "Kerkam/51"
Ex-collection: donor, New York, N.Y.
Gift of Alfred A. Doran 1962 62.31

*This study had been torn in two and taped together prior to entering
the collection.*

KERR, JAMES WILFRID (b. 1897)

***Old Erie Station – Waldwick** 1943
Oil on masonite 19¼"x42" (48.9x106.7 cm)
Signed and dated: lower right, "James Wilfrid Kerr 1943"
Reverse: signed on masonite, "James Wilfrid Kerr/7017 Bellrose,
N.E./Albuquerque, New Mexico"; two labels, extensive exhibition
history in Museum files; label, NAD 118th Annual 1944; label,
Montclair Art Museum 1944; two labels, Grand Central Art Galleries
for exhibitions at Houston, Texas (1949) and Davenport, Iowa (1948)
Ex-collection: donor, Albuquerque, N.M.
Gift of the artist 1978 78.35

*Depicted is the nonagenarian, Fanny Ryer, a familiar figure in the town at
that time. (files)*

KIENBUSCH, WILLIAM (1914-1980)

Coast Marker and Pine 1953
Casein on paper 22¼"x29⅞" (56.5x75.9 cm)
Signed and dated: lower right, "Kienbusch 53"
Reverse: label on backing, Kraushaar Galleries
Ex-collection: with Kraushaar Galleries, New York, N.Y.
Purchase 1954 Special Purchase Fund 54.168

KIGHLEY, JOHN (19th century)

The Forbes House, Newark
Watercolor on paper 5½"x6⅞" (14.0x17.5 cm)
Signed: along bottom, "To Mrs. Forbes of Newark, N.J. This view of her
house/is respectfully inscribed by John Kighley."; center bottom, coat
of arms inscribed, "Grace My Guide"
Reverse: Museum files indicate the following worn inscription (no
longer visible) was on the back of the painting: "The old Forbes House
_____ grandmother in red portrait/married on May 29 1806 by Revd
Joseph Willard Rector of/Trinity Church Newark/Mulberry St. corner
of that/and by Newark and New York railroad/into Broad St./the
house which is/st. in 1903/... from family record/of Mrs. Alexander
Forbes nee Susanna Gifford, only daughter of/ Gifford East Jersey,
married to Alex Forbes Jun 26 or 12 1776 by Bishop Brovost.... she
was my great grandmother/Cassie T./Thomas."
Ex-collection: remained in Forbes' family to a direct descendant of the
Forbes' daughter, Maria Susanna, the donor, Georgetown, Md.
Gift of Mrs. S. T. Peirce 1955 55.155

*Descendants of a Forbes' son, Cleveland Alexander Forbes, have indicated
that family crest should read, "Grace Me Guide." (corres.)*

*The Museum also owns miniature watercolor portraits of Maria Susanna
and her husband (Mr. and Mrs. Joseph Dunderdale, A.U. 56.168
and A.U. 56.169).*

KING, MAURICE P., JR. (b. 1918)

Monoliths at Assam 1945
Watercolor on Whatman board 22"x30" (55.9x76.2 cm)
Signed: lower right, "Maurice/Patrick/King/JR (symbol) 45"
Ex-collection: donor, East Orange, N.J.
Gift of Mrs. Maurice P. King 1962 62.10

KINGMAN, DONG (b. 1911)

Golden Gate Trees in October 1938
Watercolor on paper 19½"x26¾" (49.5x68.0 cm)
Signed and dated: lower left, "Kingman 38"
Reverse: label, Museum of Modern Art No. E.L.39.1809; label,
FAP#3 9950-C-M; stamp, Federal Art Project; stamp, Fed. Project #1
Catalog #3100/3001; reverse has another painting of boats and figures
which is crossed out.
Allocated by the WPA Federal Art Project 1943 43.162

The Church and the Park ca. 1935-43
Watercolor on paper 20⅛"x27⅛" (51.1x68.9 cm)
Signed: lower right, "Kingman"
Reverse: label, "Federal Art Project"
Allocated by the WPA Federal Art Project 1945 45.243

The Sun Goes Down, San Francisco
Watercolor on paper 11¾"x29¼" (29.8x74.3 cm)
Signed: lower left, "Kingman"
Ex-collection: private collection, New York, N.Y.
Anonymous gift 1957 57.143

KLEINHOLZ, FRANK (b. 1901)

The Name is Walkowitz 1943
Oil on canvas 20"x24" (50.8x61.0 cm)
Signed: upper right, "F. Kleinholz"
Ex-collection: donor, New York, N.Y.
Gift of Abraham Walkowitz 1948 48.514

Included in the exhibition, One Hundred Artists and Walkowitz,
Brooklyn Museum, 1944. Date supplied by artist.

KLIGMAN, RUTH (20th century)

The Lover 1960
Oil on canvas 72"x48" (182.9x121.9 cm)
Reverse: signed and dated lower left, "Ruth Kligman/60"; label,
Thibaut Gallery/799 Madison Avenue, NY 21
Ex-collection: acquired from the artist, New York, N.Y.
Gift of Carl Andre in memory of Robert Smithson 1977 77.198

KLITGAARD, GEORGINA (b. 1893)

Clear and Cold ca. 1938
Oil on canvas 24⅛"x36" (61.3x91.5 cm)
Signed: lower left, "G. Klitgaard"
Reverse: label, Art Institute of Chicago, *Half Century of American Art,*
1939-40; label, Art Institute of Chicago, *Forty-ninth Annual Exhibition,*
1938
Ex-collection: with Frank K. M. Rehn Gallery, New York, N.Y.
Purchase 1940 Wallace M. Scudder Bequest Fund 40.117

Awarded Honorable Mention for landscape at Art Institute of Chicago
49th Annual, 1938.

KNATHS, (OTTO) KARL (1891-1971)

B. A. Nana (Composition) ca. 1935-39
Oil on canvas 27"x36" (68.6x91.4 cm)
Signed: lower right, "Karl Knaths"
Reverse: label, WPA
Allocated by the WPA Federal Art Project 1943 43.211

The title, B. A. Nana, *was supplied by the artist and appears on the*
original WPA label. The artist supplied date of ca. 1939 (files). However,
he was dropped from the WPA in 1935 after 18 months' work.

Sketches for Murals in Music Room Falmouth (Mass.) High School
(Development of Music) 1934
Unless indicated, all are watercolors on paper:
A 4¾"x23½" (12.1x59.7 cm)
Signed: far right margin, "Karl Knaths/Provincetown/Mass"
Inscribed: center bottom, "Development of Violin"; lower right,
"PWAP/X3-F3-U10"
Reverse: label, Museum of Modern Art 36.898
B 4⅞"x22⅛" (12.4x56.2 cm)
Signed: far right, "K Knaths/Provincetown/Mass"
Inscribed: lower left, "Development of Organ"; center bottom, "Back";
right of center, "PWAP/X3-F3-U10"; further right, "Mechanism of Bells"
C 5½"x22⅝" (14.0x57.6 cm)
Gouache on paper
Inscribed: at bottom (not by artist), "Development of Piano";
lower right, "PWAP/X3-F3-U10"
Reverse: label, Museum of Modern Art 36.902
D 14⅞"x23½" (37.8x59.7 cm)
Signed: right, "Karl Knaths/Provincetown/Mass"
Inscribed: bottom, "fifes and drums"; lower right, "PWAP/X3-F3-U10"
Reverse: label, Museum of Modern Art 36.900
E 4¾"x24⅛" (12.1x61.3 cm)
Signed: right, "Karl Knaths/Provincetown/Mass"
Inscribed: bottom, "horns"; lower right, "PWAP/X3-F3-U10"
Reverse: label, Museum of Modern Art 36.894
F 4⅞"x24⅛" (12.4x61.3 cm)
Signed: lower right, "K. Knaths/Provincetown/Mass"
Inscribed: bottom, "Music Theory"; lower right, "PWAP/X3-F3-U10"
Reverse: label, Museum of Modern Art 36.899
G 9½"x19" (24.1x48.3 cm)
Signed: right, "K. Knaths/Provincetown/Mass"
Inscribed: left, "transcription"; right of center, "PWAP/X3-F3-U10"
Reverse: label, Museum of Modern Art 36.895
H 9¾"x19" (24.8x48.3 cm)
Signed: lower right, "K Knaths/Provincetown/Mass"
Inscribed: along left margin, "Mechanism of voice & acoustic";
lower right, "PWAP/X3-F3-U410"
Reverse: label, Museum of Modern Art 36.896
I Pictorial outline of the entire room
Gouache on paper 9½"x19" (24.1x48.3 cm)
Signed: upper left (artist's hand), "Music Room/Falmouth High
School/K. Knaths/Provincetown/Mass."
Inscribed: lower right, in artist's hand, "Subject: kinds of musical
instruments; their order of arrangement and historical development of
instruments suggesting the history of music";
upper right, "PWAP/X3-F3-U10"
Allocated by the Department of Treasury PWAP 1958 58.87 A-I

The PWAP existed between 1933 and 1934, prior to the formation of the
WPA. Knaths began working for the agency in 1934.

KNIGHT, CHARLES ROBERT (1874-1953)

Neanderthal Man (Early Stone Age) 1920
Oil on canvas 23⅝"x48½" (60.0x123.2 cm)
Signed and dated: lower left, "Chas R. Knight/1920"
Reverse: label, Architectural League of N.Y. Annual Exhibition;
title, Neanderthal Man 'Early Stone Age'
Ex-collection: acquired from the artist, New York, N.Y.
Purchase 1946 Louis Bamberger Bequest Fund 46.173

A sketch for the mural, Neanderthal Man, *which Knight completed in*
1920 for the American Museum of Natural History, New York, N.Y.

Cro-magnon Man (Cro-magnon Artists) ca. 1919
Oil on canvas 23⅞"x52" (60.0x130.2 cm)
Unsigned
Reverse: label, Architectural League of N.Y. Annual Exhibition;
title, "Cro-magnon Artists"
Ex-collection: acquired from the artist, New York, N.Y.
Purchase 1946 Louis Bamberger Bequest Fund 46.174

A sketch for the mural, Cro-magnon Man, *which Knight completed in*
1919 for the American Museum of Natural History, New York, N.Y.

KOCH, JOHN (1909-1978)

*Supper Table 1939
Oil on canvas 25"x30" (63.5x76.2 cm)
Signed: lower left, "Koch"
Ex-collection: with Kraushaar Galleries, New York, N.Y.;
to donor, Manchester, Vt.
Gift of Henry H. Wehrhane 1939 39.321

According to the artist's wife, painting was executed at Wilmington, Vt., in 1939. (corres.)

Study for "Pink Dressing Gown" 1958-9
Pencil and chalk on paper 8¾"x8" (22.2x20.3 cm)
Signed and dated: lower right, "Koch 58"
Reverse: label, Kraushaar Galleries, New York, N.Y.
Ex-collection: with Kraushaar Galleries, New York, N.Y.;
to donors, New York, N.Y.
Gift of Mr. and Mrs. Raymond J. Horowitz 1965 65.112

Study for the painting, Pink Dressing Gown, *collection of Mr. and Mrs. Charles C. Lucas, Jr.; started in London, 1958; completed in 1959. The artist's wife is the model. (corres.)*

KONOLYI, MANYA (1883-1968)

The Winged Chair with Table 1955
Oil on canvas 39½"x39½" (100.3x100.3 cm)
Signed and dated: "Konolyi/Zurich '55/Switzerland"
Reverse: inscribed: "Box 4"; inscribed on stretcher, "The Winged-Chair-with-Table"; top stretcher, illeg. Swiss stamp, (Malbedart)
Ex-collection: donors, New York, N.Y. (by inheritance)
Gift of Mr. and Mrs. Bernard Rosenthal 1975 75.211

Untitled 1952
Wax crayon on paper 8¼"x11¾" (21.0x29.8 cm)
Signed and dated: lower right, "Konolyi/Nov-18-52"
Ex-collection: donors, New York, N.Y.
Gift of Mr. and Mrs. Bernard Rosenthal 1975 75.233

Untitled 1953
Wax crayon on paper 8¼"x11¾" (21.0x29.8 cm)
Signed and dated: lower right, "Konolyi/Jan-53"
Ex-collection: donors, New York, N.Y.
Gift of Mr. and Mrs. Bernard Rosenthal 1975 75.234

KONOPKA, JOSEPH (b. 1932)

Party 1967
Acrylic on canvas 44"x46" (111.8x116.9 cm)
Signed and dated: upper right, "Konopka 67"
Inscribed: on reverse, "Konopka 67/'Party'"
Ex-collection: acquired from the artist, Glen Ridge, N.J.
Purchase 1968 Carrie B. F. Fuld Bequest Fund 68.217

Purchased from The Newark Museum's 7th triennial, New Jersey Artists, 1968.

KONRAD, ADOLF F. (b. Germany 1915)

Sunday in Harrison 1943
Gouache on paper 19¼"x24⅞" (48.9x63.2 cm)
Signed and dated: lower right, "Konrad '43"
Reverse: label, Associated Artists of New Jersey, exhibition blank (1943)
Ex-collection: acquired from the artist, Newark, N.J.
Purchase 1944 Thomas L. Raymond Bequest Fund 44.1

End of Day 1952
Oil on canvas 25"x30" (63.5x76.2 cm)
Signed and dated: lower left, "Konrad 1952"
Reverse: label, Whitney Museum of American Art, Annual Exhibition of Contemporary Painting and Sculpture, 1953
Ex-collection: the artist, Newark, N.J.
Purchase 1952 John J. O'Neill Bequest Fund 52.25

Purchased from The Newark Museum's 1st triennial exhibition, Work by New Jersey Artists, *1952. Executed in Konrad's studio on Fulton St., Newark, of Javas or Holsum bakery and the houses next to it on Lombardy St.*

*Reflections 1960
Oil on canvas 33"x46" (83.8x116.8 cm)
Signed: lower right, "Konrad"
Reverse: inscribed on stretcher, "Reflections/oil/1960/Adolf Konrad"
Ex-collection: purchased from artist by the National Academy of Design, New York, N.Y.
Assigned by the National Academy of Design through the Henry Ward Ranger Fund 1962 62.137

The shop window was that of the Newark Musical Instrument Repair Company, Washington St., Newark.

Untitled 1954-60
Oil on canvas board 6¾"x8¾" (17.1x22.2 cm)
Signed: lower right, "Konrad"
Reverse: inscribed in pencil, "1954 to 1960/varnished/Nov 10, 1960"
Ex-collection: donor, Plainfield, N.J.
Gift of Mrs. A. Minich 1972 72.198

The painting shows figures in front of the Newark Veterans Administration building located on Washington Place, Newark.

KORN, ELIZABETH (b. Germany 1901-1980)

Mankind 1958
Oil on canvas 46"x49" (116.8x124.5 cm)
Signed: lower right, "Korn"
Ex-collection: private collection, New York, N.Y.
Anonymous gift 1958 58.88

Included in The Newark Museum's 3rd triennial exhibition, Work by New Jersey Artists, *1958.*

KORYBUT, WANDA (b. 1907)

Old Woman from Valsugana ca. 1933
Pen and ink on paper 22⁷⁄₁₆"x17¾" (57.0x45.1 cm)
Signed: lower left, "Wanda"; lower right, drawing of horse heads
Reverse: label, entry for 43rd Annual, National Association of Women Painters and Sculptors, 1934
Ex-collection: the artist to donor, Short Hills, N.J.
Gift of Miss Cora Louise Hartshorn 1934 34.647

Artist's name later became Wanda Korybut-Kovahlsky. Miss Hartshorn was her aunt. (corres.)

KRAETZER, KATHERINE (b. 1917)

Outpost 1959
Watercolor, casein, ink, pencil and paper collage
18⅝"x24½" (47.3x62.3 cm)
Signed: lower right, "K. Kraetzer"
Reverse: label, *New Jersey Artists and Craftsmen,* Washington Park, Newark, 1959
Ex-collection: purchased from the artist, Upper Montclair, N.J.
Purchase 1959 Frederick P. Field Bequest Fund 59.85

Date supplied by the artist.

KRAMER, EDWARD ADAM (1866-1941)

Waiting for the Moon ca. 1923
Oil on composition board 12"x16½" (30.5x41.9 cm)
Signed: lower right, "E. A. Kramer"
Ex-collection: purchased from the artist, New York, N.Y.
Purchase 1923 23.1865

The Penitents 1915
Oil on canvas 25"x29¾" (63.5x75.6 cm)
Signed: bottom right, "Edward Adam Kramer, N.Y."
Reverse: label, Babcock Galleries, NYC; written on stretcher,
"Edward Adam Kramer/1865 M Hope Ave./Bronx New York City/title
The Penitents"; label, "Boston 1915/No. 18"
Ex-collection: Arthur F. Egner, South Orange, N.J.
Purchase 1945 Endowment Fund Interest and Thomas L. Raymond
Bequest Fund 45.142

Purchased from Egner sale, Parke Bernet Galleries (#163 in catalogue 70).

KREISEL, ALEXANDER (b. Russia 1901-1953)

Ding an Sich – Soliloquy ca. 1938
Oil on canvas 30"x40" (76.2x101.6 cm)
Signed: lower left, "AKreisel"
Reverse: inscribed, "2"; stamp on stretcher,
"30/Anco Inc./Glendale, L.I."
Ex-collection: private collection, New York, N.Y.
Anonymous gift 1940 40.315

Translation of title: "The Thing in Itself."

KROLL, LEON (1884-1974)

Spring ca. 1920-21
Oil on canvas 26"x32½" (66.0x82.5 cm)
Signed: lower right, "Leon Kroll"
Reverse: inscribed on stretcher, "'Spring' Leon Kroll"
Ex-collection: donors, New York, N.Y.
Gift of Dr. and Mrs. John A. Garlock 1963 63.119

Date supplied by artist after acquisition by the Museum. (files)

KRONBERG, LOUIS (1872-1965)

Ballet Girl in Yellow (Dancer in Yellow) 1916
Oil on canvas 40¼"x30¼" (102.2x76.8 cm)
Signed and dated: lower right, "-Louis/Kronberg/1916";
upper right, "1917/L. Kronberg-"; lower left,
"Louis Kronberg-/(Star of David)"
Reverse: label on backing, probably in artist's hand, "Ballet Girl in
Yellow./Louis Kronberg/This picture was/exhibited at/Guild of Boston
Artists/Chicago Art Institute 1917/Penn. Academy Phil/National Art
Coll N. York/Ballet Girl in Yellow/Louis Kronberg/Boston";
label, Pennsylvania Academy of The Fine Arts, 1919; label, Art Institute
of Chicago, 29th Annual Exhibition, 1917
Ex-collection: acquired from the artist, New York, N.Y.
Gift of Mrs. Felix Fuld 1925 25.1157

*It is assumed artist finished painting in 1916 and did revision in 1917. The
third signature is impossible to identify. The artist did several versions of
this painting, using different color schemes.*

KUEHN, GARY B. (b. 1939)

Untitled 1966
Pencil and enamel on paper three drawings,
each 26⅝"x19⅝" (67.5x49.7 cm)
Signed: lower left, "G. Kuehn 66" on each
Ex-collection: purchased from the artist, Somerville, N.J.
Purchase 1968 Felix Fuld Bequest Fund 68.218 a,b,c

*Purchased from The Newark Museum's 7th triennial,
New Jersey Artists, 1968.*

KUHN, WALT (1877-1949)

Study for Lunette 1929
Pen and ink on paper 8⅜"x13" (21.3x33.0 cm)
Signed and dated: lower right, "Walt Kuhn 1929"
Inscribed: lower left of mat, "Walt Kuhn Lunette (Drawing)"
Ex-collection: private collection, New York, N.Y.
Anonymous gift 1940 40.335

*****Girl in Gray Furs** 1927
Oil on canvas 20"x16⅛" (50.8x41.0 cm)
Signed and dated: lower left, "Walt Kuhn 1927"
Reverse: inscribed on canvas, "Walt Kuhn/Title/1927/
'Girl in Gray Furs'"
Ex-collection: Maynard Walker Galleries, New York, N.Y. to donor,
New York, N.Y.
Gift of Mrs. Bliss Parkinson 1956 56.8

KULICKE, ROBERT M. (b. 1924)

Vase of Flowers 1962
Oil on paper 9"x7½" (22.9x19.1 cm)
Signed and dated: top center, "Kulicke 62"
Anonymous gift in memory of Nell Schoellkopf Ely Miller
1975 75.195

KUNIYOSHI, YASUO (b. Japan 1893-1953)

*****Milk Train** 1940
Oil on canvas 24"x40¼" (61.0x102.2 cm)
Signed and dated: lower right, "Yasuo Kuniyoshi 40"
Reverse: label, The Downtown Gallery; label, Corcoran Gallery, *19th
Biennial Exhibition*, 1945; label, Addison Gallery of American Art,
Phillips Andover Academy, 1946
Ex-collection: with The Downtown Gallery, New York, N.Y.
Purchase 1940 Sophronia Anderson Bequest Fund 40.154

In Front of the Window 1937
Pencil on paper 22⅜"x17⅛" (56.8x43.5 cm)
Signed and dated: lower right, "Yasuo Kuniyoshi 37"
Inscribed: below artist's signature, not in his hand,
"In Front of the Window"
Allocated by the WPA Federal Art Project 1945 45.244

*****Still Life** 1928
Oil on canvas 30"x42" (76.2x106.7 cm)
Signed and dated: lower right, "Yasuo Kuniyoshi/1928"
Reverse: label, Daniel Gallery, New York, N.Y.; label in donor's hand,
"Willed to Newark Museum"
Ex-collection: Charles Daniel Gallery, New York, N.Y. to donor,
Short Hills, N.J. (1928)
Bequest of Miss Cora Louise Hartshorn 1958 58.178

Sand Dunes 1941
Pencil on paper 13⅞"x16⅞" (35.2x42.9 cm)
Inscribed: lower right, "Yasuo Kuniyoshi/(S.M. Kuniyoshi)"
Ex-collection: artist; to donor, New York, N.Y.
Gift of Mrs. Yasuo Kuniyoshi 1976 76.140

Date supplied by donor.

Western Town 1949
Pencil on paper 13⅞"x16⅞" (35.2x42.9 cm)
Inscribed: lower right, "Yasuo Kuniyoshi/(S.M. Kuniyoshi)"
Ex-collection: artist; to donor, New York, N.Y.
Gift of Mrs. Yasuo Kuniyoshi 1976 76.141

Date supplied by donor.

Portrait of Walkowitz 1943
Charcoal on paper 19¼"x14" (48.9x35.6 cm)
Signed: "Kuniyoshi"
Ex-collection: artist; to donor, New York, N.Y.
Gift of Mrs. Yasuo Kuniyoshi 1976 76.142

Date supplied by donor.

Girl with Tights 1940's
Charcoal on paper 16¾"x13¾" (42.8x34.9 cm)
Inscribed: lower left, "Yasuo Kuniyoshi/by S.M. Kuniyoshi"
Ex-collection: artist; to donor, New York, N.Y.
Gift of Mrs. Yasuo Kuniyoshi 1976 76.143

KUSAMA, YAYOI (b. Japan 1929)

Untitled 1952
Gouache on paper 14"x11½" (35.6x29.2 cm)
Signed and dated: lower left, "Yayoi Kusama 52"
Ex-collection: donors, East Orange, N.J.
Gift of Mr. and Mrs. Harry L. Tepper 1970 70.57

Untitled 1952
Gouache on paper 14"x11½" (35.6x29.2 cm)
Signed: lower right, "Yayoi Kusama 1952"
Ex-collection: donors, East Orange, N.J.
Gift of Mr. and Mrs. Harry L. Tepper 1970 70.58

KUSANOBU, MURRAY (b. Canada 1907)

Autumn Landscape 1937
Oil on canvas 23⅞"x35⅛" (60.7x89.2 cm)
Signed: lower left, "Kusanobu"
Ex-collection: purchased from the artist, Arlington, N.J.
Purchase 1941 Thomas L. Raymond Bequest Fund 41.12

*The artist stated that this was "last in series of six or seven paintings
done one fall at Garrett Mountain Reservation, overlooking Paterson, N.J.
in 1937." It was exhibited at the Cooperative Gallery, Newark, 1937, and
the New York World's Fair, 1939. Exhibited at The Newark Museum in
1939 in a preview of work to be shown at the World's Fair. (files)*

Sea, Sky, Sand 1940
Watercolor on paper 18¼"x14" (46.4x35.6 cm)
Signed: lower right, "Kusanobu"
Ex-collection: donor, Newark, N.J.
Gift of Mrs. Wallace M. Scudder 1944 44.121

Date supplied by the artist.

LA FARGE, JOHN (1835-1910)

***Evening Dance, Samoa** ca. 1890
Oil on paper pasted to mat board 8¾"x12¼" (22.2x31.1 cm)
Signed: lower right, "Samoa Savaii (symbol) La Farge" (crossed-out
material illegible)
Reverse: sticker, "From Mrs. Bayard Thayer,/261 Clarendon St.";
sticker, "Museum of Fine Arts/1746.10/La Farge/
Lent by Mrs. Bayard Thayer"
Ex-collection: Mrs. Bayard Thayer, Boston, Mass.;
to donors, New York, N.Y.
Gift of Mr. and Mrs. Victor Spark in memory of Pfc Donald W. Spark
USMCR, born August 17, 1923, Long Branch, N.J., killed in action
June, 1944, Saipan, Marianas Islands, and dedicated to the Fourth
Marine Division, Fleet Marine Force 1945 45.97

*Savaii, one of the Samoan Islands, was a popular setting for La Farge's
work in the 1890's. La Farge's trip to the South Pacific and his frequent
use of such native dances helps to determine the date.*

***Sunset at Papeete, Looking Toward Moorea**
(Sea and Distant Coast) 1891
Watercolor on paper 8¼"x13" (21.0x33.0 cm)
Unsigned
Reverse: stamp on backing, "Babcock Galleries, New York City
C-13062"; label on backing, Museum of Fine Arts, Boston, "1819.10/La
Farge" (lent by Dr. W. S. Bigelow); label, No. 17. "Sunset at Papeete/
Looking Toward Moorea/Pink Sky/Dr. W. S. Bigelow"; label, La Farge,
J./Sea and Distant Coast/Gift of Dr. W. S. Bigelow/21.1438
Ex-collection: Dr. W. S. Bigelow; on loan to Museum of Fine Arts,
Boston, Mass. (1910 and 1911); given to Museum of Fine Arts, Boston,
Mass. (July, 1921); returned to Dr. W. S. Bigelow (August, 1921);
Raymond Horowitz, New York, N.Y.
Gift of Mr. and Mrs. Raymond Horowitz 1965 65.110

*According to correspondence from Henry A. La Farge, this watercolor has
been published as* Sea and Distant Coast. *It was titled* Sunset at
Papeete, Looking Toward Moorea *in an 1895 exhibition catalog at
Durand and Ruel, New York, N.Y. (#156).*

*Dr. Bigelow was a prominent Orientalist who lived several years in
Japan. When La Farge came to Japan with Henry Adams in 1886, it was
Bigelow who guided and entertained them.*

LAMB, ELLA CONDIE (?-1939)

Portrait of Miss Stryker (Portrait of an Aristocrat)
Pastel on paper 26½"x22⅝" (67.3x57.5 cm)
Signed: lower right, "Ella/Condie/Lamb"
Reverse: on backing in artist's hand, "An Aristocrat pastel by/Ella
Condie Lamb/360 W 32 NYC."
Ex-collection: artist to her husband, the donor, Creskill, N.J.
Gift of Charles Rollinson Lamb 1942 42.133

LANDAU, JACOB (b. 1917)

***Winged Defeat** 1964
Watercolor on rice paper 54"x37" (137.2x94.0 cm)
Signed: lower right, "Jacob Landau"
Reverse: label, Cober Gallery; label, Newark Museum, *Selected Works
by Contemporary New Jersey Artists,* 1965
Ex-collection: Cober Gallery, New York, N.Y.
Purchase 1965 Mrs. Felix Fuld Bequest Fund 65.123

Purchased from the Museum exhibition, Selected Works by
Contemporary New Jersey Artists, *1965. Artist dated painting about one
year prior to that exhibition.*

LANE, FITZ HUGH (1804-1863)

***The Fort and Ten Pound Island, Gloucester** (Harbor Scene) 1848
Oil on canvas 20"x30" (50.8x76.2 cm)
Signed and dated: lower right, "F H Lane/1848"
Reverse: painting relined prior to entering the Museum collection
Ex-collection: descended through family to donor, Cheshire, Conn.
Gift of Mrs. Chant Owen 1959 59.87

LASCARI, SALVATORE (1884-1967)

Portrait of H. Kristina Lascari (1885-1937) 1917
Oil on canvas 81"x35" (205.8x89.0 cm)
Signed: lower right, "S. Lascari"
Ex-collection: donor, Lodi, N.J.
Gift of the artist in memory of H. Kristina Lascari 1964 64.240

*The artist's wife was a sculptor who is represented in the Museum
collection. This portrait was exhibited at the National Academy of Design
in 1918. The artist supplied the date. (corres.)*

LAWSON, ERNEST (b. Canada 1873-1939)

***Harlem River** ca. 1910
Oil on canvas 25"x30" (65.0x76.2 cm)
Signed: lower left, "E. Lawson"
Reverse: no pertinent data recorded prior to relining, 1969
Ex-collection: Frederick Keer, Newark, N.J. (Newark framer and
painting dealer)
Purchase 1910 The General Fund 10.11

*One of the first three American paintings purchased by the Museum. The
others were Bruce Crane's* Autumn *(10.10) and William Ritschel's*
Marine *(10.9).*

***Landscape** ca. 1901
Oil on canvas 18¼"x24¼" (46.4x61.6 cm)
Signed: lower left, "Lawson"
Reverse: stamp on frame, "New CGMS. Macklin Co./Chicago.
New York"; label, MOMA, *The Eight* (64.30); label, National Gallery of
Canada, *Ernest Lawson*, Catalogue No. 6/Box .10"
Ex-collection: donors, Newark, N.J.
Gift of Mr. and Mrs. Frederick W. Parker 1929 29.630

Although this painting was not included in the initial exhibition,
The Eight, *at the Macbeth Gallery in 1908, it was circulated in the 1964
Museum of Modern Art exhibition of the same name, in which the
catalogue dates the painting ca. 1901.*

LEA, WESLEY (b. 1914)

A Capitol City 1947
Watercolor on paper 15"x21" (38.1x53.3 cm)
Signed and dated: lower right, "Lea 47"
Reverse: inscribed on paper, "Wesley Lea 1947/A Capitol City"
Ex-collection: private collection, New York, N.Y.
Anonymous gift 1947 47.216

LEBBY, LARRY FRANCIS (b. 1950)

Summer Street 1976
Bic pen on paper 19¼"x29⅜" (48.9x76.6 cm)
Signed and dated: lower right, "Larry Francis Lebby/1976"
Ex-collection: Mrs. Raymund G. Stanton, Columbia, S.C.
Gift of Mrs. Raymund G. Stanton in memory of Colonel Raymund G.
Stanton 1977 77.183

LEBDUSKA, LAWRENCE H. (b. 1894)

Eskimo
Oil on canvas 21½"x16½" (54.6x42.0 cm)
Signed: lower right, "Lawrence Lebduska"
Ex-collection: private collection, New York, N.Y.
Anonymous gift 1940 40.328

Wild Asses
Gouache and oil on masonite 30⅛"x38" (76.6x96.5 cm)
Unsigned
Ex-collection: purchased from the artist, New York, N.Y.
Purchase 1942 Felix Fuld Bequest Fund 42.192

Waterhole
Gouache and oil on masonite 36"x43¾" (91.5x101.1 cm)
Signed: lower left, "Lebduska"
Ex-collection: purchased from the artist, New York, N.Y.
Purchase 1942 Felix Fuld Bequest Fund 42.193

LECKEY, R. (19th century)

Mrs. Byron S. Gillette [Ida Minerva Stage] ca. 1875
Oil on canvas 23¾"x19¾" (60.3x50.2 cm)
Signed: lower right, "R. Leckey./18 ___."
Ex-collection: Grace Vreeland
Purchase 1941 Edward F. Weston gift 41.9

LEE, JOHN BURNETT (1827-1917)

Broad Street Fire, Newark 1845
Oil on canvas 20⅛"x21½" (51.1x54.6 cm)
Unsigned
Ex-collection: anonymous collection, Newark, N.J.;
to donor, Newark, N.J.
Gift of Arthur F. Egner 1943 43.10

*Lee, a Newark resident, was a druggist with a pharmacy on Commerce
Street. (files)*

LEFFERTS, CHARLES M. (1873-1923)

The Hessian Prisoners
Gouache and pastel on cardboard 30"x22" (76.2x55.9 cm)
Signed: lower left, "Chas. M. Lefferts"
Reverse: on backing, "Property of/Interwoven Stocking Company/
New Brunswick"
Ex-collection: the artist; to Rodman Wanamaker; Interwoven Stocking
Company, New Brunswick, N.J.; to donor, Essex Fells, N.J.
Gift of Leonard Dreyfuss 1952 52.43

*The painting depicts the march to Philadelphia following the Battle of
Trenton, December, 1776*

The Wounding of Colonel Ball
Gouache and pastel on cardboard 31"x23⅛" (78.7x58.7 cm)
Signed: lower left, "Chas. M. Lefferts"
Reverse: on backing, "Property of/Interwoven Stocking Company/
New Brunswick"
Ex-collection: the artist; to Rodman Wanamaker; Interwoven Stocking
Company, New Brunswick, N.J.; to donor, Essex Fells, N.J.
Gift of Leonard Dreyfuss 1952 52.44

The scene depicted occurred in Trenton, N.J., December 26, 1776.

LEIGH, WILLIAM ROBINSON (1866-1955)

***Grand Canyon** 1911
Oil on canvas 66"x99" (167.7x257.4 cm)
Signed and dated: lower right, "W. R. Leigh/1911"
Reverse: sticker, "No. 176/E. C. Babcock/19 East 49th Street/
New York City"
Ex-collection: with Traphagen School of Fashion, New York, N.Y.; to
donor, New York, N.Y.
Gift of Henry Wellington Wack 1930 30.203

*The artist married Ethel Traphagen in 1921. She was associated with the
Traphagen School of Fashion, where the painting is known to have hung.*

LELLA, CARL (b. Italy 1899)

Man's Head
Pencil on paper 17"x14⅜" (43.2x36.5 cm)
Unsigned
Ex-collection: donor, Newark, N.J.
Gift of Miss Beatrice Winser 1934 34.552

LENNEY, ANNIE (b. 1910)

They Were So Young 1952
Oil on canvas 36"x48" (91.4x122.0 cm)
Signed: lower right, "Annie Lenney"
Ex-collection: private collection, West Caldwell, N.J.
Anonymous gift 1959 59.411

LENSON, MICHAEL (b. Russia 1903-1971)

Flowers 1943
Oil on wood 21"x26" (53.3x66.0 cm)
Signed: lower right, "Lenson" (vertical)
Ex-collection: purchased from the artist, Nutley, N.J.
Purchase 1944 Sophronia Anderson Bequest Fund 44.178

"LEONID" [Leonid Berman] (b. Russia 1896-1976)

*__Fishing Shrimps at Boulogne__ 1952
Oil on canvas 32"x49½" (81.3x125.7 cm)
Signed and dated: lower left, "Leonid/52"
Ex-collection: with Durlacher Galleries, New York, N.Y.
Purchase 1954 Felix Fuld Bequest Fund 54.205

LESLIE, ALFRED (b. 1927)

Still Life: Striped Background
Oil on canvas 72"x55" (182.8x139.7 cm)
Unsigned
Ex-collection: the artist; to Rachel Armour Doyle; to her sister,
Mrs. T. A. Schneider, Lexington, Mass.
Given in memory of Rachel Armour Doyle, actress, by her family
1968 68.244

LEVI, JOSEF (b. 1938)

Still Life with Ming Vase and German Master 1975
Acrylic on canvas 29"x35⅞" (73.7x91.1 cm)
Reverse: signed and dated, "Josef Levi 1975"
Ex-collection: A. M. Sachs Gallery, New York, N.Y.; to donors,
New York, N.Y. (1975)
Gift of Mr. and Mrs. Henry Feiwel 1976 76.136

LEVI, JULIAN E. (b. 1900)

Jersey Lighthouse 1937
Watercolor on paper 15¾"x22⅛" (40.0x56.2 cm)
Signed and dated: lower right, "Julian E. Levi, 1937"
Reverse: label, WPA Art Program
Allocated by the WPA Federal Art Project 1945 45.245

*__Last of the Lighthouse__ 1941
Oil on canvas 43"x35" (109.2x88.9 cm)
Signed: lower right, "Julian Levi"
Reverse: scratched onto frame, "Frame made for/Julian Levi by/Carl
Sandelin Framemaker"; label, The Downtown Gallery, N.Y.C.; label,
California Palace of the Legion of Honor, lent by The Downtown
Gallery; label, Columbus Gallery of Fine Arts
Ex-collection: with The Downtown Gallery, New York, N.Y.
Purchase 1946 Wallace M. Scudder Bequest Fund 46.129

LEVINSON, MON (b. 1926)

Untitled 1972
Pencil and crayon on paper 22¼"x29¾" (55.9x75.6 cm)
Signed and dated: lower right margin, "Levinson 1972"
Ex-collection: acquired from the artist, New York, N.Y.; to donors,
New York, N.Y. (1973)
Gift of Mr. and Mrs. Henry Feiwel 1976 76.133

Untitled 1973
Pencil and crayon on paper 22¾"x28¾" (57.8x73.0 cm)
Signed and dated: lower right margin, "Levinson 1/28/73"
Ex-collection: acquired from the artist, New York, N.Y.; to donors,
New York, N.Y. (1973)
Gift of Mr. and Mrs. Henry Feiwel 1976 76.134

Untitled 1973
Pencil and crayon on paper 22¾"x28¾" (57.8x73.0 cm)
Signed and dated: lower right, "Levinson 2/12/73"
Ex-collection: acquired from the artist, New York, N.Y.;
to donors, New York, N.Y. (1973)
Gift of Mr. and Mrs. Henry Feiwel 1976 76.135

LEVITT, JOEL J. (b. Russia 1875-1937)

Portrait of Abraham Walkowitz (1878-1965) 1917
Pencil on white matboard 14¼"x11½" (36.8x29.2 cm)
Signed and dated: lower right, "Joel Levitt"; lower left, "1917"
Ex-collection: donor, New York, N.Y.
Gift of Abraham Walkowitz 1949 49.345

Included in the exhibition, One Hundred Artists and Walkowitz,
Brooklyn Museum, 1944, although not commissioned for it.

LEWANDOWSKI, EDMUND D. (b. 1914)

Red Barns 1935
Watercolor on paper 16¾"x26" (42.5x66.0 cm)
Signed and dated: lower right, "E. D. Lewandowski/1935"
Reverse: label, DPS Form 12 Federal Works Agency A936A; inscribed
twice, "Title Red Barns/started Aug. 5th/Finished Aug. 6th/
E. D. Lewandowski"; label, WPA Wisconsin Federal Art Project 1936
Allocated by the WPA Federal Art Project 1943 43.203

Small Tug ca. 1935-43
Watercolor on paper 20"x25¾" (50.8x65.4 cm)
Signed: lower right, "E. D. Lewandowski"
Reverse: label, DPS Form 12 Federal Works Agency A936A; inscribed
twice, "Small Tug/16x25/Started July 2d/Finished July 22nd/
E.D. Lewandowski/Wisconsin"
Allocated by the WPA Federal Art Project 1945 45.246

LEWIS, JENNIE (20th century)

House Near Beach 1941
Pen and ink on paper 11⅛"x15" (28.2x38.1 cm)
Signed: lower right, "J. Lewis"
Reverse: label (WPA), "House Near Beach"; stamped, "'Oct 27 1941'
(#4537-N)"
Allocated by the WPA Federal Art Project, through the Museum of
Modern Art 1958 58.82

Scene from Ashbury Heights, San Francisco 1941
Pen and ink on paper 12"x19⅛" (30.5x48.6 cm)
Signed: lower right, "J. Lewis"
Inscribed: lower left, "Scene from Ashbury Heights/S. F. Cal."
Reverse: label (WPA); stamped, "'Oct 27 - 1941' (#5619)"
Allocated by the WPA Federal Art Project, through the Museum of
Modern Art 1958 58.83

Landscape 1941
Pen and ink on paper 11½"x15¼" (29.2x38.7 cm)
Signed: lower right, "J. Lewis"
Reverse: label (WPA), "Landscape"; stamped, "'Oct. 27 1941'
(#4537-N)"
Allocated by the WPA Federal Art Project, through the Museum of
Modern Art 1958 58.84

Sand Dunes #1 1941
Pen and ink on paper 11½"x15¼" (29.2x38.7 cm)
Signed: lower right, "J. Lewis"
Reverse: label (WPA), "Sand Dunes #1"; stamped, " 'Oct 27 1941'
(#4537-e)"
Allocated by the WPA Federal Art Project, through the Museum of
Modern Art 1958 58.85

Landscape (Buildings and Foliage) 1941
Pen and ink on paper 11¼"x13⅞" (28.5x35.2 cm)
Signed: lower right, "J. Lewis"
Reverse: label (WPA), "Landscape"; stamped, "'Oct 27 1941',
N. California"
Allocated by the WPA Federal Art Project, through the Museum of
Modern Art 1958 58.86

LIE, JONAS (b. Norway 1880-1940)

Harbor Scene early 20th century
Oil on canvas 8"x10" (20.3x25.4 cm)
Signed: lower right, "Jonas Lie"
Ex-collection: donor, New York, N.Y.
Gift of Albert H. Sonn 1932 32.153

Mountainous Landscape 1910
Oil on canvas 21"x26¼" (53.3x66.6 cm)
Signed and dated: lower right, "Jonas Lie 1910"
Ex-collection: donor, Essex Fells, N.J.
Bequest of Mrs. Frank A. Assmann 1968 68.255

Donor believes painting was executed for the Assmann family.

LIGARE, DAVID H. (b. 1945)

Sand Drawing 1973
Pencil on paper 10¾"x8⅝" (27.5x22.0 cm)
Unsigned
Reverse: label, Andrew Crispo Gallery
Ex-collection: with Andrew Crispo Gallery, New York, N.Y.; to donors,
New York, N.Y.
Gift of Mr. and Mrs. Henry Feiwel 1977 77.232

LINDENMUTH, TOD (1885-1976)

A Pennsylvania Bridge
Oil on canvas 27"x38¼" (68.6x97.2 cm)
Signed: center, "Lindenmuth Tod Lindenmuth"
Reverse: top stretcher, "A Penn. Bridge"; label, "A Pennsylvania
Bridge/Tod Lindenmuth/56 Commercial St./Provincetown Mass."
Ex-collection: purchased from the artist, Provincetown, Mass.
Purchase 1927 27.479

*View of an Allentown, Pa., landmark, Schreiber's Bridge, which crosses
the Little Lehigh River.*

LINEN, GEORGE (1802-1882)

*****Portrait of the Ballantine Children** ca 1873
Oil on board 13"x16½" (33.0x41.9 cm)
Unsigned
Ex-collection: descended in family to donors, Pauling and Brewster, N.Y.
Gift of Herbert W. Ballantine and John W. Ballantine
1958 58.164

*The children were John H. (1867-1946), Robert D. (1870-1905) and
Jeannette (1864-ca. 1872). According to family tradition, the painting was
done in 1873. (corres.)*

LIPPOLD, RICHARD (b. 1915)

Studies for Sculpture, 'New Jersey Meadows' 1961-64

White ink on black paper
A 15⅛"x20" (38.4x50.8 cm)
B 24"x26" (61.0x66.0 cm)
C 8½"x11" (21.6x27.9 cm)
D 24"x36" (61.0x91.4 cm) dated March, 1963
E 15"x34" (38.1x86.4 cm)
Unsigned
Ex-collection: the artist, Locust Valley, N.Y.
Gift of the artist 1964 64.56 A-E

*Lippold's commissioned sculpture was installed at the Museum in 1964
and placed in storage in 1979 pending relocation.*

LIPTON, SEYMOUR (b. 1903)

Untitled 1958
Wax crayon on typewriter bond paper 8½"x11" (21.6x27.9 cm)
Signed and dated: lower right, "Lipton 58"
Reverse: label, "Betty Parsons Gallery No. 9-1958"
Ex-collection: donor, New York, N.Y.
Gift of Eric Green 1974 74.101

Study for an unexecuted sculpture. (corres.)

Untitled 1966
Wax crayon on white paper 10½"x8" (26.7x20.3 cm)
Signed and dated: lower left, "Lipton 66"
Gift of the artist 1975 75.212

*Drawing for Beacon, sculpture in the collection of Museum of Art,
Rhode Island School of Design, Providence, R.I. (corres.)*

LITCHFIELD, J. H. (20th century)

Marine Repairs
Watercolor on paper 13¾"x19¾" (35.0x50.2 cm)
Signed: lower right, "J. H./Litch/field"
Label, front frame, J. H. Litchfield/Marine Repairs/Gift of Arthur F.
Egner, 1935
Reverse: "#1-A. Marine/Repairs/2 in #8 [illegible]/174442344"
Gift of Arthur F. Egner 1935 35.41

LITWAK, ISRAEL (b. Russia 1867-ca. 1956)

Harris, New York 1944
Oil on canvas 22⅛"x31⅛" (57.1x76.5 cm)
Signed and dated: lower left, "Harris, N.Y.";
lower right, "Israel Litwak 1944"
Ex-collection: donor, Gladstone, N.J.
Gift of Mrs. C. Suydam Cutting 1948 48.333

LOCKWOOD, REMBRANDT (1815-ca. 1900)

*****Study for the Last Judgement** ca. 1850
Pencil and wash on paper 37"x24" (94.0x61.0 cm)
Unsigned
Inscribed: upper left, "St. Matthew/Chap XXV/Verse ..."; upper right,
"Revelation/Chap I/Verse 7"
Ex-collection: Wilfred Thomas, Albany, N.Y. to William M. Gannon,
Stamford, Conn.
Gift of William M. Gannon and the Vose Galleries 1965 65.154

William H. Gerdts, in Painting and Sculpture in New Jersey, *1964, said
that the finished painting (27'x17') was first exhibited in Newark in 1854.
It had taken over nine years to complete. The drawing matches a line
engraving which appeared in the painting's brochure in 1854 and Mr.
Gerdts accepts it as a preliminary drawing by Lockwood. Lockwood made
his home in Newark from 1847-58 on premises subsequently occupied by
Lilly Martin Spencer.*

LORIAN, DOLIA (b. Russia 1902-1952)

The Fortress 1946
Oil on canvas 39"x30" (99.1x76.2 cm)
Signed and dated: lower right, (monogram)
Reverse: inscribed on canvas, "Dolia Lorian"
Ex-collection: estate of the artist
Gift of the Committee for Dolia Lorian 1952 52.173

Date of painting is included in artist's monogram. The Committee who selected and donated this work was comprised of Hans Hofmann, Meyer Shapiro and Milton Avery. It was formed to distribute Lorian's paintings to public institutions after her death.

LOZOWICK, LOUIS (b. Russia 1892-1973)

***Relic** 1949
Casein on paper 20⅝"x10⅝" (52.4x27.0 cm)
Signed: (monogram)
Ex-collection: purchased from the artist, South Orange, N.J.
Purchase 1957 Wallace M. Scudder Bequest Fund 57.87

The artist made a first study for this painting "around 1930." He used the unfinished work as a basis for his lithograph Tanks; *later, experimenting with casein, he returned to the older image and finished* Relic. *Date was supplied by artist. (files)*

LUKS, GEORGE (1867-1933)

Czecho-Slovak Chieftan 1919
Oil on canvas 78"x38" (198.1x96.5 cm)
Signed and dated: lower left, "•19 19•/George Luks"
Reverse: inscribed prior to relining, "George Luks"
Ex-collection: C. W. Kraushaar Art Galleries, New York, N.Y.
Gift of Mrs. Felix Fuld 1925 25.1166

Probably a portrait of Juro Michalĉêk done in Stamford, Conn., after Luks visited a delegation of men about to leave the United States to fight for Czechoslovakian independence. Like many other Luks' works, the painting was executed over an earlier work. It was exhibited at the Dallas Arts Association as early as 1921.

Boxer Resting (attributed)
Oil on canvas 34½"x30⅛" (87.6x76.5 cm)
Unsigned
Ex-collection: Peter Friese, New York, N.Y.; to donor, New York, N.Y.
Gift of Herbert Steinman 1962 62.13

The donor referred to the previous owner as"Fries." (corres.) It is assumed that this is Peter Friese, subject of a 1928 Luks portrait.

LYNN, LOUIS (1901-1961)

***Chinese Laundry**
Oil on canvas 28"x35" (71.1x88.9 cm)
Signed: lower left, "Lynn"
Ex-collection: remained in artist's family until donated by his daughter, New Brunswick, N.J.
Gift of Mrs. Ethel Lynn Lazare 1962 62.119

MacDONALD, HERBERT (1898-1972)

War in Heaven #15 ca. 1962
Watercolor on paper 18½"x23½" (47.0x59.7 cm)
Signed: lower right, "Herbert MacDonald"
Gift of Kresge-Newark 1962 62.14

Purchased from New Jersey Watercolor Society's Twentieth Annual Exhibition, 1962, at Kresge-Newark.

The Light 1964
Oil on canvas 68⅝"x65⅞" (174.3x167.8 cm)
Reverse: signed and dated on stretcher, "The Light painted by Herbert MacDonald 1964"
Ex-collection: with Grand Central Moderns, New York, N.Y. to donors, New York, N.Y.
Gift of Mr. and Mrs. Madison H. Lewis 1965 65.166

The artist indicated that this work "was a part of a larger one entitled, The Sermon on the Mount." (files)

MacIVER, LOREN (b. 1909)

Seascape (Composition) 1939
Oil on canvas 24"x36" (61.0x91.4 cm)
Signed: lower right, "MacIver"
Allocated by the WPA Federal Art Project 1943 43.158

Date supplied by the artist. (files)

MacLAREN, SUSANNA (b. Scotland, 19th century)

Lady of the Lake 1811
Oil on paper mounted to canvas 34¾"x26¾" (88.3x67.9 cm)
Unsigned
Ex-collection: remained in artist's family until sold to the Hudson Shop, Red Bank, N.J., in early 1960's
Purchase 1966 O. W. Caspersen Fund 66.36

Executed by MacLaren in Albany, N.Y. After her marriage to Jacob Rue in 1813 she moved to Red Bank, N.J. (files) Another Lady of the Lake *is A.U. 55.130.*

MacMONNIES, FREDERICK WILLIAM (1863-1937)

Portrait of John Flanagan (1865-1952) 1901-02
Oil on canvas 76"x51" (193.0x129.5 cm)
Signed: lower left, "Mac Monnies"
Ex-collection: the artist (until 1920's); to John Flanagan; to donor, Cos Cob, Conn.
Gift of John Hemming Fry 1944 44.36

According to the donor, Mac Monnies painted this portrait in Flanagan's Paris studio in late 1901 and early 1902. In the 1920's, when Flanagan made a relief portrait of Mac Monnies, the two artists exchanged works. (files)

Flanagan, a native of Newark, was the medalist who executed the bronze overdoor of the Newark Free Public Library in 1910. He created the portrait reliefs of John Cotton Dana (1928) and Louis Bamberger (1925) for the Museum's main entrance.

MAGAFAN, ETHEL (b. 1916)

White Mountain 1950
Tempera on masonite 15"x19⅛" (38.2x48.6 cm)
Signed: lower left, "Ethel Magafan"
Reverse: inscribed on panel, "'White Mountain'/Ethel Magafan/Woodstock, N.Y."
Ex-collection: purchased at Artist's Equity Building Fund Sale, 1951, by donors, Scarsdale, N.Y.
Gift of Mr. and Mrs. Alan Temple 1959 59.372

Date supplied by the artist.

MAGAFAN, JENNIE (1916-1952)

Barnyard Landscape (Landscape) 1938
Oil on masonite 22"x32" (55.9x81.3 cm)
Signed: lower right, "Jennie Magafan"
Allocated by the WPA Federal Art Project 1945 45.248

According to the artist, this work was painted for the WPA in Colorado in 1938. (files)

MAGER, CHARLES A. ("Gus") (1878-1956)

Wrestlers (Wrestlers — The Human Knot) 1936
Oil on canvas 20″x24″ (50.9x60.9 cm)
Signed: lower right, "Gus Mager"
Reverse: inscribed, "'Wrestlers — The Human Knot'/Gus Mager";
stretcher, "Gus Mager 'Wrestler — The Human Knot'"; stamped,
"Cooperative Gallery, Newark" (1937)
Ex-collection: purchased from the artist, Newark, N.J.
Purchase 1937 Felix Fuld Bequest Fund 37.6

Country Road 1932
Oil on masonite 15⅝″x24″ (39.6x61.0 cm)
Signed: lower right, "Gus Mager"
Ex-collection: purchased from the artist
Purchase 1937 Felix Fuld Bequest Fund 37.7

*Date supplied by the artist. Exhibited at the Cooperative Gallery, Newark,
N.J., in 1937. (files)*

Landscape — Sandbrook, N.J. 1915
Watercolor on paper 12¼″x9⅛″ (31.1x23.1 cm)
Signed: lower left, "Mager"; lower right, "Sunday, Mar 14, 1915"
Reverse: inscribed on backing, "'Landscape — Sandbrook N.J.'/by Gus
Mager/Painted March (Sunday) 14, 1915" and "Landscape/by Gus
Mager/Presented to The Newark Museum/June 1938"
Ex-collection: donor, Newark, N.J.
Gift of the Cooperative Gallery 1938 38.147

Sketch of my Wife, Matilda 1906
Pen and ink on paper 7″x5⅛″ (17.8x13.0 cm)
Signed and dated: lower left, "Gus Mager/1906"
Reverse: pencil inscription in artist's hand, "Sketch of my wife,/
Matilda- pen and — ink"; label, Artists of Today Gallery, Newark, N.J.
Ex-collection: benefit auction for *Artists of Today*, Newark, N.J. (1944);
to donor, East Orange, N.J.
Gift of Mrs. Hugh C. Barrett 1944 44.119

Landscape ca. 1922
Oil on canvas 14″x11″ (35.5x27.9 cm)
Signed: lower left, "Gus Mager/in Loving/Memory/of my/Mother"
Ex-collection: donor, New York, N.Y.
Gift of Mrs. Phoebus A. Levene 1947 47.211

Approximate date supplied by the donor.

Old Barnegat Salt ca. 1947
Oil on canvas 52⅜″x31⅛″ (133.0x79.1 cm)
Signed: lower right, "Gus Mager"
Reverse: handwritten label, "'Old Barnegat Salt'/Oil Painting-
/Gus Mager"
Ex-collection: donor, Short Hills, N.J.
Gift of the artist 1950 50.2080

*This portrait study was painted over another younger version
of the same model.*

MAJORS, WILLIAM (b. 1930)

Dear Martin 1968
Oil on canvas 88″x60″ (208.3x152.4 cm)
Unsigned
Ex-collection: donors, Westfield, N.J.
Gift of Mr. and Mrs. Harold N. Gast 1971 71.159

*Purchased by the donors from the Museum of Modern Art's 1968 sale, In
Honor of Dr. Martin Luther King, Jr., for the benefit of the Southern
Christian Leadership Foundation. It is titled in the exhibition checklist,
Dear Martin That's What I Had in Mind.*

MARCUS, MARCIA (b. 1928)

Greek Woman 1962
Oil on canvas 26″x19″ (66.0x48.3 cm)
Unsigned
Reverse: label, Allen Gallery
Ex-collection: Allen Gallery, New York, N.Y.
Purchase 1962 The Sumner Foundation for the Arts, Inc.
Award 62.113

*This painting of the artist's landlady was begun in Delphi, Greece, in
July, 1962. (files)*

MARIL, HERMAN (b. 1908)

Form and Flow #2 1960
Oil on canvas 36″x48″ (91.4x121.9 cm)
Signed: bottom right of center, "Herman Maril"
Ex-collection: Castellane Gallery, New York, N.Y.; to donor,
Baltimore, Md.
Gift of Miss Ruth M. Bernstein 1961 61.8

Date supplied by the artist. (files)

MARIN, JOHN (1870-1953)

***Fir Tree** 1926
Watercolor on paper 21¼″x17½″ (54.0x44.5 cm)
Signed and dated: lower right, "Marin 26"
Reverse: inscribed on paper, "Fir Tree/Deer Isle Coast Me/Series 1926/
John Marin"; label, "The Intimate Gallery"; written in Stieglitz'
hand, "Fir Tree. Deer Isle Coast Me. 1926./by John Marin.";
pencil inscription on backing, "For Henry McBride/Greetings/AS";
label, Stedelyk Museum, Amsterdam, *Modern American Painting*, 1950
Ex-collection: The Intimate Gallery, New York, N.Y. (Alfred Stieglitz);
to Henry McBride, New York, N.Y.
Purchase 1930 The Exhibit, Purchase and General Funds 30.76

*William McKim of Palm Beach, Florida, who knew Alfred Stieglitz, said
that Stieglitz told him he gave* Fir Tree *to Henry McBride of the* New
York Sun. *After selling the painting to The Newark Museum, McBride
gave the money to Marin and Marin gave him another painting. (files)*

***Autumn Coloring No. 3 – Maine** 1952
Watercolor on paper pasted to backing 14¾″x19⅞″ (37.5x50.5 cm)
Signed and dated: lower right, "Marin 52"
Reverse: label, The Downtown Gallery, N.Y.C. (with title); label,
University of Arizona, Marin exhibition, February 1953
Ex-collection: purchased from The Downtown Gallery, New York, N.Y.
Purchase 1955 Felix Fuld Bequest Fund 55.87

MARLO, MILDRED (20th century)

Mother and Child 1941
Oil on board 9″x9½″ (22.9x24.1 cm)
Signed and dated: upper right, "M. Marlo '41"
Reverse: label, "Courtesy/Artists of Today/49 New St./Newark"
Ex-collection: donor, Basking Ridge, N.J.
Gift of Mrs. Ludolph H. Conklin 1944 44.120

MARSH, FRED DANA (1872-1961)

The Lady in Scarlet (Lady in Rose; Portrait of Alice Randall
Marsh) ca. 1900
Oil on canvas 77″x51¼″ (195.6x130.2 cm)
Signed: lower left, "F. D. Marsh/Paris"
Reverse: label, Worcester Art Museum, N.D., Lady in Rose; label, *First
Municipal Art Exhibition, Rockefeller Center*, "Portrait of Alice Randall
Marsh"; no pertinent data recorded prior to relining, 1962
Ex-collection: the artist; to his second wife, the donor,
Ormond Beach, Fla.
Gift of Mrs. Fred Dana Marsh 1963 63.241

*Alice Randall Marsh was the artist's first wife and the mother of Reginald
Marsh. She was a miniaturist in her own right. The portrait was first
exhibited in 1900, the year the family returned from France to live in
Nutley, N.J. (corres.)*

MARSH, MOLLY (b. 1913)

Sea Series #17 1963
Pencil on paper 14¾"x26" (37.5x66.0 cm)
Signed: lower left, "Molly Marsh"
Ex-collection: purchased from the artist, Plainfield, N.J.
Purchase 1964 Rabin and Krueger Drawing Fund 64.11

Purchased from the Museum's 5th triennial exhibition, Work by New
Jersey Artists, *1964. Date supplied by the artist as November, 1963.*
(files)

MARSH, REGINALD (b. France 1898-1954)

Alma Mater 1933
Tempera on masonite 36"x24⅛" (91.5x61.3 cm)
Signed and dated: lower right, "Reginald/Marsh "33"
Reverse: label, *East Side, West Side, All Around the Town: A
Retrospective Exhibition of Paintings, Watercolors and Drawings by
Reginald Marsh,* University of Arizona, 1969
Ex-collection: purchased from Frank K. M. Rehn, Inc., New York, N.Y.
Purchase 1944 Arthur F. Egner Memorial Fund 44.303

First exhibited in a one-man exhibition at Rehn Gallery, 1934. The title
came from the name of the statue in New York's Union Square, where the
unemployed "lounged about" in 1933. (files)

***Steeplechase Park** 1944
Watercolor on paper 26¾"x39¾" (67.9x101.0 cm)
Signed and dated: lower right, "Reginald Marsh 1944"
Ex-collection: the artist; to his wife, the donor, New York, N.Y.
Gift of Mrs. Felicia M. Marsh 1961 61.460

***Hudson Burlesk Chorus** 1950
Chinese ink on paper 22⅜"x31⅛" (56.8x79.1 cm)
Signed and dated: lower right, "Reginald Marsh/1950"
Reverse: handwritten on backing, "Reginald Marsh/U.S. 61.461/Hudson
Burlesque [sic] Chorus/Newark"
Ex-collection: the artist; to his wife, the donor, New York, N.Y.
Gift of Mrs. Felicia M. Marsh 1961 61.461

Inscription on backing was written after the work entered the Museum
collection. Lloyd Goodrich noted in the catalogue for the Marsh
exhibition in 1955 at the Whitney Museum of American Art that the
Hudson Burlesk in Union City was a frequent inspiration for Marsh. The
verso of this drawing has an elaborate preparatory study, showing the
same five women in the completed drawing in different poses. Marsh first
used Chinese ink drawing in 1943.

MARTIN, ROBERT (1888-after 1938)

Untitled (landscape)
Watercolor on paper 15½"x21½" (39.4x54.6 cm)
Signed: upper left, "R. Martin"
Ex-collection: donor, Maplewood, N.J.
Gift of Jerome Kurtz 1978 78.94

Untitled (townscape)
Oil on canvas 20"x24" (50.8x61.0 cm)
Signed: lower right, "Robert Martin"
Ex-collection: donor, Maplewood, N.J.
Gift of Jerome Kurtz 1978 78.95

MARTINEZ, JULIAN (1887?-1943)

***Plumed Serpent and Eagle Feathers** ca. 1930
Watercolor and gouache on paper 11½"x17¾" (29.2x45.1 cm)
Signed: lower right, "Julian Martinez"
Reverse: label, Exposition of Indian Tribal Arts 1931, "Design: Horned
Serpent and Eagle Feathers/#35 166A No."
Gift of Miss Amelia E. White 1937 37.218

Plumed Serpent ca. 1935
Watercolor and gouache on paper 11"x13" (27.9x33.0 cm)
Signed: lower right, "Julian Martinez"
Reverse: label, Gallery of American Indian Art, New York, N.Y.;
inscribed, "#35 Julian Martinez San Ildefonso"
Gift of Miss Amelia E. White 1937 37.226

Artist was from the San Ildefonso pueblo, N.M.

MARTINEZ, RICHARD (Opa Nu Mu) (b. 1904)

Stag and Young Stag ca. 1930
Gouache on paper (formerly on board) 21"x30" (53.3x76.2 cm)
Signed: lower right, "Richard Martinez"
Reverse: label, Gallery of American Indian Art, New York, N.Y.; label,
Exposition of Indian Tribal Arts, 1931
Gift of Miss Amelia E. White 1937 37.246

Artist is from the San Ildefonso pueblo, N.M.

MASON, ALICE TRUMBULL (1904-1971)

***Leaven** 1950
Oil on board 20"x16" (50.8x40.7 cm)
Reverse: "Leaven, 1950/Alice Trumbull Mason"; label, Washburn
Gallery, New York, N.Y.
Ex-collection: with Washburn Gallery, New York, N.Y.
Purchase 1977 The Members' Fund 77.173

***White Appearing** 1942
Oil on masonite 12"x17" (30.5x43.2 cm)
Signed: lower left, "ATM 1942"
Reverse: inscribed top and bottom (inverted), "Alice Trumbull
Mason/1942"; torn label, Philadelphia Museum of Art; label,
Washburn Gallery, 42 East 57th Street, New York, N.Y. #39 (blue)
Ex-collection: the artist; to her daughter Mrs. Wolf Kahn,
New York, N.Y.
Gift of Mr. and Mrs. Wolf Kahn 1978 78.189

MATTSON, HENRY E. (b. Sweden 1887-1971)

Moonlight Over Sandpit ca. 1934
Oil on canvas 20"x30¼" (50.8x76.9 cm)
Signed: lower left, "Mattson"
Allocated by the U.S. Treasury Department PWAP 1934 34.302

Landscape with Red House ca. 1933
Oil on canvas 28½"x48½" (72.4x123.2 cm)
Signed: lower right, "H/Mattson"
Ex-collection: purchased from artist by Mr. and Mrs. Alfred A. Knopf,
New York, N.Y.
Gift of Alfred A. Knopf 1965 65.156

The artist supplied "ca. 1933" date some years after the work was
originally accessioned as "1929."

MAURER, ALFRED H. (1868-1932)

***Pastry on a Table** ca. 1931
Oil on gessoed masonite 18¼"x21½" (46.4x54.6 cm)
Unsigned
Reverse: label, Bertha Schaefer Gallery; #166 Pastry on a Table;
label, Finch College Museum of Art; label, Hugh and Ellber, Custom
Frames, 326 E 34th St. NY 16 NY
Ex-collection: Mr. and Mrs. Leo W. Farland, New York, N.Y.; to the
Finch College Museum of Art, New York, N.Y.
Purchase 1975 The Members' Fund 75.235

***Woman's Head**
Oil on composition board 21⅝"x11½" (54.9x29.2 cm)
Signed: upper right, "A.H. Maurer"
Reverse: label, ACA Galleries 25 E 73rd NYC "Female"
Ex-collection: T. Richard Soraci, Philadelphia, Pa.; to donors,
Flemington, N.J.
Gift of Dr. and Mrs. Charles F. Gibbs 1977 77.331

Recto of Nude *(77.332) separated by the Princeton Center for Fine Arts
Conservation in 1972. A label removed by the Princeton Center reads,
"Travelling exhibition of the College Art Association of America."
Exhibition not further identified or dated. (corres.)*

Nude
Oil on composition board 21⅝"x11½" (54.9x29.2 cm)
Unsigned
Reverse: label, ACA Gallery 25 E 73rd NYC "Nude"; inscribed,
"A. H. Maurer"
Ex-collection: T. Richard Soraci, Philadelphia, Pa.; to donors,
Flemington, N.J.
Gift of Dr. and Mrs. Charles F. Gibbs 1977 77.332

Verso of Woman's Head *(77.331).*

McCOMB, JOHN, JR. (1763-1853)

Elevation of Hall of Records, New York, N.Y. 1796
Ink and gouache on paper 16⅛"x24¾" (41.0x24.8 cm)
Signed and dated: lower left, "John McComb Jun.'/1796"
Ex-collection: donor, Newark, N.J.
Gift of Miss Sarah Elizabeth McComb 1923 23.1358

McCORMICK, HARRY (b. 1942)

The Stranger ca. 1964
Oil on canvas 20"x30" (50.8x76.2 cm)
Signed: lower right, "McCormick"
Ex-collection: purchased from The Martin Gallery, New York, N.Y.
Purchase 1965 Mathilda Oestrich Bequest Fund 65.125

Purchased from the Museum exhibition, Selected Works of
Contemporary New Jersey Artists, *1965.*

McCOY, JOHN W. (b. 1910)

The Horseless Carriage ca. 1956
Watercolor on paper 21½"x29½" (54.6x74.9 cm)
Signed: lower left, "John W. McCoy"
Assigned by the National Academy of Design, Henry W. Ranger
Fund 1957 57.44

McCRADY, JOHN (1911-1968)

Temptation ca. 1940
Oil on canvas 25"x36" (63.5x91.4 cm)
Signed: lower right, "J. Mc.Crady"
Reverse: inscribed on canvas, " 'Temptation'/J. Mc. Crady/622 Cemaine
St./New Orleans, La."
Allocated by the WPA Federal Art Project 1945 45.247

McCURDY, MAGGIE (b. 1932)

Inevitable Journey 1977
Collage: mixed media on molded paper 19¾"x10" irreg. (50.2x20.5 cm)
Signed and dated: lower right, "Maggie McCurdy '77"; on mount
lower left, "Inevitable Journey"; on mount lower right, "Maggie
McCurdy '77"
Reverse: label, Lerner Heller Gallery
Ex-collection: with Lerner Heller Gallery, New York, N.Y.
Gift of Richard McCurdy 1978 78.38

McDOUGALL, JOHN A., JR. (1843-1924)

Portrait of a Young Man 1899
Pencil on paper 6½"x4½" (16.6x11.5 cm)
Signed and dated with monogram: left, "MD '99"
Ex-collection: remained in family of artist until donated by his
granddaughter, the donor, Poughkeepsie, N.Y.
Gift of Mrs. Astor Lindberg 1967 67.395

McDOUGALL, JOHN ALEXANDER (1810/11-1894)

Swamp Angel Battery
Oil on canvas 14⅛"x23⅛" (35.9x58.7 cm)
Signed: lower left (monogram), "MD"
Ex-collection: W. S. Canon to his son, the donor, Newark, N.J.
Gift of William Wallace Canon 1918 18.232

*Colonel W. S. Canon was a member of Company K, First New York
Engineers, in the Civil War. He helped build the Swamp Angel Battery
near Charleston, S.C. This painting was made from a war-time photo.
(files)*

Landscape
Oil on canvas 16¾"x24" (42.5x61.0 cm)
Signed: lower left, "J.T."
Ex-collection: donor, Newark, N.J.
Gift of Miss Helen Cecil Wheeler 1918 18.794

***Milldam on the Whippany** 1877
Oil on canvas 13⅜"x20⅛" (34.0x51.1 cm)
Signed and dated: lower left, "MD/1877"
Reverse: No pertinent data recorded prior to relining, 1964
Ex-collection: donor, Newark, N.J.
Gift of Miss Grace Trusdell 1926 26.633

McENTEE, JERVIS (1829-1891)

Untitled 1868
Pencil and Chinese white on paper 8⅞"x13⅜" (27.5x34.0 cm)
Dated: lower right, "Tivoli — Oct. 12th 1868"
Reverse: upper left, "APG 247XXX"; lower right, "F4683"; stamp, The
Lockwood de Forest Collection of Drawings by Jervis McEntee,
Hirschl and Adler Galleries
Ex-collection: with Hirschl and Adler Galleries Inc., New York, N.Y.
Purchase 1976 Edward F. Weston Bequest Fund 76.7

McENTEE, JERVIS (see: Healy, *Arch of Titus*)

McFEE, HENRY LEE (1886-1953)

Young American 1928
Oil on canvas 40¼"x30" (102.2x76.2 cm)
Signed: lower right, "McFee"
Ex-collection: donors, New York, N.Y. (1931)
Gift of Mr. and Mrs. Lesley G. Sheafer 1954 54.212

Date from Virgil Barker's Henry Lee McFee, American Artist Series, *1931.*

Still Life: Fruit and Leaves 1930
Oil on canvas 24"x30" (57.6x76.2 cm)
Signed: lower right, "McFee"
Ex-collection: donors, New York, N.Y.
Gift of Mr. and Mrs. Lesley G. Sheafer 1954 54.213

McLAUGHLIN, W. L. (19th Century)

Portrait of Reverend Amos Holbrook (d.1850) 1814
Watercolor and pencil on paper 6¼"x5⅝" (15.9x14.3 cm)
Signed: lower left, "W. L. McLaughlin, Del·.ʳ"
Reverse: pencil drawing of a woman's head (removed and filed 1975)
Ex-collection: Reverend and Mrs. Holbrook, Newark, N.J.; to Charlotte Holbrook Johnson, Newark, N.J. (subject's daughter); to her daughter, the donor, Hingham, Mass.
Gift of Mrs. H. W. Houghton 1943 43.11

Amos Holbrook was a teacher and chorister in Newark.

Portrait of Mrs. Amos Holbrook [Sophia Cook Holbrook] 1814
Watercolor and pencil on paper 6¼"x5⅝" (15.9x14.3 cm)
Unsigned
Reverse: pen and ink sketch of a woman (removed and filed 1975)
Ex-collection: See W. L. McLaughlin, 43.11
Gift of Mrs. H. W. Houghton 1943 43.12

McNEIL, GEORGE (b. 1908)

Dithyramb 1954
Oil on canvas 48"x40" (121.9x101.6 cm)
Signed: lower right, "McNeil '54"
Reverse: label, Egan Gallery, New York, N.Y.
Ex-collection: Egan Gallery, New York, N.Y.; to donor, Westport, Conn.
Gift of Walter Gutman 1955 55.150

Artist indicated that he started this painting as early as 1950. (corres.)

McPHERSON, JOHN C. (20th century)

Guitar Player (Man Playing Guitar) ca. 1940
Watercolor on paper 29¾"x23⅛" (75.6x58.7 cm)
Signed: lower right, "J. C. McPherson"
Reverse: pencil label on backing, "J.C. McPherson/269 W 4th St./N.Y.C."
Ex-collection: purchased from artist, New York, N.Y.
Purchase 1946 Sophronia Anderson Bequest Fund 46.155

Museum's accession files show an approximate date of 1946. The artist indicated it was painted ca. 1940. (files)

MECKLEM, AUSTIN (1894-1951)

Pioneer Peak 1937
Oil on canvas 24⅛"x30⅛" (61.6x76.9 cm)
Signed and dated: lower right, "Austin Mecklem,/Palmer, Alaska. 1937"
Allocated by the WPA Federal Art Project 1945 45.249

Waterfront, Alaska 1939
Gouache on paper 22"x28" (55.9x71.2 cm)
Signed and dated: lower right, "Austin Mecklem 1939"
Allocated by the WPA Federal Art Project 1945 45.250

MEEKER, JOSEPH (1827-1889)

*Bayou Landscape 1872
Oil on canvas 20"x40" (50.8x101.6 cm)
Signed: lower right, "J. R. Meeker, 1872"
Reverse: label, Kennedy Galleries
Ex-collection: Kennedy Galleries, New York, N.Y.
Purchase 1965 John J. O'Neill Bequest Fund 65.119

Date could also be read as "1875."

MEGARGEE, LAWRENCE A. (b. 1900)

In Old Mexico
Oil on canvas 26¼"x30¼" (66.7x76.8 cm)
Signed: lower left, "Megargee/Mexico"
Reverse: label, Arizona State Fair
Ex-collection: donor, Newark and South Orange, N.J.
Bequest of Louis Bamberger 1944 44.351

The painting was executed in Mazatlan, Mexico. (files)

MELROSE, ANDREW (b. Scotland 1836-1901)

*Valley of the Hackensack from the Estate of L. Becker, Esq., Union City, New Jersey** (View of the Hackensack Valley)
Oil on canvas 28¼"x58" (71.4x147.3 cm)
Signed: lower left, "Andrew Melrose"
Ex-collection: Kennedy Galleries, New York, N.Y.
Purchase 1960 Thomas L. Raymond Bequest Fund 60.577

Four versions were painted for the Becker children. One is in the collection of the New Jersey Historical Society, Newark. Two are unlocated. (files)

MENEELEY, EDWARD (b. 1927)

*Just Before Dawn 1971
Acrylic on canvas 86"x61½"x3¾" (153.7x118.4x9.5 cm)
Reverse: "Just Before Dawn/1971/Ed Meneeley"
Ex-collection: donor, London, England
Gift of the artist 1974 74.54

MERRIGAN, DON (b. 1909)

Roller Skaters 1938
Oil on canvas 12"x16" (30.5x40.7 cm)
Signed: lower left, "Don/Merrigan"
Ex-collection: purchased from the artist, Newark, N.J.
Purchase 1940 Thomas L. Raymond Bequest Fund 40.156

Exhibited at the National Academy of Design in 1938.

Military Park, Newark ca. 1938
Oil on canvas 24"x35³/₁₆" (60.1x89.5 cm)
Signed: lower left, "Don Merrigan"
Ex-collection: donor, Newark, N.J.
Gift of the artist 1942 42.15

MEYER, URSULA (b. Germany)

Homage to 'Tiny Alice' 1966
Chalk and pencil on graph paper 22"x17" (55.9x43.2 cm)
Signed and dated: lower left, "Homage to Tiny Alice New York 1966/Armoply and Formica painted/Scale 1"=10'/Ursula Meyer"
Ex-collection: donor, New York, N.Y.
Gift of the artist 1968 68.246

MICHALOV, ANN (b. 1904)

Approaching Storm 1936
Watercolor on paper 19⅛"x24" (48.6x61.0 cm)
Signed and dated: lower right, "Michalov 36/Michalov"
Reverse: label, WPA Contemporary Art Project, New York World's Fair, 1940
Allocated by the WPA Federal Art Project 1945 45.251

MIGNOT, LOUIS REMY (1831-1870)

*Sunset on the Orinoco 1861
Oil on canvas 36"x46" (91.4x116.8 cm)
Signed and dated: lower left, "L. R. Mignot/61"
Reverse: (torn) label indicating owner as "Rem-y"; label, Montreal Museum of Fine Arts while owned by Hirschl & Adler Galleries
Ex-collection: donors, New York, N.Y.
Gift of Hirschl & Adler Galleries 1969 69.175

MIKUS, ELEANORE (b. 1927)

*Tablet #162 1967
Epoxy on wood 47"x38⅞" (119.5x98.6 cm)
Reverse: signed, "Mikus 1967/162"
Ex-collection: donor, New York, N.Y.
Gift of the artist 1972 72.197

MILES, JEANNE (20th century)

Blue and Green Motion 1957-60
Mixed media on cardboard mounted to burlap 24″x20″ (61.0x51.0 cm)
Signed: lower right, "Jeanne Miles"
Ex-collection: donor, New York, N.Y.
Gift of Mrs. Ira Morris 1964 64.243

MILL, JULIA FORD (1815-?)

Young Girl ca. 1830
Ink on paper 9¾″x7⅛″ (24.8x18.1 cm)
Unsigned
Gift of Mrs. Anna Frances Kip 1931 31.566

Drawing was made by the great-granddaughter of the first president of Princeton College, Dr. Jonathan Dickerson. She was born in Goshen, N.J.

MILLER, ALFRED JACOB (1810-1874)

*****Shoshone Women Watering Horses** (The Halt) ca. 1850's
Oil on canvas 24″x20″ (61.0x50.8 cm)
Unsigned
Reverse: label, Baltimore Museum of Art, Henri estate, owner
Ex-collection: Henri estate, Baltimore, Md. (1932); to Hirschl and Adler, New York, N.Y. (1961)
Gift of Mr. and Mrs. A. M. Adler 1961 61.444

Miller's account books list two paintings of Watering Horses *in 1854.*

MILLER, RICHARD (1875-1934)

Portrait of Wallace M. Scudder (1853-1931) 1931
Oil on wood 36½″x34″ (92.7x86.4 cm)
Signed: center right, "Miller"
Ex-collection: donor, Newark, N.J.
Gift of Miss Antoinette Quimby Scudder 1932 32.209

Commissioned by Mr. Scudder's daughter shortly after his death and painted from photographs taken in 1927. (corres.) Mr. Scudder served as president of The Newark Museum Association, 1926-31.

MILLER, WILLIAM RICKARBY (b. England 1818-1893)

Sorrento, Bay of Naples 1881
Oil on cardboard 8¼″x6¼″ (21.0x15.9 cm)
Signed and dated: lower left, "W. R. Miller.1881"
Reverse: label in artist's hand, "Sorrento/Bay of Naples/WᵐR. Miller,/61 Bleeker St./N.Y."
Ex-collection: donor, New York, N.Y.
Gift of Jack Bender 1957 57.80

*****Weehawken Bluff on the Hudson** 1871
Oil on canvas 20½″x34⅞″ (52.1x88.6 cm)
Signed and dated: lower left, "W. R. Miller.1871./New York"
Reverse: inscribed on canvas, "'Weehawken Bluff on the/Hudson'/WᵐR. Miller. 806 Broadway 1871"; label, Kennedy Galleries
Ex-collection: Kennedy Galleries, New York, N.Y.
Purchased in 1963 with a contribution from the Grad Foundation in honor of the 80th birthday of Frank Grad. 63.74

Passaic Falls, Paterson 1864
Watercolor and pencil on paper 14⅛″x20¼″ (35.9x51.4 cm)
Signed: lower left, "W. R. Miller./D64"; lower right, "Passaic Falls, Paterson.N.Jersey./July 20th 1864."
Ex-collection: William MacPherson, Boston, Mass. (dealer); Vose Galleries, Boston, Mass.
Purchase 1964 Endowment Fund: Life Membership 64.48

MILLET, FRANCIS DAVID (1846-1912)

Portrait of Abraham Lincoln (1809-1865) ca. 1912
Oil on canvas 72″x54″ (182.9x137.2 cm)
Unsigned
Ex-collection: estate of Francis David Millet; to William Kautzman, Maplewood, N.J.
Gift of Mrs. William H. Kautzman 1934 34.131

Following artist's death on the Titanic, his son gave the work to Mr. Kautzman, an assistant of Millet. (corres.)

MINOR, ROBERT C. (1840-1904)

A September Evening
Oil on canvas 12¼″x16¼″ (31.1x41.3 cm)
Signed: lower right, "Minor"
Ex-collection: donor, East Orange, N.J.
Bequest of Mrs. Felix Fuld 1944 44.329

September by the Sea 1895
Oil on wood 16″x20″ (40.6x50.8 cm)
Signed: lower right, "Minor"
Reverse: inscribed, "September by the Sea/1895/R. Minor"; label, "Winsor and Newton/Artists' Colourmen/to her Majesty"
Ex-collection: Joseph S. Isidor, New York, N.Y. and Newark, N.J.; to his wife, the donor, by inheritance (1941)
Bequest of Mrs. Rosa Kate Isidor 1949 49.467

MOELLER, LOUIS (1855-1930)

*****Dr. Abraham Coles in His Study**
Oil on canvas 18¼″x24¼″ (46.4x61.6 cm)
Signed: lower right, "Louis Moeller N.A."
Ex-collection: sitter to his son, the donor, Scotch Plains, N.J.
Gift of Dr. J. Ackerman Coles 1926 26.1227

Dr. Coles (1813-1891) was a Newark physician.

MOOTZKA, WALDO (1903-1935/40)

Whipper Kachina ca. 1935
Gouache on paper 17⅛″x10¼″ (43.5x26.0 cm)
Signed: lower right, "Mootzka"
Reverse: label on backing, Gallery of American Indian Art, New York, N.Y.
Gift of Miss Amelia E. White 1937 37.213

Artist was from Hopi pueblo, Ariz. The work was originally recorded as War Chief.

MORA, F. LUIS (1874-1940)

Color Harmony 1911
Oil on canvas 48″x36″ (121.9x91.5 cm)
Signed and dated: lower left, "F. Luis Mora/1911"
Ex-collection: the artist, Perth Amboy, N.J.
Gift of 12 trustees of The Newark Museum Association
1915 15.981

Spanish Figures (Spanish Scene)
Watercolor on cardboard 11⅛″x12⅝″ (28.3x32.1 cm)
Signed and inscribed: lower right, "To Mrs. Joseph Isidor/F. Luis Mora"
Ex-collection: Joseph S. Isidor, New York, N.Y. and Newark, N.J.; to his wife, the donor
Bequest of Mrs. Rosa Kate Isidor 1949 49.430

The dedication on this work indicates that it was owned by Mrs. Isidor prior to her husband's death. All works bequeathed by her were considered part of the Joseph S. Isidor collection.

MORAN, EDWARD (1829-1901)

Marine
Oil on canvas 21″x30″ (53.3x76.2 cm)
Signed: lower left, "Edward Moran"
Ex-collection: donor, Scotch Plains, N.J.
Bequest of Dr. J. Ackerman Coles 1926 26.1197

***Coast Scene** 1869
Oil on cardboard 8⅝″x20⅛″ (21.9x51.1 cm)
Signed and dated: lower left, "Ed Moran./1869"
Reverse: on cardboard, "Philada"; label, American Federation of Arts,
Surviving the Ages, 1963-64
Ex-collection: donor, New York, N.Y.
Gift of Miss Sylvia Such 1957 57.81

MORAN, MARY NIMMO (b. Scotland 1842-1889)

***View of Newark from the Meadows** (Newark from the Meadows)
ca. 1880
Oil on wood 8¼″x16″ (21.0x40.6 cm)
Signed: lower right, "M. Moran"
Reverse: typed label, "Exhibited Pennsylvania Academy of Fine Arts
1880, No. 29"; label, Pennsylvania Academy of The Fine Arts — *The
Pennsylvania Academy and Its Women*, 1974; label, Industrial
Exposition, Milwaukee
Ex-collection: Harry Shaw Newman Gallery, New York, N.Y., donor,
New York, N.Y.
Gift of Allen McIntosh 1956 56.171

*Mary Moran was the wife of artist Thomas Moran. This painting was
also shown at the National Academy of Design. (corres)*

MORAN, THOMAS (1837-1926)

***Sunset, Venice** 1902
Oil on canvas 20¼″x30¼″ (51.4x76.8 cm)
Signed and dated: lower left, "(monogram) TM Oran,/1902"
Ex-collection: donor, Scotch Plains, N.J.
Bequest of Dr. J. Ackerman Coles 1926 26.1313

Italian Landscape ca. 1866-71
Watercolor on paper mounted on cardboard 8½″x15⅜″ (21.6x39.1 cm)
Signed: lower left, "T. Moran"
Ex-collection: John H. Laurvik, New York, N.Y.
Purchase 1948 J. Ackerman Coles Bequest Fund 48.335

The artist's first European trip was made from 1866-71.

MORGAN, RANDALL (b. 1920)

Positano, Night (Positano) 1957
Oil on masonite 12½″x12¼″ (31.8x31.1 cm)
Signed: lower right, "Morgan"
Reverse: inscribed on backing, "Randall Morgan/'Positano'"
Ex-collection: the artist; to donor, New York, N.Y.
Gift of Francis Steegmuller 1970 70.61

Date and complete title were supplied by the artist.

MORRIS, CARL (b. 1911)

Untitled 1958
Casein on Oriental paper 17¼″x22⅝″ (43.8x57.5 cm)
Signed and dated: lower right, "Carl Morris '58"
Ex-collection: private collection, New York, N.Y.
Anonymous gift 1966 66.406

MORRIS, KYLE (1918-1979)

***Fiery Cross** 1959
Oil on canvas 60″x60″ (152.4x152.4 cm)
Signed and dated: lower left, "Kyle Morris/59"
Reverse: inscribed on canvas, "Fiery Cross/5'x5'/Kyle Morris '59";
label, Kootz Gallery
Ex-collection: with Kootz Gallery, New York, N.Y.
Purchase 1960 John J. O'Neill Bequest Fund 60.575

MORSE, SAMUEL F. B. (1791-1872)

***The Wetterhorn and Falls of the Reichenbach** ca. 1832
Oil on canvas 23″x16⅛″ (58.4x41.0 cm)
Signed: lower right, possibly "Morse" (extremely small); label on
bottom of frame, "A gift of Emily S. Coles"
Reverse: inscribed on stretcher in artist's hand, "The Wetterhorn &
Falls of the Re——ach/Vale of N——ay——ng—— Switzerland
S. F. B. Morse."; stamp on canvas, "Toile——La Venitienne/Vallé &
Bourniche/Seuls Elèves & Suc rs de Belot/Rue de l'Arbre Sec N. '3'"
Ex-collection: J. Goodhue; to donor, Scotch Plains, N.J.
Bequest of Dr. J. Ackerman Coles 1926 26.1167

*Files indicate the stretcher was inscribed in artist's hand, "J. Goodhue"
(no longer visible). This referred to one of seven of Morse's friends who
commissioned paintings as the artist set out on his 1829-32 tour of
Europe. The title was supposed to include Vale of Meyringen. The
painting was exhibited at the National Academy of Design in 1833 and
was recorded as "whereabouts unknown" in the 1932 exhibition of
Morse's work at the Metropolitan Museum of Art. The picture was
included in the bequest of Dr. J. Ackerman Coles and was not a gift
of Miss Emily S. Coles. (files)*

MORTELLITO, DOMENICO (b. 1906)

Cliffs and Sunset ca. 1934
Oil on canvas 38¼″x49½″ (97.2x125.7 cm)
Unsigned
Ex-collection: donor, New York, N.Y.
Gift of the artist 1943 43.105

Scene depicted is Gay Head on Martha's Vineyard.

Italian Laundry Woman 1934
Oil on canvas 39″x33″ (99.1x83.8 cm)
Signed and dated: lower right, "D. Mortellito/'34"
Ex-collection: donor, New York, N.Y.
Gift of the artist 1943 43.106

Subway 1934
Gouache on composition board 17¾″x12¾″ (45.1x32.4 cm)
Signed and dated: lower right, "D. Mortellito/'34"
Ex-collection: donor, New York, N.Y.
Gift of the artist 1943 43.107

Shoe Shine Boy 1934
Oil on canvas 32″x26⅜″ (81.3x67.0 cm)
Signed and dated: lower right, "D. Mortellito/'34"
Ex-collection: donor, New York, N.Y.
Gift of the artist 1943 43.108

Little Bootblack ca. 1934
Gouache on cardboard 29½″x23″ (74.9x58.4 cm)
Unsigned
Ex-collection: donor, New York, N.Y.
Gift of the artist 1943 43.109

MUELLER, GEORGE (b. 1929)

Way Out 1956
Mixed media on masonite 65½″x48¼″ (166.4x122.6 cm)
Reverse: signed and dated on panel, "/Mueller/56";
label, Grace Borgenicht Gallery
Ex-collection: Grace Borgenicht Gallery, New York, N.Y.
Purchase 1956 Felix Fuld Bequest Fund 56.240

On Reading Fenimore Cooper 1961
Ink on paper 22"x28½" (55.9x72.4 cm)
Unsigned
Reverse: label, *"Work By/New Jersey Artists*/The Newark Museum –
May 5-June 11, 1961"
Ex-collection: purchased from the artist, East Orange, N.J.
Purchase 1961 Rabin and Krueger American
Drawing Fund 61.17

Purchased from the Museum's 4th triennial exhibition, Work by New
Jersey Artists, *1961.*

MULLER, JAN (1923-1958)

Pastoral 1955
Oil on canvas 22"x22" (55.9x55.9 cm)
Signed: lower left, "J.M."
Ex-collection: donor, New York, N.Y.
Gift of Mark E. Morris 1958 58.17

MÜLLER-URY, ADOLPH (b. Switzerland 1864-1947)

Portrait of Mrs. Joseph S. Frelinghuysen, Sr. [Emily Brewster]
(1881-1967) and Son Joseph, Jr. (b. 1912) 1916
Oil on canvas 78"x46" (189.1x116.9 cm)
Signed and dated: lower left, "A. Müller-Ury 1916"
Ex-collection: remained in family to donor, Somerville, N.J.
Gift of Joseph S. Frelinghuysen 1971 71.160

*According to the donor, the work was painted chiefly in the family house
in Raritan, N. J. (now demolished), and finished in Washington, D.C.
Joseph S. Frelinghuysen, Sr., husband of the sitter, was a member of the
N. J. Senate, 1905-11, and of the U.S. Senate, 1917-23.* (corres.)

MURCH, WALTER TANDY (1907-1967)

*****Clock Study**
Charcoal, chalk and pastel on paper 20½"x14¾" (52.1x37.5 cm)
Signed: lower left, "Walter Murch"
Reverse: label, Betty Parsons Gallery
Ex-collection: Betty Parsons Gallery, New York, N.Y.
Purchase 1962 The Rabin and Krueger American
Drawing Fund 62.114

MURPHY, CATHERINE (b. 1946)

*****View of Hoboken and Manhattan from Riverview Park,**
New Jersey 1973
Oil on canvas 37¼"x44½" (93.5x113.0 cm)
Reverse: "Fox P Murphy 651"; label, Fourcade Droll, New York, N.Y.
Ex-collection: the artist with Fourcade Droll, Inc., New York, N.Y.
Purchase 1975 with a grant from the National Endowment for the
Arts and funds from the Prudential Insurance Company of
America 75.27

MURPHY, J. FRANCIS (1853-1921)

November Marsh
Oil on canvas 15⅛"x20" (38.4x50.8 cm)
Signed: lower left, "J. Francis Murphy"
Reverse: no pertinent data recorded prior to relining
Ex-collection: Mrs. T. F. Hussa, Montclair, N.J.
Purchase 1930 Felix Fuld Bequest Fund 30.468

*****The Mill Race** 1897
Watercolor on cardboard 8¼"x12¼" (21.0x31.1 cm)
Signed and dated: lower right, "J. Francis Murphy '97"
Ex-collection: donor, Newark, N.J.
Bequest of G. Wisner Thorne 1938 38.329

Landscape 1893
Oil on canvas 8"x6" (20.3x15.2 cm)
Signed and dated: lower left, "J. Francis Murphy '93"
Reverse: label, AFA, *Surviving the Ages*, 1963-64
Ex-collection: donor, East Orange, N.J.
Bequest of Mrs. Felix Fuld 1944 44.298

Landscape 1917
Oil on wood 9⅝"x12" (24.4x30.5 cm)
Signed: lower left, "Murphy"
Reverse: inscribed and dated on panel, "To 'Joe'/From 'Murph'/Apr 29
1917"; label, Jean Bohne, framer
Ex-collection: Joseph S. Isidor, New York, N.Y. and Newark, N.J.; to
his wife, the donor
Bequest of Mrs. Rosa Kate Isidor 1949 49.422

Probably dedicated by Murphy for "Joe" Isidor.

Spring Landscape
Oil on canvas 5"x7" (12.7x17.8 cm)
Signed: lower right, "JF Murphy"
Ex-collection: Joseph S. Isidor, New York, N.Y. and Newark, N.J.; to
his wife, the donor
Bequest of Mrs. Rosa Kate Isidor 1949 49.417

Summer 1905
Oil on wood 2¾"x4" (6.9x10.2 cm)
Signed: lower left, "M"
Reverse: inscribed and dated, "J. Francis Murphy-1905"; label,
"'Summer'/Loaned by J. S. Isidor"
Ex-collection: Joseph S. Isidor, New York, N.Y. and Newark, N.J.; to
his wife, the donor
Bequest of Mrs. Rosa Kate Isidor 1949 49.418

Late Summer
Oil on cardboard glued to panel 8¼"x5¼" (22.0x14.4 cm)
Signed: lower right, "J. F. Murphy"
Reverse: label, Artists Framing Co. Inc./N.Y.C.
Ex-collection: Joseph S. Isidor, New York, N.Y. and Newark, N.J.;
to his wife, the donor
Bequest of Mrs. Rosa Kate Isidor 1949 49.419

Landscape with Large Cloud
Oil on canvas 5"x7" (12.7x17.8 cm)
Signed: lower left, "J. F. Murphy"
Ex-collection: Joseph S. Isidor, New York, N.Y. and Newark, N.J.;
to his wife, the donor
Bequest of Mrs. Rosa Kate Isidor 1949 49.420

Willows 1909
Oil on wood 8⅛"x14" (20.6x35.5 cm)
Signed and dated: lower left, "J. F. Murphy '09"
Reverse: torn label, "Willows/—by J. S. Isidor"
Ex-collection: Joseph S. Isidor, New York, N.Y. and Newark, N.J.;
to his wife, the donor
Bequest of Mrs. Rosa Kate Isidor 1949 49.421

*****In the Shadow of the Hills** 1910
Oil on canvas 27"x41" (68.6x104.1 cm)
Signed and dated: lower left, "J. Francis Murphy•/1910"
Reverse: brass label on frame, "'In the Shadow of the Hills'/J. Francis
Murphy, N.S./Awarded the Inness Medal/National Academy of
Design/1910."
Ex-collection: donor, New York, N.Y. (ca. 1964)
Gift of Dr. Charles H. Poindexter 1967 67.156

MURRAY, HESTER MILLER (b. 1904)

Sparrows in the Snow (Sparrows) 1938
Gouache on cardboard 18⅞"x27⅜" (48.0x69.5 cm)
Signed: lower right, "HMM"
Reverse: inscribed on cardboard, "Hester Miller Murray/Sparrows
in the Snow/Feb 3 1938"; torn label on backing, WPA
Allocated by the WPA Federal Art Project 1945 45.252

American Animals 1940
Watercolor on paper 13½"x22¾" (34.3x57.8 cm)
Unsigned: in pencil in upper margin, "suggested for west wall of
Ray School"
Allocated by the WPA Federal Art Project 1945 45.342

Sketch for 1940 mural, American Animals.

MUSE, ISAAC LANE (b. 1906)

Leaden Sea 1938
Watercolor on paper 15"x21½" (38.1x54.6 cm)
Ex-collection: with Cooperative Gallery, Newark, N.J.
Purchase 1938 Thomas L. Raymond Bequest Fund 38.451

Portrait of a Child
Oil on canvas 24½"x14½" (62.2x36.8 cm)
Signed: lower left, "Muse"
Ex-collection: donors, New York, N.Y.
Gift of Mr. and Mrs. A. H. Ekstrom 1959 59.82

MYERS, JEROME (1867-1940)

***East Side Corner** 1923
Oil on canvas 16"x19⅞" (40.6x50.5 cm)
Signed and dated: lower left, "Jerome Myers 1923"
Ex-collection: private collection, New York, N.Y.
Anonymous gift 1924 24.858

Italian Procession ca. 1925
Oil on canvas 25⅛"x30" (63.8x76.2 cm)
Signed: lower left, "Jerome Myers"
Ex-collection: donor, East Orange, N.J.
Gift of Mrs. Felix Fuld 1925 25.1155

*One of 16 contemporary American paintings purchased by the Museum
in 1925 with funds provided for that purpose by Mrs. Felix Fuld.*

NEAGLE, JOHN (1796-1865)

***Portrait of Peter Maverick** (1780-1831) 1826
Oil on canvas 29¼"x23¼" (74.3x59.1 cm)
Reverse: signed and dated (prior to relining), "An original Portrait of
Peter Maverick Esq/Painted in New York by John Neagle and
presented/to Mr. Maverick's children by the Painter/August 29th 1826."
("26" is blurred); label, Montclair Art Association, Lent by "Mr. A. O.
Townsend/45 Lloyd Road"
Ex-collection: children of Peter Maverick; to A. O. Townsend (grandson
of Maverick); to Charles Townsend, Harrison, N.Y. (grandson of
Maverick); to his son Peter Townsend, New York, N.Y.
Purchase 1958 The Members' Fund 58.38

*The Montclair Museum has no record of the loan recorded on canvas
reverse. Peter Maverick was a well-known 19th century engraver and
lithographer who lived and worked in Newark from 1809 to 1820.*

NATT, THOMAS J. (1824-1859)

Portrait of Unidentified Man 1831
Oil on wood 25⅛"x19⅞" (63.8x50.5 cm)
Reverse: signed and dated on panel (presumably by artist), "Painted
by/Thos. J. Natt/Newark, 1831"; a typewritten paper was at one time
pasted onto the back of this painting. It read: "On July 5, 1836, Thomas
J. Natt advertised in the *Sentinel of Freedom* newspaper in Newark,
N.J., as a portrait painter and miniaturist. His address was 'Bank
Street Three Doors from Broad.' The subject is probably a Newark
resident." *(files)*
Ex-collection: donors, Somerville, Mass.
Gift of Mr. and Mrs. Frederic A. Sharf 1963 63.121

*Mr. Sharf stated (corres.) that he bought the painting in a barber shop
(unidentified) which also dealt in second-hand items. The Museum had
been offered the portrait previously by New York and Boston dealers.*

NEAL, REGINALD H. (b. 1909)

Red Times Nine 1966
Serigraph on plexiglas placed over masonite 48⅜"x48¾" (122.7x123.7 cm)
Reverse: signed and dated, "Reginald Neal 66'/Red Times
Nine/48⅜"x48⅜"; label, Amel Galleries, N.Y.
Ex-collection: donor, Lebanon, N.J.
Gift of the artist 1969 69.165

*The scale of this work puts it in this catalogue rather than in a
compendium of graphics.*

NEHAKIJE [Steven Vicenti] (1917-1948)

Bee Dance ca. 1935
Gouache on paper 9¾"x13⅞" (24.8x35.2 cm)
Signed: lower left, "Ne-Ha-Kije" (twice)
Reverse: label on backing, Gallery of American Indian Art,
New York, N.Y. #306A
Gift of Miss Amelia E. White 1937 37.215

Artist was a member of Jicarilla Apache tribe, N.M.

NELSON, BRUCE (b. 1888)

Lake – Central Park 1935-43
Oil on canvas 24¼"x30¼" (61.6x76.8 cm)
Unsigned
Allocated by the WPA Federal Art Project 1954 54.202

NEWMAN, JOSEPH (1890-1967)

Portrait of Benjamin Eggleston ca. 1926
Oil on canvas 30"x40" (76.2x101.6 cm)
Signed: bottom right, "J. Newman"
Ex-collection: donor, New York, N.Y.
Gift of Henry Wellington Wack 1927 27.471

*Artist indicated that portrait was displayed in Allied Artists Exhibition,
1926-27.* (files)

NEWMAN, ROBERT LOFTIN (1827-1912)

***The Good Samaritan** 1886
Oil on canvas 9"x11" (22.9x27.9 cm)
Signed and dated: lower left, "RL Newman./1886."
Reverse: Files indicate presence of the following labels prior to
relining 1971: label, Museum of Fine Arts, lent by John Gellatly;
label, Whitney Museum, R. L. Newman exhibition 1935
Ex-collection: John Gellatly, New York, N.Y. (1894); with Frank K. M.
Rehn Gallery, New York, N.Y. (1919; consigned by Gellatly)
Purchase 1925 25.1159

*Marchal E. Landgren feels that Gellatly purchased painting from the
artist. (corres.) The Museum purchased it from an exhibition of
Newman's paintings at the Rehn Gallery with money donated by
Mrs. Felix Fuld.*

Woman by the Spring (Woman at the Spring)
Oil on canvas mounted on wood 20¼"x24¼" (51.4x61.6 cm)
Signed: lower left, "R. L. Newman"
Ex-collection: the artist; to Dr. and Mrs. Frederick T. Van Beuren,
Morristown, N.J.; to donor, Morristown, N.J.
Gift of Mrs. William B. Connett 1962 62.151

NEWTON, RONNIE (b. 1920)

Buttermilk Falls ca. 1955
Oil on canvas 50"x24¼" (127.0x61.6 cm)
Signed: lower left, "Ronnie"
Ex-collection: purchased from the artist, Morristown, N.J.
Purchase 1955 Sophronia Anderson Bequest Fund 55.85

Purchased from The Newark Museum's 2nd triennial exhibition, Work by
New Jersey Artists, *1955.*

NICHOLS, HENRY HOBART (1869-1962)

Winter
Oil on board 13″x16″ (33.0x40.6 cm)
Signed: lower left, "Hobart Nichols"
Ex-collection: purchased from the artist, presumably Bronxville, N.Y.
Purchase 1923 23.1864

NICOLL, JAMES CRAIG (1847-1918)

How Beautiful is Night ca. 1900
Watercolor on paper 24½″x36″ (62.2x91.5 cm)
Signed: lower right, "J.C. Nicoll, N.A."
Ex-collection: donors, West Orange, N.J.
Gift of Mrs. John E. Sloane and the Hon. Charles Edison
1964 64.43

Approximate date supplied by donor.

NIESE, HENRY (b. 1924)

***Myself as a Painter** 1956
Oil on canvas 54″x42″ (137.2x106.7 cm)
Unsigned
Ex-collection: G Gallery, New York, N.Y.
Purchase 1960 The Sumner Foundation for the Arts, Inc.
Award 1960 60.576

Date supplied by artist. (files)

NORDFELDT, B. J. O. (b. Sweden 1878-1955)

***The Blue Fish** 1942
Oil on masonite 32⅛″x40″ (81.6x101.6 cm)
Signed: lower right, "Nordfeldt"
Reverse: label, Edith and Milton Lowenthal Collection
Ex-collection: Lilienfield Gallery, New York, N.Y.;
to donors, New York, N.Y. (1943)
Gift of Mr. and Mrs. Milton Lowenthal 1949 49.352

Date supplied by donors.

NOURSE, ELIZABETH (1860-1938)

Summer Hours ca. 1924
Oil on canvas 53¼″x41¼″ (135.3x104.8 cm)
Signed: lower left, "Elizabeth Nourse"
Reverse: inscribed on stretcher, "E. Nourse/80—Paris"; label in artist's
hand, "Schpt: 'Heures L'Eté/Summer Hours/at St. Gildas de
Rhony's/Morbehan/Artiste Elizabeth Nourse";
canvas stamp, Paul Foinet
Ex-collection: donor, Newark, N.J.
Gift of Mrs. Florence P. Eagleton 1925 25.851

*Date determined on stylistic grounds and dates of residence (mid 1920's)
at 80 Rue d'Assasin, Paris.*

OCHS, FREDERICK (b. Germany 1832-1923)

German Knight 1852
Crayon on paper 15½″x12″ (39.3x30.5 cm)
Signed and dated: lower left, "Erfurt Lee. F. Ochs./1852"
Ex-collection: painting remained in artist's family until donated by his
granddaughter, Newark, N.J.
Gift of Miss Louise Ochs 1963 63.73

The artist, a school teacher, resided in Newark for many years. (corres.)

OCHTMAN, LEONARD (1854-1924)

Landscape 1893
Oil on canvas 16″x22″ (40.6x55.9 cm)
Signed and dated: lower left, "Leonard Ochtman/1893"
Ex-collection: donor, South Orange, N.J.
Bequest of Mrs. Felix Fuld 1944 44.330

ODDIE, WALTER M. (1808-1865)

***Landscape** 1853
Oil on canvas 36″x50″ (91.4x127.0 cm)
Signed and dated: lower left, "Walter M. Oddie 1853"
Ex-collection: donor, East Orange, N.J.
Gift of Mrs. William Hanan 1945 45.265

*Family tradition maintained that the scene is the Delaware
Water Gap. (files)*

OKADA, KENZO (b. Japan 1902)

***Sand** 1955
Oil on canvas 68″x40¾″ (170.0x103.9 cm)
Signed: lower right, "Kenzo Okada"
Reverse: top stretcher in pencil, "Sand 1955"; label, Betty Parsons
Gallery; label, David Herbert Gallery Invitation Exhibit,
October 15-31, 1959
Ex-collection: donor, New York, N.Y.
Gift of Stanley Posthorn 1973 73.116

O'KEEFFE, GEORGIA (b. 1887)

***White Flower on Red Earth, No. 1** 1943
Oil on canvas 26″x30¼″ (66.0x76.8 cm)
Unsigned
Reverse: label in Alfred Stieglitz' hand, " 'White Flower on Red Earth,'
No. 1/New Mexico — 1943/by Georgia O'Keeffe", bottom of label is
printed, "An American Place/509 Madison Avenue, New York"; label in
Stieglitz' hand (entire label crossed out), "An American Place/
5-9 Madison Avenue — Room____ 19/____ corner 50th St.____ New
Y____k"/(rest of label is in different hand): "White Flower on Red
Earth #____/by Ge____gia O'Keeffe 1943"; label, *Painting in the
United States 1944*, Carnegie Institute, Pittsburgh, Pa.
Ex-collection: An American Place, New York, N.Y.
Purchase 1946 John J. O'Neill Bequest Fund 46.157

*Included in artist's one-man show at An American Place,
January-March, 1944.*

***Purple Petunias** 1925
Oil on canvas 15⅞″x13″ (40.3x33.0 cm)
Unsigned
Reverse: pencil on backing, "Georgia O'Keeffe/-1925"; label, The
Intimate Gallery; label in donor's hand, "Willed to Newark Museum";
label, Gallery of Modern Art, *The Twenties Revisited*, 1965; label, A.F.A.,
American Still Life Painting, 1967-68; on stretcher in pencil, "#19
12¹⁵/₁₆″ x 15¾″"
Ex-collection: The Intimate Gallery, New York, N.Y.; to donor,
Short Hills, N.J. (1926)
Bequest of Miss Cora Louise Hartshorn 1958 58.167

Green Oak Leaves 1923
Oil on canvas mounted on wood 12″x9″ (30.5x22.9 cm)
Unsigned
Reverse: label in donor's hand, "Willed to Newark Museum"; paper on
back of wood panel, "Stieglitz/same as before 18 [symbol] silver
leaf/glass & _____/St 8⅞ ″x11⅞″"
Ex-collection: Anderson Galleries, New York, N.Y. to donor, Short
Hills, N.J. (1924)
Bequest of Miss Cora Louise Hartshorn 1958 58.168

*Paper on back of panel indicates that painting is still in its original frame.
Date supplied by Hartshorn documentation which also indicated presence
of signature on reverse (not apparent) .(files)*

OLINSKY, IVAN G. (b. Russia 1878-1962)

Portrait of Abraham Walkowitz (1878-1965) 1943
Oil on canvas 16″x12″ (40.7x30.5 cm)
Signed: lower right, "Ivan G. Olinsky"
Reverse: inscribed and dated on stretcher, "Portrait of A. Walkowitz/by
Ivan Olinsky 1943 oil"
Ex-collection: donor, New York, N.Y.
Gift of Abraham Walkowitz 1949 49.347

Painting executed for exhibition, One Hundred Artists and Walkowitz,
Brooklyn Museum, 1944.

OLIVER, JANE (b. 1921)

The Kite 1950
Watercolor on paper 19½″x24½″ (49.5x62.2 cm)
Signed and dated: "Jane Oliver '50"
Ex-collection: purchased from the artist, Maplewood, N.J.
Purchase 1952 Wallace M. Scudder Bequest Fund 52.28

Purchased from Museum exhibition, Work by New Jersey Artists, *1952.*

Beach Store
Watercolor on paper 21″x33″ (53.3x83.8 cm)
Signed: lower right, "J. Oliver"
Ex-collection: donor, Newark, N.J.
Gift of Chase Department Store 1964 64.139

OQWA PI [Abel Sanchez] (1899/1902-1970)

***Deer Dance**
Pencil, ink and gouache on paper 11¼″x14¼″ (28.6x36.2 cm)
Signed: lower right, "Oqwa Pi"
Reverse: inscribed on backing, "Mr. Butcher/American Red Cross/1709
Washington Avenue/St. Louis/Mo"
Purchase 1928 28.1451

Purchased for the Museum in Santa Fe, N.M., by Edgar Holger Cahill.
Artist from San Ildefonso pueblo, N.M.

Three Rams ca. 1930
Gouache on paper 11¼″x14¼″ (28.6x36.2 cm)
Signed: lower right, "Oqwa Pi"
Reverse: label on backing, Gallery of American Indian Art, New York,
N.Y.; label on backing, Exposition of Indian Tribal Arts 154A
Gift of Miss Amelia E. White 1937 37.158

Corn Dance Figure with Banner ca. 1935
Gouache on poster board 22″x14″ (55.9x35.6 cm)
Unsigned
Reverse: label on backing, Gallery of American Indian Art,
New York, N.Y. 183A
Gift of Miss Amelia E. White 1937 37.174

Two Girls with Water Jars ca. 1930
Watercolor and gouache on paper pasted on board 14″x10¾″
(35.6x27.3 cm)
Unsigned
Reverse: label, Gallery of American Indian Art, New York, N.Y.; label,
18th Biennial International Art Exhibition, Venice, 1932
Gift of Miss Amelia E. White 1937 37.210

Turtle Dance ca. 1930
Gouache on paper (formerly on board) 12½″x19½″ (31.8x49.5 cm)
Signed: lower right, "Oqwa Pi"
Reverse: label on backing, Venice 18th Biennial Art Exhibition, 1932;
label, Gallery of American Indian Art, New York, N.Y.; label, 1935
Watercolor Exhibition, Art Institute of Chicago, Ill.; label, Exposition
of Indian Tribal Arts, 1931
Gift of Miss Amelia E. White 1937 37.211

Eagle Dance ca. 1930
Gouache on paper 11½″x19¾″ (29.2x50.2 cm)
Signed: lower right, "Oqwa Pi"
Reverse: label on backing, Venice 18th Biennial International Art
Exhibition, 1932; label, Exposition of Indian Tribal Arts, 1931; label,
Brooklyn Museum, *The Dance in Art*, 1936
Gift of Miss Amelia E. White 1937 37.231

Eagle Dancers ca. 1930
Pencil and gouache on paper (formerly on board) 11⅞″x14½″
(30.2x36.8 cm)
Signed: lower right, "Oqwa Pi"
Reverse: pencil inscription, "Eagle Dance, Oqwa Pi/#157A"
Gift of Miss Amelia E. White 1937 37.232

Buffalo Dance ca. 1935
Pencil, ink and gouache on paper (formerly on board) 11¼″x14⅜″
(28.6x36.5 cm)
Signed: lower right "Oqwa Pi"
Reverse: pencil inscription, "Buffalo Dance — Oqwa Pi 162A"
Gift of Miss Amelia E. White 1937 37.233

ORTMAN, GEORGE EARL (b. 1926)

***Zapotec** 1966
Aluminum, acrylic, canvas construction 75″x90″ (191.0x228.6 cm)
Unsigned
Reverse: stamp, "Howard Wise Gallery"
Ex-collection: Howard Wise Gallery, New York, N.Y.
Purchase 1968 Felix Fuld Bequest Fund 68.220

Purchased from the Museum's 7th comprehensive survey, New Jersey
Artists, *1968.*

OVERSTREET, JOE (b. 1934)

Untitled 1971
Watercolor on paper 22½″x30½″ (57.2x77.5 cm)
Signed and dated: lower right, "Overstreet 71"
Ex-collection: with Dorsky Galleries Limited, New York, N.Y.
Gift of The Prudential Insurance Company of America 1971 71.93

PADOVANO, ANTHONY J. (b. 1933)

Study for Sculpture 1973
Pen and ink wash on paper 10⅛″x11⅜″ (26.0x29.0 cm)
Signed and dated: lower right, "Padovano 1973"
Reverse: label on backing, Graham Gallery, cat. #44
Ex-collection: with Graham Gallery, New York, N.Y.
Purchase 1975 with a grant from the National Endowment for the Arts
and the Charles W. Engelhard Foundation 75.47

PANCHAK, WILLIAM B. (b. Ukraine 1893)

Ukrainian Procession 1938
Oil on canvas 28½″x34″ (72.4x86.4 cm)
Signed and dated: lower left, "Wm. Panchak/1938"
Gift of Ukrainian Athletic Association, Newark, N.J. 1939 39.150

PAPSDORF, FREDERICK (b. 1887)

Landscape 1942
Oil on canvas 12″x16⅛″ (30.5x41.0 cm)
Signed and dated: lower right, "Papsdorf/42."
Ex-collection: donor, Grosse Pointe Farms, Mich.
Gift of Robert H. Tannahill 1947 47.212

PARIS, LUCILLE MARIE (b. 1928)

Orange Julius ca. 1971
Acrylic on canvas 50″x50″ (127.0x127.0 cm)
Unsigned
Ex-collection: acquired from the artist by donor, Union City, N.J.
Gift of Dr. Carmen Sippo 1971 71.171

Exhibited in the Museum's 7th triennial exhibition,
New Jersey Artists, *1971.*

PARKER, ANNE (b. 1920)

A June Day 1973
Oil on canvas 19⅞″x16⅛″ (50.5x41.0 cm)
Signed: lower right, "Anne Parker"
Reverse: inscribed on top stretcher, "'A June Day'
by Anne Parker, 1973"
Ex-collection: with Roko Gallery, New York, N.Y.
Gift of Dr. Harold M. M. Tovell 1974 74.20

PARKER, ROBERT ANDREW (b. 1927)

A Battleship and a Cruiser 1958
Watercolor and ink on paper 19¾″x30¼″ (50.2x76.8 cm)
Signed and dated: along left, "Robt Andrew Parker X:1.58"
Ex-collection: donor, New York, N.Y.
Gift of John Preston 1960 60.600

Russian Soldiers 1958
Watercolor and ink on paper 18″x26″ (45.7x66.1 cm)
Signed and dated: lower left, "Robt An Parker III.8.58"
Ex-collection: donor, New York, N.Y.
Gift of Walter A. Weiss 1960 60.606

PARTON, ARTHUR (1842-1914)

***A Winter Dawn** (A Winter Sunrise-Palisades; A Winter Sunrise)
Oil on canvas 35″x45″ (88.9x114.3 cm)
Signed: lower right, "Arthur Parton N.A."
Reverse: label, in artist's hand, "A Winter Dawn/Arthur Parton"; label,
Boston Art Club, "A Winter Sunrise"
Ex-collection: donor, New York, N.Y.
Gift of Jack Tanzer 1965 65.131

PASCIN, JULES (b. Bulgaria 1885-1930)

Nude in Chair
Charcoal and yellow chalk on paper 25¼″x18⅛″ (64.1x46.0 cm)
Signed: lower right, "Pascin"
Ex-collection: Weyhe Galleries, New York, N.Y.; to donors,
Stockton, N.J.
Gift of Mr. and Mrs. Bernard M. Douglas 1957 57.37

PEALE, A. (19th century)

Natural Curiosity at St. Helena (Tomb of Napoleon, St. Helena) 1833
Pencil on paper 6¾″x4½″ (17.1x11.4 cm)
Signed and dated: lower left, "A. Peale"; lower right, "1833"
Inscribed: bottom, "Natural Curiosity/at St. Helena"
Ex-collection: descended in Rembrandt Peale family; to great-great-
granddaughter, donor, East Orange, N.J.
Gift of Miss Carol Wirgman 1949 49.238

*Several possibilities exist for the attribution of "A. Peale". Among the
most likely are Rembrandt Peale's daughters Angelica [later Goodman]
(1800-1859), Augusta (1809-1886), or his sister, Angelica Kaufmann Peale
(1775-1853).*

PEALE, CHARLES WILLSON (1741-1827)

***Portrait of Colonel Elihu Hall** (1723-1790) 1773
Oil on canvas 30″x25¼″ (76.2x64.1 cm)
Signed and dated: left of center (above chair), "C. W. Peale/Pinx 1773"
Reverse: no pertinent data recorded prior to relining, ca. 1925;
handwritten label, "Portrait of/Elihu Hall by C/Willson Peale/1773"
Ex-collection: sitter to son Charles Hall, Muncy Farms, Pa.; to son
Robert Coleman Hall; to daughter Julia Watts Hall Brock; to son
Robert Coleman Hall Brock; to son Henry Gibson Brock; with Kennedy
Galleries, New York, N.Y.
Purchase 1963 The Members' Fund 63.127

*The late Charles Coleman Sellers stated that he believed this portrait and
its companion were the prototypes from which he later painted four
replica pairs. This assessment was made from the fact that this pair is
signed and dated. Both paintings descended in one family and appear to
have remained in a single home (Muncy Farms, Muncy, Pa.) from the
early 19th century until 1961. Colonel Hall was a judge of Orphans Court,
Cecil County, Md., and was appointed a Second Major of the
Susquehanna Battalion of the Maryland Militia on June 6, 1776. His
residence in Cecil County was "Mt. Welcome". (C. C. Sellers,* Transactions
of the American Philosophical Society)

***Portrait of Mrs. Elihu Hall** [Catherine Orrick] (1736-?)
Oil on canvas 30″x25″ (76.2x63.5 cm)
Signed and dated: lower right (above flounce), "C. W. Peale/Pinx 1773"
Reverse: painting relined ca. 1925; (family legend maintained that Mrs.
Hall's portrait had a label addressing the picture from Peale to the
Halls at their Maryland Home); handwritten label, "Portrait of Mrs.
Hall/Wife of Elihu Hall/by C. Willson Peale/1773/Property of
Henry G. Brock"
Ex-collection: see C. W. Peale, 63.127
Purchase 1963 The Members' Fund 63.128

PEALE, HARRIET CANY (Mrs. Rembrandt) (?-1869)

Landscape 1858
Oil on cardboard 9⅝″x12⅛″ (24.4x30.8 cm, oval)
Reverse: inscribed (according to files, but no longer visible),
"Landscape by Mrs. Rembrandt Peale/Philadelphia 1858"
Ex-collection: descended in Rembrandt Peale's family; to his
great-granddaughter, the donor, East Orange, N.J.
Gift of Miss Carol Wirgman 1949 49.220

*According to John Mahey and Mrs. William Johnston of the Peale
Museum, Baltimore, Md., the original inscription assigning this work to
Harriet Peale seems probable on stylistic grounds. (files) Harriet Cany
married Peale in 1840 after the death of his first wife Eleanor Short, the
donor's great-great-grandmother.*

Landscape
Oil on canvas 15¾″x17⅞″ (40.0x45.4 cm)
Unsigned
Reverse: on stretcher, "B"
Ex-collection: descended in family of Rembrandt Peale; to his great-
great-granddaughter, the donor, East Orange, N.J.
Gift of Miss Carol Wirgman 1949 49.221

*John Mahey and Mrs. William Johnston of the Peale Museum feel this is
probably a work by Harriet Peale and it may be a copy of a European
painting.(files) Significance of the "B" is not known.*

PEALE, JAMES (1749-1831)

*Still Life with Grapes** early 1820's
Oil on canvas 16⅛"x22⅛" (41.0x56.2 cm)
Unsigned
Reverse: label, Allentown Art Museum; label between canvas and
stretcher, "E. M._____drichs"
Ex-collection: Mrs. Susie C. Duss, Harmony, Pa. (Estate);
to A. C. Bouchelle, New Smyrna Beach, Fla.; to M. Knoedler & Co.,
New York, N.Y.
Purchase 1955 Dr. and Mrs. Earl LeRoy Wood Fund 55.123

*Mrs. Susie C. Duss was one of the last surviving members of the
Harmonists, a communal society founded in 1805 in Harmony, Pa. The
painting is known to have been housed in the Harmonist's Museum
until that communal society ended in 1905. (corres.)*

*Still Life with Fruit**
Oil on canvas 16⅛"x22⅛" (41.0x56.2 cm)
Unsigned
Ex-collection: Elizabeth Molnar; to Wildenstein & Company,
New York, N.Y.; to donors, Far Hills, N.J. (1966)
Gift of Mr. and Mrs. Charles Engelhard 1966 66.407

Portrait of "Mr. Haines" ca. 1805-10 (attributed)
Oil on canvas 26"x22" (66.0x55.9 cm)
Unsigned
Ex-collection: with French & Co., New York, N.Y.
Purchase 1962 The Members' Fund 62.123

*The attribution of this portrait and its companion, 62.124, as well as the
identity of the sitters, Mr. and Mrs. David Haines of Haddonfield, N.J.,
have been questioned. (corres.)*

Portrait of "Mrs. Haines" ca. 1805-10 (attributed)
Oil on canvas 26"x21¾" (66.0x55.2 cm)
Unsigned
Ex-collection: with French & Co., New York, N.Y.
Purchase 1962 The Members' Fund 62.124

PEALE, RAPHAELLE (1774-1825)

*Still Life – Watermelon and Fruit** 1822
Oil on canvas 22¼"x26¼" (56.5x66.7 cm)
Signed and dated: lower right, "Raphaelle Peale Phila. 1822"
Ex-collection: Mr. Feldman, Philadelphia, Pa.; to Mr. and Mrs. Robert
Graham, New York, N.Y.; with John Graham and Son, New York, N.Y.
Purchase 1960 The Members' Fund 60.581

The Newark Museum publishes this work as Still Life – Watermelon
and Fruit. *William H. Gerdts has referred to it as* Still Life with Balsam
Apple. *The "fruit" has been identified as a balsam pear (Momordica
Charantia L.) by Dr. Robert Kiger of the Hunt Institute for Botanical
Documentation, Carnegie-Mellon University, Pittsburgh, Pa. (corres.)*

PEALE, REMBRANDT (1778-1860)

Portrait of Mrs. Caleb Halstead Shipman [Harriet Holden]
(1797-?) ca. 1834
Oil on canvas 30"x25" (76.2x63.5 cm)
Unsigned
Ex-collection: Elizabeth Ward Shipman Webb (sitter's daughter); to her
daughter, the donor, Mystic, Conn.
Bequest of Miss Elizabeth Holden Webb 1943 43.269

Mr. and Mrs. Shipman were married in 1823.

Portrait of Caleb Halstead Shipman (1797-1873) ca. 1834
Oil on canvas 30½"x25¼" (77.5x64.2 cm)
Unsigned
Ex-collection: Elizabeth Ward Shipman Webb (sitter's daughter); to
son Charles Webb, New York, N.Y.; to Yale University, New Haven,
Conn. (1933)
Purchase 1946 Sophronia Anderson Bequest Fund 46.162

*The Shipman family was prominent in Newark where Mr. Shipman
manufactured shoes in the 1830's and started a hat business in 1849
Charles Webb was the brother of the donor of the portrait of Mrs.
Shipman. (files)*

*Portrait of William Rankin, Sr.** (1785-1869) 1834
Oil on canvas 30¼"x25¼" (76.8x64.1 cm)
Unsigned
Reverse: stamp on canvas (revealed in 1952 restoration),
"Dechaux and Parmentier"
Ex-collection: William Rankin, Sr., Newark, N.J.; to his daughter,
Phoebe Ann Rankin Goble; to her sister, Caroline Rankin Hall; to a
daughter of Caroline Hall; sold by Hall estate to a "Mrs. Bliss,"
Princeton, N.J.; to donor, Princeton, N.J.
Gift of Dr. Walter M. Rankin 1947 47.52

*Family correspondence indicates painting was executed in 1834.
Dechaux and Parmentier, the canvas firm, existed in collaboration only
from 1830 or 1831 until 1834. Dr. Walter M. Rankin presumably acquired
this portrait of his grandfather from "Mrs. Bliss" since he did not inherit
it directly. See Eddy (56.172).*

Portrait of St. Peter ca. 1824 (attributed)
Oil on canvas 24⅛"x20⅛" (61.3x51.1 cm)
Unsigned
Reverse: Files indicate painting was signed and dated on canvas prior
to relining, 1962, "Rembrandt Peale 1824," but no photograph exists.
Ex-collection: donors, New York, N.Y.
Gift of Mr. and Mrs. Orrin W. June 1961 61.514

*John Mahey and Mrs. William Johnston of the Peale Museum felt that a
signature was necessary for an attribution to Rembrandt Peale, in the
absence of documented connection with a Peale descendant. (files)*

Seascape — View Near Brighton (Marine View, Brighton,
England) 1859
Oil on canvas 32⅝"x45½" (82.0x115.6 cm)
Signed: lower left, "R. Peale/Enlarged from Schmidt"
Reverse: inscribed on canvas prior to relining, "Rembrandt Peale
1859/Enlarged from Schmidt/Leton.H."
Ex-collection: sold at Rembrandt Peale's posthumous studio sale,
November 18, 1862 (#76 in catalogue); Victor Spark, New York, N.Y.;
to donors, New York, N.Y.
Gift of Mr. and Mrs. Orrin W. June 1961 61.515

*Painting entered the Museum collection accompanied by photo of
canvas reverse prior to relining.*

A MEMBER OF THE PEALE FAMILY

Landscape
Oil on canvas 14"x20" (35.5x50.8 cm)
Unsigned
Ex-collection: painting remained in Rembrandt Peale family, to his
great-great-granddaughter, the donor, East Orange, N.J.
Gift of Miss Carol Wirgman 1949 49.222

*Possibly executed by Rembrandt Peale's daughter, Eleanor, since it
descended through her family.*

PEARLSTEIN, PHILIP (b. 1924)

Tree Roots 1957-58
Ink wash on paper 18"x21⅝" (45.7x54.9 cm)
Signed: lower right, "Pearlstein"
Ex-collection: donor, New York, N.Y.
Gift of Allan Frumkin 1962 62.117

PEDERSEN, JÖRGEN (1876-1926)

Lengthening Shadows (View of Bank Street) ca. 1925
Oil on canvas 33"x38" (83.8x96.5 cm)
Signed: lower right, "Jörgen Pedersen"
Ex-collection: the artist; to his widow, the donor, Irvington, N.J.
Gift of Mrs. Jörgen Pedersen in memory of her husband
1927 27.67

Approximate date has been determined by the vintage of automobiles in this Newark scene.

PELLEW, JOHN C. (b. England 1903)

East River Nocturne #2 1941
Oil on canvas 28"x36" (71.1x91.4 cm)
Signed and dated: lower right, "Pellew 41"
Reverse: label, Museum of Modern Art (Loan #43.2325), *Romantic Painting in America*, 1943
Ex-collection: with Contemporary Arts Gallery, New York, N.Y.; to donors, New York, N.Y.
Gift of Mr. and Mrs. Milton Lowenthal 1946 46.169

PEÑA, TONITA [Quah Ah] (1895-1949)

Buffalo Dance ca. 1928
Pencil and gouache on board 8½"x14¼" (21.6x36.2 cm)
Signed: lower right, "Tonita Peña"
Reverse: pencil inscription, "Buffalo Dance"
Purchase 1928 28.1452

Purchased for the Museum in Santa Fe, N.M., by Edgar Holger Cahill. Artist was born in San Ildefonso and married into the Cochiti pueblo.

***Seven Spring Ceremony Dance** early 1920's (?)
Gouache on board 10⅞"x14" (27.6x35.6 cm)
Signed: lower right, "Quah Ah/T Peña"
Reverse: pencil inscription, "Seven Spring Ceremony Dance Tonita Peña"
Gift of Miss Amelia E. White 1937 37.197

Eagle Dancers early 1920's
Pencil and gouache on board 7½"x16½" (19.0x41.9 cm)
Signed: lower right, "Tonita Peña"
Reverse: label on backing, Exposition of Indian Tribal Arts, 1931 #165A inscribed, "Eagle Dancers"
Gift of Miss Amelia E. White 1937 37.198

Buffalo Dancers and Chorus early 1920's
Gouache on board 13½"x19½" (34.3x49.5 cm)
Signed: lower right, "Quah-ah/Tonita Peña"
Reverse: label on backing, Gallery of American Indian Art, New York, N.Y. #224A
Gift of Miss Amelia E. White 1937 37.199

Springtime Dance early 1920's
Pencil and gouache on board 14"x22" (35.6x55.9 cm)
Signed: lower right, "Tonita Peña"
Reverse: label on backing, Gallery of American Indian Art, New York, N.Y.
Gift of Miss Amelia E. White 1937 37.200

PENNELL, JOSEPH (1860-1926)

Downtown New York ca. 1922
Watercolor on paper 9½"x12¼" (24.2x31.0 cm)
Signed: bottom center, "J. Pennell"
Reverse: letter from Pennell, 1923, to Miss Dorothy Mausolff who later became Mrs. James McFadden. Also a small catalogue of Pennell's *Watercolors of New York*, held at Macbeth Gallery, December, 1922
Ex-collection: Mrs. James McFadden; to donor, Mendham, N.J.
Gift of James L. McFadden 1972 72.199

PEREIRA, I. RICE (1904-1971)

***Composition in White** 1942
Mixed media on parchment 18½"x18½" (47.0x47.0 cm)
Signed: right of bottom center, "I. Rice Pereira"
Reverse: label, Whitney Museum of American Art
Ex-collection: purchased from the artist, New York, N.Y.
Purchase 1944 Sophronia Anderson Bequest Fund 44.173

The media in this work include glyptal resin, pais lacquer, casein emulsion, varnish with filler of marble dust, silex and mica. Date supplied by artist. (files)

***Star Studding the Midnight Sea** 1963-64
Oil on canvas 50¾"x31" (128.9x74.4 cm)
Signed: lower right, "I. Rice Pereira"
Reverse: inscribed on canvas, "Star Studding/the Midnight Sea"
Ex-collection: the artist; to donor, Westbury, N.Y. 1964
Gift of Howard Weingrow 1966 66.42

Date supplied by artist who wrote a poem of the same title.

PERRETT, GALEN J. (1875-1949)

Sea Swirl ca. 1925
Oil on canvas 36"x48¼" (91.4x122.5 cm)
Unsigned
Ex-collection: the artist; to donor, Newark, N.J.
Gift of Mrs. Florence Peshine Eagleton 1925 25.512

Exhibited in Sea and Surf Paintings by Galen J. Perrett *at Ainsele Galleries, New York, N.Y., in 1925.*

Sunlit Coast
Oil on canvas 30"x39⅞" (76.2x101.3 cm)
Signed: lower right, "Galen J. Perrett"
Ex-collection: donors, Glen Ridge, N.J.
Gift of Dr. and Mrs. Herbert W. Ill 1956 56.241

The Roller (Breakers)
Oil on canvas 36"x48" (91.4x121.9 cm)
Signed: lower left, "Galen J. Perrett"
Ex-collection: donors, Glen Ridge, N.J.
Gift of Dr. and Mrs. Herbert M. Ill 1956 56.242

PERRINE, VAN DEARING (1869-1955)

Sag Harbor ca. 1940
Oil on canvas 22"x26" (55.9x66.1 cm)
Signed: lower left, "Van Perrine"
Ex-collection: purchased from the artist, Maplewood, N.J.
Purchase 1942 Felix Fuld Bequest Fund 42.547

Sketch #1
Oil on canvas 10"x8" (25.4x20.3 cm)
Unsigned
Reverse: label, Grand Central Art Galleries
Ex-collection: Grand Central Art Galleries, New York, N.Y.; to donor, Short Hills, N.J.
Bequest of Miss Cora Louise Hartshorn 1958 58.181

PERRY, ENOCH WOOD (1831-1915)

***How the Battle was Won** 1862
Oil on canvas 22¼"x30½" (56.5x77.5 cm)
Signed and dated: on table, at center, "E. W. Perry, Jr. 1862"
Ex-collection: Kennedy Galleries, New York, N.Y.
Purchase 1961 Thomas L. Raymond Bequest Fund 61.25

PESHINE, FRANCIS STRAFFORD (19th century)

Residence of John Jelliff (1813-1893) 1866
Pencil on paper 3¼"x2¾" (8.3x7.0 cm)
Signed and dated: lower left, "Sunday/June 17 1866/Strafford"; lower right, "Residence/of/John Jelliff"
Reverse: inscribed, "Residence of/John Jelliff/70 Johnson Ave/Newark, N.J./Sunday, June 17th 1860-/Pencil drawing by/Francis Strafford Peshine"
Ex-collection: donor, Newark, N.J.
Gift of the Estate of Mrs. Florence Peshine Eagleton 1954 54.14

John Jelliff was a noted Newark cabinetmaker from 1835 until his retirement in 1860. The business continued until 1898.

PETO, JOHN FREDERICK (1854-1907)

*Grapes** 1902
Oil on academy board 8¾"x5¾" (22.2x14.6 cm)
Signed and dated: lower left, "J.F Peto/1902"
Ex-collection: donor, Maplewood, N.J.
Bequest of Dr. Donald M. Dougall 1954 54.188

Dr. Dougall had known Peto when both lived in Island Heights, N.J. The paintings given to the Museum are believed to have been acquired by Dougall directly from the artist or from his estate. (files)

*Still Life: Wine Bottle, Fruit, Box of Figs** 1894
Oil on cardboard 6"x9" (15.2x22.9 cm)
Signed and dated: lower right, "JF Peto/94"
Ex-collection: donor, Maplewood, N.J.
Bequest of Dr. Donald M. Dougall 1954 54.189

Still Life: Books and Ink Bottle
Oil on academy board 6"x9" (15.2x22.9 cm)
Signed: upper left, "JF Peto"
Reverse: label, California Palace of the Legion of Honor, 1950, lent by Dougall; label, AFA, *Major Work in Minor Scale*, 1960; inscribed on backing, "M. Dougall"
Ex-collection: donor, Maplewood, N.J.
Bequest of Dr. Donald M. Dougall 1954 54.190

Still Life: Inkwell and Bills
Oil on cardboard 4¼"x6½" (10.8x16.5 cm)
Unsigned
Reverse: inscribed on backing (partially illegible), "Inkwell•/Bills #17"; label, "Fred Keer's Sons/Framers"
Ex-collection: donor, Maplewood, N.J.
Bequest of Dr. Donald M. Dougall 1954 54.193

*Still Life with Lard Oil Lamp**
Oil on canvas 14⅛"x24⅛" (35.9x61.3 cm)
Signed: lower right, "J.F.Peto"
Reverse: label, La Jolla Museum of Art, *The Reminiscent Object*, 1965; label, "UAM cat. #65"; painting has been relined
Ex-collection: donor, Maplewood, N.J.
Bequest of Dr. Donald M. Dougall 1954 54.196

PETTET, WILLIAM (b. 1942)

Crayon Dream 1969
Acrylic on canvas 65¼"x137" (165.7x348.0 cm)
Reverse: inscribed, "65x137/1969/Crayon Dream William Pettet"; inscribed on vertical stretcher, "961 Elkon Gallery"
Ex-collection: with donor, New York, N.Y.
Gift of Robert Elkon Gallery 1976 76.151

PHELPS, HELEN WATSON (1865-1944)

Copper and Gold ca. 1914
Oil on canvas 42"x33" (106.7x83.8 cm)
Signed: upper right, "Helen Watson Phelps"
Plate on frame: "Awarded Elizabeth Watson Figure Prize 1914 by Association of Women Painters and Sculptors"
Ex-collection: the artist; to her sister, the donor, New York, N.Y.
Gift of Mrs. Isabel Phelps Peck 1944 44.25

PHILIPP, ROBERT (b. 1895)

Portrait of Abraham Walkowitz (1878-1965) ca. 1944
Pastel on paper 20"x19¾" (50.8x50.2 cm)
Signed: lower right, "Philipp"
Reverse: label, Associated American Artists, New York, N.Y.
Ex-collection: donor, New York, N.Y.
Gift of Abraham Walkowitz 1947 47.221

Executed for the exhibition, One Hundred Artists and Walkowitz, *Brooklyn Museum, 1944.*

Bouquet 1950
Oil on canvas 30½"x25" (77.5x63.5 cm)
Signed: lower right, "Philipp"
Reverse: inscribed and dated on stretcher, "Robert Philipp 1950"
Ex-collection: Nathan Krueger, Newark, N.J.
Given in memory of Fannie Heller Krueger by her children 1952 52.22

PHILLIPS, AMMI (1788-1865)

*Portrait of a Woman in a Black Dress** ca. 1848
Oil on canvas 32½"x27½" (82.6x69.9 cm)
Unsigned
Reverse: typed label by former owner, "Found in Hexon, Tennessee 1966/in untreated condition and with original frame/owned by Marion F. Mecklenburg and Robert Scott Wiles"; typed label by former owner, " 'Portrait of an unidentified woman in Black/Dress' by Ammi Phillips of Connecticut/1788-1865"
Ex-collection: Marion F. Mecklenburg and Robert Scott Wiles, Hexon, Tenn.
Purchase 1966 Sophronia Anderson Bequest Fund 66.620

Painting also known as Woman with Lace Collar and Cap.

PICKEN, GEORGE ALEXANDER (1898-1971)

Landscape 1932
Watercolor on paper 11½"x17⅝" (29.2x44.8 cm)
Signed and dated: lower left, "Picken/1932"
Reverse: label, Museum of Modern Art, Loan #33.257; label, private collection
Ex-collection: private collection, New York, N.Y.
Anonymous gift 1940 40.348

Waterfront Derrick 1941
Watercolor and gouache on paper 20¾"x14¾" (52.6x37.5 cm)
Signed and dated: lower right, "George Picken/41"
Reverse: Sketch of a beach landscape
Ex-collection: with Frank K. M. Rehn Gallery, New York, N.Y.
Purchase 1944 The Endowment Fund 44.257

Included in artist's one-man exhibition at the Rehn Gallery, 1942 (#25).

Portrait of Abraham Walkowitz (1878-1965) 1943
Oil on canvas 18⅛"x16" (46.0x40.6 cm)
Signed and dated: lower right, "George Picken/1943"
Ex-collection: donor, New York, N.Y.
Gift of Abraham Walkowitz 1947 47.220

Executed for exhibition, One Hundred Artists and Walkowitz, *Brooklyn Museum, 1944.*

362

PICKETT, JOSEPH (1848-1918)

*Washington Under the Council Tree, Coryell's Ferry,
Pennsylvania ca. 1914-18
Oil on canvas 34½"x38" (87.6x96.5 cm)
Unsigned
Reverse: label, Baltimore Museum of Art, *Man and His Years*, 1954;
label, Ausstellungsleitung Haus der Kunst Munich, 1974.
Ex-collection: widow of the artist, New Hope, Pa.; to R. Moore Price,
New Hope, Pa.
Purchase 1931 The General Fund 31.152

*Coryell's Ferry was in New Hope. Popular legend maintained that the
Battle of Trenton was planned beneath the tree depicted. This painting was
#44 in Newark Museum exhibition,* American Primitives, *1930-31, lent by
Mr. and Mrs. R. Moore Price.*

*Only four paintings by the artist are known. This work has been exhibited
extensively, most recently at the Whitney Museum of American Art's*
American Folk Painting of Three Centuries, *1980.*

PICKHARDT, CARL (b. 1908)

Abstraction #313. Black on Silver Gray 1967
Acrylic on mahogany left height: 19¾" (50.2 cm); right height: 29¾"
(75.6 cm); top width: 15¾" (40.0 cm); bottom width: 24¾" (62.9 cm)
Signed: lower left, "CP"
Reverse: inscribed, "Carl Pickhardt/Abstraction #313/
Black on Silver Gray"
Ex-collection: the artist, Sherborn, Mass.
Gift of the artist 1971 71.9

Date supplied by artist.

PINE, THEODORE (1828-1905)

Portrait of Reverend Charles W. Reed 1865
Oil on canvas 29¾"x24¾" (75.6x62.9 cm)
Signed and dated: right, "Pine 1865"
Reverse: label, Vose Galleries
Ex-collection: Fannie A. B. Reed; to daughter Mrs. J. W. Chesebro; to
son C. W. Chesebro, Wollaston, Mass.; to donor, Boston, Mass. (1949)
Gift of Vose Galleries 1957 57.82

*According to correspondence from the Methodist Historical Society, New
York, N.Y., and Robert Vose Galleries, Boston, Mass., Charles W. Reed
served as a Methodist Minister in Brooklyn from 1865-70.*

Portrait of Mrs. Charles W. Reed [Fannie Amelia Bird] 1865
Oil on canvas 29¾"x24¾" (75.6x62.9 cm)
Signed and dated: left "(monogram)/1865"
Reverse: stamp, Goupil's; label, Vose Galleries
Ex-collection: Fannie A. B. Reed; to daughter Mrs. J. W. Chesebro; to
son C. W. Chesebro, Wollaston, Mass.; to donor, Boston, Mass. (1949)
Gift of Vose Galleries 1957 57.83

PLUMMER, SANFORD [Da-Yoh-Gwa-Dake]
(20th century Senaca Iroquois)

Unless otherwise noted, the following works are signed, lower right,
"S.Plummer/Da-Yoh-Gwa-Dake". All are Gift of International Business
Machines Corporation, New York, N.Y. 1962.

Law, The Reading of the Wampum
Watercolor 20⅞"x28⅞" (53.0x73.3 cm) 62.77

Great Feather Dance
Watercolor 21"x29" (53.3x73.7 cm) 62.78

Founders of the League (map)
Watercolor and ink 21"x28⅞" (53.3x73.3 cm) 62.79

Iroquois, Man of Peace by R. B. Oldfield (book jacket design)
Pencil, ink and watercolor 21"x29" (53.3x73.7 cm) 62.80

Greed
Watercolor 22"x26¾" (55.9x67.9 cm) 62.81

How the World Began
Watercolor 19¼"x24" (48.9x61.0 cm) 62.82

The Great Sky Trail
Watercolor 19¼"x23¾" (48.9x60.3 cm) 62.83

Conservation
Watercolor 19¼"x23⅞" (48.9x60.6 cm) 62.84

Mask-making Ceremony
Watercolor 17⅝"x23½" (44.8x59.7 cm) 62.85

Origin of the Little Water Medicine Society
Watercolor 24⅛"x18¾" (61.3x47.6 cm) 62.86

Bringing in the Captive
Watercolor 19⅜"x24" (49.2x61.0 cm) 62.87

Meeting of Hiawatha and Dekanawidah
Watercolor 19¼"x23⅞" (48.9x60.6 cm) 62.88

Mythology
Watercolor 16¼"x22¼" (41.3x56.5 cm) 62.89

Departure of Hiawatha
Watercolor 17¼"x19⅞" (43.8x50.5 cm) 62.90

Self-Portrait
Watercolor 14⅞"x21¾" (37.8x55.2 cm) 62.91
Signed: lower right, "To Gen-da-gi-yoh/From Da-Yoh-Gwa-Dake"
center, "S Plummer/Da-Yoh-Gwa-Dake"

Red Jacket
Gouache 17½"x13⅛" (44.5x33.3 cm) 62.92

Education
Watercolor 20¾"x28¾" (52.7x73.0 cm) 62.93

The Burning of the White Dog
Watercolor 21"x28⅞" (53.3x73.3 cm) 62.94

Spirit of the Hurricane
Watercolor 20⅛"x28⅞" (53.0x73.3 cm) 62.95

Dream
Watercolor 21"x29" (53.3x73.7 cm) 62.96

Little Medicine Ceremony
Watercolor 21"x29" (53.3x73.7 cm) 62.97

Untitled
Watercolor 20¾"x29" (52.7x73.7 cm) 62.98

Agriculture
Watercolor 20⅞"x29" (53.0x73.7 cm) 62.99

Ice Fishing
Watercolor 21"x29" (53.3x73.7 cm) 62.100

Untitled (brooch designs)
Ink 13½"x8⅞" (34.3x22.5 cm) 62.101

POLELONEMA, OTIS (b. 1902)

Hopi Girl
Gouache on board 11"x7" (28.0x17.8 cm)
Signed: lower right, "Otis Polelonema/Hopi Maiden"
Purchase 1928 28.1456

Purchased for the Museum in Santa Fe, N.M., by Edgar Holger Cahill. Artist from Hopi pueblo, Ariz.

Male Dancer
Gouache on board 10¾"x7⅛" (27.3x18.1 cm)
Signed: lower right, "Otis Polelonema/Hopi"
Purchase 1928 28.1459

Purchased for the Museum by Edgar Holger Cahill.

Hopi Good Springtime Dancers ca. 1930
Gouache on board 16"x11½" (40.6x29.2 cm)
Signed: lower right, "By O. Polelonema"
Inscribed: bottom, "Hopi Good Springtime Dancers"
Reverse: pencil inscription, "Hopi Craftsmen/#7042"
Gift of Miss Amelia E. White 1937 37.225

POLLACK, REGINALD M. (b. 1924)

Figure Study 1957
Pastel and charcoal on paper 18½"x23½" (47.0x59.7 cm)
Signed and dated: lower right, "Pollack"; lower left, "16.7.57"
Ex-collection: donor, New York, N.Y.
Gift of the Peridot Gallery 1959 59.371

POLLET, JOSEPH (b. Switzerland 1897-1979)

Forest and Hills early 1920's
Oil on canvas 40"x50" (101.6x127.0 cm)
Signed: lower right, "Joseph Pollet"
Ex-collection: the artist, New York, N.Y.
Purchase 1925 25.1158

Purchased with funds donated by Mrs. Felix Fuld.

POOR, HENRY VARNUM (1888-1970)

Boy with Bow ca. 1938
Oil on wood 48"x24⅛" (121.9x61.3 cm)
Signed: lower left, "HV Poor"
Reverse: label, Carnegie Institute of Art, Pittsburgh, Pa.; label,Virginia Museum of Fine Arts, *1st Biennial Exhibition of Contemporary American Paintings*, 1938; label, Art Institute of Chicago, *51st Annual Exhibition*, 1940 (lent by Newark Museum); label, *Exhibition of Contemporary U.S. Paintings for circulation in Latin America* through the Council of National Defense, 1941 (lent by Newark Museum); label, Museo Nacional de Bellas Artes, Buenos Aires, 1941; label, Museo Nacional des Artes Rio de Janeiro, 1941
Ex-collection: Frank K. M. Rehn Gallery, New York, N.Y.
Purchase 1940 Edward F. Weston Gift 40.116

Painting is a portrait of the artist's son.

POORE, HENRY RANKIN (1859-1940)

Sketch from Nature
Oil on wood 6"x12" (15.2x30.5 cm)
Reverse: inscribed, "H. R. Poore/Sketch from Nature"
Ex-collection: donor, Newark, N.J.
Gift of Dr. H. B. Epstein 1925 25.624

Dr. Epstein received the work in return for medical services. (files)

POPE, JOHN (1821-1881)

View Near Plainfield, N.J. 1863
Oil on canvas 14"x24" (35.6x61.0 cm)
Signed: lower left, "J Pope 63"
Reverse: label, American Federation of Arts, *Surviving the Ages*, 1963-64; handwritten label, "View Plainfield/N.J./Painted by John Pope/Aug 15/Price $55.00"; note attached to back (written by Elizabeth R. Butterworth), "View Near Plainfield N.J./Painted by John Pope, a/pupil of Gilbert Stuart/and father of well/known arch--/Russell ___. Given to Harriet R. Rockell/by Mrs. John Pope./Elizabeth R. Butterworth/Date of ___ Aug. 15th."
Ex-collection: Mrs. John Pope; to Harriet R. Rockell; to donors, East Orange,N.J.
Gift of Theron H. Butterworth and Elizabeth B. Gordon 1961 61.28

POUSETTE-DART, RICHARD (b. 1916)

*Untitled 1976
Pencil on paper 22½"x29⅞" (57.1x75.7 cm)
Unsigned
Reverse: label, Catalogue #11
Ex-collection: with Andrew Crispo Gallery, New York, N.Y.
Purchase 1978 The Members' Fund 78.77

POWELL, ARTHUR J. E. (1864-1956)

Spring – Eastern Dutchess County 1935-43
Oil on canvas 25½"x30⅛" (64.8x76.5 cm)
Signed: lower left, "Arthur J. E. Powell A N A"
Allocated by the WPA Federal Art Project 1954 54.201

POWELL, WILLIAM HENRY (ca. 1820-1879)

Portrait of Catherine Longworth Morris (?) (1811-1896) 1847
Oil on canvas painted for oval spandrel 30"x25½" (76.2x64.8 cm)
Signed and dated: lower left, "W.H.P./1847"
Ex-collection: painting remained in family, Newark, N.J., until bequeathed to the Museum
Bequest of Marcus L. Ward, Jr. 1921 21.1742

Sitter could be either of two sisters of Susan Longworth Morris Ward (1815-1901), Catherine Longworth or Almira Morris (1807-1875). Available evidence points to Catherine, whose age corresponds to that of the subject.

Portrait of Mrs. Marcus L. Ward [Susan Longworth Morris] (1815-1901) ca. 1841 (attributed)
Oil on canvas 36"x29" (91.4x73.7 cm)
Unsigned
Ex-collection: painting remained in family, Newark, N.J., until bequeathed to the Museum
Bequest of Marcus L. Ward, Jr. 1921 21.1743

(See Read 21.1751)

Portrait of Mrs. John Morris [Elizabeth Longworth] (1772-1858) ca. 1840 (attributed)
Oil on canvas 36"x28⅝" (91.4x72.7 cm)
Unsigned
Reverse: no pertinent data prior to relining
Ex-collection: painting remained in family, Newark, N.J., until bequeathed to the Museum
Bequest of Marcus L. Ward, Jr. 1921 21.1744

(See A.U. 21.1762)

Portrait of Marcus L. Ward (1812-1884) ca. 1841 (attributed)
Oil on canvas 36"x29" (91.4x73.7 cm)
Unsigned
Reverse: stencil, W. E. Rogers/16/Arcade/Philad.
Ex-collection: painting remained in family, Newark, N.J., until bequeathed to the Museum
Bequest of Marcus L. Ward, Jr. 1921 21.1745

(See Read 21.1752)

Portrait of Marcus L. Ward (1812-1884) 1847
Oil on canvas 42½"x34⅛" (108.0x86.7 cm)
Signed and dated: lower right, "W.H.P./1847."
Reverse: canvas stamped, "prepared by/Ed. Wm. Dechaux/No 4."
Ex-collection: painting remained in family, Newark, N.J., until bequeathed to the Museum
Bequest of Marcus L. Ward, Jr. 1921 21.1755

POZZATTI, RUDY O. (b. 1925)

Bay's Edge 1962
Pen and ink on paper 17½"x23¾" (44.5x60.3 cm)
Signed: lower right, "Pozzatti/'62"
Reverse: label, Weyhe Gallery
Ex-collection: Weyhe Gallery, New York, N.Y.
Purchase 1966 Rabin and Krueger American Drawing
Fund 66.405

Exhibited in artist's one-man show at Weyhe Gallery, 1964. Work was executed on Cape Cod.

PRENDERGAST, CHARLES E. (1869-1948)

***Figures** 1918
Tempera, gold leaf, gesso on wood 27¾"x23¾" (70.5x60.3 cm)
Signed: lower left (monogram)
Ex-collection: the artist with C. W. Kraushaar Art Galleries, New York, N.Y.
Purchase 1936 Felix Fuld Bequest Fund 36.90

Artist indicated this work had hung in his own home and supplied the date. (files)

PRENDERGAST, MAURICE (1861-1924)

***Landscape with Figures No. 2** (Willows, Salem) 1918
Oil on canvas 27"x32¾" (68.6x83.2 cm)
Signed: lower right, "Prendergast"
Reverse: inscribed, probably artist's hand, "Landscape with Figures/Nº 2"; torn label, C. W. Kraushaar/Art Galleries; label, Whitney Museum of American Art, *Pioneers of Modern Art in America*, 1946; label, Museum of Modern Art, *The Eight*, 1964 (64.31)
Ex-collection: William F. Laporte, Passaic, N.J. (purchased from the artist); to Kraushaar Art Galleries, New York, N.Y.
Presented in 1944 by the Friends of Arthur F. Egner, President of The Newark Museum Association 1932-43 44.17

Painting has been known as Willows, Salem, *partly because it was painted in Salem, Mass. Inscription seems to justify the new title. According to Antoinette Kraushaar, Charles Prendergast made the frame for his brother. (files)*

It should be noted that a previous owner of this painting, William F. Laporte, also owned Yankee Peddler *by J. W. Ehninger (25.876) and* Interior of a Butcher Shop *(A.U. 25.877) both of which he donated to the Museum.*

PRESSER, JOSEF (b. Poland 1907-1967)

Portrait of Grace Ridgley 1926
Pastel on parchment 19½"x13¾" (49.5x34.9 cm)
Signed and dated: upper right, "J. Presser-'26"
Ex-collection: the artist, New York, N.Y.; to donor, New York, N.Y. (1931)
Anonymous gift 1940 40.342

Date appears to be "26" although donor supplied date of 1931.

Magic Mountain 1937
Watercolor and gouache on paper 32⅞"x39⅞" (83.5x101.3 cm)
Signed and dated: upper left, "J. Presser-37"
Reverse: label, Museum of Fine Arts, Boston, *Fifteen Years of Museum School Alumni*, 1942; label, Art Institute of Chicago, *22nd International Watercolor Exhibition*, 1943 (lent by Lowenthal); label, Edith and Milton Lowenthal Collection
Ex-collection: Contemporary Arts Gallery, New York, N.Y. to donors, New York, N.Y.
Gift of Mr. and Mrs. Milton Lowenthal 1951 51.162

PRESTON, JAMES (1873-1962)

Haystacks ca. 1900-10
Charcoal, pencil, ink wash on paper on mat board 8¼"x10¾" (21.0x27.3 cm)
Signed: lower right, "James Preston"
Reverse: label and stamp on backing, Davis Galleries, New York, N.Y.; label, Margaret and Raymond Horowitz Collection
Ex-collection: Davis Galleries, New York, N.Y. to donors, New York, N.Y.
Gift of Mr. and Mrs. Raymond J. Horowitz 1965 65.109

Date was provided by donors.

PRIOR-HAMBLEN SCHOOL (19th century)

Girl in Black ca. 1840
Gouache on academy board 15"x11¼" (38.1x28.6 cm)
Unsigned
Ex-collection: Robert Laurent, New York, N.Y.
Purchase 1931 Felix Fuld Bequest Fund 31.144

Exhibited as #17 in Museum exhibition, American Primitives, 1930-31, lent by Robert Laurent.

Portrait of a Man ca. 1840
Oil on canvas 27⅛"x21⅞" (68.9x55.6 cm)
Unsigned
Ex-collection: Wood Gaylor, New York, N.Y.
Purchase 1931 Felix Fuld Bequest Fund 31.150

Mrs. Foster Damon of Providence, R.I., attributed this work and its companion, Young Woman with Flowers *(31.151) to William Paine, a Massachusetts paper maker. (files)*

Exhibited as #7 in Museum exhibition, American Primitives, 1930-31, lent by Wood Gaylor. According to catalogue, Mr. Gaylor said he had bought this work and its companion (#6) in "either New York or Connecticut."

Young Woman with Flowers ca. 1840
Oil on canvas 26¾"x21⅞" (68.0x55.6 cm)
Unsigned
Ex-collection: Wood Gaylor, New York, N.Y.
Purchase 1931 Felix Fuld Bequest Fund 31.151

Companion work to Portrait of a Man *(31.150).*

QUANCHI, LEO (1892-1974)

Jagged Essays 1952
Oil on canvas 24¼"x32¼" (61.6x81.9 cm)
Signed: lower right, "Quanchi"
Ex-collection: purchased from the artist, Maplewood, N.J.
Purchase 1952 Sophronia Anderson Bequest Fund 52.26

Purchased from Newark Museum 1st triennial exhibition, Work by New Jersey Artists, *1952. Date supplied by artist.*

An Experiment in Basic Form 1964
Oil on canvas 36"x50" (91.4x127.0 cm)
Signed: lower right, "Quanchi"
Ex-collection: donor, Maplewood, N.J.
Gift of the artist 1965 65.152

Exhibited in Newark Museum Selected Works by New Jersey Artists, 1965. Date supplied by artist.

Bouquet #2 ca. 1966
Oil on canvas 50"x28" (126.9x71.1 cm)
Signed: lower right, "Quanchi"
Reverse: label, New Jersey State Museum, *First Annual Juried Exhibition*, 1966
Ex-collection: donor, Maplewood, N.J.
Gift of the artist 1968 68.245

Presence of the New Jersey State Museum "Annual" entry form indicates painting was finished shortly before that exhibition.

Portrait of the Artist as a Little Boy (The Family) 1967
Oil on canvas 35"x49⅛" (89.0x125.0 cm)
Signed: lower right, "Quanchi 1967"; on front of frame, "Salmagundi Club Award", Audubon Artists Annual 1968
Reverse: inscribed, "Sugar Hill Road, Falls Village, Conn." (artist's address); label, The Family; label, Audubon Artists Annual at National Academy Galleries, N.Y.
Ex-collection: donor, Maplewood, N.J.
Bequest of the artist 1975 75.42

Configuration on White
Oil on canvas 50"x28¼" (127.0x71.5 cm)
Signed: lower right, "Quanchi"
Ex-collection: donor, Maplewood, N.J.
Bequest of the artist 1975 75.43

Variations
Oil on canvas 50"x36" (126.8x91.3 cm)
Signed: lower right, "Quanchi"
Ex-collection: donor, Maplewood, N.J.
Bequest of the artist 1975 75.44

Formations
Oil on canvas 28"x49" (71.7x124.2 cm)
Signed: lower right, "Quanchi"
Ex-collection: donor, Maplewood, N.J.
Bequest of the artist 1975 75.45

World Poem
Oil on canvas 14"x30" (35.7x76.4 cm)
Signed: lower right, "Quanchi"
Ex-collection: donor, Maplewood, N.J.
Bequest of the artist 1975 75.46

QUIDOR, JOHN (1801-1881)

*****Young Artist** 1828
Oil on canvas 20¼"x25⅝" (51.5x65.1 cm)
Signed and dated: lower right of center, "J. Quidor/April, 1828"
Reverse: handwritten label, "From M. Knoedler Co./14 E. 57th St. New York/3-15-54 WB#43-53/Mr. Richards"; no pertinent data recorded prior to relining, 1957
Ex-collection: Robert Lebel, Paris (1930's); to Julius H. Weitzer, New York, N.Y.; to M. Knoedler & Co., New York, N.Y. (1954)
Purchase 1956 Sophronia Anderson Bequest Fund 56.180

Painting was listed as for sale, #13, National Academy of Design exhibition 1828. In the 1942 listing of Quidor exhibition at the Brooklyn Museum, this painting was listed as location unknown.

QUIRT, WALTER (1902-1968)

The Toilette of Venus 1943
Oil on canvas 18"x20" (45.7x50.8 cm)
Signed: lower left, "W Quirt"
Reverse: inscribed and dated, "WQuirt/1943/-"
Ex-collection: with Durlacher Bros., New York, N.Y.
Purchase 1944 Sophronia Anderson Bequest Fund 44.167

RAFFAEL, JOSEPH (b. 1933)

Untitled 1967
Oil on canvas 7⅞"x8½" (20.0x21.6 cm)
Unsigned
Ex-collection: donors, New York, N.Y.
Gift of Mr. and Mrs. Paul Waldman 1969 69.171

Untitled 1967
Collage, paper on cardboard 14¾"x9¾" (37.5x24.8 cm)
Signed and dated: "For Diane on Her 1967 Birthday/Joe"
Ex-collection: donors, New York, N.Y.
Gift of Mr. and Mrs. Paul Waldman 1969 69.172

RAHMING, NORRIS (1886-1959)

Mt. Chocorua ca. 1925
Oil on canvas 30"x36" (76.2x91.4 cm)
Signed: lower left, "Norris Rahming"
Ex-collection: the artist, Cleveland, O.
Purchase 1927 27.482

This painting was exhibited widely in Ohio in 1925 and 1926.

RAND, ELLEN G. EMMET (1876-1941)

*****Portrait of Oothout Zabriskie Whitehead** (1879-1929) 1906
Oil on canvas 91½"x37½" (232.4x95.3 cm)
Label: on front frame, "Portrait of a Gentleman" Metropolitan Museum of Art 63.8 (loan #) by Ellen Emmet Rand.
Ex-collection: Sitter, Newark, N.J.; to his sons, A. Pennington Whitehead, New York, N.Y., and O. Z. Whitehead, Dublin, Ireland
Gift of A. Pennington Whitehead and O. Z. Whitehead 1978 78.79

Subject was born in Newark.

RANNEY, WILLIAM TYLEE (1813-1857)

*****The Pipe of Friendship** (The Scouting Party) 1857-59
Oil on canvas 23"x36" (58.4x91.4 cm)
Signed and dated: lower right, "W. Ranney 1857 & WSM Feb 1859"
Reverse: inscribed in different hand from signature, "The Pipe of Friendship"; stamp (illegible)
Ex-collection: donor, Scotch Plains, N.J.
Gift of Dr. J. Ackerman Coles 1920 20.1342

Francis S. Grubar has suggested that "WSM" was William Sidney Mount. It is known that Mount completed many of Ranney's pictures after the latter's death. If this painting is identical to The Trapper's Halt, as suggested by Mr. Grubar, perhaps "Dr. Bissell," who bought it at the 1858 sale of Ranney's work at the National Academy of Design, may have requested that it be finished by Mount. It is possible that the title was inscribed by Ranney or his wife.

RATTNER, ABRAHAM (1895-1978)

Dark Rain 1946
Oil on canvas 36½"x25⅞" (92.7x65.7 cm)
Signed: lower left, "Rattner"
Reverse: label on frame, in artist's hand, "-424/30P (36 3/16 x 25 9/16)/ Rattner '46/Dark Rain"; artist's label, "Frame N° 62/Armodel — Paris Size 30P/36.2x25.6"; label, AFA, Rattner Retrospective, 1960
Ex-collection: donor, New York, N.Y.
Gift of Walter Bareiss 1955 55.6

*****The Letter**
Oil on canvas 29¼"x23½" (74.3x60.0 cm)
Signed: lower left, on table edge, "Rattner"
Reverse: in pencil, on cross brace, "A Rattner/33 bis Edgar-Quinet/ Paris (?) 20.F."; sticker on frame, Milton Lowenthal, 1150 Park Avenue, N.Y. N.Y.
Ex-collection: purchased from the artist by donors, New York, N.Y.
Gift of the Edith and Milton Lowenthal Foundation 1973 73.53

RAVLIN, GRACE (1885-1956)

The Plaza 1923
Oil on canvas 23⅜"x28¾" (59.4x73.0 cm)
Signed and dated: lower left, "Ravlin/1923"
Ex-collection: purchased from the artist, New York, N.Y.
Gift of Mrs. Felix Fuld 1925 25.1170

Miss Ravlin indicated that Robert Henri interested Mrs. Fuld in this work; the scene is in front of the Plaza Hotel, New York, N.Y., on a patriotic holiday. (corres.)

READ, T. BUCHANAN (1822-1872)

*Portrait of Joseph Morris Ward** (1841-1911) 1846
Oil on canvas 50"x39½" (127.0x100.3 cm)
Signed: lower left, on sail of boat, "T.B.R. pinxt 1846"
Ex-collection: painting remained in family, Newark, N.J., until bequeathed to the Museum
Bequest of Marcus L. Ward, Jr. 1921 21.1754

Sitter is son of Marcus L. Ward (1812-1884) and Susan Longworth Morris Ward (1815-1901) (see Read 21.1752).

*Sheridan's Ride** 1870
Oil on canvas 29½"x24½" (75.0x62.2 cm)
Signed: lower left, "T. Buchanan Read./Rome 1870"
Reverse: inscription visible prior to relining, "Sheridan's ride painted for/Hon. Marcus L. Ward/by/T. Buchanan Read Rome 1870"
Ex-collection: Marcus L. Ward, Newark, N.J.; to his son, the donor, Newark, N.J.
Bequest of Marcus L. Ward, Jr. 1921 21.2052

This is a celebrated incident in the War Between the States, the ride of General Philip Henry Sheridan (1831-1888) from Winchester to Cedar Creek, Va., to take command of hard-pressed Union troops and rally them to victory.

Read was a poet as well as an artist, and during service in the Union army he composed many poems and ballads including "Sheridan's Ride." In response to a request to paint a picture based on this work, he visited General Sheridan in New Orleans, spending a month making studies of Sheridan and his black horse. He painted a number of pictures of this subject during his stay in Rome 1867-1872.

Portrait of Mrs. Marcus L. Ward [Susan Longworth Morris] (1815-1901) ca. 1846 (attributed)
Oil on canvas 42⅛"x33" (107.0x84.0 cm)
Unsigned
Reverse: inscribed, "Prepared by/Theo. Kelley/New York"
Ex-collection: painting remained in family, Newark, N.J., until bequeathed to the Museum
Bequest of Marcus L. Ward, Jr. 1921 21.1751

Sitter was the daughter of Elizabeth (A.U. 21.1762) and John Morris (A.U. 21.1761). She married Marcus L. Ward (Rand 21.1752) in 1840.

Portrait of Marcus L. Ward (1812-1884) ca. 1846 (attributed)
Oil on canvas 49"x39" (124.5x99.1 cm)
Reverse: inscribed upper left, "Presented to M. L. Ward Esq./By the artist"; stamp, "Prepared by/Edw. Dechaux/New York"
Ex-collection: painting remained in family, Newark, N.J., until bequeathed to the Museum
Bequest of Marcus L. Ward, Jr. 1921 21.1752

Marcus Ward was in the family tallow business of M. Ward and Son of Newark. He was Governor of New Jersey from 1865-68, and a member of Congress from 1873-75. The first man to devise and carry out a plan to collect and forward the pay of soldiers to their families at home, he was also responsible for the establishment of a soldiers' hospital after the Civil War.

Portrait of Marcus Ward as a Young Man (1812-1884)
ca. 1846 (attributed)
Oil on canvas painted for oval spandrel 14"x12½" (35.6x32.0 cm)
Unsigned
Reverse: Stamp: "Prepared/by/Edw. Dechaux/New York."
Ex-collection: painting remained in family, Newark, N.J., until bequeathed to the Museum
Bequest of Marcus L. Ward, Jr. 1921 21.1756

Mrs. Ward mentioned a picture in her will which could be this one (see Read 21.1752).

REALE, NICHOLAS A. (b. 1922)

Modern Naples 1957
Casein on paper 22"x28" (55.9x71.1 cm)
Signed: lower right, "Reale"
Ex-collection: purchased from the artist, Hillside, N.J.
Purchase 1959 Mrs. Earl LeRoy Wood Purchase Fund 59.84

Purchased from Newark Arts Festival exhibition, June, 1959. Artist indicated date.

Low Tide 1963
Watercolor on paper 21¼"x29¼" (54.0x74.3 cm)
Signed: lower right, "Reale"
Ex-collection: Kresge, Newark
Gift of Kresge, Newark 1963 63.124

Painting probably acquired by Kresge, Newark from New Jersey Watercolor Society annual exhibition at Kresge, Newark, 1963. Artist indicated date.

REAÑO, JOSÉ (20th century)

Basket Dance ca. 1928
Pencil and gouache on poster board 10¼"x16⅜" (26.0x41.6 cm)
Signed: lower right, "José Reaño/'Basket Dance' "
Reverse: inscribed, "CU 1/CU 1 #8"
Purchase 1928 28.1454

Purchased for the Museum in Santa Fe, N.M., by Edgar Holger Cahill. Artist from Santo Domingo pueblo, N.M.

REHN, FRANK K. M. (1848-1914)

Untitled
Oil on wood 8"x10" (20.3x25.4 cm)
Signed: lower right, "F.K.M. Rehn"
Ex-collection: Joseph S. Isidor, New York, N.Y. and Newark, N.J.; to his wife, the donor (1941)
Bequest of Mrs. Rosa Kate Isidor 1949 49.429

Beach Scene
Oil on canvas 22"x36" (55.9x91.4 cm)
Signed: lower right, "F.K.M. Rehn N.Y."
Ex-collection: donor, Englewood Cliffs, N.J.
Gift of Stanley Bard 1973 73.110

Assigned title.

REID, ROBERT (b. 1924)

A Falling Series #3 1969
Oil and collage on canvas 14"x16" (35.6x40.6 cm)
Signed: lower right, "Reid"
Ex-collection: with Alonzo Gallery, New York, N.Y.
Purchase 1971 Endowment Fellows Fund 71.92A

A Falling Series #5 1969
Oil and collage on canvas 14"x16" (35.6x40.6 cm)
Signed: lower right, "Reid"
Ex-collection: with Alonzo Gallery, New York, N.Y.
Purchase 1971 Endowment Fellows Fund 71.92B

A Falling Series #4 1969
Oil and collage on canvas 14″x16″ (35.6x40.6 cm)
Inscribed: lower right, "A4"
Reverse: "A Falling #4/Reid"; label, "(monogram) Alonzo Gallery 26 E
63rd St NYC"; label, Art Lending Service MOMA 690-128
Ex-collection: the artist, New York, N.Y.
Gift of Clair L. Young 1975 75.215

A Falling Series #2 1969
Oil and collage on canvas 14″x16″ (35.6x40.6 cm)
Signed: lower right, "Reid"
Reverse: "Reid"; label, Alonzo Gallery; label, Art Lending Service
MOMA; label, "Robert Reid/A Falling #2/Oil & collage/subtitle Figures
on the Beach"
Ex-collection: the artist, New York, N.Y.
Gift of Miss Leslie Rankow 1975 75.216

REINHARDT, AD (Adolf Frederick) (1913-1967)

***Tryptych** 1955
Oil on canvas 24″x10″ (two panels, each 8″x10″) (61.0x25.4 cm)
Reverse: " 'Tryptych'/Painting/1955/Ad Reinhardt/732 Broadway/NYC
3/ Oil on canvas/24″x10″
Ex-collection: donor, New York, N.Y.
Gift of Jock Truman 1972 72.139

Protected by a cardboard box constructed by the artist.

REINHARDT, SIEGFRIED GERHARDT (b. Germany 1925)

Portrait of Franklin Conklin, Jr. (1886-1966) 1965
Oil on masonite 42¾″x29⅞″ (108.6x75.9 cm)
Signed and dated: lower right, "Siegfried Reinhardt/1965"
Purchase 1965 65.128

*Franklin Conklin, Jr., was president of The Newark Museum Association
from 1943-63. Commissioned by the Museum through Midtown
Galleries, New York, N.Y.*

REYNARD, GRANT (1887-1968)

Washington Monument, Newark ca. 1931
Watercolor on Whatman paper mounted on board 22″x30″ (55.9x76.2
cm)
Signed: lower left, "Reynard"
Reverse: label on backing, PWAP/Northern N.J. Subcommittee/The
Newark Museum/N3"; inscribed, (artist and title) Leonia, N.J.
Allocated by the U.S. Treasury Department, PWAP 1934 34.303

Winter Promenade
Watercolor on paper 10″x14″ (25.4x35.6 cm)
Signed: lower left, "Reynard"
Reverse: metal label on frame, "Grant Reynard/Winter Promenade/
Public Works of Art Project, 1934"; label on backing, Public Works of
Art Project, New York, N.Y.; on paper, "Watercolor/'Winter
Promenade'/by Grant Reynard"
Allocated by the U.S. Treasury Department, PWAP 1934 34.304

Winter Coasters 1934
Watercolor on paper 9⅞″x13½″ (25.1x34.3 cm)
Signed: lower left, "Reynard"
Allocated by the U.S. Treasury Department, PWAP 1934 34.305

REZNIKOFF, MISHA (20th century)

Ducks
Watercolor on paper 3¼″x3¼″ (8.3x8.3 cm)
Signed: lower right, "M.R."
Ex-collection: private collection, New York, N.Y.
Anonymous gift 1940 40.346

RIBAK, LOUIS (b. Russia 1902-1979)

Kelp Driers 1943
Gouache on paper 19¾″x25¼″ (50.2x61.1 cm)
Signed: lower right, "Louis Ribak"
Ex-collection: private collection, New York, N.Y.
Anonymous gift 1944 44.168

Date of execution supplied by artist. (files)

RICHARDS, WILLIAM TROST (1833-1905)

***Twilight on the New Jersey Coast** 1884
Oil on canvas 20⅛″x40¼″ (51.1x102.2 cm)
Signed and dated: lower right, "Wm T. Richards. 1884"
Ex-collection: donor, Newark, N.J.
Gift of Robert Badenhop 1949 49.152

***Mount Vernon** 1855
Oil on canvas 30″x48″ (76.2x121.9 cm)
Signed and dated: lower right, "W T Richards Phil./1855"
Reverse: undated newspaper clipping in envelope relates story of
Mt. Vernon before Washington became President
Ex-collection: Joseph Harrison, Philadelphia, Pa. (1855); to Mrs. Joseph
Harrison, Philadelphia, Pa.; to donors, West Orange, N.J. (1940's)
Gift of Mr. and Mrs. Snowden Henry 1966 66.39

*Linda Ferber in the catalogue of the Richards exhibition at the Brooklyn
Museum (1973), published an 1854 letter from Richards stating that he
had been commissioned by the Art Union of Philadelphia to paint a
scene of Mount Vernon. The engraving was to be distributed to 1855
subscribers; the Union disbanded before the engraving was issued.
Ms. Ferber has noted that related drawings exist in the M. M. Karolik
collection at the Museum of Fine Arts, Boston, Mass., and in the
Brooklyn Museum. Listing in the annual exhibition at the Pennsylvania
Academy of The Fine Arts, Philadelphia, Pa., 1855 (#398), indicated
ownership by Joseph Harrison.*

Lone Trees, New Jersey (Lone Trees) early 1870's
Pencil on paper 11″x15″ (27.9x38.1 cm)
Unsigned
Reverse: small sketch on side of paper
Ex-collection: estate of C. Nelson Richards II (grandnephew of artist);
sold at auction, 1965, Fisher's Gallery; Washburn Gallery, New York, N.Y.
Purchase 1972 Thomas L. Raymond Bequest Fund 72.348

*Linda Ferber dated this work between 1870-83 and believed it to be a part
of studies for the unlocated painting, Lone Trees, of 1870-71; possibly
a New Jersey scene. C. N. Richards II tried to collect as much of his
great-uncle's works as possible from the rest of his family.
His collection was sold as a group in 1965 (files)*

RIDGEWAY, RONALD (b. 1949)

Receipt 1971
Collage on paper 16¾″x13¾″ (42.5x34.9 cm)
Signed and dated: center, "R. Ridgeway/7/22/71"
Ex-collection: the artist, Nutley, N.J.
Purchase 1971 Felix Fuld Bequest Fund 71.170

*Purchased from the Museum's 7th triennial exhibition, New Jersey
Artists, 1971.*

RITSCHEL, WILLIAM (1864-1949)

***Marine** ca. 1910
Oil on canvas 20″x24″ (50.8x61.0 cm)
Signed: lower left, "W. Ritschel"
Ex-collection: Frederick Keer, Newark, N.J.
Purchase 1910 The General Fund 10.9

*One of the first three contemporary American paintings purchased by The
Newark Museum. The others were Ernest Lawson's Harlem River (10.11)
and Bruce Crane's Autumn (10.10). Keer was a framer and painting dealer.*

RIVERS, LARRY (b. 1923)

The Guillon Lethière Family, After Ingres ca. 1960
Pencil and crayon on paper 16¾″x13¾″ (42.5x34.9 cm)
Signed: lower right, "Rivers"
Ex-collection: purchased from the artist by donor, New York, N.Y.
Gift of John Preston 1960 60.601

*The Ingres painting which was Rivers' model is in the
Museum of Fine Arts, Boston, Mass.*

ROBINSON, BOARDMAN (b. Canada 1876-1952)

The Road to Emmaus 1928
Watercolor on paper 15″x21¾″ (38.1x55.2 cm)
Signed: lower left, "Boardman Robinson"
Ex-collection: with Weyhe Gallery, New York, N.Y.
Purchase 1930 Felix Fuld Bequest Fund 30.228

Albert Christ-Janer in his 1946 book on Robinson lists this as #38, Sketch
for a Mural, *painted 1928. The mural was never executed although the
artist experimented with a fresco* Sermon on the Mount, *1925, which is
similar in the handling of figures and the pivotal Christ.*

ROBINSON, THEODORE (1852-1896)

* **Moonrise** (Moon Rise) 1892
Oil on canvas 15⅞″x22⅛″ (40.3x56.2 cm)
Signed: lower right, "Th. Robinson"
Reverse: old label indicating title of "Moon Rise," owned by
E. G. O. Reilly; label, Brooklyn Museum
(lent by Mrs. A. Augustus Healy)
Ex-collection: A. P. Yorston (acquired from the artist); Edward G. O.
Reilly (sold with other Reilly items at American Art Association sale,
January 24, 1917, #47); to A. Augustus Healy; Mrs. A. Augustus Healy,
Cold Spring on Hudson, N.Y. (sold with other Healy items at American
Art Association, Anderson Gallery sale, March 23, 1939, #84);
Joseph Katz; Leslie Katz (1961); with Babcock Galleries, New York, N.Y.
Purchase 1965 Felix Fuld Bequest Fund 65.120

*Executed in France in 1892; included in Robinson's first one-man show
at the William Macbeth Gallery in 1895, listed as #27.
Work was also included in the Brooklyn Museum exhibition of
Robinson's work, 1946 (#146).*

ROCKWELL, HORACE (1811-1877)

* **The Lewis G. Thompson Family** ca. 1844
Oil on canvas 66½″x72½″ (168.9x184.2 cm)
Unsigned
Ex-collection: remained in Thompson family until donated by
descendents of Ann Eliza, the girl at the piano
Gift of Mrs. John Bebout, Mrs. Gerald Schroth, Mrs. Gordon Shephard
and Mrs. Geoffrey Stephens in memory of Annie M. Reed and
Hugh B. Reed 1962 62.154

*Painting was executed at the Thompson home in Fort Wayne, Ind.
Mrs. Bebout was a resident of Cedar Grove, N.J., at time of gift. Annie
M. Reed, sister of Hugh B. Reed, the father of Mrs. Bebout and Mrs.
Shephard, wrote a history of this painting and the Thompson family.
Mr. Reed had a country house, "Reedmont", in Somerville, N.J. (files)*

ROESEN, SEVERIN (Germany ca. 1815-1871)

* **Still Life**
Oil on canvas 12⅞″x16¼″ (32.7x41.3 cm)
Signed: lower right, "S. Roesen"
Ex-collection: Mrs. Mary Hamlin; to Mrs. Franklin Chace, East
Hampton, N.Y.; to Arthur Baron, Bridghampton, N.Y. (antique dealer);
to Alice M. Kaplan, New York, N.Y.
Gift of Mrs. J. M. Kaplan 1965 65.142

*Franklin Chace's grandfather was Thomas Carol Smith, the founder of
the Union Porcelain Works. (corres.)*

ROLSHOVEN, JULIUS (1858-1930)

Deer Track 1917
Oil on panel 36″x28″ (91.4x71.1 cm)
Signed: lower right, "Taos, NM/J. Rolshoven"
Reverse: inscribed and dated, "By Julius Rolshoven 'Deer Track' Taos
Peublo (sic)/Aug 1917"
Ex-collection: the artist; to Paul Mausolff; to his daughter,
the donor, Mendham, N.J.
Gift of Mrs. James L. McFadden 1964 64.10

RONALD, WILLIAM (b. Canada 1926)

Abstraction 1962
Watercolor on paper 18″x24″ (45.7x61.0 cm)
Signed and dated: lower right, "-Ronald '62"
Reverse: label, Kootz Gallery
Ex-collection: with Kootz Gallery, New York, N.Y.
Gift of William H. Gerdts 1962 62.3

Miles 1962
Acrylic on canvas 70″x50″ (177.8x127.0 cm)
Reverse: signed and dated, "-Ronald '62/Miles"
Ex-collection: donor, New York, N.Y.
Gift of Samuel Kootz 1963 63.120

"Miles" refers to musician Miles Davis.

The Traveller 1964
Oil and paper on canvas 60″x60″ (152.4x152.4 cm)
Reverse: signed, "The Traveller Ronald/60x60 6/14/64"; label, Newark
Museum, *Selected Works by Contemporary New Jersey Artists,* 1965
Ex-collection: donors, New York, N.Y.
Gift of Mr. and Mrs. Samuel Kootz 1966 66.45

ROSE, HERMAN (b. 1909)

Safed: Cottages and Hills 1973
Oil on canvas 24⅜″x21⅜″ (61.9x54.3 cm)
Unsigned
Reverse: label, Zabriskie Gallery; on stretcher, "-10 -HR 12"
Ex-collection: with Zabriskie Gallery, New York, N.Y.
Gift of Mr. and Mrs. David Workman 1975 75.219

ROSEN, CHARLES (1878-1950)

Scow in Drydock ca. 1940
Oil on canvas 20″x32″ (50.8x81.3 cm)
Signed: lower right, "Charles Rosen"
Ex-collection: donors, New York, N.Y.
Gift of Mr. and Mrs. Lesley G. Sheafer 1954 54.214

ROSENBERG, JAMES N. (1874-?)

Coming Storm, Adirondacks 1949
Pastel on paper 20″x22″ (50.8x55.9 cm)
Signed and dated: lower left, "JNR 49"
Ex-collection: donor, New York, N.Y.
Gift of Iskander Hourwich 1951 51.25

ROSENBORG, RALPH (b. 1913)

Evening Scene 1939
Oil on canvas 24¼"x32⅜" (61.6x82.2 cm)
Signed: lower left, "Rosenborg/(arrow) 39"
Reverse: inscribed on canvas, "Rosenborg/(arrow) 39";
identification label, *WPA*
Allocated by the WPA Federal Art Project 1943 43.159

ROSS, GEORGE GATES (1814-1856)

The Woodman
Oil on canvas 24"x20" (61.0x50.8 cm)
Unsigned
Ex-collection: remained in artist's family until bequeathed by his
nephew, Newark, N.J.
Bequest of George J. Hagar 1921 21.1629

Portrait of James Ward (1764-1846) 1845
Oil on canvas 30"x25" (76.2x63.5 cm)
Unsigned
Ex-collection: remained in family, Newark, N.J., until bequeathed
to the Museum
Bequest of Marcus L. Ward, Jr. 1921 21.1741

*Portrait originally bore inscription on the reverse, "I. Ward, 1845, age 80"
and the signature, "G. G. Ross." Since there is no knowledge of a Ward
relative whose name begins with "I", it can be assumed this was
James Ward, grandfather of Marcus L. Ward (1812-1884) (files)
(see Read 21.1752).*

Portrait of Mayor James Miller of Newark (1793-1858) 1849
Oil on canvas 35¾"x28½" (90.8x72.4 cm)
Unsigned
Reverse: no pertinent data recorded prior to relining, 1964
Ex-collection: New Jersey Historical Society, Newark, N.J.; to donor,
So. Orange and Newark, N.J.
Gift of Louis Bamberger 1926 26.292

*James Miller was mayor of Newark, 1839-40 and 1848-51. Date recorded as
June, 1849. (files)*

Portrait of Horace Newton Congar (1817-1893) 1841
Oil on rectangular canvas, oval opening: 29¼"x23½" (74.3x59.7 cm);
canvas: 29⅞"x24⅞" (75.4x62.7 cm)
Reverse: signed and dated, "G.G. Ross/1841" (prior to relining 1964);
label, *Surviving the Ages*, AFA, 1963-64
Ex-collection: Horace Newton Congar, Newark, N.J.; to his daughter,
the donor, Newark, N.J.
Bequest of Miss Florence Congar 1945 45.130

Congar, a native of Newark, was editor of The Newark Daily Mercury *in
1850 before embarking on a governmental and diplomatic career, serving
under Presidents Lincoln, Johnson and Grant. He was also an officer of
the Mutual Benefit Life Insurance Co. and New Jersey Secretary of State
under Marcus Ward.*

ROSS, SANFORD (1907-1954)

Market Street Station, Newark 1931
Pencil, wash, pen and ink on paper 15⅛"x13¾" (38.4x34.9 cm)
Signed: lower right, "Sanford Ross/1931-"
Reverse: label on backing, "Painting by American Artists,"
William Macbeth, Inc., New York (March, 1932)
Ex-collection: with Macbeth Galleries, New York, N.Y.;
private collection, New York, N.Y.
Anonymous gift 1932 32.350

ROSSITER, THOMAS PRITCHARD (1818-1871)

*****The Return to London After the Crimea War** (Such is Life ... London
During the Crimea War) 1855
Oil on canvas 19⅝"x27½" (49.8x69.9 cm)
Signed and dated: lower right, "T. P. Rossiter/Paris 1855"
Reverse: handwritten card attached to stretcher, "The Return
to London/After the Crimea War/by Rossiter" (probably written
prior to relining, 1974)
Ex-collection: Harrison Earl, Philadelphia, Pa. (1861-62);
private collection, Boston, Mass.; to Victor Spark,
New York, N.Y. (ca. late 1940's)
Purchase 1961 John J. O'Neill Bequest Fund 61.20

*Harrison Earl was the owner of this painting when it was exhibited at
the Pennsylvania Academy of The Fine Arts in both 1861 (#204) and
1862 (#261). It was listed as "unlocated" in the 1957 publication,*
Thomas Pritchard Rossiter *by J. V. Rossiter.*

ROWSON, WILLIAM SMITH (1821-1892)

Landscape
Watercolor on paper 3"x5¼" (7.6x13.3 cm)
Reverse: "Mary E. Rowson/from her father/Perth Amboy/Dec. 31, 1871"
Gift of Jack Bender 1958 58.36

*William S. Rowson, a civil and mining engineer as well as a geologist,
built the Cumberland Valley R.R. of Pennsylvania, and the Bogota R.R.
in Bolivia (corres.)*

ROYBAL, JUAN CRUZ (20th century)

Design: Sun and Eagle Feathers ca. 1930
Watercolor, gouache and ink on paper 22¼"x28¼" (56.5x71.8 cm)
Signed: lower front center, "Juan Cruz Roybal"
Reverse: label, Exposition of American Tribal Arts, 1931; partial label,
Art Institute of Chicago, Watercolor Exhibition 1935
Gift of Miss Amelia E. White 1937 37.220

Artist from San Ildefonso pueblo, N.M.

RUSSELL, MORGAN (1886-1953)

Synchronist Study 1916
Oil on paper mounted on glass 12½"x12" (31.8x30.5 cm;
irregular dimensions)
Unsigned
Ex-collection: donor, New York, N.Y.
Gift of Mrs. Charmion Von Wiegand 1958 58.146

*Due to the torn nature of this piece, William H. Gerdts referred to it as a
"fragment." Date supplied by donor.*

RYAN, ANNE (1889-1954)

Mallorca 1953
Paper and textile collage on composition board 23¾"x26¼" (60.3x66.7 cm)
Signed: lower right, "A. Ryan/92 Bank St./NY City 14";
lower left, "Collage #14-1953"
Reverse: lower center, "Collage #14 — 1953"; lower right,
"A. Ryan/92 Bank St./NY City 14"
Ex-collection: private collection, New York, N.Y.
Anonymous gift 1955 55.100

Untitled
Paper and textile collage on paper 4¼"x3¾" (10.8x9.5 cm), mounted to
sheet 6¾"x5⅛" (17.1x13.0 cm)
Signed: on bottom of collage, "A Ryan"
Reverse: inscribed on paper, "A Ryan"
Ex-collection: the artist; to her daughter, the donor, New York, N.Y.
Gift of Miss Elizabeth McFadden 1956 56.161

*Untitled 1949
Paper and textile collage on paper 7¼"x6¼" (18.4x15.9 cm)
Signed: lower right, "A Ryan"
Reverse: on backing, "#273" (number enabled donor to date the work June or July, 1949)
Ex-collection: the artist; to her daughter, the donor, New York, N.Y.
Gift of Miss Elizabeth McFadden 1956 56.162

Untitled 1952
Paper and textile collage on paper 4¼"x3¾" (10.8x9.5 cm)
Signed: lower right, "A Ryan"
Reverse: on backing, "Christmas 1952"
Ex-collection: the artist; to her daughter, the donor, New York, N.Y.
Gift of Miss Elizabeth McFadden 1956 56.163

Untitled
Paper collage on paper 5⅜"x3¾" (13.7x9.5 cm; oval), mounted to sheet 6¼"x4⅞" (15.9x12.4 cm)
Signed: bottom of oval, "A Ryan"
Reverse: inscribed, "A Ryan"
Ex-collection: the artist; to her daughter, the donor, New York, N.Y.
Gift of Miss Elizabeth McFadden 1956 56.164

Small Red Collage 1953
Paper and textile collage on paper 8½"x7" (21.6x17.8 cm), mounted to burlap and canvas 11½"x9⅞" (29.2x25.1 cm)
Signed: lower right on fabric, "A Ryan"
Reverse: inscribed on backing, "A Ryan/Nov. '53"
Ex-collection: the artist; to her daughter, the donor, New York, N.Y.
Gift of Miss Elizabeth McFadden 1956 56.165

Painting X 1953
Oil on canvas 24"x29" (60.1x73.7 cm)
Signed: lower right, "A Ryan"
Ex-collection: the artist; to her daughter, the donor, New York, N.Y.
Gift of Miss Elizabeth McFadden 1956 56.166

RYDER, ALBERT PINKHAM (1847-1917)

*Diana's Hunt
Oil on canvas 18"x14" (45.7x35.6 cm)
Unsigned
Reverse: label, World House Galleries; label, Santa Barbara Museum of Art (#102)
Ex-collection: estate of artist, 1918 (Charles M. Dewey, Administrator); Vose Galleries, Boston, Mass. (purchased 1918); Ralph Cudney, Chicago, Ill. (purchased 1919 and still owned in early 1930's); William T. Cresmer, Chicago, Ill. (purchased 1936); Babcock Galleries, New York, N.Y.; Mrs. Jacob H. Rand, New York, N.Y.; Milch Galleries, New York, N.Y.
Purchase 1955 Wallace M. Scudder Bequest Fund 55.116

Shown in the Ryder memorial exhibition, Metropolitan Museum of Art, 1918. Lloyd Goodrich believed this probably an unfinished Ryder, similar to Metropolitan Museum's Forest of Arden *(1897). (files)*

RYDER, CHAUNCEY FOSTER (1868-1949)

Mt. Lovewell and the Village of Washington, New Hampshire
Oil on canvas 32⅛"x44¼" (81.6x112.4 cm)
Signed: lower left, "Chauncey.F.Ryder"
Reverse: on canvas edge, "Mount Lovewell and the Village of Washington"
Ex-collection: donors, New York, N.Y.
Gift of Mr. and Mrs. Henry H. Wehrhane 1929 29.912

Untitled
Oil on canvas 20"x24" (50.8x61.0 cm)
Signed: lower right, "Chauncey F. Ryder"
Ex-collection: Joseph S. Isidor, New York, N.Y. and Newark, N.J.; to his wife, the donor (1941)
Bequest of Mrs. Rosa Kate Isidor 1949 49.470

RYLAND, ROBERT K. (1873-1951)

Opportunity and Regret ca. 1910
Oil on canvas 95"x53" (241.3x134.6 cm)
Unsigned
Reverse: label, Architectural League of New York, 1910
Ex-collection: donor, Brooklyn, N.Y.
Gift of the artist 1932 32.640

The work was copyrighted ca. 1912.

SAGE, KAY (1893-1963)

*At the Appointed Time 1942
Oil on canvas 32"x39" (81.3x99.1 cm)
Signed and dated: lower left, "Kay Sage 42"
Reverse: inscribed in artist's hand on stretcher, "'At the Appointed Time' 1942 Kay Sage/Woodbury, Conn"; label, Katherine Viviano Gallery
Ex-collection: the artist, Woodbury, Conn.
Gift of the Estate of Kay Sage Tanguy 1964 64.54

The Viviano Gallery, New York, N.Y., handled the artist's estate. She was the wife of artist Yves Tanguy.

SAHRBECK, EVERETT (b. 1910)

Fogbound ca. 1950
Watercolor on paper 17⅞"x23¾" (45.4x60.3 cm)
Signed: lower right, "Everett Sahrbeck"
Reverse: inscribed on backing, "Everett Sahrbeck/Fogbound"; label, *Work by N.J. Artists*, 1952
Ex-collection: purchased from the artist, Verona, N.J.
Purchase 1952 Sophronia Anderson Bequest Fund 52.29

Purchased from the Museum's 1st triennial exhibition, Work by New Jersey Artists, *1952. Artist indicated scene is Rock Harbor on Cape Cod. (files)*

SANDOL, MAYNARD (b. 1930)

Paterson: The Day My World Stood Still 1958
Oil on masonite 84⅞"x94¾" (215.6x240.1 cm)
Signed and dated: lower right, "Maynard/58"
Ex-collection: donors, South Orange, N.J.

Gift of Mr. and Mrs. Harry L. Tepper 1961 61.459

SANDOR, MATHIAS (1857-1920) (see Browne, George Elmer 49.469)

SARGENT, JOHN SINGER (b. Italy 1856-1925)

*Portrait of Sally Fairchild (The Blue Veil; Lady Wearing a Blue Veil) 1890
Oil on canvas 30"x25¼" (76.2x64.1 cm)
Unsigned
Reverse: estate stamped "JSS"; label on stretcher , "Size 35x30/sold by/Frost & Adams/No 37 Cornel/__"; torn label, M. Knoedler, for exhibition John & Mable Ringling Museum; Sarasota, Fla.; label, Museum of Fine Arts Boston, Special Loan Exhibition *John Singer Sargent*, 1956 (lent by Mr. and Mrs. J. Duncan Pitney/c/o M. Knoedler); label, AFA, *American Impressionists: Two Generations*, 1963-64
Ex-collection: Sargent Studio Sale, Christie's, London (July 24-27, 1925); to David Croal Thomson, London; to M. Knoedler (September, 1925); to Charles S. Carstairs, New York (December, 1925); Charles S. Carstairs estate (d. 1929); to M. Knoedler (1930); to donors, Mendham, N.J. (1955).
Gift of Mr. and Mrs. J. Duncan Pitney 1957 57.19

Painted in Nahant, Mass., while Sargent was staying with the Fairchild family, according to Charles Merrill Mount in John Singer Sargent, *1955, p. 183.*

***Camping at Lake O'Hara** (Camping near Lake O'Hara;
Campfire) 1916
Watercolor 15¾"x20⅞" (40.0x53.0 cm)
Signed: lower left, "John S. Sargent"
Reverse: all on backing: label, Fogg Art Museum/1916.497/Friends of the
Fogg Museum; handwritten label,
"#398.25/Sargent/Lent by/Fogg Art
Museum"; label, "C.M.A./2167.17"; label, "Minneapolis/Institute of Arts/
L.18.76"; label, Smith College/Museum of Art/Loan/87.36; torn label,
"_____American_____ Art Museum_____"; label, Copley Society of
Boston/Exhibition of American Watercolors/Paris 1923; label, AFA,
American Impressionism, 1965-66; label, Harvard University, Fogg
Museum of Art #1916.497
Ex-collection: artist to Allied Bazaar (probably Boston); to Fogg Art
Museum, Cambridge, Mass. 1916; with Vose Gallery, Boston, Mass.
Purchase 1957 Felix Fuld Bequest Fund 57.86

*The scene is from Sargent's 1916 trip to British Columbia. His large oil
painting of Lake O'Hara is owned by the Fogg.* (corres.)

***Study of Drapery, Apollo, Muses** 1917
Charcoal on paper 25"x18¾" (63.5x47.6 cm)
Unsigned
Dated: lower right, "11.5.17"
Ex-collection: James Graham & Sons, New York, N.Y.
Purchase 1960 Rabin and Krueger American Drawing
Fund 60.580

SASLOW, HERBERT (b. 1920)

Bouquet, Tallith and Tapestry 1957
Oil on masonite 33"x50½" (83.8x128.3 cm)
Signed: lower right, "Saslow"
Ex-collection: with Babcock Gallery, New York, N.Y.
Purchase 1958 Sophronia Anderson Bequest Fund 58.24

Purchased from the Museum's 3rd triennial exhibition, Work by
New Jersey Artists, *1958. Date supplied by artist.*

SAUERWEIN, FRANK PAUL (1871-1910)

Indian Bead Maker 1905
Oil on cardboard 13⅞"x10⅞" (35.2x27.6 cm)
Signed: lower left, "F. P. Sauerwein/.05"
Reverse: label, "Fred.Keer & Sons, Newark" (framer and dealer)
Ex-collection: donor, Newark, N.J.
Bequest of Mrs. Lillie E. Herpers 1957 57.120

SAVAGE, EDWARD (1761-1817)

Portrait of James Ewing (1744-1823) (attributed)
Oil on canvas 26½"x22¼" (67.3x 56.5 cm)
Reverse: inscribed, "3/6"/(illegible stamp)"
Ex-collection: donor, Princeton, N.J.
Gift of Mrs. James Kerney, Jr. 1962 62.115

*Tentative attribution has been made by M. Knoedler & Co. and by family
tradition. Subject was mayor of Trenton 1797-1803.* (files)

SAVAGE, W. LEE (b. 1928)

High Table 1959
Oil on canvas 58¼"x42" (148.0x106.7 cm)
Signed: lower right, "WLS"
Reverse: inscribed, "W. Lee Savage/Jan. 1954/42x58¼/High Table"; on
stretcher, "Lee Savage Piermont, N.Y."
Ex-collection: donor, Sarasota, Fla.
Gift of Mrs. Milton Weill 1968 68.242

SCHANKER, LOUIS (1903-1981)

City Landscape 1945
Gouache on paper 31"x22¼" (78.8x56.5 cm)
Signed and dated: lower right, "Schanker-45"
Ex-collection: with Willard Gallery, New York, N.Y.; to donors,
Plainfield, N.J.
Gift of Mr. and Mrs. Benjamin E. Tepper 1946 46.165

*Exhibited at the Willard Gallery, 1946, and the Phillips Gallery,
Washington, D.C., May, 1946, prior to entering the collection.*

Composition
Gouache on paper 23¾"x33" (60.3x83.8 cm)
Signed: lower right, "Schanker"
Ex-collection: donor, New York, N.Y.
Gift of Miss May E. Walter 1958 58.35

SCHARY, SAUL (1904-1978)

Portrait of Abraham Walkowitz (1878-1965) ca. 1944
Oil on canvas 28"x22" (71.2x55.9 cm)
Signed: upper right, "Schary"
Ex-collection: donor, New York, N.Y.
Gift of Abraham Walkowitz 1947 47.218

Executed for exhibition, One Hundred Artists and Walkowitz,
Brooklyn Museum, 1944.

SCHILLINGER, JOSEPH (1895-1943)

Splash Red ca. 1934
Gouache on paper 8⅛"x11⅝" (20.7x29.6 cm)
Signed: lower right, "Joseph Schillinger (JS)" (signed by Mrs.
Schillinger)
Ex-collection: donor, New York, N.Y.
Gift of Mrs. Joseph Schillinger 1971 71.172

Series developed from The Mathematical Basis of the Arts *by Joseph
Schillinger, who was an artist, writer, composer and a teacher of musical
composition. His book formulated a system of mathematical logic
underlying art structures.* (files)

Red Orange ca. 1934
Gouache on paper 10¼"x9¾" (26.0x24.8 cm)
Signed: lower right, "Joseph Schillinger (JS)" (signed
by Mrs. Schillinger)
Ex-collection: donor, New York, N.Y.
Gift of Mrs. Joseph Schillinger 1971 71.173

SCHLEY, REEVE B. III (b. 1936)

Cape May 1974
Watercolor on paper 18⅝"x23¾" (46.7x60.0 cm)
Signed and dated: lower left, "Cape May"; lower right, "Schley 1974"
Reverse: vertical frame left, #5749
Ex-collection: purchased from the artist, Whitehouse, N.J.
Purchase 1974 Eva Walter Kahn Bequest Fund 74.57

SCHMIDT, ARNOLD A. (b. 1930)

***Square in the Eye with Grey Around It** 1965
Oil on canvas 48½"x48½" (123.2x123.2 cm)
Unsigned
Ex-collection: with Terrain Gallery, New York, N.Y.
Gift of Mrs. Dorothy Koppelman 1965 65.132

Date supplied by artist.

372

SCHMIDT, KATHERINE (1898-1971)

Fresh Figs 1940
Oil on canvas 8½″x10¼″ (21.6x26.0 cm)
Signed and dated: lower right, "Katherine Schmidt-40"; label on front, "Katherine Schmidt 1898/Fresh Figs/Purchased from the Edward Weston Fund"
Ex-collection: with The Downtown Gallery, New York, N.Y.
Purchase 1940 Edward F. Weston Gift 40.157

Still Life 1939
Oil on canvas 20″x30″ (50.8x76.2 cm)
Signed and dated: lower center, "Katherine Schmidt '39"
Ex-collection: with The Downtown Gallery, New York, N.Y.
Purchase 1944 Wallace M. Scudder Bequest Fund 44.175

SCHNACKENBERG, HENRY (1892-1971)

Portrait of Abraham Walkowitz (1878-1965) 1943
Oil on canvas 16″x12″ (40.7x30.5 cm)
Signed: lower left, "Schnackenberg"
Reverse: inscribed, "5-43"
Ex-collection: donor, New York, N.Y.
Gift of Abraham Walkowitz 1948 48.515

Executed for exhibition, One Hundred Artists and Walkowitz, *Brooklyn Museum, 1944.*

SCHRAG, KARL (b. Germany 1912)

Autumn Garden with Strollers 1968
Gouache on cardboard 26″x38⅛″ (66.0x96.8 cm)
Signed: lower right, "Karl Schrag"
Reverse: in pencil on paper, "Autumn Garden with Strollers"; label on backing, Kraushaar Galleries
Ex-collection: with Kraushaar Galleries, New York, N.Y.
Gift of the Childe Hassam Fund of the American Academy of Arts and Letters 1970 70.45

Date supplied by artist.

SCHREIBER, GEORGES (b. Belgium 1904-1977)

Autumn 1947
Oil on canvas 22″x32¼″ (55.9x81.9 cm)
Signed and dated: upper left, "Schreiber/.47"
Reverse: inscribed on stretcher, "Georges/Schreiber/'Autumn' "
Ex-collection: purchased from the artist, New York, N.Y.
Purchase 1960 Anonymous Gift Fund 60.578

Painted at Martha's Vineyard, Mass., and originally titled Our Daily Bread. *(files)*

SCHREYVOGEL, CHARLES (1861-1912)

(see Browne, George Elmer 49.469)

SCHUCKER, CHARLES (b. 1908)

Bright Stream (Abstraction) 1954
Oil on canvas 30″x63″ (76.2x160.0 cm)
Signed and dated: lower right, "Schucker 54"
Ex-collection: donors, Litchfield, Conn.
Gift of Mr. and Mrs. Harry I. Caesar 1962 62.135

SCHWABE, H. AUGUST (1843-1916)

Lost Chances (Forty-Niner)
Oil on canvas 39″x30″ (99.1x76.2 cm)
Signed and dated: lower left, "H. Aug. Schwabe/1906"
Reverse: artist's calling card with *Lost Chances* written in ms.
Ex-collection: the artist, Maplewood, N.J.
Gift of H. August Schwabe 1915 15.979

Forty-Niner *has been the published title of the painting.*

Portrait of a Man in Armor 1894
Watercolor on paper 33½″x27½″ (85.1x69.9 cm)
Signed and dated: lower left, "H. A. Schwabe 1894"
Reverse: packing label, "Owned by Samuel Clark"
Ex-collection: donor, Chatham, N.J.
Gift of Mrs. Samuel Clark 1925 25.1262

SCHWACHA, GEORGE, JR. (b. 1908)

The Blue Inn 1943
Oil on canvas 30″x36″ (76.2x91.4 cm)
Signed: lower left, "Geo. Schwacha"
Ex-collection: with Milch Galleries, New York, N.Y.
Purchase 1944 Wallace M. Scudder Bequest Fund 44.171

The scene depicts a Newark "hamburger joint," neither an "inn" nor "blue," according to the artist, who supplied the date. (files)

The Black Cloud 1952
Watercolor on paper 22½″x27¾″ (57.2x70.5 cm)
Signed: lower right, "Geo. Schwacha"
Reverse: "George Schwacha/ . . ./Painted 1952"
Ex-collection: donor, Bloomfield, N.J.
Gift of George Schwacha 1952 52.57

SCHWARZ, MANFRED (b. Poland 1909-1970)

Portrait of Abraham Walkowitz (1878-1965) ca. 1943
Oil on canvas 20″x16″ (50.8x40.6 cm)
Signed: lower right, "M. Schwarz"
Ex-collection: donor, New York, N.Y.
Gift of Abraham Walkowitz 1948 48.337

Executed for the exhibition, One Hundred Artists and Walkowitz, *Brooklyn Museum, 1944.*

SCOTT, JULIAN (1846-1901)

Civil War Scene 1872
Oil on canvas 20″x16″ (50.8x40.6 cm)
Signed: lower right, "Julian Scott/1872"
Ex-collection: donor, Scotch Plains, N.J.
Gift of Dr. J. Ackerman Coles 1920 20.1195

Scott settled in Plainfield, N.J., in 1876.

SCUDDER, JANET (1875-1940)

View in Southwest
Oil on canvas 20″x24″ (50.8x61.0 cm)
Signed: lower right, "Janet Scudder"
Ex-collection: donor, Newark, N.J.
Gift of Ralph Lum 1949 49.356

Possible date of 1936. (files)

SEIFFERT, RAYMOND (1887-1956)

Portrait of William A. Hughes 1952
Oil on canvas 45⅛″x35⅞″ (114.6x91.1 cm)
Signed and dated: lower right, "Raymond Seiffert/1952"
Reverse: label, Portraits, Inc. N.Y.C.
Ex-collection: donor, Short Hills, N.J.
Gift of William Hughes 1962 62.148

Subject was a Trustee of The Newark Museum from 1949-73.

SELIGER, CHARLES (b. 1926)

Undersea Starfish 1949
Tempera, ink and oil on cardboard 10⅞"x13⅞" (27.6x35.2 cm)
Signed and dated: lower right, "Seliger -/49"
Reverse: inscribed, "'Undersea: Starfish'/oil; tempera; ink/January 1949/Charles Seliger"
Ex-collection: Carlebach Gallery, New York, N.Y.; to donors, Union City, N.J.
Gift of Mr. and Mrs. S. L. Berne 1949 49.342

SHAHN, BEN (b. Russia 1898-1969)

Shore Party 1931
Watercolor on paper 9½"x19½" (24.1x49.5 cm)
Signed: lower right, "Ben Shahn"
Ex-collection: with The Downtown Gallery, New York, N.Y.
Purchase 1933 The General Fund 33.232

Date supplied at time of purchase.

***Little Church**
Watercolor on paper 15¾"x23¾" (40.0x60.3 cm)
Signed: lower right, "Ben Shahn"
Ex-collection: private collection, New York, N.Y.
Anonymous gift 1937 37.116

Girl in Blue
Watercolor on paper 12"x9¼" (30.5x23.5 cm)
Signed: lower left, "Ben Shahn"
Ex-collection: private collection, New York, N.Y.
Anonymous gift 1940 40.344

Don Quixote ca. 1930
Watercolor on paper 14¾"x14" (37.5x35.6 cm)
Signed: lower right, "Ben Shahn"
Reverse: label, Santa Barbara Museum of Art, *Ben Shahn Retrospective*, 1967; label, Museum of Art, Ogunquit, Maine, 1959; stamp on mount, "March 29, 1930"
Ex-collection: private collection, New York, N.Y.
Anonymous gift 1940 40.345

***Abstraction** 1956
Oil on masonite 168"x84" (426.7x213.4 cm)
Signed: lower right, "Ben Shahn"
Ex-collection: donor, New York, N.Y.
Gift of Arthur Stanton 1962 62.12

Commissioned in 1956 as decorative graph for a Volkswagen showroom on East 58th Street, New York, N.Y. (corres.)

SHALER, FREDERICK R. (1880-1917)

Still Life early 20th century
Oil on canvas 35"x27" (88.9x68.6 cm)
Signed: upper left, "Elixn" (?)
Reverse: "6(?)x90xn2./Return F. Shaler c/o B. A. Lockhart/77 Pemberton sq Boston/Mass U.S.A."
Ex-collection: with Anderson Gallery, New York, N.Y.
Purchase 1922 22.233

SHAPIRO, SEYMOUR ("Babe") (b. 1937)

Bluesatomy 1958
Mixed media, analine dyes, casein and shellac on masonite 59¼"x48⅛" (150.5x122.2 cm)
Reverse: signed and dated, "Bluesatomy/1958/S. Shapiro"; inscribed on stretcher, "Bluesatomy/S. Shapiro/68 Millington Ave/Newark NJ/1958"; label, *Work by New Jersey Artists*, Newark Museum, 1958
Ex-collection: purchased from the artist, Rutherford, N.J.
Purchase 1958 Carrie B. Fuld Bequest Fund 58.22

Purchased from the Museum's 3rd triennial exhibition, Work by New Jersey Artists, 1958.

Midnight Mournings 1958
Mixed media on mat board 13⅜"x13½" (34.0x34.3 cm)
Signed and dated: lower right, "Midnight Mournings S. Shapiro '58"
Reverse: label, Newark Arts Festival, New Jersey Artists and Craftsmen, 1959
Ex-collection: purchased from the artist, Rutherford, N.J.
Purchase 1959 Rabin and Krueger American Drawing Fund 59.81

Drawing itself is tondo image. Purchased from Outdoor Art Exhibition, Newark Arts Festival, June 1-7, 1959, where it was awarded second prize in graphics.

W. C. W. 1960
Mixed media on panel 59½"x47½" (151.1x120.7 cm)
Signed: lower right, "Shapiro 1960"
Ex-collection: acquired from the artist, Rutherford, N.J.
Purchase 1961 Carrie B. Fuld Bequest Fund 61.18

Purchased from the Museum's 4th triennial exhibition, Work by New Jersey Artists, 1961. According to the artist, William Carlos Williams showed such delight on seeing this work that it was titled accordingly. (files)

SHARPLES, FELIX (1786-after 1824)

***Portrait of Ann Wallace** (attributed)
Pastel on paper 9⅜"x7³/₁₆"(23.4x18.4 cm)
Unsigned
Ex-collection: donor, Somerville, N.J.
Gift of Dr. Mary Gaston 1934 34.576

Attribution made by Mrs. Katherine McCook Knox. Family tradition held that Ann Wallace was painted in 1812 at the age of two. She married the Rev. Dr. Hardenburgh of Newark in 1832. (files)

SHATTUCK, AARON DRAPER (1832-1928)

Cliffs on Porcupine Island, Maine 1858
Pencil on paper 10½"x17⅜" (26.7x44.1 cm)
Unsigned
Inscribed: lower right in artist's hand, "Cliffs on/Porcupine Island. Mt. Desert in the distance/Sept. 6 1858"; in margin, "Fog"
Gift of Mr. and Mrs. Stuart P. Feld 1977 77.212

SHAW, CHARLES (1892-1974)

Serenade in D Major 1956
Oil on canvas 34"x42" (86.4x106.7 cm)
Signed: lower left, "Shaw"
Reverse: inscribed, "Charles Shaw/1956"
Ex-collection: private collection, New York, N.Y.
Anonymous gift 1957 57.34

Included in artist's one-man show at Passedoit Gallery, 1957.

***Polygon** 1936
Construction: oil on shaped plywood with molding 27¼"x15⅞" (69.2x40.4 cm)
Reverse: inscribed, "Charles G. Shaw 1936."; sticker on middle stretcher, #5296
Ex-collection: with Washburn Gallery, Inc., New York, N.Y.
Purchase 1976 The Members' Fund 76.180

SHAW, JOSHUA (b. England 1776-1860)

*__American Forest Scenery__ (Defeated Indians Watching Progress of an Enemy; View of Reedy River, South Carolina) 1843
Oil on canvas 18½"x24" (47.0x61.0 cm)
Signed and dated: lower left, "J. Shaw•/1843."
Reverse: label, Vose Galleries, Boston, Mass.
Ex-collection: Gustav Klimann, Boston, Mass.; to Vose Galleries, Boston, Mass. (1955)
Purchase 1956 Wallace M. Scudder Bequest Fund 56.5

Dr. Jacob Terner of the Los Angeles County Museum of Art believed that this painting was preceded by two small oil paintings, one now at Brigham Young University, Provo, Utah, and the other then at Hirschl & Adler Galleries in New York, as preliminary studies. Both are titled Reedy River Massacre. *In his opinion, although Shaw had visited Reedy River (now Greenwood, S.C.), the action he depicted took place during the Revolution, since there were no recorded Indian actions in South Carolina in the 19th century. It was not unusual for Shaw to depict earlier events. The action probably reflects a familiar local story of the militia burning down a mill run by a Tory who was friendly to the Indians.* (corres.)

SHEELER, CHARLES (1883-1965)

*__Shaker Detail__ 1941
Oil and tempera on masonite 13¼"x14¼" (33.7x36.2 cm)
Signed and dated: lower left, "Sheeler-1941"
Reverse: label, National Collection of Fine Arts; label, Museum of Art, Carnegie Institute, Pittsburgh, *Founders of American Abstraction*, 1971
Ex-collection: with The Downtown Gallery, New York, N.Y.
Purchase 1944 Wallace M. Scudder Bequest Fund 44.169

*__Farm Buildings, Connecticut__ 1941
Tempera on cardboard 16"x21½" (40.6x54.6 cm)
Signed and dated: lower right, "Sheeler-1941"
Reverse: inscribed on backing, "Farm Buildings — Connecticut/ Charles Sheeler — 1941./Tempera Painting."
Ex-collection: with The Downtown Gallery, New York, N.Y.
Purchase 1944 Wallace M. Scudder Bequest Fund 44.170

*__It's a Small World__ 1946
Oil on canvas 24"x20" (61.0x50.8 cm)
Signed: lower right, "Sheeler-1946"
Reverse: inscribed on stretcher, "'Its a Small World'-1946/Charles Sheeler"; label, The Downtown Gallery; label, A.F.A., travelling exhibition in Germany and Austria, 1951
Ex-collection: with The Downtown Gallery, New York, N.Y.
Purchase 1946 Felix Fuld Bequest Fund 46.100

Purchased from Sheeler's one-man show at The Downtown Gallery, March, 1946.

SHINN, EVERETT (1876-1953)

*__Mouquins__ 1904
Pastel on cardboard 18¾"x22⅝" (47.6x57.5 cm)
Signed and dated: lower left, "Everett Shinn/1904"
Reverse: inscribed label on backing, "Mouquins' Old French Restaurant/at 28th St. & 6th Avenue/New York City/by/Everett Shinn/ Price"
Ex-collection: acquired from the artist, New York, N.Y.
Purchase 1949 Arthur Egner Memorial Fund 49.353

SHIRLAW, WALTER (b. Scotland 1838-1909)

__Vermont Pastoral__ A Pastoral; Pastoral Study
Oil on wood 10"x16⅛" (25.4x41.0 cm)
Signed: lower right, "W Shirlaw"
Reverse: inscribed on panel, "A Pastoral-/Walter Shirlaw"; label in artist's hand, "Vermont Pastoral/Walter Shirlaw N. A."; label in artist's hand, "Pastoral Study/Walter Shirlaw N. A."
Ex-collection: the artist's widow, New York, N.Y.
Gift of Mrs. Walter Shirlaw 1913 13.214

__The Choir Boy__
Oil on canvas 19½"x13⅛" (49.5x33.3 cm)
Signed: lower right, "W Shirlaw"
Reverse: label in artist's hand, "The Choir Boy/Walter Shirlaw N. A."
Ex-collection: the artist's widow, New York, N.Y.
Gift of Mrs. Walter Shirlaw 1913 13.215

SHUSTER, WILLIAM HOWARD ("Will") (1893-1934)

__The Rain Prayer__ (The Rain Dancer) 1924
Oil on canvas 24⅛"x36⅛" (61.3x91.8 cm)
Signed and dated: upper left, "Will Shuster'24"
Reverse: inscribed on stretcher, "'The Rain Prayer' Cochiti pueblo Will Shuster '24"; handwritten label, "The Rain Dancer/Cochiti pueblo/ Will Shuster"
Ex-collection: acquired from the artist, Santa Fe, N.M.
Gift of Mrs. Felix Fuld 1925 25.1169

SIEGEL, BARBARA (b. 1946)

__Untitled__ 1971
Acrylic on canvas 56"x56" (142.2x142.2 cm)
Unsigned
Ex-collection: acquired from the artist, West Orange, N. J.
Purchase 1971 Felix Fuld Bequest Fund 71.144

Purchased from the Museum's 7th triennial exhibition, New Jersey Artists, *1971.*

SILBERMAN, HERBERT A. (20th century)

The following were Allocated by the WPA Federal Art Project 1943:

__Glass Factory__ ca. 1940
Watercolor on paper mounted on mat board 12¼"x17¾" (31.1x45.1 cm)
Signed: lower right, "Herbert"
Reverse: WPA label, "Shop-/1300-Ea-18" 43.17

Silberman and F. Ferris both depicted the Vineland, N. J., glass industry.

__Glory Hole__ ca. 1940
Watercolor on paper 14"x21⅛" (35.6x53.7 cm)
Signed: lower right, "H. Silberman"
Reverse: WPA label on paper, "Glory Hole/1303/EA 18" 43.20

Records indicate this is signed and dated 1940.

__Shop at Work__ ca. 1940
Watercolor on paper mounted on canvas board 15¾"x21⅛" (40.0x53.7 cm)
Signed: lower right, "Herbert"
Reverse: inscribed in artist's hand, "131 . . . /3.40P./Silberman/18x24/ W.C."; WPA label 43.23

__The Gaffer__ ca. 1940
Watercolor on paper mounted on cardboard 12¼"x17¾" (31.1x45.1 cm)
Signed: lower right, "Herbert"
Reverse: on paper mount, "Ea-21/Plant #1309/Ea-19"; WPA label 43.24

__Cutting off Ball__ ca. 1940
Watercolor on paper mounted on cardboard 11⅞"x9¾" (30.2x24.8 cm)
Unsigned
Reverse: WPA label 43.25

__Waiting for the Carry-in-Boy__ ca. 1940
Watercolor on paper 11⅞"x9¾" (30.2x24.8 cm)
Signed: center bottom, "Herbert"
Reverse: inscribed on backing, "1307-Ea 17/Waiting for the Carry in Boy/ H. Silberman/10x12 WC."; WPA label 43.26

__Breaking Wall__ 1940
Watercolor on paper mounted on cardboard 12⅛"x17¾" (30.8x45.1 cm)
Signed and dated: lower right, "H. Silberman '40"
Reverse: on mount, "Breaking down wall/#1309/Ea.14"; WPA label 43.27

Prying ca. 1940
Watercolor on paper mounted on cardboard 9¾″x12⅞″ (24.8x32.7 cm)
Signed: lower right, "Herbert"
Reverse: WPA label; Inscribed, "5A/310/rying/ilberman/15x18xW.C."
43.28

SIMPSON, MAXWELL STEWART (b. 1896)

Street Scene, Moret, France 1929
Oil on canvas 24″x30″ (61.0x76.2 cm)
Signed and dated: lower right, "Simpson/Moret les Sablons '29"
Reverse: pencil inscription on left stretcher, "#465. Simpson"; label,
Marie Harriman Gallery, New York, N.Y.; label, Grand Central Art
Galleries, New York, N.Y.
Ex-collection: donor, Newark, N.J.
Gift of Arthur F. Egner 1933 33.274

Summer Colony 1934
Oil on canvas 26″x32″ (66.0x81.3 cm)
Signed: lower left, "Maxwell Simpson"
Allocated by the U.S. Treasury Department, PWAP 1934 34.309

Date supplied by artist.

Portrait of Gus Mager (1878-1956) 1938
Pencil on paper 10½″x7⅛″ (26.7x18.1 cm)
Signed: lower left, "Maxwell Stewart Simpson Dec 3rd 1938"; lower
left, in subject's hand, "Gus Mager"
Ex-collection: acquired from the artist, Scotch Plains, N.J.
Purchase 1961 Rabin and Krueger American Drawing
Fund 61.453

*This drawing is in a single frame along with Simpson's drawings of
Joseph Stella (62.9) and Louis Eilshemius (62.8).*

Portrait of Louis Eilshemius (1864-1941) 1938
Pencil on paper 11″x8½″ (27.9x21.6 cm)
Signed and dated: right of center, "Maxwell Stewart Simpson/Sept. 30,
1938"; center, in subject's hand, "Louis M. Eilshemius"
Ex-collection: donor, Newark, N.J.
Gift of Rabin and Krueger Gallery 1962 62.8

Portrait of Joseph Stella (1880-1946) 1939
Pencil on paper 9⅜″x8½″ (23.8x21.6 cm)
Signed: lower right, "Maxwell/Stewart/Simpson"; lower left, in
subject's hand, "Joseph Stella/June 22 1939"
Ex-collection: donor, Newark, N.J.
Gift of Rabin and Krueger Gallery 1962 62.9

SIMPSON-MIDDLEMAN Marshall Simpson (1900-1958)
Roslyn Middleman (b. 1929)

Painting: Series 2 #5 1951
Oil on masonite 29½″x21½″ (74.9x54.6 cm)
Reverse: signed individually, "Marshall Simpson/Roslyn Middleman/
Oil"; label, John Heller Gallery (lent by Newark Museum)
Ex-collection: acquired from Marshall Simpson, Middletown, N.J.
Purchase 1952 Mrs. Felix Fuld Bequest Fund 52.27

*Artists supplied date of Spring, 1951. Purchased from the Museum's 1st
triennial exhibition,* Work by New Jersey Artists, *1952.*

Sea Rain 1958
Oil on masonite 20″x33¼″ (50.8x84.5 cm)
Unsigned
Reverse: inscribed, "Sea Rain/Simpson-Middleman/1958"; label,
John Heller Gallery (#3276)
Ex-collection: donor, Middletown, N.
Gift of Mrs. Marshall Simpson 1964 64.6

SINGER, WILLIAM EARL (b. 1909)

Young Student 1936
Watercolor on paper 21⅞″x17⅝″ (55.6x44.8 cm)
Signed and dated: lower right, "William Earl Singer '36"
Reverse: label on backing, WPA
Allocated by the WPA Federal Art Project 1945 45.253

SIPORIN, MITCHELL (1910-1976)

*Coal Pickers** 1936
Gouache on paper 20⅛″x29⅞″ (51.1x75.8 cm)
Signed and dated: lower left, "Mitchell Siporin '36"
Reverse: label on backing, Museum of Modern Art 39.1824; label on
backing, WPA, #9950
Allocated by the WPA Federal Art Project through the Museum of
Modern Art 1943 43.163

Yard Gates (Back O' the Yards) 1937
Gouache on cardboard 20″x29¼″ (50.8x74.3 cm)
Signed and dated: lower right, "Mitchell Siporin '37"
Reverse: label on backing, WPA
Allocated by the WPA Federal Art Project 1945 45.254

SLOAN, JOHN (1871-1951)

*Picture Shop Window** (Shop Window) 1907
Oil on canvas 32″x25⅛″ (81.3x63.8 cm)
Signed: lower left, "John Sloan"
Reverse: handwritten label on stretcher, "Picture Shop Window/by
John Sloan/price_____"; label, *The Eight,* Museum of Modern Art, 1964
Ex-collection: purchased from the artist, New York, N.Y.
Gift of Mrs. Felix Fuld 1925 25.1163

Date supplied by artist.

*Church of the Penitentes, Chimayo**
(Church at Chimayo; Church, New Mexico) 1922
Oil on canvas 19⅞″x26⅛″ (50.5x66.4 cm)
Signed: lower right, "_____ John Sloan_____"
Reverse: inscribed and dated on stretcher
top, "Church of the Penitentes Chimayo '22"; on bottom stretcher,
"_____ John Sloan_____"
Ex-collection: purchased from the artist, New York, N.Y.
Purchase 1925 25.1164

Purchased with funds donated by Mrs. Felix Fuld.

SLOBODKINA, ESPHYR (b. Russia 1914)

Japanese Abstraction mid or late 1950's
Oil on masonite 33″x26¾″ (83.8x67.9 cm)
Signed: lower right, "Esphyr Slobodkina"
Reverse: torn label, Joseph Heller Gallery
Ex-collection: with Joseph Heller Gallery; to donor, Nutley, N.J.
Gift of Mrs. A. G. Van Stolk 1962 62.112

Artist supplied approximate date.

SMEDLEY, WILLIAM T. (1858-1920)

Portrait of Gov. Franklin Murphy (1846-1920), **his father William**
(1821-1905) **and his son Franklin Jr.** (1873-1932) 1911
Oil on canvas 91″x61½″ (231.0x156.2 cm)
Signed and dated: lower left (indistinct), "W. T. Smedley 1911"
Ex-collection: descended in family to donor, Mendham, N.J.
Gift of Mrs. Franklin Murphy 1947 47.54

SMIBERT, JOHN (1688-1751)

*Portrait of Reverend Ebenezer Turell** (1701-1778) 1734
Oil on canvas 29½″x24½″ (74.9x62.2 cm)
Unsigned
Ex-collection: Reverend Benjamin Colman (subject's father-in-law); to
Reverend Ebenezer Turell (by bequest, 1774); to his great-nephew
Turell Tufts (by bequest 1778); to First Parish, Medford, Mass. (by
bequest 1842), later Unitarian Universalist Church of Medford (1960)
Purchase 1972 Katherine Coffey Fund and The Members'
Fund 72.347

*Listed as #105 in Smibert's notebook. Reverend Turell was the second
minister of First Parish, Medford, Mass. Mr. and Mrs. Samuel Turell
Armstrong borrowed this painting from the church and hung it in their
home, 1842-1882. (Corres.)*

SMILLIE, GEORGE H. (1840-1921)

Landscape
Oil on wood 11″x9″ (27.9x22.9 cm)
Signed: lower left, "Geo. H. Smillie"
Ex-collection: donor, Scotch Plains, N.J.
Bequest of Dr. J. Ackerman Coles 1926 26.1287

SMITH, GEORGE (b. 1942)

Untitled 1971
Ink on paper 21½″x31¼″ (54.7x79.2 cm)
Signed and dated: lower right, "George Smith 71"
Ex-collection: with Reese Palley Gallery, New York, N.Y.
Purchase 1971 Edward F. Weston Bequest Fund 71.100

SMITH, HENRY PEMBER (1854-1907)

Canal in Venice
Oil on canvas 16″x12½″ (40.6x31.8 cm)
Signed: lower left, "Henry P. Smith"
Ex-collection: donor, Scotch Plains, N.J.
Bequest of Dr. J. Ackerman Coles 1926 26.1209

SMITH, TONY (b. 1912)

Untitled 1958
Oil on canvas 60″x48¼″ (152.4x122.5 cm)
Unsigned
Ex-collection: donor, New York, N.Y.
Gift of Mrs. Penelope S. Bradford 1975 75.67

SMITH, VINCENT D. (b. 1929)

Marcus Garvey (Black Moses – 1971) 1971
India ink and grey wash on paper sight 22″x27¾″ (55.9x70.5 cm)
Signed: lower right, "Vincent"
Ex-collection: the artist, Brooklyn, N.Y.
Gift of the Prudential Insurance Company of America 1971 71.102

SOLOMON, HYDE (b. 1911)

*****Coast** 1958
Oil on canvas 56″x50″ (142.2x127.0 cm)
Signed: lower right, "Hyde Solomon"
Ex-collection: with Poindexter Gallery, New York, N.Y.
Purchase 1961 Felix Fuld Bequest Fund 61.19

Date supplied by artist. Purchased from the Museum's 4th triennial exhibition, Work by New Jersey Artists, *1961; exhibited in artist's one-man show at Poindexter Gallery, 1960.*

SOMERS, C. (19th century)

*****Orange Mountains N.J.** (Orange Mountain Landscape)
Oil on canvas 23¾″x32″ (60.3x81.3 cm)
Unsigned
Reverse: inscribed on stretcher, "Orange Mountains N.J. by
C. Somers"; label, Vose Galleries
Ex-collection: Eustis estate, Brookline, Mass.; to donor, Boston, Mass.
Gift of Vose Galleries 1956 56.170

Recorded as "signed on stretcher," but the signature is not necessarily by the artist. Previous attribution to Carl August Sommers is unsubstantiated.

SOMMER, DR. OTTO (active 1851-68)

Voyage of Life: Youth after Thomas Cole ca. 1860
Oil on canvas 31″x46¼″ (78.7x117.5 cm)
Signed: lower right, "Dr. O. Sommer/Newark N.J."
Ex-collection: donors, Shawnee-on-Delaware, Pa.
Gift of Mr. and Mrs. Edgar Sittig 1963 63.139

Voyage of Life: Childhood after Thomas Cole ca. 1860
Oil on canvas 31″x46¼″ (78.7x117.5 cm)
Signed: lower right, "Dr. O. Sommer/Newark N.J."
Reverse: no pertinent date recorded prior to relining, 1966
Ex-collection: donors, Shawnee-on-Delaware, Pa.
Gift of Mr. and Mrs. Edgar Sittig 1963 63.140

SONN, ALBERT H. (1867-1936)

Glebe House, Charleston, S.C.
Watercolor on paper mounted to cardboard 15″x22¼″ (38.1x56.5 cm)
Signed: lower right, "Albert H. Sonn"
Inscribed: lower left, "Old Bishopstead, S.C."
Ex-collection: acquired from the artist, New York, N.Y.
Purchase 1930 Felix Fuld Bequest Fund 30.465

Sonn was once head artist at the American Lithography Company. He did many architectural studies including some of Newark. (files)

Old Alden House Doorway
Watercolor on paper 22½″x15⅜″ (64.8x39.1 cm)
Signed: lower right, "Albert H. Sonn"
Ex-collection: donor, New York, N.Y.
Gift of the artist 1931 31.1067

A detail of the building depicted by Sonn in 31.987.

SOULE, CHARLES (19th century)

Portrait of Lydia Lavina Ward (1821-1858) 1860
Oil on canvas 24″x20″ (61.0x50.8 cm; oval)
Reverse: inscribed on stretcher, "Miss LL Ward/Painted by/Charles
Soule/at Newark N.J./Oct. 1860"
Ex-collection: remained in family, Newark, N.J.
Bequest of Marcus L. Ward, Jr. 1921 21.1757

See Cuypers 21.1759.

SOYER, MOSES (b. Russia 1899-1974)

*****Dancers** 1943
Oil on canvas 40″x16″ (101.6x40.6 cm)
Signed and dated: lower right, "MSoyer•43•"
Ex-collection: donors, Plainfield, N.J.
Gift of Mr. and Mrs. Benjamin E. Tepper 1946 46.163

Purchased by donors from a 1944 A.C.A. Galleries (New York) exhibition. Artist said the model for both figures was his wife Ida. (files)

Portrait of Abraham Walkowitz (1878-1965) 1943
Oil on canvas 24″x20⅛″ (61.0x51.1 cm)
Signed and dated: lower left, "M Soyer/1943"
Reverse: inscribed on stretcher, "Moses Soyer Portrait of Walkowitz"
Ex-collection: donor, New York, N.Y.
Gift of Abraham Walkowitz 1947 47.222

Executed for the exhibition, One Hundred Artists and Walkowitz, *Brooklyn Museum, 1944.*

Portrait of Joseph Stella (1877-1946) 1943
Oil on canvas 30″x24″ (76.2x61.0 cm)
Signed and dated: lower left, "M Soyer/-1943-"
Ex-collection: donor, Newark, N.J.
Gift of Rabin and Krueger Gallery 1960 60.598

According to the artist, on completion of the work Stella remarked, "this portrait expresses me – and the people who will look at it will understand why I painted Brooklyn Bridge." It was the portrait Stella preferred among several by Soyer. (files)

SOYER, RAPHAEL (b. Russia 1899)

***Fé Alf and Pupils** 1935
Oil on canvas 40"x37⅞" (101.6x95.2 cm)
Signed: lower right, "Raphael Soyer"
Reverse: label, *Raphael Soyer*, Whitney Museum of American Art, 1967
Ex-collection: with Valentine Gallery, New York, N.Y.; Cooperative Galleries, Newark, N.J.
Purchase 1937 Felix Fuld Bequest Fund 37.5

A portrait of the modern dancer Fé Alf, who posed for Soyer. The students, however, are a composite of sketches Soyer made as he watched the dancers relaxing between rehearsals. Three preparatory studies are also owned by the Museum.

Date supplied by artist. Painting was in Soyer's one-man show at the Valentine Gallery in 1935. (files)

Fé Alf and Pupils ca. 1935
Pencil on paper three drawings (framed together)
A 10½"x7⅜" (26.7x18.7 cm)
Signed: lower right, "Raphael Soyer"
Inscribed: center right: "Fé Alf"
B 10⅜"x7¼" (26.4x18.4 cm)
Signed: lower right, "Raphael Soyer"
C 10"x7⅜" (25.4x18.7 cm)
Signed: lower left, "Raphael Soyer"
Ex-collection: donor, Newark, N.J.
Gift of Rabin and Krueger Gallery 1957 57.54 A-C

SPADER, WILLIAM EDGAR (1875-?)

In Full Bloom ca. 1925
Oil on canvas 24"x20" (61.0x50.8 cm)
Signed: lower left, "W. E. Spader"
Ex-collection: donor, New York, N.Y.
Gift of Henry Wellington Wack 1927 27.402

Probably executed shortly before its first exhibition at the Gallery of Pratt Institute, Brooklyn, N.Y., February, 1925.

SPARKS, MRS. FRANCES A. (19th century)

Sketch of the Passaic River Near Newark
Pencil on paper 6½"x6½" (16.5x16.5 cm)
Inscribed: along bottom, "Sketch of the Passaic River Near Newark/by Mrs. Frances A Sparks."
Reverse: in pencil, "Mary Johnston married John Allen sister of J Johnston/of Hyde Park/Fanny Allen Sparks — was sister to/Julia Allen Channing — /both women of fine talents,&/beautiful, — graceful, — appearance/Lady Arnold wife of Sir Edwin/Arnold — Fanny Channing"
Ex-collection: donor, East Orange, N.J.
Gift of Miss Agnes S. Zimmermann 1946 46.175

SPARKS, GAR (1888-1954)

Small Interior 1950
Oil on cardboard 11¾"x15⅞" (29.8x40.3 cm)
Signed: lower right, "Gar Sparks"
Reverse: inscribed, "Gar Sparks/1950"
Ex-collection: acquired from artist's widow, Amalia Ludwig, East Orange, N.J.
Purchase 1970 Thomas L. Raymond Bequest Fund 70.75

SPEICHER, EUGENE (1883-1962)

***The Violinist** ca. 1929
Oil on canvas 50"x40" (127.0x101.6 cm)
Signed: lower right, "Eugene Speicher"
Reverse: label, University of Illinois, *Music in Art*, 1950; label, Annual Exhibition of Painting and Sculpture, Pennsylvania Academy of The Fine Arts, 1954 (lent by Frank Rehn Gallery)
Ex-collection: purchased from artist ca. 1929-30 by donors, New York, N.Y.
Gift of Mr. and Mrs. Lesley G. Sheafer 1954 54.207

Date supplied by artist. Subject is the violinist Gaetane Britt. (files)

SPENCER, LILLY MARTIN (b. England 1822-1902)

***Portrait of Nicholas Longworth Ward** (1852-1857) ca. 1858-1860
Oil on canvas 50½"x40½" (128.3x102.9 cm)
Unsigned
Reverse: no pertinent data recorded prior to relining, 1972
Ex-collection: painting remained in family until bequeathed by the donor, Newark, N.J.
Bequest of Marcus L. Ward, Jr. 1921 21.1750

Robin Bolton-Smith and William Truettner in their catalog, Lilly Martin Spencer: The Joys of Sentiment, *National Collection of Fine Arts, 1973, suggest that this was a posthumous portrait, as evidenced by the dead flowers in a goblet inscribed with the child's name. They note similarity to Spencer's portrait of the four Ward children in use of the same rug and tablecloth. They further suggest that the Nicholas Ward portrait was substituted for a "fancy piece" commissioned in 1857.*

***Four Children of Marcus L. Ward** 1858-1860
Oil on canvas 92"x68½" (234.1x174.0 cm)
Unsigned
Reverse: no pertinent data recorded prior to relining, 1973
Ex-collection: painting remained in family until bequeathed by donor, Newark, N.J.
Bequest of Marcus L. Ward, Jr. 1921 21.1913

Anne Byrd Schumer established Spencer as the artist on documentary evidence (doctoral dissertation, Ohio State University, 1959). Date was based on artist's move to Newark in 1858 and death of Catherine in 1860. Schumer noted that Spencer generally did not sign or date works commissioned privately.

Children depicted are Joseph M. Ward (1841-1911), Marcus L. Ward, Jr. (1846-1920), Catherine A. Ward (1849-1860) and Frances B. Ward (1856-1864).

***War Spirit at Home** (Celebrating the Victory at Vicksburg) 1866
Oil on canvas 30"x32¾" (76.2x83.2 cm)
Signed and dated: lower left, "L.M. Spencer 1866"
Reverse: label, *The Civil War*, Boston Museum of Fine Arts, 1961; no pertinent data recorded prior to relining, 1973
Ex-collection: with Campbell's Frame Shop, Newark, 1866 (mentioned in *Newark Daily Advertiser*, June 12, 1860); with Victor Spark, New York, N.Y.
Purchase 1944 Wallace M. Scudder Bequest Fund 44.177

The artist's granddaughter, Mrs. Donald Gates, indicated that the woman depicted is probably a self portrait. (files)

Sketch for War Spirit at Home ca. 1865
Oil on cardboard 15"x10" (38.1x25.4 cm)
Unsigned
Inscribed: bottom, "A Study/by L. M. Spencer/Artist U.S.A."; lower left, "Painted by Lilly Martin Spencer/being her study of the mother/in her picture entitled/War Times at Home"; lower right, "Painted during/the Civil War/of the U.S.A./between the N. and S. States/M...."
Ex-collection: remained in artist's family; to artist's granddaughter, the donor, Rutherford, N.J.
Gift of Mrs. Donald Gates 1964 64.3

Child Playing with Fishbowl 1856
Oil on composition board 14¼"x11⅞" (36.2x30.2 cm; including arched top)
Signed and dated: lower right, "Lilly M. Spencer/1856"
Ex-collection: Victor Spark, New York, N.Y.; to donor, New York, N.Y. (possibly 1940's)
Gift of Mrs. George L. Cohen 1966 66.32

Companion to Spencer's Child Playing with Cat. *Robin Bolton-Smith and William Truettner suggest that both may have been studies for lithographs.*

Child Playing with Cat 1856
Oil on composition board 14¼"x11⅞" (36.8x30.2 cm; including arched top)
Signed and dated: lower right, "Lilly M. Spencer/1856"
Ex-collection: Victor Spark, New York, N.Y.; to donor, New York, N.Y. (possibly 1940's)
Gift of Mrs. George L. Cohen 1966 66.33

SPENCER, NILES (1893-1952)

*The Cove** 1922
Oil on canvas 28"x36" (71.1x91.4 cm)
Unsigned
Reverse: painting relined 1955; label, #5 in circulating exhibition, *Niles Spencer*, University of Kentucky, 1965; label, *Maine and Its Artists*, Museum of Fine Arts, Boston, 1963; label, circulating Spencer exhibition, Museum of Modern Art, 1954 (54.617); label, *Modern American Painting*, Stedlyk Museum, Amsterdam, 1950
Ex-collection: acquired from the artist, New York, N.Y.
Purchase 1926 The General Fund 26.4

Also published as Fish House. *The artist indicated a date of 1922 and said it should be titled* The Cove *(corres.), referring to Perkin's Cove, Ogunquit, Me., also depicted in Spencer 71.130, 71.140, 72.51 and 72.71. The work was #12 in the preliminary checklist for the University of Kentucky 1965 Spencer exhibition.*

THE CATHERINE BRETT SPENCER BEQUEST (71.112-142)

When Catherine Brett Spencer, Niles Spencer's second wife, died in 1971 she left to The Newark Museum all the paintings by her late husband that were then in her possession in Sag Harbor, N.Y. The following 31 works are believed to have always been owned by Spencer or his wife. Several, as indicated, were consigned at various times to The Downtown Gallery, but none is known to have actually changed ownership until this bequest. Assigned descriptive titles appear in quotes.

The University of Kentucky organized a circulating exhibition, *Niles Spencer*, in 1965. Richard B. Freeman wrote the catalogue, which included a preliminary checklist for a catalogue raisonné. The numbers on the reverse of the following works refer to this exhibition and Freeman's preliminary checklist. The dates of the then undated works included in the checklist were established by Freeman.

Bristol Harbor 1932
Oil on canvas 20"x26" (50.8x66.0 cm)
Signed: lower right, "Niles Spencer"
Reverse: label, exhibition #26, checklist #66; label, circulating Spencer exhibition, Museum of Modern Art, 1954 (lent by The Downtown Gallery); label, The Downtown Gallery, 1960 71.112

*Viaduct** 1929
Oil on canvas 18¼"x21½" (46.4x54.6 cm)
Unsigned
Reverse: label, exhibition #21, checklist #54 71.113

See Spencer 72.56

Study for Two Bridges ca. 1947
Oil on canvas 16⅛"x20¼" (41.0x51.4 cm)
Unsigned
Reverse: label, exhibition #92, checklist #44 71.114

One of two studies for Spencer's The Two Bridges *(1947) in the Roy Neuberger Collection. The other study (71.121) is less complete. Freeman entitled this study* Two Bridges, New York.

"Architectural Detail"
Oil on canvas 18"x21½" (45.7x54.6 cm)
Signed: lower left, "Niles Spencer" 71.115

This painting was found in disrepair at the Spencer home. It has since been restored.

Abstract Study 1922
Oil on canvasboard 21⅛"x18" (53.7x45.7 cm)
Signed and dated: bottom left, "N. Spencer/22; Abstract Study 1922"
Reverse: torn label, The Downtown Gallery, N.Y.C. 71.116

Probably #17 in the checklist and #8 in the exhibition.

Study for Factory Windows 1933?
Oil and pencil on canvasboard 11⅞"x15⅞" (30.2x40.3 cm)
Unsigned
Reverse: label, exhibition #29, checklist #72 71.117

This study is unfinished and has many notations of the colors to be used in specific areas.

*Study for The Watch Factory** ca. 1950
Gouache on cardboard 10½"x16" (26.7x40.6 cm)
Unsigned
Reverse: label, exhibition #57, checklist #109 71.118

Freeman entitled this study, Factory, Sag Harbor. The Watch Factory *of 1950 is in the Butler Institute of American Art, Youngstown, O.*

*Above the Excavation #3** 1950
Oil on canvasboard 15½"x10½" (39.4x26.7 cm)
Signed: lower left, "Niles Spencer"
Reverse: label, exhibition #59, checklist #112; label, The Downtown Gallery; label, Columbus Gallery of Fine Arts 71.119

The other two versions of Above the Excavation *(1950) are at the William H. Lane Foundation, Leominster, Mass., and at the Herbert F. Johnson Museum of Art, Cornell University, Ithaca, N.Y.*

*New York Alley** 1922?
Oil on cardboard 11⅞"x15⅞" (30.0x41.0 cm)
Signed: lower left, "Niles Spencer"
Reverse: label, Exhibition #6, checklist #13 71.120

Study for Two Bridges ca. 1947
Oil and pencil on canvasboard 9"x14½" (23.0x36.8 cm)
Unsigned 71.121

See Spencer 71.114

"Mural Study" ca. 1937
Oil on wood 11⅞"x16" (30.1x40.6 cm)
Unsigned 71.122

Probably a sketch for Spencer's mural in the Aliquippa, Pa., Post Office. He received the commission for that work from the U.S. Treasury Department's Section of Fine Arts in 1937. See Spencer 72.57.

*"Houses on a Hill"** 1917
Oil on wood 11⅞"x16⅛" (30.1x41.0 cm)
Signed and dated: lower left, "N. Spencer 17" 71.123

Study for Edge of the City ca. 1943
Oil on canvasboard 9"x12" (22.9x30.5 cm)
Unsigned 71.124

Edge of the City (1943) is in the collection of the Hirshhorn Museum and Sculpture Garden, Washington, D.C.

Street in Bermuda
Oil on canvasboard 17⅞"x24" (45.4x61.0 cm)
Unsigned 71.125

Checklist #52.

Washington Square 1923?
Oil on canvasboard 11¾"x16" (29.8x40.6 cm)
Signed: lower left, "Niles Spencer"
Reverse: inscribed on stretcher, "'Washington Square' Niles Spencer" (signature in artist's hand but not necessarily the title) 71.126

Checklist #20.

Loaves and Fishes 1933
Oil on canvas 20"x30" (50.8x76.2 cm)
Signed: lower right, "Niles Spencer"
Reverse: inscribed on stretcher, "Loaves and Fishes/ N. Spencer/'33" 71.127

Checklist #69.

"Still Life – Gravy Boat" ca. 1920's
Oil on wood 8½"x13" (21.6x33.0 cm)
Signed: lower right, "Niles Spencer" 71.128

The gravy boat is a frequent Spencer prop. Its shape can be seen in
Interior – Still Life of 1925 in the Mr. and Mrs. Edward Greenbaum
collection, Princeton, N.J.

Truro Hills #2 1932
Oil on canvas 12"x18⅜" (30.5x46.7 cm)
Unsigned
Reverse: inscribed on stretcher, "Truro Hills #2/1932" 71.129

Checklist #62.

Study for The Cove ca. 1922
Oil on cardboard 8"x10¼" (20.3x26.0 cm)
Unsigned 71.130

See Spencer 26.4

Study for Waterfront Mill ca. 1940
Pencil on cardboard 12"x16" (30.5x40.6 cm)
Unsigned 71.131

Waterfront Mill (1940) is in the collection of the
Metropolitan Museum of Art, New York, N.Y.

"Houses and Mountain" ca. 1921-22
Oil on cardboard 12"x15⅞" (30.5x40.3 cm)
Signed: lower left, "N. Spencer"
Reverse: inscribed, "Niles Spencer/Rome" 71.132

Possibly a different view of the structures in Spencer's drawing, 72.53.
Probably from his first European trip, 1921-22.

"Lush Forest Scene"
Oil on cardboard 12"x16" (30.5x40.6 cm)
Unsigned 71.133

"Industrial Scene"
Oil on canvasboard 12"x16" (30.5x40.6 cm)
Signed: lower left, "Niles Spencer" 71.134

"Still Life with Pitcher and Two Pieces of Fruit"
Oil on canvasboard 8⅝"x10⅝" (21.9x27.0 cm)
Unsigned 71.135

"Violent Sea Scene"
Oil on wood 8⅛"x10⅜" (20.6x26.4 cm)
Unsigned 71.136

"View of Blue Sea"
Oil on canvas mounted to cardboard 8¼"x10⅜" (20.9x26.4 cm)
Unsigned 71.137

"Corner of a Room"
Oil and pencil on canvasboard 15⅞"x12" (40.3x30.5 cm)
Unsigned 71.139

"Harbor View"
Oil on cardboard 12"x15⅞" (30.5x40.3 cm)
Unsigned 71.140

Possibly a view of Ogunquit, Me. See Spencer 26.4

"Rural Scene"
Oil on wood 12"x15¾" (30.5x40.0 cm)
Unsigned 71.141

"Still Life with Pitcher, Book and Fruit"
Oil on canvasboard 11⅞"x16" (30.2x40.6 cm)
Unsigned 71.142

THE MARY REFFELT, CHRISTOPHER HARRINGTON GIFT
(72.48-86)

Catherine Spencer bequeathed the residual aspects of her estate,
including her husband's drawings, to her sister, Mary Brett Reffelt, and
to her nephew, Christopher Brett Harrington. In 1972 Mrs. Reffelt and
Mr. Harrington gave to the Museum the following drawings as well as a
Spencer lithograph (72.80) and a series of photos of steel mills Spencer
had collected (72.81). Assigned descriptive titles appear in quotes.

"Street Scene with Horse Cart"
Pencil on paper 15½"x12" (39.4x30.5 cm)
Unsigned 72.48

***"Table, Chairs, with Sea Beyond"**
Pen and ink on paper 13¼"x10⅛" (33.7x25.7 cm)
Signed: lower left, "Niles Spencer" 72.49

"Village on Different Levels"
Pencil on paper 10"x7⅝" (25.4x19.4 cm)
Unsigned 72.50

Study of the Cove at Ogunquit (Looking Toward the Cove –
Ogunquit) ca. 1918
Pencil drawing on paper 7⅛"x8⅝" (18.1x21.9 cm)
Unsigned
Reverse: on frame, label, The Downtown Gallery 72.51

See Spencer 26.4

"Town with Wall"
Pencil on paper 12⅜"x9⅞" (31.4x25.1 cm)
Unsigned 72.52

"Pueblo-type Buildings"
Pencil on paper 7¾"x10⅛" (19.7x25.4 cm)
Signed: lower right, "Niles Spencer '_____' " 72.53

See Spencer 71.132

"Hallway and Window"
Pencil on paper 9⅞"x7⅝" (25.1x19.4 cm)
Unsigned 72.54

"Abstracted Buildings"
Pencil on paper 9¼"x7⅞" (25.5x20.0 cm)
Unsigned 72.55

Study for Viaduct ca. 1929
Pencil on paper 12⅝"x9¼" (32.0x23.5 cm)
Unsigned 72.56

Apparently a preparatory study for the oil painting Viaduct (71.113).

"Steel Mills"
A Pencil on paper 10½"x16" (26.7x40.6 cm)
B Pencil on tracing paper 13¾"x16¾" (35.0x42.7 cm)
Unsigned 72.57 A & B

Study for the mural in the Aliquippa, Pa., Post Office. See Spencer 71.122.

"Bar and Bartender"
Pencil on paper 13¼"x10¼" (33.7x26.0 cm)
Unsigned 72.58

"Houses on Street, Mountains Behind"
Pencil on paper 16⅞"x21" (42.9x53.3 cm)
Unsigned 72.59

"Table, Rocking Chair, Fireplace" ca. 1920
Pencil drawing on paper 8⅛"x10¼" (20.6x26.0 cm)
Unsigned 72.60

Probably a sketch of the artist's Maine studio in the early 1920's when he
lived year-round at Ogunquit. It includes a view of an Ogunquit
scene on an easel.

"Stylized Tree and Buildings"
Pencil on paper 9⅜"x12" (23.8x30.5 cm)
Unsigned 72.61

"Reclining Male Figure"
Pencil on paper 8"x9⅞" (20.3x25.1cm)
Unsigned 72.62

"Interior – Two Men at Table"
Pencil on paper 13¾"x8½" (34.9x21.6 cm)
Unsigned 72.63

"Man on Couch"
Pencil on paper 9½"x12¼" (24.1x31.1 cm)
Unsigned 72.64

"Table, Chairs, Large Plant"
Pencil on paper 10"x7¾" (25.4x19.7 cm)
Unsigned 72.65

"Skyscrapers"
Pencil on paper 5⅛"x7½" (13.0x19.1 cm)
Unsigned 72.66

"Man in Bathing Costume with Hat"
Pen and ink 12⅝"x9¼" (32.1x23.5 cm)
Unsigned 72.67

"Arches and Stairs"
Pencil drawing on paper 13⅛"x9¼" (33.3x23.5 cm)
Unsigned 72.68

An abstracted view of a building with arches relating to Spencer 72.53.

"Self Portrait"
Pen and ink 16⅞"x14½" (42.9x36.8 cm)
Unsigned 72.69

"Industrial Plant"
Pencil on brown paper 15"x11" (38.1x27.9 cm)
Unsigned ("#16" in upper left) 72.70

"Buildings, Flowers"
Pencil drawing on paper 8⅜"x10¼" (21.3x26.0 cm)
Unsigned 72.71

See Spencer 26.4

"Table, Chairs, Three Plates"
Pencil drawing on paper 13"x10" (33.0x25.4 cm)
Unsigned 72.72

"Preparatory Study of Buildings"
Pencil and crayon drawing 19"x25" (48.3x63.5 cm)
Unsigned 72.75

A preparatory study for an undetermined oil. Spencer has written color notations as a guide for the painting of each building.

"Row of Buildings"
Pen and ink drawing on paper 9¾"x7⅞" (24.8x20.0 cm)
Unsigned 72.79

Similar buildings are found in Spencer's Ogunquit pictures, including The Cove *(26.4).*

"Spiral notebook"
Pencil on paper (14 sheets, 7 sketches) 16½"x13" (41.9x33.0 cm)
Unsigned 72.82

"Hand Holding Scroll" 1912
Charcoal on paper 18⅞"x12¼" (47.9x31.1 cm)
Signed and dated: lower left, "Niles M Spencer-/-1912-"
Reverse: in artist's hand, "Niles Spencer/30 Summit St./
Pawtucket Rd./18 yrs" 72.85

SPINDLER, LOUIS (b. 1920)

***Houses in Belleville** 1951
Oil on canvas 23⅞"x40⅛" (60.6x101.9 cm)
Signed and dated: lower right, "Louis Spindler Dec. 26, 1951"
Reverse: horizontal inscription on middle stretcher, "Louis Spindler
Houses in Belleville/4 Melman Ter Maplewood, N.J."; frame inscribed,
(title, artist, date)
Ex-collection: acquired from the artist, Maplewood, N.J.
Gift of the Perlman Family in memory of Minnie and Louis Perlman
1977 77.184

Iridescent 1965
Oil on canvas 60"x47⅞" (152.2x121.6 cm)
Signed and dated: lower right, "L. Spindler '65"
Ex-collection: Mrs. Esther Seid, Maplewood, N.J.
Gift of Harold Graber in memory of Sylvia Graber 1977 77.185

SPRUCE, EVERETT FRANKLIN (b. 1908)

Owl and Fish 1944
Oil on masonite 18"x24" (45.7x61.0 cm)
Signed: lower right, "E. Spruce"
Reverse: inscribed and dated, "'Owl and Fish'/Oil 18x24/1944"; label,
Edith and Milton Lowenthal Collection
Ex-collection: with Levitt Gallery, New York, N.Y.;
to donors, New York, N.Y. (1945)
Gift of Mr. and Mrs. Milton Lowenthal 1949 49.349

STAMOS, THEODOROS (b. 1922)

Grey Divide ca. 1960
Oil on canvas 68"x60" (172.8x152.4 cm)
Unsigned
Reverse: on stretcher (not in artist's hand), "Stamos"
Ex-collection: acquired by donor from artist through
Marlborough Gallery, New York, N.Y.
Gift of Clinton Wilder 1972 72.339

***Moon Dunes** 1947
Oil on masonite 10"x38" (25.4x96.5 cm)
Signed and dated: lower left, "T. Stamos '47"
Reverse: inscribed, "Stamos Moon Dunes"
Ex-collection: donor, New York, N.Y.
Gift of Mrs. Betty Parsons 1972 72.346

***Tundra Sun-Box** 1969
Acrylic on canvas 70"x48" (177.8x121.9 cm)
Reverse: on stretcher, "Tundra Sun-Box 1969 (arrow) Top Stamos";
stamp and label, André Emmerich Gallery, New York, N.Y.
Ex-collection: André Emmerich Gallery, New York, N.Y.;
to donor, Oldwick, N.J.
Gift of James L. Johnson 1973 73.7

Untitled ca. 1955
Oil on paper 20¾"x22½" (52.7x57.2 cm)
Signed: lower left, "Stamos"
Ex-collection: the artist; to Tirca Karlis, New York, N.Y.;
to donor, Oldwick, N.J.
Gift of Mrs. Esther Underwood Johnson 1973 73.106

STANLEY, BOB (b. 1932)

Apollo 1964
Acrylic on canvas 32¼"x26" (81.9x66.0 cm)
Signed and dated: "Stanley/64"
Ex-collection: donors, New York, N.Y.
Gift of Mr. and Mrs. Paul Waldman 1977 77.189

STEARNS, JUNIUS BRUTUS (1810-1885)

Portrait of Earl L. Meacham 1862
Oil on canvas 30"x25" (76.2x63.5 cm)
Unsigned
Reverse: label, "Portrait of Earl L. Meacham/Painted by J. B. Stearns NA./in 1862. Presented to Newark/Library by his/sister Mabel Meacham/of Bloomfield/N.J."; on canvas, caricature study of man in profile
Ex-collection: Mabel Meacham, Bloomfield, N.J.; to Newark Free Public Library
Transferred from the Newark Free Public Library 1939 39.493

This work is presumed to have entered the Library collection prior to formation of the Newark Museum in 1909.

STELLA, JOSEPH (b. Italy 1877-1946)

**Factories at Night — New Jersey* 1929
Oil on canvas 29"x36¼" (73.7x92.1 cm)
Signed: lower right, "Joseph Stella"
Reverse: inscribed, "Joseph Stella/New York April 1929"; torn label, "Cooperative Gallery, Newark, N.J."; label, *"From Synchronism Forward,* AFA, 1967-68"; stamped on stretcher, "Cooperative Gallery"
Ex-collection: purchased from Cooperative Gallery, Newark, N.J.
Purchase 1936 Thomas L. Raymond Bequest Fund 36.534

Irma Jaffee suggested "ca. 1921" on stylistic grounds.

**The Voice of the City of New York Interpreted* 1920-22
Five works, all oil and tempera on canvas, executed between 1920 and 1922. Arranged from left to right as follows:

A The Port (The Harbor, The Battery)
88½"x54" (224.8x137.2 cm)
Unsigned

B The White Way I
88½"x54" (224.8x137.2 cm)
Signed: lower left, "Jos. Stella"

C The Skyscrapers (The Prow)
99¾"x54" (253.4x137.2 cm)
Signed: lower right, "Joseph Stella"

D The White Way II (Broadway)
88½"x54" (224.8x137.2 cm)
Signed: lower right, "Stella"
Reverse: inscribed on canvas prior to relining, "Painting/by/Joseph Stella"

E The Bridge (Brooklyn Bridge)
88½"x54" (224.8x137.2 cm)
Unsigned

Ex-collection: purchased from the Cooperative Gallery, Newark, N.J.
Purchase 1937 Felix Fuld Bequest Fund 37.288

All five canvases underwent restoration between 1970 and 1974. The group, planned as a unit, was featured in Stella's 1923 one-man exhibition at the Gallery of Société Anonyme. A preliminary sketch is in the Yale University Art Gallery. There are five other versions (1919-1941) of The Brooklyn Bridge.

**The Creche* (The Holy Manger) ca. 1929-33
Oil on canvas 61"x77" (154.9x195.6 cm)
Signed: right of center, "Joseph Stella"
Reverse: two labels, *Montra Internazionale d'Art Sacro,* Rome, 1933 (lent by the artist)
Ex-collection: acquired from the artist, New York, N.Y.
Purchase 1940 Wallace M. Scudder Bequest Fund 40.242

Irma Jaffee suggested the title The Holy Manger. *She noted that the painting may have been prepared for the exhibition of sacred art in Rome (verified by labels on reverse), and that the painting was executed shortly before that exhibition, ca. 1933. The exhibition catalogue for Stella's 1939 retrospective at The Newark Museum gives a date of 1929.*

Red Flower on Blue Ground
Crayon and pencil on paper 16¾"x11½" (42.5x29.2 cm)
Signed: lower left, "Joseph Stella"
Reverse: label on backing, "Cooperative Gallery"
Ex-collection: Cooperative Gallery, Newark, N.J.; to donor, Newark, N.J.
Gift of Katherine Coffey 1942 42.233

Five Petal Yellow Flower on Grey Ground
Silverpoint and crayon on paper 19¾"x13" (50.2x33.0 cm)
Signed: lower left, "Joseph Stella"
Ex-collection: private collection, Newark, N.J.
Anonymous gift 1943 43.234

Portrait of Abraham Walkowitz (1878-1965) 1943
Oil on canvas 20½"x16¼" (52.1x41.3 cm)
Signed: lower right, "Jos. Stella"
Reverse: inscribed on stretcher, "Christmas, 1943"
Ex-collection: donor, New York, N.Y.
Gift of Abraham Walkowitz 1947 47.217

Executed for the exhibition, One Hundred Artists and Walkowitz, *Brooklyn Museum, 1944.*

Seated Old Woman ca. 1910
Pencil on brown paper 10⅞"x8⅜" (27.6x21.3 cm)
Signed: lower right, "Joseph Stella"
Ex-collection: Rabin and Krueger Gallery, Newark, N.J.
Purchase 1963 Rabin and Krueger American Drawing Fund 63.72

Drawing is #18 in book of Stella drawings published by Rabin and Krueger Gallery, 1962. Date supplied by Irma Jaffee. (corres.)

Lillies (French Lillies) 1920's
Oil on canvas 18⅞"x15⅛" (47.9x38.4 cm)
Signed: lower right, "J. Stella"
Reverse: no pertinent data recorded prior to relining, 1959
Ex-collection: Mr. and Mrs. John C. Thompson, Morristown, N.J. (purchased ca. 1939)
Gift of Mrs. John C. Thompson in memory of John C. Thompson, a Trustee of The Newark Museum 1967 67.53

Date supplied by donor.

STERNE, HEDDA (b. Romania 1916)

Signs #19 1978
Ink on paper 7"x5" (17.8x12.7 cm)
Reverse: "Hedda Sterne/1978"
Ex-collection: with Betty Parsons Gallery, New York, N.Y.
Purchase 1978 The Members' Fund 78.88

STETTHEIMER, FLORINE (1871-1944)

**Flower Piece* ca. 1921
Oil on canvas 25"x30" (63.5x76.2 cm)
Signed: center of vase (monogram)
Reverse: label on backing, "MOMA, #46.1426"; label, *"American Still Life Painting,* AFA, 1967-68"; inscribed on frame (not in artist's hand), top, "1921"; bottom, "Florine Stettheimer"
Ex-collection: acquired from the artist by donor, New York, N.Y.
Anonymous gift 1944 44.176

Tentative date determined from notation on back of frame although notation is not in artist's hand.

STEVENS, EDWARD JOHN, JR. (b. 1923)

Palisades #3 (Palisades) 1943
Gouache on paper 20"x14¾" (50.8x37.5 cm)
Signed and dated: lower right, "Edward John Stevens. Jr. 1943"; lower left on image, "Edward John/Stevens Jr./1943"
Ex-collection: Weyhe Gallery, New York, N.Y.
Purchase 1944 Sophronia Anderson Bequest Fund 44.166

The Archaic Smelters (The Metal Workers) 1944
Watercolor on paper 19½"x23⅜" (49.5x59.4 cm)
Signed and dated: lower right, "Edward John Stevens.Jr.1944--"; lower left, "The Archaic Smelters"
Ex-collection: with Weyhe Gallery, New York, N.Y.; to donors, New York, N.Y.
Gift of Mr. and Mrs. Milton Lowenthal 1946 46.172

Dark Saint 1945
Gouache on paper 23¼"x19⅞" (59.1x50.5 cm)
Signed and dated: lower left, "Edward John Stevens.Jr.1945"
Ex-collection: with Weyhe Gallery, New York, N.Y.; to donor, Gladstone, N.J.
Gift of Mrs. C. Suydam Cutting 1951 51.151

STILES, JAMES (19th century)

Portrait of Mrs. Peter Van Riper Van Houten
[Mary A. Cadmus Boon] (1839-1875)
Oil on canvas 25½"x21½" (64.8x54.6 cm)
Unsigned
Ex-collection: the sitter; to her daughter, the donor, Orange, N.J.
Gift of Mrs. C. Brookfield Condit 1947 47.215

Correspondence states subject was painted posthumously from a photograph by a Paterson, N.J. artist, James Stiles. The Paterson City Directory of 1874-75 lists James Stiles, artist, 104 Main Street. Mrs. Van Houten lived in Paterson at the time of her death.

STOCK, JOSEPH WHITING (1814-1855)

*Portrait of Jasper Raymond Rand** (b. 1837-?) 1844
Oil on canvas 46"x41" (116.8x104.1 cm)
Ex-collection: remained in subject's family until donated by his daughter, Montclair, N.J.
Gift of Mrs. Henry Lang 1935 35.40

Stock was first associated with this painting by Paul Rovetti of the University of Connecticut. (files) The attribution was confirmed by an entry on page 63 of Stock's 1844 diary: "Aug. 20 Removed to Westfield and took/a room over the Bank where I/painted/Jasper R. Rank son 38-46 A.B." The diary is owned by the Connecticut Valley Historical Museum, Springfield, Mass.

STREET, ROBERT (1796-1865)

Portrait of an Unidentified Man 1829
Oil on canvas 30"x25" (76.2x63.5 cm)
Signed: lower left, "R.Street/1829"
Ex-collection: donors, New York, N.Y.
Gift of Colonel and Mrs. Edgar W. Garbisch 1951 51.122

Correspondence from Colonel Garbisch established the relationships of the four Street portraits. The sitter was the husband of 51.123 and the brother of 51.125.

Portrait of an Unidentified Woman 1829
Oil on canvas 29¾"x24⅞" (75.6x63.2 cm)
Signed: lower right, "R.Street/1829"
Ex-collection: donors, New York, N.Y.
Gift of Colonel and Mrs. Edgar W. Garbisch 1951 51.123

Wife of 51.122.

*Portrait of an Unidentified Man** 1830
Oil on canvas 30"x25" (76.2x63.5 cm)
Signed: lower left, "By R.Street/Philada./1830"
Reverse: no pertinent data recorded prior to relining, 1963
Ex-collection: donors, New York, N.Y.
Gift of Colonel and Mrs. Edgar W. Garbisch 1951 51.124

Husband of 51.125.

Portrait of an Unidentified Woman 1830
Oil on canvas 30"x25⅛" (76.2x63.8 cm)
Signed: lower right, "By R.Street/Philad.ᵃ/1830"
Ex-collection: donors, New York, N.Y.
Gift of Colonel and Mrs. Edgar W. Garbisch 1951 51.125

Wife of 51.124 and sister of 51.122.

STROUD, PETER (b. England 1921)

Eight Times Three 1969
Mixed media: acrylic on masonite and bass wood 69⅛"x96" (175.8x244.0 cm)
Reverse: "Eight Times 3/1969/72x96/Acrylic on masonite/Peter Stroud"
Gift of the artist 1973 73.54

STUART, GILBERT (1755-1828)

Portrait of John Willet Hood ca. 1775-88
Oil on canvas 30"x24½" (76.2x62.2 cm)
Unsigned
Reverse: handwritten label, "Gilbert Stuart/John Willet Hood Rear Ad of the/Red/Owner G.L.W. Hood"; torn label, indicates owner was J. W. Lane
Ex-collection: F. A. H. Hood, London, Eng.; to his son G. F. W. Hood, Carlisle, Eng.; to American Art Association, New York, N.Y. (where it was sold at auction, January, 1915); to James Warren Lane; to American Art Association, New York, N.Y. (where it was sold at auction, November, 1924); to donor, East Orange, N.J.
Bequest of Louis Bamberger 1944 44.252

Authenticated and dated by Laurence Park in his definitive work on Gilbert Stuart, 1926. Since it depicts an English admiral (Rear Admiral of the Red; Vice Admiral of the Coasts of Devonshire and Cornwall), it has been dated during Stuart's stay in England.

*Portrait of Mercy Shiverick Hatch** (1773-1852) ca. 1810
Oil on wood 28"x22½" (71.1x57.2 cm)
Unsigned
Reverse: handwritten label, "Mercy Shiverick Hatch/by Gilbert Stuart/Owner/Mrs C B Bowditch/99 Moss Hill Road/Jamaica Plain"; typed label, "Miss Cornelia Bowditch/99 Moss Hill Road/Jamaica Plain"; label, "Museum of Fine Arts [Boston]/396.33/Stuart"
Ex-collection: Mercy ("Matty") Hatch; bequeathed to Jonathan Ingersoll Bowditch, Jamaica Plain, Mass.; bequeathed to his son, Charles Pickering Bowditch, Jamaica Plain, Mass. (1889); to Ingersoll Bowditch, Boston, Mass. (1921); to Mrs. Ernest Codman (a Bowditch descendant); to Charles D. Childs, Boston, Mass.
Purchase 1962 The Members' Fund 62.141

Painting is in its original frame, made for Stuart by Boston framer Samuel Doggett. According to Laurence Park, the picture was willed to Bowditch in appreciation. He and his father had looked after Mercy Hatch following her mother's death in 1824. (files)

Portrait of a Man (attributed)
Oil on canvas 29¾"x24¾" (75.6x62.9 cm; oval)
Unsigned
Reverse: no pertinent data recorded prior to relining, 1968
Ex-collection: private estate, Dublin, Ire.; to a dealer by the name of "O'Connor"; to M. Michelotti, New York, N.Y.
Purchase 1957 The Members' Fund 57.29

Information and documentation of this work is too sparse to make a definite assignment to Stuart. The subject of the portrait is not known, but the name "Sir Desmond Barrington" has been associated with it. (corres.)

Portrait of Charles Merritt (attributed)

Oil on wood 24¼"x20¼" (61.6x51.4 cm)
Unsigned
Reverse: label, "Independence Hall Collection/AC956/Sec #13,392/
Mr. Merritt/Artist Gilbert Stuart/Size 19¼x24¼"
Ex-collection: with Ehrich Galleries, New York, N.Y.; sold at auction,
Anderson Galleries, New York, N.Y. (March 11, 1920), #50; to Albert
Rosenthal, Philadelphia, Pa.; with Frank Camp, Philadelphia, Pa.
(1928); and returned to Rosenthal (1929); to David Hosier, Belvidere,
N.J.; to donor, West Orange, N.J., 1952
Bequest of Mrs. Grace V. Bishop 1963 63.40

Label refers to a temporary loan to Independence Hall, 1928-29. (corres.)

STUEMPFIG, WALTER (1914-1970)

*Life Guards ca. 1954
Oil on canvas 30⅛"x40⅛" (76.5x101.9 cm)
Unsigned
Ex-collection: Durlacher Brothers, New York, N.Y.
Purchase 1954 Felix Fuld Bequest Fund 54.6

SUDNIK, GEORGE G. (b. Poland 1886)

Portrait of a Woman (Portrait of a Lady)
Oil on canvas 28"x25" (71.1x63.5 cm)
Signed: upper right, "G"
Ex-collection: donor, Newark, N.J.
Gift of the artist 1930 30.21

Artist refers to painting as Portrait of a Woman, *rather than the previously recorded* Portrait of a Lady. *(files)*

SUDY, JOHN (20th century)

Portrait of a Man 1924
Watercolor on paper 8"x5⅝" (20.3x14.3 cm)
Signed and dated: lower right, "Sudy/1924"
Ex-collection: donor, Newton, N.J.
Gift of the artist 1926 26.681

California Patio 1925
Pen and wash on paper 8⅞"x8½" (22.5x21.6 cm)
Signed and dated: lower right, "Sudy 925"
Ex-collection: donor, Newton, N.J.
Gift of the artist 1926 26.682

Mosque Interior 1925
Pen, ink and wash on paper 5¼"x7⅜" (13.3x18.7 cm)
Signed: lower right, "Sudy 925"
Ex-collection: donor, Newton, N.J.
Gift of the artist 1926 26.683

SULLIVAN, FRANCIS (1861-1925)

Portrait of Emilie S. Coles 1920
Oil on canvas 40⅛"x30⅛" (101.9x76.5 cm)
Signed and dated: lower left, "Francis Sullivan 1920"
Reverse: inscribed, "Miss Emilie S. Coles/Painted by___Francis
Sullivan/May 6, 1920"
Ex-collection: donor, Scotch Plains, N.J.
Gift of Dr. J. Ackerman Coles 1920 20.1357

Miss Coles was the donor's sister.

Portrait of J. Ackerman Coles (1843-1925) ca. 1920
Oil on canvas 30"x25" (76.2x63.5 cm)
Signed: lower left, "Francis Sullivan"
Ex-collection: donor, Scotch Plains, N.J.
Gift of Dr. J. Ackerman Coles 1920 20.1358

*Date arrived at by approximation of Coles' age and the fact that his sister
was painted by the same artist in 1920.*

SULLY, THOMAS (1783-1872)

*Portrait of John Clements Stocker (1786-1833) 1814
Oil on canvas 36"x27¾" (91.4x70.5 cm)
Unsigned
Reverse: painting glue-lined when received by Museum
Ex-collection: descended in sitter's family to his granddaughter,
Mrs. Athington Gilpin, Philadelphia, Pa.; to M. Knoedler & Co.,
New York, N.Y.
Purchase 1956 The Members' Fund 56.42

*No. 13 in the 1922 Pennsylvania Academy of The Fine Arts Memorial
Exhibition of Sully portraits. Painting #7 was the companion portrait of
subject's wife, Louise C. Francoise de Tousard (1788-1877), now at the
Santa Barbara Museum. There is documentation that Sully began this
portrait on May 12, 1814, and finished it on July 5, 1814. Upon its
completion it was sent to Stocker's father-in-law, Colonel Louis de Tousard
in New Orleans, who had commissioned the work. Stocker, a prominent
Philadelphian, was at one time a director of the Bank of North America.
(corres.)*

TACK, AUGUSTUS VINCENT (1870-1949)

The Listeners (Moment Musicale) ca. 1921
Oil on canvas 29"x40⅛" (73.7x101.9 cm)
Signed: lower right, "Tack"
Reverse: handwritten label, "'The Listeners'/Augustus Vincent
Tack/Return to C. W. Hansen Laas Art Gallery/680 — 5th Avenue";
label, *Surviving the Ages*, AFA, 1963
Ex-collection: purchased from the artist, New York, N.Y.
Gift of Mrs. Felix Fuld 1925 25.1172

The painting had both titles when purchased (files). This could be The
Listeners *listed in the 1921 exhibition,* Paintings and Bronzes by Modern
Masters of American and European Art, *at C. W. Kraushaar Art
Galleries, New York, N.Y.*

TAGGART, JOHN G. (active 1846-1864)

Portrait of William Leete Stone (1835-1908) ca. 1852
Oil on canvas 24¼"x20" (61.6x50.8 cm)
Unsigned
Ex-collection: remained in family of sitter until given by donors, Port
Charlotte, Fla.
Gift of Mr. and Mrs. Douglas Stone 1965 65.159

*The young face of the sitter and the dates of Taggart's painting activity
indicate this must be a portrait of William L. Stone, Jr., a journalist and
historian, son of Colonel and Mrs. William L. Stone. See Trumbull 61.463
(mother) and Inman 65.160 (grandfather). This painting descended with
the Inman portraits.*

TAINTER, NAHUM (1821-?)

Archery 1830's
Watercolor on paper 7"x7¼" (17.8x18.4 cm)
Unsigned
Reverse: inscribed label, "Nahum Tainter/Born June 14 1821"
Ex-collection: private collection, New York, N.Y.
Anonymous gift 1938 38.214

Nahum Tainter listed on the label is only assumed to be the artist.

TAIT, ARTHUR FITZWILLIAM (b. England 1819-1905)

The Mother's Home Again (Cattle – Maternal Anxiety; Barnyard with Cattle) 1889
Oil on canvas 24½"x35¼" (62.2x89.5 cm)
Signed and dated: lower right, "A. F. Tait NA•/1889"
Reverse: inscribed, "The Mother's/Home Again" Orange Co. N.Y./A.F. Tait N.A./N Y 1889/U/Z/From Arrow Farm/Johnsons/Orange Co, N.Y."
Ex-collection: sold at Schencks Gallery, New York, N.Y. (April 20, 1889); to donor, Scotch Plains, N.J.
Gift of Dr. J. Ackerman Coles 1920 20.1194

According to William K. Verner, Curator of the Adirondack Museum, Blue Mountain Lake, N.Y., which holds Tait's registry, the artist coded his paintings on the basis of the word "Cumberland." "U" designates "2" and "Z" is "Zero." Therefore, according to the inscription, this would be the 20th painting of 1889. It is coded as "U" or 2nd painting in the registry which reads according to the Verner correspondence as follows:

"U [crossed out: code M. N. ?] Cattle-Maternal Anxiety 24x36 [crossed out: "The Mothers" Home Again"] Orange Co., N.Y. (Johnsons Arrow Farm) [crossed out: Artist Fund Sale sent down Feb'y 26th/89 finished Feb'y 25th/89 Frame $35.00] returned not sold at a Fund. Schenckes sale April 20th/89 [II, 140]"

It appears that Cattle — Maternal Anxiety *was the artist's preferred title and that the inscription should be read as* The Mother's Home Again.

*Barnyard Fowls** (Barnyard Scene) 1869
Oil on canvas 16¼"x26¼" (41.3x66.7 cm)
Signed: lower right, "AF. Tait./NY.1869"
Reverse: inscribed, "N° 11 N° 11/AFTait/NY/1869"
Ex-collection: Carl Chace family, New York, N.Y.; to Yonder Hill Dweller Antiques, Palisades, N.Y.; to donor, New York, N.Y. (ca. 1949)
Gift of Dr. Charles A. Poindexter 1969 69.181

Tait's records at the Adirondack Museum indicate for 1869, vol. 1, page 15, "No. 11. Barnyard Fowls. Size 26x16. Sold through Mr. E. D. Nelson with No. 13, in 1868, for [$125.00] no frames." Painting previously recorded as Barnyard Scene *in Museum records.*
This painting, like the Severin Roesen Still Life *(65.142), came from the Chace family, descendents of the founder of the Union Porcelain Works.*

TAM, REUBEN (b. 1916)

Rain from the Sea 1954
Oil on gesso 24"x36" (61.0x91.4 cm)
Signed: lower right, "Tam '54 ©"
Reverse: inscribed, "Rain from the Sea/Oil 24x36/by Reuben Tam © 1954"
Ex-collection: Alan Gallery, New York, N.Y.
Purchase 1955 Felix Fuld Bequest Fund 55.122

Painted at artist's summer home, Monhegan Island, Me.

TANGUY, KAY SAGE (1893-1963) (See Sage, Kay)

TANNER, HENRY OSSAWA (1859-1937)
*The Good Shepherd** 1920
Oil on canvas 32"x24" (81.3x61.0 cm)
Signed and dated: lower left, "H.O. Tanner/1920"
Reverse: no pertinent data recorded prior to relining
Ex-collection: donors, New York, N.Y.
Gift of Mr. and Mrs. Henry H. Wehrhane 1929 29.910

Original Museum accession card shows a date of 1922. The painting was known to have been shown at the Grand Central Galleries in 1924. It was probably shown at the New York Public Library in 1921. (files)

TAUBES, FREDERIC (b. Poland 1900-1981)

Portrait of Abraham Walkowitz (1878-1965) 1943
Oil on canvas 16"x14" (40.6x35.6 cm)
Signed: lower left, "Taubes"
Ex-collection: donor, New York, N.Y.
Gift of Abraham Walkowitz 1947 47.225

Executed for exhibition, One Hundred Artists and Walkowitz, *Brooklyn Museum, 1944. Date supplied by artist.*

Untitled
Pen, felt pen and wash on paper 19¾"x13⅝" (50.2x34.6 cm)
Signed: lower left, "Taubes/to Leonard Field"
Ex-collection: donors, New York, N.Y.
Gift of Mr. and Mrs. Leonard S. Field 1977 77.188

TAYLOR, EVERITT KILBURN (1866-?)

Looking Up Broadway from the Battery 1934
Pencil on paper 22"x16¼" (44.0x41.3 cm)
Signed: lower left, "Everitt Kilburn Taylor"
Allocated by the Treasury Department, PWAP 1934 34.310

TEED, DOUGLAS ARTHUR (1864-?)

Roman Villa 1893
Oil on canvas 11⅞"x27½" (30.0x70.0 cm)
Signed: lower left, "Arthur Teed Roma 1893"
Reverse: inscribed on top of stretcher, "Roman Villa"
Ex-collection: donor, Woodbury, Conn.
Gift of Miss Margaret Kinnane 1973 73.84

TERRELL, ELIZABETH (b. 1908)

Axed 1935-43
Gouache on cardboard 16½"x27" (41.9x68.6 cm)
Signed: lower left, "Terrell"
Reverse: inscribed, "4654/Elizabeth Terrell/'Axed'"; label, WPA, 9950-C.M.
Allocated by the WPA Federal Art Project 1943 43.194

Three Mile Road ca. 1936
Gouache on cardboard 13⅛"x20" (33.3x50.8 cm)
Unsigned
Reverse: inscribed, "7606/Three Mile Road/Eliz Terrell"
Allocated by the WPA Federal Art Project 1945 45.255

Date supplied by artist.

THECLA, JULIE (?-1938)

Two Daisies 1938
Gouache on paper 24"x18" (61.0x45.7 cm)
Signed and dated: "Chicago Nov. 1938/Julie Thecla"
Allocated by the WPA Federal Art Project 1943 43.164

THEÜS, JEREMIAH (b. Switzerland 1715-1774)

*Portrait of a Woman**
Oil on canvas 30⅛"x25¼" (76.5x64.1 cm)
Unsigned
Ex-collection: Charlotte Theüs Mayer Munds (artist's daughter by his second wife); to James Theüs Munds, New York, N.Y.; sold at James Theüs Munds' estate sale, Parke Bernet Galleries, New York, N.Y. (November, 1939); to Mrs. William G. Chisholm, Leesburg, Va.
Purchase 1956 Sophronia Anderson Bequest Fund 56.61

There has been doubt as to whether the woman portrayed was the artist's first or second wife, or his mother. Since painting descended through the daughter of Theüs and his second wife, it is possibly a portrait of that wife, Eva Rosana Theüs. Mrs. M. S. Middleton, Theüs' biographer, also suggested that Eva Rosana is the sitter, although it has not been substantiated. The Frick Art Reference Library listed this painting as attributed to Jeremiah Theüs because of apparent early date of costume. Both on stylistic and historical grounds the work would appear to be by Theüs.

THIEBAUD, WAYNE (b. 1920)

*Wedding Cake 1962
Oil on canvas 30"x30" (76.2x76.2 cm)
Signed: lower right, "Thiebaud 1962"
Reverse: stamp, Allen Stone Gallery, N.Y.C.
Ex-collection: with Allen Stone Gallery, New York, N.Y.
Purchase 1963 The Sumner Foundation for the Arts Purchase
Award 63.76

THEVENAZ, PAUL (b. Switzerland 1891-1921)

Portrait of Florine Stettheimer (1871-1944) ca. 1916
Oil wash on board 40⅛"x30¼" (101.6x76.9 cm)
Unsigned
Reverse: label, From the Collection of Carl Van Vechten; label, Florine
Stettheimer by/Paul Thevenaz/from Ettie Stettheimer; label, "If none
among family or friends want it for their own use, destroy. Do not sell.
Sketch done by Paul Thevenaz"
Ex-collection: Ettie Stettheimer, New York, N.Y. (sister of sitter); to
Carl Van Vechten; bequeathed to his wife, the donor
Gift of Mrs. Fania Marinoff Van Vechten 1965 65.163

Parker Tyler, in his biography of the sitter (Florine Stettheimer, A Life in
Art, *1963) indicated that he knew of only five paintings done of her. He
notes, "... the young dancer-painter Paul Thevenaz, almost completed a
life-size oil of her (ca. 1916) owned by Carl Van Vechten..." (see
Stettheimer 44.176)*

THOM, JAMES CRAWFORD (1835-1898)

Children in a Wood late 19th century
Oil on canvas 25½"x19" (64.8x48.3 cm)
Signed: lower right, "J C Thom"
Ex-collection: donor, New York, N.Y.
Gift of Ira Spanierman 1964 64.262

THOMPSON, CEPHAS (1775-1856)

Portrait of Lieutenant John T. Newton (ca. 1793-1837)
ca. 1813-27 (attributed)
Oil on wood 30"x35" (76.2x88.9 cm)
Unsigned
Ex-collection: descended through family of Newton's son-in-law; to
donor, Oldwick, N.J.
Gift of Mrs. E. W. Clucas 1958 58.89

*Attribution was made by the Frick Art Reference Library. Newton served
as a Lieutenant in the Navy between 1813 and 1827, rising to the rank
of Commander.*

THON, WILLIAM (b. 1906)

Upland Spain #7 ca. 1960
Mixed media on masonite 22"x36" (55.9x91.4 cm)
Signed: lower right, "Thon"
Reverse: inscribed, "Upland Spain/#7/from Thon/Port
Clyde/Maine./To: Midtown Galleries/17 East 57th Street/New York,
N.Y."; label, Midtown Galleries
Ex-collection: with Midtown Galleries, New York, N.Y.
Gift of the artist 1966 66.411

THÖNY, WILHELM (b. Austria 1888-1949)

New York – First View 1936
Oil on composition board 27"x38¼" (68.6x97.2 cm)
Signed: upper right, "Thöny N. York"
Ex-collection: donor, Newark, N.J.
Gift of Alexander Harris 1940 40.120

*Artist supplied date. Painted in Paris, it recalls his first trip to New York
City in 1933. (files)*

THROCKMORTON, CLEON FRANCIS (b. 1897)

Last Train to Somerset 1949
Oil on canvas 24"x30" (61.0x76.2 cm)
Signed and dated: lower right, "Throckmorton '49"
Ex-collection: donor, Newark, N.J.
Gift of Ralph Lum 1949 49.355

TIMMONS, RANDALL (b. 1946)

*Untitled 1977
Acrylic on canvas 50½"x44" (128.3x111.8 cm)
Signed and dated: "RT 77"
Reverse: inscribed upper left, "R Timmons 1977 3rd series"; upper
right, "03-77-049"; label, Lerner-Heller Gallery
Ex-collection: with Lerner-Heller Galleries, New York, N.Y.
Gift of Mrs. Fred Dierks 1978 78.28

TOBEY, MARK (1890-1976)

Portrait of George May 1925
Red chalk on brown paper 24¾"x20" (62.9x50.8 cm)
Signed and inscribed: lower right, "To My Friend/George May/-Mark
Tobey-"
Reverse: inscribed, "Portrait of George May, 1925 — Mark Tobey"
(no longer visible)
Ex-collection: donor, Kingston, Pa.
Gift of George May 1965 65.122

TOLEDANO, EDWARD (b. ca. 1907)

The Warm Colored Earth 1971
Crayon on paper 10"x13" (25.4x33.0 cm)
Signed: center bottom, "Edward Toledano"
Reverse: label, Basil Jacobs Fine Arts Ltd. (London)
Ex-collection: donors, New York, N.Y.
Gift of Mr. and Mrs. Leonard S. Field 1977 77.187

Artist lives and works in London.

TOMLIN, BRADLEY WALKER (1899-1953)

Portrait of a Young Girl ca. 1930
Pastel on paper 21"x20½" (53.3x52.1 cm)
Signed: upper right, "Tomlin"
Ex-collection: donor, Palisades, N.Y.
Gift of John E. Hutchins 1963 63.125

Donor, a personal friend of Tomlin, supplied the date.

TOOMEY, JO T. (1896-1967)

Portrait of Dr. Frank Kingdon (1894-1972) 1937
Oil on canvas 58½"x38½" (148.6x97.8 cm)
Signed and dated: lower right, "Jo T. Toomey '37"
Ex-collection: PWAP had this portrait painted at Miss Beatrice Winser's
request
Allocated by the U.S. Treasury Department PWAP 1937 37.289

*Dr. Kingdon was president of Dana College 1934-35 and the University of
Newark 1936-40. He was a Newark Museum Trustee 1936-48.*

TRACEY, E. (20th century)

Sun Basket Dance
Pencil, ink and gouache on poster board 14"x22" (35.6x55.9 cm)
Unsigned
Purchase 1928 28.1450

*Purchased for Museum in Santa Fe, N.M., by Edgar Holger Cahill. Artist
was a Navajo living on San Ildefonso pueblo, N.M. Originally recorded
as* Sun Dance.

TRAVER, GEORGE A. (1860-1928)

Landscape with Green Wagon
Oil on canvas 18"x24" (45.7x61.0 cm)
Signed: lower right, "Geo. A. Traver"
Ex-collection: donor, Newark, N.J.
Bequest of G. Wisner Thorne 1938 38.332

Possibly depicts a river scene in Belleville, N.J. (files)

TRIANO, ANTHONY T. (b. 1928)

The Red and the Black 1960
Oil on canvas 40"x48" (101.6x121.9 cm)
Signed and dated: lower right, "Triano 60"
Ex-collection: acquired from the artist, Arlington, N.J.
Purchase 1961 John J. O'Neill Bequest Fund 61.22

Exhibited in Work by New Jersey Artists, *1961. Artist said the work was prompted by Stendahl's novel of the same title and suggests "the conflicts that ambitious youth encourage in hope of love, fortune and notoriety."* (files)

TROMKA, ABRAM (1896-1954)

The following works were donated by the artist's widow, Brooklyn, N.Y.
Gift of Mrs. Abram Tromka 1975

Gowanus Canal 1942
Oil on canvas 30"x30" (76.0x76.0 cm)
Signed: lower left, "Tromka" 75.30

Bridge at New Hope 1952
Pastel on paper 17 13/15"x21" (45.3x53.6 cm)
Signed: lower left, "Tromka" 75.31

Street in Paris 1927
Watercolor on paper 11"x7¾" (28.0x20.0 cm)
Signed: lower right, "Tromka 27 Paris" 75.35

Port Clyde Interior 1948
Sepia, brush, pencil on paper 9⅞"x13⅛" (25.2x33.5 cm)
Signed: lower right, "Tromka" 75.36

Man on Bench 1930
Charcoal on paper 13"x10" (33.0x25.4 cm)
Signed: lower right, "Tromka" 75.37

Las Vegas Three Figures 1941
Ink and brush on paper 12"x9" (30.0x23.0 cm)
Unsigned 75.38

Las Vegas Gambling Table Group 1941
Ink and brush on paper 12"x9" (30.0x23.0 cm)
Unsigned 75.39

Figure Under Bridge 1936
Charcoal on paper 9"x12" (23.0x30.5 cm)
Signed and dated: lower right, "Tromka '36" 75.40

Rockland County Town 1935
Conte crayon on paper 15"x20" (38.0x51.5 cm)
Signed and dated: lower left, "Tromka '35" 75.41

TROWBRIDGE, GAIL (b. 1900)

Butterfish 1944
Watercolor on paper 20"x24" (50.8x61.0 cm)
Signed: lower right, "Gail Trowbridge/1944"
Reverse: label on backing, Montclair Art Museum, *14th New Jersey Annual Exhibition*, 1944
Ex-collection: donor, Short Hills, N.J.
Gift of Miss Cora L. Hartshorn 1951 51.150

TRUMBULL, JOHN (1756-1843)

*Portrait of Mrs. William Leete Stone [Susannah Pritchard Wayland]
(1798-1856) ca. 1821
Oil on wood 23⅞"x19⅞" (60.6x50.5 cm)
Unsigned
Ex-collection: remained in family of sitter until acquired by Victor Spark, New York, N.Y.; to donors, New York, N.Y.
Gift of Mr. and Mrs. Orrin W. June 1961 61.463

Trumbull's portrait of "Colonel" William Leete Stone (1792-1844) is privately owned. Mrs. Stone was the daughter of Francis Wayland, an upstate New York minister, and sister of Francis Wayland (1796-1865), president of Brown University, Providence, R.I. (1827-1855). Mr. Stone (1792-1844) was a journalist and historian. Dates of both portraits supplied by Theodore Sizer in The Works of Colonel John Trumbull: Artist of the American Revolution *(New Haven: Yale University Press) 1950, p.52.*

TSIHNAHJINNIE, ANDREW [Yazzie Bahe] (b. 1918)

Bathing and Cleaning Nuts ca. 1935
Gouache on paper 12½"x16¾" (31.8x42.5 cm)
Unsigned
Reverse: label, Gallery of American Indian Art, New York, N.Y. 299A
Gift of Miss Amelia E. White 1937 37.212

Artist is a member of Navajo tribe.

TUCKER, ALLEN (1866-1939)

The Big Hickory
Oil on canvas 30"x34⅛" (76.2x86.7 cm)
Signed: lower right, "Allen Tucker"
Reverse: etched by artist on frame, "The Big Hickory"
Ex-collection: donors, New York, N.Y.
Gift of Mr. and Mrs. Lesley G. Sheafer 1954 54.216

Before Rain
Oil on canvas 25¼"x34¼" (64.2x87.0 cm)
Signed: lower left, "Allen Tucker"
Ex-collection: donors, New York, N.Y.
Gift of Mr. and Mrs. Lesley G. Sheafer 1954 54.217

*Corn Shocks and Windmill 1909
Oil on canvas 30"x36" (76.2x91.5 cm)
Signed and dated: lower left, "A. Tucker/1909"
Reverse: label, Milch Galleries; label, The American Federation of Arts, *Revealed Masters*, 1975; no pertinent data recorded prior to relining, 1974
Ex-collection: the artist, New York, N.Y.
Gift of the Allen Tucker Memorial 1964 64.44

TWACHTMAN, JOHN H. (1853-1902)

*The Cascade ca. 1890's
Oil on canvas 28"x24¼" (71.1x61.6cm)
Signed: lower left, "JH. Twachtman"
Reverse: painting has been relined; label, Margaret and Raymond Horowitz Collection
Ex-collection: unidentified New York City auction; to Ira Spanierman, New York, N.Y.; to donors, New York, N.Y.
Gift of Mr. and Mrs. Raymond Horowitz 1964 64.237

A sketch for this painting was evident on reverse prior to relining. (files)
On stylistic grounds it is considered to be a late work.

TWARDOWICZ, STANLEY J. (b. 1917)

Red Crown 1953
Oil and Ducco cement on canvas 40"x34" (101.6x86.4 cm)
Signed: upper right, "Stanley — 53"
Reverse: inscribed on stretcher, "Stanley Twardowicz/109 Park
Avenue/Plainfield, NJ/Red Crown"
Ex-collection: the artist, Plainfield, N.J.
Purchase 1955 John J. O'Neill Bequest Fund 55.86

Purchased from the Museum's 2nd triennial exhibition, Work by New
Jersey Artists, *1955.*

TWORKOV, JACK (b. Poland 1900)

*Xmas Morning** 1951
Oil on paper mounted on masonite 29⅛"x38⅞" (74.0x98.7 cm)
Reverse: "Xmas Morning/Tworkov 51"; label, Eagen Gallery
Ex-collection: Eagen Gallery, New York, N.Y.; to donor,
Westport, Conn.
Gift of Walter Gutman 1957 57.131

TYNDALL, CALVIN T. [Um Pah] (20th Century)

Buffalo Hunt 1930's
Gouache on paper 14¼"x12" (36.2x30.5 cm)
Signed: lower right, "Um Pah"
Gift of Miss Amelia E. White 1937 37.214

Artist was from Omaha or Sioux tribe.

TYTELL LOUIS (b. 1913)

Winter Beach Plum ca. 1968
Oil on canvas 40"x47½" (101.6x121.0 cm)
Signed: lower right, "Tytell"
Ex-collection: Roko Gallery, New York, N.Y.; to donor, New York, N.Y.
Gift of Mrs. Isabella Gardner Tate 1970 70.65

Date suplied by donor.

ULLMAN, EUGENE PAUL (1877-1953)

Portrait of Abraham Walkowitz (1878-1965) 1943
Oil on canvas 18¼"x15¼" (46.4x38.7 cm)
Signed and dated: lower left, "Eugene Paul Ullman 1943"
Ex-collection: donor, New York, N.Y.
Gift of Abraham Walkowitz 1948 48.24

Executed for the exhibition, One Hundred Artists and Walkowitz,
Brooklyn Museum, 1944.

UNGAR, FRITZ C. H. (b. Africa 1867-1939)

Portrait of Dr. William S. Disbrow (1861-1922) 1923
Oil on canvas 36"x22" (91.4x55.9 cm)
Signed and dated: lower left, "Ungar 1923-"; label on front, "Fritz
Ungar/Dr. W. S. Disbrow/Gift of Frederick Keer 1924"
Reverse: label, "Fred Keer's Sons/Framers/and/Fine Art/Dealers/
917 Broad Street/Newark N.J.
Ex-collection: donor, Newark, N.J.
Gift of Frederick J. Keer 1924 24.1855

*Dr. Disbrow, a Museum Trustee from 1909-22, was one of the founders of
the Museum and a benefactor. He gave the Museum its first science
collection in 1912 and bequeathed his total collection.*

VANDERLYN, JOHN (1775-1852)

Portrait of Edward Jones Elmendorf (Portrait of Master Elmendorf)
(1789-?) pre-1796 (attributed)
Oil on canvas 17¼"x14¼" (43.8x36.2 cm)
Unsigned
Reverse: painting relined prior to entering the Museum's collection
Ex-collection: John Van Derlip, Minneapolis, Minn.; to Minneapolis
Institute of Art, Minn. (1915); to Victor Spark, New York, N.Y. (1956); to
Orrin June, New York, N.Y. (1961)
Gift of Mr. and Mrs. Orrin W. June 1961 61.464

*Through the research of Herbert Cutler and Mrs. William Pratt it was
found that Edward Jones Elmendorf was baptized in the Dutch Church
in Kingston, N.Y., September 14, 1789. He was the son of Conrad E.
Elmendorf and Catherine Jones. The Elmendorf family was long
established in the Kingston area. The relationship with the Van Derlips is
not clear. John Van Derlip was born in Dansville, N.Y., in 1860 and moved
to Minneapolis in 1883.*

*Kenneth C. Lindsay has expressed some doubt about a Vanderlyn
attribution. (corres.)*

VANDERLYN, PIETER [The Gansevoort Limner] (1687-1778)

*Portrait of Catherine Ogden** (1709-1797) ca. 1730
Oil on canvas 57"x37¼" (144.8x94.6 cm)
Reverse: frame, five labels, four of which repeat incorrect family
tradition that the work was painted in 1738 by a British artist and that
Josiah Ogden was a citizen of Trenton, N.J. Two labels record gift of
painting from Isabella Ogden Reed Lyman to Elisabeth Lyman
Jackson(E. L. Robb), 1940 and 1942; painting glue-lined prior to
entering collection; relined 1977 *(files)*
Ex-collection: descended in family presumably through Jacob Ogden,
Hartford, Conn. (subject's son); to Isabella Ogden Reed; to her daughter
Clara Elizabeth Macomber; to her daughter Isabella Ogden Reed
Lyman (1937); to her daughter E. L. Robb, Beverly Farms, Mass. (1949);
with Hirschl & Adler Galleries, New York, N.Y.
Purchase 1976 The Members' Fund, Charles W. Engelhard Bequest
Fund, Anonymous Fund 76.181

*The attribution to Pieter Vanderlyn was made by Mary C. Black of the
New-York Historical Society. (files) Sitter was the daughter of Col. Josiah
Ogden of Newark and the wife of David Ogden and of Isaac Longworth
of Newark.*

VANDERPOOL, JAMES (1765-1799)

*Portrait of James Van Dyck** (1740-1828) ca. 1787
Oil on canvas 41"x33" (104.1x83.8 cm)
Unsigned
Ex-collection: Mrs. Alfred Meeker, Newark, N.J.; to Mrs. Marcus L.
Ward, Newark, N.J.; to her son, the donor, Newark, N.J.
Bequest of Marcus L. Ward, Jr. 1921 21.1749

Sitter was an uncle of the artist and ancestor of Mrs. Marcus L. Ward.

VANDERPOOL, JOHN (1764-?)

*Portrait of Mrs. James Van Dyck** [Catherine Vanderpool]
(1741-1823) 1787
Oil on canvas 41"x33" (104.1x83.8 cm)
Signed and dated: lower left, "J. V. d. Pool/Living 1787"
Ex-collection: Mrs. Alfred Meeker, Newark, N.J. (1896); to
Mrs. M. L. Ward, Newark, N.J.; to her son, the donor, Newark, N.J.
Bequest of Marcus L. Ward, Jr. 1921 21.1748

*John, a brother of artist James Vanderpool, was a painter of banners in
New York, N.Y., and a nephew of the sitter. The sitter was an ancestor of
Mrs. Marcus L. Ward.*

VARIAN, DOROTHY (b. 1895)

Interior with Stove and Nude 1930-31
Oil on canvas 25″x20″ (63.5x50.5 cm)
Signed: lower left (vertical), "D. Varian"
Reverse: label, *A Century of Progress*, Art Institute of Chicago, 1934;
label, private collection, New York, N.Y.
Ex-collection: private collection, New York, N.Y.
Anonymous gift 1937 37.120

Date supplied by the artist.

Back Country – Maine between 1935 and 1943
Oil on canvas 14⅞″x19⅛″ (37.8x48.6 cm)
Signed: lower right, "D. Varian"
Reverse: label, WPA, "Back Country/Maine/8062/DVarian"
Allocated by WPA Federal Art Project 1943 43.209

*Artist said painting was executed about one mile from Perkins' Cove,
Ogunquit, Me.*

VEDDER, ELIHU (1836-1923)

****The Philosopher** (Hermit of the Desert, The Young Saint) 1867
Oil on canvas 14⅞″x21″ (37.8x53.3 cm)
Signed and dated: lower right, "18γ.67"
Reverse: inscribed, "Elihu Vedder/Rome March 1867"; label, AFA,
Surviving the Ages 1964; carving on frame, "P. Anlane, N.Y."
Ex-collection: A. B. Stone, Rome (February, 1867); to Thomas L.
Raymond, Newark, N.J.; to Arthur F. Egner, South Orange, N.J.; sold at
Parke Bernet Galleries, 1945 (Egner sale, catalog #670, lot #58)
Purchase 1945 Arthur F. Egner Memorial Fund 45.139

*The original sale of this work to A. B. Stone was recorded in Carrie
Vedder's sales book.*

****Adam and Eve Mourning Death of Abel** 1911
Oil on canvas 14¼″x47¼″ (36.2x120.0 cm)
Signed and dated: lower left, "Elihu Vedder/Rome 1911/Copyright 1911
by E. Vedder"
Reverse: label, American Academy of Arts and Letters; label, "Barse —
September 6, 1935 #1"; torn label, Carnegie Institute; painting
relined 1961
Ex-collection: the artist; to his daughter Miss Anita Vedder, Capri;
to donor (1954)
Gift of the American Academy of Arts and Letters 1955 55.2

*A panel study of the same subject (4″x13½″) in the same year is in the
Harold Love collection. Four Vedder works in the Museum collection,
along with many other works by the artist, were distributed to American
museums by the American Academy of Arts and Letters from Anita
Vedder's holdings after she died in 1954. Jane Dillenberger noted that
the "Barse" label found on this painting and others may refer to
an old inventory made by the artist, George Barse, a friend of the
Vedders. (corres.)*

****Still Life Study: Old Pail and Tree Trunks** ca. 1865
Oil on canvas 8½″x13⅞″ (21.6x35.2 cm)
Signed: lower right, "ElihuVedder #"
Reverse: inscribed, probably by artist, "No ²⁰ Still Life Study/ . . . , Still
Life/painted when with Bicknell/in Maine-Turner, Maine-/See
Digressions/Elihu Vedder/after my return/War Time"; back of canvas
and back of frame were stamped with circular stamps, now illegible,
but presumably of the estate; label, Museum of Fine Arts Boston,
Maine and Its Artists, 1964; "label, Barse — Sept. 6, 1935 — #65"
Ex-collection: the artist; to his daughter Miss Anita Vedder, Capri;
to donor (1954)
Gift of the American Academy of Arts and Letters 1955 55.3

*Inscription on this painting further confirms tentative dating of ca.
1865. Vedder returned to America in 1860 and left again for Europe at the
end of 1865. In his Digressions of V. (1910) he mentions painting with
his friend Albion Bicknell but being unable to find "Turner, Maine"
although they found East, West, South and other descriptions attached
to the name "Turner." This inscription must have been added after the
1910 publication of* Digressions.

*Regina Soria identified this painting as the one Vedder refers to in his
Digressions (p. 270): " . . . I found in the barn an old pail and some
firewood, and made a careful study which I cherish as one of what I call
my prize studies." Jane Dillenberger indicated that this scene was
incorporated into a larger Vedder,* Lonely Spring, *#20 in the
Vedder Memorial Exhibition, Buffalo Fine Arts Academy, November,
1929. (corres.)*

Burghers and Nymphs ca. 1874
Oil on canvas 5¼″x12¾″ (13.3x32.4 cm)
Signed: lower left, "Vedder"
Reverse: inscribed on frame, "No 38 Burghers &/Nymphs NF"; label,
"Barse — Sept. 6, 1935 #31/Burghers and Nymphs"
Ex-collection: the artist; to his daughter Miss Anita Vedder, Capri;
to donor (1954)
Gift of the American Academy of Arts and Letters 1955 55.4

*Date arrived at by Regina Soria after comparing this theme with similar
ones in Munson-Williams-Proctor Institute, Utica, N.Y., Laurence
Fleishman collection and J. R. Lowell collection. This painting, listed as
Burghers and Mermaids, was exhibited as #38 in Vedder Memorial
Exhibition, Buffalo Fine Arts Academy, N.Y., November, 1929.*

Figure Study: Astronomy 1892
Crayon and chalk (lunette) on paper 18″x25″ (45.7x63.5 cm)
Signed and dated: lower right, "18V 92"
Inscribed: lower right, "Astronomia"
Reverse: label, "Barse — April 3, 1937 #17"
Ex-collection: the artist; to his daughter Miss Anita Vedder, Capri;
to donor (1954)
Gift of the American Academy of Arts and Letters 1955 55.5

*Regina Soria suggested this may be an unexecuted idea for a mural
study. It is similar to another study for* Astronomy *at the Corcoran
Gallery, Washington, D.C. Jane Dillenberger suggested this drawing as a
possible preparatory study for Vedder's painting,* Eclipse of the Sun by
the Moon. *(corres.)*

VERMORCKEN, FREDERICK MARIE (1860-?)

Portrait of Mrs. Benjamin Williamson [Emily E. Hornblower]
(?-1909) Ca. 1900
Oil on canvas 99″x57″ (251.5x144.8 cm)
Signed: lower left, "M. Vermorcken"
Gift of Social Service Bureau, Newark, N.J. 1923 23.2435

*Sitter was a prominent board member and officer of numerous charities
and institutions in Newark. President Theodore Roosevelt appointed her
a delegate to the Congress of International Prison Associations in
Budapest. She was active in the establishment of the State Reformatory
in Rahway, N.J.*

VICENTE, ESTEBAN (b. Spain 1903)

****Black in Gray** 1968
Paper collage on board 45″x47½″ (114.3x120.7 cm)
Signed: lower left, "Esteban Vicente"
Reverse: "Esteban Vicente/Collage 1968 Black in Gray"
Ex-collection: with Andre Emmerich Gallery, New York, N.Y.
Purchase 1969 Sophronia Anderson Bequest Fund 69.116

Untitled 1975
Oil on canvas 72″x48″ (182.9x121.9 cm)
Reverse: "Esteban Vicente/oil on canvas/1975/Untitled v.r."; label,
Fischbach Gallery #62
Ex-collection: with Fischbach Gallery, New York, N.Y.
Gift of Mr. and Mrs. Esteban Vicente in memory of their daughter,
Alison Peters 1978 78.85

VICKREY, ROBERT (b. 1926)

Circus Figure 1961
Tempera on canvasboard 32"x27" (81.3x68.6 cm)
Signed: lower right, "Robert Vickrey"
Ex-collection: with Midtown Gallery, New York, N.Y.
Gift of the artist 1966 66.410

Date supplied by artist.

VIDAR, FREDE J. (b. Denmark 1911-1967)

Washington Square 1936
Gouache on matboard 20"x30" (50.8x76.2 cm)
Signed and dated: lower right, "Vidar/1936"
Reverse: label, WPA, #A936A
Allocated by the WPA Federal Art Project 1943 43.196

Retrospection 1942
Oil on canvas 24"x30" (61.0x76.2 cm)
Signed and dated: lower right, "Vidar"; lower left, "Pont d'Arcade,
Paris, 1942"
Ex-collection: acquired from the artist, Montclair, N.J.
Purchase 1944 Thomas L. Raymond Bequest Fund 44.2

Painting was exhibited in the Museum exhibition, Associated Artists of
New Jersey, *1943.*

VIGIL, ROMANDO [Tse-Ye-Mu] (b. 1902)

Dancers ca. 1928
Ink and watercolor on paper 8¼"x14¼" (21.0x36.2 cm)
Signed: lower right, "Romando Vigil"
Reverse: inscribed, "San Ildefonso Pueblo"; "Dancer"
Purchase 1928 28.1455

*Purchased for the Museum in Sante Fe, N.M., by Edgar Holger Cahill.
Artist is from San Ildefonso pueblo, N.M.*

Winter Dance
Ink and gouache on paper 19½"x29½" (48.3x74.9 cm)
Signed: lower right, "Tse-Ye-Mu"
Reverse: label, Gallery of American Indian Art, New York, N.Y.; label,
18th Biennial International Art Exhibition, Venice, 1932
Gift of Miss Amelia E. White 1937 37.219

VIGIL, THOMAS [Pan Yo Pin, Pina Yo Pin, Pu Yo Bi] (1889-1960)

Comanche Dance
Pencil and gouache on poster board 9⅞"x14½" (25.1x36.8 cm)
Signed: lower right, "Pan Yo Pin"
Purchase 1928 28.1453

*Purchased for the Museum in Santa Fe, N.M., by Edgar Holger Cahill.
Artist was from Tesuque pueblo, N.M.*

Eagle Dancer
Pencil and gouache on paper 11⅜"x7¼" (28.9x18.4 cm)
Signed: lower right, "Thomas Vigil/Tesuque"
Purchase 1928 28.1457

Purchased for the Museum in Santa Fe, N.M. by Edgar Holger Cahill.

Buffalo Dancer
Pencil and gouache on paper 11⅜"x7¼" (28.9x18.4 cm)
Signed: lower right, "Thomas Vigil/Tesuque"
Purchase 1928 28.1458

Purchased for the Museum in Santa Fe, N.M. by Edgar Holger Cahill.

Eagle Dancers ca. 1930
Pencil and gouache on paper 10¾"x13¾" (27.3x34.9 cm)
Signed: lower right, "Pina Yo Pin/Tesuque"
Reverse: label on backing, Gallery of American Indian Art, New York,
N.Y. #2084
Gift of Miss Amelia E. White 1937 37.195

Rainbow Dancers ca. 1930
Pencil and gouache on paper 11¼"x16" (28.6x40.6 cm)
Unsigned
Gift of Miss Amelia E. White 1937 37.196

Originally recorded as Eagle Dancers.

VOLK, DOUGLAS (1856-1935)

Portrait of John Cotton Dana (1856-1929) 1923
Oil on canvas 40"x30" (101.6x76.2 cm)
Signed and dated: lower left, "Douglas Volk '23"
Reverse: no pertinent data recorded prior to relining
Ex-collection: commissioned by the Newark Museum
Gift of Christian W. Feigenspan 1924 24.8

*John Cotton Dana was the founder and first director of The Newark
Museum 1909-29.*

A Sketch from Life of John Cotton Dana (1856-1929) ca. 1923
Oil on canvasboard 10⅛"x7⅝" (25.7x19.5 cm)
Signed: lower right, "D.V."
Reverse: inscribed on stretcher and label, "Sketch from Life/of/John
Cotton Dana/By/Douglas Volk, N.A."; on canvasboard, "John Cotton
Dana,/Original in/Newark Museum/By/Douglas Volk N.A./1924"
Ex-collection: donor, Newark, N.J.
Gift of Louis Bamberger 1940 40.172

VON WIEGAND, CHARMION (b. 1899)

The Sign of Keeping Still 1953
Oil on canvas 30"x25" (76.2x63.5 cm)
Reverse: signed and dated: "Charmion Von Wiegand/1953/The Sign of
Keeping Still"; label, Howard Wise Gallery, New York, N.Y.; label,
John Heller Gallery, New York, N.Y.
Ex-collection: donors, New York, N.Y.
Gift of Mr. and Mrs. Robert Miller 1956 56.47

*The last digit of the date on this painting is unclear but probably "3." The
artist wrote that it was done in 1953 or 1954 and exhibited at the New
School in 1954. (files)*

WACK, HENRY WELLINGTON (1875-ca. 1955)

Slabsides ca. 1926
Oil on canvas 30"x36" (76.2x91.4 cm)
Signed: lower right, "H. W. Wack"; marked lower left,
"Copyrighted 1926"
Ex-collection: private collection, New York, N.Y.
Anonymous gift 1937 37.263

*"Slabsides" was the home of naturalist John Burroughs. The house was
located at Malden, N.Y., near Kingston.*

WALDMAN, PAUL (b. 1936)

Eternal City, 5 1962
Oil on canvas 38"x31" (96.5x78.7 cm)
Signed and dated: lower right, "Waldman 62"
Ex-collection: with Allan Stone Gallery, New York, N.Y.; to donors,
New York, N.Y.
Gift of Mr. and Mrs. Malcolm Foster and Maurice Kanbar
1964 64.5

WALDO, SAMUEL LOVETT (1783-1861)

Portrait of Miss Harper
Oil on wood 30"x24⅞" (76.2x63.2 cm)
Reverse: signed, "Miss Harper/Samuel L. Waldo/Pinxit"; inscribed,
"Miss Harper/Samuel Waldo"; label, Palace of Legion of Honor,
San Francisco
Ex-collection: John Levy Galleries, New York, N.Y. (1942); sold at Plaza
Art Galleries, 1944 (Plaza has no record of having had this painting); to
donor, New York, N.Y.
Gift of Norman Hirschl 1960 60.592

*Provenance is unclear. At one time painting supposedly was in hands of
Chappelier Gallery and Albert Schneider, both of New York, N.Y. Subject
was daughter of James Harper, a mayor of New York and founder of
Harper's Weekly. (files)*

WALDO, SAMUEL LOVETT (1783-1861) and
JEWETT, WILLIAM (1795-1873)

* **Portrait of Mrs. George Dummer** (1803-1857)
Oil on canvas 30⅛"x25⅛" (76.5x64.2 cm)
Unsigned
Ex-collection: descended in family of sitter's husband until sold by a
descendant, George P. Brower of Brooklyn, N.Y., in 1927; to donor,
New York, N.Y.
Gift of M. Knoedler & Co., Inc. 1963 63.80

*Subject was George Dummer's Second Wife. It was assumed that both
portraits were intended as companions and were executed in 1840.
William H. Gerdts has suggested that Mrs. Dummer may have been
painted at a different time. Mrs. Dummer's portrait was not done on
panel as was Mr. Dummer's. (corres.)*

* **Portrait of Mr. George Dummer** (1782-1853) 1840
Oil on wood 30¼"x25" (76.9x63.5 cm)
Reverse: signed and dated, "Geo. Dummer, Esq./late Mayor of Jersey
City/Painted by Waldo & Jewett/New York, 1840. AE. 60"
Ex-collection: painting remained in family of sitter until sold by
George P. Brower of Brooklyn, N.Y., in 1927; to donor, New York, N.Y.
Gift of M. Knoedler & Co., Inc. 1963 63.81

Portrait of Mathias Ogden Halsted ca. 1830-40
Oil on wood 37"x28½" (94.0x72.4 cm)
Unsigned
Ex-collection: remained in family of sitter until bequeathed by
Mrs. W. Wiley, New York, N.Y.; to her daughter, the donor, Carmel,
Calif.
Gift of Mrs. John P. Gilbert 1968 68.250

*Sitter was the husband of Hepziber Halsted, whose family lived in Essex
County, N.J., in the 19th century.*

Portrait of Mrs. Mathias Ogden Halsted [Hepziber Eastman]
ca. 1830-40
Oil on wood 37½"x25⅝" (95.2x72.8 cm)
Unsigned
Ex-collection: remained in family of sitter until bequeathed by
Mrs. W. Wiley, New York, N.Y., to her daughter, the donor, Carmel,
Calif.
Gift of Mrs. John P. Gilbert 1968 68.251

WALKER, WILLIAM AIKEN (1838-1921)

Peanut Seller on Old Church St. (The Old Peanut Vendor)
Watercolor on cardboard 9⅞"x6⅞" (25.1x17.5 cm)
Signed: lower left, "Walker"
Reverse: inscribed, "Peanut Seller on Old Church St."
Ex-collection: donor, Newark, N.J.
Gift of Mrs. Cornelia E. Cusack 1963 63.117

WALKINGSTICK, KAY (20th century)

Lifeless, Deathless, Endless – Ad Reinhardt 1976
Acrylic, encaustic over ink on cotton canvas 54"x72" (137.2x182.9 cm)
Reverse: signed, "WalkingStick/Lifeless, Deathless, Endless/
Ad Reinhardt'/Kay WalkingStick/1976/54x72"
Gift of Kay WalkingStick in memory of her mother Emma McKaig
Walkingstick 1978 78.40

WALKOWITZ, ABRAHAM (b. Russia 1878-1965)

Summer 1915
Watercolor on paper 15½"x29¼" (39.4x74.3 cm)
Signed: lower right, "A. Walkowitz"
Ex-collection: with The Downtown Gallery, New York, N.Y.
Purchase 1930 Felix Fuld Bequest Fund 30.278

Nude Study, Isadora Duncan (1878-1927) 1911
Pencil on paper 12¾"x8" (32.4x20.3 cm)
Signed: lower right, "A. Walkowitz"; lower left on mat, "A. Walkowitz"
Ex-collection: private collection, New York, N.Y.
Anonymous gift 1931 31.565

Donor supplied date.

Study of Isadora Duncan (1878-1927)
Crayon and wash on paper 12½"x8" (30.8x20.3 cm)
Signed: lower right, "A. Walkowitz"
Reverse: label on backing, The Downtown Gallery; label on backing,
private collection
Ex-collection: with The Downtown Gallery; private collection,
New York, N.Y.
Anonymous gift 1937 37.122

Grief (Isadora)
Ink, wash and finger paint on finger paint paper 14"x9¼" (35.6x23.5 cm)
Signed: lower left, "A. Walkowitz"
Ex-collection: donor, New York, N.Y.
Gift of the artist 1939 39.457

Flower Arrangement
Oil on cardboard 18"x15½" (45.7x39.4 cm)
Signed: bottom center on bowl, "A. Walkowitz"
Ex-collection: donor, New York, N.Y.
Gift of the artist 1939 39.475

Untitled 1917
Ink and wash on paper 6¾"x5¼" (17.1x13.3 cm)
Reverse: signed in ink, bottom center, "A. Walkowitz"; dated in pencil,
lower left, "1917"
Ex-collection: donor, New York, N.Y.
Gift of the artist 1939 39.495

Untitled 1919
Ink and wash on paper mounted on paper 6¾"x5¼" (17.1x13.3 cm),
mount 10½"x7⅛" (26.7x18.1 cm)
Signed and dated: lower right on mount, "A. Walkowitz 1919"
Reverse: signed and dated in ink, bottom center, "A. Walkowitz"; in
pencil, lower right, "1919"
Ex-collection: donor, New York, N.Y.
Gift of the artist 1939 39.496

New York Skyscrapers 1909
Ink and wash on paper mounted on paper 10½"x6¾" (26.7x17.1 cm),
mount 17¾"x11¾" (45.1x29.8 cm)
Signed and dated: lower right on mount, "A. Walkowitz 1909"
Reverse: signed and dated lower right, "A Walkowitz year 1909"
Ex-collection: donor, New York, N.Y.
Gift of the artist 1939 39.497

Untitled
Pencil and litho-crayon on paper 19"x12" (48.3x30.5 cm)
Signed: bottom center, "A. Walkowitz"
Reverse: "60"; on original mat (discarded), "67"
Ex-collection: donor, New York, N.Y.
Gift of the artist 1939 39.498

Isadora Duncan (1878-1927)
Watercolor, pen and pencil on paper 14″x8½″ (35.6x21.6 cm)
Signed: lower right, "A. Walkowitz"
Ex-collection: donor, New York, N.Y.
Gift of the artist 1939 39.501

Isadora Duncan (1878-1927)
Chalk and charcoal on orange embossed paper 20⅛″x13″ (51.1x33.0 cm)
Signed: center bottom, "A. Walkowitz"
Ex-collection: donor, New York, N.Y.
Gift of the artist 1939 39.502

Isadora Duncan (1878-1927)
Ink and watercolor on paper 14 pictures mounted together on cardboard by artist, each 6¾″x2⅝″ (17.1x6.7 cm); mount 20⅛″x13″ (51.1x33.0 cm)
Signed: "A. Walkowitz" 39.503-16
Ex-collection: donor, New York, N.Y.
Gift of the artist 1939 39.503-16

Isadora Duncan (1878-1927) 1917
Ink and wash on paper two drawings mounted together on cardboard by artist, each 10½″x6¾″ (26.7x17.1 cm), mount 16″x22″ (40.6x55.9 cm)
Signed: center bottom in ink, "A. Walkowitz" 39.517
center bottom in ink, "A. Walkowitz"; in pencil, "1917" 39.518
Ex-collection: donor, New York, N.Y.
Gift of the artist 1939 39.517-8

Improvisations of Dance #2 1918
Ink on paper three drawings mounted together on cardboard by artist, each 10½″x6⅜″ (26.7x16.2 cm)
Signed and dated: lower right, "A. Walkowitz 1918" 39.458a
Reverse: inscribed, "6"
Signed and dated: lower right, "A. Walkowitz 1918" 39.458b
Reverse: inscribed, "5"
Signed and dated: lower left, "A. Walkowitz 1918" 39.458c
Reverse: inscribed, "4"
Ex-collection: donor, New York, N.Y.
Gift of the artist 1939 39.458a-c

Dance Rhythm
Ink and wash on paper nine drawings mounted together on cardboard by artist, each 6¾″x2½″ (17.1x6.4 cm); mount 22″x30″ (55.9x76.2 cm)
Unsigned: 39.459 a-c
Signed: lower center, "A.W." 39.459 d-i
Ex-collection: donor, New York, N.Y.
Gift of the artist 1939 39.459 a-i

***Side Show at Coney Island**
Oil on canvas 26″x40″ (66.0x101.6 cm)
Signed: lower right, "A. Walkowitz"
Reverse: inscribed on top stretcher, "A. Walkowitz"
Ex-collection: donor, New York, N.Y.
Gift of Abraham Walkowitz in memory of Beatrice Winser 1953 53.31

WALT DISNEY STUDIOS

Sleepy 1937
Watercolor on celluloid 6¾″x8½″ (17.1x21.6 cm)
Inscribed: lower left front, "Sleepy"
Reverse: label, "Original Work from/SNOW WHITE/and/THE SEVEN DWARFS"; label, "This Material inflammable/HANDLE WITH CARE/Frame Under Glass/Copyright 1937/WALT DISNEY ENTERPRISES"; inscribed, upper right, "#133"
Ex-collection: Walt Disney Studios; to donor, Williamsburg, Va.
Gift of Lewis Buddy III 1938 38.175

The celluloid is a negative photographed from an outline drawing made by Walt Disney and filled in with color by Walt Disney or his associates. It was used in the making of the film Snow White and the Seven Dwarfs. *Referred to in correspondence as* Sleepy — Horn — Coach. *(corres.)*

WALTERS, EMILE (b. 1893)

Mt. Heckla, Iceland before 1947
Oil on canvas 25″x30″ (63.5x76.2 cm)
Signed: lower left, "Emile Walters"
Reverse: inscribed, "No 2"
Ex-collection: acquired from the artist, New York, N.Y.
Purchase 1936 Felix Fuld Bequest Fund 36.551

Artist supplied approximate date.

WARD, JACOB CALEB (1809-1891)

Self Portrait
Oil on canvas 29″x25½″ (73.7x64.8 cm)
Unsigned
Ex-collection: Hannah Osborne Eagles Quin; to her daughter, E. L. Quin Brown; to her daughter, the donor, New York, N.Y.
Gift of Mrs. William B. Smith II 1957 57.76

Governor Marcus L. Ward of New Jersey was an uncle of the artist.

Portrait of Hannah Osborne Eagles (1816-1894)
Oil on canvas 22¼″x19″ (56.5x48.3 cm)
Unsigned
Ex-collection: sitter to her daughter, E. L. Quin Brown; to her daughter, the donor, New York, N.Y.
Gift of Mrs. William B. Smith II 1957 57.77

Sitter was the artist's sister-in-law.

Portrait of Mrs. Jacob Caleb Ward [Polly Eagles] 1837
Oil on canvas 22″x19″ (55.9x48.3 cm)
Signed and dated: lower left, "J. Caleb Ward 1837"
Reverse: inscribed, "This was/Painted 1837 by J. Caleb Ward/born in Bloomfield N.J./Exhibited in the National Academy 1830/4 of his works Prior to this painting/Died in 1891/Polly Ward/Wife of Caleb Ward/Restored by Seymour M. Stone 1937."; no pertinent data recorded prior to Stone's relining
Ex-collection: Hannah Osborne Eagles Quin; to her daughter E. L. Quin Brown; to her daughter, the donor, New York, N.Y.
Gift of Mrs. William B. Smith II 1957 57.78

Portrait of Mrs. John Eagles [Charlotte Dodd] (1784-1852) 1837
Oil on canvas 22¼″x19″ (56.5x48.3 cm)
Signed and dated: lower left, "J. Caleb Ward 1837"
Reverse: files do not indicate whether any part of the reverse inscription appeared on the canvas prior to Stone's relining: inscribed, "This was/Painted 1837 by J. Caleb Ward/born in Bloomfield N.J./Exhibited in the National Academy 1830/4 of his works prior to this painting/Died in 1891/Charlotte Dodd Eagles/Born.Jan.2nd 1784/Married John Eagles.Nov.-14th-1806/Died Nov. 14th/1852"/Restored by Seymour M. Stone/1937."; label, "Nelson DeClark/177 Columbus Ave. at 68th St. New York City" (framer)
Ex-collection: Hannah Osborne Eagles Quin; to her daughter, E. L. Quin Brown; to her daughter, the donor, New York, N.Y.
Gift of Mrs. William B. Smith II 1957 57.79

Sitter was the mother of Mrs. Jacob Caleb Ward [Polly Eagles] and Hannah Osborne Eagles.

WASHAKIE, CHARLIE (19th-20th centuries)

The Ghost Dance 1900
Pencil and crayon on paper 24″x36″ (61.0x91.4 cm)
Unsigned
Reverse: on frame, "The Ghost Dance. Drawn by Young Washakie, son of Chief Washakie of the Arapahoes. 1900"
Ex-collection: donor, New York, N.Y.
Gift of Mrs. J. G. Phelps Stokes 1960 60.470

WATERHOUSE, MRS. (19th century)

Flower 1862
Watercolor on cardboard 14"x12" (35.6x30.5 cm)
Unsigned
Reverse: "Painted by Mrs. Waterhouse/in 1862 and presented to/Elva C. Dodge/N.B"
Ex-collection: purchased in Maine by Edith Halpert for The Downtown Gallery, New York, N.Y.
Gift of The Downtown Gallery 1930 30.498

WATERS, SUSAN (1823-1900)

*Sheep in a Landscape ca. 1880
Oil on canvas 24"x36" (61.0x91.3 cm)
Signed: lower right, "Mrs. Susan C. Waters"
Reverse: inscribed, "Mrs. Susan C. Waters Bordentown"; torn sticker, "Eber and Co./Chestnut St./Philadelphia"
Ex-collection: purchased from artist by Miss Hannah DuBell Clevenger, Bordentown, N.J. (died ca. 1905); to Vincent J. Miller, Haddonfield, N.J.
Purchase 1975 Sophronia Anderson Bequest Fund 75.28

The dog in the painting belonged to Miss Clevenger. (files)

WATKINS, FRANKLIN C. (1894-1972)

*Old Woman Reading Proof ca. 1930
Oil on canvas 40¼"x30⅛" (102.2x76.5 cm)
Signed: lower right, "F.W."
Reverse: label, Art Institute of Chicago, 1930; label, Piedmont Festival of Music and Art, Winston, Salem, No. Carolina, 1944; label, San Francisco Museum of Art, #925.39 (part of AFA exhibition); label, Philadelphia Museum of Art, *Watkins Retrospective*, 1964; label, Montclair Art Museum (lent by Frank K. M. Rehn)
Ex-collection: with Frank K. M. Rehn Gallery, New York, N.Y.
Purchase 1946 Felix Fuld Bequest Fund 46.153

Artist supplied date of 1933 but 1930 date is on Art Institute of Chicago label.

WATROUS, HARRY (1857-1940)

Louis Amiard Vibert's Celebrated Model 1884
Oil on canvas 13"x7¼" (33.0x18.4 cm)
Signed: upper right, "Watrous/1884"
Reverse: inscribed, "Painted in Paris 1884"
Ex-collection: Joseph S. Isidor, New York, N.Y., and Newark, N.J.; to his wife, the donor (1941)
Bequest of Mrs. Rosa Kate Isidor 1949 49.426

WAUGH, FREDERICK (1861-1940)

*The Coast of Maine
Oil on canvas 30⅛"x40" (76.5x101.6 cm)
Signed: lower right, "Waugh"
Reverse: label, *Maine – 50 Artists of the 20th Century*, AFA
Ex-collection: donor, Newark, N.J.
Gift of William T. Evans 1911 11.573

WEBER, MAX (b. Russia 1881-1961)

*Zinnias 1927
Oil on canvas 28"x21" (71.1x53.3 cm)
Signed: lower right, "Max Weber"
Reverse: inscribed, "Max Weber/Nassau Haven/Long Island/200/Zinnias"
Ex-collection: with The Downtown Gallery New York, N.Y.; to donor, South Orange, N.J.
Gift of Mrs. Felix Fuld 1928 28.698

Donor purchased painting from exhibition at The Downtown Gallery, May 1928, and presented it to the Museum. Weber's connections with Newark were many. He had designed the color arrangements for the Museum's art gallery in 1912 and had his first major exhibition at Newark in July, 1913. The vase depicted was presented to Weber by his students at the Art Students League in 1927.

Landscape ca. 1928
Oil on panel 18¼"x22¼" (46.4x56.5 cm)
Signed: lower right, "Max Weber"
Ex-collection: acquired from the artist, New York, N.Y.
Purchase 1928 The General Fund 28.1761

Landscape depicts part of a Long Island milk farm. The second work by Weber to be acquired by The Newark Museum, its purchase inspired Weber to write to John Cotton Dana in December, 1928:

"I have not forgotten, I assure you, that you were among the very first to give me a kindly hearing long before modern art was actually heard of in America or elsewhere except in Paris."

Nude Figure, Seated Pre-1929
Pen and blue wash on paper 4¼"x2⅝" (10.8x6.7 cm)
Signed: lower right, "Max Weber"
Reverse: stamped, "Jan 29 1929"
Ex-collection: private collection, New York, N.Y.
Anonymous gift 1940 40.338

*At the Mill 1939
Oil on canvas 40⅛"x48¼" (101.9x122.6 cm)
Signed: lower right, "Max Weber"
Reverse: label, Whitney Museum of American Art, 1943; label, Carnegie Institute of Art; label, Paul Rosenberg and Company; label, Museum of Modern Art
Ex-collection: the artist; with Paul Rosenberg and Company
Purchase 1946 Wallace M. Scudder Bequest Fund 46.159

Date given on Rosenberg label.

WEBSTER, STOKELY (b. 1912)

Fifth Avenue at Metropolitan Museum 1975
Oil on canvas 21¼"x25⅝" (53.9x65.3 cm)
Signed and dated: lower right, "Stokely Webster 75 10"
Ex-collection: donor, Dix Hills, N.Y.
Gift of the artist 1978 78.86

WEEKS, EDWIN LORD (1849-1904)

Moorish Soldier Belonging to the Bashaw of Rabat, Morocco (Sketch)
Oil on canvasboard 13¾"x11¼" (34.9x28.6 cm)
Unsigned
Reverse: stamp indicates work was part of artist's estate sale; *Edwin Lord Weeks Sale/March 15, 16, & 17, 1905*, American Art Galleries, N.Y.C.; of several notations on the board, "No. 189" has been crossed out, "No. 230" exists on support and "133" on board; label, American Art Galleries
Ex-collection: estate of the artist; to Albert H. Sonn, New York, N.Y.
Gift of the daughters of Albert H. Sonn 1940 40.115

The Weeks estate sale catalogue gives an exact title for this work, previously recorded as Sketch; *listed as #133, measurements 13"x11".*

WEINGAERTNER, HANS (b. Germany 1896-1970)

*Christmas Tree 1941
Oil on canvas 52½"x40½" (133.4x102.9 cm)
Signed and dated: lower right, "Hans Weingaertner/1941"
Ex-collection: acquired from the artist, Belleville, N.J.
Purchase 1941 Thomas L. Raymond Bequest Fund 41.819

Cloudy and Cooler 1950
Watercolor on paper 22¼"x29¾" (56.5x75.6 cm)
Signed and dated: lower right, "H S. Weingaertner/1950"
Ex-collection: acquired from the artist, Belleville, N.J.
Purchase 1950 Arthur F. Egner Memorial Fund 50.2146

Forsaken 1962
Oil on canvas 36"x48" (91.4x121.9 cm)
Signed and dated: lower left, "Hans Weingaertner/1962"
Ex-collection: donor, Belleville, N.J.
Gift of Hans Weingaertner 1965 65.153

WEINSTEIN, JOYCE (20th century)

Cityscape 1973
Collage: paper and watercolor 4⅛"x8½" (10.5x21.6 cm)
Signed and dated: lower left margin, "Joyce Weinstein"; lower right margin, "Cityscape 1973"
Reverse: inscribed on masking tape, "Weinstein #3"
Ex-collection: Gloria Cortella Gallery, New York, N.Y.; to donors, New York, N.Y.
Gift of Mr. and Mrs. Henry Feiwel 1977 77.217

Cityscape 1973
Collage: paper and watercolor 5½"x8⅜" (13.3x21.3 cm)
Signed and dated: lower left margin, "Joyce Weinstein"; lower right margin, "Cityscape '73"
Reverse: inscribed on masking tape, "Weinstein #4"
Ex-collection: Gloria Cortella Gallery, New York, N.Y.; to donors, New York, N.Y.
Gift of Mr. and Mrs. Henry Feiwel 1977 77.218

WEIR, J. ALDEN (1852-1919)

*****Fording the Stream** Between 1910-1919
Oil on canvas 25⅛"x30⅛" (63.8x76.5 cm)
Unsigned
Reverse: stamped on stretcher, "975"; label,
M. H. Hartmann, Picture Framer
Ex-collection: estate of J. Alden Weir; with Larcada Gallery, New York, N.Y.
Purchase 1966 The Members' Fund 66.404

Dates confirmed by a notation of the artist's daughter Dorothy Weir Young in her Julian Alden Weir: An Appreciation of His Life *(1921).*

WELLS, CADY (1904-1954)

Head of a Woman ca. 1940
Watercolor on paper mounted on cardboard 30¾"x23" (78.1x58.4 cm)
Unsigned
Reverse: label, Colorado Springs Fine Arts Center, *Eight Annual Artists West of the Mississippi,* 1946; label, San Francisco Museum of Art, *New Watercolors and Gouaches,* 1947;label, Museum of Modern Art, *New Watercolors and Gouaches,* travelling exhibition, 1946-7; label, Edith and Milton Lowenthal Collection
Ex-collection: with Durlacher Bros., New York, N.Y.; to donors, New York,N.Y. (1946)
Gift of Mr. and Mrs. Milton Lowenthal 1949 49.351

The artist dated this painting 1940, but it was listed as 1939 in the Museum of Modern Art travelling show.

WEST, BENJAMIN (1738-1820)

*****The Grecian Daughter Defending Her Father** 1794
Oil on Canvas 19⅛"x23" (48.6x58.4 cm)
Signed and dated: upper right, "B.West 1794"
Reverse: relined prior to acquisition; according to files, panel is inscribed on reverse, "Mr. Harding" (no longer visible); label, Fogg Art Museum 1965; label, Cleveland Museum of Art, *Neo-Classicism: Style and Motif,* 1964
Ex-collection: Mr. Bowles at Wanstead (a London dealer); to Childs Gallery, Boston, Mass.
Purchase 1956 John J. O'Neill Bequest Fund 56.177

Helmut Von Erffa pointed out that the Grecian Daughter *was a popular late 18th century play written by Arthur Murphy. The story was original, not based on a particular classical source. The painting illustrates the final scene in which the brave daughter of a Sicilian king kills the usurper of her father's throne. W. H. Gerdts noted further that there is a facial similarity between the Grecian daughter in this painting and in Gainsborough's portrait of Sara Siddons, the famous actress, who was renowned for her portrayal of the role of the Grecian Daughter, among many others.*

*****Study for the Ascension** (Assumption of Our Savior) ca. 1800
Oil on paper mounted on canvas 11⅛"x7⅞" (28.3x20.0 cm)
Signed: lower left on rock, "B.W."
Reverse: relined prior to entering Museum collection
Ex-collection: Argosy Gallery, New York, N.Y.; to donor, New York, N.Y.
Gift of A. Edward Masters 1959 59.412

Ruth S. Kraemer, in the 1975 Pierpont Morgan Library exhibition catalogue of Benjamin and R. L. West drawings, stated that this oil study might have been preliminary to the 1801 Royal Academy exhibition of a sketch of the Ascension. *The final version was intended for an unfinished chapel for His Majesty at Windsor, the Chapel of Revealed Religion. Kraemer placed Newark's study ca. 1800 and notes the similarity to an oil sketch dated 1798 at the Washington County Museum of Fine Art, Hagerstown, Md.*

WHISTLER, JAMES McNEILL (1834-1903)

*****Study, Head of Girl** ca. 1882-85
Oil on wood 11"x7" (27.9x17.8 cm)
Unsigned
Reverse: label, National Library of Wales, 1951 (lent by the Misses Davies); handwritten label, "Magt S. Davies Gregnog Collection"
Ex-collection: disappeared from Whistler's studio; J. J. Cowan, Edinburgh, Scotland; Margaret S. Davies, Newton, Montgomeryshire (1951); sold by Davies at Sotheby's London, Eng. (May 4, 1960); to Julius Weitzner, London, Eng.; to Stephen Juvelis, Marblehead, Mass.; to Vose Galleries, Boston, Mass.
Purchase 1962 Felix Fuld Bequest Fund 62.4

The late Andrew MacLaren Young, a Whistler specialist at the University of Glasgow, Scotland, helped work out the painting's provenance before his death in 1975 and it was completed by Mrs. Margaret F. MacDonald of Glasgow. Young felt that The Newark Museum's study and Whistler's Portrait of a Young Girl at the Art Institute of Chicago could both be portraits of the Baroness de Meyer whom Whistler first met in 1882. Young dated the Newark work between 1882 and 1885. (files)

WHITE, CHARLES (1918-1979)

*****Sojourner Truth and Booker T. Washington** 1943
Pencil on illustration board 37½"x28" (95.3x71.1 cm)
Signed and dated: lower right, "Charles/White/'43"
Ex-collection: acquired from the artist, New York, N.Y.
Purchase 1944 Sophronia Anderson Bequest Fund 44.100

Artist indicated that this was "a detail from a mural entitled The Negro's Contribution to Democracy" *which was painted for Hampton Institute, Hampton, Va., in 1943. (corres.) "Sojourner Truth" was the name used by Isabella Baumfree (1797?-1883), the first black woman to speak freely in the United States against slavery. She lectured widely in the United States, beginning in 1843. In White's mural she is depicted with Booker T. Washington (1856-1915), who attended Hampton Institute from 1872 to 1875 and later taught there.*

WHITNEY, L. (19th century)

*****American Landscape**
Oil on canvas 18"x28" (45.7x71.1 cm)
Signed: lower right, "L. Whitney PT"
Ex-collection: unnamed antique shop, Manchester, Vt.; to J. B. Neumann, New York, N.Y.
Purchase 1931 Felix Fuld Bequest Fund 31.149

Nothing is known about the artist. "L" could be read as "E." Exhibited as #38 in The Newark Museum exhibition, American Primitives, *1930-31, lent by J. B. Neumann. At the time of the purchase from Neumann it was noted that the painting had been found in Lyme, Conn. (files)*

WHITTREDGE, THOMAS WORTHINGTON (1820-1910)

*Millburn New Jersey ca. 1885
Oil on canvas 20⅜"x15¼" (51.8x38.7 cm)
Signed: lower left, "W Whittredge"
Ex-collection: The Old Print Shop, New York, N.Y.
Purchase 1946 Felix Fuld Bequest Fund 46.160

Files include a letter, given to the Museum by the dealer at the time of purchase, from Reverend T. H. Vincent regarding a commission to Whittredge in 1880. Whittredge moved from New York to Summit, N.J., in 1880.

Goldenfels (Callenfels) 1856
Oil on canvas 27¼"x19¾" (69.2x50.2 cm)
Signed and dated: lower right, "W. Whittredge/---1856"
Reverse: originally inscribed (according to label on stretcher), "Ruin of Goldenfels on the Nahe/Painted from Nature" (painting relined 1963); label, the American Federation of Arts, *Surviving the Ages* 1963-64
Ex-collection: George Guerry, New York, N.Y.; to donors, New York, N.Y.
Gift of Mr. and Mrs. Orrin W. June 1960 60.594

William Gerdts has shown Callenfels *is the more accurate spelling.* (files)

*The Wetterhorn 1858
Oil on canvas 39½"x54" (100.3x137.2 cm)
Signed and dated: lower left, "W. Whittredge Rome 1858"
Reverse: no pertinent data recorded prior to relining 1965
Ex-collection: remained in family of the artist; to artist's grandson, the donor, Snedins Landing, N.Y.
Gift of Mr. and Mrs. William Katzenbach 1965 65.143

WIGGINS, CARLETON (1848-1932)

Holstein Cow
Oil on canvas 40"x50" (101.6x127.0 cm)
Signed: lower left, "Carleton Wiggins, NA"
Reverse: inscribed on canvas, "'Holstein Cow'/Carleton Wiggins/Carnegie Hall/N.Y."
Ex-collection: acquired from the artist, New York, N.Y.
Purchase 1915 15.384

*The Red Oak
Oil on canvas 25¼"x30⅜" (64.1x77.2 cm)
Signed: lower left, "Carleton Wiggins"
Reverse: no pertinent data recorded prior to relining 1974
Ex-collection: donor, New York, N.Y.
Gift of Mrs. Emily Marx in memory of Selma Laufer 1929 29.263

See also George Elmer Browne. 49.469.

WIGGINS, GUY C. (1883-1962)

A Winters Morning ca. 1918
Oil on canvas 25"x30⅛" (63.5x76.5 cm)
Signed: lower left, "Guy C. Wiggins"
Reverse: inscribed in artist's hand, "A Winters Morning"
Ex-collection: acquired from the artist, New York, N.Y.
Purchase 1919 The General Fund 19.781

Previously recorded as A Winter Morning.

WILKES, MAUDE

Atlantic City Boardwalk
Oil on canvasboard 16"x18" (40.6x45.7 cm)
Signed: lower left, "Maude Wilkes"
Ex-collection: private collection, Boston, Mass.; to donor, New York, N.Y.
Gift of Miss A. M. Kraushaar 1965 65.140

Nothing is known of the artist.

WILL, JOHN M. AUGUST (b. Germany 1834-1910)

A Maple Tree 1859
Pencil on paper 10"x8" (25.4x20.3 cm)
Inscribed: lower left, "This maple tree was in a plot of/ground, opposite Catholic church/cor. Ocean Av. and/Bramhall Av./Jersey City."; lower right, "Aug./59"
Ex-collection: Will family; to Arthur L. Brandon, New York, N.Y.; to donor, Los Angeles, Calif.
Gift of Dr. E. Maurice Bloch 1957 57.1

WILLETT, JACQUES (b. Russia 1882-1958)

Evening Breeze
Oil on canvas 28"x36⅜" (71.1x92.4 cm)
Signed: lower right, "Willett"
Ex-collection: donor, New York, N.Y.
Gift of Henry Wellington Wack 1927 27.403

WILLIAMS, FREDERICK BALLARD (1871-1956)

Untitled (Farm Scene) 1895
Watercolor on paper 6"x8" (15.2x20.3 cm)
Signed and dated: lower right, "F. B. Williams '95"
Ex-collection: private collection, New York, N.Y.
Anonymous gift 1935 35.208

WILLIAMS, JOHN ALONZO (1869-1951)

Two Cats Heads
Conte crayon on paper 7"x5¾" (17.8x14.6 cm)
Signed: lower right, "JAW"
Gift 1940, acquired through Alec J. Hammerslough 40.316

Siamese Cat
Charcoal on paper 17"x13¼" (43.2x33.7 cm)
Signed: lower right, "John Alonzo Williams"; label, John Alonzo Williams/Siamese Cat/charcoal drawing
Gift 1940, acquired through Alec J. Hammerslough 40.317

Cat
Conte crayon paper 7⅛"x5½" (18.1x14.0 cm)
Unsigned
Gift 1940, acquired through Alec J. Hammerslough 40.318a

Cat
Conte crayon on paper 5"x10⅛" (12.7x25.7 cm)
Signed: lower right, "JAW"
Gift 1940, acquired through Alec J. Hammerslough 40.318b

Cat
Conte crayon on paper 9½"x11¾" (24.1x29.8 cm)
Signed: bottom, "John Alonzo Williams"
Gift 1940, acquired through Alec J. Hammerslough 40.319

Cat
Conte crayon on paper 11"x15¼" (27.9x38.7 cm)
Signed: "John Alonzo Williams"
Gift 1940, acquired through Alec J. Hammerslough 40.320a

Cat
Conte crayon on paper 2½"x5⅝" (6.4x14.3 cm)
Signed: lower right, "JAW"
Gift 1940, acquired through Alec J. Hammerslough 40.320b

Cat
Conte crayon on paper 5¾"x3½" (14.6x8.9 cm)
Unsigned
Gift 1940, acquired through Alec J. Hammerslough 40.321a

Cat
Conte crayon on paper 2¼"x4¾" (5.7x12.1 cm)
Unsigned
Gift 1940, acquired through Alec J. Hammerslough 40.321b

Cat
Conte crayon on paper irreg. 11¾″x10″ (29.8x25.4 cm)
Signed: lower left, "John Alonzo Williams"
Gift 1940, acquired through Alec J. Hammerslough 40.321c

Cats
Conte crayon on paper 9½″x13½″ (24.1x34.3 cm)
Signed: bottom, "John Alonzo Williams"
Gift 1940, acquired through Alec J. Hammerslough 40.322a

Cats
Conte crayon on paper 8¾″x5½″ (22.2x14.0 cm)
Signed: middle right, "JAW"; lower right, "JAW"
Gift 1940, acquired through Alec J. Hammerslough 40.322b

Cats
Conte crayon on paper 8¾″x5½″ (22.2x14.0 cm)
Signed: lower right, "JAW"
Gift 1940, acquired through Alec J. Hammerslough 40.322c

Cat
Conte crayon on paper 3¾″x4⅞″ (9.5x12.4 cm)
Unsigned
Gift 1940, acquired through Alec J. Hammerslough 40.323a

Cats
Conte crayon on paper 7″x6″ (17.8x15.2 cm)
Signed: lower right, "JAW"
Gift 1940, acquired through Alec J. Hammerslough 40.323b

Cat
Conte crayon on paper 5⅛″x8″ (13.0x20.3 cm)
Signed: lower left, "JAW"
Gift 1940, acquired through Alec J. Hammerslough 40.323c

WILLIAMS, MICAH (ca. 1782-1837)

***Portrait of Sarah Hasbrouck**
Pastel on paper 26″x22″ (66.0x55.9 cm)
Unsigned
Ex-collection: Fred Johnston, Kingston, N.Y.; Duncan Candler
(purchased in 1930's); Thomas D. and Constance R. Williams,
Litchfield, Conn.
Purchase 1951 Sophronia Anderson Bequest Fund 51.18

Identity of the sitter has never been firmly accepted. Drawing was backed by a newspaper of April 2, 1823, New York Tuesday Evening.

***Portrait of Abram Hasbrouck**
Pastel on paper 26″x22″ (66.0x55.9 cm)
Unsigned
Ex-collection: Fred Johnston, Kingston, N.Y.; Duncan Candler
(purchased in 1930's); Thomas D. and Constance R. Williams,
Litchfield, Conn.
Purchase 1951 Sophronia Anderson Bequest Fund 51.19

Identity of the sitter has never been firmly accepted. Drawing was backed by newspaper of March 23, 1818, Daily National Intelligencer, Washington, D.C.

***Portrait of a Gentleman** (possibly John Hoyland) ca. 1819-29
Oil on canvas (relined and mounted on masonite) 30⅛″x25⅛″
(76.5x63.5 cm)
Reverse: inscribed, center back of canvas (prior to relining), "Mr Micah
Williams/To be left at Mr John Hoylands/Grocery New York." below in
lighter script and different hand, "New [Bru]nsw[ick]/N.J."
Ex-collection: with Hampton Gallery, Amagansett, N.Y.; to donor,
New York, N.Y.
Gift of Mrs. Jacob M. Kaplan 1977 77.203

WILLIAMS, WILLIAM (1727-1791)

***Imaginary Landscape** 1772
Oil on canvas 16⅜″x18½″ (41.6x47.0 cm)
Signed and dated: far right of center, "Wm/Williams/1772"
Reverse: inscribed on backboard (prior to cleaning and relining),
"Painted by Saml. Stibs at Princeton, New Jersey, A. D. 1753."
(restorative work in 1958 revealed Williams' signature)
Ex-collection: donor, Newark, N.J.
Gift of Miss Clara A. Lee 1922 22.275

***Mary Magdalene** 1767
Oil on cradled wood 21⅛″x16¼″ (56.7x41.3 cm)
Unsigned
Reverse: stamped twice on frame, "Berry-Hill Galleries Inc 743 Fifth
#19605 C/6455 To P/ave/NYC N.Y. 10022"; label, "N.Y. Cultural Center,
2 Columbus Circle NY 10019/Lent by W. H. Gerdts/*3 Centuries of the
American Nude*"; label, #1197 Rack 4"
Ex-collection: Vose Galleries, Boston, Mass.
Gift of William H. Gerdts 1978 78.104

Pendant to Williams' Old Testament Sibyl, *now in the collection of Historical Deerfield, Mass.*

WILSON, CLAGGETT (1887-1952)

A Garden from the Songs of Solomon (Garden from the Songs)
Watercolor on matboard 19¼″x22½″ (48.9x57.2 cm)
Signed: lower left, "Claggett Wilson"
Reverse: pasted on mat, book or print inscription from *Song of Songs*
Ex-collection: donor, South Orange, N.J.
Gift of Mrs. Felix Fuld 1926 26.206

Artist indicated that this work had been exhibited prior to 1926 at the Chamberlin Dodd Galleries and the Arts Club, Chicago, Ill. (files)

WILSON, SOL (b. Poland 1896-1974)

Portrait of Abraham Walkowitz (1878-1965) ca. 1944
Oil on canvas 20⅛″x16⅛″ (51.1x41.0 cm)
Signed: upper right, "Sol Wilson"
Ex-collection: donor, New York, N.Y.
Gift of Abraham Walkowitz 1948 48.516

Executed for the exhibition, One Hundred Artists and Walkowitz, *Brooklyn Museum, 1944.*

WILTZ, ARNOLD (b. Germany, 1889-1937)

American Landscape 1934
Pen and ink on paper 10″x14″ (25.4x35.6 cm)
Signed and dated: lower left, "Arnold Wiltz 1934"
Allocated by the WPA Federal Art Project 1934 34.311

WITKOWSKI, KARL (b. Austria 1860-1910)

Portrait of Jennie Rosenband (1878-?) 1899
Oil on canvas 52″x35⅝″ (132.1x90.5 cm)
Signed and dated: lower left, "A Witkowski/99" (no longer visible)
Ex-collection: Mr. and Mrs. Burkhardt Rosenband, Newark, N.J.;
to their son-in-law, the donor, Newark, N.J.
Gift of Bernard Wiener 1927 27.1079

There was an inscription on the reverse that is no longer visible: "Jennie Rosenband 21 painted 1899." (files) Sitter was the daughter of Mr. and Mrs. Burkhardt Rosenband and sister of Olga Rosenband Wiener.

Portrait of Mrs. Burkhardt Rosenband 1899
Oil on canvas 51¾″x34½″ (131.4x87.6 cm)
Signed: upper right, "K Witkowski/99"
Ex-collection: Mr. and Mrs. Burkhardt Rosenband, Newark, N.J.; to
their son-in-law, the donor, Newark, N.J.
Gift of Bernard Wiener 1927 27.1080

Portrait of Burkhardt Rosenband 1899
Oil on canvas 51¾"x34½" (131.4x87.6 cm)
Unsigned
Ex-collection: Mr. and Mrs. Burkhardt Rosenband, Newark, N.J.; to their son-in-law, the donor, Newark, N.J.
Gift of Bernard Wiener 1927 27.1081

Mr. Rosenband was a Newark manufacturer who produced novelties. The Rosenband family lived on High Street.

Portrait of Olga Rosenband Wiener 1899
Oil on canvas 51¾"x34½" (131.4x87.6 cm)
Unsigned
Ex-collection: Mr. and Mrs. Burkhardt Rosenband, Newark, N.J.; to their son-in-law, the donor, Newark, N.J.
Gift of Bernard Wiener 1927 27.1082

Portrait of Monsignor George Hobart Doane (1830-1905) 1902
Oil on canvas 36"x28¾" (91.4x73.0 cm)
Signed and dated: lower right, "K. Witkowski/1902"
Ex-collection: donor, Newark, N.J.
Gift of James E. Bryan 1964 64.8

Monsignor Doane, a civic leader instrumental in helping to establish the Newark Museum, was pastor of St. Patrick's Church and chaplain of the Newark Regiment in the Civil War.

WOLLASTON, JOHN (ca. 1710-ca. 1770)

*****Family Group** ca. 1750
Oil on canvas 51¼"x71⅛" (129.9x180.7 cm)
Unsigned
Ex-collection: part of a 19th century English collection, presumably brought there during the American Revolution for safekeeping; with Hirschl & Adler Gallery, New York, N.Y.
Purchase 1956 The Members' Fund 56.231

Found with two other portraits of Rebecca Steward Spry and Master Steward now at the Art Institute of Chicago. This is the only extant Wollaston to depict a family of father, mother and child. Carolyn J. Weekley, Curator of the Museum of Early Southern Decorative Arts, Winston-Salem, N.C., felt that the work was probably painted during Wollaston's New York stay, 1749-52. (corres.)

WOOD, HUNTER (20th century)

Sea Witch
Oil on canvas 28"x36" (71.1x91.4 cm)
Signed: lower right, "Hunter Wood"
Ex-collection: Mr. Watts of Newark bequeathed to donor, Redding, Conn.
Gift of Miss Margaret M. Ryan 1956 56.7

WOODRUFF, HALE (1900-1980)

*****Poor Man's Cotton** 1944
Watercolor on paper 30½"x22½" (77.5x57.2 cm)
Unsigned
Reverse: inscribed on frame, "Hale Woodruff Atlanta University Atl. Ga."
Ex-collection: the artist, New York, N.Y.
Purchase 1944 Sophronia Anderson Bequest Fund 44.122

Artist indicated that he was inspired by a trip to Alabama to paint "the rhythmic movement of workers in the cotton fields as they went about their cotton chopping The cotton was poor and hence the people were poor." (corres.)

WORES, THEODORE (1859-1939)

Tree Blossoms ca. 1930-5
Oil on canvas 16"x20" (40.6x50.1 cm)
Signed: lower right, "Theodore Wores"
Reverse: on frame and stretcher, "
Ex-collection: the artist to Mrs. Louis Shenson; to donors, San Francisco, Calif.
Gift of Drs. Ben and A. Jess Shenson 1977 77.204

WRIGHT, DMITRI (b. 1948)

Black Couple in Bed Looking at TV 1971
Acrylic on canvas 54"x54¾" (137.2x139.1 cm)
Unsigned
Ex-collection: the artist, Winfield, N.J.
Gift of The Prudential Insurance Company of America 1971 71.167

Exhibited in Newark Museum exhibition, Black Artists: Two Generations, *1971. Date supplied by artist.*

WRIGHT, STANTON MACDONALD (1890-1973)

*****Yosemite Valley** 1937
Pencil on paper 27⅞"x22⅞" (70.8x58.1 cm)
Signed and dated: at bottom, "For Federal Art Project/S Macdonald Wright '37/- Yosemite Valley-"
Reverse: label on backing, WPA #5397
Allocated by the WPA Federal Art Project 1943 43.207

Synchronist Abstraction 1952
Oil on canvas 27½"x18" (69.9x45.7 cm)
Signed: bottom, left of center, "S. Wright"
Reverse: label, Little Gallery, Birmingham, Mich.
Ex-collection: private collection; to Little Gallery, Birmingham, Mich.; to donor, New York, N.Y.
Gift of Victor Spark 1963 63.126

WUST, ALEXANDER (b. Holland 1837-1876)

Untitled (Seascape) 1869
Oil on canvas 30¼"x54" (76.8x137.4 cm)
Signed: lower left, "Alex Wust '69"
Ex-collection: reportedly once in Parker House, Boston, Mass., the gift of a Mr. Coolidge; to donor, Princeton, N.J.
Gift of Arthur Yorke Allen 1976 76.156

WYANT, ALEXANDER H. (1836-1892)

Untitled (Landscape) 1870
Oil on canvas 11"x17" (27.9x43.2 cm)
Signed: lower right, "A H Wyant Aug-70-"
Ex-collection: donor, Scotch Plains, N.J.
Bequest of Dr. J. Ackerman Coles 1926 26.1261

Untitled (Landscape)
Oil on canvas 16¼"x20¼" (41.3x51.4 cm)
Signed: lower left, "A. H. Wyant"
Ex-collection: Joseph S. Isidor, New York, N.Y. and Newark, N.J.; to his wife, the donor (1941)
Bequest of Mrs. Rosa Kate Isidor 1949 49.466

Killarny Lake Scenery 1867
Watercolor on paper 5¼"x8⅜" (13.3x21.3 cm)
Signed and dated: lower right, "A H Wyant/1867"
Reverse: inscribed on mount "Killarny Lake Scenery"
Ex-collection: The Howard W. Hayes Collection
Gift of Mrs. Louis Pennington, 1949 49.541

No. 21 in the Howard W. Hayes Collection catalogue, Newark Free Public Library, 1906.

XCERON, JEAN (b. Greece 1890-1967)

*****239B** 1938
Oil on canvas 57¼"x37⅞" (145.4x96.2 cm)
Signed and dated: lower left, "Xceron/38"; lower right, "Jean Xceron"
Ex-collection: Mary Xceron; with Washburn Gallery, New York, N.Y.
Purchase 1976 The Members' Fund 76.4

YATES, CULLEN (1866-1945)

The Highway
Oil on canvas 30"x40" (76.2x101.6 cm)
Signed: lower right, "Cullen Yates"
Ex-collection: donors, New York, N.Y.
Gift of Mr. and Mrs. Henry H. Wehrhane 1929 29.909
Scene depicted is near the Delaware Water Gap.

YAZZIE, SYBIL (20th century)

Spinning and Carding Wool ca. 1934
Gouache on paper 11⅜"x16" (28.9x40.6 cm)
Signed: lower right, "Sybil Yazzie"
Gift of Miss Amelia E. White 1937 37.172
Artist was a member of Navajo tribe.

Weavers ca. 1935
Gouache on paper 16½"x19" (41.9x48.3 cm)
Signed: lower right, "Sybil Yazzie"
Gift of Miss Amelia E. White 1937 37.173

YOUNG, J. HARVEY (1870-1901)

Pike's Peak 1898
Oil on cardboard 20⅞"x30¾" (53.0x78.1 cm)
Signed and dated: lower right, "Harvey Young 98"
Ex-collection: donor, New York, N.Y.
Gift of Henry Wellington Wack 1926 26.217

YOUNGERMAN, JACK (b. 1926)

***February 11, 1968** 1968
Ink on paper 30"x40" (76.2x101.6 cm)
Signed and dated: lower right, "JY '68"
Ex-collection: the artist; to Jock Truman, New York, N.Y.;
to donor, New York, N.Y.
Gift of Eric Green 1971 71.158

YUEY, CHIN YUEN (b. China 1922)

#2018 1964
Inks and gouache on rice paper 24"x18¾" (61.0x47.7 cm)
Signed and dated: lower right, "Chin Yuen Yuey/'64"
Reverse: sticker, Byron Gallery/25 E 83 St., New York, N.Y./Oct 27
Nov 6, 1965
Ex-collection: with Byron Gallery, New York, N.Y.; to donors,
New York, N.Y.
Gift of Mr. and Mrs. Henry Feiwel 1977 77.230

ZADKINE, OSSIP (b. France 1890-1967)

Figures on a Trapeze
Crayon on paper 10⅞"x8⅞" (27.6x22.5 cm)
Signed: lower right, "Zadkine"
Reverse: written on mat, "Zabriskie 5912C1"
Ex-collection: Zabriskie Gallery, New York, N.Y.; to donor,
New York, N.Y.
Gift of Robert Schoelkopf in memory of Nathan Krueger
1961 61.454

ZERBE, KARL (b. Germany 1903-1972)

Houses on the River 1936
Gouache on paper 18¼"x25½" (46.4x64.8 cm)
Signed and dated: lower left, "Zerbe 1936"
Allocated by the WPA Federal Art Project 1943 43.199
*Prior to entering Newark Museum collection, painting was exhibited in the
Museum of Modern Art's* New Horizon *exhibition, 1936.*

***Brooklyn Bridge** ca. 1946
Encaustic on canvas 36½"x40⅛" (92.7x101.9 cm)
Signed: lower left, "Zerbe"
Reverse: stamp on stretcher, 36/Glendale L.I.; label,
The Downtown Gallery
Ex-collection: The Downtown Gallery, New York, N.Y.
Purchase 1946 Sophronia Anderson Bequest Fund 46.112
*Purchased by the Museum before the artist's one-man show at The
Downtown Gallery in 1946.*

Owl 1946
Gouache on paper 19¾"x25⅞" (50.2x65.7 cm)
Signed: lower left, "Zerbe"
Reverse: inscribed on paper, "Owl/Feb. 1946"; label on backing,
The Downtown Gallery
Ex-collection: The Downtown Gallery, New York, N.Y.; to donor,
Gladstone, N.J.
Gift of Mrs. C. Suydam Cutting 1952 52.118

***Osprey Nest** 1955
Polymer, tempera and collage on wood 49¾"x31¾" (126.4x80.6 cm)
Signed: lower right, "Zerbe"
Reverse: inscribed on panel, "Zerbe/Nov-Dec 1955/Osprey Nest"; label,
Pennsylvania Academy of The Fine Arts, 1956 (lent by Alan Gallery);
label, Alan Gallery
Ex-collection: Alan Gallery, New York, N.Y.
Purchase 1956 Felix Fuld Bequest Fund 56.185

ZORACH, MARGUERITE (1887-1968)

***Bridge, New England** (New England Bridge;
Bridge at Rockport, Maine) 1930
Oil on canvas 25⅛"x31⅛" (63.8x79.1 cm)
Signed: lower right, "M. Zorach"
Reverse: label, *Realism and Reality*, AFA, 1965; label, Museum of
Fine Arts, Boston, *Maine and Its Artists 1910-1963*, 1963 (organized
by Colby College)
Ex-collection: private collection, New York, N.Y.
Anonymous gift 1937 37.121
Date supplied by artist.

ZORACH, WILLIAM (b. Lithuania 1889-1966)

Portrait of Dahlov 1922
Pen and ink on paper 11"x8½" (27.9x21.6 cm)
Signed: lower right, "William Zorach"
Written on bottom of mat (not in artist's hand), "Wm Zorach 'Dahlov'
(artist's daughter)"
Ex-collection: private collection, New York, N.Y.
Anonymous gift 1940 40.337
Date supplied by artist.

Illouette Creek 1920
Watercolor on paper 18⅞"x13½" (47.9x34.3 cm)
Signed and dated: lower left, "William Zorach-1920-"
Reverse: on backing (presumably written by Miss Hartshorn), "Willed
to Newark Museum, 'Illouette Creek' by William Zorach."
Ex-collection: donor, Short Hills, N.J.
Bequest of Miss Cora Louise Hartshorn 1958 58.172

***Autumn** 1917-20
Watercolor on paper 15⅝"x11⅜" (39.7x28.9 cm)
Signed: lower right, "Zorach"
Reverse: on backing (presumably written by Miss Hartshorn), "Willed
to Newark Museum/'Autumn'/by William Zorach."
Ex-collection: donor, Short Hills, N.J.
Bequest of Miss Cora Louise Hartshorn 1958 58.173
*Museum files indicate this work was executed in the 1920's. Roberta
Tarbell feels a date of 1920 is logical if it is a Yosemite scene. Tarbell adds
that in 1917 the Zorachs were in the White Mountains, N.H., another
possible location. (corres.)*

Catalogue
of
Sculpture

ARTIST UNKNOWN

Bootmaker's Sign
Wood slab with bark 18½"x21"x5½" (47.0x53.3x14.0 cm)
Unsigned
Anonymous gift 00.273

Barnyard
Wood group 3¾"x8"x4⅜" (9.5x20.3x11.1 cm)
Unsigned
Ex-collection: donor, Providence, R.I.
Gift of George A. Livesey 1931 31.469

***Cat** 19th century
Painted wood 6"x11½"x4" (15.2x29.2x10.2 cm)
Unsigned
Ex-collection: donor, West Chester, Pa.
Gift of Mrs. Francis D. Brinton 1931 31.967

Lady
Carved wood figure 6" (15.2 cm)
Unsigned
Ex-collection: donor, Newark, N.J.
Gift of Miss Mabel Tidball 1931 31.968

Surf Skoter Decoy late 19th-early 20th century
Painted wood 8⅝"x16¼"x8¼" (21.9x41.3x21.0 cm)
Unsigned
Ex-collection: donor, East Orange, N.J.
Gift of Miss S. May Martin 1938 38.350

Attributed by donor to "an old fisherman at Monhegan, Me."

Fish Weathervane 1784
Wrought iron vane: 7½"x27¼"x1" (19.1x69.2x2.5 cm); shaft: 32¾"x1½"
diam. (83.2x3.8 cm); direction indicators: 23¾"x23¾"x¼"
(60.3x60.3x0.6 cm)
Unsigned
Dated: 1784 (cut out within fish-shaped vane)
Gift of the Newark Board of Education 1938 38.682

*From the Pot-pie Lane schoolhouse in Lyons Farms, Newark, originally
erected in 1728 and destroyed by fire during the Revolution. In 1784 the
schoolhouse was rebuilt of sandstone and, in 1938, moved to the Garden of
The Newark Museum with the help of the WPA. A replica is now mounted
on the belltower of the schoolhouse.*

Quail and Two Kegs 19th century
Stained wood 5¼"x4⅛"x3⅞" (13.3x10.5x9.8 cm)
Signed: "J.B.S."
Ex-collection: donor, New York, N.Y.
Gift of Mrs. Edith G. Halpert 1940 40.148

Toy Man (Pennsylvania)
Wood 8¾" (22.2 cm)
Unsigned
Ex-collection: donor, New York, N.Y.
Gift of Mrs. Edith G. Halpert 1940 40.149

Toy Pump (Pennsylvania)
Wood 8" (20.3 cm) including base
Unsigned
Ex-collection: donor, New York, N.Y.
Gift of Mrs. Edith G. Halpert 1940 40.150

Figurehead 19th century
Painted wood 42"x20"x20" (106.7x50.8x50.8 cm)
Unsigned
Ex-collection: Frank F. Sylvia, Nantucket, Mass.; through
Miss Dorothy C. Miller, New York, N.Y.
Purchase 1944 Sophronia Anderson Bequest Fund 44.161

Sandpiper Decoy late 19th-early 20th century
Wood 6"x11"x3½" (15.2x27.9x8.9 cm)
Unsigned
Ex-collection: donor, New York, N.Y.
Gift of Mrs. Edith G. Halpert 1944 44.189

Attributed to the Raritan Bay area.

Eagle on Ball Finial 19th century
Copper and lead 11⅛"x19½"x7" (28.3x49.5x17.8 cm)
Unsigned
Ex-collection: John Mendelson Antiques, Springfield, N.J.
Purchase 1952 52.113

Trotting Horse Weathervane – "Ethan Allen" 19th century
Copper and cast iron 17"x30"x2½" (43.2x76.2x6.4 cm)
Unsigned
Ex-collection: John Mendelson Antiques, Springfield, N.J.
Purchase 1952 52.114

*Listed in J. W. Fiske catalogue, Copper Weather Vanes, 1893, p. 14, #9.
Ethan Allen was the winner of numerous trotting races in the 1850's.
He lowered the mile record to 2 minutes 25½ seconds.*

Horse Toy 19th century
Painted wood and plaster, traces of leather ears and tail 14" (35.6 cm)
Unsigned
Ex-collection: donors, Stockton, N.J.
Gift of Mr. and Mrs. Bernard M. Douglas 1956 56.60

***Indian Squaw Cigar Store Figure** 19th century
Painted wood 42" (106.7 cm) including base
Unsigned
Ex-collection: donors, Sarasota, Fla.
Gift of Herbert W. and John H. Ballantine 1958 58.165

*Original paint has been covered with brown enamel over much
of the figure.*

Animal Head 18th century (?)
Red sandstone block 10"x9"x18" (25.4x22.9x45.7 cm)
Unsigned
Gift of Dr. Arthur C. Fox, David I. Fox and Richard H. Fox
1961 61.23

*Found at a demolished house "next door" to either 283 Lehigh Ave.,
Newark, N.J., owned by Richard H. Fox, or 81 Hansbury Ave., Newark,
N.J., owned by David I. Fox. Correspondence accompanying gift
is unclear.*

***Figurehead** 19th century
Painted wood 27"x12½"x10" (68.6x31.8x25.4 cm)
Unsigned
Ex-collection: James Abbe, Jr., Oyster Bay, N.Y.
Purchase 1962 J. M. Kaplan Fund Inc. 62.142

*According to vendor, the piece was from the ship "Betsy" out of
Portsmouth, N.H. (files)*

Indicates sculpture is reproduced.

Gravestone 1752
Stone 19½"x31¾"x2⅛" (49.5x80.6x5.4 cm)
Unsigned
Inscribed: "Here lyes ye body of/Mr. Henery Scudder/Who was drowned/March ye 23 AD 1752/Aged 39th year"
Ex-collection: with the Thompson Gallery, New York, N.Y.
Purchase 1962 Thomas L. Raymond Bequest Fund 62.143

Horse late 19th century
Painted wood, horsehair mane and tail (later addition) 86" (218.4 cm)
Unsigned
Ex-collection: James Abbe, Jr., Oyster Bay, N.Y.
Purchase 1966 John J. O'Neill Bequest Fund 66.402

A saddle- or harness-maker's figure.

Eagle on Ball Finial ca. 1850
Gilded copper 25"x38"x15½" (63.5x96.5x39.4 cm)
Unsigned
Ex-collection: Julia E. Kuttner, American Antiques, New York, N.Y.
Purchase 1966 Mathilda Oestrich Bequest Fund 66.638

According to vendor, the piece originated in Englewood, N.J. (corres.)

***Rooster Weathervane** probably early 18th century
Sheet iron 43½"x38½"x1⅝" (110.5x97.8x4.1 cm); shaft, 81"x1⅛" diam. (205.7x2.9 cm diam.); overall height: 102" (259.0 cm)
Unsigned
Ex-collection: Saddle River (N.J.) Reformed Church; to Ackerman Family of Bergen County; to John Gordon Antiques and Fine Arts, New York, N.Y.
Purchase 1967 Sophronia Anderson Bequest Fund 67.1

Provenance supplied by vendor.

Pole Eagle
Gilded copper 12"x34⅜"x14" (30.5x87.3x35.6 cm)
Unsigned
Inscribed: stamp, "M.J. Frand Co./Manufacturers/Camden, N.J."
Ex-collection: Parke-Bernet Galleries Inc., New York, N.Y.
Sale #2646, 1/27/68
Purchase 1968 Charles A. Edison Endowment Fund 68.240

***Ram Weathervane** ca. 1860
Copper and zinc 27"x32½"x2" (68.6x82.6x5.1 cm)
Unsigned
Ex-collection: Gerald Kornblau, New York, N.Y.
Purchase 1969 John J. O'Neill Bequest Fund 69.21

Rooster Weathervane late 19th century
Gilded copper A: vane 24"x21"x3¼" (61.0x53.3x8.3 cm); B: shaft and directionals 37"x31"x1⅝" (94.0x78.7x4.2 cm)
Unsigned
Ex-collection: Hardin Family, Chester, N.J.
Gift of Mrs. John R. Hardin in memory of John R. Hardin
1970 70.78 A-B

Horse Lightning Rod Finial 20th century
Painted zinc 10"x13⅞"x1⅝" (25.4x35.2x4.1 cm)
Unsigned
Ex-collection: Estate of Katherine Coffey, Newark, N.J.; to donor, Newark, N.J.
Gift of Miss Jewel Zelder 1973 73.55

According to Alexander Farnham, Stockton, N.J., this is a type of finial sold by St. Louis Lightning Protection Co. in the 1920's and 1930's, stamped out by firms such as Miller and Doing, Brooklyn, N.Y., and Kenneth Lynch and Sons of Wilton, Conn. (corres.)

Hand 19th century
Painted wood 19"x6"x4" (48.3x15.2x10.2 cm)
Ex-collection: John Gordon Galleries, New York, N.Y. 1968
Anonymous gift 1975 75.197

Possibly a jeweler's trade sign.

Red-Breasted Merganser Decoy
Painted wood with horse hairs 5¼"x18¾"x5" (13.3x47.6x12.7 cm)
Unsigned
Burned into bottom: "C. [or O.] W. Hallet"
Ex-collection: donor, Newark, N.J.
Gift of Mrs. Constance B. Benson 1977 77.136

Mallard Decoy
Machine-turned painted wood 5⅜"x16⅝"x5½" (13.7x42.2x14.0 cm)
Unsigned
Ex-collection: donor, Newark, N.J.
Gift of Mrs. Constance B. Benson 1977 77.137

Mallard Decoy
Machine-turned painted wood 5½"x16⅝"x5½" (14.0x42.2x14.0 cm)
Unsigned
Ex-collection: donor, Newark, N.J.
Gift of Mrs. Constance B. Benson 1977 77.138

***Dragonfly Weathervane** early 20th century
Wire mesh, copper, iron nut, found wood 8½"x26½" (21.6x67.3 cm); body 26⅛" (66.3 cm)
Unsigned
Ex-collection: Edmund I. Fuller, Woodstock, N.Y.
Purchase 1977 Charles W. Engelhard Bequest Fund 77.164

According to vendor, piece came from Lake Mohawk, N.J.

ABISH, CECILE (20th century)

Boxed Monuments-3 1969
Paper construction with three offset lithographs in plastic box
A (open) 6⅛"x16¾"x15¾" (15.6x42.5x40.0 cm);
 (closed) 6⅛"x4⅜"x15¾" (15.6x11.1x40.0 cm);
B (box) 6¼"x4⅞"x15⅝" (15.9x12.4x39.7 cm)
Signed: "Cecile Abish"
Numbered: 14/500
Gift of the artist 1973 73.107 A-B

Boxed Monuments-3 1969
An identical multiple of 73.107
Signed: "Cecile Abish"
Numbered: 13/500
Purchase 1973 Mrs. Parker O. Griffith Bequest Fund 73.108 A-B

ADAMS, HERBERT (1858-1945)

***Infant Burbank** 1905
Bronze 25½" (64.8 cm)
Signed and dated: "Herbert Adams/MCMV/©"
Founder's mark: "Roman Bronze Works N-Y-"
Purchase 1916 16.472

A replica consigned by the artist's widow was sold at Parke-Bernet Galleries, Inc., New York, N.Y., as Lot #280 in Sale #782, June 6, 1946. According to the catalogue note, three replicas existed, including The Newark Museum example. A letter from Adams' widow states that the artist kept a replica as a fountain figure in his own garden. (corres.)

ADLER, SAMUEL M. (1898-1979)

Talisman 1969
Painted wood 31¾"x19⅝"x3¾" (80.6x49.8x9.5 cm)
Signed and dated: (on reverse) "SMA 1969"
Gift of the artist 1971 71.163

ANTONAKOS, STEPHEN (b. Greece 1926)

Dream 1963
Synthetic pillow with crayon on canvas case, mounted on masonite
16"x23"x8" (40.6x58.4x20.3 cm)
Signed and dated: (on reverse) "Antonakos March 26, 1963"
Ex-collection: the artist; to donors, New York, N.Y.
Gift of Mr. and Mrs. Paul Waldman 1969 69.169

*Blue Cross Neon** 1965
Neon tubes on aluminum support and electrical components
48"x48"x9½" (122.0x122.0x24.1 cm)
Unsigned
Ex-collection: the artist; to donors, New York, N.Y.
Gift of Mr. and Mrs. Arthur A. Cohen 1972 72.337

Dream Pillow 1964
Construction: wood, epoxy, neon tubes and electrical components
19¾"x24¾"x11¾" (50.2x62.9x29.8 cm)
Signed and dated: (on reverse) "Antonakos/Neon Pillow April 1964/#1"
Numbered: 51
Ex-collection: the artist; to donors, Brooklyn, N.Y.
Gift of Mr. and Mrs. Robert E. Bruce 1973 73.117

BAERER, HENRY (1837-1908)

William Hawkins (1824-1889) 1874
Marble 26" (66.0 cm)
Signed and dated: "H. Baerer Sc./N.Y. 1874"
Ex-collection: donor, Upper Montclair, N.J.
Gift of Mrs. C. W. Romaine 1945 45.288

William Hawkins was a prominent jeweler in Newark and grandfather of the donor.

Annie E. Hawkins (1856-1880) 1874
Marble 17¾"x14" (45.1x35.6 cm) [oval]
Signed and dated: "H. Baerer Sc./N.Y. 1874"
Ex-collection: donor, Upper Montclair, N.J.
Gift of Mrs. C. W. Romaine 1945 45.289

Subject, a daughter of William Hawkins, was mother of the donor.

BALL, CAROLINE P. (1869-1938)

Bashful Boy
Bronze 5½" (14.0 cm)
Signed: "Caroline Peddle Ball • Sc."
Founder's mark: "Gorham Co OIW"
Ex-collection: Gorham Co., New York, N.Y.
Purchase 1914 14.7

In The Newark Museum exhibition, Bronzes by American Sculptors, *1913.*

BALL, THOMAS (1819-1911)

*Henry Clay** (1777-1852) 1858
Bronze 30½" including 1⅞" base (77.5 cm)
Signed and dated: "T. Ball Sculpt. Boston 1858"
Inscribed: "Patent assigned to GW Nichols"
Ex-collection: donor, Scotch Plains, N.J.
Gift of Dr. J. Ackerman Coles 1919 19.718

Located replicas: North Carolina Museum of Art, Raleigh, N.C.; Henry Clay Memorial Foundation, "Ashland," Lexington, Ky.; Addison Gallery, Phillips Academy, Andover, Mass.

BASHLOW, GEORGE (b. 1900)

Abercrombie II ca. 1952
Black Belgian marble 11¾"x10"x8" (29.8x25.4x20.3 cm)
Signed: "Bashlow"
Gift of the artist 1955 55.99

A portrait of the artist's family cat, first exhibited at Montclair Art Museum, 1952. (corres.)

BAYRAK, TOSUN (b. Turkey 1926)

V W Skin 1969
Sheet latex 192"x120" (487.7x304.8 cm)
Unsigned
Ex-collection: purchased from the artist, New York, N.Y.
Purchase 1971 Funds given by The Gehrie Foundation and Arif
Mardin 72.146 A-E

BEACH, CHESTER (1881-1956)

The Surf 1921-22
Bronze 22¼" on 1¼" marble base (56.5 on 3.2 cm)
Signed: "Chester Beach"
Founder's mark: "Roman Bronze Works N-Y-"
Label: on plaque, "First Prize/National Arts Club/Annual Exhibition 1922"
Ex-collection: purchased from the artist, New York, N.Y.
Gift of Mr. and Mrs. Felix Fuld 1926 26.2362

According to Mrs. Paul Fitchen, the artist's daughter, this original bronze was possibly cast in 1921. A marble variant (recorded from 1924) is in a private collection in New York, N.Y. (corres.)

Swimmin' 1907
Bronze 38¼" (97.2 cm)
Signed: "C. Beach/©"
Founder's mark: "Kunst – Foundry – N.Y."
Ex-collection: with Ferargil Galleries, New York, N.Y.
Purchase 1927 J. Ackerman Coles Bequest Fund 27.288

According to the artist, the piece first appeared as a small bronze and later in this fountain form, of which three were made. (corres.)

The Big Toe
Bronze 2¾" (7.0 cm)
Signed: (monogram)
Founder's mark: "R.B.W."
Ex-collection: Kenneth Dean; to donor, Chester, N.J.
Gift of Mrs. John Hardin 1961 61.29

Formerly listed as Crouching Infant. *A portrait sketch of Pierre Marot Purves (a marble life-size portrait of subject was commissioned in 1908). First record of bronze sale in 1918. (corres.)*

BEAN, BENNETT (b. 1941)

One 1967
Plexiglas 60"x14¼"x14¼" (152.4x36.2x36.2 cm)
Unsigned
Ex-collection: purchased from the artist, Staten Island, N.Y.
Purchase 1968 Anonymous Endowment Fund 68.221

Purchased from Cool Art *exhibition, May 27-September 29, 1968.*

BEITL, JOSEPH G. (1841-1929)

Bust of Unknown Man 1872
Bronzed plaster 24½" (62.2 cm)
Signed and dated: "J. G. Beitl 1872"
Anonymous gift 00.368

BERGE, EDWARD (1876-1924)

Violet 1916(?)
Bronze 7⅞" on a 2" base (20.0 on 5.1 cm)
Unsigned
Founder's mark: "Amer. Art Fdry. N.Y."
Numbered: "50"
Ex-collection: Grand Central Art Galleries, Inc., New York, N.Y.
Purchase 1927 J. Ackerman Coles Bequest Fund 27.290

A work listed under this title dated 1916 was shown at a memorial exhibition in 1925 at the Baltimore Museum of Art (#31). (files)

BOLINSKY, JOSEPH ABRAHAM (b. 1917)

Spanish Soldier 1940-41
Sandstone 25½" (64.8 cm)
Signed: "Bolinsky"
Ex-collection: with Gallery West, Buffalo, N.Y.
Gift of the artist 1943 43.213

BOLOTOWSKY, ILYA (b. Russia 1907)

***Eight Foot Trylon, Variation II** 1965-77
Acrylic paint on wood 95¾" exclusive of 1½"x18"x18" base; 8¾" on side
(3) (124.2 exclusive of 3.8x45.7 cm base; 22.2 cm on side (3))
Unsigned
Ex-collection: with Grace Borgenicht Gallery, Inc., New York, N.Y.
Purchase 1977 Katherine Coffey Fund 77.174

BORGLUM, JOHN GUTZON DE LA MOTHE (1867-1941)

*Borglum was awarded the commission on February 11, 1921, for a
monumental bronze group,* Wars of America, *to be placed in Military
Park, Newark. The wars referred to are the Revolution, the Civil War, the
Spanish-American War and World War I. Representatives from all of these
conflicts are depicted, including a Red Cross nurse, a conscientious
objector, the aviator John Purroy Mitchell, and the figure of the donor,
Amos Van Horn, as the volunteer of 1861. The work was unveiled on
Memorial Day in 1926. Its setting at the end of a long reflecting pool
produces the shape, as seen from the air, of a Tudor sword with the
monument as its handle.*

*Nine different models were made and the development of the composition
covered a period of over two years. In 1926 the City of Newark purchased
the plaster models from the artist and gave them to The Newark Museum.
(cf. Casey and Borglum)*

*Ex-collection: purchased from the artist by the City of Newark
Purchase 1926*

Wars of America ca. 1920
Group: plaster 15"x26"x10" (38.1x66.0x25.4 cm)
Unsigned 26.2793

A preliminary sketch for the bronze group.

Wars of America ca. 1920
Group: plaster 15½"x30"x11¾" (39.4x76.2x29.8 cm)
Unsigned 26.2794

A preliminary sketch.

Wars of America ca. 1920
Group: plaster 25"x64"x25½" (63.5x162.6x64.8 cm)
Unsigned 26.2795

An intermediate sketch.

Wars of America ca. 1920
Group: plaster 24"x60½"x20⅞" (61.0x154.0x53.0 cm); wood base,
9³⁄₁₆"x65¼"x28⅜" (23.3x166.0x72.0 cm)
Unsigned 26.2796

An intermediate sketch.

Wars of America ca. 1920
Group: plaster 48"x132¼"x48½" (121.9x335.9x123.2 cm) (assembled)
Unsigned 26.2797 A-F

*The work is in six sections A-F which were restored and reinforced with
polyurethane in 1974: A. 22½"x70½"x47¾" (57.2x179.1x121.3 cm);
B. 60"x46"x47¾" (152.4x116.8x121.3 cm); C. 39"x33"x47¾" (99.1x83.8x121.3
cm); D. 37"x44"x32" (94.0x11.8x81.3 cm); E. 35"x43"x33" (88.9x109.2x83.8
cm); F. 27"x29"x28" (68.6x73.7x71.1 cm)*

This is the Master Key model for the bronze group. (artist's corres.)

***Untitled** 1910
Marble 8½" (21.6 cm)
Signed and dated: "For/Ralph Lum/Gutzon Borglum/-1910-"
Ex-collection: Ralph Lum, Sr., Newark, N.J.; to donor, Chatham, N.J.
Gift of Ralph Lum, Jr., in memory of Ralph Lum, Sr. 1972 72.196

*Located replicas: a replica was listed as Lot 75A in Sotheby Parke Bernet
Galleries Inc., New York, N.Y., Sale #4076, February 1-4, 1978.*

***Seated Lincoln** 1911 or after
Bronze 22"x23¾"x16¾" (55.9x71.1x42.5 cm)
Signed: "Gutzon Borglum"
Founder's mark: "Gorham Co Founders Q 501"
Ex-collection: Robert Sarnoff, New York, N.Y.; William Doyle
Galleries, Inc.,New York, N.Y. (1978); The Stradlings, New York, N.Y.
Purchase 1978 The Members' Fund 78.89

*Replica sold at Dodge sale (Part IV), Sotheby Parke Bernet Catalogue
#3802, October 31, 1975.*

*A reduction of the heroic-sized seated figure of Abraham Lincoln, situated
in front of the Essex County Courthouse, Newark, N.J. Work on the* Seated
Lincoln *began in 1909. It was cast by Gorham Company Founders in 1911
and unveiled on Memorial Day, 1911.*

***Mares of Diomedes** 1904
Bronze 21"x34"x16" (53.3x86.4x40.6 cm)
Signed and dated: "Gutzon Borglum/1904"
Ex-collection: donor, Newark, N.J.
Gift of Joseph G. Spurr 1916 16.568

*Located replicas: R. W. Norton Gallery, Shreveport, La.; Rhode Island
School of Design, Providence, R.I.: Musée de Luxembourg, Paris, France
(fragment); Brookgreen Gardens, Murrells Inlet, S.C. (fragment); 62"
(157.5 cm) reduction in collection of The Metropolitan Museum of Art,
New York, N.Y.*

*The "Mares of Diomedes" were man-eating horses captured by Hercules in
Thrace.*

BORGLUM, SOLON H. (1868-1922)

***Blizzard** ca. 1900
Bronze 6¼"x10⅜"x7¾" (15.9x26.4x19.7 cm)
Signed: "Solon H Borglum"
Inscribed: "Solon Borglum/copyrighted"
Numbered inside the cast, "N.1."
Ex-collection: purchased by J. G. Phelps Stokes, New York, N.Y., in
1914 at a benefit auction for Belgian Relief by Silvermine Guild; to
donor, New York, N.Y.
Gift of Mrs. J. G. Phelps Stokes 1977 77.21

*Located replicas: Detroit Institutes of Art, Detroit, Mich.; R. W. Norton Art
Gallery, Shreveport, La.; Texas Memorial Museum, University of Texas,
Austin, Tex.; New Britain Museum of American Art, New Britain, Conn.*

*According to Mrs. Mervyn Davies, the artist's daughter, this was possibly
the last cast Solon H. Borglum made of* Blizzard. *There have been five
posthumous casts. There are several variations of this group, as Borglum
frequently retouched his work at the foundry. Mrs. Davies counts 11 or 12
casts of this title, more than of any other work by the artist. (corres.)*

The title Blizzard *was associated with a group also known as* The Peril of
the Plains, *shown at the Louisiana Purchase Exposition, St. Louis, Mo.,
in 1904. The figures are not the same.*

BROWN, HENRY KIRKE (1814-1886)

***Henry Clay** (1777-1852) 1852
Bronze 12¾" on a 3½" pedestal (32.4 on 8.9 cm)
Signed and dated: "H. K. Brown Sculptor/June 1852"
Ex-collection: donor, Scotch Plains, N.J.
Bequest of Dr. J. Ackerman Coles, 1926 26.1044

*Located replica: National Portrait Gallery, Smithsonian Institution,
Washington, D.C. Brown may have been the first American sculptor to cast
his own work in bronze. He installed a foundry in his New York studio and
probably cast this work there, according to William H. Gerdts, Jr. (files)*

BURROUGHS, EDITH WOODMAN (1871-1916)

*Circe 1907
Bronze 20½" (52.1 cm)
Signed and dated: "(illeg.) 1907 3rd cast/Edith Woodman Burroughs"
Inscribed: "Circe":
Ex-collection: the artist, Flushing, L.I.
Purchase 1914 14.18

*Located replica: Corcoran Gallery of American Art, Washington, D.C.
The artist was married to Bryson Burroughs.*

BUTENSKY, JULES·LEON (b. Russia 1871-1947)

Exile 1916
Bronze 25⅝" (65.1 cm)
Signed: "Jules L. Butensky"
Inscribed: "They are gone without strength/before the pursuer"
(quotation from *Lamentations* I:6), inscribed in both English
and Hebrew.
Ex-collection: purchased from the artist, New York, N.Y.
Gift of Mr. and Mrs. Felix Fuld 1928 28.763

*Located replicas: First casting 1912; White House, Washington, D.C., 1913.
Incomplete records of Roman Bronze Works indicate one was cast,
December 19, 1913. Date supplied by artist. (files)*

CAESAR, DORIS PORTER (1892-1971)

*Girls Reading 1943
Bronze 13¾"x15" (34.9x38.1 cm)
Signed: "Caesar"
Anonymous gift 1947 47.206

Date supplied by artist. (files)

CALDER, ALEXANDER (1898-1976)

*Big Red, Yellow and Blue Gong 1951
Steel, aluminum and bronze 56" x ca. 96" diam. (142.2x243.8 cm)
Unsigned
Ex-collection: purchased from the artist, Roxbury, Conn.
Purchase 1954 Sophronia Anderson Bequest Fund 54.206

*According to the artist, this piece was exhibited (without gongs) in the
Venice Bienniale, 1954, and the São Paulo, Brazil, Bienniale,
December, 1953. (files)*

CHASE-RIBOUD, BARBARA DEWAYNE (b. 1936)

*Monument to Malcolm X, II (1925-1965) 1969
Bronze and wool 78"x43"x32" (198.1x109.2x81.3 cm) (depth variable)
Unsigned
Ex-collection: with Betty Parsons Gallery, New York, N.Y.
Purchase 1971 Anonymous Gift Fund 71.143

CLAGUE, JOHN (b. 1928)

Overture in Black and White ca. 1964
Painted wood and fiberglas 55¼"x57¾"x71" (140.3x144.8x180.3 cm)
Unsigned
Gift of Mr. and Mrs. Henry Feiwel 1978 78.29

CONDIT, WILLIAM (19th century)

Bird ca. 1830
Wood and metal 8¼" (21.0 cm)
Unsigned
Ex-collection: donor, East Orange, N.J.
Gift of Mrs. Hannah Erwin 1931 31.532

Date taken from accession card. There is no supporting documentation.

COUPER, WILLIAM (1853-1942)

Evangeline
Marble 21½" (54.6 cm)
Signed: "Wm Couper"
Ex-collection: with Tiffany & Co.; to the donors, Bozman, Md.
Gift of Mr. and Mrs. William A. Couper 1943 43.122

*The artist, who lived in Montclair, was the son-in-law of the sculptor
Thomas Ball.*

CRAWFORD, THOMAS (1814-1857)

*Flora 1853
Marble 86" (218.4 cm)
Signed and dated: "T Crawford/Fecit.Romae/MDCCCLIII"
Ex-collection: Franklin Murphy, Newark, N.J.; to the donor,
Newark, N.J.
Gift of Franklin Murphy, Jr. 1926 26.2786

*A possible replica and plaster cast were in the possession of the
Commissioners of Central Park, New York, N.Y., in 1862. They are
unlocated and may have been destroyed by fire in 1881.*

*Wayne Craven has implied that this piece was exhibited at the New York
Crystal Palace in 1854. Sylvia E. Crane reported a full figure at the London
Crystal Palace in 1855 and at the Columbian Exposition in Chicago, 1893.
There is no documentary evidence that the Flora in these three exhibitions
was the Newark piece. (cf. Craven, Crane)*

CROWDER, SUSAN (b. 1943)

Twelve Pillows
Terra cotta 5½"x13¾"x4¼" (14.0x34.9x10.8 cm)
Unsigned
Ex-collection: with Parson-Dreyfus Gallery, New York, N.Y. to donors,
New York, N.Y.
Gift of Mr. and Mrs. Henry Feiwel 1977 77.239

DALLIN, CYRUS E. (1861-1944)

On the Warpath 1914
Bronze 9" (22.9 cm)
Signed: "© C.E. Dallin"
Founder's mark: "Gorham Co. Founders 0489"
Numbered: "31"
Anonymous gift 1975 75.192

*This is a reduction and variant of the 1914, 23" (58.4 cm) version shown at
the Pennsylvania Academy of Fine Arts in 1915. Countless replicas,
including posthumous casts, were made of this 9" size.*

DAVID, THOMAS (b. 1910)

*Mr. David, of Carteret, N.J., gave six decoys to the Museum, all made by
him for use in the Raritan Bay area.
Gift of the artist 1977*

Yellow Legs Decoy 1930-34
Natural wood 4"x13½"x3" (10.2x34.3x7.6 cm)
Signed: "TD" 77.442

Snipe Decoy 1930-34
Painted and natural wood 4⅝"x10½"x2⅞" (11.7x26.7x7.3 cm)
Unsigned 77.443

Yellow Legs Decoy 1930-34
Painted wood 4½"x12¼"x2¾" (11.4x31.1x7.0 cm)
Signed: "TD" 77.444

Scaup Decoy 1930-34
Painted wood 7⅛"x14"x6" (18.1x35.6x15.2 cm)
Unsigned 77.445

Black Duck Decoy 1934
Painted wood and cork 6¾"x14¾"x5½" (17.1x37.5x14.0 cm)
Unsigned 77.446

*The artist stated that the cork was from a life jacket from aboard the
SS Morro Castle which burned and was grounded off the coast of New
Jersey in September, 1934.*

Canvas Back Decoy 1930-34
Painted wood 6⅞"x15⅞"x5⅞" (17.5x40.3x14.9 cm)
Unsigned 77.447

DAY, WÖRDEN (b. 1916)

Continental Divide I 1967
Painted wood 38"x54½" (96.5x138.4 cm); outer panel support: 48"x72"
(122.0x182.9 cm)
Signed: "Wörden Day"
Inscribed (on reverse): " 'Continental Divide I'/Painted wood — high
relief by Worden Day/(monogram)"
Ex-collection: donor, Duluth, Minn.
Gift of Miss Julia Marshall 1972 72.338

*After being exhibited several times the piece was reworked and repainted
in 1967.*

DEE, LEO J. (b. 1931)

Pagan 1958
Painted plaster mounted on wood exterior: 45½"x27¼"x1½"
(115.6x69.2x3.8 cm); interior: 30"x13¾" (76.2x34.9 cm)
Unsigned
Ex-collection: the artist, Newark, N.J.; to donor, Newark, N.J.
Gift of Rabin and Krueger Gallery 1958 58.44

*Purchased from the third Newark Museum triennial Work by New Jersey
Artists, 1958.*

DER HAROOTIAN, KOREN (b. Armenia 1909)

Hercules Fighting the Vulture 1958
Blue serpentine marble 53" (134.6 cm)
Signed and dated: "KDH 58"
Ex-collection: purchased from the artist, Orangeburg, N.Y.
Purchase 1962 Louis L. Bamberger Bequest Fund 62.7

DE RIVERA, JOSE RUIZ (b. 1904)

*Flight** 1936-38
Aluminum alloy 66" high on a 69" base (167.6 on 175.3 cm)
Signed and dated: "Jose Ruiz de Rivera 1938"
Ex-collection: Federal Works Agency, WPA for the City of New York,
N.Y.C., War Services
Allocated by WPA Federal Art Project 1943 43.78

*Executed for the Newark Airport under the WPA Federal Art Project but
never installed. There was at the time a small model in the Newark City
Hall, now unlocated. The work was exhibited at the Federal Works Agency,
New York, N.Y., 1938; San Francisco Fair, San Francisco, Calif., 1939;
New York World's Fair, 1940 (Contemporary Art Building); the Museum of
Modern Art, New York, N.Y., 1941-42. The artist stated, "This sculpture
was created for an airport, as a symbol of flight. The form is a synthesis of
bird and aeronautical engineering shapes." (files)*

*Construction #4** 1953
Stainless steel 15"; 30½" diam. (38.1; 77.5 cm)
Unsigned
Ex-collection: with Grace Borgenicht Gallery, New York, N.Y.
Purchase 1955 Felix Fuld Bequest Fund 55.120

Mounted by artist on motorized turntable.

DIEDERICH, W. HUNT (b. Hungary 1884-1953)

*The Jockey** 1924
Bronze 23¼" (59.1 cm)
Signed and dated: "H Diederich 1924"
Ex-collection: with The Downtown Gallery, New York, N.Y.
Gift of Mr. and Mrs. Felix Fuld 1927 27.1073

Located replica: Seattle Art Museum, Seattle, Wash.

DILLER, BURGOYNE (1906-1965)

*Construction #16** 1938
Painted wood 31⅞"x27¾"x5⅛" (81.0x70.5x13.0 cm)
Signed and dated: (on reverse), "diller/Construction #16 1938"
Inscribed: (on reverse), "Rose Fried Gallery/40 East 68 Street/N.Y.C."
Label: Walker Art Center, Burgoyne Diller Exhibition, 11 December
1971-10 January 1972; Dallas 16 February-26 March; Pasadena Art
Museum, 9 May-2 July
Ex-collection: the artist, Atlantic Highlands, N.J.
Purchase 1959 The Celeste and Armand Bartos Foundation
Fund 59.377

DINE, JIM (b. 1936)

A Flesh Shoe for N.M. 1961
Mixed media construction 4⅝"x7½"x11⅛" (11.7x19.1x28.3 cm)
Signed and dated: "Jim Dine 1961"
Inscribed: "A Flesh Shoe for N.M."
Ex-collection: acquired from the artist by donor, New York, N.Y.
Gift of Norman Mann 1974 74.53

DUBLE, LU (b. England 1896-1970)

*Caja Poluna and Naqual** 1947
Terra cotta (Caxaca red clay) head with cock headdress 14½" (36.8 cm)
Unsigned:
Ex-collection: purchased from the artist, New York, N.Y.
Gift of the committee of the Alex Shilling Fund 1948 48.338

*Lu Duble was also known as Lucinda Davies. Artist's correspondence
identifies Caja Poluna as "rain falling on water" and Naqual as
"companion spirit or 'otherself.' "*

DUNBAR, ULRICH STONEWALL JACKSON (1862-1927)

Wayne Parker, Jr. (1892-99) 1900
Marble (Carrara) 20½"x14¾" (52.1x37.5 cm)
Signed: "Sept. 29 '92./Wayne/Parker/April 1st 1899/U.S.J.
Dunbar/Sculptor/Washington, D.C./March 1900"
Ex-collection: Richard Wayne Parker, Sr., Newark, N.J.; to donor
(sister of subject), Washington, D.C., by inheritance.
Gift of Mrs. Wayne Macpherson 1949 49.401

*A posthumous portrait. Sitter was the son of Richard Wayne Parker
(1848-1923), who represented Essex County in the New Jersey Assembly,
1885-86, and was a member of Congress, 1895-1911, 1914-19 and 1921-23.*

EAKINS, THOMAS (1844-1916)
*Group of five plaster casts taken from wax models made by Eakins in
connection with his painting, William Rush Carving His Allegorical
Statue of the Schuylkill, 1877, now in the collection of the Philadelphia
Museum of Art. The wax originals and a set of casts are also in the
Philadelphia Museum. An unknown number of casts were made by
Samuel Murray for Mrs. Eakins in 1931. The molds have not been located
nor has a possible sixth wax of the nude model. Several bronzes from the
set have appeared since 1931.*

* A **Head of William Rush** (1756-1833)
Plaster 7¼" (18.4 cm)
Unsigned

*Located replicas: Philadelphia Museum of Art, Philadelphia, Pa.;
private collection*

***B Head of Nymph**
Plaster 7½″ (19.1 cm)
Unsigned

Located replicas: Philadelphia Museum of Art, Philadelphia, Pa. under title, Head of Model; *private collection*

***C The Schuylkill Freed**
Plaster 4¾″x8½″x2¾″ (12.1x21.6x7.0 cm)
Unsigned
Inscribed: "Oct 14/31"

Located replicas: Hirshhorn Museum and Sculpture Garden, Smithsonian Institution, Washington, D.C. (inscribed "No 5 Oct 16/31"); Philadelphia Museum of Art, Philadelphia, Pa. Gordon Hendricks has suggested the title of The Schuylkill Harnessed.

***D George Washington** (1732-1799)
Plaster 8½″ (21.6 cm)
Unsigned

Located replicas: Hirshhorn Museum and Sculpture Garden, Smithsonian Institution, Washington, D.C.; Philadelphia Museum of Art, Philadelphia, Pa.; private collection

***E Nymph of the Schuylkill**
Plaster 9½″ (24.1 cm)
Unsigned

Located replicas: Hirshhorn Museum and Sculpture Garden, Smithsonian Institution, Washington, D.C., under the title Water Nymph and Bittern; *Philadelphia Museum of Art, Philadelphia, Pa.; Joslyn Museum, Omaha, Neb.; private collection*

Ex-collection: Mrs. Susan M. Eakins, Philadelphia, Pa.; to Charles Sessler, Lawrenceville, N.J. (purchased at 1939 sale of Mrs. Eakins' estate conducted by Samuel T. Freeman & Co., Philadelphia, Pa.); to donor, Princeton, N.J.
Gift of Gerald Lauck 1959 59.414 A-E

EBERLE, ABASTENIA ST. LEGER (1878-1942)

***Windy Doorstep** 1910
Bronze 14″ (35.6 cm)
Signed and dated: "A St L. Eberle/1910"
Founder's mark: "S. Klaber & Co./Founders, N.Y."
Ex-collection: donor, Newark, N.J.
Gift of Joseph S. Isidor 1913 13.304

Located replicas: Worcester Art Museum, Worcester, Mass.; Peabody Institute of the City of Baltimore, Baltimore, Md.; Cincinnati Art Museum, Cincinnati, O.; Brookgreen Gardens, Murrells Inlet, S.C.; private collection, New York, N.Y.

EDMONDSON, WILLIAM (ca. 1883-1951)

***Two Birds** ca. 1939
Limestone 6¼″x7⅛″x9½″ (15.9x18.1x24.1 cm)
Ex-collection: acquired from the artist by unnamed purchaser, 1939; to Gerald Kornblau, New York, N.Y.; to Edmund I. Fuller, Woodstock, N.Y.
Gift of Mrs. René Pingeon and an Anonymous Fund in memory of Margaret Chubb Parsons 1978 78.165

EPSTEIN, JACOB (1880-1959)

Mask of Mrs. Jacob Epstein [Margaret Gilmour Dunlop] (1887-1949) 1916
Bronze 9¼″ (23.5 cm)
Signed: (back of earrings), "JE" (monogram)
Gift of Mr. and Mrs. Felix Fuld 1928 28.45

Located replica: Edward P. Schinman Collection (entitled Second Portrait of Mrs. Epstein). *According to dealer Martin Diamond, eight replicas may have been cast. Other versions of Mrs. Epstein were sculpted earlier in 1916 and in 1918. (corres.)*

The subject was the artist's first wife. In 1905 the artist moved to England and later became a British citizen. At the time of the Fuld gift, Epstein was considered an American expatriate artist. The work was listed in the 1944 Newark Museum catalogue.

EVETT, PHILLIP JOHN (b. England 1923)

Reclining Figure ca. 1964
Welded bronze on integral wood base 8½″x13½″x4⅜″ (21.5x34.3x11.1 cm)
Signed: "Evett"
Ex-collection: acquired from the artist by donor, Newark, N.J.
Gift of William Lillys 1966 66.41

FERBER, HERBERT (b. 1906)

***Calligraph in Four Parts** 1957
Welded bronze 14⅞″x25½″x11″, including 1⅝″ base (38.0x64.8x27.9 cm,including 4.1 cm)
Signed and dated: "Ferber 57"
Ex-collection: with Andre Emmerich Gallery, New York, N.Y.
Purchase 1960 John J. O'Neill Bequest Fund 60.579

FERGUSON, DUNCAN (b. China 1901-1974)

Anatole 1926
Alabaster cat 8½″ (21.6 cm)
Signed: "Ferguson"
Ex-collection: purchased from the artist, by donors, South Orange, N.J.
Gift of Mr. and Mrs. Felix Fuld 1926 26.2360

***Mimi** [Mrs. Robert Laurent] (1895-1971)
Bronze head 13⅞″ (35.2 cm)
Signed: "Ferguson"
Founder's mark: "Roman Bronze Works N-Y-"
Ex-collection: purchased from the artist, New York, N.Y.
Purchase 1928 General Fund 28.1762

Unique bronze. In 1928 a plaster was exhibited in New York at the Whitney Studio Club and The Downtown Gallery.

Justice 1935
Plaster figure 15⅛″ (38.4 cm)
Unsigned
Gift of the artist 1936 36.6

This model was submitted to a competition conducted by The Newark Museum for the Section of Painting and Sculpture of the U.S. Department of the Treasury. The competition was to award a commission for a statue of Justice *for the Federal Courthouse in Newark. The commission went to Romuald Kraus. (files)*

FERRER, RAFAEL (b. Puerto Rico 1933)

Neon Corner 1971
Lead, glass, neon, electrical components A: 84″x2″ (213.4x5.1 cm); B: 12″ (30.5 cm); C: 2¾″x8¾″x3⅝″ (7.0x22.2x9.2 cm)
Signed and numbered: on label printed "Ferrer 1971", "Rafael Ferrer/15/50"
Ex-collection: with Makler Gallery, Philadelphia, Pa.; to donors, Hackensack, N.J.
Gift of Mr. and Mrs. Jack M. Schandler 1972 72.143 A-C

FLANAGAN, JOHN (1865-1952)

Reverse of Pennsylvania Society Medal 1909
Plaster model 24¾" diam. (62.9 cm)
Unsigned
Inscription: ".For. Distinguished.Achievement./ .Horace. Howard.
Furness./ .MCMIX."
Purchase 1913 13.177

William Penn (1644-1718) 1909
Plaster model of Pennsylvania Society medal 13¼" (33.7 cm)
Signed: "J𝔽"
Inscribed: top, ".The.Pennsylvania.Society./.Founded.M.D.C.C.IXC.";
right center, "William.Penn/.MDCXLIV./.MDCCXVIII,"; bottom,
".Dec.MCMIX"
Purchase 1913 13.178

*Numerous examples of Flanagan's plaquettes and medals are included in
the coin collection of The Newark Museum.*

Edward Guthrie Kennedy (1849-1932) 1911
Bronze head 13½" (34.3 cm)
Signed and dated: "John.Flanagan.1911"
Founder's mark: "Roman Bronze Works N-Y-"
Ex-collection: Purchased from the Roman Bronze Works,
New York, N.Y.
Purchase 1916 16.490

Monsignor George Hobart Doane (1830-1905)
Plaster bust 25⅜" (64.5 cm)
Unsigned
Ex-collection: donor, Newark, N.J.
Gift of Newark Free Public Library 1917 17.496

Joseph Henry (1797-1878) 1905
Bronzed plaster figure 39" (99.1 cm)
Unsigned
Inscribed: "Copyright 1905/By John Flanagan"
Ex-collection: Monsignor George Hobart Doane, Newark, N.J.; to
donor, Newark, N.J.
Gift of Newark Free Public Library 1916 16.180

*A model for a figure exhibited at the Louisiana Purchase Exhibition,
St. Louis, Mo., 1904. It is similar but not identical to the Joseph Henry
statue erected in Academy Park, Albany, N.Y., in 1928. (corres.)*

*Augustus St. Gaudens** (1848-1907) 1924
Bronze head 16¼" (41.3 cm)
Signed and dated: "John Flanagan 1924"
Founder's mark: "Kunst-Foundry – N.Y."
Ex-collection: purchased from the artist, New York, N.Y.
Gift of Mr. and Mrs. Felix Fuld 1926 26.2361

*Located replicas: The Metropolitan Museum of Art, New York, N.Y.;
American Academy of Arts and Letters, New York, N.Y.; Century
Association, New York, N.Y.; James Graham and Sons, New York, N.Y.*

*Begun in 1904 and resumed in 1920 after St. Gaudens' death; finished in
plaster in 1924 and cast in bronze, 1925. The Newark piece was exhibited at
the Centennial Exhibition of the National Academy of Design,
Washington, D.C., in 1925 and later in the year at the National Academy
Exhibition, Grand Central Galleries, New York, N.Y. A second (bust)
version was cast for the Artists' Pantheon at New York University,
New York, N.Y. (corres.)*

Louis Bamberger (1855-1944) 1925
Bronze portrait relief 37"x27" (94.0x68.6 cm)
Signed: "MCM J𝔽 XXV"
Inscribed: "Louis Bamberger/•He Gave This Building•/•To Newark•May
XIV•/M•C•M•XXV"
Founder's mark: "Kunst Foundry – N.Y."
Ex-collection: purchased from the artist, New York, N.Y.
Gift of William Hoffman 1926 26.2799

*Located replica: Mathematics Library of Fuld Hall, Institute for Advanced
Study, Princeton, N.J.*
Permanently installed in Museum vestibule.

John Cotton Dana (1856-1929) 1928
Bronze portrait relief 37"x27" (94.0x68.6 cm)
Signed: ".MCM J𝔽 XXVIII."
Inscribed: "John Cotton Dana/This Museum Is His Thought/and Work"
Founder's mark: "Kunst F'ndry – N.Y."
Ex-collection: purchased from the artist, New York, N.Y.
Gift of individual trustees of The Newark Museum Association
1928 28.1969

Permanently installed in Museum vestibule.

Le Poilu à Verdun 1927
Bronze relief plaque 16⅜"x10⅜" (41.6x26.4 cm)
Signed: "J𝔽"
Inscribed: top, "Le Poilu/à Ver-dun/Il ne les a/pas laissé/passer";
bottom, "Souvenir de la Grande Guerre. Dédié/aux Veterans Français
en Amerique/.New York MCMXXVII."
Founder's mark: "Kunst F'dry – N-Y-"
Purchase 1928 28.1078

Joseph Henry (1797-1878) 1924
Bronzed plaster bust 30¾" (78.1 cm)
Signed and dated: "John Flanagan 1924"
Inscribed: "Model of bust in Hall of Fame, N.Y.U."
Anonymous gift 1928 28.1400

Louis Bamberger (1855-1944) 1925
Bronzed plaster portrait relief 37½"x27⅜" (95.3x69.5 cm)
Signed and dated: "MCM J𝔽 XXV"
Inscribed: "Louis Bamberger/He Gave This Building/to Newark"
Purchase 1934 34.659

*John Cotton Dana** (1856-1929) .1928
Bronzed plaster portrait relief 37½"x27½" (95.2x69.9 cm)
Signed and dated: ".MCM J𝔽 XXVIII."
Inscribed: "John Cotton Dana/This Museum Is His Thought/and
Work"
Purchase 1934 34.660

FLANNAGAN, JOHN BERNARD (1895-1942)

*The Ass** 1932-33
Granite 8⅛"x14¼" (20.6x36.2 cm)
Unsigned
Ex-collection: Weyhe Gallery, New York, N.Y.
Purchase 1950 Felix Fuld Bequest Fund 50.2116

Listed as Tired Ass *(#23) in a 1936 Flannagan exhibition catalogue,
Weyhe Gallery, New York, N.Y. According to Robert J. Forsyth, this is one
of two known donkeys executed during the artist's second stay in Ireland,
1932-33. Two casts were made by John Asmussen from the original in
artificial stone in 1933-34. (cf Forsythe and corres.)*

FRAZEE, JOHN (1790-1852)

*John Marshall** (1755-1835) 1834
Plaster bust 32¼", including 6" base (81.9 cm, including 15.2 cm)
Signed and dated: "John Marshall by Frazee.1834."
Ex-collection: "Samuel Herrick, Washington, D.C.; to Philip F.
Herrick, Washington, D.C.; to Stephen C. Millett, Jr., Washington,
D.C., through Mrs. Helena L. Pinkney, Washington, D.C.
Purchase 1964 Felix Fuld Bequest Fund 64.19

*Located replicas: Yale University Law School, New Haven, Conn.; Harvard
University Law School, Cambridge, Mass.; Courthouse, Montross, Va.*

*In the Newark version the torso is partially exposed. It is fully draped in a
second version. The original marble, dated 1834, is in the Boston
Athenaeum; a copy is in New York City Hall. (files)*

FRENCH, DANIEL CHESTER (1850-1931)

***Abraham Lincoln** (1809-1865) 1912
Bronze figure 37½" (95.3 cm)
Signed and dated: "Daniel C French Sc/1912"
Inscribed: "Original Model for the Statue Erected in Lincoln, Neb."
Founder's mark: "Cast by Roman Bronze Works. N-Y-"
Numbered: "12/32"
Ex-collection: National Sculpture Society, New York, N.Y.
Purchase 1913 13.281

Located replicas: Chesterwood, Stockbridge, Mass.; Ball State University Art Gallery, Muncie, Ind.; Wadsworth Atheneum, Hartford, Conn.; Fogg Art Museum, Cambridge, Mass.; Stockbridge Plain School, Stockbridge, Mass.; Union League Club, Philadelphia, Pa.; Whitney Museum of American Art, New York, N.Y.; University of Nebraska Art Galleries, Lincoln, Neb.

A replica was sold at Sotheby Parke Bernet, Inc., New York, N.Y., "Dodge Sale", number 3802, item #21, Friday, October 31, 1975. At least twelve were cast. Plaster replicas are at Chesterwood and the New York Historical Society, New York, N.Y. This was a model for the heroic figure in Lincoln, Nebraska, which was cast and unveiled in 1912. There was a casting by Gorham Co., signed D. C. French and dated Jan. 1911. (cf. Richman)

***The Spirit of Life** 1914
Bronze figure 48¾" (123.8 cm)
Signed and dated: "D.C. French/May 1914"
Founder's mark: "Roman Bronze Works N.Y."
Ex-collection: with Grand Central Art Galleries, New York, N.Y.; purchased from the artist, New York, N.Y.
Gift of Mr. and Mrs. Felix Fuld 1927 27.1151

Located replicas: Chesterwood, Stockbridge, Mass. (in plaster and bronze, 1922); St. Paul's Episcopal Church, Stockbridge, Mass.; Indianapolis Museum of Art, Indianapolis, Ind. (1917); Brattleboro, Vt.; Grand Central Art Galleries, Inc., New York, N.Y.

According to Michael Richman, this was the working model for the Spencer Trask Memorial Fountain at Saratoga Springs, N.Y. The Newark Museum replica was one of six cast from 1923-31, as was the Brattleboro piece. (corres.)

***The Concord Minute Man of 1775** 1889-90
Bronze figure 32¼" (81.9 cm)
Signed: "D.C. French Sc."
Inscribed: "The Concord Minute Man of 1775"
Founder's mark: "Gorham Co. Founders (illeg. hallmark)/OARS"
Bequest of Miss Annie W. Colby 1960 60.588

Located replicas (from 1913): Mead Art Building, Amherst College, Mass.; Gallery of Art, Ball State University, Muncie, Ind.; Chesterwood, Stockbridge, Mass.; National Board for Promotion of Rifle Practice, Department of the Army, Washington, D.C.; Department of the Navy, Navy Memorial Museum, Washington, D.C.; Third National Bank of Hampden County, Springfield, Mass.; two private collections.

A reworking by French of the 1874-75 life-size monument at Concord, Mass., cast by Ames Foundry, Chicopee, Mass. The original casting of this version by M. H. Mosman of Chicopee, Mass., was installed on the gunboat Concord in 1891. A 14" reduction, in an edition of ten, was made by Gorham, 1917-39. (cf. Richman)

GELERT, JOHANNES SOPHUS (b. Denmark 1852-1923)

The Scheming Odysseus 1917
Terra cotta figure 8¼" (21.0 cm)
Signed and dated: "19 (illeg. device) 17"
Inscribed: "The Scheming/ Odysseus/ Heracles Weapon/ The Object"
Ex-collection: Mrs. John S. Gelert, East Orange, N.J.
Purchase 1925 25.165

According to Robert A. Gelert, the artist's grandson, this is a unique piece. The above title was listed in the artist's records.

Head of Loki, the Evil God 1905
Bronzed terra cotta head 5½" (14.0 cm)
Signed: "19 (monogram)"
Inscribed: "Loki 1905"
Ex-collection: Mrs. John S. Gelert, East Orange, N.J.
Purchase 1925 25.166

A unique piece, listed by above title in artist's records. (corres.)

Head of Odin or **Wotan** 1905
Bronzed terra cotta bust 9⅞" (25.1 cm)
Signed and dated: "Gelert/ 1905"
Inscribed: "Wodan"
Ex-collection: Mrs. John S. Gelert, East Orange, N.J.
Purchase 1925 25.167

A unique piece, listed by above title in artist's records. (corres.)

GLICENSTEIN, ENRICO (b. Poland 1870-1942)

Jeremiah ca. 1914
Bronze figure 33" (83.8 cm)
Signed: "E Glicenstein"
Ex-collection: purchased from the artist, Rome, Italy
Gift of Felix Fuld 1928 28.1537

Located replicas: three slightly varying replicas in the Cleveland Library, Cleveland, O.; Glicenstein Museum, Safad, Israel; and a private collection. According to artist's son, the work was cast in Italy. (corres.)

The Pilgrim 1929
American walnut wood figure 20½" (52.1 cm)
Unsigned
Ex-collection: purchased from artist's son, Emanuel Romano Glicenstein, New York, N.Y.
Purchase 1943 Felix Fuld Bequest Fund 43.132

Permission was given to the artist's son, Emanuel Romano Glicenstein, to cast five copies. One has been cast in bronze and is in the possession of The Dreyfuss-Glicenstein Foundation, Inc., New York, N.Y. (corres.)

GODDARD, RALPH BARTLETT (1861-1936)

Charles H. Parkhurst (1842-1933) 1894
Bronze relief portrait 9½"x7¼" (24.1x18.4 cm)
Signed: "Goddard"
Inscribed: "Copyright 1894/ by R.B. Goddard/ Charles H. Parkhurst"
Founder's mark: "Cast by The Henry-Bonnard Bronze Co. N.Y."
Ex-collection: donor, Scotch Plains, N.J.
Gift of Dr. J. Ackerman Coles 1920 20.1078

James McCosh (1811-1894) 1894
Bronze relief portrait 8"x6½" (20.3x16.5 cm)
Signed: "Goddard"
Inscribed: "James McCosh"
Founder's mark: "Cast by The Henry Bonnard Bronze Cᵒ· NY."
Ex-collection: donor, Scotch Plains, N.J.
Bequest of Dr. J. Ackerman Coles 1926 26.1095

James McCosh was president of Princeton University, 1863-88.

GOODYEAR, JOHN (b. 1930)

Triple Flick 1966
Acrylic paint, plastic, metal (three hanging panels) 24" sq.; display depth 9" (61.0; 22.9 cm)
Unsigned
Ex-collection: the artist, Lebanon, N.J.
Anonymous gift 1968 68.134 A-C

***Upright Light Box** 1967
Wood, electric light and plexiglas construction 77"x48¼"x11½" (195.6x122.6x29.2 cm)
Unsigned
Ex-collection: the artist, Lebanon, N.J.
Purchase 1968 Wallace M. Scudder Bequest Fund 68.224

Purchased from The Newark Museum's sixth triennial exhibition, New Jersey Artists, 1968.

GORDIN, SIDNEY (b. Russia 1918)

*Construction #5, 1951 1951
Painted steel 24⅛"x31"x8⅛" (61.3x78.7x20.6 cm)
Stamped: under paint, "SG"
Ex-collection: with Grace Borgenicht Gallery, Inc., New York, N.Y.
Purchase 1956 Anonymous Endowment Fund 56.3

GOULD, STEPHEN (b. 1909)

I Protest 1970
Bronze figure 19¼" (48.9 cm)
Label: "Stephen Gould, R.A.N.S.A.L."
Gift of the artist 1972 72.140

GREENBAUM, DOROTHEA S. (b. 1893)

*Bathsheba 1952
Hammered lead relief 35⅜"x15"x6" (89.9x38.1x15.2 cm)
Unsigned
Label: "Awarded/ Honorable Mention/ Audubon Artists 12th Annual
Exhib. 1954"
Ex-collection: with Sculpture Center, New York, N.Y.; to donors,
New York, N.Y.
Gift of Mr. and Mrs. Iskander Hourwich 1955 55.88

Date supplied by artist.

GRIPPE, PETER J. (b. 1912)

*Symbolic Figure No. 4 (Theseus in the Labyrinth) 1946
Bronze 17"x11"x22" (43.2x28.0x55.9 cm)
Signed: "G4"
Ex-collection: donor, New York, N.Y.
Gift of Willard Gallery 1962 62.146

*A unique piece cast by the lost wax method at the Modern Art Foundry.
(corres.)*

GROSS, CHAIM (b. Austria 1904)

*Mother and Child at Play 1937
Philippine blond "Palablanca" wood 56¾" (144.1 cm)
Signed: "Chaim Gross"
Ex-collection: purchased from the artist, New York, N.Y.
Purchase 1940 Felix Fuld Bequest Fund 40.121

HAAG, CHARLES OSCAR (b. Sweden 1867-1933)

Cigane pre-1926
Bronze bust 19" (48.3 cm)
Signed: "Ch. Haag"
Inscribed: "Cigane"
Founder's mark: "Roman Bronze Works. N-Y-"
Ex-collection: J. G. Phelps Stokes, New York, N.Y.
Gift of Mrs. J. G. Phelps Stokes 1960 60.599

Alone
Bronze relief plaque 8¼"x36¼" (21.0x92.1 cm)
Signed: "Copyright by Ch. Haag"
Founder's mark: "Roman Bronze Works. N-Y-"
Ex-collection: J. G. Phelps Stokes, New York, N.Y.
Gift of Mrs. J. G. Phelps Stokes 1976 76.9

HAMMARGREN, FRED E. (b. Sweden 1892-1968)

Cat
Black Gloucester granite 17½" (44.5 cm)
Signed: "F.E.Hammargren"
Ex-collection: purchased from the artist, Leonia, N.J.
Purchase 1935 Felix Fuld Bequest Fund 35.75

HAMMER, TRYGVE (b. Norway 1878-1947)

Baby's Head 1913
Bronze 11⅜" (28.9 cm)
Signed: "TH"
Founder's mark: "Amer. Art F'dry. N.Y."
Ex-collection: acquired from the artist by donors, South Orange, N.J.,
and shipped to The Newark Museum from the foundry
Gift of Mr. and Mrs. Felix Fuld 1926 26.2363

*A portrait of the artist's son, Olav Trygveson Hammer, modelled in the
artist's studio in Palisades Park, N.J., and cast by the lost wax method.
Two other bronze copies were sand-cast by Anton Kunst, New York, N.Y.
(corres.)*

HARNISCH, ALBERT E. (1843-after 1886)

*Mrs. Marcus L. Ward [Susan Longworth Morris] (1815-1901) 1872
Marble bust 26¾" (68.0 cm)
Signed and dated: "A.E. Harnisch. Roma. 1872"
Ex-collection: donor, Newark, N.J.
Bequest of Marcus L. Ward 1921 21.1990

HARTWIG, CLEO (b. 1911)

Bear Cub ca. 1941
New Jersey bluestone figure 11¼" (28.6 cm)
Unsigned
Ex-collection: The Clay Club of New York, N.Y.
Purchase 1943 Felix Fuld Bequest Fund 43.110

HARVEY, ELI (1860-1957)

Jaguar Rampant 1899
Bronze figure 11½" (29.2 cm)
Signed and dated: "Eli.Harvey.Paris.1899"
Founder's mark: "S. Klaber & Co./ Founders, N.Y."
Inscribed: "Copyright.1908.by.Eli-Harvey."
Ex-collection: purchased from the artist, New York, N.Y.
Purchase 1914 14.19

*Located replica: St. Louis City Art Museum, St. Louis, Mo.; a cast with
Kunst founder's mark was listed in a catalogue of Christie, Manson &
Woods International Inc., New York, N.Y., for a sale held Wednesday,
May 23, 1979, item #184.*

*This is a reduction of a life-size bronze first exhibited at the Paris Salon in
1899. (corres.)*

HASELTINE, JAMES (1833-1907)

*Cleopatra 1868
Marble bust 29½" (74.9 cm)
Signed and dated: "J. H. Haseltine/ Rome.1868"
Ex-collection: Dr. Jacob Polevski, Newark, N.J.
Gift of Mrs. Jacob Polevski 1940 40.420

*This piece, or possibly a replica, was exhibited at the Philadelphia
Centennial in 1876.*

HESS, EMIL (b. 1913)

Killarney Pipes 1970
Aluminum, kinetic and sound-producing 74" (188.0 cm)
Unsigned
Ex-collection: donor, New York, N.Y.
Gift of Betty Parsons Gallery 1972 72.340

HIGGINSON, HENRY (1828-1894)

***Arm and Hammer Trade Sign** before 1862
Painted wood 34½"x34"x23" (87.6x86.4x58.4 cm)
Unsigned
Ex-collection: William M. Smith, Newark, N.J.; to Fred C. Smith,
Newark; to Samuel Katzin, Newark; to donor, Caldwell, N.J.
Gift of Harry W. Smith 1954 54.173

*Displayed at William M. Smith's workmen's clothing store at 474 Broad
St. (1859 or 1862-1903) and 498 Broad St. (1903-54) in Newark. According
to the donor, the store opened in 1862 and this piece was carved at
Greenwood Lake, N.J. Newspaper account reports the store opening in
1859, while the Newark City Directory lists William Smith at 85 Broad St.
in 1867-68. (files)*

HOFFMAN, MALVINA CORNELL (1887-1966)

***Tibetan Merchant** 1931
Bronze figure 12⅜" (31.4 cm)
Signed: "Ⓒ.Malvina.Hoffman"
Founder's mark: "Alexis Rudier/Fondeur.Paris"
Ex-collection: purchased from the artist, New York, N.Y.
Purchase 1943 Felix Fuld Bequest Fund 43.120

*Also titled "A Jewel Merchant from Tibet", New York Herald Tribune,
August 13, 1933, and "Tibetan Jewel Merchant" in the New York Sun,
February 3, 1934. Janis Conner, Curator of the Malvina Hoffman Estate,
said that this figure is the second of four casts. The original was modeled
life-size in Calcutta, India, in 1931 as one of the artist's Races of Man
series for the Field Museum of Natural History, Chicago, Ill. (corres.)*

HOSMER, HARRIET (1830-1908)

***Hands of Robert** (1812-1889) **and Elizabeth Barrett Browning**
(1806-1861) 1853
Bronze 3¼"x4½"x8¼" (8.3x11.4x21.0 cm)
Signed and dated: "Hands of Robert/ and/ Elizabeth Barrett
Browning/ cast by Hosmer/ Harriet/ Rome 1853.Copyright"
Ex-collection: J. G. Phelps Stokes, New York, N.Y.
Gift of Mrs. J. G. Phelps Stokes 1976 76.8

*Located replicas: Armstrong Browning Library, Waco, Tex.; National
Portrait Gallery, London, Eng.; Boston Public Library, Boston, Mass.;
Wellesley College Library, Wellesley, Mass.; Terre Haute Public Library,
Terre Haute, Ind.; private collection*

*A replica was sold by Sotheby Parke-Bernet, Inc., New York, N.Y. at
"Giralda", Madison, N.J., sale 3791, #1034, October 9, 1975.*

HOVANNES, JOHN (b. Turkey 1900-1973)

Laundry Workers 1939
Concrete relief 38"x20" (96.5x50.8 cm)
Signed and dated: "John Hovannes/ 1939"
Ex-collection: The Clay Club of New York, N.Y.
Purchase 1943 Felix Fuld Bequest Fund 43.193

*Exhibited at the New York World's Fair, American Contemporary Art
Building. (corres.)*

HOWARD, CECILE DE BLAQUIERE (1881-1956)

Boxer – American Style
Bronze figure 12⅛" (30.8 cm)
Signed: "Howard"
Numbered: "1"
Founder's mark: "Cire/ C. Valsuani/ perdue"
Label: "Bronze"
Ex-collection: Estate of the artist; to donor, New York, N.Y.
Gift of Henry Luce III 1959 59.415

HUNTINGTON, ANNA VAUGHN HYATT (1876-1973)

***Rolling Bear** 1902-06
Bronze 3¼" (8.3 cm)
Signed: "Anna V. Hyatt"
Founder's mark: "Gorham Company Founders Q4"
Numbered: "40"
Ex-collection: purchased from foundry, New York, N.Y.
Purchase 1914 14.5

*Located replica: "R. W. Norton Gallery, Shreveport, La., under title Bear
Playing With His Feet. Unlimited edition. Subject was in the Bronx Zoo.
(corres.)*

Jaguar 1905-06
Bronze figure 6¼" (15.9 cm)
Signed: "Anna V. Hyatt"
Founder's mark: "43 Gorham Co founders Q38"
Ex-collection: purchased from foundry, New York, N.Y.
Purchase 1914 14.6

*Located replica: Josyln Art Museum, Omaha, Neb.
A larger version entitled Jaguar Crawling Off Rock was shown at the
American Academy of Arts and Letters in 1936. Jaguar was revised,
enlarged and given final form in 1926 under the title Reaching Jaguar.
(corres.)*

*Replicas of large version: The Metropolitan Museum of Art, New York,
N.Y.; New York Zoological Park (stone); The Mariner's Museum Park
(marble), Newport News, Va.; Musee National d'Art Moderne, Paris,
France; Brookgreen Gardens, Murrells Inlet, S.C.*

*Reaching Jaguar and a companion piece are studies of Señor Lopez, a
jaguar from Paraguay, acquired by the New York Zoological Society in
1902. (cf. Proske, p. 175 and Proske corres.)*

***Yawning Tiger** 1911-19
Bronze figure 8⅜"x28⅛" (21.3x71.4 cm)
Signed: "Anna V. Hyatt"
Founder's mark: "Gorham Co Founders/Q509"
Numbered: "56"
Ex-collection: purchased from the artist, New York, N.Y.
Gift of Mr. and Mrs. Felix Fuld 1926 26.2364

*Located replicas: Concord Art Association, Concord, Mass.; Wadsworth
Atheneum, Hartford, Conn.; Columbus Gallery of Fine Arts, Columbus, O.;
Huntington Galleries, Huntington, W. Va.; listed in Sotheby Parke-Bernet,
Inc., catalog sale 3978, April 21, 1977, #66 entitled Yawning Panther; also
in Sotheby Parke-Bernet, Inc. "Dodge Sale" number 3802, October 31,
1975, #130, under title Yawning Tiger.*

According to Beatrice G. Proske the piece was cast in three sizes. (corres.)

Jaguar Looking Up ca. 1905-06
Bronze figure 8⅝" (22.0 cm)
Signed: "Anna V. Hyatt"
Founder's mark: "Gorham Co Founders/Q494 #20"
Ex-collection: with Grand Central Art Galleries, New York, N.Y.
Purchase 1927 J. Ackerman Coles Bequest Fund 27.289

Sebastopol Geese 1936
Aluminum group 12½" (31.8 cm)
Signed and dated: "Anna Hyatt Huntington 1936"
Founder's mark: "Roman Bronze Works N-Y-"
Gift of the artist 1938 38.567

Located replica: Museum of Fine Arts, St. Petersburg, Fla.

***Riders To The Sea** (White Horses of the Sea) before 1912
Bronze 18½"x24"x21" (47.0x61.0x53.3 cm)
Signed: "Anna V. Hyatt"
Founder's mark: "Roman Bronze Works N-Y-"
Ex-collection: Dr. Wells P. Eagleton, Newark, N.J., 1916
Gift of Estate of Mrs. Florence P. Eagleton 1954 54.135

*Located replica: Bowdoin College, Brunswick, Me. A larger aluminum
version, 36½" (92.7 cm), is in the collection of the Toledo Museum of Art,
Toledo, O.*

IVES, CHAUNCEY BRADLEY (1810-1894)

***Ariadne (?)** ca. 1871 (?)
Marble bust 25½" (64.8 cm)
Signed: "C.B. Ives./ Fecit. Romae"
Anonymous gift 00.352

*Located replicas: 12 busts were made; 3 replicas have been located in
private collections, including one dated 1871. A replica entitled* A White
Marble Bust of Classical Female *was listed as item #159 in a Christie,
Manson and Woods sale in New York on May 23, 1979.*

Previously recorded as Allegorical Bust.

***Sailor Boy** ca. 1860
Marble bust 17½" (44.5 cm)
Signed: "C.B. Ives./ Fecit./ Romae."
Ex-collection: donor, Newark, N.J.
Bequest of Marcus L. Ward, Jr. 1921 21.1991

Located replica: private collection.
One replica sold in 1883 at Madison Square Art Rooms, New York, N.Y.

Jephthah's Daughter 1874 or after
Marble figure 62" (157.5 cm)
Signed: "C. B. Ives.Fecit./ Romae."
Acquired 1926 26.2787

Located replica: Buffalo and Erie County Historical Society, Buffalo, N.Y.
Four to six other replicas were made after 1874. (files)

JENNEWEIN, C. PAUL (b. Germany 1890-1978)

***Cupid and Crane** 1926-27
Bronze group 21½" (54.6 cm)
Signed: "C. P. Jennewein/©"
Founder's mark: "P.P.B. C⁰ Munchen made in Germany ©"
Ex-collection: purchased from the artist, Larchmont, N.Y.
Gift of Mr. and Mrs. Felix Fuld 1927 27.1152

*Located replicas: Wadsworth Atheneum, Hartford, Conn.; California
Palace of the Legion of Honor, San Francisco, Calif. (copyright date: April
24, 1926); artist's studio, 1975. (files)*

*This example was one of the first three of an edition of 10-12, and was
executed in Italy. (files)*

JEROME, MILDRED KATHERINE (b. 1899)

Sylvia with Cat 1934
Plaster with terra-cotta tint 13½" (34.3 cm)
Signed and dated: "M Jerome/ 1934"
Ex-collection: U.S. Treasury Public Works of Art Project, New York
Regional Committee
Allocated by the Public Works of Art Project through the Whitney
Museum of American Art 1934 34.307

PWAP #3133

Boy with Pup 1934
Plaster with terra-cotta tint 14" (35.6 cm)
Unsigned
Ex-collection: U.S. Treasury Public Works of Art Project, New York
Regional Committee
Allocated by the Public Works of Art Project through the Whitney
Museum of American Art 1934 34.308

PWAP #4452

JUSZKO, JENO (b. Hungary 1880-1954)

Abraham Lincoln (1809-1865) 1925
Bronze seated figure 13½"x13¼"x7⅛" (34.3x33.7x18.1 cm)
Signed and dated: "J Juszko/ 1925/ ©"
Founder's mark: "Amer. Art F'dry N.Y."
Ex-collection: The Joseph S. Isidor Collection, Newark, N.J.
Gift of Joseph S. Isidor 1926 26.230

KAGANN, THEO (19th-20th centuries)

Bearded Man 1917
Bronzed plaster 16" (40.6 cm)
Signed and dated: "T Kagan [sic]/ 1917"
Numbered: "I"
Ex-collection: Dr. Jacob Polevski, Newark, N.J.
Gift of Mrs. Jacob Polevski 1940 40.290

Woman's Head 1915
Bronze 13⅛" (33.3 cm)
Signed and dated: "Theo Kagann/ © 1923 Paris 1915"
Founder's mark: "Roman Bronze Works N-Y-"
Ex-collection: Dr. Jacob Polevski, Newark, N.J.
Gift of Mrs. Jacob Polevski 1940 40.291

Child's Head 1918
Bronze 11½" (29.2 cm)
Signed and dated: "© 1923 Kagann/ 1918"
Founder's mark: "Roman Bronze Works N-Y-"
Numbered: "VIII"
Ex-collection: Dr. Jacob Polevski, Newark, N.J.
Gift of Mrs. Jacob Polevski 1940 40.292

KALISH, MAX (b. Poland 1891-1945)

***Laborer at Rest**
Bronze figure 15¼" (38.7 cm)
Signed: "M. Kalish."
Ex-collection: with Ferargil Galleries, New York, N.Y.
Purchase 1927 J. Ackerman Coles Bequest Fund 27.285

First exhibited in 1924.

KALLEM, HERBERT (b. 1909)

Figure 1956
Brass 13¼" (33.7 cm)
Signed and dated: "Kallem/ '56"
Ex-collection: acquired from the artist, New York, N.Y.
Gift of Paul Ganz 1959 59.408

Artist indicated that this is a unique piece. (corres.)

KEARNS, JAMES J. (b. 1924)

***Seated Model**
Bronze figure 11⅜" (28.9 cm)
Unsigned
Founder's mark: "Modern Art/Fdry.. N.Y."
Ex-collection: purchased from the artist, Dover, N.J.
Purchase 1959 59.379

*Replicas: Artist has the original plaster; two other replicas were made.
(corres.)*

Purchased from the Newark Art Festival exhibit, 1959.

KEYSER, ERNEST WISE (1875-1959)

Lady of the Lotus 1926
Bronze figure 64"x53"x12" (162.6x134.6x30.5 cm)
Signed and dated: "Ernest W Keyser/ 1926"
Ex-collection: acquired from the artist, New York, N.Y.
Gift of Louis Bamberger 1926 26.2785

*Designed as a fountain for the central Court of The Newark Museum and
cast by Gargani and Sons, Brooklyn, N.Y.*

KITSON, HENRY HUDSON (b. England 1865-1947)

James Bryce (1838-1922) 1913
Bronze bust 28″ (71.1 cm)
Signed and dated: "Henry H. Kitson/ Fecit 1913"
Inscribed: "James Bryce"
Founder's mark: "Cast by Griffoul.Newark.N.J."
Ex-collection: purchased from A. Griffoul and Brothers, Newark, N.J.
Purchase 1916 16.181

Located replica: Smithsonian Institution, National Collection of Fine Arts, Washington, D.C.

KNOWLTON, GRACE F. (b. 1932)

***Untitled** 1973
Group of five ferro-concrete spheres Diam.: A- 63¼″ (160.7 cm); B- 43¾″ (111.3 cm); C- 41½″ (105.4 cm); D- 37¼″ (94.6 cm); E- 24″ (61.0 cm)
Unsigned
Ex-collection: with Razor Gallery, New York, N.Y.
Gift of Mrs. Charles W. Engelhard 1974 74.22 A-E

KONOLYI, MANYA (1883-1968)

Russian Dancer ca. 1930
Black marble bust 24¼″ (61.6 cm)
Signed: "Manya Konolei"
Ex-collection: the artist; to donors, New York, N.Y.
Gift of Mr. and Mrs. Bernard Rosenthal 1966 66.46

Portrait of an emigré living in Paris. The artist, born Mary Connolly, was married to Arthur Barnwell. Donor was a goddaughter of the artist.

KONTI, ISIDORE (b. Austria 1862-1938)

***Dancer** 1927
Bronze figure 14½″ (36.8 cm)
Signed: "I. Konti"
Founder's mark: "Roman Bronze Works N-Y-"
Ex-collection: donor, Newark and South Orange, N.J.
Gift of Louis Bamberger 1927 27.111

Located replicas: National Arts Club, New York, N.Y.

First cast January 7, 1926. The plaster model is in the collection of Mrs. Erik Kaeyer, the artist's niece. Thalia Zanow, a well-known dancer, was the model. (cf Madigan)

KORBEL, JOSEF MARIO (b. Czechoslovakia 1882-1954)

Violet
Bronze figure 5¾″ on 1½″ (14.6 on 3.8 cm)
Signed: "Mario Korel [sic]"
Inscribed: "© No 1"
Founder's mark: "R.B.W."
Ex-collection: with Ferargil Galleries, New York, N.Y.
Purchase 1927 J. Ackerman Coles Bequest Fund 27.286

KRAUS, ROMUALD (b. Austria-Hungary 1891-1954)

Seated Nude 1934
Terra cotta figure 19¼″ (48.9 cm)
Signed and dated: "P.W.A. 1934/ Romuald Kraus"
Ex-collection: U.S. Treasury Public Works of Art Project, New York Regional Committee
Allocated by the Public Works of Art Project through the Whitney Museum of American Art, New York, N.Y. 1934 34.165

PWAP #4982

LACHAISE, GASTON (b. France 1882-1935)

***Head of a Woman** (Egyptian Head) 1923
Polished bronze 13″ (33.0 cm)
Signed and dated: "G. Lachaise/©1923"
Ex-collection: acquired from the artist, New York, N.Y.
Gift of Mr. and Mrs. Felix Fuld 1927 27.1153

Located replicas: (an edition of seven); The Museum of Modern Art, New York, N.Y.; Whitney Museum of American Art, New York, N.Y.; The Hirshhorn Museum and Sculpture Garden, Smithsonian Institution, Washington, D.C.; three in private collections and the Newark example.

The Lachaise Foundation has made six posthumous casts, according to Robert J. Schoelkopf, Jr. The Hirshhorn example lists "R. B. W." as founder's mark; a possibly incomplete founder's mark on the Newark example appears to be "RON." (files)

***Figure of a Woman** (Standing Woman with Pleated Skirt) 1926
Bronze 15¼″ (38.7 cm)
Signed and dated: "Lachaise/©1926"
Ex-collection: purchased from the artist, New York, N.Y.
Purchase 1935 Thomas L. Raymond Bequest Fund 35.15

Located replicas: Two were cast in 1926, this piece and one in an unlocated private collection. The Lachaise Foundation has made seven posthumous casts out of a possible edition of ten, according to Robert J. Schoelkopf, Jr. (files)

***Woman Walking** 1922
Polished bronze figure 18¼″ on 1⅛″ base (46.3 on 2.9 cm)
Signed and dated: "Gaston Lachaise/©1922"
Ex-collection: purchased from Mrs. Gaston Lachaise through E. Gargani and Sons, Brooklyn, N.Y.
Purchase 1938 Exhibit Purchase Fund 38.571

Located replicas: (six lifetime casts); The Museum of Modern Art, New York, N.Y., Walking Woman; Honolulu Academy of Arts, Honolulu, Hawaii, reported as 19½″ (49.5 cm); The Currier Gallery of Art, Manchester, N.H., Striding Woman, on loan from Mrs. Paul Strand; two private collections and the Newark example. There were three posthumous casts, according to Donald B. Goodhall, through Robert J. Schoelkopf, Jr. (files)

***Peacocks** 1922
Bronze 22¼″x55¾″x9″ (56.5x141.6x22.9 cm)
Signed and dated: "G Lachaise/©1922"
Founder's mark: "Roman Bronze Works N-Y-"
Ex-collection: donors, Newark, N.J.
Gift of Mr. and Mrs. Franklin Conklin, Jr. 1952 52.96

Located replicas: Metropolitan Museum of Art, New York, N.Y.; Phillips Collection, Washington, D.C.; The Detroit Institute of Arts, Detroit, Mich.; Mr. and Mrs. Meyer P. Potamkin Collection, Philadelphia, Pa.; Bella and Sol Fishko, New York, N.Y.; private collections.

Fourteen replicas were made from a proposed edition of 20, according to Antoinette Kraushaar. (files)

LAMIS, LEROY (b. 1925)

Yellow Cube 1964
Five nested cubes: sheet plastic 8¼″x8½″x8″ (20.9x21.7x20.3 cm)
Signed and dated: "1964/ Lamis"
Numbered: "56"
Ex-collection: with Staempfli-Morris Gallery, New York, N.Y.; to donors, New York, N.Y.
Gift of Mr. and Mrs. Henry Feiwel 1977 77.227

LANDSMAN, STANLEY (b. 1930)

***Snooker** 1968
Light sculpture: wood, glass, electric parts 37¼″x10⅝″x10⅝″ (94.6x27.0x27.0 cm)
Unsigned
Ex-collection: Leo Castelli Gallery, New York, N.Y.
Gift of Mr. and Mrs. Henry Feiwel 1976 76.138

Bearsville 1967
Light sculpture: wood, glass, electric parts 13¼"x24¾"x7½"
(33.7x62.9x19.1 cm)
Unsigned
Ex-collection: Leo Castelli Gallery, New York, N.Y.
Gift of Mr. and Mrs. Henry Feiwel 1976 76.139

LASCARI, HILDA KRISTINA GUSTAFSON (b. Sweden 1885-1937)

Awakening 1925
Marble figure 62¼" (158.1 cm)
Signed and dated: "Hilda Kristina Gustafson Lascari ©/ 1925"
Ex-collection: donor, Lodi, N.J.
Gift of Salvatore Lascari in memory of H. Kristina Lascari
1964 64.239

Carved in Rome, Italy, during the artist's fellowship, 1919-22. The work received the Elizabeth Watrous Gold Medal from the National Academy of Design, New York, N.Y. in 1926.

LASSAW, IBRAM (b. Egypt 1913)

*****Galactic Cluster #1** 1958
Manganese bronze, silicon bronze and nickel silver 33"x38½"x16"
(83.8x97.8x40.6 cm)
Signed and dated: "Lassaw 58"
Ex-collection: with Samuel M. Kootz Gallery, Inc., New York, N.Y.
Purchase 1960 Sophronia Anderson Bequest Fund 60.583

Correspondence with artist establishes this and Tanith *as unique pieces.*

Tanith 1960
Bronze 19¼" (48.9 cm)
Signed and dated: "Lassaw 60"
Ex-collection: with Samuel M. Kootz Gallery, Inc., New York, N.Y.;
to donors, New York, N.Y.
Gift of Dr. and Mrs. John A. Cook 1962 62.5

LAURENT, ROBERT (b. France 1890-1970)

*****Young Duck** 1921 (?)
White wood 21" (53.3 cm)
Signed: "Laurent"
Ex-collection: purchased from The Downtown Gallery, New York, N.Y.
Gift of Mr. and Mrs. Felix Fuld 1927 27.1072

Date assigned by Peter Moak in the catalogue, Robert Laurent Memorial Exhibition, *University of New Hampshire, 1972.*

LENZ, ALFRED DAVID (1872-1926)

Señorita Hootch 1922
Bronze figure 7¼" (18.4 cm)
Signed and dated: "Alfred Lenz ©1922"
Ex-collection: The Joseph S. Isidor Collection, Newark, N.J.
Gift of Joseph S. Isidor 1922 22.108

Exhibited at National Academy of Design, 1922.

LEWITT, SOL (b. 1928)

3 Part Variations on 3 Different Kinds of Cubes 1968, remade 1974
Painted steel.
A 144"x18" (365.7x45.7 cm)
B 54"x18" (137.2x45.7 cm)
C 54"x18"x18" (137.2x45.7x45.7 cm)
D 54"x18"x18" (137.2x45.7x45.7 cm)
E 54"x18"x18" (137.2x45.7x45.7 cm)
F 54"x18"x18" (137.2x45.7x45.7 cm)
G 54"x18"x18" (137.2x45.7x45.7 cm)
H 54"x18"x18" (137.2x45.7x45.7 cm); assembled: 54"x198"x18"
(137.2x502.9x45.7 cm)
Unsigned
Ex-collection: the artist to donor, London, England
Gift of John W. Wendler 1978 78.190

LIPPOLD, RICHARD (b. 1915)

New Jersey Meadows 1961-64
Stainless steel wire and Muntz metal 144"x144"x96"
(365.8x365.8x243.8 cm)
Unsigned
Purchase 1964 Sophronia Anderson, Louis Bamberger and Edward
Weston Bequest Funds 64.57

Commissioned by The Newark Museum. Drawings for the sculpture are also in the collection (64.56 A-E). The work is temporarily dismantled.

LOEFFLER, MORITZ (b. Germany 1871-1935)

Babies of the Jungle
Wood group 13" (33.0 cm)
Signed: (monogram)
Ex-collection: purchased from the artist, Bloomfield, N.J.
Purchase 1934 34.173

LOPEZ, CHARLES ALBERT (1869-1906)

Seated Minerva and Youth ca. 1903
Bronzed plaster group 36" (91.4 cm)
Unsigned
Labeled: "Original plaster model, metalized, of a detail of the
monument to William McKinley, erected at Philadelphia in 1906.
By Charles Albert Lopez, 1869-1906 Spanish Sculptor, born in Mexico
and an American citizen. Given to the Museum by
Mrs. Marion Lopez-Berry."
Ex-collection: donor, Irving, N.Y.
Gift of Mrs. Marion Lopez-Berry 1915 15.161

This was the artist's final work. It was shipped from the National Metalizing Company, Garwood, N.J.

Original plaster model of a detail of a monument to William McKinley, erected in Philadelphia in 1906-07. Lopez won the competition for this monument in 1903, but died before executing his design. Isidore Konti carried out the memorial, utilizing Lopez' sketch. (cf. Madigan)

Meriwether Lewis (1774-1809) ca. 1904
Bronzed plaster figure 36" (91.44 cm)
Unsigned
Ex-collection: the artist; to The American Museum of Natural History,
New York, N.Y.; to donor, Irving, N.Y.
Gift of Mrs. Marion Lopez-Berry 1915 15.978

Bronzed by the National Metalizing Company, Garwood, N.J., for Mrs. Lopez-Berry. Original model for a large work designed for the Louisiana Purchase Exposition, St. Louis, Mo., 1904. (corres.)

MacMONNIES, FREDERICK WILLIAM (1863-1937)

*****Pan of Rohallion** 1890
Bronze figure 30" (76.2 cm)
Signed and dated: "France/ Frederick MacMonnies/ Copyright 1894
Paris 1890"
Inscribed: "To.Pan.of.Rohallion Anno Domini. M.D.C.C.C.L.X.L."
Founder's mark: "H. Rouard.Fondeur"
Ex-collection: purchased from the artist, Paris, France
Gift of Mr. and Mrs. Felix Fuld 1926 26.2365

Located replicas: R. W. Norton Art Gallery, Shreveport, La.; Cranbrook Foundation, Bloomfield Hills, Mich.; Buffalo Academy of Fine Arts, Buffalo, N.Y.; University of Kansas Museum of Art, Lawrence, Kan.; Oceanic Library, Rumson, N.J.; Morris Museum of Arts and Sciences, Morristown, N.J. (49¾" high); two in private collections.

The original Pan was a heroic version made for Edward Adams' "Rohallion," Rumson, N.J., in situ until the winter of 1977; present whereabouts unknown. Adams gave the artist permission to make unlimited replicas, none to exceed 36" h. Several replicas have appeared at Sotheby Parke Bernet sales in recent years.

MALDARELLI, ORONZIO (b. Italy 1892-1963)

Judith 1938
Marble figure 25½" (64.8 cm)
Signed: "O. Maldarelli"
Ex-collection: with Midtown Galleries, New York, N.Y.
Purchase 1950 Felix Fuld Bequest Fund 50.2111

MALLARY, ROBERT (b. 1917)

*Infanta 1960
Cardboard construction with paper collage 53" x 28" (134.6 x 71.1 cm)
Signed: "Infanta/ R. Mallary/ Aug- 1960/ New York"
Ex-collection: donor, New York, N.Y.
Gift of Willard B. Golovin 1967 67.401

MARTINELLI, EZIO (1913-1980)

*Ancestral Woman 1958-59
Welded iron figure 84" (213.4 cm)
Signed: "Ezio Martinelli"
Ex-collection: the artist; to donor, Locust Valley, N.Y.
Gift of Richard Lippold 1962 62.145

McKENZIE, ROBERT TAIT (1867-1938)

*The Youthful Franklin (1706-1790) 1914
Bronze figure 36½" (92.7 cm)
Signed and dated: "R. Tait McKenzie/1914"
Inscribed: "1723/1706 The Youthful Franklin 1790"
Founder's mark: "Roman Bronze Works N-Y-"
Ex-collection: acquired from the artist, Philadelphia, Pa.
Purchase 1914 14.1073

*Located replicas: University of North Carolina, Chapel Hill, N.C.;
Brookgreen Gardens, Murrells Inlet, S.C.; life-size version in front of
Weightman Hall, University of Pennsylvania, Philadelphia, Pa.*

McNEELY, STEPHEN (b. 1909)

Stephen Crane (1871-1900) 1934
Plaster head 14⅞" (37.8 cm)
Signed and dated: "Stephen M. McNeely/ '34"
Ex-collection: U. S. Treasury Public Works of Art Project, Northern
New Jersey Sub-committee of the New York Regional Committee.
Allocated by the Public Works of Art Project 1934 34.321

*Located replica: Newark Free Public Library, Newark, N.J.
PWAP #N63B*

MESTROVIC, IVAN (b. Yugoslavia 1883-1962)

Portrait of a Lady 1925
Bronze bust 24½" (62.2 cm)
Signed: "I Mestrovic"
Founder's mark: "Roman Bronze Works N-Y-"
Numbered: "771"
Ex-collection: donor, Niantic, Conn.
Gift of Arthur Nikoloric 1955 55.89

*The artist's widow thought that the sitter was Mrs. Arthur Nikoloric.
(corres.) This piece was executed during a visit to the United States before
the artist became a permanent resident.*

MIESTCHANINOFF, OSCAR (b. Russia 1884-1956)

Head of Miss J. W. 1933
Bronze 13⅜" (34.0 cm)
Signed: "Miestchaninoff"
Founder's mark: "Cire/ Valsuani/ perdue"
Ex-collection: donor, New York, N.Y.
Gift of Mrs. Oscar Miestchaninoff 1959 59.416

MILES, JEANNE PATTERSON (20th century)

Sphere #1 1967
Polyester and brass 6" diam. sphere; 5"x4⅛"x4⅛" base; 11" overall
height (15.2; 12.7x10.5x10.5; 28.0 cm)
Signed and dated: "Miles 68"
Ex-collection: the artist, New York, N.Y.
Gift of Ira Morris 1967 67.403

The base is a new one made by the artist in 1968.

MOZIER, JOSEPH (1812-1870)

White Lady of Avenel 1864
Marble figure 63⅜"x26¼"x20" (161.0x66.7x50.8 cm)
Signed and dated: "J. Mozier Sc./ Rome 1864"
Inscribed: "Here lies the volume thou boldy has sought/ touch it, and
take it —'twill dearly be bought"
Ex-collection: Noval Antiques, New York, N.Y. (ca. 1966); to donor,
Piermont, N.Y.
Gift of James Ricau 1978 78.191

*A 51" replica was sold at Sotheby Parke Bernet sale #4435M,
October 17, 1980.*

NADELMAN, ELIE (b. Poland 1882-1946)

*Head of a Woman 1916-18
Marble 17⅜" (44.1 cm)
Signed: "Elie Nadelman"
Ex-collection: donor, New York, N.Y.
Gift of Carman Messmore 1952 52.116

*This is possibly Girl with Veil in the Robert Isaacson Gallery show, Elie
Nadelman, October 18-November 19, 1960. Donor stated in 1952 that it
was a unique piece. (files)*

NAKIAN, REUBEN (b. 1897)

*Seal 1929
Bronze 8¾"x14" (22.2x35.6 cm)
Signed: "Nakian -"
Ex-collection: with The Downtown Gallery, New York, N.Y.; to donor,
New York, N.Y.
Gift of Mrs. Edward S. Harkness 1931 31.8

Unique piece. Date supplied by artist. (corres.)

NELSON, HELEN (b. 1913)

Case History 1938
Silvered dextrine figure 35" (88.9 cm)
Signed and dated: "H. Nelson 1938"
Labeled: "--- Administration Contemporary/ New York World's Fair
1940, Queens"
Allocated by the WPA Federal Art Project through The Museum of
Modern Art, New York, N.Y., 1943 43.152

*Included in The Museum of Modern Art's circulating exhibition, Fifteen
American Sculptors, before transfer to The Newark Museum.*

NEVELSON, LOUISE (b. Russia 1900)

*Dark Shadows 1957
Painted wood 72"x9¾"x4½" (182.9x24.8x11.4 cm)
Signed: "Nevelson"
Ex-collection: with Grand Central Art Galleries, Inc., New York, N.Y.
Gift of Benjamin Mildwoff 1957 57.12

NICKERSON, J. RUTH (b. 1905)

Release 1934
Plaster group 42½" (108.0 cm)
Signed and dated: "J R Nickerson/ 1934"
Ex-collection: U.S. Treasury Public Works of Art Project, New York
Regional Committee through the Whitney Museum of American Art,
New York, N.Y.
Allocated by Public Works of Art Project 1934 34.166

*Designed for use in a park in an East Side housing rehabilitation, this
work was to be carved in stone and mounted on a 6' (182.9 cm) simple
pedestal. PWAP #4565*

NOCK, LEO F. (1875? — ?)

Elephant 1905
Bronze 5⅝" (14.3 cm)
Signed and dated: "LF. Nock/ 1905"
Founder's mark: "Gorham Co. (illeg.) 0I0"
Ex-collection: Gorham Co., Inc., New York, N.Y.
Purchase 1914 14.8

Presumably by a Gorham workman.

NORTON, FRANK L. (1872-1950)

Hand Saw Weathervane second quarter, 20th century
Painted wood 14⅜"x29½"x4⅜" (36.5x74.9x11.1 cm)
Unsigned
Ex-collection: the artist to his son, the donor, Edgartown, Mass.
Gift of Winthrop B. Norton 1973 73.77

Canada Goose Decoy second quarter, 20th century
Painted wood 11"x19¾"x7" (27.9x50.2x17.8 cm)
Unsigned
Ex-collection: the artist to his son, the donor, Edgartown, Mass.
Gift of Winthrop B. Norton 1973 73.113

PARK, RICHARD HENRY (1832- after 1890)

Young Girl with Butterfly (Anticipation) 1879
Marble 49" (124.5 cm)
Signed and dated: "Prof. R. H. Park/ Sculp 1879"
Ex-collection: donor's uncle (name unknown)
Gift of Mrs. Anna B. Campbell 1964 64.245

A work Park entitled Anticipation *is known to have been commissioned in
1873 by F. J. Bostwick of Milwaukee, Wisc., after a bozzetto by Salvatore
Albano of Florence, Italy. It was described as a young girl reaching for a
butterfly in a letter dated January 28, printed in the New York* World,
Sunday, March 1, 1874. (corres.)

PARSONS, BETTY (b. 1900)

Theatre 1972
Wood construction 21¾"x40"x4¼" (55.2x101.6x10.8 cm)
Unsigned
Ex-collection: purchased from exhibition at The Museum of Modern
Art, New York, N.Y.
Gift of Mrs. Robert M. Benjamin 1974 74.30

PAVIA, PHILLIP (b. 1914)

*****No Object** 1969
Carrara and African marble (12 blocks) 60¾"x38¾"x35"
(154.3x98.4x89.9 cm)
Unsigned
Ex-collection: purchased from the artist, New York, N.Y.
Purchase 1974 with a grant from the National Endowment for the Arts
and funds from the Charles W. Engelhard Foundation 74.23

POWERS, HIRAM (1805-1873)

*****Charity** after 1871
Marble bust 25½" (64.8 cm)
Signed: "H. Powers/ .Sculp."
Ex-collection: donor, Scotch Plains, N.J.
Gift of Dr. J. Ackerman Coles 1919 19.792

*Located replicas: first cut, ordered by Marshall Woods, 1866, delivered
1871; J. B. Speed Museum, Louisville, Ky.; American National Red Cross,
Washington, D.C.; Raydon Gallery, New York, N.Y.; private collection.*

Richard P. Wunder lists four unlocated busts. (corres.)

*****Proserpine** 1860-61
Marble bust 20⅛" with integral base (51.1 cm)
Signed: "H. Powers Sculp"
Ex-collection: J. Schoenberger, New York, N.Y.
Gift of Mrs. John H. Schoenberger 1922 22.81

*Located replicas of two-thirds size with leaf border (Newark version):
Maryland Historical Society, Baltimore, Md.; Art Gallery of New South
Wales, Sydney, Australia; Judson College, Marion, Ala.; two private
collections. At least 133 examples were made in various sizes, 16"-25", with
leaf, beaded and plain borders. (files)*

Ordered by J. Schoenberger in 1860 and shipped in 1861. (corres.)

*****Greek Slave** 1847
Marble figure 65½" (166.4 cm)
Signed and dated: "Hiram Powers/ Sculp./ L'anno 1847."
Ex-collection: commissioned by Sir Charles Coote, Dublin, Ireland
(not purchased); with Miner Kellogg, agent (1848-51); purchased by C.
L. Derby, Sandusky, O., 1854 (Cosmopolitan Art Association); by
lottery to Mrs. Kate Gillespie, Brady's Bend, Pa., 1855; repurchased by
Cosmopolitan Art Association, 1858; by lottery to Miss Coleman,
Cincinnati, O., 1858; purchased from Miss Coleman by Alexander T.
Stewart; purchased by "Captain Delmar" from or through American
Art Association after Mr. Stewart's death, 1887; collection of Franklin
Murphy, Sr., Newark, N.J. to donor, Newark, N.J.
Gift of Franklin Murphy, Jr. 1926 26.2755

*Located replicas (listed in order produced): Raby Castle, County Durham,
England; made for John Grant, Devonshire, in 1844 and shown at Crystal
Palace, London. Corcoran Gallery of Art, Washington, D.C., 1846;
promised to Lord Ward, released to James Robb, New Orleans (differs from
Newark version in omitting one twist of drapery and some fringe).
Newark's version was third. The fourth replica, made for Lord Ward, was
destroyed in the 1944 Blitz at Whitby Court. Yale University Art Gallery,
New Haven, Conn.; originally purchased by Prince Paul Demidoff, San
Donato, Italy, and passed to the Earl of Dudley (similar to Raby and
Newark versions). Brooklyn Museum, Brooklyn, N.Y., made for E. W.
Stoughton, New York, N.Y. (differs from Raby, Newark and Yale versions
in showing manacles rather than a chain). There are several smaller
replicas, numerous bust-length versions and countless parian ware and
ceramic reproductions.*

*The Newark replica was seen by vast numbers of people throughout the
United States and was shown at the New York Crystal Palace in 1853. (cf.
Gerdts)*

*****Joshua Huntington Wolcott** (1804-1891) ca. 1867
Marble bust 25" (63.5 cm)
Signed: "H Powers/ Sculp."
Ex-collection: purchased at estate sale of Roger Wolcott conducted by
Louis Joseph, Inc., Boston, Mass., October 12, 1965, lot #141
Purchase 1965 Thomas L. Raymond Bequest Fund 65.151

PRESSMAN, IRVING (20th century)

Deer
Wood, lignum vitae 6¼"x15"x9" (15.9x38.1x22.9 cm)
Signed: "I. Pressman"
Ex-collection: executed under WPA Federal Art Project; exhibited in
Newark City Hall; transferred to Newark City Hospital and discarded
when Martland Medical Center opened
Gift of Dr. Samuel Berg 1959 59.380

PRUITT, LOUIS W. (b. 1935)

Untitled 1970-71
Polyester resin and canvas 84"x12¼"x12¼" (213.4x31.1x31.1 cm)
Unsigned
Ex-collection: purchased from the artist, Summit, N.J.
Purchase 1971 Felix Fuld Bequest Fund 71.169

Purchased from the seventh Newark Museum triennial, New Jersey
Artists, *1971.*

QUINN, EDMOND THOMAS (1868-1929)

*****Eugene O'Neill** (1888-1953) ca. 1922
Bronze bust 13¾" (35.0 cm)
Signed: "Quinn Sc"
Gift of Charles C. Rumsey 1958 58.187

*Located replicas: Yale University, New Haven, Conn.; Philadelphia
Museum of Art, Philadelphia, Pa.*

RAUSCHNER, JOHN CHRISTIAN (b. Germany 1760-after 1811)

*****John McComb, Sr.** (1734-1811)
Wax relief bust 3¼" (8.3 cm)
Unsigned
Ex-collection: donor, Newark, N.J.
Gift of Miss Sarah Elizabeth McComb 1923 23.481

*A duplicate, dated ca. 1800, is in the collection of The New-York Historical
Society, New York, N.Y. John McComb, Sr., was the father of John
McComb, Jr. (1763-1853), the architect of New York City Hall. John
McComb, Sr., held the office of City Surveyor in New York, 1784-88. (files)*

Joseph Bagley McComb as a Baby (1803-1887) ca. 1804-05
Wax three-quarter relief diorama 6½"x8½" (16.5x21.6 cm); figure 4½"
(11.4 cm)
Signed: "Rauschner"
Ex-collection: donor, Newark, N.J.
Gift of Miss Sarah Elizabeth McComb 1923 23.482

*Subject was grandson of John McComb, Sr. (23.481), and son of Isaac
(23.483A).*

Issac McComb (ca. 1780-1810)
Wax relief bust 3¼" (8.3 cm)
Signed: "Rauschner"
Ex-collection: donor, Newark, N.J.
Gift of Miss Sarah Elizabeth McComb 1923 23.483A-C

*23.483B is a plaster mold for the above, inscribed "Isaac McComb".
23.483C is a broken, less defined mold for the same. Subject was the son of
John McComb, Sr.*

REIBACK, EARL (b. 1943)

Tranquility 1966
"Lumia composition," sheet aluminum with electrical and optical
components 41"x36"x16" (104.1x91.4x40.6 cm)
Unsigned
Ex-collection: Howard Wise Gallery, New York, N.Y.
Purchase 1967 Membership Endowment Fund 67.50

REIMANN, WILLIAM P. (b. 1935)

Sketch for Endo Project 1964
Plexiglas and steel cone 33"x15⅛" (88.9x38.3 cm)
Unsigned:
Ex-collection: with Galerie Chalette, New York, N.Y.; to donors,
New York, N.Y.
Gift of Mr. and Mrs. Henry Feiwel 1977 77.226

REMINGTON, FREDERIC (1861-1909)

*****Trooper of the Plains**
Bronze mounted figure 26¼" (66.7 cm)
Signed: "Copyright by/ Frederic Remington"
Founder's mark: "Roman Bronze Works N-Y-"
Numbered: "N° 13"
Ex-collection: donors, Peapack, N.J.
Gift of Mr. and Mrs. William V. Griffin 1952 52.167

*Located replicas: Metropolitan Museum of Art, New York, N.Y. (#5);
Remington Art Museum, Ogdensburg, N.Y.; R. W. Norton Art Gallery,
Shreveport, La. (#14); Amon Carter Museum of Western Art, Fort Worth,
Tex.; Thomas Gilcrease Institute of American History and Art, Tulsa, Okla.
(#N4); a replica was listed in Sotheby Parke-Bernet, Inc., sale #3913,
October 28, 1976, item #105.*

*First cast in 1909. More than 15 castings were made before the molds were
destroyed in 1919. In 1957 copies were made for the Remington Art
Museum and are marked R.A.M. (corres.)*

RHIND, JOHN MASSEY (b. Scotland 1860-1936)

Peter Stuyvesant (1592-1672) 1913
Bronze figure 38¼" (97.2 cm)
Signed and dated: "J. Massey Rhind/ 1913"
Founder's mark: "Roman Bronze Works N-Y-"
Ex-collection: purchased from the artist, New York, N.Y.
Purchase 1914 14.171

*Study for a work in Bergen Square, Jersey City, N.J., unveiled October 18,
1913. This version was cast to order for The Newark Museum. (corres.)*

Robert Burns (1759-1796) 1914
Bronze figure 36¼" (92.1 cm)
Signed and dated: "Massey Rhind 1914"
Founder's mark: "Roman Bronze Works N-Y-"
Ex-collection: Purchased from the artist, New York, N.Y.
Purchase 1915 15.374

Study for work erected in Schenley Park, Pittsburgh, Pa. (corres.)

*****On the Lookout** 1919
Bronze figure 22½" (57.2 cm)
Signed and dated: "Massey Rhind. Sc/ 1919"
Founder's mark: "Roman Bronze Works N-Y-"
Ex-collection: donor through John B. Stobaeus, Jr., Maplewood, N.J.
Gift of Frederick W. Smith 1961 61.30

*Located replica: private collection; listed in Sotheby Parke Bernet, Inc.
catalogue #3548, lot #124.*

Charles Dudley Warner (1829-1900) after 1900
Bronze figure 13¼" (33.7 cm)
Signed: "Massey.Rhind.Fecit."
Founder's mark: "Roman Bronze Works N-Y-"
Ex-collection: Joseph S. Isidor, Newark, N.J.; to Newark Free Public
Library, Newark, N.J.
Gift of Newark Free Public Library 1977 77.214

*Study for a proposed statue to be erected in Bushnell Park by the Park
Board of Hartford, Conn.; modeled from a death mask taken by Mr.
Rhind. Charles Dudley Warner was for 40 years editor of the* Hartford
Courant, *and for 16 years associate editor of* Harper's *magazine. (files)*

RICKEY, GEORGE W. (b. 1907)

*****Six Lines Horizontal Extended** 1966
Stainless steel kinetic sculpture 24"x69" (43.8x175.3 cm)
Signed and dated: "Rickey '66"
Ex-collection: with Staempfli Gallery, New York, N.Y.
Purchase 1966 Wallace M. Scudder Bequest Fund 67.52 A-G

RINEHART, WILLIAM HENRY (1825-1874)

***Leander** ca. 1859
Marble figure 40½″ (102.9 cm)
Signed: "W.H. Rinehart"
Ex-collection: acquired from the artist by Edward Clark, New York,
N.Y.; purchased from Andrew John, Inc., New York, N.Y.
Purchase 1962 Mr. and Mrs. George K. Batt Fund 62.6

Located replica: one subsequent, in a private collection

***Hero** 1871
Marble figure 34″ (86.4 cm)
Signed and dated: "Wm H. Rinehart. Sculpt. 1871"
Ex-collection: Mrs. George Small; to Peabody Institute of the City of
Baltimore, Md.
Purchase 1964 Mr. and Mrs. George K. Batt Fund 64.7

*Located replicas: Library, Peabody Institute of the City of Baltimore, Md.
(1867); Pennsylvania Academy of the Fine Arts, Philadelphia, Pa. (1869);
private collection (1867)*

No less than eight were cut. (cf: Ross, Rutledge)

ROGERS, JOHN (1829-1904)

The Town Pump
Painted plaster group 13″ (33.0 cm)
Signed: "John Rogers/ New York"
Inscribed: "The Town Pump"
Anonymous gift 00.16

*Type B – Canteen at right hip (after 1866); 21 to 30 copies were known to
Wallace. (q.v.)*

Courtship in Sleepy Hollow (Ichabod Crane and Katrina Van
Tassel) 1868
Painted plaster group 16½″ (41.9 cm)
Inscribed: "Courtship in Sleepy Hollow/ Ichabod Crane and Katrina
Van Tassel/ Patented Aug 25 1868"
Gift of the Newark Free Public Library 1917 17.489

*Bronze master model is in the New-York Historical Society, New York,
N.Y.; 21 to 30 copies were known to Wallace.*

Why Don't You Speak for Yourself, John? 1885
Painted plaster group 22″ (55.9 cm)
Signed: "John Rogers/ New York"
Inscribed: "John Alden Priscilla 'Why Don't You Speak for Yourself
John?'/ Patented. Feb. 10 1885"
Purchase 1927 27.1338

*Bronze master model at the New-York Historical Society, New York, N.Y.;
41 to 50 copies were known to Wallace.*

***Why Don't You Speak for Yourself, John?** 1885
Painted plaster group 22″ (55.9 cm)
Signed: "John Rogers/ New York"
Inscribed: "John Alden Priscilla 'Why Don't You Speak for Yourself
John?'/ Patented Feb. 10 1885"
Ex-collection: Mrs. George A. Rogers, Newark, N.J.
Gift of Mrs. George A. Rogers 1929 29.470

A wedding gift to the donor. (files)

***Coming to the Parson** 1870
Painted plaster group 22″ (55.9 cm)
Signed: "John Rogers/ New York"
Inscribed: "Coming to the Parson/ Patented/ Aug. 9.1870."
Gift of G. R. Searing, Sr. 1932 32.226

*Bronze master model is in the New-York Historical Society; over 50 copies
were known to Wallace.*

School Days 1877
Painted plaster group 21¼″ (54.6 cm)
Signed and dated: "John Rogers/ New York/ 1877."
Inscribed: "School Days/ Pat. June 26-1877."
Ex-collection: William H. Gregory
Gift of Mrs. William H. Gregory in memory of William H. Gregory
1934 34.170

*Bronze master model is in the New-York Historical Society; 21 to 30 copies
were known to Wallace. William H. Gregory, a native of Newark, was
manager of one of the first Bell Telephone Exchanges of New York. This
group was presented to him by the employees of this Exchange. (corres.)*

The Home Guard (Midnight on the Border) 1865
Painted plaster group 23½″ (59.69 cm)
Signed: "John Rogers/ New York (partially illeg.)"
Inscribed: "The Home Guard/ Midnight on the Border/ Patent applied
fr Mar 1865"
Ex-collection: estate of donor's mother
Gift of Miss Marie Meiborg 1934 34.347

Eleven to 15 copies were known to Wallace.

Is It So Nominated in the Bond? 1880
Painted plaster group 23″ (58.4 cm)
Signed and dated: "John Rogers/ New York/ 1880"
Inscribed: "Antonio, Bassanio, Portia and Shylock/ 'Is It So Nominated
in the Bond?'/ Patented/ June 1/ 1880"
Ex-collection: purchased from Mrs. R. Patterson, Montclair, N.J.
Purchase 1939 39.263

*Bronze master model is in the New-York Historical Society; 41 to 50 copies
were known to Wallace.*

Weighing the Baby 1876
Painted plaster group 21″ (53.3 cm)
Signed: "John Rogers/ New York"
Inscribed: "Weighing the Baby/ Patented/ Nov. 21. 1876"
Ex-collection: Miss Emma L. Shapter, Summit, N.J.
Purchase 1939 39.272

*Bronze master model is in the New-York Historical Society; 31 to 40 copies
were known to Wallace.*

The Favored Scholar ca. 1883
Painted plaster group 21″ (53.3 cm)
Signed: "John Rogers/ New York"
Inscribed: "The Favored Scholar"
Ex-collection: Miss Emma L. Shapter, Summit, N.J.
Purchase 1939 39.273

Forty-one to 50 copies were known to Wallace.

The Elder's Daughter ca. 1887
Painted plaster group 21½″ (54.6 cm)
Signed: "John Rogers/ New York"
Inscribed: "The Elder's Daughter"
Gift of Miss Helen Kuebler 1942 42.233

*Bronze master model is in the New-York Historical Society; 16 to 20 copies
were known to Wallace.*

***Taking the Oath and Drawing Rations** 1866
Painted plaster group 23″ (58.4 cm)
Signed: "John Rogers/ New York"
Inscribed: "Taking the Oath/ and/ Drawing Rations/ Patented Jan 30
1866"
Gift of Mrs. Claude S. Nunn 1945 45.1578

*Master model is in the New-York Historical Society; 41 to 50 copies were
known to Wallace, who notes that over 300 of these casts were sold before
the bronze master model was cast. Some bronzes were made in 1966.*

Parting Promise
Painted plaster group 22″ (55.9 cm)
Signed: "John Rogers/ New York"
Inscribed: "Parting (illeg.) se"
Gift of Mrs. Louis A. Kass 1946 46.127

Type B: with mustache (Wallace).

ROGERS, RANDOLPH (1825-1892)

Ruth Gleaning 1853
Marble figure 45¾" (116.2 cm)
Signed and dated: "Randolph Rogers, Sculpt Rome 1853"
Ex-collection: Anton Meisler, New York, N.Y. with Parke-Bernet
Galleries, New York, N.Y. (Meisler Estate Sale, March 31, 1966)
Purchase 1966 Wallace M. Scudder Bequest Fund 66.38

*Located replicas: The Detroit Institute of Arts, Detroit, Mich.; The
Woodmere Art Gallery, Philadelphia, Pa.; The Hay House, Macon, Ga.;
The Metropolitan Museum of Art, New York, N.Y.; Mamma Leone's
Restaurant, New York, N.Y.; Virginia Museum of Fine Arts, Richmond,
Va. (reported as 41½" [105.4 cm]).*

Rogers made two versions of Ruth Gleaning; *there is also a 35½"
(90.2 cm) reduction. (cf. Rogers)*

RÖNNEBECK, ARNOLD (b. Germany 1885-1947)

Arthur Hartmann (1881-1956) ca. 1928
Plaster bust 22½" (57.2 cm)
Signed: "A. Ronnebeck."
Ex-collection: donor, New York, N.Y.
Gift of Arthur Hartmann 1943 43.93

Hartmann was a violinist, composer and teacher in New York City. (files)

ROSATI, JAMES (b. 1912)

*****Pennine III** 1966
Stainless steel 65½"x42"x115" (166.4x106.7x292.1 cm)
Signed: "Rosati"
Ex-collection: with Marlborough-Gerson Gallery, Inc., New York, N.Y.
Purchase 1969 with funds from the National Council on the Arts and
Trustee contributions 69.25 A-E

ROSENTHAL, BERNARD (b. 1914)

*****Rockingdam Castle** 1962
Bronze 11½"x13½"x8⅛" (29.2x34.3x20.6 cm)
Signed and dated: "Rosenthal 62"
Ex-collection: with Samuel M. Kootz Gallery, Inc., New York, N.Y.
Purchase 1962 Louis Bamberger Bequest Fund 62.144

Unique piece. (corres.)

ROSZAK, THEODORE (b. Poland 1907)

*****Airport Structure** 1932
Copper, aluminum, steel and brass 19⅛"x7" diam. (48.6x17.8 cm)
Signed and dated: "Theo. Roszak 1932"
Ex-collection: with Zabriskie Gallery, New York, N.Y.
Purchase 1977 The Members' Fund 77.23

ROTH, FREDERICK GEORGE RICHARD (1872-1944)

*****Drinking Rhinoceros** 1904
Bronze 7⅝" (19.4 cm)
Signed and dated: "Copyright 1904/ by/ FGR Roth"
Founder's mark: "Roman Bronze Works N-Y-"
Numbered: "N-4-"
Ex-collection: with William Macbeth, New York, N.Y.
Purchase 1914 14.118

ROTHSTEIN, IRMA (b. Russia 1896-1971)

Mask 1939
Bronze 8" (20.3 cm)
Unsigned
Ex-collection: donor, Long Island City, N.Y.
Gift of Bernard D. Klein 1940 40.153

*A possible likeness of Baroness Ilonka Vetsera. Further efforts to identify
the subject have been unsuccessful. (files)*

RUMSEY, CHARLES CARY (1879-1922)

*****Polo Player** 1911
Bronze figure 20¼" (51.4 cm)
Signed and dated: "C.C.Rumsey/ (illeg.) 1911"
Founder's mark: "Roman Bronze Works N-Y-"
Gift of Miss Mary A. H. Rumsey 1958 58.185

SAFFERSON, MATTHEW (b. England 1909)

*****Rooster**
Bronze 26½"x17¾"x5⅝" (67.3x45.1x14.3 cm)
Unsigned
Ex-collection: WPA Federal Art Project, transferred through The
Museum of Modern Art, New York, N.Y.
Allocated by the WPA Federal Art Project 1943 43.151

SAINT-GAUDENS, AUGUSTUS (b. Ireland 1848-1907)

*****Abraham Lincoln** (1809-1865) 1887
Bronze figure 40½" (102.9 cm)
Signed and dated: "Augustus.Saint-Gaudens Sculptor.
M.D.C.C.C.LXXXVII"
Inscribed: "Copyright.1912.by.A.H. Saint.Gaudens"
Founder's mark: "Gorham Co. Founders (hallmark)/OAWM"
Gift of Franklin Murphy, Jr., in memory of Franklin Murphy
1920 20.1350

*Located replicas: Fogg Art Museum, Cambridge, Mass. (reported as 40¾"
[103.51 cm]), copyright 1919, dated 1887; Museum of Art, Carnegie
Institute, Pittsburgh, Pa. (reported as 39½" [100.3 cm]), copyright 1912,
dated 1887; Saint-Gaudens National Historic Site, Cornish, N.H.*

*A posthumous reduction of the 1887 heroic statue in Lincoln Park,
Chicago, Ill. A larger reduction is in the Carnegie Institute, Pittsburgh, Pa.*

*****Victory** (Nike-Eirene) 1904
Bronze head 8" (20.3 cm)
Signed and dated: "A. S.T. Gaudens.Aspet.MCMIV."
Inscribed: "NIKH-EIPHNH" ("Victory-Peace" in Greek)
Ex-collection: with Ferargil Galleries, New York, N.Y.
Purchase 1927 Dr. J. Ackerman Coles Bequest Fund 27.287

*Located replicas: Metropolitan Museum of Art, New York, N.Y. (dated
1905); Smithsonian Institution, National Collection of Fine Arts,
Washington, D.C.; Saint-Gaudens National Historic Site, Cornish, N.H.;
Rose Nichols House, Boston, Mass.; private collection, Cambridge, Mass.;
a cast was listed in Sotheby Parke Bernet, Inc., New York, N.Y., "Dodge
Sale" number 3802, October 31, 1975, item #29, Gorham Company
founder's mark.*

Second study (not used) for head of Victory *for the Sherman Memorial,
Grand Army Plaza, New York, N.Y.*

SALEMME, ANTONIO (b. Italy 1892)

The Prayer 1922
Bronze figure 22⅜" (56.8 cm)
Signed and dated: "A. Salemme/ 1922"
Ex-collection: donor, Newark, N.J.
Gift of Joseph S. Isidor 1922 22.109

SANDER, C. H. (19th-20th centuries)

Portrait of Theodore Roosevelt (1858-1919)
Bronze relief 13" (33.0 cm)
Unsigned
Ex-collection: donor, Scotch Plains, N.J.
Gift of Dr. J. Ackerman Coles 1926 26.1096

SCHIMMEL, WILHELM (b. Germany 1817-1890)

*****Wooden Eagle** after 1865
Carved and painted wood 7¾"x12¼"x8½" (19.7x31.1x21.6 cm)
Unsigned
Ex-collection: George G. Frelinghuysen, Morristown, N.J.; purchased
from Leah and John Gordon, New York, N.Y.
Purchase 1975 The Members' Fund 75.29

SCHMID, ELSA (b. Germany 1894-1970)

St. Christopher 1936
Mosaic in concrete 56"x29¾" (142.2x75.6 cm)
Signed: "Elsa Schmid"
Ex-collection: donor, Gladstone, N.J.
Gift of Mrs. Charles Suydam Cutting 1941 41.811

*Artist's son, Peter Newmann, gives birthplace and date as Germany, 1894.
(corres.) Who's Who in American Art 1970 lists 1897 as birthdate.*

SCHREYVOGEL, CHARLES (1861-1912)

*****The Last Drop** 1904
Bronze group 12" (30.5 cm)
Signed and dated: "Copyrighted 1903 by/ Chas Schreyvogel"
Founder's mark: "Roman Bronze Works N-Y- 1904"
Ex-collection: donor, Newark, N.J.
Gift of Joseph S. Isidor 1925 25.1280

*Located replicas: Eleven replicas are listed in Bronzes of the American
West by Patricia Janis Broder, 1974 (casts not differentiated). A green
patinated cast, copyright 1900, by the Hoboken Foundry; a brown
patinated cast (#8) was listed in Sotheby Parke Bernet catalogue 3981,
April 21, 1977, item #67; a green patinated cast (#137) was listed in
Sotheby Parke Bernet catalogue 4038 of October 27, 1977, item #122; a
"dark patinated" cast inscribed "Cellini Bronze Works N.Y." was listed in
Sotheby Parke Bernet catalogue "Dodge Part IV", number 3802, October
31, 1975, item #56. Patination of Newark piece is brown.*

SCHWARTZ, LILLIAN (b. 1927)

#182-68 1968
Cast acrylic
A 31¼"x24½"x7½" (79.4x62.2x19.1 cm)
 Signed: "L Schwartz"
B 37"x27½"x12½" (93.9x69.9x31.8 cm)
 Signed: "L Schwartz ©"
Ex-collection: acquired from the artist, Maplewood, N.J.
Gift of Miss Belle Schuller 1968 68.243 A-B

SEGAL, GEORGE (b. 1924)

*****The Parking Garage** 1968
Mixed media environment: plaster, wood, metal, electrical parts.
assembled: 117¾"x155" (300.0x393.0 cm); figure: 43¼" (109.9 cm)
Unsigned
Ex-collection: with Sidney Janis Limited, New York, N.Y.
Purchase 1968 with funds from the National Council on the Arts and
Trustee contributions. 68.191 A-J

SELEY, JASON (b. 1919)

Exaltation 1951
Cast and welded aluminum figure 49⅛" (124.8 cm)
Signed and dated: "Seley/ 1951"
Ex-collection: private collection, France
Anonymous gift 1959 59.418

*Replicas: This is the first of three castings. The other two are in private
collections.*

*****Hanover II** 1968
Welded chromium-plated steel 96"x48"x30" (243.8x121.9x76.2 cm)
Unsigned
Ex-collection: donor, Ithaca, N.Y.
Gift of the artist in memory of his parents, Simon M. Seley and Leah
K. Seley 1969 69.180

SMITH, DAVID (1906-1965)

*****Untitled** 1964
Stainless steel 117½"x62½"x16¾" (298.5x158.8x42.5 cm)
Signed and dated: front, "David Smith"; back, "1964 April ten"
Ex-collection: estate of David Smith with Marlborough-Gerson
Gallery, Inc., New York, N.Y.
Purchase 1967 The Charles W. Engelhard Foundation 67.157

SMITH, TONY (1912-1980)

For J.C. 1969
Welded bronze 80"x80"x57" (203.2x203.2x144.8 cm)
Unsigned
Ex-collection: acquired from the artist, South Orange, N.J.
Purchase 1975 with a grant from the National Endowment for the
Arts and funds from the Prudential Insurance Company of
America 75.232

*Fabricated in 1975 for The Newark Museum by Industrial Welding
Company, Newark, N.J. The first of an intended edition of six; the artist's
proof is on exhibition at the Walker Art Center, Minneapolis, Minn.*

"J.C." refers to Jean Charlot (1898-1980) a French cubist painter.

*****For J.C.** (maquette)
Painted wood 20"x20"x14⅜" (50.8x50.8x36.5 cm)
Unsigned
Ex-collection: acquired from the artist, South Orange, N.J.
Purchase 1975 with a grant from the National Endowment for the
Arts and funds from the Prudential Insurance Company of
America 75.309

For J.C. (maquette)
Oak tag paper and tape, painted black 9¼"x9½"x6½"
(23.5x24.1x16.5 cm)
Unsigned
Ex-collection: acquired from the artist, South Orange, N.J.
Purchase 1975 with a grant from the National Endowment for the Arts
and funds from the Prudential Insurance Company of
America 75.310

STANKIEWICZ, RICHARD (b. 1922)

*****Australia No. 11** 1969
Welded Cor-Ten steel 78" (198.1 cm)
Signed and dated: "R.S." (dotted script)/ Aust/ 1969" (stamped)
Inscription: "Sydney" (paint)
Ex-collection: with Zabriskie Gallery, New York, N.Y.
Purchase 1974 with a grant from the National Endowment for the Arts
and funds from the Charles W. Engelhard Foundation 74.55

STEPPAT, LEO LUDWIG (b. Austria 1910-1964)

Bull
Bronze 15⅛" (38.4 cm)
Unsigned
Ex-collection: the artist; to Robert D. Kaufmann, New York, N.Y.
Gift of Walter A. Weiss (executor of Robert D. Kaufmann estate)
1960 60.607

STEVENS, LAWRENCE TENNEY (1896-1972)

Bear 1922-25
Bronze 5⅜" (13.7 cm)
Unsigned
Ex-collection: with Ferargil Gallery, New York, N.Y.
Purchase 1927 J. Ackerman Coles Bequest Fund 27.284

STIX, MARGUERITE (1907-1975)

Young Girl [Elizabeth Stix (b. 1941)] 1958
Bronze figure 9¼" (23.5 cm)
Unsigned
Numbered: "IV"
Ex-collection: donor, New York, N.Y.
Gift of Hugh Stix 1975 75.97

*Located replicas: Hirshhorn Museum and Sculpture Garden, Washington,
D.C., plaster, 1957; cast in bronze, 1958.*

*Newark piece was patinated by the artist and cast by Roman Bronze
Works, New York, N.Y., in an edition of three. (corres.)*

STORRS, JOHN (1887-1956)

*Abstract Forms #1 1917-19
Granite and marble 34⅝″x3¼″x7½″ (88.0x8.3x19.1 cm); base,
3⅞″x8″x5¾″ (9.8x20.3x14.6 cm)
Unsigned
Ex-collection: estate of the artist; with Robert Miller Gallery, Inc.,
New York, N.Y.
Purchase 1978 The Charles W. Engelhard Bequest Fund and The
Members' Fund 78.106

STORY, WILLIAM WETMORE (1819-1895)

*Young Augustus
Marble bust 23″ (58.4 cm)
Unsigned
Ex-collection: purchased from the artist in Rome by donor,
Morristown, N.J.
Gift of Samuel S. Dennis 1927 27.1247

Copy of a Roman original in the Vatican. Young Augustus *was copied by
many American and European artists throughout the 19th century;
another copy by an unknown artist is in the Museum collection.*

STREETER, TAL (b. 1934)

Flying Red Line 1972
Paper, bamboo and string kite 103¾″x48⅜″ (263.5x122.9 cm)
Signed: "Tal Streeter"
Ex-collection: with A M Sachs Gallery, New York, N.Y.
Purchase 1974 Newark Museum Fund 74.3

SWANSON, JONATHAN M. (b. 1888)

Felix Fuld (1868-1929) 1928
Bronze relief bust 9⅞″ diam. (25.0 cm)
Signed: "JMS"
Inscribed: "Felix/ Fuld; 1928"
Founder's mark: "Roman Bronze Works N-Y-"
Ex-collection: the artist; to donor, Westwood, N.J.
Gift of Frank I. Liveright 1940 40.416

SWARZ, SAHL (b. 1912)

Landmark III 1965
Iron and concrete 72″ (182.9 cm)
Signed: "Swarz" (monogram)
Ex-collection: purchased from the artist, Cliffside Park, N.J.
Purchase 1965 Felix Fuld Bequest Fund 65.150

Purchased from The Newark Museum sixth triennial Selected Works by
Contemporary New Jersey Artists, *1965.*

VONNOH, BESSIE ONAHOTEMA POTTER (1872-1955)

* The Dance 1897
Bronze figure 12¼″ (31.1 cm)
Signed: "Bessie Potter Vonnoh/ No XI."
Founder's mark: "Roman Bronze Works N-Y-"
Ex-collection: donor, Newark, N.J.
Gift of Joseph S. Isidor 1914 14.407

*Located replicas: Corcoran Gallery of Art, Washington, D.C.; American
Academy of Arts and Letters, New York, N.Y.; The Rochester Athenaeum,
Rochester, N.Y.; The Carnegie Institute, Pittsburgh, Pa.; The Brooklyn
Museum, Brooklyn, N.Y.; The Metropolitan Museum of Art,
New York, N.Y.*

*Butterflies
Bronze figure 13⅛″ (33.3 cm)
Signed: "Bessie Potter Vonnoh/ — (illeg.) VI"
Founder's mark: "Roman Bronze Works N-Y-"
Ex-collection: Bessie Potter Vonnoh Keys; to donor, Newark, N.J.
Gift of Joseph S. Isidor 1914 14.408

WAITZKIN, STELLA (b. 1920)

Untitled
Glass and plastic light box
A 11¼″x9″ (28.6x22.9 cm);
B 8″x6″x6″ (20.3x15.2x15.2 cm)
Unsigned
Ex-collection: the artist; to donor, Englewood Cliffs, N.J.
Gift of Stanley Bard 1971 71.147 A-B

WARD, JOHN QUINCY ADAMS (1830-1910)

Abraham Coles (1813-1891) 1897
Marble bust 28¾″ (73.0 cm)
Signed and dated: "J.Q.A. Ward/ 1897"
Inscribed: "Abraham.Coles/ A.M., M.D., Ph.D., LL.D./ 1813-1891"
Ex-collection: donor, Scotch Plains, N.J.
Gift of Dr. J. Ackerman Coles 1919 19.791

*Put into marble from the bronze in Washington Park, Newark, N.J.,
presumably by the Piccirilli Brothers. Dr. Coles was an outstanding
physician and surgeon in Newark. The titles of the books forming the base
are works by Coles:* The Microcosm and Other Poems *and* Latin Hymns
and Psalms. *(files)*

WARGER (19th century)

Abraham Lincoln (1809-1865)
Marble bust 26¾″ (67.9 cm)
Signed: "Warger"
Ex-collection: estate of Mrs. Benedict Prieth
Gift of Mrs. Henry J. Thielen 1921 21.2060

WHITE, THOMAS J. (1825-1902)

*Captain Jinks of the Horse Marines 1879 (attributed)
Painted wood figure 69½″ on 5½″ base (176.5 on 14.0 cm)
Unsigned
Ex-collection: Feary's Cigar Store, 134 Market Street, Newark, N.J.; to
donor, Newark, N.J.
Gift of Herbert E. Ehlers 1924 24.9

*Located replicas: Shelburne Museum, Inc., Shelburne, Vt. (63″ on 12″ base
[160.0 on 30.5 cm]); Smithsonian Institution, National Museum of
History and Technology, Washington, D.C.; an unlocated example was
reported in Detroit, Mich. (1937).*

*A possible caricature of Samuel A. Robb (1851-1928), a cigar and carousel
figure maker in New York City. He was the father-in-law and employer of
the artist. (cf. Fried)*

WHITNEY, ANNE (1821-1915)

***Lotus Eater** 1868
Plaster figure 35¼" (89.5 cm)
Unsigned
Ex-collection: remained in artist's summer home in Shelburne, N.H., until becoming property of donors, Newton, Mass., in 1961
Gift of Mr. and Mrs. Hugh S. Hince 1963 63.75

A second version, probably unique. The original Lotus Eater *was put into life-size marble in 1861-64 and is unlocated. A life-size plaster, 1862, was destroyed in shipment to Rome in 1867. (corres.)*

WINGATE, ARLINE (b. 1906)

Abraham Walkowitz (1880-1965) 1944
Plaster head tinted terra-cotta 11⅜" (28.9 cm)
Signed: "A W H"
Ex-collection: commissioned by the donor, Brooklyn, N.Y.
Gift of Abraham Walkowitz 1947 47.219

A unique piece, according to artist's correspondence. Exhibited in the Brooklyn Museum exhibition, One Hundred Artists and Walkowitz, *1944.*

WRIGHT, ALICE MORGAN (1881-1975)

***Lady Macbeth** 1920
Bronze figure on integral wood base 12⅜" (31.4 cm)
Unsigned
Ex-collection: the artist; to donor, Newark, N.J.
Gift of Joseph S. Isidor 1923 23.1860

Cast by Kunst for Milch Galleries in 1920. There were four plasters in the artist's studio in 1975, one of which is signed and dated: "Alice Morgan Wright 1918."

Located replicas: Folger Shakespeare Library, Washington, D.C.; artist's studio. (cf. Fahlman)

WRIGHT, PATIENCE LOVELL (1725-1786)

Admiral Richard Howe (1726-1799) ca. 1770 (attributed)
Wax portrait miniature 2½"x1¾" (6.4x4.4 cm)
Signed: "(monogram) Wright. F."
Ex-collection: donor, Bordentown, N.J.
Gift of Jay B. Tomlinson 1965 65.141

According to Charles Coleman Sellers (q.v.), there is no contemporary documentary evidence that portrait miniatures of this type attributed to Patience Lovell Wright were actually done by her.

YOUNG, MAHONRI M. (1877-1957)

Bovet Arthur — A Laborer 1904
Bronze figure 16" (40.6 cm)
Signed: "M.M.Young"
Founder's mark: "Roman Bronze Works N-Y-"
Labeled: Barnet Sculpture Prize
Ex-collection: with William Macbeth, New York, N.Y.
Purchase 1914 14.117

The portrait of a canal boatman, modelled in Paris. (cf. Cahill)

***The Rigger** 1917
Bronze figure 26⅝" (67.6 cm)
Signed: "Young" (plus thumb print)
Founder's mark: "Roman Bronze Works N-Y-"
Ex-collection: purchased from the artist, New York, N.Y., and cast to the order of The Newark Museum
Purchase 1917 Associated Membership Dues 17.819

Located replicas: Detroit Institute of Arts, Detroit, Mich. (signed "Young" plus thumb print); Brookgreen Gardens, Murrells Inlet, S.C., 1922 (signed "Mahonri" plus thumb print)

After 1920, works were generally signed "Mahonri." (files) Also referred to by the artist as Steel Man *and* The Iron Worker. *The head is a caricature of the marine painter, Paul Dougherty (1877-1947). (cf. Cahill)*

The Rigger 1917 (or earlier)
Bronzed plaster figure 27¼" (69.2 cm)
Signed: "Young"
Ex-collection: donor, New York, N.Y.
Gift of the artist 1917 17.1046

ZORACH, WILLIAM (b. Lithuania 1889-1966)

Head of a Woman 1922-23
Pink Tennessee marble 13⅞" (35.2 cm)
Unsigned
Ex-collection: purchased from the artist, New York, N.Y.
Gift of Mr. and Mrs. Felix Fuld 1928 28.333

A plaster cast exists. The artist stated, "This head happens to be the second piece I carved in stone – the first was Childs Head. This head owned by The Newark Museum is not a portrait in the usual sense of any one person, but made from pencil studies of two different women and is perhaps a combination of the qualities of the two different women plus very much the quality of myself." (corres.)

One of the two women has been identified as the artist, Martha Ryther (1896-1981) [Mrs. Morris Kantor] by Mrs. Kantor and Roberta K. Tarbell. (corres.)

In addition to a sizeable collection of Flanagan plaquettes and medals, The Newark Museum has a large collection of medals, including some by the following artists represented in the sculpture collection:

Adams, Herbert (1858-1945); Beach, Chester (1881-1936); French, Daniel Chester (1850-1931); Hoffman, Malvina (1887-1966); Howard, Cecil (1866-1956); Huntington, Anna Vaughn Hyatt (1876-1973); Jennewein, Carl Paul (1890-1978); Juszko, Jeno (880-1954); Konti, Isidore (1862-1938); McKenzie, Robert Tait (1867-1938); Mestrovic, Ivan (1883-1962); Saint-Gaudens, Augustus (1848-1907); Young, Mahonri (1877-1957)

Index of Native American Artists

Index of American Folk Art

TWO-DIMENSIONAL WORKS

ARTIST UNKNOWN

Papyrtomania 17.34
Birds and Flowers (tinsel) 21.557
Mount Vernon 28.1310
Portrait of Henry Knoerr 29.438
Flowers in Vase 30.535
Parrot on Cherry Branch 30.536
Girl with Flowers 31.145
Baby with Cane 31.146
Mother and Child 31.147
Trinity Church, Newark 31.414
Responding to an Alarm 32.87
Portrait of Henry Anderson 36.82
Bowl of Flowers (Theorem) 36.86
Still Life (Theorem) 36.87
Landscape with Castle (Theorem) 36.88
Civil War Sketches 36.695 A-D
Still Life (Theorem) 37.123
Portrait of "The Goying Child" 38.213
Seated Woman (Pin Prick) 38.424
Hall House 39.264
Bookmark 40.158
Still Life 40.159
Portrait of a Black Man 40.162
Frakturs 43.246-9
Broad and Market Streets 44.84
Shippen Home 44.209
Stephen Crane Home 45.264
Portrait of Josiah James 46.158
Portrait of "Becker" Woman 50.2144
Portrait of "Becker" Man 50.2145
Portrait of an Architect 51.126
Nash House 54.118
Lady of The Lake 55.130
Portrait of Joseph Dunderdale 56.168
Portrait of Mrs. Joseph Dunderdale 56.169
Waters House 58.20
Little Henry Hills 61.21
Portrait of Carrie L. Pridham 64.242
Birthday Regester: Abigail Clark 66.408
Three Children with Their Dog 66.409
Mourning Picture: Raymond Family 67.55
Still Life (tinsel) 67.69
Three Cummins Children 68.216
Hudson River (after W.H. Bartlett) 73.85
Still Life 73.86
Portrait of a Man 73.88
Voyage of Life: Youth (after Cole) 73.90
Fraktur: Ann Elizabeth Gill 77.116
Fraktur: Thomas S. Gill 77.441

ANDERSON LIMNER
BERRY, JOHNNIE E.
BURNETT, SUSAN
CARTER, CALEB
CREEMER
DALZEL, M. J.
EVANS, J.
GOODELL, IRA CHAFFEE
GULICK, HENRY
HICKS, EDWARD
HUTH, ABRAHAM
JENNY, JOHANN
JOHNSTON, JOSHUA
JOY, JOSEPHINE
LITWAK, ISRAEL
MacLAREN, SUSANNA
McDOUGALL, JOHN
McLAUGHLIN, W.L.
PHILLIPS, AMMI
PICKETT, JOSEPH
PRIOR-HAMBLEN SCHOOL
ROCKWELL, HORACE
STOCK, JOSEPH WHITING
STREET, ROBERT
TAINTER
VANDERPOOL, JAMES
VANDERPOOL, JOHN
WATERHOUSE
WHITNEY, L.
WILLIAMS, MICAH

SCULPTURE

ARTIST UNKNOWN

Bootmaker Sign 00.273
Barnyard 31.469
Cat 31.967
Lady 31.968
Decoy 38.350
Fish Weathervane 38.362
Quail and Kegs 40.148
Praying Man 40.149
Pump 40.150
Figurehead 44.161
Decoy 44.189
Finial Eagle 52.113
Horse Weathervane 52.114
Horse 56.60
Cigarstore Figure 58.165
Architectural Detail 61.23
Figurehead 62.142
Gravestone 62.143
Horse 66.402
Finial Eagle 66.638
Rooster Weathervane 67.1
Finial Eagle 68.240
Ram Weathervane 69.21
Rooster Weathervane 70.78
Finial Horse 73.55
Jeweler's Sign 75.197
Decoys 77.136-8
Dragonfly Weathervane 77.164

CONDIT, WILLIAM
DAVID, THOMAS
EDMONDSON, WILLIAM
HIGGINSON, HENRY
NORTON, FRANK L.
SCHIMMEL, WILHELM
WHITE, THOMAS

Note: Other Folk Art objects: quilts, embroidered pictures, samplers, chalkware, etc., are included in the Decorative Arts Collection.

Index of Illustrations

(s) Indicates sculpture
(c) Indicates that painting or sculpture
 is reproduced in color

Selected Bibliography

American Federation of Arts. *John Frederick Kensett.* New Haven: Eastern Press, 1968.

Armstrong, Tom, et al. *200 Years of American Sculpture* (exhibition catalogue). Boston: David R. Godine in cooperation with the Whitney Museum of American Art, 1976.

Baur, John I. H. *Eastman Johnson, 1824-1906: An American Genre Painter.* Brooklyn: Institute of Arts and Sciences, 1940.

————. *Theodore Robinson, 1852-1896.* Brooklyn: Brooklyn Museum, 1946.

Block, Maurice E. *George Caleb Bingham.* Berkeley: University of California Press, 1967.

Bolton, Theodore, and Cortelyou, Irwin F. *Ezra Ames of Albany.* New York: New York Historical Society, 1955.

Bolton-Smith, Robin, and Truettner, William. *Lilly Martin Spencer: The Joys of Sentiment.* Washington, D.C.: Smithsonian Institution Press, 1973.

Borglum, Mary, and Casey, Robert J. *Give The Man Room.* New York: The Bobbs-Merrill Co., Inc., 1952.

Born, Wolfgang. *Still-Life Painting in America.* New York: Oxford University Press, 1947.

Bradshaw, Elinor Robinson. *American Folk Art in the Collection of The Newark Museum.* The Museum New Series vol. 19 (Summer-Fall 1967). Newark: The Newark Museum.

Breeskin, Adelyn D. *Mary Cassatt, 1844-1926* (exhibition catalogue). Washington, D.C.: National Gallery of Art, 1970.

Broder, Patricia Janis. *Bronzes of The American West.* New York: Harry N. Abrams, Inc., 1974.

Brooklyn Museum. *One Hundred Artists and Walkowitz* (exhibition checklist). Brooklyn: Brooklyn Museum, 1944.

Cahill, Holger. *A Museum in Action: Catalogue of an Exhibition of American Painting and Sculpture from the Museum's Collections* (exhibition catalogue). Newark: The Newark Museum, 1944.

Christ-Janer, Albert. *Boardman Robinson.* Chicago: University of Chicago Press, 1946.

Cincinnati Art Museum. *Paintings by the Peale Family* (exhibition catalogue). Cincinnati: Cincinnati Art Museum, 1954.

Colley, Edna Ida. "An Exhibition of Wood Carvings and Bronzes." *Fine Arts Journal* 34 (April 1916): 183-187.

Cortelyou, Irwin F. "Micah Williams, New Jersey Primitive Artist." *The Monmouth Historian Journal of the Monmouth County Historical Association* (Spring 1974): 4-15.

Crane, Sylvia E. *White Silence.* Coral Gables: University of Miami Press, 1972.

Craven, Wayne. *Sculpture in America.* New York: Thomas Y. Crowell Co., 1968.

Daingerfield, Elliot. *Life, Art, and Letters of George Inness.* New York: The Century Co., 1917.

Dana, John Cotton. *American Art; How it can be made to Flourish.* The Hill-of-Corn Series, No. 1. Woodstock, Vt.: The Elm Tree Press, 1929.

————. "The Museum as an Art Patron." *Creative Art* 4 (March 1929): pp. xxiii-xxvi.

Dickason, David H. *William Williams Novelist and Painter of Colonial America 1727-1791.* Bloomington: Indiana University Press, 1970.

Dickson, Harold Edward. *John Wesley Jarvis: American Painter 1780-1840.* New York: New York Historical Society, 1949.

Eastman, Crystal. "Charles Haag, An Immigrant Sculptor of His Kind." *The Chautauquan* 48 (October 1907): 249-262.

Exhibition of the Work of John La Farge. New York: Metropolitan Museum of Art, 1936.

Fahlman, Betsy. "Alice Morgan Wright 1881-1925." *Avant-Garde Painting and Sculpture in America 1910-1925* (exhibition catalogue). Wilmington: University of Delaware and Delaware Art Museum, 1975, p. 152.

Fairleigh Dickinson University. *The Works of Sir Jacob Epstein From the Collection of Mr. Edward P. Schinman.* Rutherford: Fairleigh Dickinson University Press, 1967.

Ferber, Linda. *William Trost Richards: American Landscape and Marine Painter* (exhibition catalogue). Brooklyn: Brooklyn Museum, 1973.

Ford, Alice. *John James Audubon.* Norman: University of Oklahoma Press, 1964.

Forsyth, Robert J. *John B. Flannagan: His Life and Works.* Ph.D. dissertation, University of Minnesota, 1965.

Frankenstein, Alfred Victor. *After the Hunt: William Harnet and Other American Still Life Painters, 1870-1900.* 2nd ed., rev. Berkeley: University of California Press, 1969.

Freeman, Richard B. *N. Spencer.* Lexington: University of Kentucky, 1965.

Fried, Frederick. *Artists in Wood.* New York: Clarkson N. Potter, Inc., 1970.

Fries, Waldemar H. "John James Audubon: Some Remarks on His Writing." *The Princeton University Library Chronicle* 21 (Autumn 1959-Winter 1960): 1-7.

Gale, Robert L. *Thomas Crawford American Sculptor.* Pittsburgh: University of Pittsburgh Press, 1964.

Gardner, Albert TenEyck. *American Sculpture; A Catalogue of the Collection of the Metropolitan Museum of Art.* Greenwich: New York Graphic Society, 1965.

Gaston Lachaise Retrospective Exhibition (exhibition catalogue). New York: The Museum of Modern Art, 1935.

George Luks 1866-1933 an Exhibition of Paintings and Drawings Dating from 1889 to 1931. (exhibition catalogue). Utica: Munson-Williams-Proctor Institute, 1973.

Gerdts, William H. *Additions to the Museum's Collections of American Paintings and Sculpture: 1956-1960.* The Museum New Series vol. 13 (Winter-Spring 1961). Newark: The Newark Museum.

_____. *Additions to the Museum's Collections of Painting and Sculpture: European and American Acquired Since 1950.* The Museum New Series vol. 8 (Spring-Summer 1956). Newark: The Newark Museum.

_____. *A Survey of American Sculpture: Late 18th Century to 1962* (exhibition catalogue). Newark: The Newark Museum, 1962.

_____. *Church, Healy, McEntee.* The Museum New Series vol. 10 (Winter 1958). Newark: The Newark Museum.

_____. *The Great American Nude.* New York: Praeger Publishers Inc., 1974.

_____. *Painting and Sculpture in New Jersey.* Princeton: D. Van Nostrand Co. Inc., 1964.

_____. *People and Places of New Jersey.* The Museum New Series vol. 15 (Spring-Summer 1963). Newark: The Newark Museum.

_____. *Sculpture by 19th Century American Artists.* The Museum New Series vol. 14 (Fall 1962). Newark: The Newark Museum.

Goodrich, Lloyd. *Reginald Marsh* (exhibition catalogue). New York: Whitney Museum of American Art, 1955.

_____. *Thomas Eakins, His Life and Work.* New York: Whitney Museum of American Art, 1933.

Grubar, Francis S. *William Ranney Painter of the Early West.* Torino, Italy: Tipografia, for the Corcoran Gallery of Art, 1965.

_____. *William Tylee Ranney: Painter of the Early West.* New York: Clarkson N. Potter, Inc., 1962.

Hendricks, Gordon. *Albert Bierstadt: Painter of the American West.* New York: Harry N. Abrams, Inc., 1973.

_____. *A Bierstadt* (exhibition catalogue). Fort Worth: Amon Carter Museum, 1972.

_____. *The Life and Work of Thomas Eakins.* New York: Grossman Publishers, 1974.

_____. "Eakins' William Rush Carving His Allegorical Statue of the Schuylkill." *Art Quarterly* 31 (Winter 1968): 383-404.

Hills, Patricia. *Eastman Johnson* (exhibition catalogue). New York: Whitney Museum of American Art, 1972.

Hirshhorn Museum and Sculpture Garden. *Selected Paintings and Sculpture from the Hirshhorn Museum and Sculpture Garden.* New York: Harry N. Abrams, Inc., 1974.

Hoffman, Malvina. *Heads and Tales.* New York: Charles Scribner's Sons, 1936.

Holbridge, Barbara C., and Lawrence B. *Ammi Phillips: Portrait Painter 1788-1865.* New York: C.N. Potter, 1968.

Ireland, LeRoy. *The Works of George Inness.* Austin: University of Texas Press, 1965.

Jaffee, Irma B. *Joseph Stella.* Cambridge: Harvard University Press, 1970.

J.W. Fiske 1893. The American Historical Catalog Collection. Princeton: The Pine Press, 1971.

Kirstein, Lincoln. *Elie Nadelman.* New York: The Eakins Press, 1973.

Kraemer, Ruth S. *Drawings by Benjamin West and His Son Raphael Lamar West.* New York: Pierpont Morgan Library, 1975.

Landgren, Marchal E. *Robert L. Newman.* Washington, D.C.: Smithsonian Institution Press for the National Collection of Fine Arts, 1974.

Lawall, David B. *Asher Brown Durand; His Art and Art Theory in Relation to His Times.* New York: Garland Publishing Inc., 1977.

Lipman, Jean, and Winchester, Alice. *The Flowering of American Folk Art 1776-1876.* New York: Viking Press for Whitney Museum of American Art, 1974.

Macbeth Gallery. *Theodore Robinson.* New York: Macbeth Gallery, 1895.

Madigan, Mary Jean Smith. *The Sculpture of Isidore Konti 1862-1938* (exhibition catalogue). Yonkers, N.Y.: Hudson River Museum, 1975.

McCausland, Elizabeth. "The Life and Work of Edward Lamson Henry." *New York State Museum Bulletin,* 339 (1945) p. 36. Albany: New York State Museum.

McHenry, Margaret. *Thomas Eakins Who Painted.* Orland, Pa.: privately printed, 1946.

Middleton, Margaret Simons. *Jeremiah Theus, Colonial Artist of Charles Town.* Columbia, S.C.: University of South Carolina Press, 1953.

Miestchaninoff Sculpture and Drawings (exhibition catalogue). Los Angeles: Los Angeles County Museum, 1955.

Moak, Peter. *The Robert Laurent Memorial Exhibition* (exhibition catalogue). Durham, N.H.: University of New Hampshire, 1972-1973.

Motter, Persis. *The Marcus L. Ward Bequest.* The Museum New Series vol. 1 (July 1949). Newark: The Newark Museum.

Mount, Charles Merrill. *John Singer Sargent.* New York: Norton, 1955.

National Gallery of Canada. *Ernest Lawson.* Ottawa: National Gallery of Canada, 1967.

The Newark Museum. *Twentieth Century Sculpture.* The Museum New Series vol. 2 (Summer-Fall 1950). Newark: The Newark Museum.

Nordland, Gerald. *Gaston Lachaise.* New York: George Braziller, 1974.

The R.W. Norton Art Gallery. *American Sculpture: a Tenth Anniversary Exhibition* (catalogue). Shreveport, La.: The R. W. North Art Gallery, 1976.

Park, Lawrence. *Gilbert Stuart.* New York: W.E. Rudge, 1926.

Payne, Elizabeth Rogers. "Anne Whitney, Sculptor." *The Art Quarterly* 25 (Autumn 1962): 244-261.

Piwonka, Ruth. *A Catalogue and Checklist of Portraits Done in Columbia County and Elsewhere by Ira C. Goodell (1800-ca. 1875).* Kinderhook, N.Y.: The Columbia County Historical Society, 1979.

Preston, Stuart. "A Puritan in Paradise." *Art Studies for an Editor: 25 Essays in Memory of Milton S. Fox.* Edited by Egan, Patricia, and Hartt, Frederick. New York: Harry N. Abrams, Inc., 1975.

Prime, Samuel I. *The Life of Samuel F.B. Morse.* New York: Appleton, 1875.

Prown, Jules David. *John Singleton Copley.* Cambridge: Harvard University Press for the National Gallery of Art, 1966.

Proske, Beatrice Gilman. *Brookgreen Gardens Sculpture.* Murrells Inlet, S.C..: Brookgreen Gardens, 1968.

Quick, Michael. *American Expatriate Painters of the Late Nineteenth Century* (exhibition catalogue). Dayton, Ohio: The Dayton Art Institute, 1976, p. 88

Reich, Sheldon. *John Marin: A Stylistic Analysis and Catalogue Raisonné.* Tucson: University of Arizona Press, 1970.

Reynolds, Donald Martin. *Hiram Powers and His Ideal Sculpture.* New York: Garland Publishing Inc., 1977.

Rice, Howard C., Jr. ed. "The World of John James Audubon" (exhibition catalogue). *The Princeton University Library Chronicle* 21 (Autumn 1959-Spring 1960). Princeton: Princeton University Library.

Richardson, Edgar Preston. *Washington Allston, a Study of the Romantic Artist in America.* Chicago: University of Chicago Press, 1948.

Richman, Michael. *Daniel Chester French: An American Sculptor* (exhibition catalogue). New York: The Metropolitan Museum of Art for the National Trust for Historic Preservation, 1976-1977.

Robinson, Elinor. *American Folk Sculpture* (exhibition catalogue). Newark: The Newark Museum, 1931-1932.

Rogers, Millard F., Jr. *Randolph Rogers: American Sculptor in Rome.* Amherst: University of Massachusetts Press, 1971.

Rosenzweig, Phyllis D. *The Thomas Eakins Collection of The Hirshhorn Museum and Sculpture Garden.* Washington, D.C.: Smithsonian Institution Press, 1977.

Ross, Marvin Chauncey, and Rutledge, Anna Wells. *A Catalogue of the Work of Henry Rinehart, Maryland Sculptor, 1825-1874.* Baltimore: The Walters Art Gallery and the Peabody Institute, 1948.

Savage, Gail; Savage, Norbert H.,; and Sparks, Esther. *Three New England Watercolor Painters.* Chicago: The Art Institute of Chicago, 1974.

Schaefer, Rudolf. *J.E. Buttersworth: 19th Century Marine Painter.* Mystic. Conn.: Mystic Seaport, 1975.

The Sculpture of Gaston Lachaise. New York: The Eakins Press, 1967.

Sellers, Charles Coleman. *Patience Wright, American Artist and Spy.* Middletown, Conn.: Wesleyan University Press, 1976.

_____. "Charles Willson Peale with Patron and Populace." *Transactions of the American Philosophical Society New Series* 59 (May 1969). Philadelphia: American Philosophical Society.

_____. "Portraits and Miniatures by Charles Willson Peale." *Transactions of the American Philosophical Society* 42 (May 1969). Philadelphia: American Philosophical Society.

Sizer, Theodore. *The Works of Colonel John Trumbull.* New Haven: Yale University Press, 1950.

Soria, Regina. *Elihu Vedder, American Visionary Artist in Rome* (1836-1923). Cranbury, N.J.: Fairleigh Dickinson Press, 1970.

Spargo, John. "Charles Haag, Sculptor of Toil, Kindred Spirit to Millet and Meunier." *The Craftsman* 10 (July 1906): 432-442.

Spencer, Anne, and Thurlow, Fearn. *As the Seasons Turn: Southwest Indian Easel Painting and Related Arts* (exhibition catalogue). The Newark Museum Quarterly vol. 28 (Spring 1977). Newark: The Newark Museum.

Stebbins, Theodore. *The Life and Works of Martin Johnson Heade.* New Haven: Yale University Press, 1975.

Stein, Roger B. *Seascape and the American Imagination* (exhibition catalogue). New York: Whitney Museum of American Art, 1975.

Talbot, William S. *Jasper F. Cropsey 1823-1900.* Washington, D.C.: The Smithsonian Institution Press, 1970.

_____. *Jasper F. Cropsey 1823-1900.* New York: Garland Publishing Inc., 1977.

Tarbell, Roberta K. *Catalogue Raisonné of William Zorach's Carved Sculpture.* Ph.D. Dissertation, University of Delaware, 1976.

_____. "William Zorach (1889-1966)." *Avant-Garde Painting and Sculpture in America 1910-1925* (exhibition catalogue). Wilmington: University of Delaware and Delaware Art Museum, 1975, p. 158.

Tuchman, Henry. *Book of the Artists.* New York: G. Putnam and Son, 1867.

Tyler, Parker. *Florine Stettheimer: A Life in Art.* New York: Farrar, Straus, 1963.

Valentiner, W.R. Introduction to *Letters of John B. Flannagan.* New York: Curt Valentin, 1942.

Vedder, Elihu. *The Digressions of "V".* Boston: Houghton, Mifflin and Co., 1910.

Wallace, David H. *John Rogers, the People's Sculptor.* Middletown: Wesleyan University Press, 1967.

Weinberg, H. Barbara. *The Decorative Work of John LaFarge.* New York: Garland Publishing Inc., 1977.

Weiss, Ila. *Sanford Robinson Gifford.* New York: Garland Publishing Inc., 1977.

Whitney Museum of American Art. *Catalogue of the Collection.* New York: Whitney Museum of American Art, 1975.

Willis, Nathaniel Parker. *American Scenery of Land, Lake and River.* London: Virtue, 1840.

Wilmerding, John. *Fitz Hugh Lane.* Salem, Mass.: Essex Institute, 1964.

_____. *Fitz Hugh Lane.* New York: Praeger, 1971.

Young, Dorothy Weir. *Julian Alden Weir: An Appreciation of His Life and Works.* New York: The Century Club, 1921.